NORMAN ROCKWELL

My Adventures as an Illustrator

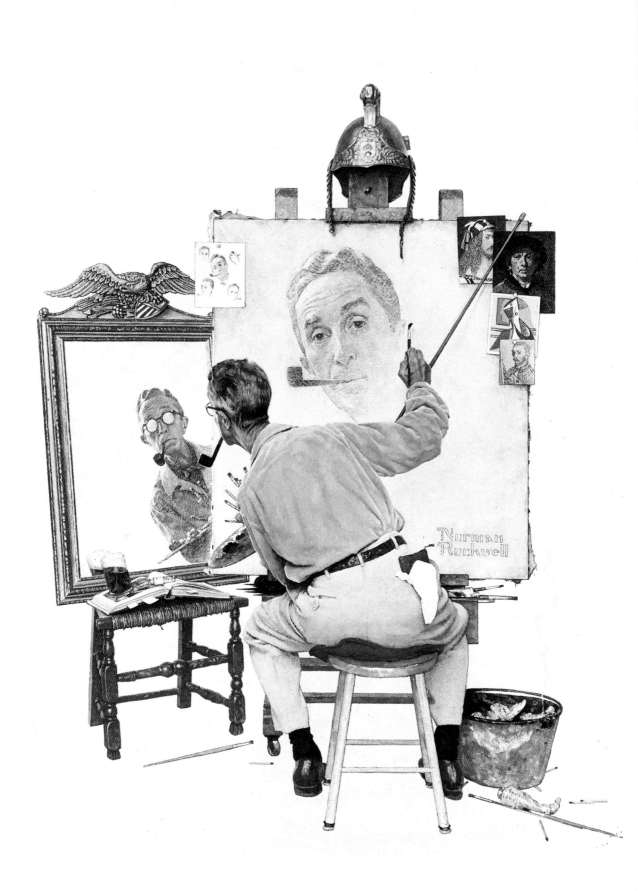

NORMAN ROCKWELL

My Adventures as an Illustrator

By Norman Rockwell,
as told to Tom Rockwell
With a *Foreword* and *Afterword* by Tom Rockwell

Harry N. Abrams, Inc., *Publishers*, New York

Editor: Eric Himmel

Designer: Dirk Luykx

Rights and Reproductions: Barbara Lyons

Frontispiece: *Triple Self-Portrait,* oil painting for *Saturday Evening Post* cover (13 February 1960)

Library of Congress Cataloging-in-Publication Data
Rockwell, Norman, 1894–1978.
　Norman Rockwell, my adventures as an illustrator/by Norman Rockwell, as told to Thomas Rockwell; with an afterword by Thomas Rockwell.
　　p. cm.
　Includes index.
ISBN 0–8109–1563–4
1. Rockwell, Norman, 1894–1978.　2. Illustrators—United States—Biography.　3. Painting, American.　4. Painting, Modern—20th century—United States.　I. Rockwell, Thomas, 1933–　　II. Title.
ND237.R68A2 1988
759.13—dc19
[B]　　　　　　　　　　　　　　　　　　　　88–3366

A Times Mirror Company

Printed and bound in Japan

Contents

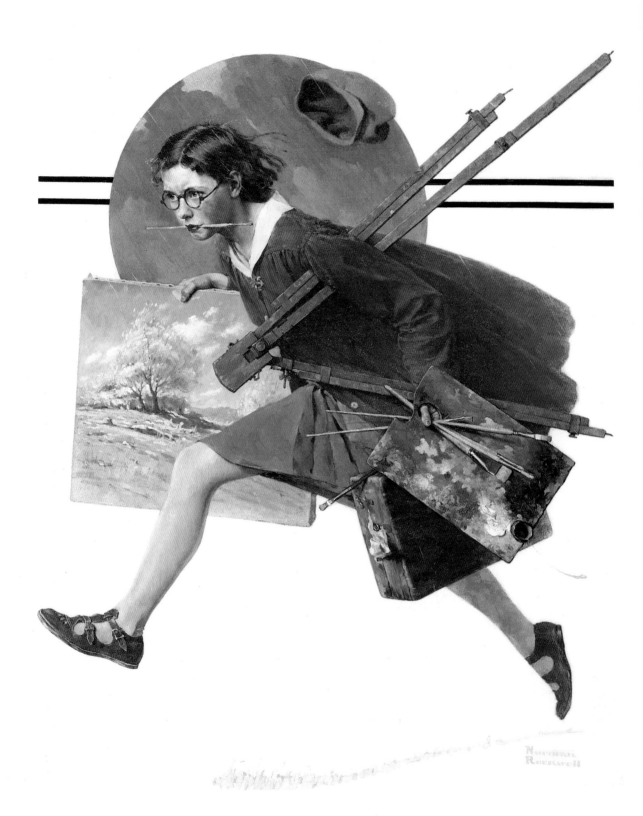

Girl Running with Wet Canvas, oil painting for *Saturday Evening Post* cover (12 April 1930)

Foreword

FOR THIS new edition of my father's autobiography, I have added a final chapter continuing his life from 1960, when the autobiography was first published, to 1978, when he died. A few minor corrections have been made in the text, but no substantive changes have been made even in those areas where such changes would be largely factual—for instance, my father's mistaken impression that he had been in the Navy during World War I for a year and a half rather than, as I have learned since, only about four months. I have also respected my father's choice not to write about certain things, such as my mother's struggles with alcohol and other problems. His autobiography was the way he chose to see his own life, and it seemed best to leave it that way.

A note on how this book came to be written: Doubleday, the original publisher of the autobiography, had arranged with the *Post* for use of the magazine's color plates of my father's covers, and the book as originally conceived was to have been a book of pictures with a short text by my father, rather than a full-blown autobiography. He found he did not like working with the writer sent to help him, and so it was arranged that I would help instead. He started by talking into a dictaphone all by himself in the kitchen after supper; even a book about his life and work couldn't be allowed to interfere with his work. But he wasn't comfortable with that arrangement, either. He said it was like talking to himself, and I think it made him nervous to be telling the story of his life, in effect, to Charlotte Markham, who transcribed the tapes for us, as well as to me. For instance, he used to add parenthetically about some anecdote, "I don't think this should get in the book," or half seriously tell Charlotte not to listen to something risqué. An example of both, which we didn't put in the book: My grandfather used to say of his brother Sam (my father's uncle) that he would do business with a man and then go home and make love to the man's wife. So finally we gave up the dictaphone and I just took notes while he talked. When I thought we had accumulated enough material, I would organize and write it up and then he would read and correct it, often adding sentences or remembering other things to put in. A lot of his memories he had already organized into stories, often funny, since he liked to be entertaining and kid himself. After a few months we realized we had more than the text for a book of pictures, and the publisher agreed to publish two books: the *Norman Rockwell Album*, a book of pictures with incidental text, which is now out of print, and this autobiography, which was basically text, but is here reissued by Harry N. Abrams with numerous illustrations.

Finally, I would like to take this opportunity to thank Barbara Lyons of Harry N. Abrams for all of her generous efforts on behalf of my father over the years, without which this and many other books would not have been published.

TOM ROCKWELL

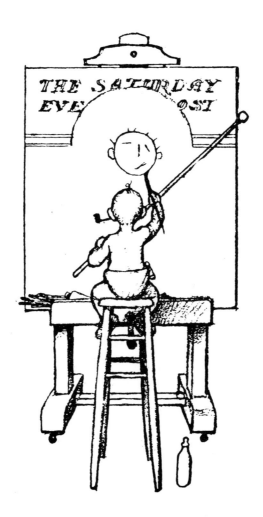

1

"Scairt as a rabbit, bold as a bear"

THERE are, to begin with, scattered memories of my childhood. Auntie Paddock and her pince-nez, the horse-drawn fire engines clattering over the cobblestones, the vacant lots, playing on the stoops of brownstone fronts, sitting at the dining-room table in my family's apartment on a winter's evening, my head scrunched down on one elbow, a pencil clutched in my fist, drawing a picture of Mr. Micawber while my father reads *David Copperfield*. My mother sewing, her chair drawn up to the table to catch the light from the gas lamp with the large green glass shade fringed with red silk ribbons which hung above the center of the table; my brother Jarvis doing his homework beside me. And the dark room outside the wavering circle of gaslight; the ticking of the clock on the ornate plaster mantelpiece; the low rumble of a cart and the gruff snort of a horse in the street below. I'd draw Mr. Micawber's head, smudge it, erase it and start over, my tongue licking over my upper lip as I concentrated. Then I'd ask my father to read the description of Mr. Micawber again. Where it told about his head. And my father would read: ". . . a stoutish, middle-aged person, in a brown surtout and black tights and shoes, with no more hair on his head (which was a large one, and very shining) than there is upon an egg, and with a very extensive face . . ." So I'd draw Mr. Micawber again, struggling with his large, shiny head, as my father read on: " 'My address,' said Mr. Micawber, 'is Windsor Terrace, City Road. I—in short,' said Mr. Micawber, with the same genteel air, and in another burst of confidence—'I live there.' "

 Or walking up Prospect Street in Mamaroneck to school, my scrawny neck protruding from the high, upright collar of my grandfather's paddock coat, which had been handed down to me. I hated that coat. Of a heavy black cloth, it was double-breasted with a wide, pleated skirt, broad velvet lapels, and immense velvet cuffs with brass buttons. At first I'd been sort of proud of it. No other kid in school had such a magnificent coat. But it was too big for me—the skirt swept around my ankles, the

cuffs lapped against my knuckles—and pretty soon it became the laughingstock of the whole school. But my mother insisted I wear it. "The coat is warm and well made, Norman Percevel," she'd say when she caught me trying to sneak out of the house without it in the mornings. "I won't hear another word about it." (That's a queer feeling: to imagine myself looking up—four feet tall in knickers—at my mother.) All winter that coat tortured me; it was a burden to me. So the first warm day of spring I lugged it out to the back yard, poured turpentine on it, and burned it. I can see myself, squatting on my heels before my grandfather's paddock coat as the flames eat into it, poking it with a stick, stirring it to make sure *nothing* is left, my boy's face grim and serious.

Adventures. Riding my bicycle up to the White Plains Fair. (And as I remember that day I look down at my feet, sitting like two old respectable gentlemen under the table. It's ridiculous. Those same feet pressing on the pedals of a bicycle fifty-five years ago, the metal biting into my insteps as I stood up to pump harder on a hill.) And walking around the fairgrounds, licking a froth of pink spun candy, jostled by the crowds. (Not, as now, by shoulders, but elbows and hips. And hardly able to see the sky with all those grownups towering above me.) After a while, when I'd run through my fifty cents, I wandered over to the side show and stared at the gaudy posters—the fat lady, the thin man, the midgets, the snake charmer, fire-eater, sword swallower, the lion-headed boy. And the barker for Amy the Wild Woman, who was lolling about under the posters with the stub of a fat cigar in his teeth, noticing me, said, "Cummere, boy." And he said he'd give me a dollar if I'd pretend to be caught by the wild woman. Business was slow; he needed a crowd puller. I remember I was bashful and didn't know what to say (and my mother had told me not to speak to strangers). So he took my hand and led me up the stairway to the walk around the top of the wooden pit where Amy the Wild Woman was incarcerated and introduced me to her—a colored woman with long black hair, dressed in a tattered, faded leopard skin, sitting on a pile of white bones, her legs manacled in chains. "Stand here, boy," said the barker. "Ready, Amy?" "Okey-dokey," said Amy, smiling at me and mussing her hair.

The barker strode to the head of the stairs, banged his cane on a bass drum tied to the outside of the rail, and bellowed, "Amy, *Amy*, AMY-the-wild-woman. See Amy, *Amy*, AMY-the-wild-woman. There's many wild women at large but Amy, *Amy*, AMY'S the only one in captivity. When captured, her skin was white as the driven snow, but long captivity has turned it black. See Amy, *Amy*, AMY-the-wild-woman. She dines on raw flesh and blood." A crowd began to gather. The barker beat a booming tattoo on the drum and muttered under his breath, "Let 'er go, Amy."

And Amy let out a bloodcurdling whoop, thumped a bone against the side of the pit, slung it high into the air, and grabbed my foot. Snarling and shrieking, she began to chew and tug on it as if she wanted to drag me into the pit and eat me. I clutched the railing at the edge of the pit and cried out fearfully. At that the barker spun around and, snatching up a bull whip, belabored Amy about the shoulders, shouting, "Let 'im go, let the poor boy go! Let 'im loose, I say." And he lashed her with the whip turning to the crowd, his face crimson. "She don't unnerstand, folks,

she don't unnerstand!" Then back to Amy, who all the while was howling and chewing on my foot. "Let 'im go. *Down*, beast, *down*! Let the poor child go!" I began to scream, really terror-stricken. "Damme for a fool," yelled the barker. "I've gone and forgot her two o'clock feed. She's hungry!"

Just as I was about to faint with terror and slide meekly through the railing, Amy released my foot and, dropping back into the pit, began to fling the bones about, growling and roaring. I sank down against the outside railing. The barker bellowed, "Amy, *Amy*, AMY-the-wild-woman. Gather round folks, gather round. Quarter a look. Tigers raised her up, wolves suckled her. Gather round." The people thronged up the stairs. Amy rattled her chains and howled.

Afterward, when the crowd had left, the barker dried my tears (with a clean white handkerchief which the now subdued Amy had taken from the bosom of her leopard skin) and took me to a refreshment stand where he bought me all the lemonade and popcorn I could eat. When I'd finished he led me back to the pit. "I gotta go home," I said, and began to snuffle. "You ain't *scared*?" asked the barker. "I wanta go home," I said, tears starting in my eyes. "Why, lookey here," said the barker, "she ain't gonna hurt ya. Here, Amy, shake hands with the boy." Amy and I shook hands. She reached up and ruffled my hair. "Don't you be scairt, boy," she said. "Iz all jus' an act." "Yeah," said the barker, "c'mon, I'll give ya ten cents extra." And he led me to the railing around the pit.

But when Amy the Wild Woman grabbed my foot I got frightened all over again and hung onto the railing for dear life, bawling my head off. And the third,

Oil painting for the story "Willie Takes a Step" by Don Marquis (*American Magazine*, January 1935). Rockwell chose to illustrate the scene where Willie meets the artists at a county fair

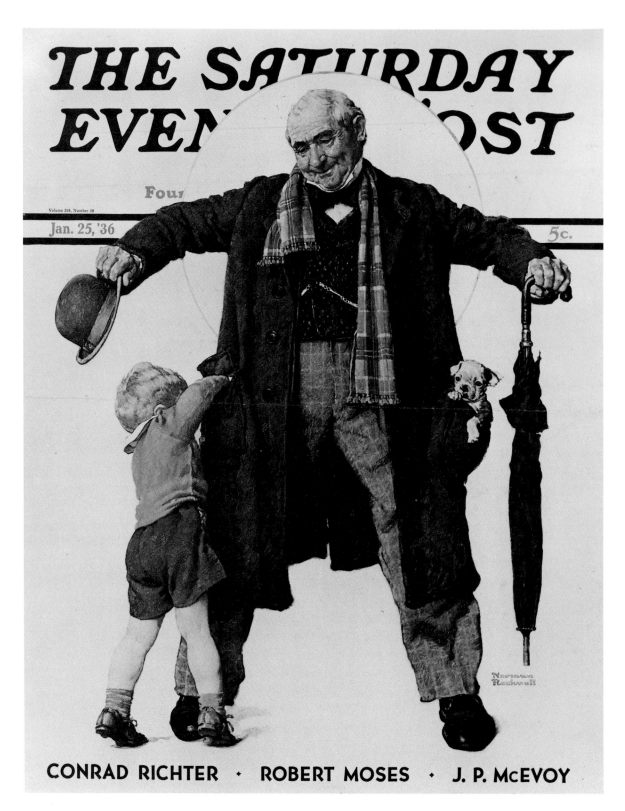

Little Boy Reaching in Grandfather's Overcoat, Saturday Evening Post cover (25 January 1936)

fourth, and fifth times we did it the same thing happened. I just couldn't get used to Amy's howls and yankings. Then suddenly, in the midst of a scream of terror, I discovered that I was rather enjoying myself. I looked down at Amy. She winked at me, chewing ferociously on my shoe. And after that, though I still carried on as loudly as before, I wasn't frightened.

Late in the afternoon I told the barker I had to go home, "But could I come back tomorrow?" I said, looking up into his beefy red face and feeling very proud of myself. "Ain't he the sketch, Amy?" the barker said. Amy laughed. "Scairt as a rabbit one minute, bold as a bear the next." "*Can* I come back?" I insisted. "Boy," said the barker, "'f you don't, I'll feed ya to the wild woman. You're the best mangled boy we ever had. Ain't he, Amy?" "Sure God," said Amy.

So the next day I was back at the pit, yowling and crying. That evening I rode home with two dollars and ten cents in my pocket, worn out, hoarse, triumphant, my heel sore where Amy the Wild Woman had rubbed it against the edge of the pit while chewing on my foot, the setting sun hot on my neck.

But behind these and all my other memories there are pictures. 305 *Post* covers; illustrations, ads, posters. The story of my life is, really, the story of my pictures and how I made them. Because, in one way or another, everything I have ever seen or done has gone into my pictures.

Every so often, usually when I've bogged down on a picture—the story I'm trying to tell is muddy, unclear; I can't work it out; I'm struggling at a blind impasse—I lay out reproductions of the 305 *Post* covers I've done since 1916 in neat rows on the floor of my studio and, walking around among them, try to decide if my work has progressed in all those years. If it hasn't, I say to myself, I'm dead, washed up; if it's the same as it was in 1916, it's no good. But as I look at the covers I can't help remembering things about each one. The models, the trouble I had with it, how the public reacted, something that happened to me while I was painting it. And I never seem able to decide whether or not my work has progressed because my memories keep intruding; I can't clear my head of the people, incidents, feelings which have accumulated in it over the years and which the covers bring sharply to mind.

I look, for example, at my cover of January 25, 1936. That's my Uncle Gil Waughlum. He was a well-to-do elderly gentleman who in his youth had been something of a scientist and inventor. It was always told with pride in my family that, from a tower on the southwest corner of Washington Square, Uncle Gil, in the course of one of his experiments, had flown the great Gil Waughlum kite. I don't know what the experiment proved or disproved (something to do with Benjamin Franklin and electricity, I believe), but it was important, for in their day Gil Waughlum and the great Gil Waughlum kite were well known.

But when I knew him he had given up science. A stout old gentleman with round pink cheeks and a bald head, he was very jovial, always giggling and nudging Jarvis and me with his elbow to make sure we were being properly merry. Whenever I think of him, I'm reminded of Mr. Dick, the kindly gay simpleton who was, as you remember, Betsey Trotwood's companion in Dickens' *David Copperfield*. I don't

mean that Uncle Gil was a simpleton. He wasn't. He talked very good sense. But he did have one eccentricity. He got his holidays mixed up.

On Christmas Day, with snow on the ground and a cold wind in the trees, Uncle Gil would arrive loaded with firecrackers to celebrate the Fourth of July. On Easter he would bring us Christmas gifts; on Thanksgiving, chocolate rabbits. The next year, firecrackers on my birthday, chocolate rabbits on Christmas Day. We never knew what to expect. (I used to wonder where he got the firecrackers in December or the Christmas wrappings and cards in April. But, as I said, he was well to do and evidently the merchants in Yonkers understood his problem.)

He often sneaked into the house and hid our gifts—under pillows, mattresses, behind the couch in the parlor, in dresser drawers—so that we might have the pleasure and he the merriment of a treasure hunt.

One Easter Sunday Uncle Gil arrived with his arms full of Christmas gifts while we were away at church. Somehow he mistook the neighbors' house for ours and, creeping inside, hid the presents all over their house. When they returned from church Uncle Gil was seated in an overstuffed armchair beside the fireplace in their living room, beaming with smiles and Christmas cheer. They didn't know what to make of the strange elderly gentleman who on seeing them began to puff and stammer and wave a bunch of Christmas cards about over his head. But finally Uncle Gil gasped out his name and they explained his mistake and helped him to find the gifts he had so painstakingly hidden.

When we came home Uncle Gil was standing on our front steps with his packages scattered about his feet, almost in tears because his surprise had been ruined and his packages mussed and his Christmas in April was altogether a failure.

Later on Uncle Gil's eccentricity broadened and he was put away in an institution by the family. But I remember him as he was on his visits to us. He always had a kind of spirit of Christmas about him—jovial, warmhearted, shouting, "Warm, Norman, warm!" as I approached a hidden present and "*Hurrah!*" when I found it. Then in a moment he'd become quite bashful, all atremble to see whether I liked what he had picked out. I don't think I have ever enjoyed any gifts as much as I used to Uncle Gil's.

In 1936 when I painted a *Post* cover of a small boy digging into the pockets of his grandfather's greatcoat in search of a present while the grandfather beams down at him, I was really painting Uncle Gil and the old-fashioned spirit of Christmas which he has always typified for me.

And that is what I meant when I said that everything I have ever seen or done has gone into my pictures in one way or another.

Everything? That's a large order and brings up the question of accuracy. But the great thing about a railroad train or a book is, I think, that it moves, so I'd better get started. I'll just put down everything as I remember it. I don't have time or patience to write letters and hunt up people to verify whether or not I had my left front tooth pulled when I was seven. Maybe I was eight. It's of no importance. Memory doesn't lie, though it may distort a bit here and there. In the end it's all even Stephen,

as we used to say when I was a kid—a little added here, some taken off there: the story of my pictures and how I made them, *as I remember it.*

But here I am only fifteen pages into this book and already I have violated the one rule I know about writing biographies and autobiographies. Whenever a writer asked Mr. George Horace Lorimer, the editor of the *Saturday Evening Post* from 1899 through 1936, about writing a biography, Mr. Lorimer said, "Get him out of short pants." I'm not even born yet.

Well, I was born . . . No, that will have to wait. I'd better get my ancestors and relatives out of the way first.

The Rockwells are distinguished by their lack of distinction: no millionaires in the family, but no poor starving wretches; no philanthropists or saints, but no horse thieves or swindlers. With one exception. Some years after the Civil War a Dr. Alphonso Rockwell of Flushing, Queens, helped to design the electric chair. As I understand it, he had attended several hangings at which the rope had broken and the executioner had had to prop his victim up and do it all over again. Being a humane man, Dr. Rockwell was disturbed and thought there should be a better way of disposing of an undesirable citizen. So he served on a commission to work up blueprints for an electric chair. I won't vouch for our kinship; a geneologically minded relative claims him. If he's wrong, he may have the story back.

My father's father was in the coal business at number 1 Battery Place in New York City. My father's mother was descended from the Yonkers Gettys, a very genteel family founded upon rug factories and Robert Parkhill Getty, a wealthy businessman after whom the main square in Yonkers was named. My grandmother was stout and dignified. She wore her hair in a meager topknot of gathered swirls. Like the rest of her family, she was highly substantial, heavily respectable, and well to do. The money had been made several generations before, and wealth and the solid comforts which go with it had become a family trait, like blue eyes or baldness. Everybody in the family had a large house and kept a carriage, a coachman, and horses. A typical Victorian family in comfortable circumstances. The women had wonderful old-fashioned names—Aunt Phoebe, Aunt Amelia, Aunt Abigail, Auntie Paddock.

Most of the family we didn't see very often. But once or twice a year my mother, my father, Jarvis, and I would make a pilgrimage from Mamaroneck to Yonkers to visit Auntie Paddock. She lived in a tall narrow house of gray stone in a very handsome residential district. A low, wrought-iron filigree fence overhung by great elms enclosed a neat lawn and an intricate pattern of well-kept flower beds. In the rear there was an ivy-covered carriage house and barn. A tidy gravel path ran straight from the street to the high front door.

From the dazzling sunlight and color of the lawn and gardens we entered a dimly lit hall and were ushered into the parlor by a maid. The parlor, where we waited as the bells summoning Auntie Paddock tinkled through great rooms and down long corridors, was lighted only by shafts of sunlight shining through the half-closed inside shutters of the tall French windows. The floor was black and white squares of marble.

The mahogany paneling which covered the lower third of the walls glowed richly in the dim light behind what-not stands and small bookcases filled with volumes bound in deep red, green, and gold leathers. The wallpaper was dark, the design only half visible. There was a large horsehair sofa with lace antimacassars on the arms and back, ornate rosewood chairs, and on the walls family portraits, among them, I remember, one tall and narrow painting of a little boy in a red kilt holding his hoop and stick and standing before a green glade. This and a similar portrait of his sister, her blond hair falling in long ringlets over the shoulders of her blue satin dress, were on either side of the black marble fireplace. And over all this rich, formal interior there hung the heavy odor of incense.

We waited in silence. Then firm footsteps would be heard descending the front stairs and Auntie Paddock would enter the parlor. She was a tall handsome old lady. Her hair was white, beautifully coiffured, with tight sculptured little curls arranged on her forehead. She carried a silver-topped cane, not leaning on it but walking with it, very erect and dignified. She always wore a white lace cap, a high stiff collar, and a black satin dress decorated with jet or sequins. Her dress swished softly as she entered the room, nodding her head in greeting and raising her pince-nez, which was attached by a silver chain to a spring device pinned over her heart, to her eyes.

Auntie Paddock would inquire about our health and our affairs. We would answer in hushed voices, the room so silent that I could hear above the low questions and answers the soft whir of the silver chain running in and out of the spring device as Auntie Paddock gestured with her pince-nez to each of us in turn. "Waring, I am pleased that you could come. Nancy, my dear. You are well, I hope?"

But suddenly we'd hear a hurried bustling in the hall and in would bounce Miss Jenny Larkhart, Auntie Paddock's paid companion. No two women could have been more unlike. Aunt Jenny, as we used to call her, was round and stout and jolly. She wore gay flowered dresses with frills and ribbons on the shoulders, bodice, hem, and neck. Silver bracelets tinkled on her wrists; a pin in the shape of a bird, butterfly, or flower sparkled on her breast. Her hair was set in little loose ringlets which shook merrily up and down as she bounced about on her toes, making a great to-do about our visit. "Oh, Waring, Waring," she'd say to my father, "you heartless man. A whole year." Then on to my brother: "Jarvis. Chicken today with dumplings, Jarvis." Then all of a sudden mock dismay, pretending not to see me: "And Norman? Ill?" and turning, she'd pounce on me: "*And Norman!*"

But when the greetings were over Auntie Paddock would say, "Jenny, my dear, we must all go upstairs before dinner." In a minute Aunt Jenny would be solemn and, taking my brother and me by the hand, would lead everybody upstairs for our visit to the room which had been Auntie Paddock's little boy's before his death. For there was a tragedy in Auntie Paddock's life. Many years before I was born she had lost her husband and her little son during the same week. Yet she kept her child's room exactly as he had left it the day he died—tin soldiers standing before a half-completed fort of blocks, a toy wagon lying on its side, a dump cart loaded with sand. It always

seemed to me that the wheels of the overturned toy wagon had just stopped spinning; I half expected the boy to reappear suddenly and set it upright again. For all was clean and dustless, with no appearance of disuse or time passed; Auntie Paddock and Aunt Jenny dusted carefully around the toys every day.

And in the front hall on a staghorn hatrack hung Mr. Paddock's top hat, over-coat, and cane just as he had left them when he went upstairs for the last time.

But Auntie Paddock was not forlorn or morbid. She didn't dwell on her trag-edy. Perhaps she half expected her husband and child to return someday and take up their lives where they had left them. Or perhaps she just found it the best way to pay her respects to the dead. Instead of planting flowers on their graves she dusted their rooms.

When we sat down to dinner after our visit to the dead child's room we soon became merry again. The cook brought in the roast chicken or leg of lamb; Aunt Jenny, giggling, tied a napkin about my neck; Auntie Paddock told us about her last trip to Sing Sing.

These trips to Sing Sing were Auntie Paddock's and Aunt Jenny's lifework. Once a week, rain or shine, winter or summer, the coachman drove them up to Ossin-ing and they distributed and read Bibles to the convicts at the prison. I always won-dered what kind of reception they got—the tall stately Auntie Paddock and the round jolly Aunt Jenny. Perhaps they took candy and cake as well as Bibles.

Auntie Paddock was quite wealthy. The unspoken thought in my family was that perhaps when she died she would leave us some of her money. We didn't visit Auntie Paddock because of her money. We genuinely liked her. Still, the thought of the money did cross our minds. And I was sort of resentful that with all her money she never gave me anything for Christmas but a hand-embroidered washcloth with my name stitched on it. I wasn't strong for washcloths in those days. But I thought this was a pretty evil thing to think, so I repelled it. Besides, she gave similar washcloths to all her relatives.

When Auntie Paddock died I didn't get anything, my father didn't get any-thing, but my brother was left a hundred dollars "as," wrote Auntie Paddock in her will "a fitting memorial to my husband and son." The bulk of her fortune was left to perpetuate the giving of Bibles to the convicts in Sing Sing.

Of course there were the black sheep of the family, the rakes. Every well-to-do Victorian family had one or two—mutations from the central strain of solid respecta-bility—nature reasserting itself.

There was Uncle Sam, referred to in the family as "that gay rascal Sam." He had magnificent mustaches and amazing charm, could play the guitar, piano, banjo, and water glasses. Women were crazy about him. He finally got locomotor ataxia, a rather special disease caused by too great an intimacy with too many women, and became paralyzed from the waist down. Still, two adoring old maids took care of him until he died.

And a cousin (I can't recall his name) who used to hang around with wealthy

A painting
of quails
by Howard Hill
that hung in
Norman Rockwell's
studio

people like the Vanderbilts and the Astors. He never did a day's work in his life. But he was a sportsman, a man among men, and his wealthy friends supported him by making foolish bets with him, like whether the fly on the horse's rump would move to the right or to the left. If my cousin lost, he gave an IOU; if his friends lost, they paid cash. You see, they felt it would be undignified just to give him money.

That was my father's family—substantial, well to do, character and fortunes founded on three generations of wealth. To this was added my mother's family.

Her father, Howard Hill, was a poverty-ridden artist whose whole life was overshadowed by one experience: as a small boy in short pants he had sung a solo at Buckingham Palace before Queen Victoria. That finished him for life. Later on,

whenever he began to look upon something he'd done as pretty fine, bang would come the awful glory of that solo and trample him down again.

Howard Hill came to America sometime after the Civil War. He hoped to open a studio as a portrait and landscape painter. Instead he fathered twelve children and became a painter of animals, potboilers, and houses.

He would go from house to house in Yonkers until he found someone, usually a wealthy farmer or merchant, who had a pet dog or a favorite cow or pig. Then, if the owner was agreeable, my grandfather would make a painting of the animal. He painted in great detail—every hair on the dog was carefully drawn; the tiny highlights in the pig's eyes—great, watery, human eyes—could be clearly seen. I sometimes think that's one of the reasons I paint in such great detail.

His income from these animal paintings was irregular. He added to it by manufacturing potboilers—paintings of sentimental pseudo-poetical subjects like an Indian maiden floating on a moonlit lake in a canoe or a mother grieving as her son sets off into the sunset to make his fortune. I say he "manufactured" these potboilers because of his method of doing them. Five or six of his children would line up beside a long table. My grandfather, who sat at the head of the table, would paint the Indian maiden in her canoe. Then he would pass the painting along and my mother would put in the moon, my uncle Percy the lake, my uncle Tom the forest, my aunt Kate the reflections of the canoe in the lake, and so on down the line until the painting was completed. My grandfather limited the subject matter of these potboilers, so that finally the children became skilled in their parts and paintings were turned out rapidly. Three subjects—the Indian maiden, the grieving mother, and *Homeward Bound*, a picture of a clipper ship cleaving the white waves towards its (dimly seen) home port—were repeated over and over without variation or embellishment. My mother told me that her father used to get twenty-five dollars for one of these pictures with a frame and fifteen dollars for one without a frame. My grandfather was the real inventor of the assembly line; Henry Ford just got all the credit.

When he (and the twelve children) were desperate for money, my grandfather painted houses. He was terribly ashamed of his house painting and refused to speak of it himself or allow anyone in the family to so much as mention it. When he left the house in the mornings he would mumble, his right hand buried in his beard, "Portrait of Tumley today. Fascinating subject. Third and Warren." Then my grandmother would know that he was going to paint Mr. Tumley's house, which was located on the corner of Third and Warren streets.

But the family was always poor. They were never reduced to starving in a garret, only because the twelve children wouldn't have fitted into a garret.

My grandfather did paint some landscapes, quite good ones in fact. The old Union Square and Murray Hill hotels owned several of his paintings. But he never became the noted artist he had wanted to be.

Disappointment, the oppressive glory of that solo and public expectation, drove him early to drink. In those days artists drank; it was expected of them. It went with their rather mysterious trade. My grandfather lived up to his public's expecta-

tions. He drank. To forget—which he did regularly. Once he took the children to town with him and returned home without them. Another time he bought twelve pairs of children's shoes all the same size and was mildly disturbed that they didn't fit. But the children wore them all the same; there wasn't enough money to buy others.

My mother grew up despising her father for his queer ways and his poverty. She took her mother's side and her mother's ancestry, the Percevels, an old English family, of which more later.

Aunt Bessie, my mother's sister-in-law, used to whisper to me after we'd listened to one of my mother's complaining tirades against her father that, really, the old man wasn't so bad. "He did drink," she'd say, "and when drunk, he would always accuse your grandmother of infidelity, tearing about the house tipping over chairs and bumping into tables. But he was very handsome." "That doesn't excuse him," I'd say, "does it, Aunt Bessie?" "Well, no. It doesn't," she'd say, "but wasn't he a fine artist?" "I've never seen his work," I'd say. "Mother told me —" "Your mother was never fair to him," Aunt Bessie would say. "I know he came to this country to paint the portrait of an important political figure." "Who?" I'd ask. "And I've heard he was on some kind of citizens' committee at the time of the draft riots in New York City during the Civil War," she'd say hurriedly, ignoring my question. "But he *was* difficult to live with, wasn't he?" I'd say. "Yes," she'd say, "very dictatorial and stern." "There," I'd say.

From other relatives I have heard that he was always considered to be very talented but that he did not make the most of his talent. I have been told that he was a painter for Currier and Ives, the famous American print makers.

Those were my ancestors—on one side, a respectable Victorian family; on the other, an impoverished painter of animals, potboilers, and houses. I'm a queer mixture.

I sign my name in blood

I WAS BORN on February 3, 1894, in the back bedroom of a shabby brownstone front on 103rd Street and Amsterdam Avenue in New York City. My only recollection of this apartment, from which we moved when I was two years old, is of a blank sunlit wall suddenly obscured by slowly moving sheets, shirts, socks, and brightly colored print dresses.

My mother, an Anglophile (I wore a black arm band for six weeks after Queen Victoria died) and very proud of her English ancestry, named me after Sir Norman Percevel ("Remember, Norman Percevel," she'd say, "it's spelled with an *e; i* and *a* are common"), who reputedly kicked Guy Fawkes down the stairs of the Tower of London after he had tried to blow up the House of Lords. The line from Sir Norman to me is tortuous but unbroken, and my mother insisted that I always sign my name Norman Percevel Rockwell. "Norman Percevel," she'd say, "you have a valiant heritage. Never allow anyone to intimidate you or make you feel the least bit inferior. There has never been a tradesman in your family. You are descended from artists and gentlemen."

But I had the queer notion that Percevel (and especially the form Percy) was a sissy name, almost effeminate. Nobody ever called me Percy, except occasionally, but I lived in terror. I darn near died when a boy called me "Mercy Percy"; to my relief it didn't stick. When I left home I dropped the Percevel immediately, despite my mother's earnest protestations.

My family moved to a railroad apartment on 147th Street and St. Nicholas Avenue when I was two years old. It was narrow and gloomy—only the parlor, which

faced St. Nicholas Avenue, and the dining room, which looked out on a bleak back yard, had windows. Every morning before he went to work my father had to carry coal for our two stoves up four flights from the basement. But the flat was uptown from 103rd Street and that (in those days) meant we had risen in the world.

It was a pitifully genteel neighborhood—a few private houses but mostly four- or five-story apartment houses; a grocery store or saloon on every corner; here and there a vacant lot, grassless, with a few stunted sumacs and scattered piles of bottles, old clothes, cans. On election nights the Third Avenue gang and the Amsterdam Avenue crowd would meet in a pitched battle on 147th Street and St. Nicholas Avenue. We used to watch from the roof. But ours wasn't a slum neighborhood, just lower middle class with a smattering of poorer families. The tough slum districts were east of us toward Third Avenue.

When I was six or seven my father's mother died and we moved in with my grandfather, who lived in a railroad apartment at 152nd Street and St. Nicholas Avenue. No trolley ran on St. Nicholas Avenue; there were two small elm trees in the point where two streets merged in front of our house and a mock fireplace with a plaster mantelpiece in the apartment. So we considered it a step up from 147th Street.

There was (I hope it's changed; it's a nasty, stupid business) a lot of racial prejudice in New York City in those days—we called Italians wops, Frenchmen frogs, Jews kikes—and class feeling was strong. Everybody was classified: the highest were boys whose families lived in private houses; then (switching the basis of classification) came those whose fathers were white-collar workers; and last (and least) the boys whose fathers worked with their hands.

I remember one boy, Ewald E. Swenson, whose mother took in washing. That put him below the rest of us kids socially and we somehow knew it. But Ewald wanted desperately to go with us. He was a thin, white-faced little boy, but he'd do anything just so we'd let him hang around with us.

One day we were sitting in the library of Jack Outwater's house speculating (we were rather scientifically inclined) on how many encyclopedias could be dropped on a boy's head before he would pass out. Ewald, who had sneaked in behind us, piped up: "Whyn't we try it?" So we sat him on a stool and dropped one encyclopedia on his head. "Aw, that don't hurt," said Ewald. When we got to four Ewald just let out a grunt and collapsed.

But Ewald was finally accepted with honors by us kids (showing, I think, that our prejudices weren't ingrained in us, just rubbed on by our parents). One day his uncle, a drunkard, dropped dead in front of the little ramshackle house where Ewald lived. When the police arrived in the pie wagon to take the body away we were gathered around, Ewald among us. The policeman, after examining the body, asked, "Who is this anyway?" We pushed Ewald to the front, but when he saw his uncle he got very excited and vague and began to bawl. So we said, "It's Ewald's uncle." "Where's his mother?" asked the policeman. But Ewald's mother was out delivering the wash. "Well," said the policeman, "come on, the whole bunch of you, get in the

wagon. Ewald there will have to identify the body down at the station." We grabbed Ewald, who was almost paralyzed with fright, and piled into the patrol wagon.

We were thrilled. The patrol wagon was a thing of stunning glory to us kids. We used to watch it rattling by, the driver lashing the galloping horse and stomping madly on the pedal of the gong, a burly Irish cop hanging on the back, his feet planted firmly on the little step, his hands spread wide to grip the handles at the sides. Sometimes it would pull up before an alley in the neighborhood to break up a crap game and we'd gather around, staring into the dark interior where, on the two benches which ran along the sides, sat the cutthroats and painted women, all *handcuffed* together. ("I seen the handcuffs." "Naw, ya did not." "I did, I did. I *seen* the hand-cuffs." That was the great thing—to see the handcuffs.) And here we were—crowded on those very benches with Ewald's uncle laid out in the aisle between, handcuffs banging against the wall behind us and a cop hanging on back. All because of Ewald.

When we got to the police station and they had carried the body to a back room, the desk sergeant came over and asked, "Which one of you kids knows that body?" We said, "It's Ewald's uncle." The sergeant looked at Ewald, who had his hands over his face crying, and said, "Bring him along. He's gotta identify his uncle." So we all trooped into the back room, pushing Ewald, who began to let out real shrieks and screams, in front of us. When we got there the sergeant picked Ewald up by the back of his shirt collar, threw back the top of the sheet covering the body, thrust Ewald to within six inches of the dead man's face, and asked, "Is that your uncle?" Ewald took one look at his uncle and vomited. The sergeant dropped Ewald, threw back the sheet, and said, "Now *nobody* can identify him!"

We returned to the neighborhood triumphantly in the patrol wagon. The kids who hadn't gone stood about, awe-stricken, while the policeman helped us down from the wagon. "Say, Norm, Norm." No answer, disdainful glance. "Say, Norm, where ya been?" "We been to the station house," swaggering. We were heroes for a week. From then on Ewald was an honored member of our gang. We even initiated him into our secret society, the Jamel Athletic Club. He signed his name in blood and swore eternal secrecy.

The JAC (called by envious non-members the Jackass Club) was devoted to knowledge. We made expeditions along the Hudson River or into an empty room in Jack Outwater's house to look at the pictures of African native ladies in the *National Geographic* magazines—not from a geographical point of view, I'm afraid, but from an anatomical one.

We read the Rover Boys, Horatio Alger—*From Canal Boy to President, Phil, the Fiddler*—and G. A. Henty, who was considered a peg above the rest because it always said "Based on Historical Fact" on the title pages of his books. We went over to Amsterdam Avenue to look under the swinging doors of saloons (it gave us a terrible thrill to see the feet of the men standing at the bar). We cheered the fire engines as they dashed past. I remember how when we heard the clang of the bell we'd gather on the sidewalk, jostling and shoving for a better place. The engine, drawn by three horses abreast, would career around the corner and we'd huzzah and wave our hats,

Phil, the Fiddler, charcoal sketch, c. 1950. A sketch for an unpublished series of illustrations of major characters from American literature

then run for fear of being kindled by the cloud of sparks which rolled from the boiler. The best description of those old fire engines I ever heard was the remark attributed to the Irishman who saw one going by the saloon where he was drinking: "They're moving Hell, and there goes the first load."

Hungering to adventure to far exotic places, we dug holes to China in vacant lots under the square of sky encased in high smutty walls, and kneeling down, one ear pressed to the shallow bottom of the hole, listened intently. "D'ya hear anything?" "Yeah, yeah, I hear something. Quiet!" (Breathless silence.) "Whatta ya hear?" "Voices." "Whatta they saying?" "They're talking Chinese; I can't understand them."

We boasted about our families. I was thought to be tops in culture because my family had two Caruso records. We climbed telegraph poles, played prisoner's base, sat on the stoops of our houses in the evenings watching the lamplighter climb his ladder and light the gas lamps. I guess we led the average life of the city kid around the turn of the century.

I don't remember many of the kids I played with in those days. Let's see, there was Jack Outwater and Ewald and Gerald Dumphy (Jerry Dumpcart to us) and, my gosh, I've forgotten Dirty Dewey. I don't recall (if I ever knew) his real name. We called him Dirty Dewey because he was always dressed in a dilapidated cheap imitation of the uniform worn by Admiral Dewey, who at that time (it was just after the Spanish-American War) was a national hero. The uniform or "Dewey suit" consisted of a flimsy cotton jacket, white, with a high collar, tin buttons, and huge epaulets; white pants secured by a black cardboard belt from which hung a tin sword; and a little officer's cap decorated with gold paper. But Dirty Dewey's uniform had known hard times. The visor of the cap had come loose and flapped across his eyes; the high collar sagged about his neck; the tin sword was crumpled and bent; and the entire uniform was begrimed with soot, oil, and snatches of breakfast oatmeal, luncheon pudding, and supper gravy. He was a chubby little boy, always running after us saying, "C'mon, fellas, wait up!" his tin campaign medals rattling (they were, I remember, enormous, covering the entire top half of the jacket), his tattered pants cuffs tripping him up at every step so that he ran with a sort of jerky hop, step, trip, hop.

One day in Sunday school the teacher asked the class, "Children, what did Jesus say to the money-changers in the temple?" Dirty Dewey flung his hand into the air. The teacher, somewhat surprised at this unexpected display of eagerness, nodded her head to him. "Yes, dear, what did Jesus say to the money-changers?" "Disperse, ye rebels!" replied Dirty Dewey with a triumphant air.

He had a bow and arrow which he shot continually at cats, baby carriages, windows, us, gas lamps. One day he shot an arrow into the yard of a bad-tempered old man, the neighborhood child hater, who of course refused to give the arrow back. So Dirty Dewey stood all afternoon on the sidewalk in front of the old man's house shouting: "Mis-TAH, gimme the arr-AH. Mis-TAH, gimme the arr-AH. Mis-TAH, gimme the arr-AH," until the old man in desperation threw it out the window. Dirty Dewey had a determined spirit beneath that flimsy filthy Dewey suit.

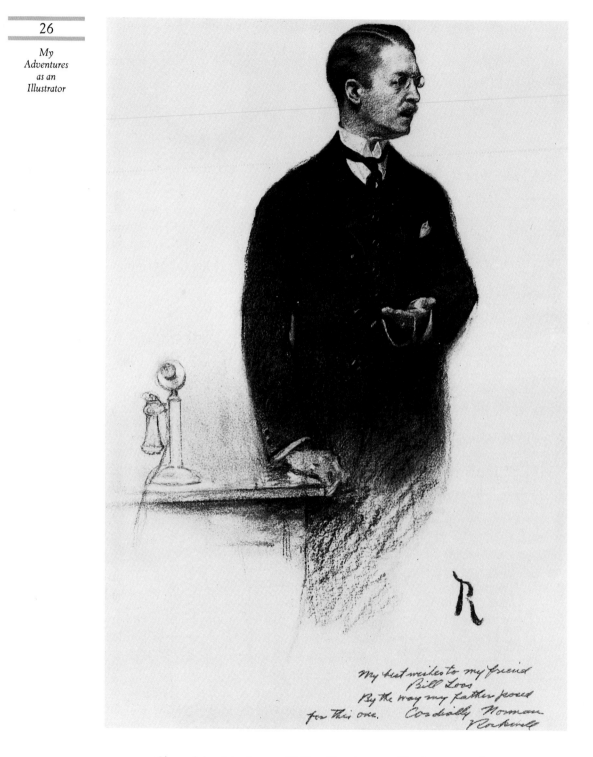

Charcoal sketch for the story "A First Class Argument" by George M. Johnson
(*St. Nicholas,* May 1915), inscribed "My best wishes to my friend Bill Loos. By the way
my father posed for this one.
Cordially Norman Rockwell"

Whenever I think of my parents a certain scene invariably presents itself, a scene which was repeated day after day during my childhood.

It is late afternoon. I am playing on the stairs or in the hallway of the apartment house. The front door opens and closes and my father comes up the stairs, worn out from his day at the office and his hour ride on the trolley. He goes into the apartment and I can hear him ask my mother: "Well, now, Nancy, how are you?" "Oh, Waring, I've had such a hard day. I'm just worn out." "Now, Nancy, you lie down on the couch there and I'll get a cold towel for your head." And then he'd shut the door and all I could hear would be my mother complaining, interrupted at long intervals by my father in tones of gentle sympathy and concern.

"Your father's a saint!" the neighbors used to tell me. "He's a wonderful, wonderful man." And I agreed. Soon after he married my mother, a small pretty woman, she fell ill. That was the beginning of a long series of illnesses continuing through her whole life (she lived to be eighty-five years old). Whether or not this almost constant sickness was a way of drawing attention to herself, I don't know. The doctors often said there was nothing wrong with her. She did have eleven brothers and sisters. I think she felt that my father was lowering himself when he married her, the daughter of a wild, impoverished artist. In any case my father's life revolved around her to the exclusion of almost everything else. He cared for her constantly and with unflagging devotion.

He was a very handsome man. There was something aristocratic about him, the way he carried himself or the set of his fine dark eyes. His substantial mustache was always neatly trimmed. He wore dark, well-tailored suits and never removed his coat in the presence of ladies. He did not drink but was a gentlemanly smoker. Dignified, holding to the proprieties, gentle and at the same time stern; but distant, aware of Jarvis and me, but always, even when we were children, treating us as sons who have grown up and been away for a long time—that's how I remember my father. I was never close to him.

He worked all his life for George Wood, Sons & Company, a textile firm in New York City, rising from office boy to manager of the New York office. He was intensely loyal to the firm. Every so often he would come home from the office beaming with pleasure. Then we all knew what had happened that day—Mr. Wood had been in the office. At dinner after my mother had said grace he would unfold his napkin and arrange it carefully across his knees. Then he would lean back in his chair and say: "Mr. Wood was in the office today." My mother would continue eating, but Jarvis and I would beg him to tell us what Mr. Wood had said. And he would recount his conversation with Mr. Wood verbatim.

I was never close to my mother either. When I was a child she would call me into her bedroom and say to me: "Norman Percevel, you must always honor and love your mother. She needs you." Somehow that put a barrier between us.

I really remember very little about my parents. They were very religious. Jarvis and I weren't allowed to play with our toys or read the funny papers on Sunday. I

was a choir boy first at St. Luke's and then at the Cathedral of St. John the Divine. I didn't enjoy it much. At the cathedral we sang four services every Sunday, then there were rehearsals three afternoons a week after school and a dress rehearsal of the full choir on Friday evenings. So it was pretty hard work.

After the Spanish-American War many churches organized miniature army units. All the boys of the congregation were drilled by some member of the church who had had military training (we had an ex-colonel who later on, much to the dismay of our parents and the befuddlement of us kids, was sent to jail). On holidays we would march in parades, dressed in Spanish-American War uniforms and carrying wooden guns. I was the smallest boy in the St. Luke's Battalion and marched alone in the rear—my father used to call me The High Private in the Rear Rank. I remember I'd be strutting along trying to hold myself ramrod straight, eyes front, chin out, et cetera, and the motorman of the trolley following the parade would bring his car quietly up behind me, then clang the bell and nudge me with the cowcatcher—to the great detriment of my military bearing.

We did do things together, though we certainly weren't a closely knit family. On Sundays, if my mother was too ill to go to church we would sing hymns in the parlor. On weekday evenings, after Jarvis and I had finished our homework, we would sit around the dining-room table and my father would read Dickens out loud to us. I would, as I've said, draw pictures of the different characters—Mr. Pickwick, Oliver Twist, Uriah Heep. They were pretty crude pictures, but I was very deeply impressed and moved by Dickens. I remember how I suffered with Little Dorrit in the Marshalsea Prison, had nightmares over Bill Sikes and Fagin, felt ennobled by Sydney Carton: "It is a far, far better thing that I do . . ." The variety, sadness, horror, happiness, treachery, the twists and turns of life; the sharp impressions of dirt, food, inns, horses, streets; and people—Micawber, Pickwick, Dombey (and son), Joe Gargery—in Dickens shocked and delighted me. So that, I thought, is what the world is really like. I began to look around me; I became insatiably curious. (I still am.)

And I began to look at things the way I imagined Dickens would have looked at them. One day I overheard a grownup call my uncle Gil Waughlum (he had just brought us Christmas presents on Washington's Birthday) a simpering idiot, adding, "He ought to be put away." At first I was puzzled and upset, because I had to admit there was some justification for the remark, yet I liked my uncle Gil a lot, and except for that one eccentricity he seemed as sensible as anyone I knew and certainly gentler and kindlier and more generous than most. Then I remembered Mr. Dick of *David Copperfield* and was reassured. I guessed it was all a matter of how you looked at something. Mr. Dick was a simpleton, yet Dickens saw that he was something more: kindly, generous, loving, and endowed with a measure of uncommon common sense.

This way of looking at things has stuck with me from those nights when my father would read Dickens to us in his even, colorless voice, the book laid flat before him to catch the full light of the lamp, the muffled noises of the city—the rumble of a cart, a shout—becoming the sounds of the London streets, our quiet parlor Fagin's

hovel or Bill Sikes's room with the body of Nancy bloody on the floor (I squirmed and lifted my feet to the chair rung).

On summer evenings as the first cool breath of the sunset wind rustled in the dusty leaves of the two scrawny elms across the street, my family used to walk to Amsterdam Avenue to catch the trolley for our evening airing. The trolley would come lumbering up the hill, the sooty pigeons scattering before it, and rattle to a stop, rocking backward and forward on its springs. The conductor would help the ladies up the two high steps which ran along the sides of the trolley and blow his whistle to let the motorman know that all was ready. Then as the trolley started off he'd move down the car to collect the five-cent fares, jingling the loose change in his leather-edged change pockets. The trolleys were open in those days and at the back of each seat was a pole from roof to floor. In fair weather the conductor walked along the outside top step, swinging from pole to pole with a careless, hand-over-hand motion, pausing to lean into the trolley to collect the fares or pass a gallant compliment to a lady, his cap with the bronze plaque—CONDUCTOR—set at a rakish angle, his devil-may-care attitude only increasing as the trolley picked up speed. His hands were always gray from handling the change all day.

Smoking was permitted in the two rear seats. At night the back platform, which was divided from the rest of the trolley by a glass partition, was sacred to lovers. Jarvis and I always sat on the seat directly behind the motorman, the wind catching at our caps, the motorman spinning the handle of the brake ratchet, gloved, majestically aloof, stern.

The trolleys were always crowded on Sunday afternoons and warm evenings; sometimes you had to let three or four packed trolleys go by before one came along that you could squeeze onto. For the poorer people of the city, trolley riding was a popular entertainment, almost an institution. (From the Battery to the far Bronx and back, an evening's pleasure, for only ten cents.) I remember that everyone I knew—grownups, kids, maiden aunts—had a trolley pillow which had been made by the ladies of the family especially for these Sunday and evening excursions.

At first there would be small groups of people waiting for the trolley on every corner. But as we reached the less thickly populated outskirts only an occasional stop would have to be made and the trolley would pick up speed. Then the ladies would clutch their wide flowered hats and their children, and the men would look unconcerned, for it was feared the trolley would jump the track as it sped rocking and swaying by the amazed pedestrians.

At the end of the line the trolley company had placed benches among the trees so that the passengers might sit and enjoy the country scenery while the conductor and motorman prepared the trolley for the return trip. Often we would take a picnic supper and, spreading our second-best tablecloth on the grass, would enjoy a meal in the country, then catch a later trolley back to the city.

After the passengers had disembarked from the trolley at the end of the line, the motorman and the conductor would step off and stretch their legs a bit, the motor-

man carrying his brake handle and his power bar so that no young scamp could jump into the trolley and abscond with it. Then, while the conductor held the brake handle and power bar, the motorman would pull down the pole topped by a "trolley" wheel which rested against the electric wires overhead and, holding it by a rope, walk it around to the front of the trolley (which became the rear for the return trip; the old trolleys were double-ended). The lights in the trolley would go out and all the passengers, sitting on the benches or walking among the trees, would fall silent. The only sound would be the crunch of the motorman's heels in the gravel as he walked past the dark, ghostly trolley. Then he would release the pole. The "trolley" wheel would glance off the wires with a sudden bright shower of sparks, and the lights in the trolley would flash on, then off. The motorman would haul down the pole and try again: another shower of sparks, shooting blue and white into the darkness. The women would look about apprehensively and call their children; the conductor would step back a pace or two. Electricity was a new and rather frightening thing in those days; one could never be sure—something might explode; it was best to be on your guard. But finally the "trolley" wheel would catch against the wires, and the lights would go on in the trolley, glistening on the wooden seats and on the rails stretching away into the darkness at either end. Then the conductor, with great dignity, would turn over the destination placards at the front and rear of the trolley, and all of us kids would climb on and help him reverse the long seats. The motorman would mount to his place. The passengers would scramble in (every kid wanted an outside seat; the staid grownups sat in the middle). The conductor would collect another fare and blow his whistle. And the return trip would begin.

As we passed through the outskirts of the city the brightly lighted trolley with its load of passengers all in their Sunday best ran through darkness broken only by the lamp in a window of an occasional house. Soon, however, as the houses began to crowd up on one another, each corner was lit by a street lamp. Then, as the street became thronged with carriages and wagons, the lamps multiplied and we were home again—weary, seat sore (for the benches in a trolley were made of wood and hard in spite of our thin pillows), and somewhat dazed by our glorious afternoon or evening on the trolley.

Two memories of the city overshadow all else, unfairly perhaps. One is of the night President McKinley was shot. I remember the streets were dark except for the yellow pools of light beneath the gas lamps. The newsboys were shouting: "Extra, Extra, Extra. McKinley assassinated. Extra. Extra." And people were gathering under the gas lamps, reading the news and brushing off their faces the moths and flies which swarmed about the light. There was a kind of horror in the streets. Because I did not understand the meaning of the word "assassinate," I thought McKinley had been killed in some cruel, torturing way. I was only seven at the time. The next day we went to church, where they played "Nearer, My God, to Thee," McKinley's favorite song, and my father and mother cried.

The other memory is of a vacant lot in the cold yellow light of late afternoon, the wind rustling in the dry grass and a scrap of newspaper rolling slowly across the

patches of dirty snow. And a drunken woman in filthy gray rags following a man and beating him over the head with an umbrella. The man stumbling through the coarse littered grass, his arms raised to cover his head, and the woman cursing and scream- ing, beating him incessantly until he fell, then standing over him, kicking and striking him again and again about the head and belly and legs. And I remember that we kids watched, silent, from the edges of the lot, until a policeman ran up and grabbed the woman. Then the man got slowly up and, seeing the policeman struggling with the woman, attacked him, swaying drunkenly and swearing.

I forget how it ended. But the memory of that night and of that drunken woman became my image of the city.

Against this image of the city—exaggerated and distorted as it is, I have never been able to rid myself of it entirely—I set the country.

My family spent every summer until I was nine or ten years old in the country at various farms which took in boarders. Those country boardinghouses weren't like the resorts of today. The advertisement in the New York papers would state: Tennis Court. But when you arrived, there wouldn't even be an old tennis ball kicking around on the floor, so you'd ask: "Say, where's the tennis court?" And the farmer would reply: Oh, if you look under the hall stairs, you'll find the net. You string it anywhere in the meadow you want."

Those boardinghouses were just farms. The grownups played croquet or sat in the high slat-backed rockers which lined the long front porch. We kids were left to do just about anything we wanted. We helped with the milking, fished, swam in the river or the muddy farm pond, trapped birds, cats, turtles, snakes and one glorious morning a muskrat, smoked corn silk behind the barn, fell off wagons, horses, out of lofts—did everything, in fact, that country boys do except complain about the drudg- ery and boredom of the farm.

It's queer: if I have no bad memories of my summers in the country, I also have few specific memories, memories of incidents of, say, just what I did during the summer I was eight years old or of my stay at the boardinghouse in Florida (New York). Of my winters in the city I have both a general impression—the sordidness, the filth, the drunks—and many memories of specific events and particular people— Ewald, the choir, Dirty Dewey. But those summers, as I look back on them now more than fifty years later, have become a collection of random impressions—sights, sounds, smells—outside of time, not connected with a specific place or event and all together forming an image of sheer blissfulness, one long radiant summer. God knows, a country cur has just as many fleas as any city mongrel. But I didn't see them or, if I did, they were crowded out by the first sleepy cries of the whippoorwills at dawn—poor will, poor will, *whip* poor will—and long lazy afternoons spent fishing for bullheads, the emerald dragonflies darting around our heads (we called them darning needles and endowed them with a deadly sting). Oh, it sounds corny enough when I tell it, rather like those potboilers my grandfather used to paint. But that's the way I thought of the country then and still do in spite of myself.

Later on I came to realize (reluctantly) that ugly things happen in the country as well as in the city. Still, that didn't change my ideas. I like the country better. One

Off to School, oil painting for *Literary Digest* cover (4 September 1920)

End of the Working Day,
Literary Digest cover
(6 November 1920)

time I signed a year's lease on a studio in New York. Two months later, as I was walking down Sixth Avenue under the el, a man and woman ran out of a tenement yelling at each other. Suddenly the man knocked the woman down. The same day I was having my lunch at Child's Restaurant when an old man who was leaning against the window about six feet from me collapsed and died. These things happen in the country, but you don't see them. In the city you are constantly confronted by unpleasantness. I find it sordid and unsettling.

Those blissful summers in the country. I remember the farm horses, their long shaggy manes hanging almost to the water as they drank, snuffling and blowing, after a day in the hayfields. The horse would raise his head for a moment, snorting and shifting his great hoofs, then drop it again to the water so suddenly that I'd slide right down his neck, kerplunk, into the stream, the horse stopping his drinking to look calmly at this sudden apparition splashing in the shallows. And the hot heavy smell of the horses as we currycombed them in the barn afterward, stretching up on tiptoe to

reach the broad expanse of their backs, watching with satisfaction as the marks left by the harness disappeared.

I remember wrestling and tumbling in the mow until we collapsed, exhausted, in the warm fragrant hay and lay dazed, with the rough-hewn beams of the roof dark and immense above us and dust motes swirling in the shafts of late afternoon sunlight. I remember throwing off my shoes and socks to wiggle my bare toes in the cool green grass on our first day in the country, then running off gingerly over the gravel road and hay stubble in the field to the river for our first swim. The hayrides, all the boarders singing (I remember my father sang a pretty good tenor) as the horses trotted along the dark country lanes; the excitement of eating lunch with the threshing crew at the long board tables; hunting bullfrogs with a scrap of red silk tied to the end of a pole; the turtles and frogs we carried back to the city in the fall, snuffling and crying on the train because summer was over and we had to leave the country. I remember we'd put the frogs and turtles in a bowl of water and feed them religiously every day. But invariably, two months later, we'd find them floating, dead, in the bowl. And then that summer was dead too.

Sentimental trash? Maybe. But that's how I saw the country. I actually lived the idealized version of the life of a farm boy in the late nineteenth century. I remember that, once in the country, even I changed. In the city we kids delighted to go up on the roof of our apartment house and spit down on the passers-by in the street below. But we never did things like that in the country. The clean air, the green fields, the thousand and one things to do, the rawboned farmers, their faces burned a deep brick red by the sun and wind (but with that circle of pure white skin just below the hairline where their hats shaded their foreheads), got somehow into us and changed our personalities as much as the sun changed the color of our skins.

I would not have dwelt so long upon these summers I spent in the country as a child, except that I think they had a lot to do with what I painted later on.

Every artist has his own peculiar way of looking at life. It determines his treatment of his subject matter. Coles Phillips, another illustrator, and I used to use the same girl as a model. She was attractive, almost beautiful. But in his paintings Coles Phillips made her sexy, sophisticated, and wickedly beautiful. When I painted her she became a nice sensible girl, wholesome and rather drab. To put it in another way, if you asked Picasso and me to paint a picture of, say, a woman sitting before a mirror—well, I guess you see what I mean. The two paintings would be totally different, yet both would be of the same woman before the same mirror.

The view of life I communicate in my pictures excludes the sordid and ugly. I paint life as I would like it to be. (Somebody once said that I paint the kind of girls your mother would want you to marry.) In 1951 I painted a *Post* cover for the Thanksgiving issue of an old woman and a boy saying grace in a shabby railroad restaurant. The people around them were staring, some surprised, some puzzled, some remembering their own lost childhood, but *all respectful*. If you actually saw such a scene in a railroad station, some of the people staring at the old woman and the boy would have been respectful, some indifferent (probably a majority), some insulting and rude, and perhaps a few would have been angry. But I didn't see it that way. I just

naturally made the people respectful. The picture is not absolutely true to life; it's not a photograph of an actual scene but the scene as I *saw* it.

Frederic Remington painted the romantic, glamorous aspects of the West—cowboys sitting around a campfire, an attack on a stagecoach. Any old-timer can tell you that the West was a lot more than that—that life in the wild West was at times pretty drab. But Remington, who was born and raised in upstate New York and traveled in the West as a tourist, didn't experience that drudgery and boredom. Just as I missed the dullness of farm life. I doubt that I would have idealized the country if I had grown up as a farm boy.

I sometimes think we paint to fulfill ourselves and our lives, to supply the things we want and don't have. I knew a real country yokel in art school. Five years later I met him again. He wore spats, carried a cane, and kept his black derby on when he painted. He had become a famous fashion illustrator and cosmopolite.

Maybe as I grew up and found that the world wasn't the perfectly pleasant place I had thought it to be I unconsciously decided that, even if it wasn't an ideal world, it should be and so painted only the ideal aspects of it—pictures in which there were no drunken slatterns or self-centered mothers, in which, on the contrary, there were only Foxy Grandpas who played baseball with the kids and boys fished from logs and got up circuses in the back yard. If there was sadness in this created world of mine, it was a pleasant sadness. If there were problems, they were humorous problems. The people in my pictures aren't mentally ill or deformed. The situations they get into are commonplace, everyday situations, not the agonizing crises and tangles of life.

The summers I spent in the country as a child became part of this idealized view of life. Those summers seemed blissful, sort of a happy dream. But I wasn't a country boy. I didn't really live that kind of life. Except (heads up, here comes the point of the whole digression) later on in my paintings.

Of course, country people do fit into my kind of picture better than city people. Their faces are more open, expressive, lacking the cold veneer behind which city people seem to hide. I guess I have a bad case of the American nostalgia for the clean simple country life as opposed to the complicated world of a city.

Other things contributed to making me paint what I do the way I do. For one thing, I have always wanted everybody to like my work. I could never be satisfied with just the approval of the critics (and, boy, I've certainly had to be satisfied without it) or a small group of kindred souls. So I have painted pictures that didn't disturb anybody, that I knew everyone would understand and like. (Everybody who comes into my studio from the grocery boy to the vice-president of an advertising agency has to comment on the picture I'm painting and I take all the comments to heart.) Maybe (to be completely honest) the fact that this type of picture pays well has something to do with it too.

I sometimes think all this is a weakness. I know I'm not satisfied with my work. At times it seems shallow, incomplete. But that keeps me working. If I thought I was perfect or even close to it I'd probably pawn my brushes and quit.

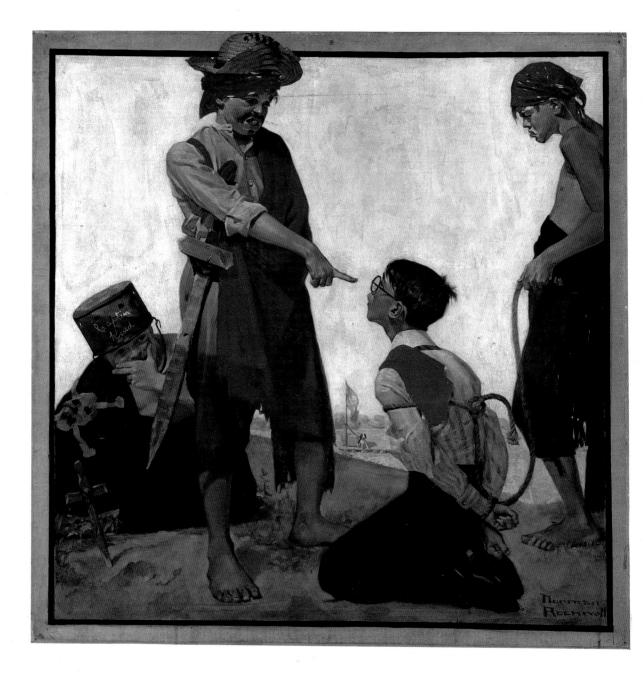

Cousin Reginald Plays Pirates, oil painting for *Country Gentleman* cover (3 November 1917)

3

I meet the body beautiful

I THINK I've always wanted to be an artist. I certainly can't remember ever wanting to be anything else. Not that I awoke one morning with the full-blown idea swimming about in my head. It was gradual. I drew, then I found I liked to draw, and finally, after I had got to know something about myself and the people and things around me, I found that I didn't want to do anything else but draw.

At first, though, my ability was just something I had, like a bag of lemon drops. Jarvis could jump over three orange crates; Jack Outwater had an uncle who had seen a pirate; George Dugan could wiggle his ears; I could draw. I never thought much about it. A bunch of us kids would be sitting around on the stoop and somebody would say, "Let's go up to Amsterdam Avenue and look in the saloons." "Naw, we did that yesterday." Silence. "Say, Norm, draw something." So I'd draw a lion or a fire engine on the sidewalk with a piece of chalk. But it was just as likely that someone would ask George Dugan to wiggle his ears.

I remember that when I was six or seven years old I used to draw ships on pieces of cardboard for my brother and another boy. I worked from the picture cards of ships which were included in every package of American Fleet cigarettes in those days and which all of us kids collected and traded back and forth. (Cards and cigarettes celebrated Admiral Dewey's victory at Manila Bay.) Jarvis and his friend would cut the ships out and make little stands for them. Then they'd arrange their fleets in battle order on the floor and each would try to cut up the other's with scissors. It was sort of a frustrating form of art for me: five minutes after I had drawn the fleets, laboriously copying with much smudgy erasing, Jarvis and his friends would have cut them to shreds.

My father used to copy drawings from magazines in his spare time. I sketched dogs, houses and vegetables, and, from my imagination, pirates, whales, Indians. I drew pictures, as I said, of the characters in Dickens. I found I liked to draw. Every so

often at school a teacher would hang one of my drawings on the blackboard or I'd be sent to show a drawing to Mr. Holly, the principal. Once, I remember, after I'd shown him a drawing, I went home and told my mother that he'd asked me to stand in assembly, before the whole school, and holding up my drawing, describe how I'd done it. The next day my mother came to school, all excited, and said to my teacher, "Isn't it wonderful! Mr. Holly had Norman Percevel show his drawing in assembly!" The teacher glanced at me. I looked down at my desk blushing, terribly ashamed.

But if my ability to draw impressed the grownups occasionally, it didn't knock down any horses in the estimation of the other kids. And it counted even less as we grew older. George Dugan lost stature when the ability to wiggle his ears became less impressive to us kids, than, say, how well he played baseball. I lost stature in the same way. I could draw. So What? Could I play baseball? Or throw a rock over Mr. Cheeney's house? Or lick my brother? Those were the important things now, both to me and to the other kids. Our values had changed. The athlete was top dog.

I was a skinny kid, not unhealthy but not robustly healthy either. My mother used to call me Snow-in-the-Face, because I was so pale. The other kids called me Mooney, because I wore glasses (round glasses were new then, the more usual type being long and narrow; our oculist was progressive so I had the round rimless kind.) How I hated that name Mooney.

When I was ten years old I began a program of exercises to strengthen myself. Every morning I would do push-ups, deep knee bends, jumping jacks, et cetera, before the mirror in my room. But every morning when I picked myself up, panting, and looked in the mirror to see the improvement, I was confronted by the same long neck with that protruding Adam's apple which was such an embarrassment to me, the same narrow shoulders, jelly arms, and thin measly-looking legs. After a month or so I gave up the exercises.

My parents bought me all sorts of orthopedic shoes to correct my pigeon toes, until I began to think I was some sort of a cripple. I used to practice walking with my toes turned out. If I heard someone coming up behind me on my way to school, I'd wrench my feet into a V and walk on the sides of my shoes. After a while I gave that up as a lost cause too.

But my brother Jarvis, who was a year and a half older than I (I had no other brothers or sisters by the way), was the best athlete in the school. He was a real boys' boy—adventurous, fearless, always ready to take a dare, strong, athletic. I remember there was a candy store about four blocks from our house in Mamaroneck (where, again by the way, we had moved when I was nine or ten) and some kid or other was always yelling: "C'mon, last one to the store's a rotten egg." Jarvis always came in first; I always came in last, puffing and blowing. There's always competition between brothers. I just couldn't compete with mine. Bob Titus, a big handsome athlete who had been my closest friend, drifted away from me and began to hang around with Jarvis.

So when I got to be ten or eleven and began to be aware of myself and how I stood with the world, I didn't think too much of myself. I could see I wasn't God's gift

to man in general or to the baseball coach in particular. A lump, a long skinny nothing, a bean pole without the beans—that's what I was. I used to pull my sleeve over my hand when we walked along the street so that people would think I had only one hand and feel sorry for me. Or I'd develop a crooked limp.

At that age boys who are athletes are expressing themselves fully. They have an identity, a recognized place among the other boys. I didn't have that. All I had was the ability to draw, which as far as I could see didn't count for much. But because it was all I had I began to make it my whole life. I drew all the time. Gradually my narrow shoulders, long neck, and pigeon toes became less important to me. My feelings no longer paralyzed me. I drew and drew and drew.

During my first year in high school I went every Saturday to study art at the Chase School in New York City. After Thanksgiving the high school principal let me off every Wednesday so that I could attend the Chase School twice a week—Wednesdays and Saturdays. I would get the trolley at Palmer Avenue in Mamaroneck at seven in the morning and ride to 188th Street and Bronx Park where I took the subway, transferring to the West Side at 125th Street. It was a two-hour trip each way. Going by train would have been faster and simpler, but the longer way was cheaper.

In the middle of my sophomore year in high school, when I was sixteen years old, I quit and began to go to art school full time.

I put everything into my work. A lot of artists do that: their work is the only thing they've got that gives them an identity. I feel that I don't have anything else, that I must keep working or I'll go back to being pigeon-toed, narrow-shouldered—a lump. When I was younger I used to work night and day, possessed by a sort of panic that I'd lose everything if I didn't drive myself. I've given up the night work lately, but the drive is still in me. People ask me why I don't take vacations or retire altogether. I can't stop work, that's the long and the short of it.

I've told you what kind of a kid I was *part of the time*. Don't think (though I've given you that impression) that I was as gloomy as a squashed blueberry *all the time*. I did lots of things besides snivel about the size of my Adam's apple. I helped build a bobsled (we called it the Jolly Eight). I went camping and Snoozer Maurice (true to his name) went to sleep and fell head first into the pot of beans we were cooking for supper. (He became an aviator in World War I and was killed in France.) I was a member of the Fortnightly Club, a club of cultural uplift (the other members were older than I was and only let me in to pair me off with a girl who had clammy hands).

I can remember walking into a room in a friend's house during a swimming party one summer afternoon when I was ten or twelve years old. The sunlight was streaming through the open windows; a warm breeze curled in the curtains. All around the room, lying in disorder on chairs, tables, the window sills, were girls' underthings—white bloomers, white bodices with blue frills, lacy slips. I stopped, utterly thrilled by a sense of femininity. I could hear the shouts of the bathers on the beach below the open windows. The pink ribbons on a bodice stirred in the breeze. I felt I had penetrated into the strange, secret world of girls which had heretofore been closed to me. I could hardly breathe, the sense of it was so strong. The delicate, frilled

underthings, white and soft in the sunlight, seemed suddenly, for the first time in my life, to show me what girls were. They weren't just annoying creatures who threw a baseball awkwardly, with only their forearms and wrists. Girls were different. And I didn't understand how they were different, but I felt it, standing in that room with the gulls screeching outside and the shrill cries of the bathers drifting up to me.

Jarvis, Bob Titus, Hurlbert McAndrew, and I watched a disinterment. Around the corner and down one block from our house in Mamaroneck there was a small back lot. The remnants of a picket fence—a toppled post or two, some rotting palcs—were scattered about the edges of the lot. From the weeds and refuse protruded five or six old gravestones, crusted with moss and gray lichen. The top of one lay broken in the weeds; another had been uprooted by the gnarled tree which many years before had sprouted up in the center of the lot; the others sagged, pulled to the ground by vines.

One rainy night about nine o'clock two black, covered carriages and an open wagon drove up to the old graveyard. A new pine coffin glimmered whitely on the wagon. Several men in business suits got out of the carriages and two men in overalls unloaded some picks and shovels from the wagon. After the men in business suits had examined the gravestones by the light of a kerosene lantern they set the lantern on the ground beside a grave and the two men in overalls began to dig. As they worked, their shovels now and then screeching on a rock, the earth piling up to one side, a wind blew up from the Sound and sighed through the scraggly branches of the old tree. A dog barked over on Prospect Street; the lantern hissed; one of the horses snorted and stamped. Jarvis, Bob, Hurlbert, and I edged closer together.

Then there came a dull thud from the grave and the two men tossed their shovels onto the pile of dirt and climbed out. One of the men in business suits pulled a trowel from his pocket and lowered himself gingerly into the grave while another spread out a white sheet on the weeds. After banging and stamping about for a minute the man in the grave swore softly and, sucking his thumb, handed up some rotted boards, splintered and broken. Then he passed up a leg bone and after that some arm bones, a pelvis, fingers, fragments of a backbone, while his companions assembled the skeleton on the sheet, pausing now and then to argue in hushed tones about the placement of one of the bones. A few tatters of cloth hung to the ribs; angleworms and beetles dropped from the bones as they appeared over the edge of the grave. Finally up came a dark moldy brown skull, caked with mud, long wisps of hair ruffling in the wind.

After each one of the men in business suits had taken the lantern into the grave and scuffled and scraped about, they loaded the sheet of bones into the coffin, snuffed out the lantern, and drove off. With the last clatter of the wagon rounding the corner into Prospect Street, the spell dissolved and we realized to our horror that the night was black and we were alone beside an open grave. Even the company of body snatchers was better than none at all.

So we ran home, only to learn to our great disappointment that the affair was legitimate. A party of historians and professional gravediggers had been sent to disinter the remains of a colonial figure and remove them to a more decent graveyard.

I sang in the choir of our church, not enjoying it very much, though in Mamaroneck it was a less arduous duty than at St. Luke's in New York City. There the choirmaster, an old German, had bullied and threatened and harshly scolded us until we sang, as everybody said, like little angels. At rehearsals we had to sit on high stools around a grand piano, our heads just on a level with the broad, shiny top. When one of us hit a false note or dozed off, the choirmaster would slide a hymnbook sharply across the smooth surface of the top of the piano so that it cracked the culprit on the head. It was uncanny; he never missed. We were mortally afraid of him. He'd rage about on his piano bench, calling us all sorts of names, reaching out to cuff the boys nearest him, while we perched there, silent, white-faced, on our stools. He was a tyrannical master, a real martinet. But I dare say he could not have got us to sing as beautifully as we did except by treating us harshly. We were only kids, most of us not more than seven or eight years old, and we would have skipped rehearsals or sung lackadaisically if we had not been so fearful of provoking his wrath. Jarvis and I had a reason for not wanting to attend rehearsals. A slum lay between our house and the church. We'd walk hurriedly through the dim, gaslighted streets. Gangs of ragged children taunted us. Drunken men lurched against us. We clutched rocks in our fists, expecting every minute to be set upon.

But in Mamaroneck, a quiet commuters' town, the choir boys were treated with more leniency. And so we had good times and enjoyed ourselves more. And, of course, sang jarringly at times, never matching the excellence of the St. Luke's choir. One thing rankled. I was paid a dollar and a half every Sunday, but my mother always made me give it back. I didn't understand that. I thought that I had earned the money and was entitled to keep it.

A hill jutted up beside the church in Mamaroneck. On top of it was a wayward girls' home. After services on Sunday four or five of us would climb up into the belfry of the church in our black cassocks and white surplices and yell across at the wayward girls, teasing them. One day the sexton locked us in the belfry by mistake. For two hours we shouted and waved our surplices at the passers-by in the street below. They glanced up and waved back. A dog came along and barked at us. Finally someone understood and let us out so we could go home for dinner. "Norman Percevel," said my mother, "you're late. Dinner is spoiled. And after I worked so hard." "I was locked in the belfry," I said. "And what were you doing in the belfry?" asked my father. "I . . . unh . . . felt faint," I said, "I wanted air." So I was dosed with castor oil.

The front of the choir stall was of openwork carved wood. When one of our friends came forward to be confirmed, shuffling slowly along with the other boys and girls, four abreast, we'd reach through the carving and grab his knickers. He'd try to move, find he couldn't, blush, jerk his leg forward. We'd jerk it back. "For cripes sake," he'd mutter, "lemme go, *will ya!*" And he'd lunge forward, knocking against the kid in front of him.

Sometimes we'd get ahold of a girl's skirt. She'd reach around and pull at it, staring straight ahead. "Norman Percevel *Rockwell*," she'd whisper fiercely, "You let go of my skirt this minute or I'll tell your mother on you." "Tattletale," I'd say, letting go.

When my voice changed I became crucifer. But I had other duties as well. On rainy Sundays when few people came to church there would be sacramental wine left over. But it could not be thrown away; it had to be drunk. So the minister, the sexton, Bob Titus, and I would drink it. And I'd go home for dinner, soused.

The choirmaster, a carpenter with a magnificent voice, often *came* to church soused. Then Bob Titus, the sexton, and I would have to wrestle him into his cassock and surplice and march him out to the choir stall. It was all we could do to support him. Yet he always sang beautifully.

That was the underside of church life. That and the sexton polishing the altar cross. He'd spit on it and rub it with a soiled cloth, all the while grumbling and swearing under his breath. I used to wonder about that. Somehow it didn't seem right. But after a while I learned to accept that sort of thing.

I helped hang the high school principal's long underwear on the flagpole. I cheered at football games:

> I thought I heard my grandmother say
> The M·H·S won a game today;
> Wit a ree·bo, and a ri·bo, and a ree·bo·ri·bo rum—
> BOOM get a cat·trap
> Bigger than a rat·trap,
> SIS, BOOM BAH.
> Mamaroneck High School, RAH, RAH, RAH.

I was assigned a paper on Tennyson's *Lady of the Lake* and, having learned that the teacher, Miss Genevieve Allen, only read the first and last pages of our essays, I put ten blank sheets of paper between two sheets covered with writing. When Miss Allen said, "Norman has written the best essay in the class," I straightway determined on a life of crime (it paid). But when she added, "And now he will read it to us," I suddenly discovered the fires of hell and, as I couldn't sink into my shoes (though, Lord knows, I strained), I blurted out the truth. Honesty, I thought, if not the best policy, was at least the safest.

We were awful mean to Miss Allen. She was a tall, thin, high-strung woman with graying hair. I'd wave my hand frantically. "Misallen, Misallen," I'd call, "I ain't got no pencil." "Norman," she'd say, "I don't know how many times I've told you. You must say, '*I haven't got a pencil.*'" A few minutes later Bob Titus would throw up his hand and say, "Misallen, Misallen, I ain't got no pencil." She would correct him. Then another boy would say the same thing. Then another. After fifteen or twenty minutes of this, Miss Allen would begin to cry. "Oh," she'd sob, "oh. You *do* know how to say it. I know you do. Oh. I can't . . ." And she'd run out of the room, sobbing. It was a horrible thing to do. I cringe whenever I think about it. Children are heartless sometimes.

I fell passionately in love with Miss Helena Geer, becoming dizzy and dazed whenever she passed in a haze of cloyingly sweet perfume down the aisle, her silk petticoats rustling about her trim little feet and ample hips.

I was not a good student, even in art. The lowest passing grade was seventy. In Advanced Art—Drawing I got just that, a seventy. In Advanced Art—General I received a seventy-five. But I led the class in, of all things, algebra. Nobody could understand it.

I was sixteenth in a contest we held to see who had the biggest feet (a girl named Jeanne d'Arc Corrigan won). Jarvis and I had a sailing dory which we raced against Mr. Fry, a middle-aged man who owned a champion dory. We'd do anything to beat him. Once, just after the race began, a dense fog blew in and blanketed the course, so instead of rounding all the buoys we sailed in a circle for ten or fifteen minutes and then crossed the finish line five hundred yards in front of a livid Mr. Fry.

I went out with girls. One Sunday afternoon, polished and pomaded, I took the trolley to White Plains to see a girl but lost my nerve and, after strolling for a half hour up and down outside the white picket fence which surrounded her house, went home in despair. Another afternoon I fought Earl Quick in a grove of chestnuts in defense of Eleanor Bordeaux's honor. (He won, but Eleanor heard about it so I had what the generals call a strategic victory.)

I did, in short (?), the things most boys do.

My favorite memory of those days is of Miss Julia M. Smith, my eighth-grade teacher. She taught me what little I know about geography, arithmetic, grammar, et cetera. But I remember her mostly because she encouraged me in my drawing: every year she asked me to draw a Christmas picture on the blackboard in colored chalks; in history class I drew Revolutionary soldiers and covered wagons; in science, birds, lions, fish, elephants. That meant a lot to me; it was sort of a public recognition of my ability. I guess . . . No. I *know* she saw where I was headed and, because she was a fine teacher, helped me along. God bless her.

Forty-odd years later I received a letter from a woman who was taking care of Miss Smith (she had married and her name was now Mrs. Ottley; but I've never been able to think of her as anyone but Miss Smith) somewhere in upstate New York. Miss Smith, the woman wrote, was going blind but every time one of my covers appeared on the *Post* she would ask her friend to describe it to her. Then she'd tell about how I used to be her pupil, how I used to draw on the blackboard at Christmastime. And she'd asked her friend to write the note to me just to see if I remembered those old times. I wrote back, asking the woman to tell Miss Smith that she had been my favorite teacher and that I remembered her very well because she'd done me so much good.

That letter and others which followed brought back my school days. I recalled how devoted and kind Miss Smith had been. Then I thought of how hard-working and underpaid schoolteachers were. And after I'd mulled all this over for a while I decided to do a *Post* cover of a schoolteacher—sort of a tribute to Miss Smith and all the other schoolteachers.

Well, I don't know how the general public liked the cover but it was very unpopular with the schoolteachers. I got all kinds of letters saying very indignantly, "We're not like *that!*" A superintendent of schools in Texas wrote that there was not

Children Dancing at Party, oil painting for *Saturday Evening Post* cover (26 January 1918)

one teacher in all Texas as plain-looking as the one I'd painted. I hadn't felt that way at all. I'd just wanted to portray a patient, hard-working, devoted person. I thought if I made her a beautiful girl I wouldn't get my feeling across. Even after forty-three years of painting *Post* covers I can't tell what the reaction to a cover will be.

One afternoon I was over at a party at Jack Savage's house and as we were eating the ice cream (it was peach and delicious, I remember) I said, "Boy, Jack, you really can make ice cream!" "*Make* ice cream?" said Jack. "No, we *bought* it." I chewed over that (the remark, not the ice cream) for a week. I was humiliated that I had let those wealthy young men know that my family made our ice cream instead of buying it.

I won't say I was obsessed with money, because I wasn't. But I was painfully conscious of the differences—in manners, clothes, speech, position—which (or so I believed) money wrought.

And I was on the wrong end of the stick. My father never made much money. We certainly weren't dirt poor or even respectably poor. The butcher never dunned us; there was always enough to eat, decent clothes to wear. It was just that we had to be careful—persistently, naggingly careful. My mother would ask, "Waring, shall we have a roast this Sunday?" And my father would reply, "Not this week, I think, Nancy." Little things. I remember the antimacassars on the parlor sofa were always sort of yellow with age and washings before new ones were purchased. Jarvis and I never had pocket money like the other kids. The pinched and faded tidiness of our front parlor; the way our bath towels and even Aunt Paddock's washcloths would get used until the nap was worn away and you could see through them.

But it was more than that, more than stew on Sundays, yellowed antimacassars. I remember once I was talking to Mrs. James Constable, the widow of Mr. Constable of Arnold Constable, the New York department store, in her splendid breakfast room. (I delivered her mail every morning and she always paid me personally on Mondays.) We were speaking of policemen and I wanted to say a policeman never looked as grand in his civilian clothes as in his uniform. Instead I said civvi-il-i-on. Mrs. Constable said, "Civilian, my dear." I reddened down to my kneecaps. But that mistake didn't surprise me any—how could I expect to talk correctly when my father didn't make much money? I imagined that if you had money you talked correctly. And more—you were self-confident, well-mannered, free from embarrassing accidents, debonair, handsome, et cetera. How money performed these prodigies I never stopped to think. It just *did*, that's all.

So I set out in fiery pursuit of it and immediately fell to the depths of commercialism. Jack Arnold, my cousin, came home from Annapolis one holiday and offered me fifty cents to take *my* girl and him out in *my* boat. And I did it; I rowed facing the front of the boat while Jack and my girl hugged on the rear seat.

It was easy work but not steady and showed some signs of losing me the esteem of the girls in the neighborhood, so I gave that up and went to mowing lawns and raking leaves.

When I decided (I believe I was in the eighth grade) that I definitely wanted to go to art school I began to look about for steadier, more profitable jobs. I knew I'd have to earn my own tuition.

The first job came through our minister. A wealthy lady asked him if he knew of anyone who would take her and her friend, Ethel Barrymore, out sketching. The minister suggested me. So I spent every Saturday afternoon that summer sketching with Ethel Barrymore . . . and her friend. I went along more for companionship than anything else, I think. We would paddle out in a canoe to Hen Island or some deserted beach, where I'd set up the easels in a sheltered spot and show the ladies how to hold the brushes or mix the paint to get the dry green of the beach grass. After an hour or so we'd have a little snack from the picnic basket they always brought along, I'd pack up and we'd return.

Ethel Barrymore didn't sketch very much. I remember she was beautiful, absolutely magnificent. That must have been a sight—me, a long gawky kid bending over the graceful Ethel Barrymore, guiding her shapely hand across the paper, the sea wind ruffling her hair, my great Adam's apple churning up and down my neck. She was very gracious, queenly; I was almost dumb with admiration, awe.

Many years later I was in Hollywood taking photographs for a *Post* cover. All the people in it were to be movie stars and Ethel Barrymore was to be one of them. The photographer and I waited for her in a still studio on the MGM lot. First of all her make-up woman came in, then her agent, then her maid. Then there was a silence and Ethel Barrymore made her entrance. When she saw me she said in that deep, marvelously throaty voice of hers, "Why, Norman Rockwell, I knew him years and years ago." I was immensely flattered that she'd remembered me.

That fall I bought the mail route out to Orienta Point from another boy for twenty-five dollars. The wealthy people living on the Point each paid a boy twenty-five cents a day to deliver their mail; the regular mailman didn't go out that far from town.

Every morning at half past five I would bicycle to the post office and load the mail into my leather shoulder bag. Then I'd ride about two and a half miles to the end of the Point, stopping off now and then to leave the mail at a customer's house.

I really enjoyed that job: riding with a rustle through the piles of leaves along the curb in the still gray light of the autumn mornings; pumping courageously through snowdrifts—"Not snow, nor rain, nor heat, nor gloom of night stays these couriers from the swift completion of their appointed rounds" spinning in my head; on the first morning of spring tying my heavy winter sweater about my waist and riding so furiously that it rippled out behind me.

I enlisted some new customers and after a month or two was making two-fifty or more a day. I figured to be rich in no time at all. One of my customers, Mrs. Constable, whom I mentioned a while back, was very good to me. Every Monday her butler, a tall old Englishman, would show me up the great curving staircase of her mansion to her breakfast room. Mrs. Constable would pay me for the week and chat with me for a few moments, asking about my progress in earning my tuition, mentioning

friends who lived out on the Point and who might want their mail delivered every morning. Afterward the butler would take me down to the kitchen and give me a piece of cake or some leftover ice cream. That Christmas Mrs. Constable commis- sioned me to do four Christmas cards and paid me very well (outrageously, in fact, considering my inexperience).

Another job I had in connection with my mail route—tutoring the two sons of one of my customers—led to . . .

Well, one day our front doorbell rang violently—clang, clang, clangclang- clang. I looked out through the stained-glass window beside the door and there on the doorstep, tinged with the red, green, yellow, and blue of the window, was an enormous middle-aged gentleman presiding over the doormat. His thick face sat on rolls of beefy fat plumped up to bursting by his high stiff collar. A suit of bristly tweed snugged his corpulent body. He carried a cane and wore spats and a derby.

I opened the door and said, "Yes?"

"Your name, young man," said he, his eyes fixed on the ceiling above my head.

"Norman Rockwell," I replied.

"The pedagogue?"

"I only tutor two boys," I said, "I'm not a peda—"

"*Stop!*" said he, banging his cane on the doorstep and at the same moment snapping his eyes down from the ceiling to me. "Money waits for no man. Make haste. You flit away your time on those two boys. I am prepared to pay—at interims of one week—the sum of twenty-five dollars for your services at my academy. Permit me to show you our prospective."

And he pulled a little pamphlet out of his vest pocket and handed it to me. It was a prospectus of Pennington's Academy for Boys: Headmaster, Dr. J. J. Pen- nington (here followed a long list of degrees, honors, prizes, testimonials, etc.); and under that, Instructor in English, French, and Athletics, Norman (I started in amaze- ment) Percevel Rockwell.

"I have," said Dr. Pennington, noting my start, "taken the liberty of including your name in the list of pedagogues. I knew," he added in a confidential whisper, "that a man of your perspiception could not refuse so generous an offer."

"But I can't speak French," I said.

"Neither can the boys," replied Dr. Pennington.

The upshot of the matter was that I was engaged on the spot to teach French, English, and athletics at Pennington's Academy during the summer session. He agreed to pay me twenty-five dollars a week, a princely sum, and provided one meal a day.

That settles my art school tuition, I thought to myself the next Monday as I rode on my bicycle between the two great stone pillars and up the curving tree-lined drive which led to Pennington's Academy. Through the trees I could see an ivy-laden stucco mansion surmounted by five or six gabled turrets. I rode off down a path marked TRADESMEN to the rear of the mansion. The lawn in front was neat, but as it

trailed off to the sides it became sparse and ragged, ending in a dirt and pebble area around the kitchen door murky with clouds of blackflies.

"He ain't *here*," said a fat woman who was stirring a pot of stew on the kitchen stove, on my asking for Dr. Pennington. "Try the parlor. Upstairs, second door to the right."

"Norman Percevel," said Dr. Pennington as I entered the parlor, "my wife," and he waved at a middle-aged woman with a large soft body and a raw face who was sitting across from him at the table.

Then he rummaged about in a pile of books on the floor and handed me a French grammar textbook, announcing that my class awaited me in the state bedroom—down the hall, first door on the left.

So off I went to begin my career as a teacher of French, my one advantage over my students being that I had a textbook and they didn't.

The class went off pretty well. Opening the book at the first page, I found that *oui* was "yes" in French. So I taught the class that. Then I found that *je* was "I" and taught them that. And so on until by the end of the first class, we had learned to say, "*Oui, je swiss a homme.*" (I never did get the indefinite articles straightened out.)

The trouble began during athletic class. One of my students was bigger and stronger than I was. "Let's box," he said. I refused. So he said I was yellow. I pretended I hadn't heard him. This went on all summer—he trying to provoke a fight, I trying to avoid it. I knew that if he did get me into a fight and licked me (a cast-iron certainty), I would lose my job. So I kept it off and kept it off, until on the last day of school he just pitched in and gave me a beautiful shellacking without bothering about the formalities.

It was rather hard to maintain any semblance of dignity and discipline with this fellow threatening to beat me up all the time. But the other children were all right. I used to take them out for rides in the school's rickety motorboat. It's a wonder we weren't all drowned. I gave swimming lessons. We spent a month building a huge model airplane out of bamboo, wire, and wrapping paper. It was a beautiful thing. We hauled it up to the topmost peak of the highest turret and shoved it off. It glided out, nose-dived, and socked into the ground, whammo.

I don't know whether or not Dr. Pennington got rich running his academy, but he tried hard. Most of the children were unwanted by their parents—actors and actresses who didn't have a home for them or rich people who couldn't be bothered. So Dr. Pennington was left pretty much alone. Oh, one day the parents of one of the boys did come for a visit. It turned out to be a short one. When they saw me in a bathing suit and learned from their son that I was the instructor in French, English, and athletics, the mother bundled the boy into their carriage and the father had hot words with Dr. Pennington. ("Irrascitional," said Dr. Pennington to me later. "I would have thrashed him with my stick had not my daughter intercessioned.")

Dr. Pennington's seventeen-year-old daughter, who taught mathematics, and I were the only teachers. The mansion was run-down and leaky; there were no recreational facilities other than the old motorboat; and the meals were chiefly greens, thin

soups, and mysterious stews. It was so bad that after the first week I brought my lunch. I swear the children almost starved. For instance, Dr. Pennington used to preach that the British never ate butter at dinnertime. So the children never got any butter. He was an unbelievable character, which is why I remember him so clearly, perhaps.

Dr. Pennington's profiteering extended, I am sorry to say, to me. The first time I asked him for my money he said: "Saturday, my boy, Saturday. Bank closure." The second time (I made sure it wasn't a Saturday) he mumbled something about "dividendstuitionslateweekafternext." The third time he took me into his confidence: rich people were notoriously neglectful; *he* couldn't afford tobacco at the moment; but he was *determined*; he would fall upon the parents in tomorrow's mail; I must be patient.

Well, I never got a cent. The last day of school he vowed on his LL.D. to send me my money by mail. I didn't know what else to do but trust him. My father said I had to manage my own affairs when I asked him about it. Of course Dr. Pennington never sent it. So the whole summer was shot—a long, hard summer, too—and I went off to art school with barely enough money to get me through the first term.

I drew from plaster casts of Mercury, Hercules, Venus, the Discus Thrower, during my first two months at the National Academy School. The antique class met in a large, high-ceilinged room lit by a ground-glass skylight. Along one wall stood forty or fifty white plaster casts of Greek statues, mostly gods and goddesses, with a few "blockheads" (simplified casts showing the planes of the human head) on pedestals scattered among them.

The casts were old and battered: Mercury had lost his nose; Venus had a mustache and goatee in bright red chalk; the Discus Thrower had lost three fingers and his empty white eyes stared through a pair of ornate spectacles. The floor was always gritty with the pulverized noses, fingers, toes, ears, and unmentionables of the casts.

Drawing from plaster casts eight hours a day, six days a week, was tedious and dull. But you can learn to draw much faster from a cast than from a live model. Casts don't move; even the best model will shift an arm or turn his head a bit during a pose. So every student began in the antique class; then, when he had learned the fundamentals, was promoted to the life class.

At the National Academy the life class and the antique class met in adjoining rooms separated by a pasteboard wall. As I toiled away at my drawing of Mercury or Venus, the teacher strolling among us, stopping now and then to correct a student's drawing, I could hear from the other side of the wall the monitor of the life class call out to the model, "Rest," or one of the students say, "Monitor, she's shifted her hip." And I'd sneak a look through one of the peepholes carved in the wall. (Every month the student authorities stopped up the holes and every month the students bored through again.) I couldn't see much—maybe the legs of the model and the backs of a few students—but if I looked long enough and concentrated, I got a sense of being in the life class. So then I'd make a little sketch of the part of the model I could see and

turn back to my drawing of Mercury or Venus with determination and a new hope. After about two months in the antique class I was promoted (O glorious day) to the life class.

In the life class they had two-week poses; that is, every morning for two weeks the model would take the same pose. At the end of the two weeks the instructor graded the students' work, giving the best drawing number 1, the second best number 2, and so on until every student had a number. The following Monday, after the monitor had posed the model for the next two weeks, the student who had got number 1 selected the position from which he wanted to draw the model. He could sit or stand anywhere in the room. Then the student who had got number 2 chose his place, then number 3, etc. The students with the highest numbers had the worst view of the model.

When I entered the life class I didn't, of course, have any number at all. After the other students had taken their places I set up my easel in a corner. The model was posed lying on her side, her head propped on one elbow. All I could see were the soles of her feet and her rather large rear end. So that's what I drew during my first two weeks in life class. But I didn't care; at least I was working from a live model. Besides, it was the first time I'd ever seen a lady close up in such décolletage.

I didn't study long at the National Academy. It was free, but stiff and scholarly—two-week poses, examinations, a lot of still life being done, no illustration, only fine arts. There was no camaraderie between teachers and students, and most of the students were a good deal older than I; many of them just stayed in the school on the off chance that they would be awarded the Prix de Rome. It was a generally stilted atmosphere, no sense of excitement among the students, just a sort of plodding doggedness.

I switched to the Art Students League. Other students had told me something about the League and it sounded like the kind of school I wanted to go to.

4

Charcoal, perspiration, and turpentine

I<small>T'S QUEER</small> how important decisions, ones that affect your whole life, are sometimes made haphazardly. My first day at the League I was standing at the bulletin board trying to decide whom I should take life class with: George Bridgeman or Kenneth Hayes Miller. I didn't know anything about either man and was too shy to ask the other students. I just stood there looking at the two names, now and then glancing hopefully out of the corner of my eye at the groups of young men and women, all carrying portfolios under their arms, laughing and talking in the corridor. But no one offered to help me. Finally, in desperation, I flipped a mental coin and signed up with George Bridgeman.

As I soon learned, George Bridgeman was the academic drawing teacher and Kenneth Hayes Miller was an extreme modernist. If I had signed up with Mr. Miller, I might be a modernist now. I guess it's a good thing I didn't, because my ability evidently lies in telling stories and modern art doesn't go in much for that sort of thing. I probably would have been lost in modern art with my temperament and experience, my Dickensian view of people.

I really never thought seriously of going into fine arts. Oh, I did join the classes at Robert Henri's school once. But during my second day there I suddenly realized that everything they taught contradicted Mr. Bridgeman and somehow I couldn't take that. So I returned to Mr. Bridgeman's class.

In those days there wasn't the cleavage between fine arts and illustration that there is now. In art school the illustration class was just as highly respected as the

portrait or landscape classes. Art Young, Charley Kuntz, and I signed our names in blood, swearing never to prostitute our art, never to do advertising jobs, never to make more than fifty dollars a week. That sounds like something only fine-arts students would do, but all three of us were dead set on being illustrators. (That oath has long since been broken. But it signifies nothing. At the time I was like the little boy who vowed he would never grow up to be a man—I just didn't know myself.)

It was the end of what you might call the golden age of illustration. We thought of an illustrator then as a recorder of history and the contemporary scene, as an interpreter of the classics—Shakespeare, Dante, Milton.

Howard Pyle was a historian with a brush. His drawings of colonial days, of the Revolution, of pirates, were authentic re-creations, backed by years of study and research. Edwin Austin Abbey's, Gustave Doré's, and Arthur Rackham's illustrations of the classics were in themselves classics.

Perhaps most important of all, the best contemporary writing of that time was being illustrated—William Dean Howells, Mark Twain, Thomas Hardy. Illustration was in the main stream of the arts, was vitalized by contact with fine writing.

To us it was an ennobling profession. We sat in the lunchroom at the League questioning a model who had posed for Howard Pyle. How did he begin a painting? What kind of paints did he use? Did he make preliminary sketches? We were even, at times, pretentious and stuffy, deploring the pretty-girl art of Charles Dana Gibson as degrading to our noble profession, damning the hacks who did advertising jobs. Had Pyle or Abbey done advertisements? we asked each other. No. And we wouldn't either. We quite literally felt the weight of a century of great illustration on our backs. We slaved at our drawings six days a week. We locked the door of the classroom when the loafers of the art school came through the halls whooping it up the day before the annual Art Students' Ball. We were in deadly earnest—dedicated, serious as mourners.

And in a sense we were mourners. For the golden age of illustration was dying. Howard Pyle, Edwin Austin Abbey, and Frederic Remington died while I was in art school. (I remember that the day Howard Pyle died Mr. Bridgeman came to class tipsy and with tears in his eyes.) Most of the other great illustrators were long since dead. Gradually the market for fine illustration narrowed. The popular magazines, which were springing up and spreading like a brush fire, didn't use the kind of illustration Pyle, Rackham, and Cruikshank had done. Photographs were crowding the illustrators and the artist-reporters right off the pages of many magazines and newspapers. Book publishers were using less illustration of any kind.

Illustrators, as a friend of mine said, were getting to be businessmen with a knack for drawing. (I cringe at that; the shoe not only fits, it pinches.) That was, and is, only partially true. There were still a lot of fine illustrators around. But the heart was out of it.

Pyle's pupils lacked his sense of mission, his sincerity. When Pyle had to paint a Spanish galleon he hunted through old books until he had learned what a galleon actually looked like. N. C. Wyeth, one of Pyle's successors, painted *his idea* of

a galleon, more romantic perhaps but lacking the authority and the research of a galleon by Pyle. The illustrators who followed Wyeth (he was a darn good one in spite of all) took to painting in a lavishly romantic manner—great splashes of rich color, huge earthenware jars all over the place, stalwart men and beautiful ladies. If there's a blood-red sunset in the picture, who cares whether the castle's authentic?

To tell you the truth I don't know, really, what killed the golden age of illustration. I *think* it can be traced to a change in audience. The people who bought the mass magazines, the best-selling books, didn't particularly care about fine illustration. They were as well satisfied with a good illustration as a great one. Or with none at all.

But then, it might have been something altogether different. All I know for certain is that the golden age of illustration existed and that it ended. And that end has always been typified for me by one experience. When I first left art school and was making the rounds of the various magazines looking for work, the office of the very aristocratic and dignified art director of the *Century* magazine was dimly lit, quiet, and furnished like a living room in a wealthy home. In winter a fire crackled merrily in the marble fireplace. We rarely, if ever, mentioned money. A few years later the *Century* moved uptown. The new art director's office was functional and efficient. Light blared through the curtainless windows. The furnishings consisted of a desk, two plain chairs, and three gunmetal-blue filing cabinets. The quiet air of dignity and refinement had vanished; everything was done on a strict business basis—MONEY: PROFIT, LOSS. The golden age of illustration was as dead as poor Yorick. You can't conduct a golden age with a heart of copper.

That's part of the reason I went into illustration. It was a profession with a great tradition, a profession I could be proud of. I guess my temperament and abilities were the other part. Being somebody to my parents and brother and to my friends in Mamaroneck meant a lot to me. I wasn't a rebel.

The classrooms at the Art Students League, like those at the National Academy, were lighted by enormous ground-glass skylights slanting up from the top of the north wall of the room to the roof peak. An eternal, soft, slate-gray light filtered through the skylight onto the dingy walls smudged and daubed with the scrapings of students' palettes and onto the floors littered with paint rags, pieces of gum eraser, cigarette butts and pipe ashes, and begrimed with paint, turpentine, and charcoal.

Along the wall under the skylight and continuing down the adjacent wall to the door were the students' lockers, dark green metal chipped, scarred, and battered. Against the wall opposite the skylight, in the corner farthest from the door, was the screen behind which the models undressed and dressed. Near the screen but farther out toward the center of the room was the model stand, a cloth-covered wooden box five feet by five feet on which the model posed.

Punctually at one o'clock every afternoon we'd get our charcoal and scrapers and pads of Michalet drawing paper from our lockers while the model undressed, hanging her flower-laden hat on a corner of the screen, draping first her stockings,

then her dress and petticoats over it. As she walked to the model stand the talk, the clatter of easels being rigged, the clang of locker doors, the rasp of charcoal on scrapers and rustle of paper would die out and everyone would take his place.

The students—about thirty-five to each class (all men; there were no mixed life classes; it was felt in those days that it would be indecent for men and women to look at a nude model together; in the nineteenth century nude female models in men's classes had worn blindfolds)—were grouped in three tight semicircles about the model stand, the first row sitting on low stools, their drawings propped on the legs of overturned chairs; the second row sitting on chairs, their drawings resting on the seats of other chairs; and the third row standing, their drawings set up on stick easels. That way no one blocked anyone else's view of the model.

But it was crowded. When somebody stepped back to look at his drawing from a different angle—through his legs or his cupped hands, over his shoulder—as Mr. Bridgeman urged, he was sure to kick over a bottle of fixative or nudge another student and be told that his drawing was bad from any angle and why didn't he sit down and stop acting like an alligator in a butcher shop.

And what with the crowd, the spilled turpentine and paint, the numerous pipes and cigarettes with here and there a five-cent cigar and all the windows shut so the model wouldn't catch cold, it wasn't long before the classroom began to smell like a gymnasium and a paintshop rolled into one. I remember that one day a student who worked as a sewer cleaner for the city came to visit Mr. Bridgeman in his work clothes and as he passed somebody said, "Thank God for a breath of fresh air." But the smell gave us sort of a warm cozy feeling.

After everyone had taken his place the monitor would pose the model and we'd set to work. At twenty-five minute intervals the monitor would say to the model: "Rest." Then the model would shuffle into her slippers and pull on a flimsy kimono. Sometimes she'd sit on a stool behind her screen during the five-minute rest period; but usually she'd walk around among us, looking at our work and chatting. Some of the models didn't bother to put on a kimono during the rest periods. One, a Russian girl, used to smoke cigars. She'd light up and, puffing away, stroll among us nude, commenting in broken English on our drawings. When the rest period was over she'd carefully snuff out the cigar on the edge of the model stand and lay it in one of her slippers.

The models were our comrades in art; together we were creating something fine. They weren't the flotsam and jetsam of the city—tramps and bums—but artists. Modeling was a regular profession. Some amateurs, of course—after Christmas a lot of girls who had come to the city to work in the department stores during the Christmas rush would try to get modeling jobs—but chiefly professionals, proud, in some cases vain, of their profession.

I remember one celebrated model, Antonio Corsi, who had posed for John Singer Sargent, J. A. M. Whistler, and other great artists. His dark-skinned body was lithe, strong, and supple—wonderful to draw. His gray hair hung in long wavy locks about his shoulders and he dressed in corduroy trousers, a loose peasant smock, and a

flowing cloak. On street corners he would suddenly throw up his arms as though he were beseeching God, and stand so a full minute, his eyes riveted tragically on the sky.

Antonio Corsi was extremely proud. Every so often he would bring his large leather-bound scrapbook to school and, gathering us around him with an imperious wave of his hand, show us photographs of the famous paintings he had posed for or of himself standing with Sargent or Whistler in their studios. And as he leafed through the scrapbook he'd recount anecdotes about the famous artists he had worked with and we'd listen awe-stricken. Gosh, how we respected him. At the beginning of class he wouldn't wait for the monitor to set the pose but would strike one of his own choosing, usually a very difficult one like the crucifix (feet together, arms stretched out at right angles to his body). And the monitor would say, "Uh . . . Mr. Corsi, you . . . uh . . . gave us that pose last week. Couldn't you . . . uh . . ." "John Singer Sargent," Antonio Corsi would interrupt, "liked this one." That stopped us. Who were we to contradict the great John Singer Sargent?

Then there were two old-maid German sisters who in their youth had posed for many of the famous German artists, such as Menzel and Von Lenbach. Once a month they would invite a few of the dedicated, conscientious students over to their apartment to tea. Never any of the loafers—the sisters had a burning disrespect for them. "Ach," one of them would say, "riffraffians. They should not draw my little finger, if I had the say."

The door of the classroom was screened by a pasteboard partition so that visitors and busybodies couldn't look in at the nude model. The figure models were very particular about that. I remember one afternoon we were all working quietly in Mr. Bridgeman's class when suddenly the model shrieked and, jumping off the stand, ran behind the screen. A voice from the skylight exclaimed, "A nekked woman!" We looked up. Two workmen were staring down through an opening in the skylight, dumfounded. "My Gawd, Mike, look at them grrown men staring at that nekked woman."

It may seem queer that a model who was posing nude before thirty-five men should object to one or two more. Perhaps I can explain by describing two life-size paintings which covered the wall of a classroom at the League when I was a student there. One showed an art student in class struggling to draw a beautiful nude model, squinting, perspiring, measuring with his thumb on his pencil how many heads to the body. The other drawing showed the same art student ogling a girl who in boarding a trolley had lifted her petticoats and skirts so that her ankle peeped out.

You see, in class we were so engrossed in trying to do a good job and learn how to draw that we just didn't think of the model as a woman. Of course we had men models too, now I come to think of it. Funny, maybe their sex did make a tiny bit of difference to me.

Once a rather pretty girl was posing (generally the models weren't the gorgeous creatures people think of as artists' models, just women with good anatomical

figures, lean, lightly muscled—good-to-draw figures, not *Vogue* or *Playboy* figures). It was late on a winter's afternoon and the light on the model was gray, cold, and shadowless. We were all in our shirt sleeves, working intently at our drawings, the absolute quiet in the room broken only by the occasional creak of a chair as a student rose to get a better look at his drawing. Somebody said, "Turn on the lights. I can't see the model." And suddenly she was bathed in warm yellow light and so beautiful that we all murmured, "Ahh." I remember she became quite embarrassed.

I wanted to be a great illustrator. I was so dedicated and solemn that the other students called me "The Deacon." The lunchroom crowd, students who wore beards and soft wide-brimmed hats and chatted about art all day long over cups of coffee in the lunchroom, regarded me with a mixture of scorn and awe. One of them said to me once, "You know, if I worked as hard as you do I could be as good as Velásquez." I just asked, "Why don't you?" and dropped the subject. I couldn't understand his attitude. If he worked he could be a great artist. Well, why didn't he sharpen his charcoal and begin? But I couldn't be bothered trying to understand. I wiped my hands on my smock and returned to the vexing problem of the eye—how to draw it so it looked like an eye and not a fried egg.

My methodical working habits used to bother me. A student would shuffle into class pale and blear-eyed and slump into a chair. "You sick?" I'd ask him. "Sick?" he'd say. "Lord, no. I just couldn't stop. Worked for thirty-six hours straight. The brush just swam across the canvas. *Swam.* Couldn't stop myself. Forgot all about food."

I've never missed a meal. I used to think I painted with my stomach instead of my soul and brain. I've always kept regular hours, eaten three meals a day. It used to worry me something terrible. What kind of artist are you, I'd ask myself, no inspiration, passion, ecstasy? Just a methodical hack? I'd read somewhere that Sir John Millais had swooned when he first saw the *Mona Lisa*. You don't swoon, I'd say to myself. Then I'd get mad and go up to the Metropolitan and stand before a Rembrandt, telling myself, Swoon, damn you, swoon. Faint. Cry. Do *something*.

It never worked. I guess I'm just not that type. I am, and always was, hard-working, regular.

During my second year in art school I was chosen to be monitor of Mr. Bridgeman's class, probably because of my serious steadiness. Monitors got their tuitions free, which was important to me, and it wasn't a difficult job. I posed the model and kept order in the class when Mr. Bridgeman wasn't there. Discipline was no problem though. It was understood that if you wanted to loaf or talk you went out in the hall or up to the lunchroom. If you stayed in class you worked.

On Friday afternoons the monitors of the different classes—seven or eight of us—would meet in one room to select the models for the next week. The models would come in and show us their figures and we'd pick the ones we wanted. It was rather pathetic sometimes. A girl who hadn't understood what modeling involved would refuse to take all her clothes off, posing up on the stand for us in her slip and

Dyckman House,
oil painting,
1912

stockings. Of course we rejected her. Then sometimes she'd begin to cry and say she needed the money and what was she going to do. I used to feel awful sorry for her, but I had no choice really. The life class would have ridiculed me and I'd have been cashiered as a monitor if I'd selected a girl who refused to pose nude. Besides, I wanted to learn to draw and you can't do that very well when the model is wearing a slip and stockings.

Not that we didn't get some queer ones for all my caution. I remember once I selected a squat, bowlegged, muscular young woman. The next Monday when I said, "Rest," she asked me, "Say, can you do a double back flip?" I said, "Me? . . . No. No." "Look here," she said, "it's easy," and she did a double back flip right on the model stand. Then she did a cartwheel off the stand and another back onto it. She stood on her head and flipped back, then forward, and, getting warmed up, ran through a series of flips, bends, somersaults, twists, et cetera, while we sat there, open mouthed and unmoving. (I don't know whether or not you've ever experienced it but it shakes you up considerably to see a nude woman doing cartwheels.) Finally she stopped and said, "There. It takes some skill, if I do say so myself, but practice is most of it. I'm a circus bareback rider, you know. Don't work in winter, but I've got to keep trim." All that week she performed for us during the rest periods.

At five minutes past one on Tuesdays and Fridays Mr. Bridgeman would enter the classroom and, throwing his coat to me, ask, "Mr. Monitor, how many students do we have here?" I'd reply, "Thirty-five, Mr. Bridgeman." He'd look around the class intently for a full minute as if searching for something. Then he'd say, "Out of the thirty-five maybe two of you will make a success." And every man jack of us thought, Mr. Bridgeman means me; I'll be one of the two.

We worshiped George Bridgeman. He was a short stocky man. His hair was always rumpled, his clothes always mussed and untidy. He wore suspenders and smoked big black cigars. He had, I remember, sort of a rough, red, grouchy-looking face and swore (for emphasis) a great deal.

I don't think Mr. Bridgeman ever arrived in class stone sober. Not that his drinking ever interfered with his teaching. The only way we could tell how much he'd had was by the position of his necktie. If it was in the center of his collar he'd only had a few. If it was wrenched to one side, half hidden by his collar, he'd had more than a few. But it never changed him except perhaps to make him a little more enthusiastic. I was in his class for three or four months before I even realized that he drank at all.

After his opening colloquy with me Mr. Bridgeman would rummage a huge piece of Russian charcoal out of the box containing his supplies which I held out to him and, starting at one end of the row farthest from the door, would criticize each student's work individually. When he came around to me I'd get up and he'd take my seat. Then he'd study my meticulous drawing, on which I'd been working very carefully with a finely pointed piece of charcoal all week. After a minute he'd burst out, "You haven't got the main line of the action. Look here. Down *through* the hip." And he'd demonstrate, charcoaling a heavy black line down the center of my drawing. (I took my drawing home at the end of the week to show my parents, so I had to spend all the next day laboriously trying to clean off Mr. Bridgeman's black line.)

Occasionally Mr. Bridgeman would sketch the head, a muscle, the pelvis, on the side of my drawing to show me what he meant. I treasured those little sketches, for though he was not a great creative artist he was a fine draftsman. Professional artists, muralists mostly, often commissioned him to draw in the figures in their pictures.

Mr. Bridgeman kept a skeleton in his locker at the League. When he wanted to explain some difficult point of anatomy he'd haul it out and, holding it up by a brass ring in the skull, point out the bones he was describing and work them back and forth to demonstrate his point. "See that," he'd say, folding the wrist back toward the forearm, "this structure here does it," and he'd go on to explain how the bones and muscles of the wrist worked. "It's a damned wonderful thing," he'd say. "Take the pelvis. Or the rib cage. Every cruddy little bone and muscle working together. How many muscles d'you think it takes to move your little finger? ELEVEN . . . ELEVEN." Then, falling silent, he'd rotate the chest of the skeleton and move the arms about, shaking his head. "It's a damned wonderful thing," he'd say.

Then he'd hand the skeleton to me and go on to the next student while I stuffed the skeleton back into his locker. I used to have a terrible time getting it into

the locker. I'd sit it on the floor and push its legs and arms against its chest. Then I'd slowly and carefully shut the door, but just as I was about to slam down the latch an arm would come rattling through the crack and the whole skeleton would topple against the door. So I'd begin all over again. But, sure enough, at the last moment out would come that arm, clattery-bang. I finally discovered that if I draped the arms over the coat hooks in the locker they'd stay put. It took me six months to figure it out, though.

Sometimes as he went from student to student Mr. Bridgeman would stop suddenly in the midst of a comment and, raising his voice, say, "You know, boys, a queer thing happened to me after I left the class last Tuesday. There was a coal wagon backed up onto the sidewalk on Forty-eighth Street shooting coal into a cellar. As I passed by a fellow stuck his head, all begrimed with coal, out of the cellar and said, 'Hello, Mr. Bridgeman.' I said, 'Why, hello there, who are you?' 'Oh,' the fellow said, 'don't you remember me, Mr. Bridgeman? I was number 1 in your class all last year.'" Then Mr. Bridgeman would lower his voice and go right on with his comment to the student whose drawing he had been criticizing.

The story varied; sometimes it was an iceman or a voice from a manhole. The results, however, were invariable—the Sistine chapels, the *Last Suppers* we had just, in imagination, been commissioned to paint, crumbled and we were art students again, art students who had better stop imagining triumph and work harder. Still, Mr. Bridgeman told that story in such a way that every one of us thought, He doesn't mean me, not if I work hard anyway.

I remember one time as he went around the class he was telling everybody, "Don't make it so dark. Work light. My God, man, light—the sun, stars, moon—light, damn it, light." When he got to me I was desperately trying to lighten my drawing. He leaned over and whispered, "You leave yours dark; it looks good that way." He'd say something like that to me and I'd feel all set up for a week and redouble my efforts.

One Friday afternoon after Mr. Bridgeman had finished grading our work I slumped down on a stool and buried my head in my hands. I had got number 2, not number 1, and I was pretty discouraged. Mr. Bridgeman came over and asked me what was the matter. I said, "I'm just no good, that's all." He said, "Look, don't worry about being number 1. Be an individual."

I guess he realized that the student who got number 1 all the time didn't have any originality, that he was just a complete Bridgeman draftsman. But he had to give that student number 1, because he did just what Mr. Bridgeman wanted and, to be fair, did it well. Most of the others—McClelland Barclay, E. F. Ward, Raymond Neilson—who later became well-known painters or illustrators, didn't very often get number 1 either.

After he had been all around the class Mr. Bridgeman would stand in the corner behind us and make general comments on drawing, on the construction of a certain organ, on shading. "Anatomy," he'd say, "muscles. You can't draw a leg if you don't know what makes it move backward from the knee instead of forward. The

body isn't a damned hollow drum covered with skin. The bones, muscles give the body its shape, determine how it moves. Why, the whole bunch of you act like quack surgeons who'll cut a hole in the chest to get at the tonsils. You've got to know what's underneath the skin of the belly to draw it. Now look here . . ." And digging a nubbin of soft red chalk from his shirt pocket, he'd walk to the model stand and draw the muscles of the stomach and the line of the rib cage right on the model with his chalk. (The models disliked this. They used to say it gave them a queasy, squirmy sort of feeling to have their muscles marked on their skin in soft red chalk. And then there was no place at the League where they could wash properly and they'd have to go home with their muscles outlined in red. Antonio Corsi, when he saw Mr. Bridgeman starting for him, used to say, "Mr. Bridgeman, may I remind you that I am *not* a plaster cast. John Singer Sargent—" "All right, you damned old fool," Mr. Bridgeman would say good-naturedly, his enthusiasm broken, "all right. I won't touch your precious belly." But most of the models liked Mr. Bridgeman so much that they didn't object. His enthusiasm was measle-like—catching.) "There," Mr. Bridgeman would say when he'd finished. "When you can do that for the whole body you'll be able to draw it." "Then he'd go back to the corner. But pretty soon he'd burst out again: "Don't think color's going to do you any good. Or lovely compositions. You can't paint a house until it's built." I learned a lot from George Bridgeman.

One student, a big husky Irishman—methodical, sincere, and terribly in earnest, but not very good—lapped up Mr. Bridgeman's teachings as a cat laps cream, wholeheartedly, without reservation. In illustration class where the models wore costumes—a moth-eaten replica of a Pilgrim maid's dress, a shabby imitation of an eighteenth-century ball gown—he'd start off by carefully drawing the skeleton of the model. Then he'd put on the muscles, then the skin, then the underwear, and finally the outer garments. (The models didn't like this; they felt as if they were being undressed in public.)

When the student showed him the drawings Mr. Bridgeman was rather nonplussed. I guess he felt like the thirsty man who fell into a well—that's what he wanted, but not quite so much. Still, he helped the student with his drawing, showing him that he had got the bicep too far up the shoulder, the trapezius too low. (This student later became a foot doctor.)

Mr. Bridgeman was never abusive or sarcastic. He didn't teach merely to earn a living; he liked to teach and consequently liked most of his students. The only ones he couldn't stand were the show-offs, students who always signed their drawings or dressed like artists, talked like critics, and loafed like pigs in summer. One Friday a beginning student whose father was a rich Wall Street broker hung his drawings on the rack framed. They were very ornate frames, hand carved and gold leafed. All the rest of us, as usual, set our drawings on the rack unframed. Mr. Bridgeman came into grade our work. Halfway across the room he saw the frames and stopped, dumfounded. Then he went up to the drawings and began to study them. He peered at them, walked back a few steps, ran his hand down the frames. Finally he asked, "Who did these?" The student piped up: "I did, Mr. Bridgeman." "It's piffle," said

Mr. Bridgeman without turning around, "take it away." That night the student packed his frames and went back to Wall Street. We never saw him again.

After class was over and most of the students had left, Chris, the janitor, would bring Mr. Bridgeman a beer and he'd sit and talk to a few of us. We'd pull up a stool to flop down on the floor around him. The model would put on her clothes behind the screen and then come out and sit with us, lacing her shoes or adjusting her hat. The light would gray down until it was almost dark in the classroom. And Mr. Bridgeman would tell us about Howard Pyle or Edwin Austin Abbey or show us the construction of some muscle, sipping his beer and sketching idly on a scrap of paper. How we loved him!

The profiteering of Dr. Pennington having left me, as I said, with barely enough money to get through my first semester at art school, I took a job as a waiter at a Childs Restaurant on Fifty-ninth Street and Columbus Circle from eight to twelve in the evenings. It was a lifeless job.

One day as I was complaining about the dullness of waiting on people, Harold Groth, a fellow student, said, "Why don't you come down to the Metropolitan Opera with me and be a supernumerary? It's certainly not dull. Meet me at the corner of Broadway and Thirty-ninth Street at seven tonight." "All right," I said. "Oh, and by the way," he said as he walked back to his easel, "be sure to bring a suit of long underwear."

Long underwear? Was Groth kidding me? But I took along a suit just in case. That night, backstage at the opera, as we were lining up in our long underwear to receive our costumes from the wardrobe attendant, I asked Groth, "Why the long underwear?" (For there were fifty or sixty supernumeraries and every one had a suit on.) "You'll see," said Groth, grinning. The attendant tossed a costume at me (loose blouse and baggy pants—Russian peasant; the opera was *Boris Gudunov*). I shook it out and . . . understood. It was grimy, foul. There were little ridges of dirt in the seams; the blouse glistened greasily; the collar was caked with black scum. It smelled like an old horse blanket. "It's not so bad with the underwear," said Groth, noticing my look of dismay, "you'll get used to it." I pulled it on, gagging.

The pants would have fitted an elephant perfectly; I thought I'd drown in the dirty sea of blouse. But when I timidly asked the wardrobe attendant if I could have another size he laughed. "You look great—a regular Ivan the Terrible." (I looked even worse other nights. At that time no man, woman, or child was permitted to appear barelegged on a stage in New York City. So when an opera called for bare legs we wore flesh-colored tights. They were old and misshapen, hanging in sagging rolls and muddy creases down my long, skinny legs. I must have been an appetizing sight!)

At one point in *Boris Gudunov* all the peasants have a snowball fight in front of the tsar's palace. We started out tentatively, tossing the tightly rolled balls of papier-mache coated with white paint carefully at each other. But after a while we got into the spirit of the thing, hitched up our ill-fitting pants, shoved our sleeves up (so that the long underwear showed), and pelted each other, not paying much attention to the

opera. Then a snowball hit me in the back of the head (they were solid and hard—like rocks) and I dropped the torch I was carrying. I snatched it up but it had gone out. Suddenly I heard a terrific yell from the wings: " Hey, you with the torch out. Put that torch on. *Put that torch on.*"

I was mortified. I was being yelled at in front of thousands of people. I'd ruined the opera. What would the Vanderbilts think? I slunk off the stage. And into the arms of Speck, the stage manager, who handed me another torch and said: "Now, for Lord's sake, don't drop this one." "You didn't have to yell so," I said rather ruefully. He looked at me in amazement and shoved me back on stage. Later Groth explained that because of the marvelous acoustics of the Met the audience couldn't hear you if you shouted *across* the stage from the wings.

I was the victim of numerous mishaps during the two years I worked at the opera. Once in *Boris Gudunov* I got careless and hit one of the principals with a snow-ball. Speck darn near fired me.

While the children are wandering through the woods in the opera *Hansel and Gretel* (by Engelbert Humperdinck, which fact I include because I like the name; it galumphs off your tongue like a large, affectionate, and woolly sheep dog), no extras are needed. So Groth and I and a couple of other extras used to climb up the inside of the proscenium and pull ourselves out over the middle of the stage on a little wheeled platform which ran across the top of the stage on a track. Then we'd watch the opera from there, enjoying the strange view: the singers moving about like ants, far away and unreal, their voices muffled; and the immense gauze curtains which were dropped between the audience and singers to simulate the coming of night swoosh-ing down just in front of us (one curtain after another would be dropped, progres-sively dimming the audience's view of the stage). One night we were sitting there, dangling our feet over the edge of the little platform and watching Hansel and Gretel wandering in the forest at nightfall, when suddenly one of the gauze curtains struck our feet. Startled, we tried to shove it off. But before we could untangle our feet another curtain piled on the first. Then another and another and another as we franti-cally pushed and clawed at the voluminous folds. Well, that day, night fell in the forest rather suddenly, because finally, in desperation, we all shoved and kicked at once and the whole mass of gauze curtains dropped in a bunch, kerchung.

In another opera Groth and I were detailed to carry Emmy Destinn, an enor-mous woman, very busty and weighing at least two hundred and fifty pounds, off stage. As I recall it, her lover, played by Enrico Caruso, had just been shot, causing her to swoon. The first few times we had no trouble. Groth, who was a husky fellow, grabbed her under the arms and I took her legs. But one night we got turned about. Groth picked up her feet all right but I couldn't budge my end. I wrenched and heaved at her soft shoulders while she giggled up at me, her whole body shaking with mirth, and the orchestra played the same passage over and over. Caruso, who was lying close by, laughing uproariously, chanted, "One, two, *heave!*" Groth whispered hoarsely, "Come *on*, Norm, come *on!*" I strained, red-faced and puffing. Then Speck

yelled, "Change ends, you damned fools, change ends!" So I went around and got her by the feet and Groth and I staggered off with her. Speck never gave us that job again.

Caruso liked Groth and me. He knew we were art students; maybe he felt we were kindred spirits. I remember in *Aïda* we used to be the guards who lead Radamès down into the tomb. We'd walk about the stage beside Caruso, carrying spears, while he sang and moaned, resolving to die nobly, etc. Then the three of us, Caruso still singing, would march down into the little room beneath the stage which served as a tomb. Once down there we'd have to sit with Caruso while he, or Radamès rather, died of suffocation. There were a few old Morris chairs in the room and a light which blinked in time to the music so that Caruso would know when to groan. We'd talk with him and show him our work. He'd make caricatures of the other singers (he was quite a good caricaturist), laughing and telling us stories about them. And every so often he'd let out a great booming groan, sort of offhand, without getting up from his chair or taking his pencil from the paper.

In one opera all the extras, dressed as soldiers and carrying spears, stand on the top of a wall at the back of the stage. Caruso would walk behind the wall and stick each one of us in the ankle with his dagger. It must have startled the audience some to see that whole line of soldiers one after another suddenly stiffen with a start.

He was a character all right. And what a voice! I remember how he used to rip full-throated into *Pagliacci* and halfway through break, sobbing, to continue in a voice still deep and swelling but somehow torn. But then, of course, and it was somewhat disillusioning, Caruso would come back behind the curtains and gargle with a mouthwash, spitting it out on the floor.

In *Aïda* the great thing was to be inside the head of one of the elephants. There were two or three life-size replicas of elephants which could be pushed across the back of the stage during crowd scenes. You'd sit in a sort of jockey seat in the head and work the trunk. And when your friends marched out as soldiers you'd sock them in the seat of the pants with the trunk, knocking them over, or thrust it between their legs, tripping them up. Which would cause considerable confusion in the ranks and impede the majestic flow of the armies of imperial Egypt.

There were only about a hundred extras but the effect of a vast army was required. So we'd march across the stage smartly—all in step, spears up—then, when we reached the wings, run helter-skelter around behind the backdrop, re-form into ranks, and march out onto the stage again. That way the effect of a continuous and mighty stream of men could be given.

All the while this was going on—the marching, the mad dash behind the backdrop, the elephant knocking over soldiers like tenpins, all of us breathless, panting, dropping our spears, helmets, turning around to glare at the fellow in the elephant—the real action of the opera would be going on out front: the principals singing magnificently, walking about, embracing, the orchestra playing; and no doubt, beyond, the audience would be deeply moved by the rich spectacle and exalted music.

As a supernumerary at the opera I was paid fifty cents a night. Later on Groth and I were promoted to curtain boys. (We had become regulars, appearing in almost every production. All the singers knew us by name; we used to play with Louise Homer's children backstage.) The heavy gold curtains were opened and shut by a steam engine. To make the opening and closing graceful and smooth, not a bump, we'd guide the curtains back and out. We wore fancy scarlet cutaways, short bloomers, and *clean* white tights and received a dollar a night. It wasn't enough to dine at the Ritz on, but it helped keep me in art school and charcoal until I began to earn a bit from my art.

In the morning at art school . . . The chapter's backward—I just realized it. I've told about my afternoon class first. But it's all right. Mr. Bridgeman taught me not all I know about art but perhaps the most important part of what I know. That's why he comes first here. I worshiped George Bridgeman, absorbing his every word, not to the suffocation of my own ideas and abilities, but to the development of them. I entered Mr. Bridgeman's class raw; I came out browned to a turn.

Oh, there were other influences. In illustration class (in the mornings—which cleans up those dangling phrases above) we studied the works of the great illustrators. Thomas Fogarty, who taught the class, would sketch the outlines of a story and discuss how to illustrate it with us—what scene in the story we should select, the characters, how they dressed, etc. He'd show us reproductions of illustrations which Pyle or Abbey or Remington had made for the story, pointing out how they'd managed to catch the tone of the story, why they'd used a dark instead of a light background, why they'd done a line drawing instead of a wash drawing.

It's hard to say what one artist gets from studying the works of other artists. You learn how they use color, light, line—technique, technical triumphs or failures: a red chair on a fuchsia rug, a head painted so that it is the focal point of the portrait and yet doesn't stick out like a naked light bulb. But you don't, you can't, copy these things, putting a red chair and a fuchsia rug into your painting only because someone else did it successfully.

I guess an artist just stores up in his mind what he learns from looking at the work of other artists. And after a while all the different things he has learned become mixed with each other and with his own ideas and abilities to form his technique, his way of painting. You start by following other artists—a spaniel. Then, if you've got it, you become yourself—a lion.

Sometimes, of course, you use another artist's work more directly. In 1946, remembering Dickens' description of David Copperfield and the waiter and H. K. Browne's illustration of the scene (during which the waiter ate all of David's chops and nine tenths of his pudding, and then, when David asked how much tip he should leave, pled his family (down with "cow pock"), his parent (aged), and his sister (lovely), and the fact that he lived on "broken wittles" and slept "on coals" to such effect that David left him ninepence)—remembering that scene, I painted a *Post* cover of a boy on a train trying to figure out how much to leave for a tip while the

waiter looked benevolently down on him. The feelings conveyed by my picture and H. K. Browne's are very different, but the composition is similar and Browne's did spark mine.

Most of the time, though, no one but myself can tell that I had another artist's work in mind. Not with the intention of copying the painting, but of capturing a similar effect—the way the light falls across a face, the movement of the picture.

I can't say who has influenced me really. Or at least I can't say *how* the artists I have admired have influenced me. Some of those I admire—Picasso, for example— have had no discernible effect (to say the least) on my work. Ever since I can remember, Rembrandt has been my favorite artist. Vermeer, Breughel, Velásquez, Canaletto; Dürer, Holbein, Ingres as draftsmen; Matisse, Klee—these are a few of the others I admire now. During my student days I studied closely the works of Edwin Austin Abbey, J. C. and Frank Leyendecker, Howard Pyle, Sargent, Whistler.

Thomas Fogarty—a little birdlike man, slim, dapper, and very polite—was practical about teaching illustration. In giving an assignment most instructors asked their students to make an illustration of a broad subject such as "Storm." It is extremely easy to do a picture with such a general title. If you draw houses well, you do a picture of a house with some black clouds behind it. If scarecrows are your specialty, you draw a scarecrow with his coattails flying in the wind. Simple.

But Mr. Fogarty would say to us, "Gentlemen and ladies," (the illustration class, unlike the life class, admitted ladies), "the assignment for next week is the third story in this month's issue of *Adventure* magazine." Then we'd have to read the story, select a scene to illustrate, get authentic costumes and props, etc. It was very much like an actual assignment from a magazine.

Mr. Fogarty condemned all flights of fancy, insisting that our illustrations be faithful to the story in every detail. "An illustration," he used to say, "is an illustration. Quite simply that. Nothing less, nothing more. An author's words in paint, gentlemen and ladies, an author's words in paint." And pointing sharply to a student, he'd snap, "Mr. Young, I see your mind. It is misguided. Not an excursion of your imagination, starting point the story. No. Emphatically not. But a meeting, Mr. Young, a meeting of artist and author."

For the same reasons Mr. Fogarty insisted on authenticity. If the author sat a character in a Windsor chair, the chair in the illustration had to be just that, even if it meant we all had to go up to the Metropolitan Museum to find out what a Windsor chair looked like.

His favorite dictum was that to paint a good illustration you had to feel it. "Step over the frame, Norman," he'd say to me, "over the frame and live in the picture. Drawing? A distraction. Learn it and forget it. Forget yourself. Live in the picture; step over the frame." Then he'd ask me, "Norman, what are you painting there?" I'd say, "A little boy fishing, Mr. Fogarty." He'd ask, "What d'you know about that little boy?" Of course, I was trying to paint the little boy; I hadn't thought about him much. So I'd consider a minute and say, "He wants to catch fish." "Ah," Mr. Fogarty

Howard Pyle, *Arrival of Stuyvesant in New Amsterdam*, oil painting for the article
"Colonies and Nation" by Woodrow Wilson (*Harper's Monthly Magazine,* February 1901)

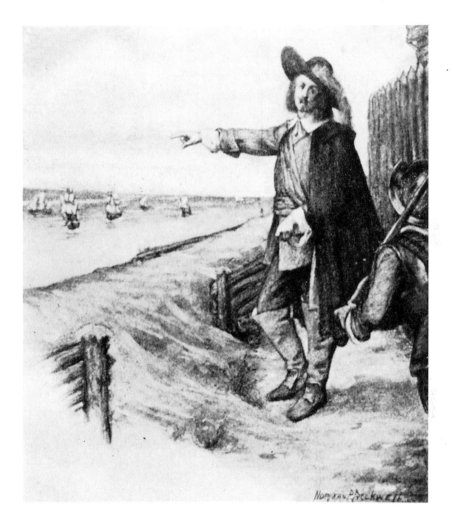

Approaching Ships, early book illustration, 1911

would say, "wants to catch fish, does he? Why? Hungry? Amusement? Father beats him if he don't? Eh, Norman?" I'd admit I didn't know. "You *must*," Mr. Fogarty would say. "Essential. Otherwise just picking over somebody else's work. Mortician, not artist. Can't expect to paint a live boy unless you know him, everything about him."

Mr. Fogarty extended this idea of living in the picture while you paint it to every kind of subject matter. I remember one day he asked us to paint the captain of a ship standing on the bridge during a storm. "The roar of the sea, pitch and roll of the ship," said Mr. Fogarty, swaying and waving his arms. "You aren't in class. You're on the bridge of that ship. Step over the frame; live in the picture." The next morning everyone in class was whistling and rocking back and forth to imitate the wind and the motion of the ship. Then someone who was really living his painting moaned as the spray lashed across his face and we all broke down and laughed until the easels rattled. We'd carried Mr. Fogarty's idea a bit too far. Still, he was right. He used to say, "Painting a picture's like throwing a ball against a wall. Throw it hard, ball comes back hard. Feel a picture hard, public feels it the same way."

Sometimes Mr. Fogarty, who was a practicing illustrator himself, would get one of the cheap magazines to give him a story to illustrate. He would assign it to his class and if anybody turned out a good enough illustration the magazine would use it. Then the student had a sample to show art directors when he made the rounds looking for work. That's very important. When you're breaking into illustration your first concern is to convince the art directors that you can be trusted to do an acceptable job and deliver it on time. If your work has been published, even in a shoddy little magazine, the art directors will be sufficiently impressed to try you out with some unimportant bit of illustration. After that, if you're good, you'll get more jobs. Convincing the art directors that you are a professional, not just another vague art student, is the hard part.

I was awarded a scholarship at the end of my first year in Mr. Fogarty's class. My charcoal drawing of a little boy in bed with the mumps, looking out of the window at the Fourth of July fireworks cascading down the night sky, was judged the best illustration made in class during that year. The scholarship covered my tuition for Mr. Fogarty's class during the next year. But by then it didn't mean much, for I was beginning to get jobs from children's magazines and didn't have time to attend his class regularly. (I continued to go to Mr. Bridgeman's class, however.)

Pass the prunes,
Mrs. Frothingham

One day I was sitting alone in the lunchroom at the League staring listlessly at the fly struggling to get out of my half-filled coffee cup. Mr. Fogarty happened in and, seeing me sitting there, asked if anything was the matter. "Oh, nothing," I said. "I don't know. I just don't seem to be getting anywhere." "How old are you?" asked Mr. Fogarty. I told him I was seventeen and three quarters. "Desperate," he said, "discouraged. All through at seventeen and three quarters." Then he laughed. "Come over to my studio after class. Seventy-eighth Street. You know it."

When I got there, "Are you a Catholic?" he asked. No. "Well," he said, "*well*. Job's at the Paulist Fathers'—Fifty-ninth street. Christmas booklet. Santa Clauses, angels, cherubs with trumpets. They'll give the job to a Catholic. Anybody else? No. Don't say you're a Catholic if you don't want to. But otherwise, no job."

I thanked him and went to see the Paulist Fathers. When the father asked me if I was a Catholic I mumbled incoherently. I think he knew I wasn't a Catholic but he didn't say anything, just showed me what the job was—a few simple drawings of Santa Claus, children, angels, for a Christmas booklet—and told me when he wanted it.

Mr. Fogarty knew I was having sort of a rough time staying in school and used to get me little jobs quite often. Once I drew in the backgrounds—trees, grass, people strolling—on almost a hundred photographs of tombstones for the catalogue of a tombstone company. I had to letter in the inscriptions, too, but that was fun. I used the names of my fellow art students: "In beloved memory of Arthur Young" (who sat beside me in class) and "Weep not overlong for Harold Groth, he sings with angels."

I did what were called surgical orders, drawings of different parts of the body for medical textbooks. One, I remember, I set up my drawing board every morning for three weeks in a room lined with bottled fetuses and drew the various stages of a baby's development in the womb. Nobody interrupted me all day long. I brought my lunch in a paper bag the first day; after that I went out to eat. It got rather cloying along about the fourth day.

I picked up a few jobs on my own—a sign for a store down the street from the League, a few posters for church suppers. Every smidgen helped.

Then Mr. Fogarty sent me down to McBride, Nast & Company, which published books and a little magazine called *Travel,* and they gave me a children's book to illustrate. It was called *Tell Me Why Stories.* The child would ask his father or mother "Why does the sun set?" or "Why do rainbows appear in the sky?" Then the parent would explain by telling a little story. I did ten or twelve illustrations for the book and was paid a hundred and fifty dollars.

On the strength of that, my first really professional job in illustration, I rented my first studio. E. F. Ward, another art student, and I went halves on the attic of a brownstone front on the upper West Side. We had been close friends for some time, though we used to have terrific arguments. He was always saying, "First of all I want to be a MAN!" and he followed baseball closely, went to boxing matches, and was generally virile. I just wanted to be a great illustrator; I was oblivious to everything else. He'd say to me, "Sure, you want to be an illustrator. But you've gotta be a MAN"—he always said the word in capital letters—"first." I'd ask, "Can't a woman be an illustrator?" which would make him mad and we'd go at it, curse and insult, for an hour. But we were great friends.

The studio, as I mentioned, was the attic of a brownstone front. A rough wooden stairway without railings led up to a trap door in the third-floor ceiling. The room was small—whenever someone wanted to come up we had to move our easels so the trap door would open—but there was a skylight and it was quiet away up there under the eaves. The middle-aged woman who rented us the studio provided three or four chairs and we brought our own easels.

Right off we noticed that there was something queer about that house. We'd come in at nine in the morning and there wouldn't be a soul stirring. Then along about noon someone would begin to play a piano somewhere downstairs and keep it up without a break until we left late in the afternoon. And every so often one of the girls who lived in the house would come up to our attic in a dressing gown and smoke a cigarette and talk to us. They didn't seem to have jobs or anything much to do. But they were very pleasant girls, a bit older than we, and all quite pretty.

One day while we were working in the attic there was a commotion downstairs and then a loud knock on the floor and a policeman stuck his head around the trap door and asked us if Mr. So-and-so had stayed in the house last night. We said we didn't know, we never slept there.

All this puzzled us a bit. But nobody bothered us and we were busy making samples to show the art directors and doing an occasional job.

Illustration for *Tell-Me-Why Stories*, 1912

Then about three months after we'd moved in my father came to see me. He climbed the stairs, shut the trap door very carefully, and asked, "Do you boys know what you are doing?" "Sure," we said. "What d'you mean?" "Do you realize," he said, "that you have a studio in a house of prostitution?"

Well, we understood that piano and those girls in kimonos then. Evidently the madam had realized that two pink-cheeked young men dashing in and out of her house all day long with portfolios under their arms was a wonderful front. We moved out the next day. The madam and her girls accompanied us to the door, the madam wringing her hands and saying how sorry she was to lose us. We went off down the street carrying our easels and paintboxes, rather shamefaced, because the girls had come out on the stoop in a crowd and were waving and calling good-by to us.

With four or five other young artists we rented quarters in a studio building right next to the Brooklyn side of the Brooklyn Bridge. Two of the others lived there all the time, sleeping in hammocks strung on hooks in the ceiling. I was staying with my parents at Mrs. Frothingham's boardinghouse in New York City at the time. (Housework had become too much of a burden for my mother, ill most of the time now, and my father had sold the house in Mamaroneck.)

We had one large room, a very good studio except for the elevated trains. The tracks were ten feet from one of our windows and when the trains ran past most of our light was cut off, everything in the room shook, and the roar was earsplitting.

It was a rickety, smudged old building. The courtyard in the center was roofed with glass, and alley cats used to sneak in and sun themselves and yell and roughhouse there. Everybody whose studio looked down on the glass roof kept an air rifle to shoo the cats away. A cat would yowl in the courtyard. A minute later, in all the surrounding windows, you could see people crouching with air rifles. Ping, ping, ping. Another yowl, a clatter, and the roof would be bare. Once we caught a workman out on the roof, kneeling with his back toward us. We pinged him on the rear. He jumped and looked all about, rubbing the seat of his pants. Then he went back to work. We pinged him again. "I saw you," he yelled, whirling around. "I'll report you." He kneeled again—gingerly, waiting. We didn't shoot. After a minute he set to work, whistling. Ping. "You'll hear about this," he shouted. "I'll have the law on you." And he left the roof. The manager of the building, suspecting who the culprits were, came up to our studio. "Not us," we said innocently. He was angry. "You watch your-selves," he said. "Any more of your shenanigans and I'll throw the lot of you out."

There were a few well-known illustrators in the building. One day Ernest L. Blumenschein knocked on our door and said he needed a young man as a model. We all lined up eagerly, for we wanted to see how he worked. Once one of the other fellows posed for an artist in the building all day for nothing. He was sitting in a chair with a beautiful girl on his lap.

McClelland Barclay, who later became a celebrated illustrator, worked in the studio. And Don Dickerman, though he wasn't there very often. At that time he was

preparing to open the Pirate's Den, the first of a series of fabulous restaurants which he founded through the years. He had bought or rented (I don't remember which) a three-story loft building on Sheridan Square and he and his mother and a couple of helpers had cleaned it up. A large freight elevator ran up through the center of the building and he put the orchestra on that so that it could play at all three levels of the restaurant. He hired a man with a wooden leg as a doorman and a lot of tough-looking men as waiters, dressing them all as pirates. The food he served, I remember, was pretty bad, but what atmosphere! A dimly lit cavern decorated with rope and cork, the ferocious waiters, and every so often from the alley behind the building the crash of breaking bottles, bloodcurdling yells, moans, and a voice screaming, "He walks the plank at dawn!"

Later on Don opened the County Fair, which featured greased pigs, hay-mows, waitresses in calico; and the Hi-Ho Restaurant, where Rudy Vallee picked up his famous greeting: "Hi-ho, everybody!"

Awhile after I finished the *Tell Me Why* job, Edward Cabe, the editor of *Boys' Life*, asked me to illustrate a handbook on camping which he had written. He liked the way I handled the assignment and began to give me other stories to illustrate for *Boys' Life*. Then he made me art director of the magazine, paying me fifty dollars a month. I had to do the cover and one set of illustrations for each issue. I went into the office once a week to interview artists, assign stories, and approve the finished jobs. The extraordinary part of it was that I had to okay my own work. That part of being an art director wasn't difficult.

With my illustrations for *Boys' Life* and *Tell Me Why* I felt I had a presentable portfolio of samples and began to make the rounds of the other children's magazines—*St. Nicholas, Youth's Companion*—and the book publishers.

I had already had a business card printed. At considerable (and rather painful) expense, by the way. In the center of it, in bold capitals, was my name: NORMAN P. ROCKWELL. Running down the left side of the card was the following modest description of me and my abilities: "*Artist, Illustrator, Letterer, Cartoonist; sign painting, Christmas cards, calendars, magazine covers, frontispieces, still life, murals, portraits, layouts, design, etc.*" (I had included everything in the art line I could think of and concluded with that omnipotent "etc." because I didn't want to miss any job through reticence or selling myself short.) Below my name on the card was the special, trick signature which I had worked out so laboriously. (In those days every artist had such a signature; Charles Dana Gibson's and J. C. Leyendecker's were, we art students felt, no small part of their success.) Mine was elaborate, clever and . . . illegible. Print a capital N; on the first vertical of this N, draw the loop of a P so that it touches the second vertical of the N, from which, in turn, draw the loop and slanting line of an R. (I can assure you that this explanation is no harder to decipher than the signature which it purports to describe.)

Armed with this card (and the gall and callowness of youth), I tramped around from art director to art director. The card probably suffered a myriad indigni-

ties (such as being torn up the minute I left the office) but I was undaunted. I would do anything—well, almost anything—to get an assignment.

Once I laid siege to the art director of the American Book Company, a textbook publisher. I persuaded the janitor of the building to let me into the anteroom outside the art director's office at seven in the morning before any of the office help had arrived. I'd sit there with my portfolio open and when the art director came in I'd stand up and say very quickly before he could get by me: "Mr. So-and-so, mynameisNormanPRockwellI'manillustratorhaveyouanywork?" For three weeks he brushed past me without replying. Then one day he stopped, said, "For Lord's sake," and went on into his office. I knew I had him then. Two days later when I introduced myself he asked, "If I give you a job will you permit me to digest my breakfast in peace?" I said yes, and he assigned me a book on American history.

It was rumored about among the art students that Will Bradley, the art director of *Colliers*, favored artists from the West Coast, especially San Francisco, where he'd grown up. When I heard that I rushed over to *Colliers* and sent in my pictures to Mr. Bradley with a note pinned on them: "Just in from San Francisco." He came right out and shook my hand. "Well," he said, "from San Francisco, eh?" "Just off the train, Mr. Bradley, just off the train," I said. "Whereabouts in San Francisco did you live?" he asked.

The rat in the trap? Me. I'd never been west of Jersey City. The only thing I knew about San Francisco was that *Sunset* magazine was published there. So I said, "Sunset Street, sir. Yes, Sunset Street." "Oh," said Mr. Bradley, looking puzzled, "Sunset Street, eh? I don't believe I know it. What district is it in?" I looked around for the exit. "The Sunset District," I said. "I see," he said, not looking puzzled any more. "Say, you'll have to excuse me a minute. I'm expecting a telephone call," and he went back into his office. He knew darn well I wasn't from San Francisco and wanted to give me a chance to escape. I took it. And I didn't bother to wait for the elevator either; I went out the fire exit and down the stairs.

Later on I got to know Mr. Bradley very well. He used to laugh about the incident. Every time I entered his office he'd say, "Here comes the kid from the West. Born and raised on Sunset Street in the Sunset District of sunny San Francisco."

A good many of my forays into the offices of art directors were successful. I really didn't have much trouble getting started; the kind of work I did seemed to be what the magazines wanted. Even in art school the other students always said, "You don't have to worry. Your stuff will sell."

William Fayal Clarke, the editor of *St. Nicholas* magazine, gave me several stories by Ralph Henry Barbour, a famous children's author of the time. Then I illustrated a number of Barbour's books—*The Crimson Sweater*, for one. The *Youth's Companion, Everyland, American Boy*, and the other children's magazines assigned me stories and articles regularly.

Almost all the pictures I painted for the children's magazines were in black and white or brown and white. A few years ago a collector of American illustration sent me two of the illustrations I did when I was eighteen or nineteen. They were, I

Oil painting for the story "The Magic Foot-ball" by Ralph Henry Barbour
(*St. Nicholas,* December 1914)

ABOVE: Oil painting for the book *The Red Arrow*
by Elmer Russell Gregor, 1915

OPPOSITE: Oil painting for the story "Pride-O-Body"
by C. H. Claudy (*Youth's Companion*, 24 February 1916)

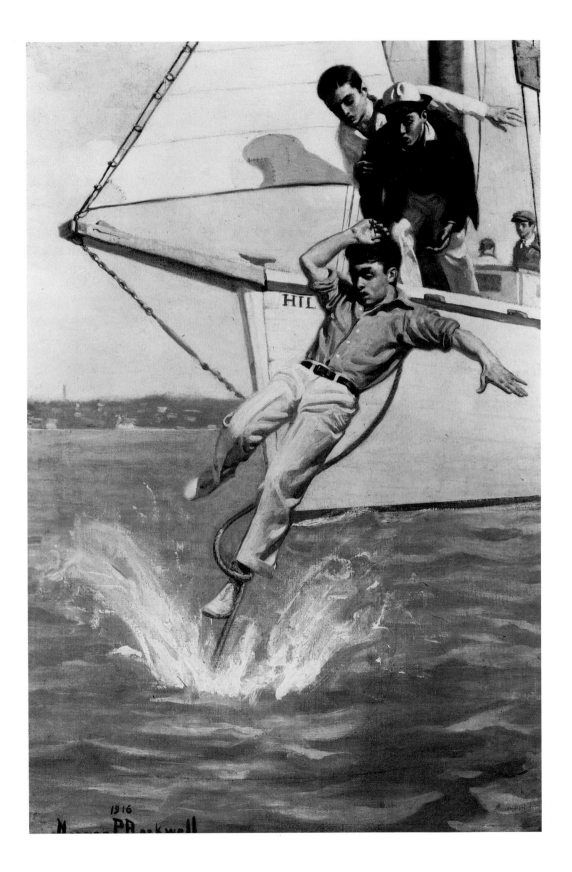

remember, for a story called "The Magic Football." They're pretty bad; I guess I have learned something over the years.

I did boating stories and baseball stories, cowboys, hunters, stories imitating Booth Tarkington's *Penrod* or Horatio Alger, adventure stories ("How Dick Connor Saved the Ship," "George Jackson and the Night Thief"). I took all the work I could get and enjoyed every job thoroughly. I was an illustrator.

I'd lie in bed at night while Jarvis snored soundly beside me and exult over my mounting prosperity. But then, all of a sudden, I'd begin to doubt my ability. Maybe I'd stumble, blunder, lose everything. I'd think about the painting I was working on and be all in a sweat to look at it, see if it was good, reassure myself that I wasn't slipping.

When the management of the building in Brooklyn evicted us for sweeping our trash out the door and down the hall to the door of a well-known artist's studio, I rented the second floor of the deserted brownstone front beside Mrs. Frothingham's boardinghouse so that, if I had a sudden inspiration during the night or, conversely, a cold sweat, I could slip out and work on my picture.

On winter mornings I'd climb out through the window of my bedroom and inch along the ledge to the window of my studio. Then I'd light the little coal stove which heated my studio and go downstairs, outside, and around to the boarding-house for breakfast, passing on my way the boardinghouse slavey sweeping the front stoop, a tattered cardigan draped over her thin shoulders, the dusty wind whipping about her bare legs.

The dining room was in what corresponded to the cellar. You entered it by a door underneath the front stoop. It was a dim, low-ceilinged room where the gas lights burned all day, the two windows being small, dirty, and grated thickly with iron against thieves. A massive oak sideboard, a long heavy table surrounded by ten or twelve straight chairs from which the mahogany veneer was peeling, and two smaller tables with four chairs each were crammed into the room. A squat chandelier hung from the ceiling like a huge bug.

At one end of the rear wall there was a swinging door to the pantry and, behind it, the kitchen; at the other, a dark, narrow hallway leading to the back of the house. Just down the hallway was a stairway, lit by a gas lamp, to the first-floor parlor.

Breakfast was served punctually at seven—dry toast, weak coffee, syrupy oatmeal, and prunes (Mrs. Frothingham flooded us with prunes, known in those days as the boardinghouse delight). The two Misses Palmer presided at breakfast, pouring coffee for the men of the house. Mrs. Frothingham and the wives never rose for breakfast.

I can see the two Misses Palmer now: thin, slat-backed, frail; their dyed blonde hair wrapped around rats and pinned in elaborate pompadours above their foreheads; so tired, drawn, from endless gray days spent standing behind the ladies' lingerie counter at Altman's. They were very kind and, I expect, very unhappy, though in a numb sort of way.

The door of their little room beside the stairs on the second floor was always ajar and whenever I came out of my room and started down the stairs, one of them would poke her head out and say, "Oh, Mr. Rockwell, do stop for a cup of chocolate." And when I explained that I had a deadline to meet and couldn't stop, she'd say, "You must hurry then, mustn't you?" "Yes," I'd say, "I'm afraid so. Thanks very much for—" "Oh, you run along now," she'd say quickly, "some other time perhaps." As I went on down the stairs I could hear her say to her sister, "He can't stop just now. He's got a deadline to meet; the picture—you remember it, the little boy and his dog—must be finished by noon. He's doing very well, you know. Such a young man, and . . ."

But sometimes I accepted the invitation. Then I'd sit in one of the two easy chairs squeezed in beside the beds while water for the chocolate heated on the tiny gas stove which they kept on the bureau. One of them would flutter about, laying out the cups, arranging a few crackers on a plate, spooning out the chocolate; the other, seated on the bed, her hands clasped anxiously in her lap, would ask me about my health, my work, never allowing the conversation to lag for a moment, never talking of their own affairs, trying so hard to be cheerful, gay. I've noticed that about lonesome, unhappy people: they don't discuss themselves, they're scared it won't interest you and you'll go away.

On winter evenings when they'd had to walk home through the slush and rain and had been splashed perhaps with icy mud by a carriage or wagon, they used to come in to dinner smoothing down their frocks and sighing. One of the men would say to one of them, "Nasty day, Miss Palmer, nasty day." And she'd brighten up a bit and, patting her hair, reply, "Oh yes, Mr. Dean, but we girls don't mind. Oh no, no, no. The wind brings out the red in our cheeks and then we ensnare you wicked men. Ask Sister. Do. A very kind young gentleman took her hand across the street. Very proper and polite. Oh yes. He begged the favor of a call." And then the two of them would giggle shyly behind their hands. The gentleman never called.

After breakfast I'd go back to my studio, where a model would be waiting, and work until noon (and outside my window I could hear Mrs. Frothingham berating the slavey, who would be washing windows or putting out the garbage, and the cries of the vegetable man, the rag merchant, and the fellow who put up clotheslines in back yards: "Line *up*, lady, put your line *up*; line *up*, lady, put your line *up*"), when I would return to the boardinghouse for lunch.

The men of the house never came home to lunch, so I was alone with the wives. They would troop downstairs—seven or eight of them, fat, thin, tall, short—in their silk wrappers, mussed and frowzy with sleep, their hair wrapped loosely around their heads and stuffed haphazardly under silk boudoir caps or hair nets. And they'd sit there at the long table, their wrappers half open over their nightgowns (I was just a boy; I didn't count), shuffling their feet in their sloppy slippers, sighing dolefully, and eating.

Pretty soon, after the third or fourth cup of coffee, one of them would begin to abuse the slavey: the food wasn't fit for pigs, her spoon had a spot of dirt on it, the

coffee was cold, her eggs were burned, etc. Then one of the others would chime in: why didn't Jack (her husband) make more money so they could move out of this horrible place; she couldn't even get out to the opera or the drama.

And the chorus would begin. They'd all complain about their husbands (who had, of course, been working for three or four hours before their wives got out of bed): no ambition, passed over in last year's promotions, made her live in one room and eat slop.

Well, I was sick. It was a pretty sorry bunch. My resentment at having to live in a boardinghouse among people I didn't like and couldn't respect darn near choked me at lunchtime. I guess I'm not over my resentment yet. I still can't look at a boudoir cap without cringing or eat a prune without gagging.

I wasn't the only one who found the complaints objectionable, though. At one end of the table, her head just above the level of her plate, sat Mrs. Frothingham, bristling, muttering, bobbing up and down with suppressed wrath. About halfway through lunch she'd burst out, rapping the table with her large cameo ring, "Go elsewhere, elsewhere, if my house is not to your taste. Applicants are never wanting for a clean house, a well-laid table." And she'd pick at the sleeves of her flossy flowery dress and pat her frizzy hair all in one motion. "Just yesterday I turned away a gentleman who begged, ladies, *begged* to be admitted. He was positively down on his knees, his *knees*. 'No,' I said, 'it cannot be, sir. Others are before you. Wait your turn, sir,' I said, 'wait your turn.'" Then, like a miniature, bustling volcano, she'd subside and sit fidgeting in her chair, staring hard at the ceiling one moment, at her plate the next, across the table the next.

After some minutes of silence a faraway look would come into her eyes. "Oh," she'd wail, "if *only* Mr. Frothingham were yet alive. I am a woman in reduced circumstances, a poor, lone woman in *much* reduced circumstances. If *only* Mr. Frothingham were yet alive." Then she'd tell us about the *huge* mansion they'd owned in Gramercy Park, the *multitude* of servants, her *high-class* friends, the *magnificent* Mr. Frothingham.

"Yes, my friends," she'd say lugubriously, softened by the opportunity to speak on her favorite subject, "I am, at present, far below the levels I was used to in happier days. Then I would have perished, my friends, *perished*, had I known I was doomed and destined to be the proprietress of a boardinghouse, howsomever fashionable."

By the time dessert came around I'd have reached the peak of indignation and disgust. Then I'd look at the poor slavey dashing in and out of the kitchen, goaded on by Mrs. Frothingham's busy tongue and called down constantly by the other women, and my indignation and disgust would slide out of me like water down a rain gutter. I just couldn't take any more. I'd go back to my studio feeling as limp as a wet washcloth.

I've never been able to understand that slavey. She was young—about thirty—and quite pretty. She certainly could have found an easier job. But no, she stayed on at Mrs. Frothingham's, working herself into the grave, scolded, insulted,

up at five every morning to prepare breakfast and not in bed before nine that night, toiling away at the meals, scrubbing floors, taking coffee to the lazy wives. My mother was nice to her, but the rest of the women were horrible. (Mrs. Frothingham, who preserved a dignified idleness, never lifting a bony finger except in reprimand, was the worst.) I don't know why the slavey stood it. But she did, and never a word of complaint, either. She wasn't dumb. Or crippled. A mystery (and a misery as far as I was concerned).

By the time the husbands came home from their offices the wives would be dressed, powdered, and rouged—all set to go out and *do* something. And when the slavey rang the Chinese gong in the parlor we'd go downstairs to dinner to a chorus of complaints: Jack hadn't bought theater tickets; William, fat as he was, had spent his extra change on lunch; Henry's breath smelled beery, etc., interminably, down the narrow stairway, up the dark hall and crowding—all eighteen of us—into the dining room where the ladies' perfume mingled with the odor of gaslight and leftover boiled mutton.

Mr. Leffingwell, the star boarder, would help Mrs. Frothingham into her chair and then take his seat at the head of the table and ladle out the stew, the pork and beans, the sauerkraut and knockwurst or whatever. My family sat at one of the smaller tables, two couples at the other.

And then, above the clatter of knives and forks on china, the muttered complaints, the creak of the swinging door as the slavey hurried to and from the kitchen, Mr. Leffingwell would hold forth upon some burning topic of the day, soothed and encouraged by the admiring ohs and ahs and "*No. You don't* say, Mr. Leffingwell!*" of the Misses Palmer and our proprietress.

Oh, how Mrs. Frothingham and the other ladies adored him! They hung like sloths upon his every word, spoke in awed tones of his gentlemanly bearing, well-tailored suits, delicate mustaches, fine white hands.

I used to think he was sort of terrific, too, the way he'd throw out his chest and, sticking his thumbs into the pockets of his vest, condemn the scandalous carryings-on of Edward, King of England, chorus girls and railway barons. He'd talk on any subject—politics, the price of corn in Kansas, raising chickens—and talk you right through the floor and into the basement, too.

Though cheap, Mrs. Frothingham's boardinghouse was not exactly the most desirable place to live. Take Dr. Boston. He was respectable but he had bad habits. A tall, burly, white-bearded Scotsman, almost stone deaf, he was a celebrated authority on dogs—Scotch terriers, I believe, though I might be wrong. Every year he served as a judge at the Westminster Kennel Club show in New York. But he drank, often and in quantity, and when he drank he fought.

I remember one night we were all eating supper quietly. It was a week or so after the sinking of the *Titanic* and for days the papers had been full of news of the disaster. One of the names mentioned had been that of Captain Stanley Lord of the S.S. *Californian*.

Well, that night as Mr. Leffingwell was proclaiming his views on (as I recall it) the best methods of selling cutlery (he traveled for a cutlery concern), Dr. Boston suddenly leaped up from his chair and began banging on the table with his fist and shouting at the top of his voice, "Damn Captain Lord! *Damn* Captain Lord! *Damn Captain Lord!*" We all started up amazed (nobody had mentioned Captain Lord).

Mr. Leffingwell admonished Dr. Boston severely, but the doctor continued to pound on the table until the tea cups rattled, screaming all the while, "*Damn Captain Lord.* DAMN CAPTAIN LORD." My father said to Mr. Leffingwell and the other men, "We must remove Dr. Boston. He is using profanity in front of the ladies." So we all gathered around him and backed him toward the door under the front stoop. Just as we were about to open the door and force him outside, Dr. Boston slipped on the rug and fell backward through the imitation stained-glass window in the top of the door. It scalped the back of his head as clean as a peeled potato.

When he returned from the hospital he had a large round bald spot on the back of his head. He was never able to grow hair there again.

Another night, just as we were about to go down to dinner, Dr. Boston lumbered in with his right eye black and blue and swollen. When we asked him what on earth had happened he drew himself up proudly and bellowed, "I was defending a lady's honor on the elevated train."

I don't think there is any place in America where you can see more of human character, or the lack of it, than in a boardinghouse. So often a boardinghouse is a place for people who are unwanted by their families, who drink too much or have never done very well, misfits. Wives and husbands who are unhappily married and don't want the responsibility, the intimacy, of a home. I always felt that those at Mrs. Frothingham's were immured in unhappiness, used to it and sort of happy in it, too. Lonesome people. And I guess a boardinghouse does offer a *kind* of home. There are people to talk to and eat with, after all. Even the angry chatterings of Mrs. Frothingham probably made Connie feel better than nothing, the utter silence of a rented room in a rooming house. (My own parents I can't explain, except that my mother was ill, as I've said, and couldn't do housework.)

All this didn't disturb my work particularly. I have the ability to shut myself off from unpleasant or disturbing experiences. Or, rather, to shut off the part of me which paints. And I wasn't really involved in all the goings on at Mrs. Frothingham's. I *observed* them.

But what a place it was! A native of Greece took a room at the boardinghouse. He was quite young—seventeen or eighteen—but a big, strapping fellow. Late one night one of the Misses Palmer awoke to find him bending over her bed, staring at her. When she screamed he backed out of the room, apologizing for having waked her. The next day, at supper, he apologized again. Miss Palmer forgave him. Mr. Leffingwell scolded him. "One does not enter ladies' rooms at night, my boy," he said. "I am sorry," said the Greek dejectedly. And everyone forgave him because he was such a nice, polite young man and a foreigner, from whom one expects strange, outlandish

behavior. "Why did you do it?" asked Mr. Leffingwell in a friendly tone of voice. The Greek hung his head, embarrassed. "She has such *white, white* skin," he said, looking at his plate.

On warm Sundays in spring and summer the whole boardinghouse—Dr. Boston, Connie and Mr. Hopkins, Mrs. Frothingham, Mr. Leffingwell, all the lazy wives and downtrodden husbands, my family—would promenade up to Central Park for ice cream. Mrs. Frothingham and Mr. Leffingwell, arm in arm, would lead the parade and the slavey, alone, would bring up the rear, everyone in their Sunday best, a jumbled line half a block long.

One Sunday we all marched over to Broadway to see the Harry Lauder parade. In those days before movies and television itinerant musicians used to go from one boardinghouse to another, performing for the assembled lodgers in the parlor and at the end of the evening passing the hat. One of these musicians had boasted to us that he was a star performer, second only to Mr. Lauder in the troupe. So we gathered on the sidewalk in high hopes of being greeted by Harry Lauder and the musician. The sun was shining brightly; a light, cool breeze sprang up. Harry Lauder passed in his kilts. Some dignitaries went by. Then some bagpipers. Then actors, more dignitaries, and a troupe of extras. Then a band, at the very end of which, beating the bass drum, marched our friend. We were intensely disappointed.

One sweltering evening in May of 1912 the whole boardinghouse was sitting on the stoop listening to Mr. Leffingwell, who was expounding his political views from his customary perch on the top step. The slavey was passing out glasses of lemonade; Mrs. Frothingham was delicately daubing her brow with a lace handkerchief; the wives were complaining in desultory, listless whinings; the backs of the Misses Palmer's frail dresses were damp with perspiration. The night seemed to grow hotter, the air heavier by the minute.

Suddenly I felt as if I couldn't breathe, as if everything—the steaming night, the drone of Mr. Leffingwell, the whinings, the smell of soot—was crushing my chest, pressing down with the weight of a carload of earth. I got up and walked off down the street. I decided I'd had enough. At least for a while. I had to get away.

Late that night I resolved to spend the summer in Provincetown on Cape Cod studying under Charles W. Hawthorne.

White curtains billowed out over my head in the cool sea breeze, gulls screamed in an immensity of sky and sunlight, when I awoke that first morning in Provincetown. I jumped out of bed and, leaning out of the window, saw a Portuguese lobsterman striding up the street from the docks, a huge mottled green lobster clutched in each burly fist.

No whining, frowzy women in boudoir caps, I thought. No soot. No scramble for the toilet. No pitiful Misses Palmer. *No Mr. Leffingwell!* I pulled on my clothes and ran downstairs to breakfast. It was fish, I remember, fish and pancakes, steaming hot and served by a cheerful mountain of a woman, the mistress of the boardinghouse.

After breakfast I walked over to the art school. Down the hill to the main street, scuffing my sneakers in the clean white sand which blew along the pavement, then past the old white church and town hall and by the docks where fishermen in hip boots shoveled fish and whirring cranes dropped nets into the holds of ships and, hauling them out a moment later, cascaded a thousand squirming, sliding, flopping fish in silver piles upon the wet black timbers of the dock. Then up a little alley festooned with drying nets to the old sail loft which housed the art school.

White gulls, not grimy pigeons, I thought as I entered the school, a view of the sea, not two brownstone fronts. No dirty, stifling breeze!

The wind blew through the open windows which ran all around the barnlike room and through the enormous doors, one facing the harbor, the other the dunes. While the students gathered by one of Mr. Hawthorne's paintings in a corner (I noticed they seemed considerably less ecstatic than I about the view, wind, et cetera), I stood at one of the doors, looking out at the harbor, the breakwater of black boulders, and, beyond, the sea—a choppy blue.

Then Mr. Hawthorne led us across the dunes to the seaward side of the Cape and we set up our easels in the sand. The model, a Portuguese girl, dark-skinned, black-eyed, exotic, stood on a hillock against a yellow dune. The dusty green beach grass blew over her feet; the sun glinted in her long black hair.

No knobby little boys to draw, I thought to myself as I sketched her swarthy shoulder, no dull black-and-white illustrations for petty, persnickety art directors. No dreary anterooms, no deadlines!

I unsnapped the lid of my paintbox, opened my jar of turpentine, squeezed out some paint on my palette, and began to load paint on the canvas with my palette knife—slashes of yellow, a gob of scarlet, green, bronze, and cerulean blue.

I began to whistle. No picky brushes for me, I thought, no grays, browns, or muddy blacks. COLOR! (All that first day I thought in capital letters and exclamation points.)

An idyl, an idyllic interlude during which I sluffed off my responsibilities, my city cares, even my ambitions, and lived the life of the most bohemian artist—that's what that summer was. I didn't do any illustration, just painted what I pleased—the fishermen and their wives and daughters, an occasional seascape. I refused to think about my career, editors, the commercial rat race.

I don't know. Maybe it sounds silly. But let it go. I had a grand time.

I met a girl in art class, Frances Starr. She was a frail, timid, pretty girl. She tied up her hair in a knot on the back of her head and always wore an artist's smock. I've never known anyone more wholeheartedly devoted to art. Her sole means of support was a job as an usherette in a theater in Chicago. For two years she had scrimped and saved so that she could spend the summer in Provincetown studying under Mr. Hawthorne.

Afternoons we'd walk to the seaward side of the Cape to swim in the breakers. She'd go off down the beach one way and I the other. Then, each behind a scrub oak,

Gramercy Park, oil painting, 1918

we'd change into our bathing suits. Until the sun was just a sliver of crimson behind the shadowed dunes, we'd swim and lie on the sand, discussing art.

Evenings we'd sit in the kitchen of the boardinghouse and stretch canvases. Or we'd walk about the town—down to the piers to watch the fishermen repair their nets or out along the breakwater.

I never tried to kiss her; I didn't even hold her hand. Somehow I felt that would ruin things. Perhaps I was being dumb and adolescent, but both of us were living and breathing art.

Another student, Bill Bogar, and I decided to give up money and study in Paris that winter. We ripped a map of Paris out of a Baedeker and tacked it up on the wall of his room. Almost every day we'd study it to prepare ourselves for life in Paris. Bill would say to me, "Now you're standing at the northwest entrance of the Jardin du Luxembourg. You want to go to the Opéra. How do you get there?" Then, with my eyes shut so I wouldn't look at the map, I'd say, "I go up the Rue Bonaparte, turn left on the Boulevard St. Germain, and continue along till I come to the Seine, which I cross on the Pont de la Concorde. I walk straight by the Obélisque and up the Rue Royale. Then I bear right into the Boulevard de la Madeleine and four short blocks and one long bring me to the Opéra." We did this hour after hour until we knew Paris by heart. And we decided whom we wanted to study with, where we wanted to stay, the café we'd sit outside in the evenings, sipping absinthe and talking art.

Then the next summer we'd come back by cattle boat to New York, strap our paintboxes and sketchbooks on donkeys, and walk from New York to Provincetown.

We lived a careless, crazy, easy life. None of us gave a dried fish head for anything but art. Frances didn't have enough money to buy both art supplies and three meals a day, so she gave up breakfast and every so often lunch too. Once she didn't eat anything except a little bread for two days and had to go to bed to recuperate. But when I went up to her room she had a pad of paper propped on her knees and was sketching the view out the window.

Bill read in the paper one day that some scientists at Columbia University had concluded after a series of experiments that a person could go without sleep for four days and nights. "Four days," yelled Bill. "The pikers! I can stay up *five* days with my hands tied behind my back." So he and Hawthorne Howland, a fellow student, and I decided to conduct our own experiment. Hawthorne contributed four boxes of fine Havana cigars which his father had given him, Bill and I bought two or three cans of coffee, and we started. The first day and night we drank about twenty cups of coffee apiece and chain-smoked cigars. We sang all through the second night though our tongues felt like kippered herrings and our throats like the inside of a coal stove in January. The third day we put our feet in tubs of ice water and woke up at ten o'clock that night, sniffling and shivering.

For the end-of-the-season costume ball at the city hall Bill, Hawthorne, and I made a dragon out of green paper and tinsel over a wooden frame. I, on my hands and

knees, was the tail; Hawthorne, crouching, was the middle; Bill, standing, was the head. We wove through the crowd at the ball, Bill swinging the head from side to side and puffing on a big cigar to simulate the dragon's fiery breath. I reared and kicked and Hawthorne screeched and growled. We won grand prize.

Oh, it was a wonderful summer. I returned to New York refreshed, my mind cleared of debris. But Bill and I didn't go to Paris that winter; I didn't even go back to Provincetown the following summer. Frances died two or three years later of tuberculosis; she'd had it when she was in Provincetown, though none of us, least of all Frances, had paid any attention to it.

I picked up my work right where I'd left it. The children's magazines began to assign me stories and covers regularly. I was earning from fifty to seventy-five dollars a week, a lot of money in those days, and beginning to make a name for myself. Fortune (and the art directors) smiled on me.

Then I met John Fleming Wilson, a famous best-selling author. He had written *The Man Who Came Back*, a celebrated book about a man who went from drink to worse . . . and worse . . . and worse, until finally in an opium den in Hong Kong he met a beautiful girl who reclaimed him. The book had been a great success, not least because Wilson's life had been similar to his character's. He had ruined himself with drink and then had written *The Man Who Came Back*.

As art director of *Boys' Life*, I had assigned myself, as artist, one of John Fleming Wilson's stories. It concerned a shipwreck and I found I needed a life raft. Mr. Cave, the editor, suggested I ask Mr. Wilson if he could help me. So I went over to his hotel on Broadway and sent my name up.

After about half an hour a small thick man with a brutish face, from which bulged a black mole as big as a strawberry, came lumbering across the lobby and pumped my hand. "Wilson," he said, "John Fleming Wilson. Let's have some breakfast." And slinging his arm across my shoulders, he propelled me into the bar. He ordered a double whiskey, straight, and two fried eggs for himself and the same for me. When I protested that I didn't drink he said, "If you wanta be an artist, boy, you've got to *live*. You follow me. I'll show you life." But he canceled my whiskey, ordering me coffee instead, and began to caress his mole with the thumb of his left hand, muttering to himself.

After he'd slugged down his whiskey he cheered up considerably and asked me what my problem was. I told him I needed a life raft. At least I wanted to see one before I drew it. "That's the ticket," he said. "Out into the dirty world. See everything, do everything. Stick with me. I'll show it to you."

He took me in a cab to one of the Hudson River ferries and I sketched a life raft. Then we stopped in a bar and he had a drink. He was all for going on to some other bar where, he said, the company was gayer—women and all—but I told him I'd already hired a model for the afternoon. So he said I should come around to his hotel the next day early because something big was going to break for him any day now and he was going to get me in on it.

I can't say I liked the man, but he *was* a very famous author and he *had* prom-

ised to do something for me. What, I didn't know, except that it was certainly con-
nected with my work.

I smelled liquor on his breath the next morning at nine when he ushered me
into his suite, saying that he had to finish a story before we went out. It took him
about half an hour. He dictated his stories to his secretary, cursing obscenely and
walking about the room, a bottle of whiskey in one hand, a glass in the other. I later
learned that when Wilson had finished dictating the secretary, who was very well
paid, would edit out the profanity, fix the grammar a bit, and organize the story a little
better. Wilson's gusto obscured his learning and his grammar somewhat. But he had
been an English instructor, and talked the stories pretty well.

After Wilson had completed his story we went over to the offices of Charles
Scribner's Sons, publishers of *Scribner's* magazine. Wilson left me in the anteroom
and strode into the editor's office. An hour later he came out and said, "It's all set.
We're going to the Panama Canal to do a series of articles. I'll write 'em, you'll illus-
trate 'em. We'll blast the canal and Davis and Pennell into the bargain." (Richard
Harding Davis and Joseph Pennell had just done a series on the canal for one of the
other big magazines. They had pictured the canal as a rousing success.)

"We're in, boy, *in*," he shouted. "I'll be the greatest writer, you'll be the great-
est illustrator. America'll go down on its fat red knees and kiss our feet when we get
through." And he insisted that I accompany him to his favorite tavern to celebrate.

But he stopped at a little bar just around the corner from Scribner's first and
when we boarded the trolley he was soused and fell against the motorman. The
motorman shoved him away and Wilson began to curse him. So the motorman just
pushed a little harder and Wilson fell on his back in the street. He got up and swore
he'd get that motorman. If he'd just come down off his trolley, he (Wilson) would
disfigure him for life. At that the motorman jumped on him and they rolled in the
street, pummeling each other and cursing, until some workmen and I managed to
separate them. I dragged Wilson off around the corner, calmed him, and took him
home.

That was the beginning of a strange two months. Almost every day Wilson
would "show me life." He had the idea that you can't be a great artist unless you've
lived deeply, experienced everything. I'd hate to tell you the places he took me to. But
the queer thing was he never insisted I *do* anything. I'd wait in the lobby of some
dilapidated hotel while he went upstairs. I'd stand at the bar with him, he drinking
whiskey, I a lemonade.

I suppose I should have dropped him. I knew he was wild; I half suspected
he was lying to me about the trip to Panama. My father kept saying, "I would like to
meet this Mr. Wilson," and I always replied, "He's an awful busy man," and slid out
of it.

That trip to Panama held me. I was (I need hardly repeat it) intensely ambi-
tious. And here was my chance to become a great illustrator almost overnight. I was

scared, but I couldn't let an opportunity like that slip by simply because Wilson drank, swore, etc.

So I accompanied him on his excursions into the black underside of life. And every three or four days we'd go up to Scribner's and he'd talk to the editor, coming out of the office bursting with information about our trip to Panama.

"It's all set," he'd say. "Now get yourself a pith helmet. And five suits of cotton pajamas (that's all they wear in the tropics). And sandals. And have your teeth fixed—in Panama they'll rot like raw meat in summertime." So I bought all those things and went to the dentist (my teeth have never recovered).

The next week he'd tell me to buy a revolver. I'd buy that. The next week he'd advise me to buy a machete. I'd buy that. The date of our sailing got nearer and nearer. He told me he'd purchased the tickets, even the name of the boat we were to sail on.

I'd dropped most of my own work in the excitement. All I did was a few tentative sketches for a book, *The Aurora Borealis*, which he said he was writing and which he wanted me to illustrate when we returned from Panama.

So the trip built up and built up in my mind until I was shaking with anticipation. I was going to be a great illustrator, like Pyle or Abbey or Remington. I packed my outfit in the special knapsack he'd insisted I buy and strapped on a roll of mosquito netting.

Then, two days before we were scheduled to leave, I went over to his hotel and he was gone. The manager of the hotel had no idea where he was. Or where his wife was. Or the secretary. Or *his* wife. I went over to Scribner's. Yes, of course, they knew John Fleming Wilson. A series of articles on the Panama Canal? No. They'd never heard of that.

I was crushed. I went home and sat in my studio amidst the litter of my tropical gear. My mind was empty. Everything—all my dreams of becoming a great illustrator, of working for the big magazines—shattered, lost. The light faded along the walls, grayed, and was gone. I sat there, unable to rouse myself. Late that night my father came in and led me off to bed. But I didn't sleep, tossing and rolling all night long.

I guess I came as near to having a nervous breakdown as I ever have. I couldn't work. Or sleep. Or eat. Or go out anywhere. I wouldn't talk about it. I just sat in my studio, staring at the pigeons strutting on the ledge outside my window.

Finally my father sent me away to the mountains for a month. I lived with a farmer's family we'd stayed with once or twice. I took long walks through the snowy countryside, not trying to think, just letting the cold wind burn on my face, the sleet sting my eyes. And gradually I got out of it.

One day after I'd been back in the city for two or three months Wilson came around to my studio. He explained that he'd been called away unexpectedly, that he hadn't had time to notify me. The trip, he said, was still on. I felt a surge of hope. All my dreams came back stronger than before.

The next night my girl friend from Mamaroneck, Eleanor Bordeaux, and I went over to his apartment in Brooklyn to his birthday party (by a strange coincidence it was George Washington's birthday too). The minute I stepped in the door I knew I'd been kidding myself. Everybody at the party was drunk, men and women were lying together on the sofas, a disheveled middle-aged woman was dancing alone in the center of the room—an unbelievable orgy.

I realized right then that it was no good. Wilson was duping me again. (I don't to this day know why he did it.) So I said Eleanor and I had to go home. But he got in front of the door and wouldn't let us. The party got worse (I won't say how, but take my word for it, it did). I began to get scared; I could see Eleanor was scared. Then Wilson decided that everybody must go for a sleigh ride. I volunteered to get the sleigh. He told me where the livery stable was and I grabbed Eleanor by the hand and we ran out. We didn't go to the livery stable, we went home.

That was the last I ever saw of John Fleming Wilson. I heard later that he burned to death somewhere out West.

Partly because of Wilson (I was scared he'd call me or come over to my studio drunken mad) and partly because of the life at Mrs. Frothingham's, my family soon after moved to Brown Lodge, a boardinghouse in New Rochelle. I'd had enough of city life to last me for quite a while.

6

Great Expectations

BROWN LODGE was conducted by Mrs. Brown, a lady, like Mrs. Frothingham, in reduced circumstances. But evidently she had not been as greatly reduced, for Brown Lodge was a reputable boardinghouse, clean, neat, and inhabited mostly by schoolteachers.

The night of my arrival I went out walking with Gertrude, Mrs. Brown's niece. As we crossed a vacant lot I tried to kiss her. She fended me off, saying, "Oh, I wouldn't kiss anyone unless I was engaged." I asked, "Would you kiss me if we were engaged?" She said yes, so I kissed her. "*Well,*" she said, "now we're engaged." Somehow I couldn't dredge up the nerve to stand firm and say, "No, we're not."

Mrs. Brown was overjoyed when Gertrude announced our engagement the next day. I guess I was a good prospect—steady; hard-working; respectable family; earning a splendid fifty dollars a week with every indication of more before too long. She became excessively cordial—plying me with three eggs for breakfast, an orange slipped into my lunch, unlimited helpings of brown Betty at supper—and hurried Gertrude and me off to town to buy a ring. Conferences were held concerning the gown, a minister, the wedding supper. Gertrude was happy; the schoolteachers were excited; my parents were pleased.

I was miserable. Gertrude was a pretty girl; I liked her. But I certainly didn't want to be married. Not yet anyway. Finally, after a week of dazed meandering, I led Gertrude up to the trunk room of Brown Lodge (every boardinghouse had such a room, usually the attic, where the lodgers stored their trunks, all sorts of trunks—small, large, battered, new, leather, cloth—jumbled together in the dimly lit, dusty cavern under the eaves). I seated Gertrude on a lady's trunk. Then I sat down on

another opposite her and, taking her hand, said, "Gertrude, I'm not worthy of you. I'm no good." "You mean you don't want to be engaged?" said Gertrude. "No. No," I said, "I'm not worthy of you. You're a fine girl, Gertrude; I'm no good, I'm rotten." So she gave me back the ring.

Mrs. Brown took it very hard. Two or three days later Gertrude and I walked back from town together. Mrs. Brown saw us coming up the road and screamed out the kitchen at Gertrude, "Come in here. What're you doing with that no-good artist?" My palmy days at Brown Lodge were ended. However, my family and I continued to live there.

My studio was in the Clovelly Building at 360 North Avenue in New Rochelle. There were stores on the first floor (the proprietor of the dry-cleaning establishment owned the building) and five offices on the second floor. I rented an office in the middle of the building.

Dr. Bugden, a dentist, occupied the rear office. On Saturdays a crowd of school children milled about in the hall and a succession of screams—high, low, and agonized—issued from his office, for he had the school tooth concession and was not a particularly gentle man. Or so I assumed from the screams and his appearance— short, red-faced, a yellow cloth jacket strapped tightly across his barrel chest.

In the office of Sutton's Real Estate at the front of the building old Mr. Sutton, who was stone deaf, presided over an all-day poker game six days a week and frequently on Sundays. The other players were continually shouting at him, "Ante up, Mr. Sutton, ante up!" and he'd yell back in a high, cracked voice, "I anted. I anted."

The first time I heard Mr. Sutton's telephone bell I snatched my picture off the easel and ran into the street, thinking it was the fire alarm. He couldn't hear the regular telephone bell and had installed a special one. When it rang the windows rattled and the birds nesting on the sills flew off squawking.

Another office was rented by Mr. Oden, a German photographer who was getting on in years and used to have trouble lugging his large black camera, tripod, and film boxes up the stairs. I'd hear assorted thuds and grunts on the stairs and then Mr. Oden would call, "Mr. Rockwell. Mr. Rockwell." I'd go out and find him stuck halfway up the stairs, his camera under one arm, his film boxes under the other, and his tripod lying between his feet, blocking his path. So I'd go down and carry up his tripod for him.

Adelaide Klenke, a blonde, husky, beautiful Brunhild of a woman, published the *Tatler*, a monthly society magazine, in the office beside mine. However, she was a butcher's daughter and society snubbed her so she became catty and the *Tatler* failed. When she vacated her office I rented it and knocked down the wall which separated it from mine.

With the addition of the second office, my studio was even a bit too big. I used to feel sort of loose and airy when I contemplated it; it was the biggest studio I'd ever had. That didn't last long, however. I met an illustrator who had recently come east from Peoria and didn't have a place to work. "Why don't you move in with me

until you can get a place of your own?" I asked, relieved that I'd found a way to stop my lightheadedness (it was like working in the middle of a field).

For the first few weeks the arrangement worked out very well. He was an easygoing, quiet fellow and I'm an amiable guy if I'm not pressed. We worked at our easels in opposite corners of the room, talking when we felt like it, criticizing each other's pictures gently, now and then going downstairs and across the street for a cup of coffee.

Then a hardware company commissioned him to do the drawings for their catalogue. The next day there were two easels set up in his corner of the studio. "Norm," he said, "I want you to meet So-and-so. I've brought him on from Peoria to help me with the catalogue." "Okay," I said. (Let's face it, I'm amiable, pressed or unpressed.)

The following morning I arrived to find them unpacking two huge crates. "Our models," he said cheerfully, displaying a handful of monkey wrenches. During the course of the day there emerged from the crates an assortment of hammers, pinch bars, watering cans, rakes ("Norm," he said, "I wonder if you'd mind moving more over into the corner. I want to set these tools out where we can see them"), shovels and tin pails, paper bags of screws and nails ("Would you put your brushes on the palette table, please? I need that chest for these packages"), a lawn mower, a wheel-barrow and, incidentally, an enormous quantity of wrapping paper (which he folded neatly and laid on my stack of frames) and excelsior (which he piled on the model stand).

That evening as I pulled my jacket from beneath a heap of wrenches and picked my way through the tools, stubbing my toe on a pail, barking my shin on the wheelbarrow, I wondered where *my* model would fit in.

The next morning I wasn't sure *I'd* fit in. Two more crates had arrived. Some-where behind them lurked my easel; my chair was surrounded by mounds of excel-sior; wrapping paper hid my palette table. "Say," I meekly suggested, "couldn't you throw away the crates and wrappings?" "You want to ruin us?" he said in an injured tone of voice. "Take the bread out of our mouths? We gotta send all this stuff back when we're done with it." "Okay," I said, "but I haven't got much room here." So he took the wrapping paper off my palette table and piled it underneath. "There," he said, "how's that?" "Fine," I said, "just fine." "Good," he said, smiling. "I knew the minute I saw you that we'd get along."

For two weeks I waded through tools, bags, pails, and excelsior to my dark little corner and painted to the clatter of dropped wrenches and whispered discus-sions of how best to portray the ball-peen hammer. Then I told a forceful friend about my situation and left for a two-week vacation.

When I returned the studio was again a broad expanse of open floor in the center of which sat my easel like a primitive god. Somehow I never again had those airy, loose, lightheaded feelings when confronted by the empty room.

At this time I was working almost exclusively for the children's magazines.

That meant that most of my models were children. Of course, when I arrived in New Rochelle, I didn't know anyone and had a bit of trouble finding models.

Say I was doing a picture of a boy and a dog running. First off I had to locate the right boy. For days I'd hang about the grade schools at recess, peer over fences into back yards, haunt the vacant lots, and stop little boys on the street, turning them around and sideways to see if they were the type I wanted. When I'd finally found the right boy I had to persuade him to pose. "Gee, mister," he'd say, "I gotta play ball on Satiddy. I can't do no posin'." "Fifty cents an hour," I'd say. "I dun know," he'd say. "You gonna pay me fifty cents just ta stand there?" "Sure," I'd say, and launch into a long explanation of pictures and models and stories and magazines. The boy would listen very attentively, staring into the gutter and scraping the side of his shoe on the curb. When I'd finished he'd say, "I dun know. I gotta play ball on Satiddy. I dun know."

But finally I'd cajole him into asking his mother about posing. Then I had him, because most of the mothers thought it was just wonderful that little Clarence was going to appear in *American Boy* or *St. Nicholas*, and little Clarence would be down at my studio at nine o'clock Saturday morning, ball game or no.

The dog was more complicated. First I had to find him; then I had to follow him about until I learned where he lived. Once I chased a dog all afternoon through vacant lots, over fences, down and up gullies, through briars, burrs, and nettles. He was a perfect mutt, the best I've ever seen—black patch of fur around one eye, woe-begone, lanky, and rough. But he was tricky and escaped through a back yard criss-crossed by clotheslines hung with clammy sheets and shirts.

After I discovered where a dog lived I had to persuade his owner to let me take him up to my studio. Some of the owners thought I was a vivisectionist, others that I was the dogcatcher or just crazy. One old lady who had seen me chasing dogs about the neighborhood accused me of an inveterate and perverse taste for dog meat.

But finding the dog and the boy was nothing to posing them. You take a young mutt who's been reared on rats and garbage. *There's* exuberance and all-around *joie de vivre* for you. I'd set him up on the model stand, pushing him down on his haunches. He'd sit quietly for a few minutes, staring at me. Then he'd catch sight of his tail out of the corner of his eye and determine *he'd* put a stop to that impudent wagging before long; then it would be a flea behind his ear; then he'd take exception to the way I was holding my brushes and prance about the model stand, barking (which upset Dr. Bugden's patients and sadly disturbed the concentration at the all-day poker game, though old Mr. Sutton, being unable to hear the dog, never could understand what all the fuss was about).

But an old dog was the worst, one who'd been in and out of fights and garbage pails for eight or nine years, flop-eared, mangy, and resolute. He'd plop down on the model stand, growling every time I approached. I kept a sack of bones in the studio, but a bone was no help with an old dog—only made him worse. He'd snatch the bone and retreat under one of the sinks in the studio. Then he'd lie under there gnawing the bone and snarling.

Still, I had to have dogs. The editor of the old *Life,* John Ames Mitchell, once told me that the most popular subject for a magazine cover was a beautiful woman, the second most popular a kid, and the third a dog. Later on when I was doing *Post* covers I'd receive letters from the readers saying, "I love that little boy, but, oh, that *dog*—with those human, beseeching eyes."

Occasionally I'd need some other kind of animal. Once, I remember, I was doing a picture with a duck in it. I called the local butcher and asked him to bring a fat one over. When he set it on the floor of the studio it waddled off and hid behind a chest. "How am I going to pose it?" I asked. "You got a hammer and some wide-topped tacks?" he asked as he retrieved the duck. "Sure," I said. "Give 'em here," he said. "I don't want to hurt the duck," I said (it was looking at me and quacking mournfully). "Don't worry," he said, "you just hold the duck where you want him." So I did and he began to tack the duck's feet to the model stand. "Hey," I said, "stop." "It don't hurt him," he said, continuing to drive in tacks while the duck pecked cheer-fully at the hammer. "You could pound a railroad spike in the web of his foot and he wouldn't blink an eye. Don't have no feeling there."

And sure enough, the duck wasn't at all disturbed by the tacks. When the butcher was finished, it quacked twice, stretched its neck, and tried to jump off the stand, but the tacks held it fast. "That's fine," I said. "Okay," said the butcher, putting on his hat and coat. "I'll pick him up at four." So all afternoon I painted the duck while it stood tacked to the stand, quacking and heaving itself up on its legs, though after a while it stopped trying to move and just stood there looking at me. Every so often, "*Quack,*" it would say very indignantly, "QUACK, QUACK."

There's a trick to posing a chicken, too. Any farmer knows it. You pick up the chicken and rock him back and forth a few times. When you set him down he will stand just as you've placed him for four or five minutes. Of course you have to run behind the easel pretty quickly to do much painting before the chicken moves. But it's better than trying to paint him when he's dashing about the studio.

If you want to paint the chicken full face the procedure is even more compli-cated because the eyes of a chicken are on the sides of his head and when he looks at you he turns his head. I puzzled about that for quite a while. Finally I got a long stick and after I'd set the chicken down and gone behind my easel I'd rap the wall at one side of the chicken and he'd turn his head toward me to look at the wall. It's very strenuous painting a chicken, what with rocking him, placing him, running behind the easel, and rapping with the stick.

But it's nothing to an experience I once had with a turkey. I was doing a Thanksgiving cover for *Life* and asked the manager of an estate where turkeys were bred to lend me one. He brought it up in a crate. "I'll leave him with you," he said. "Don't let him out of the crate. He's a prize one and very valuable." However, the slats hid all but the turkey's neck and head. I unlatched the door of the crate and tried to coax him out. I can handle that bird, I thought.

At first he wouldn't budge. I got down on my hands and knees and, grabbing him by the leg, said, "Here, turkey. Here, turkey." All of a sudden old Mr. Sutton's

A PILGRIM'S PROGRESS

ABOVE: *A Pilgrim's Progress*, oil painting for *Life* cover (17 November 1921)

OPPOSITE: *Boys Bathing Dog*, watercolor idea sketch for *Country Gentleman* cover, c. 1920

telephone bell rang. The turkey leaped out of the crate, bowling me over, and ran into a corner. When I stood up he charged me. I ran behind the easel. He retreated to his corner. Every time I peeped out from behind the easel he started at me, cackling ferociously. Trapped by a turkey, I thought. What'll I do? But I was closer to the door than he was so I made a dash for it. As I flung open the door the turkey scaled my back into the hallway, flew down the stairs, and ran off along North Avenue. Escaped, I thought, prize turkey, valuable. I ran out after him. It was a merry chase. Over fences, through lots, up one side of a porch and down the other. But finally with

the help of five or six small boys I cornered the turkey. While they kept him in the corner by shouting, dancing, and waving their arms, I went and got the crate. Then we forced him into it, I stood them a round of ice cream, and we dispersed.

When the estate manager returned to pick up the turkey he asked, "Everything go all right?" "Smooth as cream," I said. "It wouldn't have, if you'd let him out," he said. "That's a high-spirited bird." "Oh, I don't know," I said, "looks pretty calm to me."

The kids were easier to pose than the dogs, chickens, or turkey, but it was just as difficult to get them to stay put. I'd prop the kid's feet into a running position with bricks or boards, making him as comfortable as possible. But five minutes later he'd begin to squirm. "Say, Mister, you almost through?" And ten minutes after that: "I gotta go home, mister." Then: "Geez, my back hurts. You done yet?" When, after twenty-five minutes, I'd tell him to rest, he'd put on his coat and hat. "Hey," I'd say, "we aren't finished. I'll need you all morning." "*All morning!*" he'd say. "Yes," I'd say, "come on. Fifty cents an hour. You've only earned twenty-five cents so far." Well, then the kid would want to take his twenty-five cents and leave. I'd say he couldn't and he'd become very disgruntled (some of the smaller kids would begin to snuffle). But finally I'd bribe or threaten him into staying.

After two or three months of this I hit upon a device which eliminated most of the restlessness. At the beginning of the modeling session I'd set a stack of nickels on a table beside my easel. Every twenty-five minutes, when it came time for the model to rest, I'd transfer five of the nickels to the other side of the table, saying, "Now that's your pile." The kids liked that. (I'd learned previously that they wanted cash; checks didn't mean anything to them. And coins were better than bills—hard, bright, and jingly.) I didn't have too much trouble after I'd instituted the piles of nickels, except that the kids always wanted to count their piles during the rest periods. With the younger ones I used pennies—their pile was bigger, then, and grew faster.

I never asked my models to assume and hold the entire pose at one time. I'd pose the kid's right leg and draw that; then I'd pose his left leg and draw that; then his right arm, left arm, head, and facial expression. The more recalcitrant ones or those with pressing engagements elsewhere used to argue with me: "You already *did* my left leg." "No, I didn't. Prop it up on that box." "You did so. I remember it. *Geez,* what a guy."

The facial expression was the hardest part of all. "Smile," I'd say, and the kid would grit his teeth and lift the corners of his mouth. "No, no," I'd say. "*Smile.* You're not in pain. Make believe it's June. School's out. You're going swimming." "It ain't June," the kid would say, "it's only April. Whatta ya mean go swimming?" "Make believe," I'd say, "make believe. Pretend." "I dun know," the kid would say, looking puzzled, "I think I gotta go." "Look," I'd say, "here's an extra nickel. How about that?" "Boy," the kid would say, his face breaking into a magnificent smile. "Hold it," I'd yell. "That's what I want. Hold it."

Girls were much less trouble than boys. Quieter, more polite. But more

Oil painting
for the story
"The Clock Fairy"
by Jessie McKee
(*St. Nicholas,*
February 1916)

expensive. Besides paying the model I had to pay a chaperone, the mother or some other lady. Artists were considered a pretty dangerous lot in those days. A mother asked Adelaide Klenke about me once and, after Adelaide had given me a good character, said: "Well, I thought he seemed a nice boy. But I heard he'd been to Paris."

I was always too involved in my picture to pay much attention to the models. After a while I got quite a reputation for being well behaved and moral. The mothers even permitted their daughters to pose for me without a chaperone. It became oppressive. One mother told me, "I wouldn't let my daughter sit for any other artist. You're so *good*." I began to wonder what was the matter with me.

After about two years at Brown Lodge my family and I moved to Edgewood Hall, which was even more respectable. Note that its title was in no way related to the name of the people who ran it, the Millers, and that Mrs. Sadie Miller was not reduced at all, Mr. Freddy Miller being in the best of health.

Sadie, who was four feet eight inches tall, adored Freddy, who was a stout six feet two. She managed the boardinghouse while Freddy, wearing a sporty vest, caroused at the local taverns. One day the boys at Chris Cruse's Bar and Grill bet him he couldn't drive home on three wheels. They lost. He was so big that his weight balanced the car, a high old flivver. When Sadie saw that he had wrecked the car she lit into him and they went off around the corner of the house, Freddy shuffling his feet and hanging his head, Sadie covering him with imprecations.

Sadie was violently sentimental about love. In her youth she had spent some time in Paris. "Ah, love," she'd say. "Ah, Paris. Hand in hand in the Trulleries. The moon on the Iffel Tower. *Amour toujours*." And then she'd sigh and roll her eyes, suggesting wild affairs of passion. She always wore French perfume. The slightest reference to France would call forth from her a cloud of intimations, incoherent exclamations, and giggles. She sat through every moving picture on France three times, finally going all to pieces and leaving the theater bathed in nostalgic tears. Later on, when I was about to be married, she'd come into the bathroom while I was shaving before breakfast and, putting down the toilet cover, sit on it, her feet barely touching the floor, and give me detailed advice about marriage placed with random comments on love in Paris and her marriage with Freddy.

At Edgewood Hall I discovered three of the best models I've ever had: Billy Paine, Eddie Carson, and Lambert, a mongrel pup. Billy and Eddie, who were both about eight years old when I started to use them, could act; if I wanted a sad expression, a belly laugh, disdain, or a sneer, they could give it to me. And *hold* it all morning (another problem: you have no idea how much a smile will sag or a frown melt during the course of a morning). Lambert was the thoughtful type. I'd place him in position on the stand and he'd just sit there with his head cocked to one side, thinking, hour after hour.

After I'd been in New Rochelle for four or five months I'd built up a list of available models and wasn't forced to chase stray kids and dogs around the streets. I'd started by asking the kids to write their names and addresses in a notebook. But one

day I couldn't find my notebook so I told the kid to write his name and address on the wall. The next kid did the same. Pretty soon all four walls and the ceiling were covered with names and addresses, some small and in pencil (girls), others scrawled across the whole length of a wall in bold red, green, blue, and yellow paint (boys). It finally became a contest as to who could write his name the gaudiest and largest. Billy Paine, I remember, won; he painted his name on the wall in block capitals a foot high, part chartreuse, part scarlet, part gold. All this certainly spruced up the mud-colored walls, but it made a kind of disturbing background when I was studying the model.

Having steady models wasn't all soup and fish. Take Lambert, for instance. The only thing he wasn't thoughtful about was cats. When he saw one he lit out after it crash, bang. Billy and Eddie knew this, so one day Billy smuggled in a cat under his jacket. The cat and Lambert had been around the room four times—over the sinks, under the easel, through a stack of frames—before I realized what had happened. I yelled at Billy and Eddie but they were rolling on the floor with laughter. Finally the cat climbed the easel. Lambert tried to follow but couldn't make it, so a stalemate was reached: Lambert at the foot of the easel, leaping and barking; the cat at the top, hissing and spitting.

One day Billy discovered that if he put the palm of his hand under the faucet of one of the sinks in the studio and turned on the water full blast, he could shoot a stream of water to all corners of the room. So we had water fights. Grand ones. The two sinks were in opposite corners of the room. I'd get at one and Billy and Eddie at the other. Sometimes Billy would sneak into the studio and, before I knew he was there, squirt me.

Four ground-glass windows faced the hallway leading to the other offices. When Billy and Eddie saw the shadow of a passing person on the glass, they'd shuffle their feet and scream, "Oh, Mr. Rockwell, *don't*. Please. *Oh, Mr. Rockwell, we* didn't know you were *that* kind of man." And I could see the person stop and turn his head to listen. Then Billy and Eddie would fall silent and the person would put his head close to the window so that he could hear better. But Billy and Eddie always ruined their own game at this point by breaking into shouts of laughter.

All this commotion didn't draw any complaints from my fellow tenants. Dr. Bugden couldn't hear much above the screams of his patients; old Mr. Sutton couldn't hear anything at all beyond the circumference of his poker table; Mr. Oden was too nice a man to complain; and Adelaide Klenke rather enjoyed the goings on. Besides, the ruckus rarely seeped out into the hall. I can remember only one time that it did. Billy and Eddie called up all my models and, imitating my voice, told each one I wanted him to pose the next morning. When I climbed the stairs I was met by twenty-five or thirty boys and girls boiling boisterously about in the hall outside my studio. Dr. Bugden was rather put out, for he'd got several children into the chair before discovering that they weren't patients. But as at least ten of the crowd *were* his patients, I disregarded his indignant huffings. The mob didn't disturb the poker game in the least; as I shooed everyone downstairs I could hear old Mr. Sutton yelling: "I anted. I anted."

I used Billy Paine in countless illustrations and covers and, later on, in fifteen *Post* covers. (He posed for all three of the boys in my first *Post* cover.) But after a while he developed a swelled head and refused to pose as I directed. I used to hear him talking to his friends. Buddy Ogden would say, "I posed for Mr. Rockwell today." "Oh," Billy would say, "that's nothing. I've been on six *Post* covers. Earned three dollars yesterday. He ain't got a better model." "Yeah?" Buddy would reply, "well, I'm on the one that comes out next week." Then Billy would get mad and punch Buddy, who was a fat little boy. Later he'd come up to the studio and ask me what I wanted to use a lunk like that for and scold me.

The only way to cure Billy was to stop using him for a while. At first he'd preserve a dignified silence. Then he'd begin to hint that he was free on Friday, wasn't doing anything that Saturday. I wouldn't say a word. Finally he'd come up to the studio and ask in a mournful voice, "Why ain't you usin' me any more, Mr. Rockwell?" "Don't need you," I'd say. "Jimmie Sanders is modeling for me now. Real good type." "Kin he do this?" he'd ask, screwing himself into a caricature of a running position. "Looket the faces I kin make," and he'd smile, frown, bare his teeth in a snarl, and laugh violently. "Kin Jimmie do that?" he'd ask. "Huh, Mr. Rockwell, huh? Kin he?" "Wellll," I'd say, "that's all right, Billy, but will you do it when I want you to?" "Sure I will," he'd say, "*sure*. Whatta you want? Smile? Frown?" "All right," I'd say, "you come up on Saturday. Remember, though, no funny stuff." "Okay," he'd say, all excited and cheerful again, "I'll be here. I'll do just want you want. You'll see." Oh, he was terribly jealous of his position as chief model. The only competition he could endure was Eddie Carson, who was his fast friend and so privileged to pose occasionally.

When he was thirteen Billy was climbing out of a window in the second story of Edgewood Hall with a girdle he'd stolen from a lady's room, and lost his footing, falling to the sidewalk below. A few days later he died. Eddie was grief-stricken. I never saw a kid take on so; he mooned about for weeks, wouldn't pose or eat much, just sat in his room. I was sort of struck by Billy's death, too. He was a swell kid, a regular rapscallion. I missed him a whole lot. Still do when I look at the old *Post* covers. He was the best kid model I ever had.

In New Rochelle I was surrounded by success. Men of affairs, commuters, lodged at Edgewood Hall. Downtown I often saw Coles Phillips, the celebrated pretty-girl artist, or Clare Briggs, the well-known cartoonist. Almost every day on my way to work I'd pass J. C. Leyendecker, the famous *Saturday Evening Post* illustrator, walking to the railroad station to catch the train for New York, where he had his studio. Sometimes, as I was taking a model home at dusk, I'd pass his palatial mansion with its formal gardens, wide lawns, and white-graveled drive.

And I'd return to my studio and, getting out my portfolio, sit there in the quiet of the deserted office building looking at my work. Illustrations for *St. Nicholas*, covers for the *American Boy, Boys' Life, Youth's Companion*, drawings for a *Handbook of Camping, Tell Me Why Stories*, a history book. All black and white, all for children's

Boy with Baby Carriage, oil painting for *Saturday Evening Post* cover (20 May 1916)
Billy Paine modeled for this *Post* cover, Rockwell's first

magazines or books. I'd go through the whole portfolio: fifteen dollars for this job, ten for that, twenty dollars here, twenty-five there. Who'd ever heard of me besides a lot of kids? Who'd *ever* hear of me? And I'd look at the painting on the easel, dim and blurred in the failing light but unmistakably the same sort of thing as all the illustrations and covers which I'd scattered on the floor from my portfolio.

I was at a dead end: my work wasn't improving, the children's magazines were the only ones who would publish it; same old jobs day after day, nothing new, no challenge. Look at the damned thing, I'd say to myself, flinging my hand at the picture on the easel, the Rover Boys and their lousy dog with the Mounted Police. And I'd feel like grabbing it off the easel and ripping it to shreds.

So then I'd run over to Edgewood Hall and drag my new-found friend, Clyde Forsythe, a celebrated cartoonist, away from his dinner and back to my studio. He was about the only person I knew who would give me any real criticism, who wouldn't just oh and ah over the *sweet* little boy and the *woeful* dog. When he said something I'd done was good, I believed him; he'd been a newspaperman and a cartoonist for a number of years and knew his way around in the commercial art world. Like most newspapermen, he had very few illusions; he faced things squarely, didn't try to wiggle around them as I did. (I should add that he was making a lot of money, owned an automobile and a motorboat, and was a member of the local yacht and tennis clubs; in other words, he was established, which carried a great deal of weight with me.)

So he'd leave his supper and accompany me to my studio. He always managed to prop up my sagging confidence. "What're you moaning about?" he'd ask. "It's a damn good picture. Get off your hands and knees and work. You'll make it. Give it time. Hell, Lincoln was fifty-one before he was elected President. Give it time."

After I'd interrupted his lunch and supper ten or twelve times and we'd become good friends, Clyde suggested we rent Frederic Remington's old sculpture studio together. It was a corrugated iron barn which Remington had built so that he could do life-size statues, principally the "Bronco Buster," which stands in Fairmount Park in San Francisco now. The sheets of corrugated iron had been slapped on a wooden frame and it didn't look very solid. Ebenezer Beasely, the handy man about the place, told us it was hot in summer and that in winter the old potbellied stove which sat in the center of the one large room toasted everything within ten feet of it and left the rest to freeze. But the studio was big and inexpensive, so we took it.

Ebenezer Beasely was a dwarf. He had a normal-sized body but stunted legs so short that his hands almost scraped the ground when he walked. One winter's day Ebenezer and I were going down the stone steps outside the studio. I slipped on a patch of ice and tumbled down head over tin kettle. Ebenezer simply dropped his arms to the ground, spread his palms, and came down the steps on all fours. He used to get his words mixed. Once, I remember, he was talking of Adam and Eve and said: "They weren't even wearing a gurgle."

Years later Ebenezer fell upon hard times, but just as things were blackest he

had a magnificent stroke of luck. Before Remington left New Rochelle he built a bonfire to burn all the sketches and paintings which he didn't like. Ebenezer was mowing the lawn that day and when Remington had thrown everything on the fire and gone back into his studio Ebenezer ran over and snatched most of the paintings and a good many of the sketches out of the flames, took them home, tied them up in bundles, and stored them in a back closet.

Then, years later, a collector of Remington's work appeared in New Rochelle. Someone told him about the bundles in Ebenezer's back closet. He contacted Ebenezer, examined his bundles, and bought them for a large sum of money, reportedly in the neighborhood of $20,000.

At that time Clyde was doing a daily comic strip about a dumb Swedish prize fighter, Axel, and his cunning manager, Flooey. He spent about two hours a day on it. Every morning at ten o'clock he'd come in and thread his way through my piles of paraphernalia—costumes, frames, model stand, canvases, paints, palette table, props—which cluttered the studio. Then he'd sit down at his drawing table in the corner under the window and, pulling a piece of paper out of a little cabinet, think up an idea for his comic strip. (The cabinet, drawing table, and a chair, huddled together in the corner, were the only signs that he paid half the rent. He was more good-natured about clutter than I ever was with the hardware artist from Peoria.)

The comic strips weren't serials then; every day Clyde had to have a complete gag—like Mutt and Jeff now, only cruder: Axel said something to Flooey, Flooey shoved Axel, Axel shoved Flooey, and they both fell over backward. The public loved it.

But it was torture for me. When he'd make a rough sketch of the gag Clyde would show it to me and I'd have to laugh and carry on about how funny it was. You try and laugh at a comic strip every day for a whole year sometime. It's worse than the rack. I did it, though, because Clyde was my friend. It ruined comic strips for me; I haven't been able to look at one with any pleasure since.

After I'd appreciated his gag Clyde would make the finished drawings of the strip, spending not more than an hour and a half on them, and he'd be through for the day. It sounds easier than it was; Clyde had to do a strip *every* day of the year, including Saturdays, Sundays, Christmas, Thanksgiving, and Easter.

I was desperate to improve my work. I painted "100%" in gold at the top of my easel; everything I did was going to be 100% as good as I could make it (Clyde pointed out that everything I did was *under* 100%, but I paid no attention). I'd pester Clyde to rate my picture according to a scale I'd painted on a piece of matboard and tacked to my easel: EXCELLENT, upper middle, middle, lower middle, bad. "What d'you think?" I'd ask him as he was about to leave the studio at noon. "The kid's not bad. Upper middle?" And so he'd come back and stand in front of the picture. "Well, yes," he'd say, "the kid's good. But that dog's kinda lopsided. I don't think it rates more than a lower middle. Not with that dog the way he is. Nooo, lower middle,

Dorbad, lower middle. (Clyde called me Dorbad, which is Norman with a cold, and I called him Glyde, which is Clyde with a cold.) Then I'd make him explain exactly what he thought was wrong with the dog and right with the boy. I guess he went through as much torture criticizing my pictures every day as I did laughing at his comic strip. I must have been pretty ridiculous with my charts and my gold 100%. But Clyde was always helpful.

He kept urging me to show my portfolio to the adult magazines and book publishers. I hesitated, wanting new outlets for my work but scared to risk a refusal. Then somebody introduced me to one of the art directors at Harper & Brothers. When the art director saw me walking into his office a couple of days later his face dropped. "*Gosh,*" he said, slapping his forehead, "if you'd only come in yesterday. Oh, *Lord.* If you'd only come in yesterday I had just the thing for you, the very thing." Then, throwing his head back, he stared at the ceiling with a look of utter despair. But, recovering, he said, "Well, no matter, no matter. Now look, you go back to your studio. Don't take any other jobs; don't start anything. *Wait.* We've got something big coming in here in a few days. It'll be just the thing for you; I want to try you out on it. Remember, now, don't take on anything else."

So I went home and sat down in the studio to wait. Maybe I'll get a ten-volume set of Shakespeare to illustrate, I thought, or a new edition of Woodrow Wilson's *A History of the American People.* Two weeks later I was still sitting; the art director hadn't called. I went back to his office. "*Gosh,* he said when he saw me, "if you'd only come in yesterday. I had just the thing for you, the very thing," etc., etc. That art director was probably the kindest man I've ever known. He was so kind that he couldn't turn anyone out bluntly, hated to refuse anyone point-blank. Every time I walked into his office he told me the same thing: "Don't take any work. *Wait.* I'll call you in a couple of days." After the first time I knew what all this rigmarole meant—he didn't have any work for me. He finally gave me a few frontispieces for books; nothing special and badly paid.

But I wasn't really interested in book illustration anyway. Or magazine either, for that matter. I had a secret ambition: a cover on the *Saturday Evening Post.* In those days the cover of the *Post* was the greatest show window in America for an illustrator. If you did a cover for the *Post* you had arrived.

But I was scared. I used to sit in the studio with a copy of the *Post* laid across my knees. "Must be two million people look at that cover," I'd say to myself. "At least. Probably more. Two million subscribers and then their wives, sons, daughters, aunts, uncles, friends. Wow! All looking at my cover." And then I'd conjure up a picture of myself as a famous illustrator and gloat over it, putting myself in various happy situations: surrounded by admiring females, deferred to by office flunkies at the magazines, wined and dined by the editor of the *Post,* Mr. George Horace Lorimer.

But the minute I thought of that name the spunk and dreams got soft and rotten. Mr. George Horace Lorimer had built the *Post* from a two-bit family journal with a circulation in the hundreds to an influential mass magazine with a circulation in the millions. He was THE GREAT MR. GEORGE HORACE LORIMER, the baron of pub-

lishing. What if he didn't like my work? I'd think. Supposing he denounced me as an instance of incompetence, banished me. He's got a lot of influence. I'd go down, down, down. The kids' magazines would drop me, then the dime novels and pulps would refuse to use me; I'd end up doing the wrappers for penny candies. And visions of a pale starving wretch with a huge Adam's apple lying in a flophouse on the Bowery would rise in my boiling brain.

Well, one day as I was mentally rolling on my lousy cot in the flophouse Clyde came into the studio and asked me what in God's name made me moan so. I hemmed and hawed but finally told him. "Why don't you do a cover and show it to them?" he said. Oh, I was scared; maybe they'd reject it; THE GREAT MR. GEORGE HORACE LORI-MER was tough. "For Lord's sake," shouted Clyde, "stop chewing on your tongue and do a cover. What the hell, you're as good as anybody. Lorimer's not the Dalai Lama." Then he set himself to encouraging me, convincing me I was good, the *Post* and Mr. Lorimer would love my work. Finally he extracted a promise from me that I'd think up some ideas for *Post* covers and do at least one of them during the next two weeks while he was away.

I had had my ideas ready for a long time; all I'd needed was the push Clyde gave me. I set to work the next morning on a painting of a handsome Gibson man in evening dress leaning over the back of a sofa to kiss a gorgeous Gibson girl in evening dress seated on the sofa. High society, just the sort of thing the *Post* was using at that time. The next day I left that painting to start another: a beautiful ballerina curtsying before a great curtain in the glare of a spotlight. Two weeks later when Clyde returned, I had both of them nearly finished. I was pretty well pleased with myself.

"C-R-U-D, crud," he said on seeing them. "Terrible. Awful. Hopeless. You can't do a beautiful seductive woman. She looks like a tomboy who's been scrubbed with a rough washcloth and pinned into a new dress by her mother. Give it up." Then he snatched up one of the illustrations I'd just completed for a story in *Boys' Life*. "Do that," said Clyde. "Do what you're best at. Kids. Just adapt it to the *Post*. Hell, they don't want warmed-over Gibson. If they take your stuff it'll havta be good. And you're a terrible Gibson, but a pretty good Rockwell." (I didn't start the vogue for *Post* covers of kids, Clyde Forsythe did.)

So I junked the girl on the sofa and the ballerina, called in Billy Paine, and set to work. I thought up six or seven ideas: two boys in baseball uniforms scoffing at another boy who was dressed in his Sunday suit and pushing a baby carriage; a kids' circus, one kid in long underwear as a strong man, another in a top hat as barker, others as spectators, etc. I made finished paintings in black, white, and red of the two ideas I've described and rough sketches of three others.

Meanwhile I'd been making other preparations for my trip to Philadelphia to see the editors of the *Saturday Evening Post*. I purchased a new suit—gray herring-bone tweed, I remember—and a new hat—black and conservative. But the big prob-lem was how to carry my pictures. Usually when I went to see an editor I tied up my paintings and sketches with brown paper and twine. It made a neat package. But after I'd shown my work to the editor I had to rewrap. That was the fly in the butter,

because the paper would get frayed and rumpled and the string snarled. And while I struggled with the pictures, paper, and string the editor would have to wait, making exasperated and sporadic attempts to help me or just fuming and rustling the papers on his desk. I felt it would be a bad business to keep the great Mr. George Horace Lorimer waiting; I wanted everything to go smoothly.

So I went to a harness maker in New Rochelle and asked him to make me a suitcase. "I want it big," I told him. "Oh, about thirty by forty inches and a foot wide. And as inconspicuous as possible; I guess black would be best." He followed my instructions conscientiously and when he brought it around to the studio it was long, thick, tall, and *all black*—even the little gadgets which kept the lid closed were painted black. It was, bluntly speaking, a gruesome affair, but just what I wanted and I was satisfied.

So one cold morning in March of 1916 I set out for Philadelphia and the *Post* (and Mr. Lorimer, though I tried not to think of that). The trip didn't begin auspiciously. When I tried to board the subway at Grand Central to go to Penn Station, "Here," said a guard, pointing to my suitcase, "you can't go on the subway with that thing in the rush. You'll have to wait." So I tried the el, but a guard stopped me, saying: "Not until after rush hour, young man. You'd be takin' a place from three men or five children with that black box of yours." So I walked to Penn Station.

As I sidled up the broad steps of the Curtis Publishing Company building—white marble gleaming and sparkling in the sun, imposing, magnificent—all I could think of was what Adelaide Klenke had told me once. "Norman," she'd said, "you have the eyes of an angel and the neck of a chicken." I could feel my Adam's apple sink beneath my collar. Maybe I'd better work on the paintings some more. Then I thought of Clyde—*"You mean you didn't even go into the office?"*

I asked the receptionist which floor Mr. Lorimer's office was on. Sixth. "Hold on," said the elevator attendant, pointing at my box. "You can't bring that in here. Take the freight elevator. Outside the building and around the corner to your left." So I entered the anteroom of the editorial offices by the back door.

When I asked to see Mr. Lorimer (I hadn't called for an appointment; I was afraid he'd refuse to see me), the receptionist asked me why. I explained and she said she'd call Walter M. Dower, the art editor, and would I please sit down. I did, thinking, "The eyes of an angel and the neck of a chicken."

There were two men walking around the reception room. The secretary had greeted them as Mr. Cobb and Mr. Blythe. Lord, I thought, it must be Irvin S. Cobb and Samuel G. Blythe, the famous writers. Pretty soon Mr. Cobb came over to where I was sitting, stared quizzically at my box, tapped it lightly with his fist, and listened intently. Then he looked at me and walked back to Mr. Blythe. They put their heads together and discussed something in whispers. Mr. Blythe came over and examined my box. The discussion continued. Finally Mr. Cobb said to me, "Young man, will you answer a question?" "Oh yes, Mr. Cobb," I said (I was very impressed at seeing him). "Tell me," he said very solicitously, looking hard at my box, "is the body in there now?"

Mr. Dower showed my paintings and sketches to Mr. Lorimer and brought back word that Mr. Lorimer was pleased, would accept the two finished paintings, and had okayed the three sketches for future *Post* covers. He added that I was to receive seventy-five dollars for each cover. (WOW!)

I went down on the *passenger* elevator and strode like a conquering hero across the marble steps. I was elated. A cover on the *Post!* *Two* covers on the *Post.* Seventy-five dollars for one painting. An audience of two million! I had arrived. All my problems were solved; I would live in ease, comfort, and distinction for the rest of my life. As I crossed a grating in the sidewalk, blissfully contemplating my success, I happened to look down and for a moment I thought I was walking on air.

I returned to Edgewood Hall and asked Irene O'Connor, a schoolteacher I'd met there, to marry me. At first she refused, saying she was already engaged to an agricultural student at Michigan Sate. Then she accepted. We set a date and I went to work on my third *Post* cover—an old man playing baseball with a bunch of kids.

But when I took it down to the *Post* the lid blew off the pot. Mr. Dower brought word out that Mr. Lorimer thought the old man was too rough and tramplike. Would I do the painting over? Of course. I stretched a new canvas and began again. "Better," said Mr. Dower. "Mr. Lorimer thought it was better. But the old man's too old, he thought." I did the painting over again. The boy was too small. I did that painting over five times before Mr. Lorimer accepted it. By the time he finally okayed it I had decided that doing *Post* covers wasn't all soup and fish; it appeared that life was going to be a bit more complicated than I had expected. (Mr. Lorimer later told me that he'd been testing me. I wonder if he ever knew how near I came to flunking his test.)

But my disappointment at finding that life wasn't a golden chute-the-chute was mitigated by my first fan mail. I got five or six letters on the *Post* cover which had already been published. The public liked me!

When I had added the *Post* cover to my portfolio the art directors of other magazines began to give me assignments. *Life*, which was a humor magazine in those days, was second in importance to the *Post*. Every Tuesday all the artists would gather to see Mr. John Ames Mitchell, the editor. As we entered the anteroom of his office Miss Berry, the receptionist, would give each of us a little card with a number on it. Then we'd all sit on a bench which ran along one side of the room and wait for Miss Berry to call our number.

While we waited, each one of us would hold his portfolio between his legs or across his knees and rearrange the drawings in it. I always started out by putting my best ideas last, so that Mr. Mitchell would look all through the portfolio. (Most *Life* covers were jokes; for instance, I painted a picture of a Pilgrim boy being chased by Indians. Title—all *Life* covers had titles—"a Pilgrim's Progress.") But when I sat down in the anteroom I'd get cold feet and figure that maybe Mr. Mitchell would become discouraged before he arrived at the good ideas and reject everything. So I'd put the good ideas first while I waited for my number to be called, taking great care

Mother Tucking Children into Bed, Literary Digest cover (29 January 1921).
Irene Rockwell posed as the mother in this painting

Under the Mistletoe, oil painting for *Literary Digest* cover (20 December 1919).
Norman Rockwell's mother-in-law posed as the woman in this painting

that none of the other artists saw them. I didn't trust anyone (the feeling was mutual); the others might snitch my best ideas. I'd open my portfolio a crack and, reaching in, rearrange the drawings by bending them over each other or pulling one on its end and shuffling the others around it. All the other artists were doing the same. You can't imagine the contortions we'd go through to conceal our drawings from each other. We must have looked like a side show at a circus, all of us sitting in a line along that bench, struggling with our drawings and glancing suspiciously at each other.

About ten o'clock every Tuesday morning the door of the anteroom would slam open and James Montgomery Flagg, the tycoon of illustrating at that time, would hurry in. He'd go right past us into Mr. Mitchell's office without waiting for a number or even to be announced. We'd hear shouts of greeting as the door closed and there'd be silence for half an hour or so. Then he'd rush out, slamming the door again, and Miss Berry would begin to call our numbers. Flagg never said hello to any of us—he was too grand and mighty for that—just dashed in and out while we humble coolies looked on in silence and awe.

Next in importance after *Life* was *Judge* magazine. If Mr. Mitchell didn't want a drawing I'd take it to *Judge*. Then if *Judge* rejected it I'd take it to *Leslie's*. If they turned it down I'd crate it up and send it to the *People's Popular Monthly* in Des Moines, Iowa. They paid fifty dollars for covers; it hardly covered the cost of my models and material, but at least I wasn't forced to toss the drawing on the ash heap.

Very few of my drawings sank as low as Des Moines. That year I did six *Post* covers and sold many paintings and drawings to *Life, Judge,* and *Leslie's*. In short, I prospered. So much so that I married Irene O'Connor in the fall.

One week after we were married Irene left to visit her parents in Potsdam, New York, for two months, leaving me alone in the dingy third-floor apartment we'd rented in New Rochelle. Four days later I discovered cockroaches in the icebox.

I mention the fact because it sort of typifies our marriage. It wasn't particularly unhappy, but it certainly didn't have any of the warmth and love of a real marriage. After we'd been married awhile I realized that she didn't love me. She was still in love with the agricultural student she'd been engaged to and had married me because my prospects were better, which is a roundabout way of saying I was making quite a lot of money and stood to make more in the future. Not that she wasn't an awful nice girl. I don't mean that. She just made a mistake.

But it was my fault too. When I realized that she didn't love me and, later on, that I didn't love her, I didn't say, "Let's quit." I didn't say much of anything. So the marriage lasted fourteen years.

We got along well together; never quarreled or made a nuisance of ourselves. We gave parties, belonged to a bridge club. Everybody used to like us together. We just didn't love each other, sort of went our own ways. She didn't take any interest in my work; after a while her mother and two brothers and sister came to live with us. Well, I guess you see what I mean. That's about all I can think of to say. She was a very pretty girl, brown hair, blue eyes.

7

The battle of Charleston

HEN the first draft call of World War I was sent out I was declared exempt. I don't remember why; too many dependents maybe. But I didn't object: I wasn't a fire-eater (so far as I know, no Rockwell ever was).

Still, I felt a bit guilty, so when the authorities organized a Harbor Patrol in New Rochelle to guard the approaches to Fort Slocum, a big enlistment center, Clyde and I joined up. The fort was on an island just south of New Rochelle Harbor and there was a great deal of talk about Germans poisoning the water supply or sabotaging communications.

The headquarters of the Harbor Patrol was an old bedbug-ridden yawl anchored in the middle of Pelham Bay. One night a week Clyde and I would report to the yawl, where our captain assigned us to a rowboat loaded with rifles, pistols, and knives—a regular arsenal—and we rowed with muffled oarlocks about the pitch-black choppy bay all night, clutching our pistols and listening for the swish and clank of German submarines surfacing.

One rainy night as we were drifting along we heard the squeak of oars in oarlocks off to one side. We snuck up to within ten feet of the other boat and, bravely shouting out a challenge, switched our flashlight on. And there in a battered old rowboat sat two women. The one sitting in the stern of the boat was the biggest woman I've ever seen. She filled the seat and even slopped over a bit on each side. Her companion was a skinny, pert young woman, a regular little chickadee.

The fat one cursed us while the other tried clumsily to row away. But Clyde grabbed the side of their boat and I got out the printed form we were supposed to fill

in when we encountered anyone on our patrols. I asked them what their names were. "I'm Lillian Russell," said the fat one, and the other: "I'm Sarah Bernhardt." I put down that on the form and requested their addresses. "5579861054321 Kaiser Wilhelm Boulevard, Berlin," said the fat one, giggling. I wrote in that (I wasn't too startled at these answers to my questions; other patrols had met up with other "ladies" sailing out in the dead of night to cheer up the boys at Fort Slocum).

"You're pretty cute," said the thin one. "What're two beautiful gents like you doin' in the bay at this time of night?" "What are *you* doing?" Clyde asked. "Oh," said the fat one, patting her stomach, "just out for the row." "Tell 'em the truth, Miss Russell, do," said the other. "We're going out to the fort to enlist in the army." Then both of them laughed uproariously. When they'd subsided, the fat one puffing and mopping her brow, we told them they'd have to return to shore. "And deprive the army of our services?" asked the fat one. "We can't row," said the other. So Clyde attached a rope to their boat and we towed them to shore where they abandoned their boat and went off toward town, the fat one cursing the uneven ground good-naturedly and the other us.

One of the most difficult problems in painting magazine covers is thinking up ideas which a majority of the readers will understand. The farmer worries about the price of milk; the housewife fusses over the drapes for the dining room; the gossip gossips about Mrs. Purdy and her highfalutin airs. You have to think of an idea which will mean something to all of them. And it's darned hard to be universal, to find some situation which will strike the farmer, the housewife, the gossip, *and* Mrs. Purdy.

In wartime the problem vanishes. Everyone in the country is thinking along the same lines, the war penetrates into everyone's life. Johnny Sax, the boy next door, joins up; sugar can't be bought for blood or money; war bond posters are plastered all over town.

Take the *Post* cover I did at the end of World War II of a soldier coming home. That scene was being repeated all over the United States—in the slums of the big Eastern cities, in the country towns of the Middle West, in Dallas, Seattle, Peoria, and Musselshell, Montana. I could be pretty sure that nobody would scratch his head and say, "Now what is that soldier standing about in the back yard for? And why, in the name of all that's holy, is that woman delightedly screaming at him?"

And during a war there's always a crowd of new and different ideas hanging around. Everything's changed. Men go off to war; women go to work; draft boards, rationing boards, bond drives; soldiers in France, England, Ireland. In 1917 I couldn't read a newspaper without finding an idea for a cover. "French Populace Cheers Doughboys"—I did a cover for *Life* showing a little French girl inserting a poppy in an American soldier's buttonhole. Title: "The Tribute." (A cute little girl— same sort of thing I'd been doing right along, but a new situation.) "Sergeant Awarded the Croix de Guerre, Bussed by French General"—I painted a startled doughboy being kissed on the cheek by a French general. (The only trouble with that one was that four other illustrators read the same news item, thought it was a good

idea, and did covers of it. Three months later four magazines came out in the same week with covers of a French general kissing a doughboy. What a row! Everybody called up everybody else and threatened to sue. But nothing came of it; no one could prove first rights.)

Oh, ideas were dropping from trees, from the lips of babes. One of my kid models remarked that his sister's boy friend had left for the war. The next day I started a cover of a group of girls gazing out to sea beneath a black and stormy sky. Title: "Till the Boys Come Home." A friend told me that a woman in town had two sons in service. I painted a smiling mother with a soldier on one arm, a sailor on the other. Title: "The Lord Loveth a Cheerful Giver." (I wasn't responsible for the titles. But the ideas were mine so I guess I can't slide out from under the charge of sledge-hammer sentimentality.)

All this made my work much easier. I was pretty well satisfied with myself, knocking out covers and illustrations for *Life*, the *Post*, *Judge*, *Leslie's*, *Country Gentleman*, receiving three or four fan letters a week, making quite a bit of money.

Then one day in June 1917, as I was riding uptown on the subway, six or eight badly wounded merchant seamen boarded the train. I gave one of them my seat—a big, rawboned man on crutches with a bandage over his forehead and one eye. All I could think of as he lowered himself clumsily into the seat was how easily I'd got out of it, of the careless way I rocked on my feet with the motion of the train. By the time I left the train at New Rochelle, I'd made up my mind. I took a taxi to the Pelham Bay Naval Training and Receiving Center.

But the doctors rejected me. I was seventeen pounds underweight for my height and age. I caught a train back to New York. Maybe the doctors at the enlistment center at City Hall would accept me.

The yeoman who weighed me at City Hall had been a student at the Art Students League. "Hello, Norm," he said. "Jump aboard." I got on the scales. "You've overdone the starving artist bit," he said. "You're underweight." I sighed dejectedly. "You really want to get in?" he asked. I told him I did. "Wellll," he said, looking me over, "it won't do any good to weigh you with your clothes on." (I was stripped for the examination.) "Besides, it's against regulations. You *sure* you want to enlist?" "As I hope to paint a good picture," I said, swearing the most terrible oath I knew. "Follow me," he said. "We'll talk to a doctor."

He led me into a dark, drafty little office and explained my problem to a doctor who was sitting with his legs up on a desk, smoking a cigar. "Norm's an artist," he concluded. "If we get him in they'll give him a special assignment, painting the insignia on airplane wings or something. It won't matter if he's underweight." "How much under is he?" asked the doctor, chewing his cigar and looking at me thoughtfully. "Seventeen pounds," said the yeoman. "Won't do," said the doctor. "We can waive ten pounds but not seventeen." The yeoman glanced furtively around. "How about the treatment?" he whispered. "He don't look big enough," said the doctor. "I want to get in," I said, shivering—the chill drafts were running up and down my legs; my feet

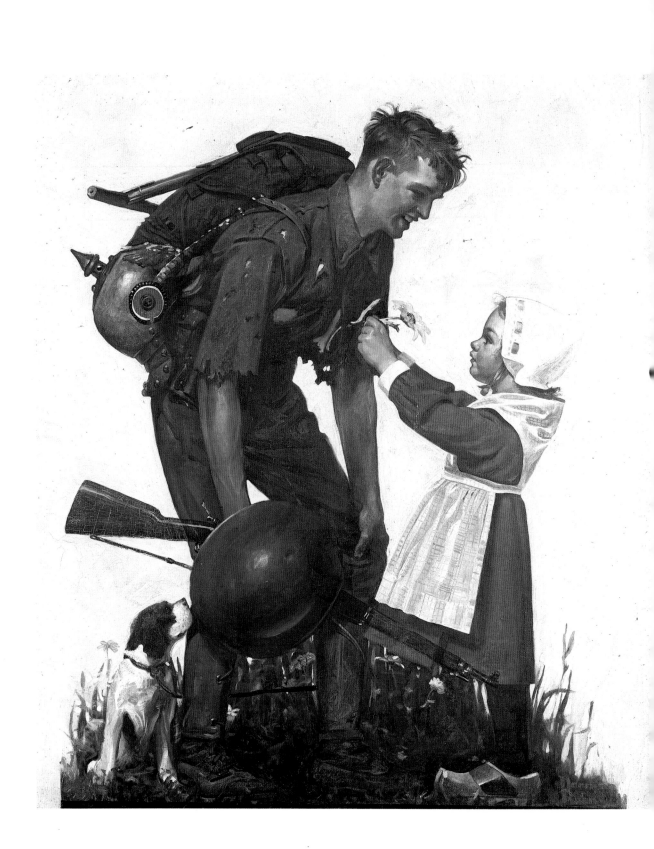

The Tribute, oil painting for *Judge* cover (10 August 1918)

If Mother Could Only See Me Now, oil painting for *Life* cover (13 June 1918)

Back to His Old Job, oil painting for *Literary Digest* cover (14 June 1919)

felt like blocks of ice against the cement floor. "What's the treatment?" "Bananas, doughnuts and water," said the doctor. "You eat seven pounds' worth, we waive the other ten pounds, and you're in." "All right," I said. "It's your stomach," said the doctor, pulling open a large file drawer at the bottom of the desk. "Sit down." The drawer was filled with bananas and doughnuts. I eased onto an icy chair, my teeth chattering. The yeoman drew a pitcher of water at the washbasin in the corner and set it before me on the desk. The doctor heaped bananas and doughnuts around it. "Go to," he said, and I began to eat doughnuts and bananas and drink the water. The doctor scratched a match on the seat of his pants and lit his cigar. The yeoman hummed softly, staring at the ceiling. I ate and drank.

After a while, "Weigh him," said the doctor. I staggered to the scales. "Not yet," said the yeoman. "Five pounds to go." So I ate some more and drank some more. The doctor's cigar went out. The yeoman stopped humming. Both watched me intently. "I'm going to burst," I said, "I'd better quit." But by then the doctor and the yeoman had adopted my enlistment as a personal cause; it wasn't just one sailor more or less any more; it was their battle against the Kaiser and all his forces of darkness. "Oh no," said the yeoman, "you aren't going to quit now." "Come on," said the doctor, peeling a banana for me. "Four more doughnuts and as many bananas. Wash 'em down with water."

I stuffed . . . and stuffed . . . and stuffed. The yeoman weighed me again. "Hurrah!" he shouted. "We've won." And the doctor and he congratulated each other. I could hardly walk; the seven pounds of doughnuts, bananas, and water sloshing about in my stomach threw me off balance. But I managed to struggle into my clothes—my fingers were so stiff with cold that I couldn't button all the buttons—and totter home.

Not many days later I was called to duty as a "landsman for quartermaster." A grand title, I thought proudly, not realizing that a landsman is defined as "a sailor of little experience rated below an ordinary seaman." I was ordered to report to the Brooklyn Naval Yard where I would embark for the base at Queenstown, Ireland. My duties would be those of a painter and varnisher; I would paint the insignia on airplanes.

We sailed that night, blacked out because of the submarines. I stayed on deck, watching the lights of New York slide away behind us. Suddenly a light sparked from the darkness about two hundred yards ahead of the ship. There was a commotion on the bridge. Somebody yelled, "A submarine!" Then in the faint glare of the light I made out a naval officer standing on what appeared to be the conning tower of a submarine and shining a flashlight on a small American flag. He shouted across to the captain of the ship I was on, ordering him to change course and go down along the coast to Charleston, South Carolina. A German submarine was lurking in the Atlantic just ahead.

The next morning we docked at Charleston. I was issued a uniform, given shots, and detailed with the rest of the new arrivals to pull stumps in a corner of the

base where new barracks were to be erected. I set to with a crowbar, pounding it down under a stump, then heaving and wrenching, yanking it out, and jamming it under again until I was wringing wet and panting. I figured if I worked hard they'd make me an admiral and assign me to a soft desk job.

But pretty soon the old sailor who was in charge of the work party sauntered over. After he'd watched me for a few minutes he said, "Take it easy. Take it easy. You wanta ruin the navy?" I stopped heaving at my stump and looked around. Everybody was staring at me. "Relax," said the old sailor, "relax. It ain't much fun bein' admiral. Think of the worry. And the paperwork." An enlistee who was standing beside me tittered. I laid down my crowbar and lighted my pipe. But if hard work wouldn't get me anywhere, what would?

It wasn't going to be my martial bearing. I realized that later that night. Flu was raging through the camp like a pack of rabid wolves; men were dying every day. Being short of able-bodied men, the authorities assigned the new arrivals in the camp to guard duty and burial squads. I got a piece of both. At dusk twelve of us were issued guns and marched off behind a wagon laden with rough pine coffins. When we reached the cemetery the coffins were unloaded. Then the bugler bugled taps while the coffins were lowered into the graves, the officer said: "Readyaimfire," and bangety, bang, bang, bang . . . bang, we fired. (That last bang was me; I hardly knew the butt of a rifle from the barrel.)

Guard duty was cold, damp, and frightening, but uneventful. I stood in a mud puddle for four hours, scared silly of snakes, Germans, and my fellow guards, who had a propensity for shooting wildly at anything which made the least sound. As the cold yellow light of morning shimmered in the puddle at my feet I decided that sailoring, or at least the military aspects of it, wasn't for me. But what was I going to *do* in the navy?

The next day I found out. In the morning we filled out questionnaires on our civilian work experience and training. I put down "illustrator." The chief petty officer, who was looking over the questionnaires, asked if I would do his portrait. I did. That afternoon an ensign saw the portrait and asked if I'd draw him. I did. He showed it to a captain and the captain called me into his office. I entered in my new uniform—bell-bottom trousers, tight blouse, and little white cap; I looked like a toadstool turned upside down. The captain said, "Oh, my God," and assigned me to the camp newspaper, *Afloat and Ashore*, giving me ten days' leave to go to New York and get my art supplies. "Your job's morale," he said. "You'll do more good that way than swabbing decks or stoking boilers." As I left the room he added, "You'd make a helluva sailor anyway."

I disagreed with the captain. I *was* a sailor, an old salt, in fact. When I landed from the train in Pennsylvania Station I set my cap, crushed fore and aft, jauntily on my head, slung my sea bag over my shoulder, and strode with a sailorman's roll, swinging my arm, up the platform to where Clyde and Irene were waiting. There was brine in my veins and the sparkle and glint of white waves in my eyes. "Ahoy there,

Admiral Dewey," said Clyde. "Heave to and come aboard." "Shiver my timbers," said Irene. "Avast and belay bow and stern, starboard and larboard." I stopped. "Ahoy once more," said Clyde, looking as if he had an orange in his mouth. "Say what's going on?" I said, throwing down my sea bag. Clyde and Irene broke down and laughed. "There never was a man for adopting a role like you," said Clyde. "Three days in the navy and you're already an old salt. As you came up the platform I could hear the whole Atlantic Ocean churning about in your stomach. Oh, Lord, what a man!" And he and Irene laughed some more.

But I wasn't completely cured yet. Way down beneath my toenails I still believed I was a sailor. A few nights later Clyde took me to a dinner for illustrators and artists at the Salmagundi Club in New York. World War I was a poster war. Charles Dana Gibson did posters of beautiful girls dressed as Columbia and calling on America to save the world from the Kaiser; James Montgomery Flagg did his famous poster of Uncle Sam pointing his finger and saying, "I want YOU." Posters urged people to buy bonds, conserve coal, nab spies, and save peach pits. If the government wanted something done, not done, or undone they stuck posters up on every blank wall in the country. The dinner at the Salmagundi Club was held to whip up enthusiasm among the illustrators and artists.

Toward the end of the evening Gibson, who was toastmaster, said, "I want every man in uniform to stand up and salute our august visitor, this celebrated warrior" (a French general or admiral). I stood up and awkwardly but solemnly raised my hand to my forehead. Clyde whispered, "Ahoy," and pinched me and I let out a whoop, flinging my hand above my head in surprise. After dinner Henry Reuterdahl, an illustrator who was a lieutenant commander in the naval reserve, chewed me out for creating a ruckus. "You are a disgrace to the uniform you wear," he said, "an insult to your profession, your comrades in arms, and your country. You should be drummed from the service." I resolved to stop trying to be a sailor and just be myself. It was the only safe solution. In spite of my uniform and airs I wasn't going to be a crashing success as a sailor.

When I returned to camp I was installed in a corner room in the officers' quarters. Two days a week I drew cartoons and made layouts for *Afloat and Ashore;* the rest of the time I was allowed to do my own work as long as it was in some way related to the navy. I painted a *Post* cover of one sailor showing another a picture of his girl; a *Life* cover of a group of smiling soldiers, sailors, and marines. (Title: "Are we Downhearted?" Everywhere you went during the war—in bars, trolleys, meetings—somebody would yell, "Are we downhearted?" and everyone would chorus, "*No!*") I drew countless portraits of officers and ordinary sailors, not because I was ordered to do so, but because I thought it was a good morale builder. Most of the men sent their portraits home to their wives and sweethearts; it seemed to cheer them up considerably, especially if they were about to be shipped overseas. (Promotions were so rapid that I had to paint the officers one rank above their present rank; I expect that cheered them up too.)

I have to admit that doing portraits of officers made my life less complicated. If I wanted a pass to town I'd just ask one of my sitters. He could hardly refuse; I might have elongated his nose or weakened his chin. One portrait I did even saved my life. When I caught the flu I went to the hospital. A doctor whose portrait I had drawn discovered me there. "Get out of here," he said. "The place'll kill you. The germs are as thick as blackstrap molasses in here. Go back to your hammock and pile blankets on yourself. Sweat it out." I did as he directed and recovered.

But in spite of the fact that I worked hard, it was an easy life. I was getting my room, board, and clothes free and still earning almost as much money as I had as a civilian (an ensign figured out that with the free meals, etc., I was making more than an admiral). I had no military duties and aside from the two days a week at *Afloat and Ashore* could do pretty much as I wished.

I even had an unofficial bodyguard. One day a burly, rough-tough sailor named O'Toole asked me to do his portrait. I said sure. When I'd finished he was so pleased that he appointed himself my personal bodyguard. "Any guy tries ta shove ya round, tell *me*," he'd say. "I'll fix his liver." And he'd pull two brass hammock rings which he had sharpened along one edge out of his pocket and, fitting them around his fists like brass knuckles, shadowbox violently with my imaginary enemies.

O'Toole had been a taxi driver in Chicago before the war. Other sailors used to worry about their wives. Not O'Toole. "She kin lick anybody on the block," he'd tell me. "Ain't nobody gonna get aheada her. Nosiree. She'd womp 'em. Did me oncet. I went all blue in the eyes. She's a ten-carat woman. There ain't another like her between Lake Michigan and the stockyards."

I was real proud of O'Toole. He was the he-man who knew how to handle himself. I was the "pale artist plying his sickly trade." He took good care of me. At meals, unless you managed to get a seat at the head of the table where the waiters set the bowls of food, you darn near starved because the bowls were always empty by the

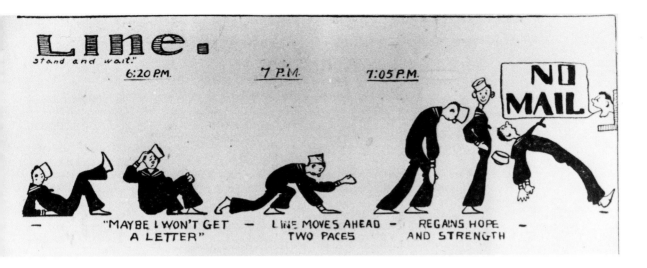

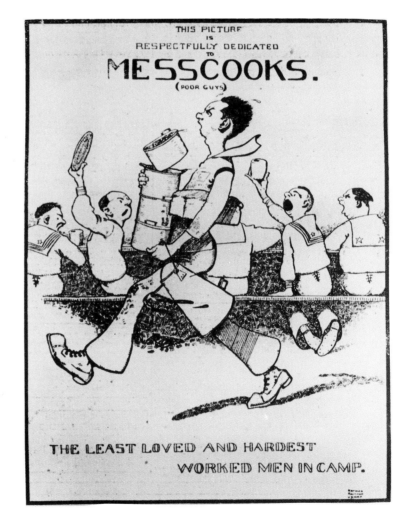

ABOVE:
Mail Line,
cartoon for
*Afloat and
Ashore*
(13 November 1918)

RIGHT:
Mess Cooks,
cartoon for
*Afloat and
Ashore*
(13 November 1918)

time they'd passed six or eight men. When the bugler sounded mess call every sailor on the base would drop what he was doing and rush pell-mell to the mess hall. I'd fling down my brushes and run too. But as I was going out the door O'Toole would lay his hand on my arm. "Slow down," he'd say. "Slow way down there. Ain't no hurry." And we'd walk calmly to the mess hall. When we got there O'Toole would barge and jostle up to the head of the line, dragging me behind him. "What'd I tell ya?" he'd say to me. "No call to rush. No call to sweat up." Nobody ever objected to this high-handed behavior twice. O'Toole flattened them the first time and that was enough.

O'Toole was proud of me too. He'd come into the room where I was working and look at my drawings. "Juuudas Priest," he'd say, "I never knew a guy like you. An artist. Look at that," he'd say to one of the other fellows. "If that ain't Ensign Simmons, it ain't *nothin'.*" And Lord help the other fellow if he didn't agree.

It was the considered opinion of O'Toole that I should only do portraits of officers. "It don't get you nothin' drawin' them mugs," O'Toole would say, referring to the ordinary sailors (he was a sharp operator; wangled an easy berth in special services though his only special talent was for crafty undetectable gold-bricking). "Leave 'em alone. Say I'm drivin' my hack along Michigan Bulward. A bum waves a bottle of red at me. Do I stop? Not on your sweet head, I don't. I cruises around till I spots a fella with a cane and a shinin' hat on wagglin' his thumb at me. I wouldn't have no hack 'f I picked up bums. Same with you. Officers put ya here. Sailors ain't nothin'."

One day as he was going on like this a sailor stuck his head in the door and asked which one was Norman Rockwell, the artist. Quick as a cobra, O'Toole says, "Me. Whatta ya want?" The sailor asked, "Would you paint my portrait, Mr. Rockwell?" "Sure," says O'Toole. "Come back at four." So the sailor thanked him and left. I asked, "What did you do that for?" "I'll fix him," said O'Toole. "Lemme handle it. You jus' sit over there in the corner and don't say nothin'."

When the sailor returned O'Toole was seated before my easel. "Come in, come in," he says to the sailor in a lofty voice. The sailor came in. O'Toole looked him over in silence for a minute. "Juuudas Priest," he says, "ain't that a fine face. Look at them bones there. Noble, I calls it, noble. It'll be a pleasure to paint that face." Then he led the sailor over to the window and began to pose him, turning him this way and that and muttering to himself, "No, the light ain't right that way. No. No. There. But no. Profile's better." Finally, after having twisted the sailor's head almost off his neck, he sighed and said, "I can't do it justice. But it'll havta do," and he walked over behind the easel upon which he had previously set a huge piece of drawing paper. Then he said to me, "Jack, hand me my brushes," and proceeded to paint, flourishing his brushes and moaning as if in an agony of inspiration.

Every so often O'Toole would ask one of the sailors in the room for his opinion of the picture (he had thoughtfully provided himself with an audience) and the sailor would comment learnedly. "Mr. Rockwell," he'd say to O'Toole in a humble tone, "don't you think the nose is a hair too big? And the eyes a trifle beady?" Then

O'Toole would jump up, fling down his brushes, stamp his feet, and swear he couldn't work in such an atmosphere of ignorance. But we'd soothe him, saying it was a masterpiece, caught that aristocratic look about the eyes and all, and after grumbling a bit O'Toole would go back to work.

All this while the poor sailor whose portrait was being painted stood there with his head wrenched over his left shoulder, trembling with anticipation and terribly anxious to see the portrait. If he so much as blinked an eye O'Toole would shout, "It can't be done. If you don't stop wobbling I'll havta ask your pardon and leave." Then the sailor would stiffen, hardly daring to breathe.

Finally O'Toole announced that he was finished. With great fanfare and ceremony he led the sailor over to the portrait. The sailor gasped when he saw it, for it was a hodgepodge of lines and circles in the center of which sat a neat game of ticktacktoe. Wow, was that sailor mad! But you know what O'Toole was, so nothing came of it. O'Toole told him he was a mug and had no business bothering me and sent him packing.

Of course this didn't stop the parade of sailors who wanted their portraits painted. But it provided a diversion, which we sorely needed. We led an easy life but a dull and lonesome one too. Almost every afternoon O'Toole, who got off work at two o'clock (as I said, he was a sharp operator), would come over to my studio and if I wasn't busy we'd take a bus into Charleston. We always wanted to get out of camp, away from the long rows of drab unpainted barracks and the clouds of sand which blew up and down the street, stinging our eyes and leaving a gritty residue in the food, our clothes and hammocks. But when we left the bus at Charleston there was nothing to do. We'd walk around the Plaza or up to the old Slave Market, window-shop, and watch the boats in the harbor. No decent girl would speak to sailors. Bars and grubby dance halls were the only places which would tolerate us.

Finally O'Toole and I, stuffed to the ears with boredom and feeling somewhat guilty about our easy life, decided to transfer from special services to a fighting outfit. One morning we went down to the docks in Charleston to pick a ship. We toured a destroyer, a battleship, and a mine sweeper. None of them appealed to us. Then we came to a navy freighter which had steam up in preparation for departing on a voyage. I said, "We don't want a freighter, O'Toole." "C'mon," he said, "let's look anyway." So we boarded the ship and after a while found ourselves in the huge, gloomy, cavernlike boiler room. In the harsh red glare spouting from the open furnace doors we could see a crew of stokers, stripped to the waist and gleaming with perspiration, shoveling coal. As each shovelful struck the fire, flames would burst out the door and singe the stoker. It was unbelievably hot; the rotten-egg stench of soft coal burning almost choked us. We hadn't been there three minutes before our warlike spirit vanished. We went back to special services, resolved to endure, if not enjoy, our comfortable berths.

The navy wasn't all paradise, though. The food was monotonous; navy beans, navy beans, navy beans, and every Friday night blackberry jam, which no one would eat because we suspected that it was laced with saltpeter to curb weekend

wildness. And the regimentation, which galled my independent, artist's soul. Everything in the navy was done on a grand, individual-burying scale. The doctors didn't decide that *you* needed a laxative; they decided that the whole camp needed one. So they'd sneak some into the beans, and all night long there would be long lines of impatient sailors stamping about outside the "head." A hundred and fifty men to do this, a hundred and fifty men to do that; never one man, always a crowd. Everyone muffled under the blanket of blind obedience: a sailor would say, "I think . . ." and the officer would reply, "*You* don't think; *we* do the thinking around here."

Still, it wasn't so bad. Every night we had a movie either at the YMCA (which we didn't like because they wouldn't let you in unless you answered a questionnaire and because there was a small admission charge) or the Knights of Columbus (which we liked because they let anyone in and it was free) or at the camp theater (which was even better because after the movie amateur theatricals were held). Once, I remember, *Poor Little Rich Girl* starring Mary Pickford was shown and as she refused one plate of scrumptious food after another (the poor little rich girl—she didn't want peach melbas or six-inch steaks, she wanted love), the audience got wilder and wilder. "Try her on navy beans," we yelled, "try her on navy beans. That'll fix her precious stomach."

It's amazing the mixture of men you meet in the navy. Some of the fellows hadn't worn shoes before. One man from the backwoods of Kentucky had never used a fork. He ate with his face three inches from the plate, shoveling in the food with his knife. So we all stopped eating and stared at him. Pretty soon he noticed that the table was quiet and looked up. "Waas all th' matter?" he asked. "Oh, nothing," we said, "nothing at all." But after a while he caught on and we saw him begin to experiment with his fork, muttering to himself and cursing as the beans rolled off it.

The navy was an education to me, too, though in a different way. I'd never lived among men like that. If they were amazed at knowing me ("An artist. My God, *an artist!*"), I was astounded at knowing them. One day I walked into the bathroom and there were two chief petty officers taking showers and swearing at each other at the top of their voices. They were experts and were having a good-natured cussing match. They didn't stop with execrating each other's parents, they dug back to the grandparents and distant cousins. Oh, it was grand to hear. First one would call in question (in a deep, bull-throated voice) the morals of the other's maternal grandmother, then the other would bellow out a load of imprecations on his companion's great-uncle's personal habits. Then they'd fall to, thick and fast, on each other's grandfathers. It was magnificent; it was monumental; it was biblical.

I'd never heard such things before. It was a fascination to me. I was glad to get out of the navy (they offered to make me an ensign if I'd take charge of the camp newspaper at the base at Newport News; I refused), yet I was almost sorry to leave all the horseplay and all my friends.

Two months after our tour of the fighting ships, O'Toole and I received a rude jolt. A new commander was appointed to the Charleston naval base. Even O'Toole

was perturbed. "I can't figure it," he'd say, shaking his head. "You got to know what kinda officer he is before you can go to get around him. Liable to bump us all off to Russia before we have time to figure him." Then he'd sit about and scratch his head. "Juuuudas Priest," he'd say, "it's the waitin' chews ya."

O'Toole was right. The new commander might transfer all of us from special services to active duty. He might assign all of us to the Russian route. (Duty on the ships which carried supplies to Russia was known to be the worst in the entire navy.)

One afternoon O'Toole and I were in my studio discussing the situation when the door was suddenly flung open, a voice yelled "A-ten-*shun!*" and in walked the new commander in full-dress uniform—white jacket and trousers, gold braid and white gloves—a big, handsome, beefy-looking fellow. His wife—a square, mannish lady smartly dressed—accompanied him.

"Carry on, men, carry on," he said. I went back to work on the portrait I was painting and O'Toole fussed with a pile of old canvases in the corner. The new commander stood behind me, looking at the portrait. After a minute I happened to glance around and saw that he was leaning on my palette table, one of his white-gloved hands squished down in the gobs and smears of oil paint. Oh, Lord, I thought, Siberia, here I come. "Ah, Commander, sir," I said, "your hand, sir. Paint, sir." He lifted his hand and looked at the glove, sticky with paint of many colors. I composed a brave farewell letter to my friends at home. But then he laughed and, stripping off his glove, said, "A souvenir," and handed it to me. He chatted a bit, asking about my work and how I liked the navy, and left the room. O'Toole was of the opinion that the new commander could be "got round," but, he added, the wife was a fish of a different color. She worried him.

The next day I was transferred to the commander's personal staff and went to live on the U.S.S. *Hartford*, which had been Admiral Farragut's flagship when he sailed into Mobile Bay during the Civil War, saying, "Damn the torpedoes! Go ahead!" and which was now moored in Charleston Harbor as the official headquarters and residence of the commander of the Charleston naval base.

The *Hartford* had been refurbished since Mobile Bay and was a sumptuous palace. In the center of the ship a grand, red-carpeted staircase swept down to a huge ballroom whose walls were decorated with ornate, hand-carved scrollwork. The staterooms, which were the officers' quarters, were lavishly appointed and hung with all manner of rich velvets and tapestries. Down all the carpeted hallways ran handrails of gleaming brass. The kitchen, stocked with goodies by the merchants of Charleston who hoped to obtain the business of supplying the camp, was staffed by a horde of cooks—meat cooks, pastry cooks, vegetable cooks, salad cooks, sauce cooks, etc. A marine band—scarlet jackets, blue trousers, white belts, and all—was kept always at readiness and marines in full-dress uniforms—dark blue coats, light blue trousers—guarded the gangplanks.

O'Toole (I'd got him a job as chauffeur on the commander's staff by drawing a portrait of the ensign in charge of transportation), myself, and a tenor lived in a plush stateroom. The tenor and I dined, or rather feasted in barbaric splendor, with the

commander and his wife, who very kindly explained how we were to go about using the multitude of forks, spoons, and knives which surrounded our plates. When the commander entertained visiting dignitaries—senators, French or English admirals—the tenor sang and I displayed my work before the assembled guests in the ballroom.

But I soon learned that the real purpose of my being on the *Hartford* was to paint portraits of Captain Mark St. Clair Ellis and his wife. Mrs. Ellis, who was very wealthy and had been the first woman ever to receive a mining degree, had a lot to do with running the camp. Her husband put up a very dignified and military front, but I don't think he had much administrative ability. Every order that he issued was a brief synopsis of some passage from the *Bluejacket's Manual*, which he knew by heart and spoke of in reverential tones. When a situation arose which wasn't covered by the *Manual*, he stretched, squeezed, twisted, or simplified it until it *was* covered by the *Manual*. O'Toole always insisted that Mrs. Ellis was the brains behind the gold braid. All the sailors liked her. If the camp didn't have something—say a movie projector— she'd buy it. We used to cheer her when she passed through camp.

The trait in Captain Ellis' personality which I came in contact with most often was his vanity. I did two portraits of him—one in his uniform and one in civilian clothes. He was very anxious about them. All his ribbons had to be just so. First his eyes didn't have the right sparkle—lively but dignified and stern as befitted the eyes of the commander of the Charleston naval base. Then his chin was too round or his nose too short. He really shouldn't have worried; he *was* a handsome man.

Finally I got everything to his satisfaction and started on the portrait of him in civilian clothes. It was a revelation to me. When he took off his uniform he sank from a mastiff to a spaniel. Still handsome but nowhere near as impressive. He was quite disappointed.

I was just finishing the second portrait when the false armistice burst upon us. O'Toole, the tenor, the marine band, the cooks, and I decamped for Charleston to celebrate. We commandeered a moving van, dumped all the furniture out on the road, and drove into town. There we abandoned the van, hijacked a carriage and, loading five or six girls into it, towed it all over Charleston through the crowds. As we were passing one of the fine hotels an old Southern gentleman with a white goatee and wide-brimmed hat hailed us and insisted on climbing into the carriage among the girls. So we hauled him all over town, stopping at every bar we came to for drinks at his expense. After a while O'Toole became so plastered that he fell under the wheels of the carriage. The third or fourth time this happened he scraped his nose, got mad at the carriage, pulled everyone out of it, and tipped it over. We spent the rest of the night in a combination dance hall and saloon.

The next morning we awoke to find that it had been a false armistice. But everyone knew the real thing wasn't far off and so applied for a discharge. The navy, of course, couldn't allow that. To prevent a stampede, an order was issued that no honorable discharges were to be granted. All leaves were canceled too.

Portrait of Commander Mark St. Clair Ellis, oil painting, 1918

Well, I wanted to get out real bad. I could see there was no use my remaining in the navy; I wasn't doing any good. And I was eager to resume civilian life. So I told Captain Ellis that the only place in the whole country where truly beautiful frames could be bought was Knoedler's in New York. "I can pick out just the right ones," I said, "big, ornate, gold-leafed. It'll make the portraits look marvelous. Knoedler's has the finest frames money can buy or man make." He considered his portraits stunning masterpieces (one tenth because of the painting; nine tenths because of the model), so he sent an aide to look up discharges. The aide reported back that under the existing order prohibiting honorable discharges there were only two ways to get me out of the navy: a dishonorable discharge (that was going too far, even for me) or an inaptitude discharge, which meant that I was unfit for my duties in the navy or, in other words, a moron. "Give him that," said Mrs. Ellis. I agreed. "*My God!*" said Captain Ellis. "He can't go through life with an inaptitude discharge! What'll his friends say? What'll his wife think of him?" "Don't be silly, Mark," said Mrs. Ellis, and worked at him until he consented to sign my inaptitude discharge.

In the whole Charleston Navy Yard there was only one book, a paperback, describing the procedure to be followed on discharges. Captain Ellis gave it to me so that I could fill out my papers properly. That night when I returned to my stateroom the lights were out and O'Toole and the tenor were asleep. Not wanting to wake them, I laid the book, which was open to the page on inaptitude discharges, face down on the table and undressed in the dark.

The next morning I discovered to my horror that the book was lying face down in flypaper. The only book of its kind in the camp. Ruined. I wouldn't get out of the navy for six months.

After O'Toole had laughed himself sick we set to work to try and unstick the flypaper. We tried everything—steam, hot water, cold water, hair tonic, machine oil, soap, mashed fish scales (that from an old sailor who swore it would rip the skin off a snake's back; maybe it would have, but it didn't work on the flypaper). Finally we succeeded (I've always thought it was sheer wish power that did it), I made out the papers, and on November 12, 1918, one day after the actual armistice, I was discharged as unable to adapt myself to the duties of a "landsman for quartermaster" in the United States Naval Air Reserve. My service record reads:

> Discharged with Inaptitude Discharge. Rockwell is an artist and unaccustomed to hard manual labor. His patriotic impulse caused him to enlist in a rating for which he has no aptitude. Moreover, he is unsuited to Naval routine and hard work.

And below this is the terse comment:

> I concur in the above statement.
> (signed) Norman Rockwell

The next day I visited Knoedler's in New York and asked them to ship three of their gaudiest frames to Captain Mark St. Clair Ellis at the Charleston naval base. Years later I heard that he had left the navy and was living outside Paris, in a former hunting lodge of Louix XIII.

The last vestiges of my stint in the navy soon vanished. I joined the American Legion, but as the meetings were largely taken up with the recounting of gruesome war stories and noble war records, I was left pretty much out in the cold. ("What battles were you in?" "I was in Charleston." "Oh.") After a few meetings and parades I quit. Then one day I ran out of paint rags. That was the end of my uniform.

Portrait of Franklin Lischke, charcoal, 1925

Lost — $10,000

W HEN I arrived in New Rochelle, after my discharge from the navy, I walked straight home, slung my sea bag in the closet, kissed Irene, and rushed out to look at my studio. It was a cold November day, a raw wind flecked with snow rattling the dry bare branches of the trees. But when I saw the window of my studio behind the row of houses I went all warm inside. There it was. My studio. With my brushes upright in jars, my easel with "100%" in gold paint on its top, my comfortable old chair before it.

After marrying Irene I'd moved my paints, easel, etc., out of Remington's former studio and into our apartment. But it was no good. When the grocery boy rang the doorbell I had to lay my wet brushes on a chair and walk down a long hall to let him in. The same with the butcher's boy, the postman, and every wandering salesman who thought our door looked promising, I couldn't get any work done. So I rented the top of a garage on Prospect Street.

At the southeast corner of the garage there was a little porch, roofed and with low white railings at each side. *My* porch, I thought, carefully wiping my feet on the mat. I opened the door and ran up the stairs. On the landing between the stair well and the inner door to my studio were the familiar stacks of frames and canvases and my old artist's manikin slumped against the wall, his feet sticking through the stair railings. I fumbled my key into the lock, pushed open the door, and there it was, all twenty-five by thirty feet of it, *my studio!* At the farther end the huge, floor-to-ceiling bay window I had installed by removing the north wall. Dirty, I thought, light's bad; have to get it cleaned. The four smaller windows, two to each side, with their trim

curtains of monk's cloth. The high peaked roof with its sturdy brown beams (I had taken off the inside ceiling). The walls which I had covered with burlap and hung with prints. Captain Kidd by Pyle. (Look at that fiery crimson coat against the dull green sea, I thought. I'll try that sometime.) A drawing by Abbey from *She Stoops to Conquer*. Vermeer: *Lacemaker, Girl Asleep at Table*. I went up to the last; I wanted a closer look at that rug. But it was all cobwebs and dust. So I skipped back to the center of the room. My studio. There was my bookcase. There was my model stand, squatting before the easel like a turtle. There was the walking stick I'd carved from a gnarled limb. And the overstuffed chair. And my fireman's helmet. And just in front of the bay window . . . my easel, palette table, and chair. I sat down in the chair and began to think about the next *Post* cover. I was home again.

I worked in this studio until about 1926. It had three disadvantages, two of which I was never able to solve. In summer it was like an oven; the dog days of August stripped me to my underwear. In winter it was like an icebox (the kerosene stove downstairs was decidedly inadequate); cold days forced me into an overcoat and mittens. (My work suffered then. Did you ever try to paint in mittens?)

The other disadvantage involved the doorbell, which was on the outside door. Whenever it rang I had to go downstairs to answer it. So I installed two mirrors, one on the porch and one on the window nearest my easel. Then I could just glance at the mirrors to see who was at the door. If it was someone I wanted to see I'd stick my head out the window and tell him to come right up. If it was someone I didn't want to see I'd go back to my easel and pretend I wasn't in the studio.

One day Alexander Dumas III (he claimed to be descended from *the* Alexander Dumas), a pompous insurance salesman who was always pestering me to buy some splendid policy—life, fire, theft, or what have you—rang the doorbell. I looked in my mirror. Him again, I thought, oh no, not today, thank you. And I just stood there, chuckling, while he rang and rang and rang, stamping with impatience. Finally he turned to go. But then he saw the mirror and, in it, me. "Lemme in," he yelled, red-faced with rage, "lemme in, you insignificant piker. I've seen the Chief Justice. I've visited the President!" So I had to let him in. Most people didn't see the mirrors.

I rented my studio from George Lischke. He was a slim bedraggled-looking man who worked as secretary to the president of the Royal Baking Powder Company. His wife was small and plump. They had two sons, George, Jr., and Franklin. Every Sunday the whole family would put on dusters and goggles and go for an automobile ride in the country. When they returned, all of them would troop up to my studio and tell me about the ride. They'd driven all the way to Stamford, Connecticut, or Ossining, New York.

Franklin, a narrow-shouldered, stringy adolescent with a round head, used to pose for me a lot. He was one of the most gullible kids I've ever known. He'd come rushing up to my studio as if he'd just thought of something terribly important he had to tell me. "Can you speak French?" he'd ask. "Sure," I'd reply. "*Gosh*," he'd say, "say

something." So I'd rattle off a phrase or two: *"Parlez-vous français aujourd-hui toujours l'amour?"* "What's that mean?" he'd ask breathlessly. "Oh," I'd say, "It means, 'Franklin Lischke ran up and down the stairs with a monkey on his back.'" *"Wow!"* he'd say. "Say something else."

His ability to digest fantastic stories was immense. Clyde used to tell him the most atrocious things. He'd sit in the big armchair rubbing his knees and gulping it all in. Then he'd dash downstairs to tell his father, and later on Mr. Lischke would laugh about it with us. Franklin was an awful nice little boy and a good model. We always used to kid him because just after he was born his older brother George had looked in the cradle and said, "What is it?"

One night when I was sitting in the bathtub at home Mr. Lischke called to tell me that there was a burglar in my studio. I dressed and hurried over. By the time I got there a policeman had arrived. The policeman, Mr. and Mrs. Lischke, George, and Franklin were gathered around the back door of their house. We held a whispered conference. Mr. Lischke wanted to storm the studio, the policeman wanted to wait for help, and Franklin was positive it was the gang of thirty bloodthirsty thieves which Clyde had told him was, as he put it, "infesticating the neighborhood." Courage prevailed and we crept silently to the little porch. We could hear somebody scrabbling about upstairs. "All right," said the policeman in a fierce voice, "whoever you are, come out of there." The scrabbling stopped for a minute, then started again. The policeman drew his pistol, I flung open the door, and he sidled in, shining his flashlight up the stairs. And there, hanging over the stair railing, was a body dressed in ragged, tattered clothes. The policeman jumped back, muttering something about "foul play" and the necessity for calling "a detective." I laughed. Not because I was brave or hysterical, but because I recognized the body as my manikin which I had that afternoon dressed as a bum for a Fisk tire ad (I painted the details of the clothing from the manikin to save money on live models). We discovered later that the scrabbling noises were caused by squirrels on the roof.

My first thought on leaving the navy was for the art directors. I hadn't seen any of them for over a year. Did they remember me? Did they feel I was neglecting them? Had I lost a year? Would they, in short, give me work?

I have never practiced the art of gentle bribery with art directors—entertaining them at expensive restaurants, sending them gifts at Christmas. Many artists do. I've always thought that an artist's work was the important thing. If the public doesn't enjoy it, buttering up the art director won't do any good.

Still, when I left the navy I decided that it wouldn't do any harm to be especially nice to the art directors. I had been out of circulation for more than a year. Besides, I considered that it was about time I upped my prices for covers and illustrations. I invited one of the art directors to dinner.

At the time Irene and I were living in the smaller half of a two-family house owned by Frederick Smythe of Wadley & Smythe, the swank Park Avenue florists. It

wasn't an ordinary two-family house; Mr. Smythe, who lived in the larger half with his widowed mother, had built onto the main house only because he wanted someone to be close by his mother when he went away. So it was quite elegant. (Mr. Smythe used to hold high-stakes poker games. One night he invited Irene and me to one. I was scared; I knew how to play poker but I was terrible; I might lose my shirt. I had nothing to fear. Irene won two hundred and seventy dollars. But we didn't go again.)

After we had finished dinner the art director, Irene, and I sat about in the living room, which Irene had fixed up very prettily but simply. I gave the art director a cigar and he lighted it and, puffing away, surveyed the room—the armchairs covered in gay prints, the sideboard with its modest display of silver plate, my pipe rack—a comfortable, unostentatious room. "Well, Norman, now that I see how simply and inexpensively you live, I don't agree that you should ask such a high price for your work. It's not necessary. You don't need it. *Don't* corrupt your little home with riches."

It was a long while before I asked another art director to my house for dinner. That was low, below the belt, traitorous. I'll entertain the art directors out, I thought, it'll be safer.

When the art director of one of the more important magazines wrote me that he was coming to New York and would like to have dinner with me, I reserved a table at Bertolotti's, a fashionable Italian restaurant (called "Dirty Lotti's" by the wits), and bought tickets for the bald-headed row at the *Ziegfeld Follies*. I was going to give that art director the real kid-glove-and-oysters treatment.

Accompanied by George O'Connor, my brother-in-law, whom I'd asked along out of a suspicion that I didn't really know how to give someone *a good time*, I met the art director at Penn Station. (I'll call him Mr. C rather than by his real name; you'll see why later.) C greeted us cordially. He was a tall handsome fellow with a smooth, cultured face, the slim lips accented by a trim mustache. His suit was of a fashionable cut and black. He wore a high white collar, a soft fedora and, over his manicured hands, suede gloves.

As we rode away from the station in a cab, "We must," he said, "have some absinthe to celebrate our gay evening together." I hardly knew what a cocktail was at that time, but I agreed. George said: "Why, you can't buy that in New York. It's illegal." "Oh," said C with an airy wave of his hand, "there are ways, there are ways. To one acquainted with the old town, nothing is impossible." And he directed the cab driver to an address on the lower East Side. When we got there he left the cab and went into a shoddy brownstone front, returning a few minutes later with a bottle of absinthe in a paper bag.

At Bertolotti's C gayly toasted in absinthe the evening, me, George, his editor, his magazine, the publishing company, the President of the United States, the Statue of Liberty, and "the grand old flag." George, drinking scotch, and I, drinking watered bourbon, stopped trying to keep up with him after the third or fourth toast.

Still, when we left the restaurant, C was apparently under control, though he did abuse the waiter genteelly over the amount of the check (I paid, of course). Then during the first act at the *Follies* he excused himself and went out. A few minutes later

we heard a loud commotion in the rear of the theater. An usher ran up to me and whispered that I'd better come to the back. My friend was in trouble.

I hurried out and found C struggling with two policemen and shouting for *justice, justice, justice,* by God. When he saw me he quieted down somewhat, assuring me in a low tone that he was greatly put upon, the victim of miscarriage, gross miscarriage. I couldn't make head or tail of what had happened until one of the policemen told me that C had accused the men's room attendant of stealing a twenty-dollar bill out of his pocket and, when the attendant had indignantly denied it, had knocked him down and jumped on him. The policemen wanted to put C in jail but I convinced them that I could take care of him. "I'll sober him up and put him to bed," I said, adding, "He's a very important person." So I led C outside while the usher called my brother-in-law out of the theater.

Then we dragged C down the street to a Childs Restaurant to get him some coffee. But when we put him in the revolving door of the restaurant he sat down, braced his feet, and refused to budge. Nobody could go in or out. I rapped on the glass and motioned to him to get up. He shook his head. A crowd gathered. "Please, Mr. C," I said, "let us in." But he paid no attention, just stiffened his legs. "Get that guy outta there," said someone in the crowd behind me. "We wanta go in." So I dropped down on my hands and knees on the sidewalk and, putting my face to the glass, shouted: "*Please,* Mr. C, PLEASE. TAKE—UP—YOUR—FEET. Everybody's waiting to get in." "Break the door down," a man yelled and shook his fist at C, who cursed him out in muffled yells and didn't budge. "C'mon, Mr. C," I begged, "there's a good fellow. Lift up your legs now. Up, now. Just a teensy bit. We'll get you a nice cup of coffee." Then the man shook his fist at C again and C jumped up and started for him. But George and I quickly shoved the door *in* and we entered the restaurant, where we weren't exactly welcome.

At first C refused to drink any coffee. But George, who was fairly husky, forced him to. The coffee didn't help much. When we hauled him out of the restaurant he was in a lunging mood. We'd pass a woman; C would lunge at her. We'd pass a lamppost; C would lunge at it. Not saying a word, weaving up the street and suddenly—whoom toward something or somebody, arms outstretched, mouth gaping. George and I hung onto him, though, and we managed to stagger and sway down the street, C lunging violently, George and I hauling him back. (I was very careful of him; drunk or sober, he was still the art director. I was scared to death of drunks anyway.)

A block from the Commodore Hotel, where he was staying, he broke away and grabbed the back of a victoria in which two old ladies were riding. The horse took fright, reared, and galloped off; C ran behind, hanging onto the back and sticking out his tongue at the two ladies, who had leaped from their seats and clutched the coachman when C suddenly jounced the carriage backward on its springs. Just in front of the hotel C dropped off and rolled into the gutter, swearing.

George and I picked him up and wrestled him into his hotel room. He sat down on the bed, rummaged a little black book out of his pocket, and began telephoning girls. When they said hello, he'd shout an obscene remark and hang up.

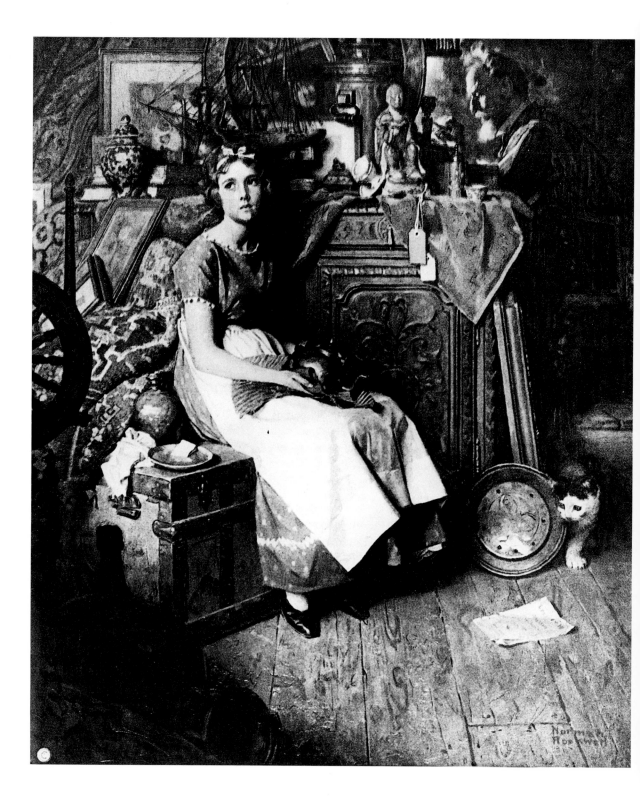

Dreams in the Antique Shop, Literary Digest cover (17 November 1923)

After ten minutes or so of this there was a knock on the door. The house detective. "Get that guy off the telephone," he said, "or I'll throw the lot of you in jail." So George and I threw C into his bed and he dropped off to sleep, muttering imprecations at us, his editor, his magazine, the publishing company, the President of the United States, the Statue of Liberty, and "the grand old flag."

It was a long while before I asked another art director to go to dinner and the theater with me. I decided that I'd let my work speak for me. If it deserved a high price I'd get it. If it didn't—well, I'd be satisfied with a lower price.

Of course I've always wanted to have a good relationship with art directors. Too strong a personal friendship, however, is just liable to put your work in jeopardy. If something happens to the friendship you're out. Flat. Whereas if you and the art director are only casual friends it is unlikely that anything serious will happen.

With some art directors even simple friendship is impossible. I remember one, Rudy Leppert, the art editor of the *Literary Digest* during the early twenties. He was a misanthropic kind of guy, always bellyaching, acted all the time as if your stuff was terrible. "Can't you paint a better kid than that? Whatta ya mean smilin'? The kid's frowning. C'mon, Norman, get the lead out, paint, don't slobber all over the canvas." He was impossible. His idea of the best way to work with artists was to criticize their work unmercifully. All of us hated him.

I don't carry the business of not becoming personally involved with art directors to its obvious conclusion, though. I've never had an agent; I've always believed in personal contact. I want to show the cover or illustration to whomever I've done it for, so that I can see directly what he thinks of it. An agent doesn't permit an artist to talk with an art director. I have listened to art directors explain to agents what they don't like about a picture and I've heard the agents relay that information, minutes later, to the artists. The agents' version was nearly always distorted or, in a few instances, the opposite of what the art director had said. Showing your own work to the art director is hard on shoe leather and sensitivity perhaps, but it's the best way. I think. Nowadays most artists have agents.

Maybe it's because the role of the art director has changed so radically over the years. When I first left school, art directors were cultured gentlemen who enjoyed an honored and useful position in the hierarchy of editorial staffs. Then they fell upon hard days. The editor became all-powerful. Art directors weren't much better than office boys. But in the twenties the advertising agencies reared their heads (whether they were ugly or pretty I leave to you; they've been very good to me), and art directors rose, like Lazarus, from the grave. No longer were they nonentities, errand boys who toted the illustrations and covers from the artist to the editor and back again. They were art directors once again and they *directed* art. Gradually, however, they began to overdirect. They usurped the role of the artist. Nowadays many illustrators use the art director's ideas rather than their own. And illustrators who are given ideas won't do as good work; they won't *feel* the pictures they are painting; the pictures aren't part of themselves. It all goes back to what Thomas Fogarty used to say in art school: "Step over the frame and live in the picture. Otherwise you're just picking

Girl Reading Palm, oil painting for *Saturday Evening Post* cover (12 March 1921)

OPPOSITE: *Courting Couple at Midnight,* oil painting for *Saturday Evening Post* cover
(22 March 1919)

Pencil study for *Saturday Evening Post* cover
Cellist and Little Girl Dancing (3 February 1923)

Watercolor study for *Saturday Evening Post* cover
Boy with Stereoscope (14 January 1922). In the final
version, the boy is looking at "The Sphinx"

over somebody else's work. You're a mortician, not an artist." I believe that. An artist can't surrender himself, becoming just an executor of another's ideas. Or, rather, he can but he *shouldn't*. At present, however, a lot of the art directors demand that he do just that. I understand the art directors' viewpoint and I know that many of the illustrators seem to want it this way. But I still don't think it's healthy. Illustration is at a low point now. Maybe it's because so many of the illustrators have surrendered their own dignity and possibilities.

Of course, the general appearance of the magazines, both editorially and in the advertisements, has improved tremendously. I'm an illustrator, though, and that's what I care about. Pyle's, Remington's, and Abbey's illustrations were not fatally harmed by bad layouts. I'd rather see great illustrations in horrible layouts than mediocre illustrations in beautiful layouts. But that's just me. You don't need to pay attention.

From 1899 through 1936 one man commanded the fortunes of the *Saturday Evening Post*—the great Mr. George Horace Lorimer.

Cyrus H. K. Curtis, the founder of the Curtis Publishing Company, had, in 1883, begun publication of a small pamphlet of dress patterns designed by his wife, who was a talented dressmaker. As the pamphlet became more popular, Mr. Curtis had added stories, recipes, and other features, and the *Ladies' Home Journal* had blossomed into a full-fledged magazine.

Then, in 1897, he purchased the *Saturday Evening Post*, a struggling family magazine published in Philadelphia. The property consisted of its name and that of its founder (Benjamin Franklin), a few cases of worn type, and a circulation list of less than 2000 names. A year and a half later, the circulation down to almost nothing, Mr. Curtis installed an obscure young newspaperman as editor, saying, in effect, "Here's the property. Make something of it." The new editor was George Horace Lorimer and he made of the *Post* the first great mass-circulation magazine, building a success on success stories, for his theme was high-class Horatio Alger. His own book, *Letters from a Self-Made Merchant to His Son*, is typical of the material which he featured in the *Post*.

George Horace Lorimer was an impressive man. His long, massive head was crowned with an unruly shock of sandy hair shot through with steel gray. He had a strong, square jaw, piercing eyes, and a nose which was large, straight, and angular. He wore dark, double-breasted suits and continually paced the floor, his heels thudding on the green carpet which stretched from wall to wall in his office.

His desk, huge and always clear of papers, was situated before a pair of wide, tall windows at the end of the office farthest from the door, so that when he stood up to greet you as you entered he was silhouetted powerfully against the light. A long conference table, whose surface shone like polished glass, was set in front of his desk, and upholstered armchairs were scattered about the high-ceilinged, paneled room.

He ran the *Post* with an iron hand. It was *his* magazine, his alone. He made the final decision on every story, okayed every cover, approved every article assign-

Christmas: Santa with Elves, oil painting for *Saturday Evening Post* cover (2 December 1922)

ment. And he thought the *Post* was the greatest magazine ever published. One day I walked into his office with a copy of the *Atlantic Monthly* under my arm. "What are you doing with that magazine?" asked Mr. Lorimer. "I just like to read it," I replied. "Do you realize," he said, "that every story in there was refused by us?" After that I always carried a copy of the *Post* when I went to see him.

Mr. Lorimer had an ironbound conviction that the advertising department should have no voice in editorial matters. One day while I was in his office one of the advertising executives came in. An illustration (not one of mine, thank God) was lying on the conference table. "You know," said the ad man, "I like that." "That's too bad," said Mr. Lorimer, "now I won't be able to use it." And he didn't. Advertising was not going to pollute the editorial policy.

Every so often when the circulation was ripping along at a record rate and increasing every day, and the advertising was up, and the readers were writing in day after day about how much they enjoyed the magazine, the editors would get smug and satisfied. Then Mr. Lorimer would announce that the *Post* was at the end of its rope, *Collier's* had made a tremendous scoop, catastrophe (mysterious and terrible) was threatening.

I was in the office one day just after Mr. Lorimer had made his dire predictions. Everybody was rushing about looking scared. I asked Mr. Dower, the art editor, what was the matter. "*Collier's* circulation jumped last week," he said. "We're in a fix. Last week's issue was down 10,000 on the newsstands. *Mr. Lorimer is worried.*"

If Mr. Lorimer was worried, I was worried. And the *Post* must be sinking fast, I thought. Just last month everyone had been congratulating himself on the condition of the magazine.

When I went in to see Mr. Lorimer I was depressed. And looked it. If the *Post* failed I wouldn't be able to do *Post* covers any more. The work I enjoyed most. Almost the only job which allowed me full freedom to do the pictures I wanted.

"Why, what's the matter, Norman?" asked Mr. Lorimer. "Gosh, Mr. Lorimer," I said, "I can't help but be upset when I hear the *Post* is on the rocks. Mr. Dower just told me about it." Mr. Lorimer chuckled. "Threw a scare into you too, did I?" he said. "Don't worry. The editors were getting a bit smug. Thought they had the bull by the tail." And he explained that his predictions of catastrophe were only a means of putting the editorial department on its mettle again. He did this periodically. Nothing, he added, ruined a magazine faster than complacency.

Mr. Lorimer had a strong sense of what the public liked and accepted stories, covers, articles, illustrations according to his first impression of them. I'd show a cover to him. He'd pace up and down before it two or three times. Then he'd stop, say, "Good," and scrawl "OKGHL" on the side of it. That was that. The cover was accepted. He never fidgeted over a decision or told me to leave the cover so that he could decide later whether or not to accept it. The first glance, its first impact, was his criterion. "If it doesn't strike me immediately," he used to say, "I don't want it. And neither does the public. They won't spend an hour figuring it out. It's got to *hit* them."

He rarely asked me to make minor changes—a red cap instead of a green, more smile on a kid. The cover was either good or bad.

Mr. Lorimer never okayed more than three of my ideas for *Post* covers at one time. If I showed him six he'd accept three. If I submitted eight he'd accept three. I didn't wise up to this for quite a while and, in consequence, was forced to discard a great many excellent ideas. (It was no use resubmitting an idea; Mr. Lorimer had a fantastic memory, as sure and deadly as a bear trap. I'd come up with an idea similar to one I'd shown him ten years earlier, "You showed me that already," he'd say, handing the rough drawing back to me.) After I'd caught on, however, I used to sketch out five ideas, three I liked and two I didn't like. Mr. Lorimer would accept the three good ones and reject the others. I don't think he would have okayed all five ideas if they had been submitted by Michelangelo.

I always acted out my ideas for Mr. Lorimer. It was strenuous, but I felt it was the best way to get across my meaning. Say I had the usual five ideas, one of an old cowboy sitting on a slab bench and dreaming of his past exploits, one of a boy on a stump playing a flute while a ring of little animals danced around him, and three others, two of which I didn't care anything about.

I would lay the five sketches on his desk before him. Then, pointing to the one of the cowboy, I'd say, "He's an old cowboy. See his chaps, his spurs, and his ten-gallon hat? Been on the range roping cattle, branding calves, for forty years. Fought Indians maybe. Maybe defended a lady's honor with his pistols. Gambled, brawled, spent nights under the stars around the campfire." Then I'd slump into a chair. "But he's old now," I'd say, "about all he has left is his memories. He's dreaming of the old days now." And I'd relax my face until it had what I imagined was a sad, dreamy expression. "I've got the perfect model," I'd say out of the corner of my mouth so as not to disturb my expression. "You know him, Mr. Lorimer. He's got these huge, drooping mustaches and big, sad, dog eyes with heavy lids. His cheeks sort of sag. Real doleful. What do you think?" "Good," Mr. Lorimer would say and he'd write "OKGHL" on the corner of the sketch.

Then I'd mix in one or two of the ideas which I didn't like, not bothering to be enthusiastic, acting them out listlessly, without running commentary. "Bad," Mr. Lorimer would say with a note of what I always thought was triumph in his voice. And finally I'd dramatize my third good idea, Mr. Lorimer would okay it, and I'd leave, worn out but happy.

I don't want to give the impression that Mr. Lorimer was an infallible, monosyllabic tyrant. He wasn't that. He had his quirks. I remember once he asked me, "Why do you always use the same mutt in your covers? Why don't you use some other kind of dog?" "I don't know," I said, rather surprised. "I have this good model and he's a mutt. I just use him because it's easier. His name is Lambert." "Well," said Mr. Lorimer, "I have a photograph of a Spitz dog here. Put *him* in one of your covers." So I did. When I showed the finished picture to the art editor he said, "Why, that's Mr. Lorimer's dog. Where did you get a photo of him?"

And Mr. Lorimer had a sense of humor. One hot summer day Mrs. Bessie Riddell, who had succeeded Mr. Dower as art editor, took me in to see Mr. Lorimer. She was a handsome, husky woman, a favorite of Mr. Lorimer's and one of the nicest persons I've ever known. Before she left, she happened to remark that she was "sweating." "Horses sweat," said Mr. Lorimer, "ladies perspire." "I'm a horse," said Mrs. Riddell. Mr. Lorimer laughed for five minutes.

And he hated to fire anyone. Sometimes he'd save up any firing that had to be done until it came time for his vacation. Then he'd leave (he often shipped his car to Chicago and drove to California through the desert, which he loved). The day after his departure there would be a note on the desk of the person who was being dispensed with, notifying him of his dismissal and enclosing two months' salary. By the time Mr. Lorimer returned the person had to be out of the building with his trappings, his desk and office cleared of any traces which might remind Mr. Lorimer of him.

Employees in the upper echelons were rarely fired except during Mr. Lorimer's vacation. So when it was rumored that he was about to take a vacation, some of his staff people would tiptoe about the office, whispering, "I hear Mr. Lorimer is planning a trip," and shaking in their boots. It was a time of uneasiness.

I was introduced to Mr. Lorimer about six months after being discharged from the navy. Meeting him was a great honor, a privilege, and it took the place of a raise. I wouldn't have thought of asking for more money until at least a year after our first meeting. My own sense of the deep honor which had been bestowed upon me was enough to seal my lips. No one had to tell me.

Mr. Lorimer called me Norman from the start; I called him Mr. Lorimer. (No one had to tell me that either.) Our relationship was cordial but businesslike.

Then in 1924 the fabulously wealthy Patterson and McCormick interests in Chicago founded *Liberty,* a national magazine to compete with the *Post* and *Collier's.* They began it with great fanfare, offering a prize of twenty-five thousand dollars to the person who thought up the best name for the magazine, hiring famous editors, and enticing celebrated writers and artists away from *Collier's* and the *Post.*

The new art director of *Liberty* came out to my studio in New Rochelle and told me he would double whatever the *Post* was paying me (at that time two hundred and fifty dollars a cover) if I would work exclusively for *Liberty.* I refused his offer. Clyde Forsythe said, "Don't be a damn fool. He's offering you twice what you're getting now. What loyalties do you have to the *Post?"* The art director agreed, adding that I'd come around and that he had been ordered to remain with me until I did.

So all afternoon he sat in the studio, urging me to accept his offer. After a while Irene dropped by. "Of course you should go with *Liberty,"* she said when I explained the situation to her. "Has Mr. Lorimer ever doubled your price? You've been working for him for eight years now and all you get is measly little raises. And only two in eight years." At suppertime I still hadn't decided what to do. Clyde and Irene left; the art director said he'd stay with me all night if necessary.

I felt as if someone had blindfolded my eyes, spun me around and around, and set me on a tightrope. I didn't dare move for fear of falling on my face. I did not

want to desert Mr. Lorimer, but everyone battering the opposite opinion at me had muddled my thinking.

At ten o'clock that evening I excused myself, saying I had to go to the bathroom, and went downstairs. I snuck off home and went to bed. Sleep would clear my bubbling brain. But I didn't sleep, just tossed and turned. At four-thirty I got out of bed, dressed, and took the train to Philadelphia.

When I arrived at the *Post* I asked Mrs. Riddell if I could see Mr. Lorimer. She said yes and took me into his office. He was seated at his desk. "What is it, Norman?" he asked. "Mr. Lorimer," I said, "when I left the studio last night there was a man there from this new magazine called *Liberty.* He said he'd double my price if I'd work for them." Mr. Lorimer stood up. "Well," he said, "what are you going to do?"

I looked down at the desk, waiting. But Mr. Lorimer didn't say anything else. Then I noticed that he had his thumb pressed so hard down on the desk that the tip of it had turned white. I glanced at him, saw his powerful, square jaw and piercing eyes. "I'll stay with you, Mr. Lorimer," I said. "All right," he said, "I'll double your price."

He would not have given a cent more to keep me, but after I had proven my loyalty to him and to *his* magazine, after I had demonstrated what the *Post* meant to me, he showed me that the *Post* valued my work. But he wouldn't have stooped to compete with *Liberty.* The *Post* was his life; it wasn't just a salary check to him. And he demanded that others feel the same way. If they didn't he didn't want them.

Those artists and writers who accepted *Liberty's* offer were henceforth anathema to him. He refused to use or even look at their work under any circumstances. They had betrayed him, had been traitors to his magazine.

After the crisis I became almost intimate with Mr. Lorimer—in a sort of father-son way; whenever I went to see him we'd chat for half an hour or so. I was always careful to leave before he stood up, though, and I never saw him out of his office or his office without him. Once I received an engraved invitation to a party at his house. To me it was a sort of royal summons. I bought a new suit and trembled. But two days before the party was to be held I received another engraved card notifying me that it had been called off.

Mr. Lorimer was very indulgent toward my foibles. As my work increased in popularity I took to signing my name larger and larger on my paintings. It was unconscious; the signature just seemed to grow by itself, naturally. First, norman rockwell, then Norman Rockwell, then NORMAN ROCKWELL. Pretty soon it was threatening to outstrip the words *"Saturday Evening Post"* on the cover. Finally Mr. Lorimer suggested that I try to curb my signature. "Make it as large as you like," he wrote, "but not larger than the title of the magazine. We must preserve proportion. You appear on the *Post,* not the *Post* on you." I was surprised. But I curbed my signature. And my vanity.

At one period I wasn't painting as many covers as usual for the *Post.* My mother noticed it and asked, "Why aren't you doing more for the *Post?*" "I guess they don't want me," I said, all of a sudden worried. "Well, dear," said my mother, "all the

*New C
on the Re
Willys-Ov
advertiser
1919*

neighbors are talking about it." "Get them to write in," I said. "Then maybe Mr. Lorimer will want more of my stuff." (Of course it wasn't Mr. Lorimer's fault; I had had too much other work and had neglected the *Post*.)

Several months later Mr. Lorimer asked me, "Who is it that lives in Providence, Rhode Island?" "My mother does," I said, having forgotten all about my conversation with her. "Why?" "Oh, I just wondered," he said. "We've been receiving hundreds of letters from a certain neighborhood up there, all trumpeting: Norman Rockwell is the greatest artist in America. Why don't his pictures appear on your cover more often?" "Ah," I replied. When I got home I wrote my mother, asking her to call off her friends.

I worked for Mr. Lorimer for more than twenty years. Then all of a sudden he retired. But I'd better tell the story of that in its proper place.

After the war Irene and I opened a savings account at the New Rochelle Trust Company. I don't think either of us had any idea of what we were saving for, but it

Grandpa's Gift, oil painting for Pratt & Lambert advertisement, c. 1920

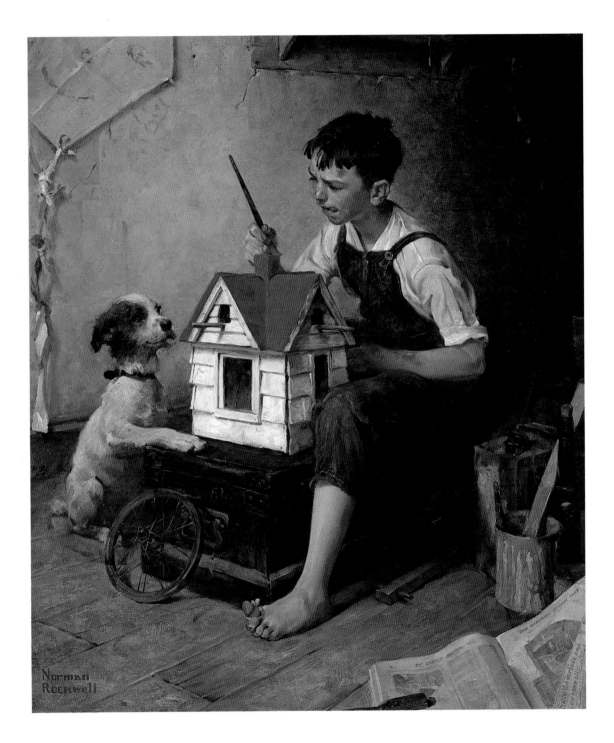

Painting the Little House, oil painting for the Save the Surface Campaign, 1921

seemed the thing for a young married couple to do. Every week we deposited as much money as we could spare. I was doing covers and illustrations for quite a few magazines and had gone into advertising in a big way—Willys Overland Car Company, Jello, Fisk bicycle tires, Orange Crush soda pop, et cetera. Mr. Lorimer had advised me to charge exactly twice as much for an advertising job as I got for a *Post* cover, and the money began to pile up in the bank.

When we had accumulated ten thousand dollars I, of course, began to boast. (Pride goeth before a fall.) I hadn't been boasting three days before the star boarder at Edgewood Hall, John J. Roach, approached me.

My parents had invited Irene and me to Sunday dinner at Edgewood Hall, where they were still lodging. At dinner the talk turned naturally upon my career, for I had not visited at the Hall since entering the navy. I told about the magazines I was working for and Mr. Lorimer and the advertising agencies. "You must be doing very well," said Sadie Miller. "Do have some more turnips." "He has saved ten thousand dollars," announced my mother. At this, Mr. Roach, who had been recounting the story of his latest financial coup to the lady on his right, stopped talking. "A mighty sum," he said to my mother. "Yes," replied my mother, "and the Trust Company gives him three per cent interest. Oh, I assure you, if I were not so worried about my back (it's gotten worse lately, you know; the doctor hints at lumbago), I would rejoice." "Ah," said Mr. Roach, "and so you should. And so you should." And he contemplated the steaming heap of white turnips on his plate with great concentration, the manicured fingers of one dainty white hand sliding delicately back and forth on the gold watch fob which dangled across his silk-embroidered vest.

He was a short, stocky man with a small potbelly. His head was rather large and very round and his features tiny—thimble nose, button eyes. His little black mustache, which he waxed and rolled into dagger points at the tips, contrasted sharply with his florid complexion and his prematurely white hair. He was a natty dresser and always wore a silver stickpin in his tie and a heavy gold ring on the third finger of each hand.

After dinner I walked out on the porch to smoke my pipe (some of the ladies objected to pipes). Mr. Roach followed me. "Norman, Norman," he said, "Norman-Norman-Norman-Norman. Your money lying fallow—where moths corrupt and snakes sneak in and steal. Ah-ah-ah." And he looked very downcast, patting his hair, which lay flat and neat on his head. "Men of affairs," he said, his fingers beginning to move across his watch fob, "invest. Invest and profit. Profit and grow rich. Grow rich and retire. Mr. Rockefeller, Carnegie, Morgan, Mellon, Morgenthau, Merrill and Lynch, invested, profited; grew rich, retired. Some started with nothing. Some with a thousand. Some with five thousand. Few with ten. You start with ten. A mighty sum. If invested in a scheme of certain growth—say ten per cent per annum—it would multiply like . . . like . . . *rabbits.*" By this time his fingers were sliding back and forth across his watch fob furiously. "I have a safe, sane, sure, and profitable investment," he said. "Capitalization? Immense. Backers? Eminent. Risk? Nil. Expectations?

Grandiose. Chance in a lifetime; one in a million; death overtake us before such another; invest now, today, this hour." And he stopped, rather short of breath.

But I hadn't drowned in this torrent of words. I knew Mr. Roach. And some of the people who had invested in his schemes. I didn't want any part of him. *He* had made money. But somehow everyone else had lost. One of his sure-fire investment plans went like this. You put a thousand dollars into one of his companies which was drilling for oil. If they struck oil they'd plug the well and notify you that no oil had been found. Then another of his companies would buy the supposedly worthless well for next to nothing, unplug it, and rake in the profits. If no oil was found, of course, you lost your money anyway. No. I'd keep my ten thousand dollars in the bank. Three per cent interest wasn't much, but it was safe.

"Thank you very much for thinking of me, Mr. Roach," I said, "but I don't want to retire. I'll just save my money and let it increase slowly." And I knocked out my pipe on the porch railing and walked back into the house. He glanced at me, then looked up at the sky. His fingers were sliding slowly back and forth on his watch fob.

Everyone at Edgewood Hall admired Mr. Roach in spite of his penchant for shady deals and cheating his friends. Or, rather, not Mr. Roach himself, but his money. All the lodgers deferred to his wealth.

One day, I remember, we were all riding in his automobile. Mr. Roach sneezed and his false teeth shot out of his mouth, bounced on the roadway, and caromed into a field. We spent the rest of that pleasant Sunday afternoon searching among the buttercups and daisies for John J. Roach's high-priced teeth. (We found them.)

Our admiration for his riches was exceeded only by his wife's admiration for his person. A dumpy little woman, she was much given to raptures. She'd walk outside on a spring morning, "*Oh!* The sun," she'd cry, flinging her pudgy arms toward it. "*Oh!* the sky. So clear, so blue, so—so *glorious! Oh!* Shall I be able to stand it? OH!" One evening she and several other ladies were playing cards in the living room of Edgewood Hall and somehow the conversation fell on Mr. Roach's charms. "He has *such* a beautiful back," said Mrs. Roach, laying down her cards, "I tremble to think of it. *Oh!* Skin as clean and white as the drifted snow. As soft as duck down. I *do* wish you could see it." "Why, yes," said one of the other ladies, "it would be a treat." "You have no *idea,*" said Mrs. Roach, "no idea. *Oh! Such* a lovely back." Then she thought a moment. "He's taking a bath," she said. "We could just peek in." So the ladies trooped upstairs and peeked through a crack in the bathroom door at Mr. Roach's back.

There was a tragic side to Mr. Roach's life. Some years before I knew him his two daughters had died suddenly. He used to go to the opera a lot; said that only among the crashing cymbals, moaning violins, and soaring arias could he forget his daughters.

Not long after my conversation with Mr. Roach about investments my nose became infected (it was pure coincidence; there was no connection between the two

events). The doctor sent me to the hospital and the surgeons took some cartilage from a man's knee and put it in my nose to replace the damaged bone. On leaving the hospital I went to Louisville Landing on the St. Lawrence River, where Irene's mother had a summer cottage, to convalesce.

A couple of days after I had left, Mr. Roach's chauffeur "happened" to bump into Irene at the grocery store. Irene asked how he was. A casual question. "Couldn't be better," said the chauffeur, "healthwise and moneywise." "Oh?" said Irene. "Yeah," said the chauffeur. "Mr. Roach's put me onto a good thing. I ain't rich yet, but I ain't worried no more about moola."

A week or so later Irene met the chauffeur again. "How is your investment getting along?" she asked him. "That Mr. Roach sure can pick 'em," he said. "I've made over a thousand already. On only five hundred to begin with." "Do you think Mr. Roach would let me invest in the same thing?" asked Irene. "Well," said the chauffeur, "it's secret, of course. Can't have everybody hearing about it. Shoot the price up. But maybe he'd let *you* in on it. I've heard him speak very well of you and Mr. Rockwell. You ask him. But don't tell him I tipped you off. There ain't a better man than Mr. Roach, but he don't like his information blabbed about."

So Irene went to Mr. Roach. When she inquired about the investment Mr. Roach said, "It's good. No question. One of a series of sleepers I've searched out, plumbed, invested in, and profited from. Oh yes. Goodwisesecure. Pride myself. Safe haven. Cost? Low. Value? Up. Growth? Rapid." Irene told him she would like to invest. "No-no-no-no-no," said Mr. Roach. "Certainly not. Norman would object. Disapprove. He does not favor investments. Though they are profitable. We cannot deny that. Double your money. Riches. Yachtsfurcoatsmansions, WEALTH. But no. No. We must not, should not, can't." And he absolutely refused to take Irene's money, in spite of her coaxing and her objections that I was only an artist and didn't understand the world of high finance. "He'll be overjoyed when he learns that we've doubled his savings," she said. "Please help us, Mr. Roach." But Mr. Roach would not; he would hear no more about it; in short, he would not risk my displeasure.

Irene kept after him, her desire constantly whetted by "chance" meetings with his chauffeur, who continued to expound on the virtues and financial wisdom of his employer. Finally, with great reluctance, Mr. Roach consented to take her money and Irene gave him the ten thousand dollars.

That was the last anyone other than Mr. Roach ever saw or heard of it. When two weeks later I returned home and learned to my horror what Irene had done, I hurried over to Edgewood Hall. "Where's my ten thousand dollars?" I shouted at Mr. Roach. "Ah, Norman, Norman," he said, looking very sad, "fortune rules us. Tyrannizes. An oil well gushes oil one day. Black gold. The next it's dry. Dust and ashes. Hair shirts. Our little sche—" "No more of that hogwash," I said, "I want my money. I'll sue. I'll take you to the Supreme Court. I'll wring your neck!" At this, the chauffeur, who was a rugged fellow, strolled up. So I left, determined to sue Mr. Roach for my money.

But there was nothing I could do. Irene hadn't even got a receipt from Mr. Roach. We were out ten thousand dollars. Flat broke. I'd planned to take it easy for a while, let my nose recover leisurely. But here I was without a cent to my name. I had to go back to work immediately.

Later on several of his other victims and I banded together to take revenge. We knew he was a terrible coward and morbidly afraid of water so we planned to kidnap him some dark night and set him adrift in the middle of a lake in a rowboat without oars. But nothing ever came of it. I forget why we dropped the conspiracy. Not long after he got my ten thousand dollars, Mr. Roach left Edgewood Hall and moved into a big house on Pintard Avenue. And gradually I forgot the whole thing.

I knew another entrepreneur in those days. He was a big man, barrel-chested and handsome. One day someone served him reindeer meat for supper. It was delicious, he thought, like beef and chicken mixed. So he hired a freighter and sailed through the Bering Strait to Wrangel Island off the northeast coast of Russia. There he purchased a boatload of reindeer. Back in San Francisco he butchered a few head and put the meat out experimentally in several butcher shops. No one bought it. No American man, mother, or child would eat Santa Claus's reindeer. Nothing daunted, he hired an airplane and flew all across the country, renting or selling (I never knew which) reindeer to department stores for the Christmas season. When he returned to San Francisco, having contracted to dispose of the entire herd, he discovered that the reindeer had shed their antlers as the boat came south into warmer weather. So he had papier-mâché antlers made and attached to the reindeer by rubber bands under their chins. And that Christmas beside Santa Claus in every good-sized department store in the United States stood a reindeer with papier-mâché antlers. I always wondered who was the more discomfited: Santa Claus because of the huge, odoriferous beast or the reindeer because of the itch under his chin from the rubber band that held on his antlers.

A few years after my run-in with Mr. Roach, I was witness to another get-rich-quick scheme. I was not a participant, partly because I'd learned my lesson under Mr. Roach, who, you'll agree, was a good teacher, and partly because the originator of the scheme wouldn't let anyone invest. He wanted all the gigantic profits for himself.

I'd met him before the war when he came to ask Clyde Forsythe for advice on how to become a successful cartoonist. One day I entered the studio to find Clyde explaining to a young man the words cartoonists used to indicate the sounds which accompanied every action in comic strips in those days. "If one character hits another over the head with a tennis racket," Clyde was saying very seriously, "it's 'ploop.' If a fellow gets hit with a brick, it's 'kronch.' A stick of wood is 'wonk.' A pillow is 'plomp.' Remember now. It's very important." "Yes, Mr. Forsythe," said the young man, "I'll remember." "All right," said Clyde. "Now if a character falls over backward with amazement it's 'whoopff,' but if he or she falls forward it's 'whapff.' When a woman strikes a man, it's 'blap'; when a man strikes a man, it's 'bop.' When a man hits a

woman (very rare; the readers don't like it; men aren't supposed to hit women), it's 'blip.' There now. If you can remember all that you can be a cartoonist. Otherwise you'll never make it. No cartoonist of any standing would ever put down 'smack' when one character hits another with a tennis racket. It's got to be 'ploop.'" "I really appreciate the help you've given me," said the young fellow. "I was putting down 'blap' for 'blip' and 'plomp' for 'ploop' all the time." "Oh, Norman," said Clyde, "here's a cartoonist I want you to meet. Name's Jack." "How do you do," I said, and we shook hands. "Is there much money in cartooning, Mr. Forsythe?" asked Jack. "Enough," said Clyde. "Maybe you'll get syndicated." "Gee, I hope so," said Jack. "I certainly want to make money."

I saw Jack on and off during the next five or six years. Evidently cartooning wasn't as lucrative as he had hoped, for every time I met him he was bursting with a million-dollar scheme. None of them seemed to pan out though. Then one day I ran into him on the street in New Rochelle. "Norman," he said, grabbing me by the lapel and pulling me behind a tree, "I've got it." "What have you got?" I asked. "I can't tell you," he said, "but I'm going to be a millionaire." I congratulated him. "Couldn't you give me a hint?" I asked. "Well," he said, glancing furtively over his shoulder like a counterspy, "you've heard of Eskimo Pie?" "Yes." "And eating Eskimo Pie is a national habit, isn't it?" "Yes." "The inventor made his fortune?" "Yes." "And if you had an idea like that, only better, you'd make millions?" "Yes." "That's what it is— it's like Eskimo Pie only better." "That sounds wonderful," I said. "You bet," he said smugly.

In the ensuing weeks I saw Jack several times. He was very busy. "Got to run," he'd say after we'd greeted each other. "Preparing my ideas, you know." And he'd bustle off. Or he'd mention tremendous profits which were just over the hill, just a few months away.

Finally my curiosity got the better of me and I asked him to explain his scheme. He refused. "Couldn't. Might get out. Ruin it." "Oh, c'mon," I said, "I won't tell anyone." "Welll," he said, "you promise? Will you swear to keep it secret, not to breathe a word of it to a living soul?" "Yes," I said, "I swear not to." "All right," he said. "Now. What's the most popular drink during hot weather?" "Lemonade?" I said. "Right," he said. "And what would be more popular than lemonade?" "I don't know," I said. "What?" "*Frozen . . . lemonade . . . on . . . a . . . stick!*" he said triumphantly. "Oh," I said. "It's stupendous," he said. "It's exactly like Eskimo Pie only better. I can't help but make millions."

Then he showed me the salesmen's ledgers he'd made up. Big books, the name of his company hand-lettered beautifully in gold on the covers and in blue and red at the head of each page above various headings (in an intricate script) such as "sales," "buyer," "address." He told me he had divided the country into territories and was assigning a salesman to each territory. The local taxi man had signed up and several grocery-store clerks who wanted to better themselves and a couple of accountants and a traveling salesman for a leather-goods concern. I understood that there had been a great deal of haggling over who was to get the best territories—downright

squabbles, in fact, during which hard words had been exchanged—though of course none of the prospective salesmen had the faintest idea what they were going to be selling. Jack had a peculiarly persuasive way of talking, however—sort of a pedantic, swelling enthusiasm which could construct from a mixture of fact and imagination the most convincing and logical preposterous schemes anyone had ever heard. I expect the salesmen threw themselves heart and soul into his frozen lemonade idea before he'd talked five minutes. After he'd explained it to me I suspected pretty strongly that it *would* make him a millionaire.

"What do you figure the profits will be?" I asked him when he'd finished telling me about his salesmen and their territories. "How many towns are there in the United States with a population of 10,000?" he demanded. "Gee, Jack, I don't know," I said. "There are seven thousand," he said. "Now it stands to reason that on a hot day you could sell 500 frozen lemonade sticks in each of these towns. Correct?" "Yes," I said. "All right," he said. "Now how many cities would you say there are in the United States with a population of 25,000?" "How many?" I asked. "Four thousand," he said, "and certainly you could sell 1250 frozen lemonade sticks in each of those cities on any warm day of the three summer months?" I agreed. And he went on through the cities of 50,000 inhabitants, 100,000, 250,000, 500,000, 1,000,000, etc., until he'd covered all the cities in the country. Then he said, "Now bear in mind that I plan to sell my lemonade sticks for a nickel apiece. What does that come to a day? Less three cents a stick for manufacture, distribution, and salesmen's commission." "I don't know," I said. "How much?" He scribbled on a large piece of paper for about ten minutes. "Check my figures," he said, handing me the paper. "I make it $25,000,000 a day." "Wow," I said. "Of course," he said, "we won't extend our sales campaign to the entire country the first year. We must build a base of operations in the Eastern states. But then," he said, getting all fired up, "in the Southern states we may be able to conduct a year-round business. And I haven't counted the hot days in April, May, September, and October. Or the people who will buy two or even three of my frozen lemonade sticks on any given day. Or the assured increase in sales which a really hot day—say 110° in the shade—will bring." "It sure sounds wonderful," I said. "You bet," he said. "Now if you'll excuse me, I think I'll figure up the sales in just the New England states during August. That's the section we're going to hit first."

The next week he rented a large barn and painted it a bright lemon yellow. That was to be the home office of his frozen lemonade stick empire. And he scurried about, signing up more salesmen, assigning territories, lettering ledgers, and figuring his sales.

Then the day arrived when he was to present his idea to Mr. Ranger, the proprietor of a large ice cream parlor in New Rochelle, who would manufacture the first frozen lemonade sticks in his candy-making department. Later on, of course, a proper factory would be built. Jack asked me to go along as witness.

We entered the ice cream parlor and asked for Mr. Ranger. A girl ushered us into his office at the rear of the store. Jack locked the door and swore Mr. Ranger to secrecy. "I've got a million-dollar idea," he said. "You've heard of Eskimo Pie?" Mr.

Ranger nodded. "It's bigger than that," said Jack, "and I'm going to give you five per cent of the profits. You're to take charge of the manufacturing end." Then Jack told him about the sales force and figured up a typical summer day's profits. Mr. Ranger was fascinated. "What's the idea?" he kept asking. "What's the idea?" "The most popular drink in summer all over the United States is lemonade," said Jack, "right?" Mr. Ranger agreed. "And what would be more popular even than lemonade?" said Jack, and he paused. Mr. Ranger admitted he didn't know. "*Frozen . . . lemonade . . . on . . . a . . . stick!*" said Jack. "Gee," said Mr. Ranger, "you can't do that." "Whatta you mean?" said Jack. "You can't freeze lemonade," said Mr. Ranger. "It just won't freeze." "Why, it's just water with a little flavor," said Jack. "Whatta you mean it won't freeze?" "It just won't, that's all," said Mr. Ranger. "Everybody knows it won't." And he explained the difficulty (as I remember it, at that time you couldn't freeze any of the citrus fruits because of the acid; of course, they have since discovered how to do it). Finally Mr. Ranger convinced Jack that his idea was an impossibility. So Jack and I went home.

But Jack didn't lose heart or weep on his ledgers. (It took a little time to liquidate the frozen lemonade empire. The salesmen swore rather irate, especially the taxi man, who issued dire threats against Jack's health. You can't take twenty-five thousand dollars a year from a man without irking him a bit.) A week after the debacle Jack thought up a new idea for making his fortune. Those were the fabulous twenties. Everybody had a golden goose. I swear you could almost smell money in the air if you took a good sniff.

9

The mansion on Mount Tom Road

ONE DAY in 1920 I asked a clerk in Gimbels to send some socks I'd bought to my home. "Name?" he asked. "Norman Rockwell," I said. He drew back. "Not *the* Norman Rockwell? The one that does covers for the *Saturday Evening Post*?" "Yes," I said, "that's me." "Wait'll I tell the missus," he said. "She'll be thrilled." I mumbled modestly and suppressed a sudden impulse to hug the man. He had recognized my name!

As I floated down the aisle between alarm clocks and costume jewelry I chortled to myself: Not *the* Norman Rockwell, not *the, the, the, the* Norman Rockwell. Oh no. His wife would be thrilled, eh? Gee, I must be famous!

I straightway determined to have that lovely, glorious, scrumptious tingling in my blood again. So I stopped at the doodad bargain counter and, picking up a handful of thimbles, said, "Send these to my home, please. Name's Norman Rockwell." "Cash on the line," said the salesgirl. "My name is *Norman Rockwell*," I said. "So what?" said the salesgirl. "My name's Gussie Simpson. Cash on the line." "But——" I said. "You nuts?" she asked. "Cash on the line." So I paid up, put the thimbles in my pocket, and walked out, stunned.

But by the time I reached my car I had recovered some of my equilibrium. After all, one out of two wasn't bad. Even if only half the population recognized my name I was famous. A little bit anyway Well, *one* person had recognized it. That was better than nothing.

Not long after this I received what I thought was a real indication that I was sitting in the world's eye. The New Rochelle Art Association invited me to a banquet to raise funds for a statue commemorating the soldiers who had fought in World War I. The invitation read: "A seat has been reserved for you at the speakers' table." I was to sit with all the big illustrators, with Joe Leyendecker, Coles Phillips, Clare Briggs. I had arrived! (In those days I was always "arriving" somewhere; you've probably noticed it. I was young and enthusiastic.)

Shortly after the armistice the town council had announced that they planned to hire the Mott Iron Works to do a statue commemorating New Rochelle's war dead and veterans. But the statues manufactured by Mott were cast iron, cheap and crude. So the New Rochelle Art Association had risen up and shouted, "No! *Not* the Mott Iron Works. We're going to have a good statue." The town council, greatly relieved, had said, "All right, you handle it." And the Art Association had commissioned a fine sculptor and were now holding a money-raising banquet.

Charles Dana Gibson was to be the toastmaster at the banquet. The Wykagyl Country Club, a posh place, had been rented for the night. All the famous illustrators and artists who lived in New Rochelle were to be present. (At that time it was a question whether New Rochelle was lousy with artists or whether there were a lot of lousy artists in New Rochelle). It was understood that everyone at the speakers' table would be asked to take a bow.

So I reserved a table at the banquet and invited all my friends. "I won't be sitting with you," I said in an offhand manner, "I'll be up at the speakers' table. You know, take a bow and all that sort of thing. The price of fame." In the privacy of my studio I practiced my bow and the modest smile which would accompany it.

The night of the banquet arrived. Dressed in a new tuxedo (my first), I found my place at the speakers' table. J. C. Leyendecker sat on one side of me, Coles Phillips on the other. We chatted as equals and munched on our hard rolls, chicken à la king, and celery.

Then Charles Dana Gibson rose and began the introductions. My great moment approached. I went over my bow in my head. First I'd push back my chair, then rise slowly and, leaning slightly on the table, incline my head to the left, to the front, to the right, smiling.

One after another the men at the table acknowledged the plaudits of the crowd. Gibson asked the man sitting beside Mr. Leyendecker to take a bow. He did. I trembled. Then Gibson asked Mr. Leyendecker to stand. I was next. Leyendecker sat down.

And Gibson called on Coles Phillips!

For a minute I didn't know what had happened. Then it came to me. Gibson had skipped over me. I wanted to crawl under the table and hide. But I couldn't. I just sat there, silent, staring down at my hands. Gibson had skipped me. After all my talk. Before Irene and Clyde and all my expectant friends.

Neither Mr. Leyendecker nor Coles Phillips said anything to me, but they concocted a note to Gibson telling him that he had failed to introduce me. Gibson

didn't pay any attention to it; he just went right on with his speech. He could have worked me in somehow. The next day he did send me a note apologizing for his oversight. But that wasn't any good; that didn't rub off any of my humiliation.

The banquet wasn't all sackcloth and ashes for me, though. I had met the great J. C. Leyendecker. The next day I didn't leave the house until sunset. Then I sneaked through the back streets (so as not to meet any of my friends) to Mr. Leyendecker's mansion on Mount Tom Road. It sat on a hill at the extreme western end of a large plot of ground surrounded on all sides by a high wall. To the rear of the house, which resembled a French château, stretched formal gardens. A short, semicircular, cobblestoned driveway led up to the front door. I peeked around the wall and up the driveway to Mr. Leyendecker's studio windows, gilded by the last rays of the sun, opaque. Should I ask him to dinner? I thought. He was friendly at the banquet. Yes. But he's so famous. And I thought of all the times I'd followed him about town just to see how he acted. And how I'd asked the models what Mr. Leyendecker did when he was painting. Did he stand up or sit down? Did he talk to the model? What kind of brushes did he use? Did he use Winsor & Newton paints?

Then the sun dropped behind the row of houses at my back and for a minute the windows of the mansion were dark. Maybe I'd better not, I thought. He might be offended. Suddenly a light flicked on in the mansion and I could see a man standing beside a table in one of the rooms. All alone. A little man. I'll ask him to dinner, I thought. It can't hurt. He might like to come.

So the next morning, after picking up and putting down the telephone a hundred times, I steeled myself and called Mr. Leyendecker. Yes, he remembered me. Uh . . . yes, he and his brother Frank would be pleased to come to dinner. Tuesday at six? Fine.

I hired a cook, Irene cleaned the house, and we concocted a menu. Roast turkey, mashed potatoes, string beans, gravy, cranberry sauce, etc. Like Thanksgiving dinner. Maybe it was silly to have Thanksgiving dinner in July, but it was safe—everybody enjoys it. I didn't want to risk liver or spaghetti. I'd stick to Rock of Gibraltar certainties; and what could be more so than Thanksgiving dinner?

At five-thirty on Tuesday I took a last look at the turkey gurgling and hissing in the oven, tasted the cranberry sauce, string beans, and potatoes, smelled the milk to see that it hadn't gone sour in the last ten minutes, and took up my place at the window to watch for Mr. Leyendecker and his brother. Pretty soon I saw them coming down the street. They were quite short and walked in step, with real military precision, the tips of their canes and their black and white saddles shoes hitting the pavement at precisely the same instant. They wore white flannels, double-breasted blue blazers with shiny brass buttons, and stiff straw hats. One-two, one-two, one-two, they marched toward me. As they turned sharply, without breaking step, into our yard, I could see that they were both very handsome—dark-complexioned with high cheekbones and straight, delicately molded noses. Like Spaniards. And trim, well built, the line of their jackets falling straight from shoulder to hip.

THESE AND FOLLOWING PAGES: Three works by Rockwell suggesting Leyendecker's influence
on him, and one of Leyendecker's own well-known illustrations for Arrow Shirts

Kaynee Blouses and Wash Suits Make You Look All Dressed Up, oil painting
for Kaynee Company advertisement, 1919

J. C. Leyendecker, Arrow Shirt Company advertisement, early 1920s

Naval Academy Oarsman, oil painting, 1921

Off to Fish on a Bike, advertisement for Fisk Rubber Company, 1919

I opened the door. "Good evening, Mr. Leyendecker," I said. "Oh," he said as if he were surprised to see me, "yes. Good evening, Mr. Rockwell. This is my brother Frank."

I ushered them into the living room and we sat down. "It was very warm today," I said. "Yes," said Mr. Leyendecker, "it was." "But I thought it looked like rain just now," I said. "Well," said his brother, "the sky was blacking up as we came in." "Yes," I said. Then Irene came in, I introduced her, and she sat down. Silence. Was the banquet a success? I understand it was. Silence. Mr. Leyendecker staring at his shoes, his brother at the piano, I at the wall. Irene smiled brightly. More silence. Unbearable.

Then the cook announced that dinner was served. We trooped into the dining room and sat down. Much scraping of chairs, straightening of jackets and ties, and fumbling with napkins. Then the cook came through the kitchen door with the turkey, slipped on the edge of the dining-room rug, and CRASH—the platter smashed on the floor and the turkey rolled under the table.

While Irene ran for another platter I crawled under the table from one side

and Mr. Leyendecker from the other. We met over the turkey, which was lying on its side among the table legs, one drumstick torn away from the body, stuffing gushing from the breast. I looked at Mr. Leyendecker. "That smells good," he said and, sticking his finger into the heap of stuffing, tasted it. "Chestnut," I said. "How is it?" And I tried a bit. "Wonderful," he said, and he ate some more. "You know," he said, "I have a Filipino cook and he can't cook turkey. Refuses to, in fact. Says if I want American food I can hire an American cook. This is a real treat." And he sampled the stuffing again. "I say," said his brother, looking under the table at us, "bring that turkey out of there. Mrs. Rockwell and I would like some." So I put the turkey on the platter which Irene had shoved under the table and hauled it out. The cook brought a damp sponge and we cleaned the turkey, talking and laughing. "Don't throw away any of that stuffing," said Mr. Leyendecker. "It didn't touch the floor." "Righto," I said. "And don't sponge off all the juices," said his brother. "You know," said Mr. Leyendecker, "a turkey—browned to a turn and steaming—is one of the hardest things to paint. That quality of crispness and juiciness rolled into one is almost impossible to render on canvas. I remember once . . ." And we didn't stop talking all evening. When that turkey bounced under the table we all of a sudden became friends. We remained friends for over twenty-five years.

Joe and Frank Leyendecker had grown up in Chicago, where their father worked for a brewery. When the boys were very young the family had decided that Joe was a genius and, like many immigrant families, had henceforth concentrated all their efforts on helping him to fulfill himself. I guess the family felt that only one of their children had a chance to distinguish himself and so they fixed on the one who had a talent and sort of sacrificed their lives to him. Many immigrant families seem to have regarded a talent as a gift from God and therefore something which was to be respected and aided, which it would be somehow sacrilegious to waste. The Leyendeckers scrimped and saved and went without until they had gathered together enough money to send Joe to Paris to study art. Frank, his younger brother and inseparable companion, went along.

Joe at once became the star pupil at the Academie Julien and at Calorossi's, two of the most celebrated art schools in Paris. Twenty years later, when I visited Paris, they still talked about Joe Leyendecker at Calorossi's. Some of his figure drawings were still hanging on the walls; the teachers used to cite them as outstanding examples of the art of drawing the human body.

When Joe returned to this country he was still young, but he immediately became a famous illustrator. He had made something of a name for himself even before leaving Europe. At seventeen he had illustrated the Bible. But now he was universally acclaimed as a genius, as a man who would someday rank with the titans of the golden age of illustration—Pyle, Abbey, Cruikshank. He illustrated the Lord's Prayer for *Delineator* magazine. I've seen the drawings; they were beautifully done, real masterpieces. Then he illustrated the Twenty-third Psalm. Another wonderful job. Glorious stuff. He was headed for great things; in art school we said, "One day we'll be as good as Pyle or Abbey or J. C. Leyendecker."

But he was supporting his parents and his sister Augusta by this time and living splendidly—the mansion, servants, an automobile. Joe believed that an artist should live just a little bit beyond his means so that there would always be a challenge. "Buy more than you can afford," he used to say, "and you'll never stop working or fret so over a picture that it never gets done. If every day you have to save yourself from ruin, every day you'll work. And work hard." But this is a bad credo for an artist to have. If he adheres to it, his work suffers, for finishing the picture, rather than the picture itself, becomes the primary consideration. And he takes on too much work, not more than he can do but more than he can do *well*. Joe took on advertising jobs—a lot of them, all he could get. And magazine covers. And illustrations. And posters. As a result, when someone offered him a job which was badly paid but artistically challenging, something which would raise his stature as an artist, he had to refuse it. He was asked to do the ceilings in the New York Public Library once. But he turned it down. Too busy. Couldn't let up on his commercial jobs; he needed the money.

If there wasn't a deadline or pressure, Joe worked with agonizing slowness. The town of New Rochelle published a brochure illustrated with reproductions of paintings by all the famous artists who lived in the town. Joe worked on his painting for months and months, starting it over five or six times. I thought he'd never finish it.

Still, his work was fine, really good. There wasn't an illustrator in the country who could draw better.

Then one day a man called Beach (that was his surname; I never knew his given name), a Canadian, visited Joe in his studio. He had fallen in love with a girl in one of Joe's drawings and come all the way from Canada to meet her. He was tall, powerfully built, and extraordinarily handsome—looked like an athlete from one of the Ivy League colleges. He spoke with a clipped British accent and was always beautifully dressed. His manners were polished and impeccable.

Joe began to use him as a model for Arrow collar and House of Kuppenheimer clothes ads and for his sports posters, which had titles like "Rushing the Line" and "The Kickoff" and which college boys framed and hung about their rooms.

After a while Beach went to live with Joe in the mansion in New Rochelle. At first he just swept up the studio and washed the brushes after Joe had finished work for the day. Then he began to make Joe's business arrangements for him—take his *Post* covers to Philadelphia; speak to the art directors when they called; deposit the checks in the bank. Little by little, day by day, he insinuated himself into Joe's life.

By the time I met Joe he had become in a great measure dependent upon Beach. Beach would lay out his brushes, squig out his paints on the palette, and welcome the model every morning. Then, when everything was ready, he would call Joe. At the end of the day Beach would pay the model and clean up the studio. Beach transacted all Joe's business for him, did everything but paint his pictures. Mr. Lorimer once told me that he had never met Joe or even spoken to him over the telephone, though Joe had done *Post* covers for almost forty years. Beach hired the models, bought the art supplies, rented the costumes, paid the gardeners and servants.

But more than that. Before he met Beach, Joe had had many friends—artists, writers. He had gone to parties, invited people to dinner. In other words, he had lived a normal life, been in touch with society and the art world. A great Russian writer had come to this country with his mistress. When the hotels refused to admit him and the woman Joe had invited them to stay at his home.

All that changed after Beach moved in. He built a wall around Joe, cut him off. I knew Joe for almost twenty-five years and in all that time the only persons he ever saw besides his models were myself, his sister Augusta and brother Frank, a family of cousins named Sullivan, and a colonel from West Point. He rarely even *spoke* to anyone else. Beach answered the telephone (Joe stammered a bit when he talked on the telephone). After he had given up his studio in New York City he scarcely left the mansion. For exercise (for he always kept in trim, his muscles hard) he walked about the gardens. I can see him in my mind's eye now: a small compact figure dressed in gray flannels and a tweed sport coat, with a white silk scarf knotted about his neck; pacing beside a pool or down a pathway between two rows of clipped boxwood, stopping now and then to give an order to one of his gardeners. And always just behind him comes Beach, his eyes riveted on Joe's back as if they were tied to it with a cord. (But that's not how I remember Joe. Whenever I come upon a painting of his in a book or hear his name mentioned I see him in his studio or standing straight and stiff before my easel, his hands jammed into the pockets of his jacket, his chin thrust out a little, tearing my picture to pieces. You never asked Joe—or Frank—what he thought of your painting unless you wanted a real critique; he thought nothing of starting a picture all over again. "No," he'd say, "the hands are out of drawing. The nose doesn't fit. You'd best scrap it and start over.")

After Beach went to live in the mansion Joe became extremely timid, almost morbidly so. I can remember walking down Fifth Avenue with him once in the early days of our friendship. He kept his eyes focused about twenty feet in front of his shoes, never once looking at the buildings or into the store windows or at the passers-by. He didn't seem to see anything around him. I waved at an acquaintance across the street, stopped to examine a painting in the show window of a gallery. Joe kept right on walking. I think he'd trained himself not to notice anything. Or anybody. A man came up to him and said, "Joe, how are you? Lord, I haven't seen you in ten years. Where are you keeping yourself?" Joe mumbled something about work, his eyes locked on the ground, tapping his cane against the curb. The man began reminiscing about the good old days. Joe answered politely, but I could see he wanted desperately to get away. Finally he mentioned a pressing appointment, shook hands hurriedly with the man, and strode off.

I've always wondered why he accepted my invitation to dinner. I suppose it was just his fear of hurting me by a refusal. I'd been humiliated at the Art Association banquet and he didn't want it to appear as if he were snubbing me. For he was a gentle, sweet person, very kind and considerate, not wanting to hurt anyone. He never interfered in my affairs or asked a personal question. We talked about art, my work, his, the mansion.

At first Joe paid Beach a small salary and gave him his room, board, and clothes. Then Beach somehow wrangled a percentage of what Joe was paid for each picture. (*Not* a percentage of Joe's total income—that wouldn't have been so bad. But getting a part of what Joe made on each picture was almost like drinking his heart's blood, feeding off the core of his life. I always felt as if every brush stroke Joe put down on the canvas was part Beach's. If Beach had been paid a percentage of Joe's total income he would have been like a servant. But no, *part of each picture* was his.) After Beach had arranged things so that he was paid his percentage, he always spoke of Joe and himself as "we." If you asked him what Joe was working on, he'd say, "*We* are painting a *Post* cover." Or he'd say to Joe, "*We* had better get back to work now." And he'd pressure Joe to finish the picture so that he could get his percentage, "*We'd* better get the picture done, Joe. *We* haven't had much income this month." That didn't help Joe's work any.

He was a real parasite—like some huge, white, cold insect clinging to Joe's back. And stupid. I don't think I ever heard him say anything even vaguely intelligent. Not that he talked very much. While Joe and I sat talking he'd pad softly about the studio, picking up invisible pieces of dust, or perch all hunched over in a chair, chewing his fingernails. He would never leave us alone unless Joe specifically asked him to. (Hints were no good.) And if Joe mentioned something about going out he'd say, "Had we better, Joe?" Then Joe would stop and think a minute and decide that, well, maybe he wouldn't go out after all.

Beach always acted jealous of me. And I remember once Joe went off on a trip with one of his models without telling Beach. (It surprised me.) The next day, when Beach found out, he came down to my studio and asked me all about the model. After I'd told him what I knew he began to curse and call the model all sorts of vile names. Then he cried and pitied himself, saying he was mistreated and badly used. All of a sudden he flared up again and cursed the model, stamping his feet and waving his arms about in a kind of fit. But after a minute he slumped down in a chair, sobbing. This went on until he'd tired himself out and could only crouch in a chair and mutter under his breath. Then I remembered that Joe had said something about going to Canada. I told Beach. He jumped up from the chair and ran out. I learned later that he hired a car and drove up to Canada looking for Joe.

I think Beach resented me too. At least he was very distant and cold toward me. He never would call me Norman. I'd ask him to and he'd say, "Oh no, Mr. Rockwell, I couldn't," in a very polite but vaguely nasty tone of voice.

He treated Frank the same way. Polite but cold. And Augusta. Both Frank and Augusta lived with Joe in the mansion. Frank was a good illustrator (some people said he was better than Joe—more sensitive, more feeling in his pictures), but he was erratic and had trouble getting his work out. In the days before Beach came down from Canada Joe and Frank had been inseparable. They had studied together in Paris, lived together all their lives. Joe's studio was in one end of the mansion, Frank's in the other. They had had the same friends, gone everywhere together, even painted alike, though Frank never had Joe's facility or technical polish. And they shared a

secret medium (that's what you mix your oil paint with). Only Joe and Frank knew the formula. For years they had kept it secret, refusing even to exhibit their pictures for fear that some other artist would discover it. The use of this medium gave their paintings a special quality. You could see each brush stroke in the finished painting. Very distinctive.

And when Joe stopped seeing people or going out, Frank did the same. So that no one ever came to the mansion except models, delivery boys, and the postman. Just Joe and Frank and Augusta and Beach. All by themselves. But I guess even that was too many for Beach.

One Sunday afternoon Frank, Joe, Irene, and I were having tea before the great French fireplace in the living room of the mansion. Beach was lurking behind us. I could hear a chair scrape on the floor as Beach straightened it, or a lamp click on and off. Then, "Beach," said Frank over his shoulder, "put another log on the fire, will you?" "Put it on yourself," snapped Beach. I almost collapsed, I was so shocked. What was going on? I'd never heard Beach speak that way to Frank before. Frank looked at Joe but he continued to stare silently into the fire. I knew he'd heard, though, because he was holding his body so rigid that his hands were trembling.

That was the first time I noticed that something was wrong. Over the next year or so Beach's hostility toward Frank and Augusta became more overt. Gradually, with the cunning and persistence of a weasel, Beach corrupted Joe's relationship with his brother and sister, fouling it so slowly that Joe didn't realize what was happening, though if he had I doubt he could have stopped it, his dependency on Beach ran so deep. I don't know how Beach did it; Augusta, who told me all this, never went into detail. She did tell me that one day when she was in Joe's studio Frank entered and said, "Joe, I can't make my half of the payment on the house this month." Joe said, "All right, I'll take care of it." Beach, who was fussing at the window, said, "Don't you bother, Joe. Let me do it. I've saved a little. Let me. I'd like to." So he paid Frank's share that month. And the next month he paid Frank's part of a bill for improvements in the gardens. And the next month another of Frank's bills. And so it went. Whenever Frank was short of money (and he was chronically short because of the difficulty he had finishing his pictures), Beach helped out, believing, I guess, that this was one way in which he could come between the brothers. Finally, when he owned a greater share of the mansion than Frank, Beach felt he was his equal. All of it was more his than Frank's. Now it was Joe's and his.

But, as I say, Augusta never told me in detail how Beach polluted Joe's relationship with her and Frank. I can *imagine* how he did it. Nasty insinuations. Snide comments. A slow ooze of hate. Subtly provoking Augusta, who was hot-tempered and intensely loyal to her brothers. Toward the end Beach had open fights with her and, because he was cold and not muddled by conflicting loyalties as she was, he was always able to keep his temper and make it appear as if she was in the wrong. Frank never had any open arguments with Beach. Like Joe, he was timid, gentle, and his years of isolation and his sensitivity made him unfit for this kind of combat. When

Augusta and Beach had the final flare-up and she spit in his face and slapped him, and Joe, upset, confused, asked her to leave the house, Frank went along with her, partly out of loyalty, I guess, and partly out of a dim realization that Joe didn't want him around any more.

Augusta took up lodgings in a rooming house. For a while Frank did the same. But he couldn't paint there, so after about a month I found him a studio above a garage next door to mine. (He wouldn't accept any money from Joe; Augusta did.)

It was one large room, roughly finished—no inside walls, just raw siding nailed on two-by-fours. Frank had the furniture from his bedroom in the mansion moved in: a magnificent, four-poster, baroque Italian bed and a few hand-carved chairs of the same vintage. The bed, which he set against the west wall, occupied half the floor space, its intricately carved, spiraling columns incongruous against the bare, rough walls. Above the head of the bed he hung a crucifix, one of the most beautiful I've ever seen: medieval—ebony inlaid with gold and about a foot tall. He installed a bathroom, put a large window in the north wall and a small bay window in the south wall, and started to hang curtains.

But then he gave up, not even bothering to fix the floor, which canted sharply toward the east, or paint the raw wood sashes of the new windows. He never unrolled the large rug he'd brought over from the mansion; it lay against the wall, cobwebs streaking the bright, multicolored patterns. (The floor sloped so badly that it was almost impossible to draw in the studio. I did a picture there later of an old man sitting in the bay window. The drawing was all balled up. I couldn't get my bearings straight; after all, you get the horizontals and verticals from the lines of the room.)

Frank didn't spend much time in his studio. He did a job now and then—just enough to pay the rent and buy a little food. (The queer thing was that in all the pictures he painted after leaving Joe the shoes looked as if they were on the wrong foot. He worked from the model, but it didn't seem to make any difference. The people in his paintings always looked as if they'd put the right shoe on the left foot and the left shoe on the right foot.) And Frank slept in his studio, of course. But every morning about ten he'd knock on the door of my studio and ask if he could come in. All day he'd sit quietly in a corner, reading a book or watching the shadows crawling on the floor. At dusk when I was cleaning up to go home he'd say, "Gee, do the dark corners bother you?" "What dark corners?" I'd say. "Don't the corners get all black," he'd say, "as if there was a pit behind them?"

I didn't know it, but he was taking some sort of drug. The separation from Joe and the loneliness had broken him as a hunter breaks the back of a wounded squirrel. He was a lost soul, confused, afraid. I guess besides Augusta I was the only friend he had. He kept wanting to do something for me to express his gratitude. Finally one day he came into the studio and set three little bottles on my palette table. After swearing me to absolute secrecy, he said, "Norman, I . . . ah . . . want to give you the formula for the medium, Joe's and mine." And he wrote it down on a piece of paper—so much turpentine, so much stand oil, so much linseed oil. "These bottles are in the right proportion," he said. "I've labeled them. Every morning you mix up fresh." I

said, "Gosh, Frank, that's swell. Thanks a lot." I knew what that secret meant to him. It had been Joe's and his. And now he had given it to me. (Incidentally, I was never able to use the medium; it was too slippery.) I thanked him again. I really didn't know what to say. So I shook his hand and then we just stood there, looking at the three little bottles. After a minute I happened to glance at his face and for the first time I noticed that the skin had gone slack over his cheekbones, that his eyes were blood-shot and sort of cloudy. And his clothes, though still dapper and in good taste, hung loosely on him as if he'd shrunk. All of a sudden I realized he was dying.

But it wasn't quick. He made sporadic attempts to recover himself. Once he took me into New York with him to see a psychiatrist. (I asked the psychiatrist what had given Beach such a hold on Joe. He explained it was not unusual for a stupid person with only one idea in his head to gain control over a sensitive, timid person. He said it happened frequently in marriages. The stupid one just drove his one idea slowly, steadily into the other's brain, now holding back, waiting, now driving it deeper. But always working at it, never wavering or forgetting or becoming muddled; going after what he wanted doggedly because it was the only thing he wanted.)

The psychiatrist didn't help Frank. He kept on taking the drug; didn't eat much. Finally he died. On Good Friday night. Joe went to the funeral. And some-body pulled the great baroque Italian bed apart and loaded it and the chairs and the dusty rug into a truck and took them back to the mansion.

So Beach had Joe all to himself at last. Just the two of them and a couple of Filipino boys in that huge mansion, surrounded by beautiful things—tapestries, exquisite antique French furniture, the sunken gardens with their little pools stocked with goldfish. And everything in good taste—Joe insisted on that. One day when I entered his studio he was tinting his smock (he always wore a smock when he painted) so that it would go with the walls of the studio. And once he had a full-grown elm moved twenty feet because it didn't fit into the design of the gardens.

But for days on end he wouldn't talk to anyone but Beach and his models. As a result his work suffered. It was perhaps true that there had always been more tech-nique than feeling in it. He didn't look at a picture as the depiction of a scene, a scene with flesh-blood-and-breath people in it; he saw it as a technical problem. Whenever he was tired or discouraged about a picture he'd just put more technique into it. And technique alone is a pretty hollow thing.

You could see his emphasis on technique in the way he painted a picture. He would make endless little sketches from the model—two or three of the hands, a cou-ple of the head, the torso, the eyes, the folds of the dress, the shoes—until he had drawn everything exactly as he wanted it. Usually he filled three or four canvases in this way. Then he would combine the sketches on another canvas and that was his finished painting. By working this way, he explained, he could forget draftsmanship when painting and concentrate on his brush strokes, his technique. But of course he lost the feel of the model and the situation. In painting, the whole isn't the sum of the parts. You have to see the whole thing at once all the time you're painting.

Now that Joe had isolated himself from life his work became even emptier

than before. You can't do human-interest pictures from an ivory tower (a commercial ivory tower, but an ivory tower nevertheless). You've got to go out and meet people, see what everybody's doing. Maybe people don't change radically, but the surface of things does. And the surface is very important in illustration—the kind of clothes people are wearing, the houses they're living in, what they're talking about. Joe didn't know any of this. And besides, there was a lot he'd never known. Women, for instance. Joe could never paint a woman with any sympathy.

I think he realized that something was missing in his painting. But here again his hermitlike way of life, his lack of contact with the world around him, prevented him from seeing what was the matter. I don't think he would have been able to change anyway. That technique of his had him by the throat. He refused to make the slightest alteration in his system. Other illustrators began using photographs. It was quicker, easier, and you could catch the model's expression (no more frozen smiles) and any action that you wanted. And then you could take photographs from any angle, whereas when painting from a model you were limited. Joe damned photographs. "Are you going to be an artist or a photographer?" he'd ask. (I always agreed with him. But I began to use photographs. One day I had hundreds of photographs scattered all over the floor of my studio. I was picking parts out of all of them—the best leg, the best expression, et cetera. Joe came in. We talked for an hour, neither one of us looking at the floor, keeping our eyes fixed on each other's face. Then he left. He never said anything about this to me.)

In 1939 I left New Rochelle and moved to Arlington, Vermont. I saw Joe only once after that. His cousin called me up and asked me if I would visit Joe. He was very lonely. When I got there everything was the same. The mansion and grounds were still beautifully kept. Joe hadn't aged a bit—still the trim, tight little man who'd marched one-two, one-two, up to my house for dinner twenty years before. And Beach was there, handsome and remote as ever. Joe and I talked a bit, we ate dinner, and I went away.

Then in 1942 when Ben Hibbs became editor, Joe was dropped from the *Post*. The advertising agencies stopped using his work for the big magazine campaigns. He no longer got the prestige jobs. But Joe couldn't retire; he'd never saved any money and he had to keep up the mansion. That, and all the beautiful things in it, were all he had. So he did covers for the *American Weekly* and a few billboard posters for Amoco gas. Jobs like that. Badly reproduced. Cheap. I was shocked when I saw them.

He died in 1951. I went to the funeral. The coffin was in his studio. His smock was hanging on the closet door; his brushes were laid out on the table. And I thought of him painting those New Year's covers for the *American Weekly*. The same cherubs he had done for almost forty years for the *Post*. Sitting there in his chair laying on the paint in those exact, wide brush strokes. And Beach hovering about the corners of the studio, straightening the pillows on the couch or dusting a table. And then I looked out at the black sky and the rain beating on the windows and dripping off the clipped evergreens in the gardens. Joe in Paris. At the Académie Julien with a bunch

of students clustered around his easel watching him draw the delicate curve of the model's shoulder. The star pupil. The virtuoso.

Beach touched my elbow. The funeral was about to start. There were five people in the studio besides the priest and the undertaker: Beach, Augusta, myself, and the daughter of Joe's cousins, the Sullivans, and her husband. That was all.

As the coffin was lowered into the grave I thought of what Joe had said to me once just before I moved to Arlington. "I guess if I had to live it all over again," he said, "I'd have done it differently. I don't know. Maybe I couldn't have."

After Joe's death Beach went all to pieces and began to drink. He sold all of Joe's originals very cheaply to buy liquor. Pretty soon he was dead.

And that was the end of it all. It scared me. Joe had been the most famous illustrator in America. Then the *Post* had dropped him; the advertising agencies had dropped him; the public had forgotten him. He had died in obscurity. It might happen to me. When I got home I went out into the studio and looked at my picture. I was naturally depressed. Still, it wasn't a reassuring sight. But then I noticed that the eyes of the man in the picture needed just a touch of white to give them a sparkle. So I sat down and got to work. After a while I thought to myself, Well, here I am. And I can still hold a brush.

36—24—36 Wow!

I N 1922 the Atlantic City Chamber of Commerce invited a group of artists to be judges at the second annual Miss America Beauty Contest: Howard Chandler Christy, James Montgomery Flagg, Coles Phillips, Charley Chambers, myself, and several others. The year before there had been only one judge, Howard Chandler Christy, and I guess the Chamber of Commerce had decided that the contest would appear to be a more serious and solemn occasion if a panel rather than only one man judged it. And I dare say they hoped for greater publicity too.

Somewhere the Chamber of Commerce had dredged up the fantastic notion that artists were hard to get, that we were all so dedicated, in fact wedded, to our easels that only promises of regal luxury would pry us away. We were advised in hum-ble letters that all our expenses would be paid, that every effort had been made to ensure our comfort and happiness. All of us, flabbergasted by this splendid offer, accepted. The Chamber, still fearful that we might become temperamental and back out, invited us to a banquet at the Waldorf-Astoria. There, each of us accompanied by a lovely lady companion supplied by the Chamber (for they thought boys will be boys and artists more so), we gorged ourselves on caviar, breast of spring duckling, and champagne. The men from the Chamber hovered about us anxiously. No sooner was a glass drained of champagne than it was filled, a cigarette put to one's lips than a lighted match appeared. Boxes of fine Havana cigars were handed around as the table was cleared. Oh, it was grand, it nourished the soul. We were oriental nabobs; we knew the luxury and splendor of fabled kings.

Two or three days later we drove to Atlantic City. At the hotel a car and chauffeur (a member of the Chamber) were assigned to each of us. No plebeian busses or middle-class taxis for us. The wives who had come along (all expenses paid, of course) were presented with gorgeous corsages. The manager of the hotel greeted us and ushered each of us in turn to a suite of rooms. I turned to tip the bellboy. The man from the Chamber of Commerce leaped forward: "Oh no, Mr. Rockwell. Please allow me." And *he* tipped the bellboy.

That evening after another exquisite banquet we were driven, each in his own car, to the opening ball, during which the contestants were to be introduced to the judges. We entered the grand ballroom to find Howard Chandler Christy standing on the platform at one end of the room flanked by two enormous potted palms. His wife, a big, handsome, blonde woman who always reminded me of an 1890s burlesque queen, was leading the contestants one by one up onto the platform to meet her husband. It looked like a reception for Christy. I didn't care (as long as the guinea hen and burgundy held out, I didn't care if someone put a blanket over my head), but James Montgomery Flagg and some of the other judges, who had tasted fame and liked it and wanted more, were miffed. "Why, that no-good, conceited publicity hog," said one of them, referring to Christy." "What does he think he is?" Christy had scored off us.

He continued to score off us the rest of the week. We were helpless. At the right moment, when the photographers were clustering around trying to get a good picture and shouting at us to smile, move in, move out, stand up, sit down, Christy would appear in a white suit and broad-brimmed Stetson with a beautiful contestant on each arm, and the photographers would leave us milling about and run to take his picture. During our frequent parades up and down the boardwalk behind the girls, someone in the crowd would invariably yell, "Which one is Mr. Christy? Which one is Mr. Christy?" Then the parade would halt and Christy's wife would lead him out to the edge of the boardwalk. The crowd would rush to shake his hand and the photographers would snap pictures of him. One day the chamber asked all of us to go to the pool in the hotel to have our pictures taken with Jack Dempsey, who was just beginning his career as heavyweight champion. We trooped over and greeted Dempsey. Christy can't do us in this time, we thought, we're here, on the spot. But when the photographers entered the room Christy grabbed Jack Dempsey's hand, thrust out his chest, and swept off his hat, uncovering a great shock of white hair. And it made such a good picture — the tall, rugged, powerful Jack Dempsey in a dark suit clasping hands with the short, stocky, pugnacious Christy in a white suit—that the photographers shooed the rest of us out of the way and snapped Dempsey and Christy.

All this damaged our egos. Still, we couldn't dislike Christy for it. He had such a warm, jovial personality: flamboyantly good-natured, boomingly cheerful. And if he liked publicity so much and was so good at getting it, well, I couldn't hate him for it. It seemed to go with his character. It fed him and he fed it. Publicity and he were right for each other. Like pearls and duchesses or cole slaw and church suppers.

Christy certainly had the most tremendous knack for it. Wherever there was a chance of it, there was Christy. You could count on it. If he wasn't present the occasion was second rate, doomed to pass unnoticed into the swirling mists of time. Later on at the beginning of World War II I saw Christy in Washington. "I guess the war is really on," I said to my friend Mead Schaeffer. "Christy is here." And when the portraits of the members of Coolidge's cabinet were to be painted, who was selected? A skilled, experienced, distinguished portrait painter? No. Howard Chandler Christy. An illustrator! Who did rather bad portraits! He and Mrs. Christy stayed at the White House with the Coolidges. *That* must have been something to see. The flamboyant, jovial Christy and his blonde Brunhild eating dinner with the dour, tight-lipped, rock-ribbed-New-England Coolidges. Mrs. Christy told me later that she showed Mrs. Coolidge how to fix her hair.

So while Christy posed for the photographers and received the plaudits of the crowds at the beauty contest, the rest of us stood around with our hands in our pockets and watched.

But that was the least of our problems. What we worried about was judging the contest. The Chamber of Commerce couldn't tell us how to go about it; they didn't have any system worked out. "Just *judge* it," they said.

So we talked it over among ourselves. It was all very confusing. The first night one girl looked absolutely stunning in her evening dress. "That's the one for us," we said. But next day when she strolled down the boardwalk in her bathing suit we saw that she was just a trifle knock-kneed.

Then one judge had an idea. "Look," he said, "it's a beauty contest, isn't it?" We agreed. "Then let's judge beauty," he said. "We'll give each feature—eyes, nose, lips, etc.—and each part—legs, shoulders, neck, etc.—an ideal score of ten points, and then we'll grade each feature and every part of every girl, add up the scores, and the girl with the higher score wins." Well, none of the rest of us could think of anything better so we tried the system.

The judge who thought it up had a wonderful time measuring all the girls—bust, waist, hips, etc. But unfortunately his system didn't work. A girl might not have anything wrong with her features or figure and so receive a very high score. But then she might not have anything right either. Individually her features were lovely, but put together they left one cold or bored. We found you can't judge a woman's beauty piecemeal; you have to take the whole woman at once. Charm, after all, is important. So we gave up trying to figure out a system and resolved to trust our eyes. It led to squabbles, because all of us didn't see things in the same way, but it was the best we could do. And Miss America of 1922 was selected. (Which made every mother but one furious. "She looks like an enraged lizard," said a judge of one of the mothers who was particularly angry.)

I had enjoyed the week enormously except for one incident. One day several of us judges (not Flagg and Christy) sneaked off to go swimming. As we were splashing about in the surf near the boardwalk, appareled in those old-style bathing suits

which had tops and sleeves as well as bottoms and were always black, along came the contestants. They gathered around us, laughing. "You're judging *us?*" they shouted. "Look at yourselves. Old crows and bean poles." And they laughed some more and heckled us.

Well, none of the other judges seemed to mind, but I had a little potbelly at the time which I was very sensitive about. So I blushed and sat down in the water to hide it. Afterward, as we were walking back to the hotel, I noticed a big sign painted on the wall of a building. "YOU TOO CAN HAVE A YOUTHFUL FIGURE," it read. "BUY A CORSET TODAY * * * So-and-so's Corsetorium." And way down in one corner: "Gentlemen accommodated."

I looked down at my potbelly. A corset is just the thing, I said to myself. I'll creep out this afternoon and buy one; not an intricate one with lots of bone and stays; I'll keep it simple.

When I sidled into So-and-so's "Corsetorium" later that day, a little fat man wearing a soiled morning coat pounced on me from behind the door. "Yeaaaas?" he asked, pulling the frayed cuffs of his dress shirt down over his knuckles. "I'd like a small corset," I whispered. The shop was full of ladies. "A *corset?*" he said in a loud voice. All the ladies turned to look at me. "Yes," I whispered, motioning him to keep his voice down. "Weeeeel," he said even louder than before, "pink or baby blue?" And he glanced around to acknowledge the appreciative titters which greeted this sally. "See here," I snarled, "If you want my business, keep your voice down." "All right. All right already," he said in an oily undertone. And he led me to a cubicle in the rear of the store. After I had tried on four or five corsets I found one I liked. It was pink and laced up the middle but it wasn't bulky and I decided that no one would be able to tell I was wearing it. "That will be $23.95," said the fat man. "Shall I wrap it or will you wear it?" "I'll *wear* it," I growled. "Guuuude," he said, and pulled his shirt cuffs down again. The ladies in the shop giggled behind their hands as I left.

But when I got out in the street and took a furtive glance at my reflection in the store window I was overjoyed. The little potbelly had vanished; all was smooth and flat as a buttermilk pancake. I threw out my chest and swaggered off to find the other judges.

An hour later as I was talking with Charley Chambers, a suave, handsome fellow, I suddenly realized that he wasn't looking me in the eyes. He was staring with an expression of utter astonishment at my stomach. I glanced down. And there, hanging out of my shirt and flip-flopping in the breeze, were two tiny pink silk laces with metal tips. "Oh, my gosh," I said, clasping my hand over the laces, "I forgot." And I dashed off down the boardwalk. Then, still holding my stomach as if I had a pain, I slunk back to my hotel room and ripped off the corset. "Better a potbelly than public ridicule," I said, flinging it deep into the trash basket.

But in spite of my abortive attempt to flatten my potbelly (it was really a very small bulge; I was just hypersensitive), I had enjoyed my stay in Atlantic City. It's very nice to be treated like the Prince of Wales and eat caviar and sturgeon and crepes

Suzette for dinner every night when all you have to do in return is stare at beautiful girls.

So the next year when the Chamber of Commerce invited me to judge the Miss America contest again, I accepted immediately. But some blackhearted, vicious, vile scoundrel had been meddling. The Chamber had somehow discovered that artists weren't hard to get after all; in fact you had only to ask them to be judges and they'd fall all over themselves to accept the honor.

We took taxis to and from the hotel. At our expense. We ate in the hotel dining room. At our expense. Corsages for our wives? We bought them. Tips? We paid. One night when the waiter brought the check the other artist I was dining with signed it and handed it to the waiter. "That's no good," said the waiter, "I want cash." "That autograph," said the artist, tapping the check with his finger, "that autograph will be worth a whole lot more to you than the check someday." "I want the money," said the waiter. We paid.

That week in Atlantic City cost me almost five hundred dollars. When the Chamber asked me to be a judge the next year I refused. Not because I didn't want to go again. I just couldn't afford it.

Oh, by the way, the second year James Montgomery Flagg won at least second prize in the battle for publicity. The day after we returned to New York he announced to the press that "there wasn't a single pretty girl in the entire contest." The remark caused a furor and Flagg was spread across the front page of every newspaper in the country. Of course it was just a gimmick; coming back on the train he had expounded at great length to us on the wonderful, beautiful girls at the contest.

I've never liked long-term contracts. They're like a bag of stones strapped to your neck. Every time you get an idea and start to execute it the contract, like a bag of stones, bangs against your shins, reminding you that the idea will have to wait until the terms of the contract are fulfilled. Contracts restrict your freedom and I've always liked my freedom, especially where my work is concerned.

But the trouble with me is that half the time I know what I want and the other half I'm unsure. My head's clear one minute and muddy the next, like a rain barrel. And when you add to this that most of the contracts I've been offered through the years stipulated that I was to be paid a large amount of money, you have an idea of the state of my mind when someone asks me to sign a contract.

Luckily I've nearly always muddled and fuddled through without signing. I did accept a contract once from Orange Crush soda pop. They asked me to do twelve pictures for them at three hundred dollars apiece. That was in 1921 and it seemed like such a lot of money that I couldn't resist. I knocked off the first two or three pictures without any trouble. Then I began to experience some difficulty in working the bottle into the scenes. It had to be prominently displayed and the label clearly legible. All right, I'd say to myself, I've got a young man and woman sitting in a car. They're drinking Orange Crush, the delectable refreshment (I had to keep repeating the slogans to work up the proper enthusiasm). Now the girl is drinking from the bottle. How's that? No, the label will be upside down. Well, shall I have the man handing

ABOVE AND OPPOSITE: Four oil paintings for Orange Crush advertisements, 1921

the girl the bottle? No. His hand would cover up part of the bottle. How about setting the bottle on the running board of the car? No, then they're not enjoying it; then it look as if Orange Crush isn't the most important thing in their lives. Which of course it is. Young America dotes on Orange Crush, wouldn't be without it, carries it to weddings, wakes, and quilting bees, has it for breakfast, sips it with the rosy smile of ecstasy upon its face. Stop, I thought, that way lies madness. Think constructively.

Finally I stood the man outside the car and balanced the bottle precariously on the door with the woman's fingers pushing at the back of it as if she were giving it to him. And I put some spring blossoms and a joyful sky in the background to convey the sense of bliss which ipso facto accompanied (and still does for all I know) the drinking of Orange Crush.

That was the fourth or fifth picture of the series. You can imagine what a state I was in by the time I got to the eleventh and twelfth pictures. I dreamed about bottles of Orange Crush, long lines of them—quart size, regular size—marching down on me, all the labels distinctly readable. A stampede of bottles. I'd wake up in the middle of the night screaming, "Orange Crush. Orange Crush."

It was the contract that did it to me. Just knowing that I *had* to do twelve pictures featuring those darned bottles. I did one ad a year for Coca-Cola for a number of years and it didn't rack me at all. But there wasn't a contract; I could have refused the ad.

So when I finished the series for Orange Crush, I resolved that never again would I sign a contract. Two years later Lennen and Mitchell, an advertising agency, offered to pay me twenty-five thousand dollars a year if I would work exclusively for them. Mr. Philip W. Lennen invited Clyde and me to dine with him in his sumptuous private dining room and, after he'd applesauced me up to the ears (and poured me full of fine French wines), made his proposition. Twenty-five thousand dollars a year! Wow! I wasn't making anywhere near that much on my own. Clyde advised me to accept. "Look at the security," he said. I wavered. Then I said no. I was just smart enough (and sober enough) to realize that I would be unhappy if I accepted the contract. I'd be forced to do pictures that I didn't want to do; I'd have to give up the *Post*.

I've known quite a few illustrators who have signed long-term contracts. Most of them thought they could make a quick killing. And they did, but it finished them. One fellow I knew painted a great many ads for the Fisher automobile body company. Afterward no other advertiser would use his work. It had become identified with Fisher. My distaste for *any* contract may be a personal quirk but *exclusive* contracts are, I think, plain bad. An illustrator should never allow his work to become identified with one product. The quickest way to cut your own throat is to become known as the Lux Toilet Soap man or the Johnny Walker whiskey man.

One of the more tragic examples of what a contract can do to an illustrator was Leslie Thrasher, who painted one of the most famous *Post* covers ever published. I still get letters from people who think I did it. It depicted a lady and a butcher standing on either side of a scale in which lay a chicken. The lady was pushing up on the scale; the butcher was pushing down. The cover appeared on 3 October 1936.

*But You
Have Ligh
the Touch
a Finge
advertisen
for Edison M
1925*

Some months later Thrasher came to my studio to ask my advice concerning an offer *Liberty* magazine had made him. It was a five-year contract calling for Thrasher to do fifty covers a year at one thousand dollars apiece. "I can live on ten thousand dollars a year," said Thrasher, "so I can save forty thousand. At the end of five years I'll have two hundred thousand dollars. I'll be well off and secure for the rest of my life." I told him I didn't think he or anyone else could do fifty covers for even one year, let alone five. "Don't accept," I said. "You'll work yourself to death. And after the contract runs out, what'll you do? Nobody else will want your stuff." Well, he didn't know; maybe it wouldn't be so bad; he thought he'd give it a try. And he signed the contract.

Liberty thought up a family around which Thrasher was to build his series (I forget the details; mother, father, children, and grandparents—something like that), and he set to work. One cover a week. He didn't last a year. After eight or nine months his house burned and he was so run-down and tired from overwork that he caught pneumonia and died. But the poor guy would never have lasted the full five years anyway. No man could have. Fifty covers a year? That's just too much.

I still hesitate a bit between yes and no when somebody offers me a fat contract. Then I think of Leslie Thrasher and I can't say no quickly enough. Security is very nice, but not if you have to kill yourself or your work to get it. Same with money.

Over the years I've done many series of ads. But never under exclusive contract. I've always kept up my other work—*Post* covers, illustrations. And I've tried to accept only those jobs which I believe I'll enjoy doing. The few times I agreed to do ads which I knew I wouldn't enjoy, I either experienced the tortures of the damned or got into trouble. Once, I remember, a representative of the Arrow Cigarette Company pestered me for weeks to do a series of ads. Finally, just to get him off my back, I said all right, I'd paint his pictures. So he sent me the layouts. I thought it queer that none of the pictures was to show anyone smoking a cigarette, only different types of men. After I'd finished the first one I found out why. It wasn't for cigarettes, it was for chewing tobacco. "There's my out," I said, and flatly refused to complete the series. The Arrow Cigarette Company took it to court and I had some bad moments worrying about what would happen to me. But all they could get was an injunction enjoining me from doing any ads for other chewing tobacco concerns. That was a *real* hardship.

I've enjoyed most of the advertising campaigns I've done: for Edison Mazda Lamp Company, Montgomery Ward, Massachusetts Mutual Life Insurance Company. One of the best was never published. It was for Old Gold cigarettes. The agency built the campaign around the idea that the cigarettes were "Pirates' Gold," and I did four paintings of pirates. Then someone came up with the slogan "Not a cough in a carload," and the agency junked "Pirates' Gold" and my paintings. (I always wondered what happened to the paintings; as far as I know they were never used.)

The series for Edison Mazda was such a great success that the art director, T. J. MacManus, a brawny, barrel-chested fellow with a face like an old-line Irish police

sergeant, decided that we deserved a vacation. So he arranged an all-expenses-paid trip to South America, ostensibly an inspection tour of the Edison Mazda agencies throughout South America, but really a vacation. I went along as his assistant. It was the wildest trip I've ever been on.

We sailed on a rusty old boat which was making its last voyage before being scrapped. After a stop in Puerto Rico we docked at Curaçao, a little Dutch island where it never rains, and everybody on board went ashore and got drunk on a mixture of warm coconut milk and rum. Everybody, that is, but one officer, myself, and another passenger named Charley Owen. The officer stayed on board the ship and Charley and I went sketching. Poor Charley. He had just graduated from college and had signed up to spend four years in Venezuela with an oil company. He didn't know it, but the oil companies were running a sort of a racket. They hired you, sent you out to an oil camp in the jungles where you were the only American, and then never gave you enough money to get home. So it wasn't a four-year stint; you stayed in the jungles with the mosquitoes and the snakes and the fever until the oil company deigned to permit you to return home. When some people on the boat explained all this to Charley he got very upset. But he was helpless; *he'd signed a contract*. I always wondered what became of him.

Well, when Charley and I arrived back on board the ship, everybody—captain, crew, and passengers—was dead drunk. We sailed anyway. At dusk a storm blew up and the ship began to pitch and roll. Mac, Charley, myself, and several other Americans were sitting at one of the two tables in the men's smoking room and a group of South Americans—big, swarthy men with black mustaches—at the other. A supply of coconuts and rum had been brought on board and everyone was chopping open the coconuts and pouring rum into them and drinking the potent mixture. The lamp suspended from the ceiling was swaying back and forth and crazy dark shadows were running up and down the walls. Pretty soon Mac began to curse. One of the South Americans at the other table told him to shut up. Mac called him a vile name. The man smashed the bottom of a bottle against the wall and started for Mac. I began to slide under the table.

But just then the ship's radioman stumbled into the room, soused to the ears and shouting, "Harvard. Harvard. Rah! Rah! Rah!" He sat down at our table and said, "Harvard beat Yale. Harvard beat Yale. Rah! Rah! *Rah!*" Mac stopped cursing and turned toward the radioman. "How do you know Harvard beat Yale?" he asked. "Heard it on the radio," said the radioman. "Harvard. Harvard. Rah, rah, rah." "What are you cheering about anyway?" asked Mac. "You didn't go to Harvard." "Yes, I did." said the radioman and he began to yell, "Harvard. Harvard. Harvard. Rah, rah, rah," over and over. "Shut up," said Mac. "Harvard, Harvard, Harvard," screamed the radioman. "Rah! Rah! Rah!"

Then the officer said, "We've got to get the radioman back to his post. It's a federal offense for him to leave his station while at sea." So he and Charley and I hauled the radioman out the door and down the deck through the seas which were breaking over the side. But as we were shoving him up a ladder to the radio shack a

Sea Captain with Young Boy, oil painting, possibly for blanket company advertisement, c. 1925

Boys and Girls First Aid Week, oil painting for Bauer & Black advertisement, 1926

wave hit the ship broadside, knocking us down. The radioman tumbled off the ladder to the deck, breaking, as we discovered later, his collarbone. Finally, however, after much pushing and pulling, we got him into the radio shack and, propping him up against the wall, put on his earphones. Then we left.

By this time the winds were howling in the rigging and the ship was lumbering heavily through gigantic waves—down into a trough with a crash which shook it from bow to stern, then slowly up, the wave breaking over the bow and cascading down the decks. As Charley, the officer, and I hurried back to the lounge, expecting the rickety, rusty ship to founder at any moment, we heard above the roar of the wind and sea and creakings of the ship two voices singing a hymn. We looked into the public room and there, kneeling together in the middle of the floor, were two nuns. Every time the ship pitched, both of them would fall over in a heap. But they never stopped singing and praying.

When we got back to the door of the lounge I said to Charley, "We'll have to do something about this. You stand outside the porthole behind the table." Then I went inside and surreptitiously gathered up all the bottles and coconuts I could find and passed them out to Charley through the porthole. He dumped them over the side.

The next morning we arrived in La Guaira, Venezuela. We disembarked and went off to Caracas, which is in the mountains above La Guaira.

As soon as we walked off the boat two seedy-looking men wearing old hats, torn shirts, and tattered white suits fell in behind us. Their hats hid the upper half of their faces and ragged beards the lower. An American who had lived in Venezuela told us they were secret-service men. Evidently word of Mac's anti-Gómez sentiments had preceded us. Throughout our stay in Venezuela they followed us. We'd go into a fancy restaurant for lunch. They'd wait outside, slouched against a wall munching sandwiches or bananas. They slept curled up on the floor outside our doors at night; trotted after us all day.

At first we tried to shake them. Out on the street we'd suddenly break into a run, dash around a corner, and slip into a café. But it was no use. When we'd leave the cafe five or ten minutes later there they'd be, squatting on their haunches across the street. Then we tried being nice to them, inviting them to have a drink with us, kidding them about their hard life. They'd just pull their hats farther own over their faces.

Finally we resolved to put up with them. We went our ways blithely. Followed by those two ragamuffins.

We had a very good time at first. We attended a rather amateurish bullfight, a wedding, and the ceremony held to announce the winners of the national lottery. Having at odd hours of the day and night heard scattered rifle fire from an outlying district, we asked the hotelkeeper what was going on. "Revolution," he said. "Is it dangerous?" we asked. "No," he said. "You want to see it?" We said yes and he hired a guide for us. The guide took us down to the barricades—heaps of old chairs, tables, wagons, and mattresses across the streets—and we peeked at the revolutionaries. Then he led us through some alleys to the opposite barricade and we peeked back at

the government troops. He assured us we were perfectly safe. It was understood that nobody was really to shoot *at* anyone else. They'd fight for three days and kill one horse. Besides, neither side dared shoot an American; some silly fool in Washington would have sent a battleship full of marines.

Mac and I did inspect the Edison Mazda agency in Caracas. All I remember about it was that the owner had a bathroom in his home which was larger than his living room. Enormous.

Then one night after we'd been in Caracas for nine or ten days I told Mac, "I'm going home." He reluctantly agreed and we caught a little wood-burning train to Puerto Cabello, stayed the night at the Hotel Los Baños (the "baths" were a washtub punched full of holes and suspended from a post; you stood under it while an old woman dumped pails of water into it), and took a ship for New York. And so ended our South American tour. (Oh, not quite. In Puerto Rico a man ran up the gangplank pursued by three other men who were firing pistols at him.)

In spite of all, I'd enjoyed the trip. It had stirred me up, sort of bounced my insides about. When you boil a lobster it turns red. Something like that had happened to me. (I don't mean I returned sunburned, though I did.) The dusty, sun-baked streets; the old stone fort above the harbor in Curaçao; the grizzled Spaniard who watched for ships through his spyglass from the fort and, when he saw one, fired off a bronze cannon to notify the people down below to start the donkey engine and swing back the bridge which spanned the mouth of the harbor; and the town of Curaçao, all the houses, even the municipal buildings, constructed of pink coral—I'd never seen things like this. Caracas, the jagged mountains, the fever town of Puerto Cabello, the barricades, the black rough-feathered vultures circling above a dead dog which was lying in the street outside the hotel one morning, then flapping down and landing with a short run to waddle the dog—all that had shaken me up and I liked it. I wanted to be shaken up again. In short, I'd developed a chronic wanderlust. A bad case—I haven't got over it yet.

At 4 A.M. one autumn night in 1923 I suddenly sat bolt upright in bed. The wind was rustling in a heap of dry leaves and rolling them along the gutter; a branch was scraping on my window. What'd I do that for? I said to myself in a loud voice. I thought a minute. I'd better go to Europe, I said. It's the only way. Then I went back to sleep.

The next morning at breakfast I told Irene about waking up in the middle of the night. "That's silly," said Irene. "I don't know," I said, "it doesn't sound like such a bad idea to me." "Eat your cereal," said Irene. "No," I said, pouring milk on my cereal, "it's really a good idea. I think I'll go to Europe." "What'll you tell Mr. Mac-Manus?" asked Irene. "The ad for Edison Mazda is due next month." "I'll only go for a month," I said. "Want to come?" "No," said Irene, "I'm perfectly satisfied right here." "Oh, come on," I said, "it'll be fun." "No, thank you," said Irene. "Okay," I said, "but pack my bags for me, will you? I'm going to leave as soon as possible. My work's pretty well caught up. We've got a little money in the bank. I've never been to Europe; it might broaden me."

So a week or two later I left for Europe, not telling anyone but Irene that I was going. (The art director at the *Post* was hurt: "Gee," he said, "you might at least have sent me a penny post card.") The first day out I watched the cold gray-green waves slide past the boat, the wind picking white foam off their tops. The second day I watched the wake boil up and slide astern; I saw a whale. I was bored stiff. And lonesome. The fourth day I won the ship's pool, but I didn't have the money long enough to get much enjoyment from it. Every steward on the ship was sending a son through Oxford.

I walked all over Paris the first night: through the Place Pigalle and Montmartre; by the Sacré Coeur, its dome silver in the moonlight; through the crowds leaving the Opéra and thronging around the tables outside the Café de la Paix; by the Louvre, immense and silent; up the Champs Elysées with its brightly lighted cafés and the taxicabs lined up in the middle of the street; past the Arc de Triomphe beneath which an old dog sat, licking its paws; and down the boulevard which runs along the Bois de Boulogne. Then across the Seine and through the dark, narrow streets of Montparnasse, my footsteps echoing on the cobblestones, to Notre Dame cathedral where I watched the sunrise firing the river between the dark wall of houses on either bank. It looked like a scarlet lizard slithering in a coal bin.

Then, tired out, I sat outside a café, sipping a glass of wine and watching a sleepy waiter sweep the sidewalk. I'll go to the Louvre today, I thought. And tomorrow. Then maybe I'll enroll in an art school. A horse, drawing a cart piled high with cabbages, clip-clopped by in the deserted street. Two women passed, chattering in French and waving their arms. Gosh, I thought, I certainly would like to hear somebody say something I could understand.

"Norman," said a voice. I looked around, startled. And there was Edmund Greek Davenport—Davie—who had studied at the Art Students League with me, standing in the gutter with his arm around a pretty girl. "Hip and holler," said Davie. "How are you? This is Sal. We're on our honeymoon." And he and Sal sat down at my table. "All alone," he asked, "or with friends?" "Alone," I said. "Hurrah," said Davie, "we're off on a tour of the Riviera tomorrow. Why don't you come along?" "Wouldn't I be in the way?" I asked. "Oh no," said Sal, "we've been married a month. Do come." "Yes," said Davie, "you'll get gangrene of the vocal cords if you stay here all alone with no one but Frenchmen to talk to." "You're right," I said, "I can feel it coming on already. I'll come."

So that night we took the train for Marseille. We traveled third class, which meant sitting up all night, because Sal and Davie had very little money and I was trying to be frugal. But we had a grand time. At first we played poker among ourselves. Then a monk who was sitting in our compartment said he'd like to play. Okay, we said. "What'll we play for?" asked Sal. "A forfeit," said Davie. "Whoever loses has to pay a forfeit." That was all right with the monk so we taught him how to play poker and began. At sunrise we totaled up our scores. The monk had lost. "What eez my forfeet?" he said. Sal and Davie and I looked at each other. "Well," said Sal, "I suppose I shouldn't say it, but I'd like you to show us what you have on under your robe."

Portrait of an Old Man, charcoal, 1923. A Paris sketch from Rockwell's 1923 trip to Europe

The monk chuckled good-naturedly and pulled up his robe. He had on long black pantaloons.

We toured Marseille that day and stayed that night in a single room in a cheap hotel (Sal and Davie slept in the bed; I slept in the bathtub). The next morning we went to Monte Carlo. "Hip and holler," said Davie when he saw the casino, "I'm going to make my fortune." So we played roulette all afternoon, winning a hundred and fifty dollars between us. Davie and I wanted to quit, but Sal said no, she felt a lucky streak coming on. "How do you know?" asked Davie and I. "The hair rises on the back of my neck and plays 'Yankee Doodle,'" said Sal. "Come on," Davie and I said, "we're through gambling." "Oh, let's play," said Sal, "I do feel lucky. Really." Well, Davie was a newlywed and I was sort of a guest. We went back into the casino. But when we got there the guards wouldn't let us in. We weren't wearing evening clothes. Davie and I were relieved. Sal was undaunted. She put a rose in her hair, tied a scarf around her waist, and let out the hem of her skirt. When the guard at the casino tried to stop her she said haughtily, her nose in the air, "Don't insult me, my good man, this is the latest style of evening dress," and breezed on in. Davie and I hitched up our knickers and sat down on the steps to wait. An hour later Sal came out, looking very dejected. She had lost all our winnings of the afternoon.

We spent the night in the waiting room of the railroad station, then the next morning went on to Florence. There Davie and I decided we had to sketch the Ponte Vecchio. We tried sketching from both riverbanks. No good. The best view, the view we had to have or die unhappy, was from the middle of the river. So we hired a row-boat. Davie rowed us into position and then gave the oars to Sal. "Keep the boat just here," he said to her. But we hadn't been sketching five minutes before the boat began to drift downstream. "For Lord's sake, Sal," said Davie, "keep rowing. We're out of position." Sal bent to her oars. Davie and I went back to our sketching, commenting to each other now and then on the beauties of the old bridge, the way the light fell across the walls. But pretty soon there we were again, ten yards too far downstream. "C'mon Sal," I said, "you've fouled us up again." And Davie and I adjured her to row harder. For a minute the oars thrashed the water furiously. "That's it," said Davie without looking up from his drawing. "You've got the idea at last." Suddenly there was silence; the oars had stopped. "Hey," I said. "Look, Michelangelo," said Sal, wiping the perspiration from her brow with the back of her hand, "and you too, Leonardo"—pointing at Davie—"this has gone far enough. Your humble galley slave revolts." And she put down her oars. Davie and I finished our sketches from the bank.

We stayed in Florence about a week, visiting the art galleries, churches, and tombs. Davie used to upset our guides terribly. We'd be walking along, the guide describing the beauty of an arch or house, when Davie would suddenly spin about and dash off down the street. "Whattsa ma foolie?" (or something to that effect) the guide would say considerably startled. "Is that a Renaissance building?" Sal would ask him. The guide would pull himself together and go on with his spiel. Pretty soon Davie would come sauntering back as if nothing had happened. But after a minute, just as the guide was reaching the climax of an involved exposition of the beauties of

some obscure chapel, Davie would jump up in the air, click his heels together, and run off as fast as he could go.

He could break down a *good* guide, one with a full bass voice who had done ten hours a day for fifteen years, in half an hour. The guide would begin to complain of the heat, running a trembling finger around his collar. Then he'd stammer a bit and look nervously about. Finally he'd give up entirely and cancel the tour.

We didn't bother to sleep much while we were in Florence. We'd rented a single room again, but it didn't have a bathroom so Davie and I had to sleep on the floor. Besides, there was so much to do and see: a fete in a little town near Florence, a new restaurant, a sidewalk café we hadn't sat outside of. By the time we left for Venice we were sort of silly from lack of sleep. On the train Davie and I curled up in the baggage hammocks above the seats of the compartment while Sal stretched out on a seat. When we awoke the next morning there was an Italian family—mother, father, and three children—huddled on the seat beneath Davie, glaring at us. I guess they were afraid Davie was going to tumble out on them. But they needn't have worried, those hammocks were sturdy.

In Venice we took a tour. While we were down in a cellar or catacomb looking at the relics of some duke with a group of serious tourists—real bloodhounds for culture—Davie stuck the lighted taper he was carrying behind his ear. As the guide was describing the exploits of the duke, Sal and I happened to glance around at Davie and somehow he looked so comical with that little taper jutting out from behind his ear that we began to giggle. The others shushed us. We stopped. Then we looked at Davie and broke into giggles again. The serious tourists were shocked, but we were so lightheaded from lack of sleep that we couldn't stop. The guide expelled us from the tour.

That was the way the rest of our trip went. We giggled at St. Mark's cathedral, in gondolas, before the *Last Supper* in Milan. When we got back to Paris I rented a room all to myself and slept for twenty-four hours straight.

Then, having about a week and a half before my boat left for the United States, I enrolled in an art school, Calorossi's. The first day I propped my pad of drawing paper on a chair and immediately became absorbed in making a realistic drawing of the model. It went very well and I began to hum under my breath and compliment myself. That's a nice line there, Norman old boy, I thought, real nice. There's blood and bones underneath that shoulder. As I was going on like this, another American who was studying at the school walked by. "Oh, my God," he said, looking at my drawing, "how old are you?" "Twenty-nine," I said. "You must be older," he said. "You can't have been born after 1860." "No," I said, "I was born in 1894." "I can't understand it," he said. "Where'd you study?" "At the Art Students League," I said, "with George Bridgeman." "Well, that explains it," he said, and walked off.

I scratched my head. What the devil did that mean? I had a vague feeling that it had something to do with my drawing. But what? I looked around at the other students' drawings. My gosh, I thought, modern art. The student on my left had

drawn three piles of mud-colored cubes jumbled into a rough triangle. The student on my right had painted a crimson tree trunk on a sky-blue background.

So that's what he meant, I said to myself. I'm old-fashioned. And I began to sweat and remember the things some of my friends back in New Rochelle had said to me (I hadn't paid any attention at the time; too busy). "You're not in the swing, Norman." "You're behind the times." "Dated." "An anachronism." Whew, I said to myself. I've been so busy doing Orange Crush ads that I've fallen behind. I'll be finished in five years.

I went out to have a glass of wine in the café nearby and think things over. A group of American bohemians were lounging at the table next to mine. "Cubism is dead," said one of them. "What can you do with a cube?" "There's triangles too," said one of his companions. "What can you do with a cube *and* a triangle?" demanded the first one. "It's limited. A dead end. Corpse. Rottener than realism. Color's our own salvation. Thank God for cerulean blue." And he ran on about color for fifteen minutes. I listened closely. So that's it, I said to myself when he'd finished. Color, just color.

I ran back to the art school, tore up my drawing, put my charcoal in my pocket, and set out to learn something about modern art and color. I attended lectures in the back rooms of shabby cafés in Montmartre, eavesdropped on conversations at the art schools, tramped around from gallery to gallery, the respectable ones and the little avant-garde ones—up teetering outside staircases to attics, down pitch-black slippery stone steps to cellars.

It was rather discouraging, because after a while I realized that I just didn't see things as the modern artists did. I liked the way some of them distorted jugs and people and so on, and the wild way they used color. But I knew I could never paint that way. So what? I thought. I'll adapt my style, I'll make it more modern. Maybe I'll still be behind the times. But I won't be as far behind.

On the boat going home I had an idea. The fellow said color, I thought; all right, it'll be color. Winter and spring. Winter'll be an old man. Being driven out by spring, a beautiful young girl. I'll do winter in cold colors—blues and icy grays—and spring in warm colors—yellows, apple green. Symbolic figures. That's modern.

Oh, I had my doubts about all this being modern art, but I strangled them and, by wrenching some things about and closing my eyes to others, worked myself into a state of enthusiasm. When I returned to New Rochelle I put aside all my other work and did a *Post* cover of my idea.

Two weeks later I took the finished painting down to Mr. Lorimer. He was surprised (I hadn't bothered to show him a sketch) and paced up and down before it for a long time, while I explained about Paris and modern art and catching up with the latest style. He kept on pacing, bending down every so often to get a closer look at old man winter or young girl spring. After a while I stopped trying to explain. Suddenly he turned about on his heel and looked at me. "No," he said. And he walked over to his desk and sat down. "Norman," he said, "we had a writer once. Did articles on subjects like county fairs, life on a farm, a town meeting in New England. Good

articles; he caught the flavor of that sort of thing nicely. Then the war came along. He decided he should do articles with bigger themes, subjects that, as he put it, had a bearing on the world crisis. 'I must pull myself out of the nineteenth century,' he said. 'Small towns don't count any more. It's the cities now.' So he did a few articles like that. They were terrible. He was out of his element." "I see what you mean, Mr. Lorimer," I said. "I'll *tell* you what I mean," said Mr. Lorimer, who didn't like to be interrupted. "If you do something well, stick to it. Don't go off on a tangent just because people tell you you're old-fashioned or narrow. I don't know much about this modern art, so I can't say whether it's good or bad. But I know it's not your kind of art. Your kind is what you've been doing all along. Stay with that.

"Now," he said, "what is your next cover for us going to be? Which of the ideas you showed me in September before you went to Europe?" I told him and we discussed it for a few minutes. Then I left.

On the train back to New York I began to get all discouraged. My cover had been rejected; Mr. Lorimer thought I was a damned fool; I *was* a damned fool. *And* a lousy illustrator. *And* a poor excuse for a human being. But then I remembered something I'd read in a book once: if you fall on your face, don't lie there and moan, *get up*.

So when I arrived in New York I went directly to the Grand Central Barber Shop, climbed into a chair, and said to the barber, "Give me everything you've got— manicure, shave, haircut, shampoo, facial, shoeshine. And one of your best massages, too." (The sign read: "Our massages are equal to five hours of sleep.") An hour and a half later I rose from the chair a new man. I tipped the barber two dollars, picked up my painting, and walked at a brisk pace, chin up, chest out, to the *Elks* magazine, where I sold the painting. Then I had dinner at a fancy restaurant and went home. The next morning I started a new *Post* cover.

Lovers of modern art were not the only ones who couldn't understand why I painted as I did. Coles Phillips, the celebrated pretty-girl artist, with whom I'd become acquainted after the New Rochelle Art Association banquet, couldn't understand it either. But I didn't lose any sleep over *his* criticisms. He didn't like Howard Pyle. Or Rembrandt. Or Degas. Or Leonardo da Vinci. Or Constable. Or Sargent. Or Rousseau. In fact he didn't like anybody and couldn't understand why an artist would want to paint anything but pretty girls. "Old men and boys," he'd say, referring to the principal subject matter of my pictures. "Haven't you got any guts? You're young. Haven't you got any sex? Old men and boys. For Lord's sake!"

Coles didn't decide to be an artist until he'd finished college. And he'd already decided that he was going to make a hundred thousand dollars before he was thirty-five. As he was a smart fellow (I always felt he would have risen far whatever line of work he'd chosen), he did become an artist and did make a hundred thousand dollars before he was thirty-five. (And he married a very beautiful girl, too.)

He used to get marvelous prices for his work, as much as, if not more than, any other illustrator. First he'd think of the best price he could hope for; then he'd think of his four children and add four hundred dollars. In the twenties he received two thousand dollars a picture, which was fabulous.

Coles never painted anything but pretty girls. And he always used the same model. Miss McBain. She had a marvelous figure but was not particularly good-looking. I asked him one day why he didn't hire a beautiful woman as his model. "A plain woman awakes my sense of beauty," he said. "If I painted from a beautiful woman, all I would do is copy. There wouldn't be any juice in the picture." Miss McBain must have been just the right combination, because whenever he used any other model the picture was drab and dull. Of course most of the women in his paintings looked alike—glorified Miss McBains. He rarely bothered to change anything but the hair and clothes.

After a while he became such a roaring success that he hired three assistants and a secretary. The assistants painted in the backgrounds, usually a flat design, of his paintings; the secretary handled his correspondence and business affairs.

This set me to thinking. I'm successful; maybe I should engage a secretary. To keep up appearances, show I'm aware of the responsibilities of success. I put an ad in the local paper.

Two days later I heard footsteps on the stairs and then a woman, rather pretty but shabbily dressed, opened the door. "Excuse me," she said. "Are you the gentleman which advertised for a secretary?" "Why, yes," I said, "but I'm afraid I wanted a man. There's some heavy work involved." "Oh, that's fine," she said, coming into the studio followed by three small children. "It's my husband wants the job." Then she pulled a little boy from where he was hiding in her skirts and, brushing his hair back from his forehead, said to me, "This is Clarence. My Eldest. Clarence, shake hands with the gentleman." Clarence and I shook hands. "Now, Clarence," she said, "you run quick and fetch your father. You remember where we left him, don't you?" The little boy ran off and the woman turned to me. "My husband wanted to be sure we had come to the right place," she said. Then she set her two other children before me and introduced them. "This is Betty," she said, "and this is Agatha." "How do you do," I said to the two little girls. "Do," they chorused, giggling. "You *are* the artist which does those lovely pictures on the magazines, aren't you?" the woman asked. I told her I guessed so. She praised my work in the most flattering terms.

Then Clarence came running up the stairs. "Here he is," he shouted, "here he is." And after a minute in strolled a tall man with long skinny arms and legs and a bony face. A lock of coarse dusty-yellow hair hung across his forehead. "Oh. This is my husband," said the woman, becoming rather flustered. "He's very experienced. He's served as private secretary to the presidents of many firms. He's . . ." And she went on at great length concerning her husband's accomplishments while he gazed languidly about the studio. When she had finished he shook hands with me and asked, "What are the hours?" "Nine to five," I said, "Monday through Friday." "What's the salary?" he asked. "Thirty-five dollars a week," I replied. "Do you mean to starve me?" he demanded, his face going white. "Do you —" "That's fine," the woman said, cutting her husband off in mid-sentence, "that's very generous." The man sighed, shrugged, and lit a cigarette. "Do you have references?" I asked. "Oh

yes," said the woman quickly, and she showed me several letters from various vice-presidents and directors of local firms. They looked all right to me. "Of course," I said, "I can't give you a decision now. There are several applicants. Could I call you when I've made up my mind?" The man bristled but before he could say anything his wife spoke up. "Yes. I've written down a number on this scrap of paper. It's not our phone but the people will let us know you've called. Thank you ever so much for your time." And she left, preceded by her husband, Clarence, Betty, and Agatha.

I was in a quandary. I didn't much like the behavior of the husband, but the wife had been so nice. And the three little kids. Finally I decided: well, I'd try him. If he didn't work out I could always fire him.

The next Monday he arrived at my studio at ten o'clock to take up his position as my private secretary. I hadn't quite figured out what he was to do yet so I told him to look over some letters in my desk while I thought about it. I went back to work. He sat at the desk for five minutes, shuffling the letters. Then he got up and, pulling a newspaper from his pocket, arranged himself comfortably in my overstuffed chair. "Did you examine all the letters?" I asked him. "Oh, my God," he said, "can't I have a moment's peace? My eyes got tired. Do you want me to go blind? Just let me rest a minute. A man deserves a little rest." I didn't know what to say so I didn't say anything.

After lunch he requested a week's salary in advance. I gave it to him and he put on his hat and coat and started for the door. "Hey," I said, "where are you going?" "That's a fine question. Where am I going?" he said. "Where do you think I'm going? Where *does* a man go in the afternoon?" "I don't know," I said, "but the working day's not over yet." "Is that the kind of guy you are?" he asked, taking off his hat and coat and slamming them down on a chair. "Drive, drive, drive? Work, work, work all day? Compulsive?" "Now look here," I said. "All right," he said, taking up his newspaper and sitting down in the armchair again. "All right. All right. *All right.* I'm not leaving, am I? Aren't I still here? Can't you see me?" And he tore open his newspaper and proceeded to read it, grumbling furiously.

This went on for a month. All day long he'd sit in the armchair, rattling his newspaper. Sometimes he'd go to sleep and snore. When I asked him to do something he'd bawl me out: "You gonna make me go out in all that rain? You want me to catch my death of cold? And die?" Or he'd jump up and stamp his feet. "Haven't you got any feelings? Don't I rate any rest?" I wouldn't answer him. "Won't answer? All right. *All right.* Just don't think everybody has your compulsions. Some of us get tired." And he'd go back to his newspaper.

I guess he was the laziest man I've ever known. He had a firmly rooted conviction that the world in general and I in particular owed him a living. When I'd try to fire him he'd bawl me out. Then I'd get flustered and forget the speech of dismissal I'd prepared. He kept me off balance all the time.

And about every ten days his wife would come up to the studio with Clarence, Betty, and Agatha, "Oh, Mr. Rockwell," she'd say, "I know I shouldn't ask it, but could you give me an advance on my husband's salary? We don't have any coal in

the house and the children haven't eaten a good meal all week." I'd look at the children. They did appear to be half starved and they all had runny noses, though I could see that their mother was doing all she could, for their clothes, though shabby and full of patches, were neat and clean. So I'd give the woman some money.

One day I went over to their house to find my secretary. He hadn't reported for work for two days. There was hardly any furniture in the house, but the floors were well scrubbed and the woman had hung pictures from the Sunday supplements on the walls.

I didn't know what to do. I couldn't go on like this indefinitely. The man was driving me crazy, rattling his newspaper and scolding me. My work was going all to pieces.

Then one day I gave him some money and told him to go to New York and pick up some costumes for me. Instead of getting the costumes he bought himself an excellent dinner and went to the theater. That was the last straw. When he told me about it I demanded, "What do you mean, you didn't get the costumes? What kind of behavior is that?" He flared up. "By God, " he said, "a fellow has to have *some* pleasure in life. Whatta you take me for? A hermit? I deserve *some* fun." "Well, have it on your own money," I said. "You're fired." "Isn't that typical?" he asked. "Isn't that just what could be expected? Turn a man out for nothing. Spite. Is that what's wrong with you? Spite? Huh?" I didn't answer. "I'm not going," he said, sitting down in the armchair. "I *won't* go. I'll sit here till doomsday. You can't fire me because I had a little pleasure. I know my rights. Every man deserves *some* pleasure in life." "Get out," I yelled, completely exasperated. "Get out!" And I started for him, brandishing my painting stick. He grabbed his hat and coat and ran down the stairs. Whew, I thought, that's ended. "I'll have you in court," he shouted from the bottom of the stairs. "D'you think you can threaten a man?" "Go on," I yelled, starting after him. "Scram. Shoo. Get out of here." He ran outside, stopped, and shouted at me again. Finally I had to chase him into the street. That was the last I ever saw of him.

My models

A BOY perched on a weathervane gazing over the rooftops out to sea; an old man playing a cello while a little girl dances; a young couple spooning in a buggy; and dogs, dogs everywhere—mournful mutts, comical mutts, playful mutts, loving mutts; and costume pictures—a boy going home for Christmas on a merry-old-England stagecoach; carol singers dressed as if they'd stepped from Dickens' *Christmas Carol;* Santa Clauses. You could do that sort of stuff in the twenties—even in the thirties. People liked it. They laughed at the kids, remembering their own childhood, or thought nostalgically of the nineteenth century when life had been (supposedly) so uncomplicated and carefree. They accepted the simple, innocent view of life and enjoyed it and so did I.

I was doing nine or ten covers a year for the *Post* besides all my other jobs. I worked hard but I didn't stew over how I painted the pictures. And *Post* covers were easier to do in those days. The figures were silhouetted against white; I didn't have to relate them to a background as I do now. I toiled blithely away, using sable brushes, which give a kind of slick, tricky quality to the painting (I thought it was smart to be tricky). Oh, I worried some about being old-fashioned or the steady rise of my prosperity. I'd think about how right from the start I'd been successful and about how every other illustrator I knew had had to work in an art service or wash dishes for a while. It can't last, I'd say to myself, it's going to stop. But these worries didn't sit around and hammer at the insides of my skull. I'd receive an especially nice fan letter or become absorbed in a picture and they'd vanish.

The only real trouble I had during those years was digging up ideas for pictures. I look back now over the scrapbooks of my work and I can't understand it. All

those pictures—*Post* covers, ads, illustrations, posters. Did I actually struggle over ideas? I couldn't have. Look at the amount of work I did. I must have been bursting with ideas. But a good idea is hard to come by. And suddenly I remember how I used to feel during my first years as an illustrator when I'd sit down in the evening to think up a batch of new ideas—all washed out, blank, nothing in my head but a low buzzing noise. I'd stare at the wall and doodle. Then I'd begin to examine the wall more closely and wonder how they got the strips of wallpaper to match so perfectly. Or I'd try to figure out where the various beams and crossbeams bisected and why there and not two feet higher. And I'd notice a little cobweb in a corner and a black spider crawling toward it. Why don't spiders fall off the wall? I'd think. Then I'd doodle some more. Then I'd look for the spider again and see him two feet higher on the wall, still crawling, and wonder about where he was going since he'd already passed the cobweb.

One day after I'd been aimlessly scribbling and sketching and crumpling up sheets of paper and gazing at the walls, floor, ceiling, table for four or five hours, I said to myself, This has got to stop; I can't sit here with my mind as empty as a beer barrel at the Elks' club; I've got to start somewhere; otherwise I'll just doodle and muse all day. So I figured out a system. I used it for, oh, twenty, twenty-five years.

When I had run out of ideas and had to have some new ones I'd eat a light meal, sharpen twenty pencils, lay out ten or twelve pads of paper on the dining-room table, and pull up a chair. Then I'd draw a *lamppost* (after a while I got to be the best lamppost artist in America). Then I'd draw a drunken sailor leaning on the lamppost. I'd think about the sailor. His girl married someone else while he was away at sea? No. He's stranded in a foreign port without money? No. Then I'd think of the sailor patching his clothes on shipboard. That would remind me of a mother darning her little boy's pants. Well, what did she find in the pockets? A top. A beanshooter. An apple core. A frog. A knife handle. A turtle. A turtle—how can I use that? So I'd sketch a turtle slouching slowly along to . . . Slowly. That would make me think of a kid going to school. No, it's been done a thousand times. How about the kid in school? Pulling Suzy's braids, writing on the blackboard, reciting. Nothing there. Of course the kid hates school. Gazes out the window at his dog. I'd sketch that. The dog runs off after a cat. Cat climbs a tree. Dog ambles about, looking for trouble. Sees an old bum stealing a pie from the kitchen window. Latches onto the seat of his pants. I'd sketch that. Bum escapes. Eats the pie. Sheriff enters. Collars bum. I'd sketch that. Bum to jail . . . etc.

I'd keep this up for three or four hours, the rough drawings piling up on the floor. Then, worn out, I'd arrive at the absolute conviction that I was dried up. There just aren't any more ideas in me, I'd think. I'm through, finished, kaput. I'd better give it all up and go to Madagascar and eat fish. But I can't give it up. It's all I know or have ever done. So I'd go to bed, completely discouraged.

The next morning I'd be desperate. After pawing at my eggs for a few minutes I'd push them away and drag myself out to the studio. What was I going to do? No ideas. I'd kick my trash bucket and suddenly, as it rolled bumpety-bump across the

floor, an idea would come to me, lighting up the inside of my head like a flash of lightning in a dark sky. I'd given my brain such a terrible belaboring the night before that it was in a tender, sensitive state, receptive to ideas. Or I'd go through the pile of sketches. That one doesn't look so bad, I'd think, maybe there's something in it. I'd rough it out again, trying different angles, characters. Pretty soon I'd have a *Post* cover.

Thinking up ideas was the hardest work I did in those days. I never saw an idea happen or received one, whoosh, from heaven while I was washing my brushes or shaving or backing the car out of the garage. I had to beat most of them out of my head or at least maul my brain until something *came* out of it. It always seemed to me that it was like getting blood from a stone except, of course, that eventually something always came.

There was one kind of idea which I didn't have to struggle over—the timely idea. I'd just keep my ear to the wind and, when I heard of a craze or fad or anything which everyone was talking about, I'd do a cover of it: the ouija board, the first radios, crossword puzzles, the movies.

In 1920 the whole country was talking about Model T Fords and Henry Ford (sample joke: "Who was the greatest benefactor of mankind?" "Henry Ford— because he made walking a pleasure."), so I did a cover (July 1920) of a family riding in a Model T.

The day after Lindbergh flew the Atlantic I called up the art editor at the *Post*. "How about a cover on the pioneers of the air?" I asked. "Okay," he said. "When can you get it to us? It'll have to be fast or we'll miss the boom; it won't be news." "Tomorrow afternoon," I said. I hired a model, dug up an aviator's cap, and set to work. Twenty-six hours later I finished the cover, sent it to Philadelphia, and staggered off to bed.

Nineteen twenty-nine was the year of the speed traps. Instead of asking their citizens to pay taxes, all the small towns hired cops who set up speed traps and fined their victims heavily. Two or three industrious, clever cops could rake in over a thousand dollars a day. The towns grew fat. Finally the newspapers and the automobile clubs began to make a fuss and I heard about it and did a *Post* cover of a policeman holding a stop watch and hiding behind a town-limits sign.

I did a cover based on the jazz craze (1929), one on the stock market crash (a butcher's boy, a housewife, a grandmother, a millionaire, and a dog, all staring at the stock market reports), one on the hundredth anniversary of baseball in 1939, the 1940 census, the hitchhiking fad (1940), the blackout, women war workers (Rosy the Riveter), the USO, soldiers returning from the war, television. Right now I'm trying to think up some way of painting a cover based on the explorations into space. I've thought of doing a little green man from Mars talking to a boy. But that's no good. I need a situation with some humor in it, a fillip. Which shows that timely ideas aren't all succotash and chicken fat. After I've become aware of a craze or public interest I still have to translate it into a cover, think up a scene which people will recognize and enjoy. Still, I have a start, I know the general subject.

People sometimes suggest ideas too. Unwittingly, I mean. Someone comes into the studio and stands about talking to me or I see someone walking along the street. Gee, I think, noticing the way his ears stick up like two daffodils from the sides of his head or his peculiar stance, maybe one foot wrapped around the other, rocking back and forth, or the way he circles around a question, then pounces on it like a cat with a snake. Gee, I think, I'd like to paint that person. So then I mull him over in my mind, trying him out in different situations, trying to build something on his ears or stance or personality, and after a while, if I'm lucky, I come up with a *Post* cover.

James K. Van Brunt, one of my regular models during the twenties, used to suggest a cover almost every time I saw him. I'd look at him and right off I'd want to paint him. I guess the day he turned up at my studio (that's not it; he didn't "turn up" like an ant from under a stone, he *bristled forth* like a thistle in a flower patch) was one of the luckiest days of my life.

I remember it was June and terribly hot. I was working in my underwear and not getting along too well because my brushes were slippery with perspiration. Suddenly the downstairs door banged and I heard someone come up the stairs treading on each step with a loud, deliberate thump. My word, I thought, here comes a monster. A sharp, peremptory knock rattled the door. "Just a minute," I said, reaching for my pants. Another knock. "I'll be with you right away," I said, buttoning my shirt. Another knock. "Come in," I said. The door was thrust open and a tiny old man with a knobby nose, an immense, drooping mustache, and round, heavy-lidded eyes stamped bellicosely into the studio. "James K. Van Brunt, sir," he said, saluting me and bowing all at once. "Five feet two inches tall, sir. The exact height of Napoleon Bonaparte." And he pushed out his thin little chest, which was encased in a fawn-colored vest. "I have fought the Confederate Army at Antietam, Fredericksburg, and in the Wilderness," he said. "I have battled the nations of the Sioux under Dull Knife, Crazy Horse, and Sitting Bull. I have fought the Spaniards, sir, in Cuba." And he rapped his cane on the floor and looked at me very belligerently. Then, having ascertained that I wasn't going to contradict him, he took off his gloves and his wide-brimmed hat, laid them on a chair, and patted his mustache. "This mustache, sir," he said, "is eight full inches wide from tip to tip. The ladies, sir, make much of it." And he winked at me and walked over to my mirror to stare at his mustache.

It *was* a magnificent mustache; there was no denying it. It bushed out from just beneath his nose in a plump arc, hiding his upper lip. It was slightly parted in the middle and the ends swept down and out from his nostrils to his jaw. The bottom edge turned under just a trifle and the whole, fat, gray, glorious expanse was neatly brushed and trimmed. You couldn't help admiring it. I've got to paint him, I thought, I've *got* to. "That certainly is the finest mustache I've ever seen," I said.

"I offer it, sir, and myself," he said, pivoting toward me on his heel, "as a model." I almost fell over with sheer joy. "Of course, of course," I said. "Sit down. Please. I'll make a sketch now. I'll work up an idea tonight." So he clambered up onto a high stool and I got out a pad and pencil and began to draw him.

I hummed, I whistled softly, I tapped my foot to a ragtime tune. Oh, I was in seventh heaven. My pencil flew. What a face! And mine, I gloated, all mine. That knobby nose, thick and square at the end with a bump in the middle; those big, sad, dog eyes which, however, burned with a fierce, warlike sparkle; that mustache. And all crammed together in a small, narrow head so that if you glanced at him quickly that was all you saw—eyes, nose, and mustache.

I worked out an idea for a *Post* cover featuring Van Brunt that night at dinner between the soup and custard. The idea was simple—a tramp cooking two sausages (one for himself and one for his dog) on a stick over a fire in a tin can. It didn't do justice to his military background or ferocious spirit, but it had the eyes, nose, and mustache and I was satisfied. That's what I wanted to paint.

He was a very good model, holding himself absolutely still. And he was pleasant company, for he regaled me with stories of army life on the Great Plains and during the Civil and Spanish-American wars, all delivered in a loud, fierce voice as if he were giving commands to a troop of cavalry on a windy day in Wyoming. During rest periods, which he said were unnecessary but which I insisted on, he continued his stories while strutting about the studio to stretch his legs, for, as he said, "They are military legs, Mr. Rockwell, military legs. Accustomed to maneuvers. Carried me up San Juan Hill and down again, Mr. Rockwell, and down again." And he'd draw himself up to his full five feet two inches and glare at the wall as if it were a fortress full of Spaniards.

After we'd known each other for a few days he told me about his wife, who had died a number of years before. "There was a woman, Mr. Rockwell," he'd say, "there was a woman. Weighed two hundred and twenty-two pounds exactly. Dandled me on her knee like a baby. She swore that if I got any smaller she'd stuff me in a milk bottle and seal it up and lay me by." And he'd chuckle and go on about her virtues—what a good cook and housekeeper she had been, how she had darned his socks. "A soldier's wife!" he'd exclaim. "Rawhide, sir, rawhide to the bone." Then he'd stop and all the sparkle would go out of his eyes and he'd look at the floor. "But tender, Mr. Rockwell. And loving. A wonderful, *wonderful* woman."

One day as I was finishing up the cover I discovered that I hadn't got his mustache quite right. So I went over to the rooming house where he lived to ask him to pose for me again. "The old boy's up in his room, dearie," said the landlady, sticking her head all covered with curlers out of her door. "Fourth floor, last room on the left, number fifteen." I walked up the four flights of dark, dingy stairs and after tripping over a broken toy wagon and an old chair and lighting nine or ten matches found Mr. Van Brunt's room. The door was ajar and I could hear a gramophone playing softly, so I rapped and went in. For a moment he wasn't aware that I had entered. He was sitting in a wicker garden chair gazing at a few kernels of dry, yellowed popcorn which he held in his open palm. His face wore a sad, dreamy expression. Embarrassed at catching him in such a private mood, I remained silent and looked about the room. It was very small, really no more than a cubbyhole. But all around it, set out a foot or two from the walls and extending from the floor almost to the ceiling, was a

ABOVE LEFT:
*Man Looking
at Saxophone,
Saturday
Evening Post*
cover
(2 November 1929)

ABOVE RIGHT:
*Phrenologist
Examining Head,
Saturday
Evening Post*
cover
(27 March 1926)

LEFT:
*Hobo and Dog,
Saturday
Evening Post*
cover
(18 October 1924)

OPPOSITE:
*Three Ladies
Gossiping,
Saturday
Evening Post*
cover
(12 January 1929)

James K. Van Brunt posed for these paintings and the one on page 207

green lattice like that used in old-fashioned grape arbors. Hundreds of pale blue artificial morning-glories had been twined through the slats of the lattice and from behind it shone a soft, reflected, yellow light which faintly resembled late afternoon sunshine filtering through a vine-covered trellis. The wicker table beside Van Brunt's chair held a pot of crêpe-paper roses and an ancient gramophone, its battered brass trumpet stuffed with more morning-glories. The needle scratched and bumped through "Jeanie with the Light Brown Hair." On top of the lattice there was a narrow shelf crowded with shiny glass domes of every size beneath which lay a curious collection of objects: a cigar butt, a bit of cracked brown leather, a piece of charred wood, a handful of steel shavings, a sea shell, and many others, all set on neatly labeled blocks of wood.

I coughed and Mr. Van Brunt looked up, startled. When he saw me his face lighted up with pleasure. He rose and saluted me. "Welcome to my little garden, Norman," he said. "My garden of mementos. You see this popping-corn? It's from a bag I bought my wife, Annabella, at the World's Columbian Exposition in Chicago in 1893. When I look at it," he said, walking over to the shelf and carefully placing the kernels under a glass dome, "I remember our trip and the Exposition and her." Then he led me to the corner of the room nearest the door and, pointing to the label on the block of wood under the cigar butt, said, "Read this, Norman. Out loud." I read, " 'This cigar was smoked and dropped by General Ulysses S. Grant on the night of . . . during a dinner given in his honor at the 7th Regiment Armory in New York City.' " "And this," said Mr. Van Brunt, smiling happily as he read the label affixed to the block under the bit of leather: " 'My drum—which I carried at Antietam, Fredericksburg, and in the Wilderness during the great conflict between the United States of America and the Confederate States of America, 1861–1865.' And this"—pointing, proud as a diminutive peacock, at the charred wood—" 'A piece of rafter burned in the Iroquois Theater fire in Chicago on the thirtieth of December, 1903, in which fierce conflagration six hundred and two persons lost their lives.' I was an usher in the theater at the time, Norman. I saw the flames and smoke and the rush to the exits and the bodies. And this"—the steel shavings. " 'My visit February 4, 1909, to the Bethlehem Steel Company in Pittsburgh, Pennsylvania.' And this sea shell: 'Commemorative of mine and Annabella's excursion to Atlantic City, June 15–18, 1914.' " And so he led me all around the room, reading the label on each block of wood under each glass dome and explaining it to me.

"You see," he said after he'd read the last label, "I have everything here right before me. And when I want, I can recall anything I like and think about it and remember what a good time we had, Annabella and I. Or the excitement of a scout in '62 or a skirmish on the prairie with Crazy Horse. Everything. It's all here."

And I could see him trudging up the dingy, cold stairs on a rainy night, tired out and lonesome (for he had no relatives), and going into his room and turning on the lights behind the lattice and cranking up the gramophone. Then sitting down in his wicker chair and looking at his mementos, remembering all the fine times he'd had with Annabella or his days in the army. At San Juan Hill, Antietam, galloping his

horse on the plains. Just sitting there, remembering and patting his mustache and maybe sipping a cup of tea.

But James K. Van Brunt wasn't forlorn. Or pitiable. He had too much spirit for that. He carried his cane like a sword and dressed like a dandy. During World War I he had tried repeatedly to enlist, though he must have been over seventy at the time. Every Fourth of July, attired in his Civil War uniform (it was fancier—epaulets, gold braid, a sword—and more colorful than his cavalry or Spanish-American War uniforms), he marched with the Grand Army of the Republic in the annual parade, strutting along like a bantam rooster, the heels of his boots thudding on the pavement. On scorching days, it was said, you could see the marks of his heels in the soft asphalt, running straight as a die down the center of the street. And he was a gay old dog, carrying on flirtations with the waitresses at the restaurant where he ate his supper every night, joshing and winking slyly at the girls who posed for me. One day he proudly announced that a woman had threatened to sue him for breach of promise. And several days after I'd sent off a cover he'd posed for, he'd come into the studio. "Norman," he'd say, "how did they like it?" "Oh," I'd say, "they liked it fine, Mr. Van Brunt." "Did they really like it?" he'd ask. "Oh yes," I'd say. Then he'd come up beside me and nudge me with his elbow. "Did you get the check?" he'd ask. "Yes," I'd say, "yesterday." "That's the thing, Norman, get the check," he'd say. "Get the check."

After I'd used Mr. Van Brunt in two or three covers and a number of illustrations and ads, Mr. Lorimer said to me, "I think you're using that man too much. Everybody's beginning to notice it. Maybe you'd better stop for a while. That mustache of his is too identifiable."

The next morning Mr. Van Brunt thumped up the stairs and into my studio. "Well, Norman," he said, laying his hat and cane on a chair, "it's been two weeks. Another cover to be done? Eh?" And he patted his mustache. I told him what Mr. Lorimer had said. "If you take off your mustache I can use you again," I said. "Otherwise I just can't. I'd like to, but I can't." "Why," he said, "why. Well. No. . . . No. I couldn't do that." "Gosh," I said, "I guess I won't be able to use you then." "Well," he said, "well. I couldn't do that." And he picked up his hat and cane and left. I'd expected it, but my hands were tied. I knew Mr. Lorimer was right.

Two weeks later Mr. Van Brunt came to me and said that if I'd give him ten dollars he'd shave off his mustache. I guess the notoriety he'd gained from posing for me had overcome his pride in his mustache. And then posing gave him a new interest in life, something to do. So I paid him the ten dollars and he shaved off his mustache. It upset me; it was like the felling of a great oak or the toppling of a statue which had been for years a monument to man. When I saw the result I was even more upset. Mr. Van Brunt's lower lip stuck out beyond his upper lip by about an inch and was just as identifying as the mustache. But now, of course, I had to use him. I made a great fuss about having him pose for the first *Post* cover in full color (Mr. Lorimer had made as big a fuss about giving the cover to me), so as to make him feel more important and forget the loss of his crowning glory, about which he was, though he tried to hide it,

very downcast. Then, because I knew Mr. Lorimer would begin to object if I used him soon again, I thought up ways to hide his mouth. I did a cover of a phrenologist measuring a man's head with calipers and posed Mr. Van Brunt (as the phrenologist) with his hands in front of his mouth. Next I used him in a painting of an old scholar standing before an outdoor bookstall absorbed in a book. Really absorbed in it—his chin, mouth, and nose buried in it, in fact. And I used him in several ads, concealing his mouth in one way or another. But it got to be more of a chore and worry than the mustache. I couldn't go on painting pictures of an old man with the lower third of his face hidden behind his hands or a book or his hat. Yet I couldn't dismiss Mr. Van Brunt now. I didn't want to either; those eyes and that nose and my recollection of that mustache haunted me. So finally I told him that it was all right now, enough time had passed, I could use him with a mustache again. And he grew it back. He spent hours in the studio combing it and almost every day he'd ask me what I thought of the progress it was making. I always said, "Fine, it's coming fine." But the truth of the matter was that it wasn't going too well. I guess it takes years to grow such a magnificent mustache and there just wasn't time. And then he was an old man, over eighty years old; perhaps the vigor of youth had given it that special luxuriance. In the end it never attained its former sweeping plumpness, its majestic swoop at the ends. But when I did my next cover of him—the picture of the old cowboy playing a gramophone and dreaming of his past (you can see where I got that idea)—I faked the mustache bigger and fuller to please him. I did the same in the next two. And there I was again—using Mr. Van Brunt too often. Luckily I'd had an idea on hand for quite some time—three old ladies with their heads together, gossiping—which I had been unable to do because I couldn't find any old ladies who were funny-looking enough. One night as I was scurrying about in my brain trying to find ways to use Mr. Van Brunt, I thought of the solution to both the stymied idea and Mr. Van Brunt. I'll use him as a model for the old ladies, I thought. And I did. And almost laughed myself into the grave at the way he pranced around the studio in the old maid's costume, lifting the long skirt and curtsying, a flossy little hat tilted rakishly over one eye, his pipe sending up clouds of smoke from its perch behind the mustache.

I did one other cover of Mr. Van Brunt. Once more I put his hand over his mustache. A few months later he died. Not because of the failure of his mustache to regain its former splendor, however. He never buttoned up his coat properly, vowing that it was unnecessary. *He* never caught cold; his years out in all kinds of weather as a soldier had toughened him. (I think he liked to show off his vests, too.) But one winter's day he did catch cold and it went to his chest and he died. The veterans' groups of New Rochelle gave him a soldier's funeral.

In those days before I began to photograph my models it was a problem to get anybody who could and would take the time to pose. I used to figure that, working from the model, it took me three days to paint a single figure. Sometimes longer. I'd draw the model in charcoal on the canvas, then paint over that. So I was forced to use many of the models who did have the available time over and over again. As with Mr.

ABOVE: *Man Reading Book of Chivalry*, oil painting for *Saturday Evening Post* cover
(16 February 1929)

OPPOSITE: *Magician with Two Children*, oil painting for *Saturday Evening Post* cover
(22 March 1930). Harry Seal posed for both of these covers

Van Brunt, this often brought the problem of overexposure. Neither the public nor Mr. Lorimer (nor, for that matter, the advertisers) wanted to see the same character more than once or twice a year even if he did have a nose with a bump, dog eyes, and an enormous mustache (or jutting lower lip).

Harry Seal, another of my regular models, was too much of a character all over to use very often. He had a round, fat body with a great bowl of a belly and spindly little arms and legs. (Someone once said he looked like a turtle.) His face was plump and square with a chunky, turned-up nose and large, round eyes, amply pouched, and with high, startled, dark eyebrows. Beneath his nose his face slanted back in a straight line unbroken by his tight small mouth to his double chin and chubby jowls, propped up and puffed out by the high wing collars that he always wore. His complexion was florid. And for good reason, I guess.

Many years before I knew him the Royal Baking Powder Company had paid him a large sum of money—I think he said it was half a million dollars—for his half interest in the company (his father had been one of the founders; invented the powder or something). Harry had lived like a king on the Riviera, in Paris, London, Bath, Berlin, for twenty or twenty-five years, dining on pheasant and chocolate éclairs and lobster Newburgh, and sipping burgundy, port, champagne, et cetera. Then the money ran out. Harry returned to America broke. He took up lodgings in a rooming house in Brooklyn and became a model at the Art Students League.

But he was still a gentleman—well bred and polite. His clothes were conservatively sporty: a seedy but well-tailored suit, neatly pressed and brushed, spats, white waistcoat, kid gloves and, as I mentioned, a high wing collar, always dazzlingly white. And he could never rid himself (not that he tried) of his taste for rich foods and strong drink. He had lived too high for too many years. One day he was posing for me seated comfortably in an armchair in slippers and smoking jacket. He was portraying a man who had fallen asleep over a book and I guess he was really living the part off and on. Suddenly he started. "I'm getting faint," he said, glancing wildly about. "You haven't a drop of whiskey somewhere?" I ran into the house and brought out a bottle. He drank a shot. "Ahhh," he said, "s'better, better. That was a near thing, Mr. Rockwell, a near thing." So every day after that he'd suddenly feel faint and I'd have to revive him with a spot of whiskey.

And he was a man of impulse. We'd be listening to the radio. A woman would come on, speaking in a soft, husky voice. "Boy, I'd like to meet that woman!" he'd say. One day we were eating lunch together (my models always ate lunch with me). I had a cook at the time who shaped the butter pats into little globes, and that day there were fifteen or twenty of them on a plate in the center of the table—a fat golden pile with little chunks of ice glistening all through it. Harry kept eying it. Finally, "Gee," he said, "I'd like something." "What is it, Mr. Seal?" I asked. "Do you mind if I eat all that butter?" he asked. "No," I said, "go right ahead." So he ate the plateful of butter. And once he ate a whole bowlful of whipped cream. "I can resist anything but temptation," he'd say as he forked a third helping of asparagus with hollandaise sauce onto his plate, his eyes sparkling.

I used Harry in three covers in one year. Then Mr. Lorimer rejected a very good idea which featured him, I took the hint, and Harry was out. At least as a model for *Post* covers. I used him off and on for ads. He continued to pose at the League. I never heard what finally happened to him.

Thinking of Mr. Van Brunt and Harry Seal makes me wonder about why I painted old men and kids so much during the twenties and early thirties. Part of it, I guess, was my experience on the children's magazines. But more than that: early in my career I discovered that funny ideas, pure gags, were good, yes, but funny ideas with pathos were better. Not only pathos, though; just something deeper. An idea which is only humorous doesn't stay with people, but if the situation depicted has some overtones or undertones, something beyond humor, it sticks with people and they like it that much more. Take my cover of Van Brunt carrying a violin under his arm and looking quizzically at a saxophone to which is affixed a sign reading, "Jazz it up with a *sax*." His face and his baggy trousers and the idea of the old man "jazzing it up with a sax" are comic, yet there's something more to it (at least I hoped there was when I painted the picture). The old confronted by the new and wondering what it's all about and whether he should take up the new ways or hold to the old, "jazz it up with a sax" or continue to saw at his fiddle. Well, I don't know if that's something more than humor, but at the time I thought it was.

Old men show their lives in their faces—the ups and downs and turn-arounds, the knocks and pushes. Van Brunt's face was more than just comic; in a sense, Antietam, Fredericksburg, the Wilderness, and Annabella were all in it. I guess that's why I painted old men so much.

With kids, as I've mentioned before, people think about their own youth. Nostalgia sets in. And yet the kids' antics are humorous, so the people laugh too. It's like Dickens: tragedy and comedy, tears and laughs in the same picture give it a greater impact.

I used to think putting the characters in costume had a similar effect, gave sort of an added dimension to the picture: nostalgia again. But that wasn't the real reason I did so many costume pictures. I just loved to paint the costumes: a swirling scarlet cape; a flowered, bouncy bustle; rugged riding boots; lace collars; pantaloons with frills and furbelows upon a pretty leg. Costumes are colorful and picturesque; modern clothes are drab and dull. A fedora and a golfing cap don't compare, unless tattered and rotten, with a high top hat or brass guardsman's helmet.

I'd still like to do costume pictures. But I don't any more. People don't enjoy them. In 1935 I did a cover of a mother presenting her little boy to his schoolteacher. The two ladies and the boy were dressed in costumes of the 1870s. Every school-teacher in the country wrote to me complaining about how ugly I'd made the teacher in the painting (either schoolteachers are a touchy lot or I'm perennially unfair to them; you remember the same complaints erupted in 1956). The writers were person-ally insulted by my characterization, just as if the costumes made no difference, as if

the schoolteacher was in modern dress. I wasn't surprised by this attitude. Before the war there wasn't a break between the past and the present as there is now. Everything was sort of *now*—both past and present were one, a single unit. Nowadays most people would look at the cover and say, "What's going on, a fancy-dress ball?" And they wouldn't enjoy the cover. They certainly wouldn't identify themselves with the characters in the painting. I guess the contemporary scene is too exciting.

I used to rent most of my costumes from Charles Chrisdie & Company, an old costumer located in a dilapidated four-story building set among a lot of dingy warehouses and hole-in-the-wall bars on Eighth Avenue behind the Metropolitan Opera House. There was always an actor or two and maybe a couple of chorus girls lounging on the rickety benches and chairs along the walls of the gloomy hallway which ran down the center of the first floor. As I waited for the ancient freight elevator to clank and rattle down to me I'd watch the actors meticulously combing their hair or studying a script, their lips mouthing the words silently. Or I'd look over the platinum-blonde heads of the chorus girls, bobbing up and down as they chattered away in shrill voices, into the glass-enclosed office opposite the elevator shaft at the front of the building where Mr. Kelly, the ornery Irishman who ran the business, would be pricing some ball gowns for a group of high school girls from Brooklyn. Sometimes I'd catch a glimpse of Mr. Chrisdie, a small, red-faced, white-haired man, wandering in the back among the display cases piled with ornate crowns, gem-encrusted scabbards, tiaras, and jewelry, all glinting softly in the dim, dusty light. After a minute he'd disappear into the rear office. He never spoke to anyone.

I'd ride up in the elevator with a Portuguese pirate, an Anglican minister, and three vestal virgins. Or walking up the stairway, I'd turn a corner and run smack into an Indian carrying a tomahawk and conversing with a knight in full armor with a crossbow under one arm and a lance under the other. Chrisdie's was a very melodramatic place.

If I wanted a lady's costume I'd go to the second floor. Then I'd wait until Gussie, who was in charge of the ladies' department, had finished with whatever customers were already there. I'd sit on the tier of drawers which had been built in under the windows along the front wall, sniffing the odor of mothballs mixed with talcum powder, cheap perfume, and dust which pervaded the room and watching Gussie fit a bustle or pin up a colonial gown. Gussie was a wispy little person with small black eyes and her pale hair drawn back into a knot. She wore a blue apron snugged in at the waist by a string from which dangled a long pair of scissors and a sewing kit. To the top of the apron was sewn a piece of quilted cloth covered with pins, hooks, and threaded needles. She was always in a hurry, always bustling about, getting fifteen peacock feathers for fifteen chorus girls, rummaging through the heap of dresses, coats, scarfs, shoes, wigs, and belts on the long table near the windows, running behind the row of dressing rooms to get a costume from the racks.

Sometimes there'd be a night-club chorus line waiting to be fitted, some of the girls standing by the table, some perched on the tier of drawers, some curled grace-

fully on chairs, smoking, talking, powdering their beautiful faces, tugging at the seams of their stockings. And Gussie would be scurrying among them, giving one her costume, pinning up a skirt here, letting out a blouse there. All of a sudden the bell by the elevator would sound an earsplitting clang, summoning Gussie downstairs. Gussie would go right on with whatever she was doing. The bell would clang again. And again. And again. Finally Gussie would say, "Drat that Kelly," and going over to the elevator shaft, shout down it, "I'm coming, I'm coming." But the bell never stopped until she went, for Mr. Kelly was an impatient man.

Sometimes the floor would be deserted. I'd wedge my way through the racks of costumes to the little workroom in the back where two or three old ladies sat at sewing machines repairing costumes. And Gussie would be there, sewing busily at a ruff or threading a needle by holding it up to one of the naked light bulbs dangling on cords from the ceiling, her eyes all asquint.

Most of the time, though, Gussie would be in the midst of preparing a big shipment. For an amateur theatrical group in Ohio perhaps or a costume ball in Pennsylvania. When she saw me she'd say, "Just a minute now, just a minute," and finish pressing a gown. Then she'd brush the loose strands of hair out of her eyes and come up to me. "Well," she'd say, "you again, is it? What'll it be this time?"

Once when I walked off the elevator Gussie was fitting the female half of an adagio dance team with a costume. The male half was watching. Pretty soon he stamped his foot and said, "There. What'd I tell ya? You've gone and gained weight. The costume's too small." "I have *not*," said the woman indignantly. "Whatta ya telling me?" said the man. "I know how much I'm throwing around. I got to toss twenty pounds more than last year. No wonder I'm dead tired at the finale." And he began to abuse the woman and she to slander him. Gussie returned to her ironing. After a bit the man and woman calmed down and settled on ten pounds, she'd only gained ten pounds. A compromise. Gussie finished letting out the seams of the costume. (None of the costumes ever fit perfectly, but they all had seams which could be taken in or loosened easily.)

Gussie was crazy about Joe, who was in charge of the men's department. "We're gonna git married someday," she'd say whenever I asked her about him. One snowy night I found Gussie alone at the sink in the little washroom off the workroom. The windows were all frosted up and it was as cold as a dead trout in there, but she had her blouse off and was splashing suds over her head and shoulders and scrubbing under her arms. "What the deuce are you scrubbing for, Gussie?" I asked. "Me and Joe's gettin' married tonight," she shouted. And she went on about the great event— the license, her gown, the wedding supper—all excited, shouting above the clank of the old faucets and the roar of the water, laughing, tossing the suds about and getting them in her eyes and hair. A month or so later I asked her about the wedding. "No," she said, "we ain't married yet, worse luck. But we're gonna hitch up any time now. Couple of weeks, maybe a month. Any time now. Soon as the rush lets up."

Joe was very smug about Gussie's affection for him. He was a skinny, harried little man, all dusty and smudged from running about among the costumes. He wore

suspenders and carried a tape measure slung over his shoulder. His vest was stuck as full of pins and needles as a pincushion.

Joe considered himself an authority on costumes. "Take it from me," he'd say when I expressed some doubt as to the authenticity of a costume. "Take it from yours truly Joe. I done research. That's what they wore. Red coats. Ain'tcha never heard of the Redcoats? Ain't that a red coat? 'S as red as the inside of Lotte Lehmann's mout' when she hits high C. And lookit that hat," he'd say, whipping off the wrinkled cap he always wore and trying on a Redcoat's shako. "It's a natchrul-born daughter of the proper hat. The spittin' image, lemme tell ya. I studied books, I researched them things." And he'd take off the shako and look at it. "Damn near old enough to be genuine, too," he'd say. Then he'd toss the coat and shako on the table, slap his cap back on, and saying, "Trousers, au-ten-tic trousers!" plunge into one of the narrow aisles between the racks of costumes which filled the rear of the floor. I'd follow him, shoving my way through the dank, musty costumes, through the Santa Claus suits, the leopard skins for cave men, the tuxedos, frock coats, pantaloons, the rustling silks, smooth satins, heavy brocades. The sharp, penetrating odor of mothballs would become more intense; it would get darker and darker as the light from the grimy windows at the front of the building faded behind the costumes. But we'd push on like two benighted travelers in the jungles of Ecuador. Then Joe would stop and, telling me to turn on the light, begin to pull things off the racks. I'd grope for the light cord, waving one hand round and round above my head. When I'd finally found the cord Joe would drape pants over his shoulders and head so that I could choose the pair I wanted. Then we'd push our way back through the costumes, emerging suddenly into the lighted area around the long table. I'd select a pair of boots, a wig, a belt, and a sword from the drawers under the windows and Joe would put the shako on his head, the coat over one shoulder, the pants over the other, grab the wig and the belt in one hand, the sword and the boots in the other, and we'd go downstairs.

There Joe would dump everything on the table in the glass-enclosed office and yell for Kelly, who after a moment would come trotting out of the rear office, grumbling at something or other and pulling a pencil out of his shirt pocket, a brown fedora cocked on the back of his head, his shirt sleeves rolled up above his knobby white elbows. He'd fuss with the costume, flopping the coat over, staring at the inside of the shako, tugging at the belt, and then announce a price. I'd hesitate. "Come on, come on, come on," he'd say irritably, "we haven't got all day." "Couldn't you make it a bit lower?" I'd ask. "What'sa matter with what I told you?" he'd demand. "That's a fair price. Belt, wig, coat, sword, boots, hat. Let's go, let's go." So I'd say all right and start to write out a check. He'd rub his thin, bony hands together and shuffle his feet. "Come on, come *on*," he'd say. "Get the lead out. I got things to do."

Once in a while I'd find I'd selected the wrong belt or wig. When I told him I'd have to go back upstairs and get another one, he'd jerk his hat forward on his head and ask, "Don'tcha know what you want? You been up there once, ain't you? Nobody hurried you? You wasn't pushed, was you?" I'd look at him guiltily. "Well,

go on, go on," he'd say. So Joe would yell up the elevator shaft, "What the hell you doing with that elevator?" and pretty soon it would descend, traveling as much sideways as down, and we'd go back upstairs and choose another belt. "You sure you got what you want?" Kelly would growl when I returned to the office. "You ain't gonna start off again? How 'bout this coat? Them buttons all right? You sure you don't want brass? And that hat there. It ain't too white for you?" "No," I'd say, "everything's fine now." "All right," he'd say. "As long as you're satisfied. We sure put out to satisfy the customers around here. Anything for the customers."

Besides being about the most irritable man I've ever met, Kelly was always trying to gyp the customers. However, Joe, who liked artists, used to tip me off on what he thought I should pay for the costumes, so I was able to hold my own with Kelly. He wasn't all bristles and cactus, though. Once I lost my wallet while in New York and he lent me five dollars to get home.

Chrisdie's had every kind of costume and costume accessory imaginable, everything from Adam and Eve on up—fake stomachs even. The costumes were plausibly authentic and in pretty good repair. Terribly dirty, though. Every so often Joe and Gussie would initiate a grand scheme to clean the costumes. But then a big order would come in and the scheme would be lost in the rush and the costumes would stay dirty.

Only Gussie and Joe knew where, in all that dark sea of racks, the various costumes hung—where the Spanish grandees' outfits were and the pirates' capes, the Elizabethan gowns, the Pilgrims' knickerbockers. Kelly just priced the costumes. All he knew was the current rental prices, say how much the market would bear for a (fake) diamond-studded tiara. I don't think he could have distinguished a Redcoat's uniform from a Minuteman's.

One day Joe showed me a genuine colonial boy's suit. It was a beautiful thing: white satin breeches, yellow velvet vest, and purple velvet jacket. The jacket and vest were magnificently embroidered. "We gotta sell this," he said to me. "Won't last in the trade a week. Whyn't ya buy it from Kelly?" "I'd like to," I said, "but wouldn't it be awful expensive?" "Naw," he said, "Kelly don't know his way from here to Hoboken. Offer him twenty-five dollars." So I did and Kelly accepted.

All my friends admired the suit. Then one of them asked, "Are you sure it's real?" I wasn't. Someone suggested I take it to the Metropolitan Museum and get an expert to authenticate it. "Sure," said the man at the Metropolitan, "we'll look at it for you." So I left it. I didn't hear anything from the museum for two or three months. Then one day I received an engraved certificate in the mail. It read: "The Metropolitan Museum gratefully acknowledges Mr. Norman Rockwell's *gift* [my italics] to the Museum of one colonial boy's dress suit." I did write and ask them about the suit; they said it was one of the few examples of genuine punch velvet extant.

The best costume model I ever had was James Wilson. He looked like a caricature of an old-time English ham actor, a nineteenth-century Hamlet: tall and thin and cadaverous with a long, gaunt nose, deep-set eyes, sunken cheeks, and a pointed

chin. And a melodramatic, hand-on-chest, rolling-eyes manner. In fact he was English and had been an actor. Perhaps that was why you just had to throw a costume at him and he'd look as if he'd worn it all his life. He owned a good many costumes and carried some of them about with him in an old Gladstone bag. I remember he had a magnificent Catholic cardinal's costume—red robes, a skullcap, a silver and gold sash. When he attired himself in it, I think he could have walked into St. Patrick's Cathedral on Sunday and said mass without a voice being raised to stop him.

Wilson had not been a success on the stage. He laid his failure to type casting. "The theater in America," he'd say in his deep, oratorical voice, flinging an arm at the ceiling, "is o'ercast with a pale and sickly hue. Do you ask why?" And he'd look around the room at his rapt audience (the tables, chairs, rug, easel, and me). "Why?" he'd repeat, his voice rising. "Why? . . . *Type casting.*" And he'd pause. "They want an old man," he'd exclaim, "they *get* an old man. Why, I can do King Lear. Or I can do Tiny Tim. I have stridden the boards as Sir Toby Belch on Thursday and again on Friday as the stripling Romeo." Then he'd roll his eyes to the floor. "But we have fallen on evil days," he'd say, passing his hand across his eyes. "Acting has perished in America. It was not always thus. When Ellen Terry lived and walked upon the stage with me . . ." And he'd reminisce hour after hour about the great days, the golden days, when he and Ellen Terry (or Joseph Jefferson or David Warfield) had amazed the continents with their versatility and power. He'd darn near kill you with his memories. It was no good trying to avoid the subject; the most oblique reference would set him off. I'd remark that my pipe wasn't drawing well. "I never smoke," he'd say. "Tobacco has been the ruination of a myriad of actors. I recall a young man who played Laertes to my Hamlet back in . . ." And that was it; he'd rumble on for hours, now soft-voiced and tragic, now loud and noble, now passionate and fierce. From the young actor who "toppled from the pedestal of fame" by smoking to his triumph in Scranton to his near escape in a theater fire to his opinion (bad) of movies to his triumph in Wilkes-Barre. I used to try silence, but even that was to no avail. If nothing else started him off his tea, which he brought with him and prepared himself, always did.

In a sense, though, Wilson was a successful actor. To paraphrase Shakespeare: all the world was his stage. He had created a role for himself. He was strict in morals, never took a drink, and dressed conservatively. However, I never realized the full significance of all this until I visited his apartment. It was a cold-water flat on First Avenue in the sixties—a bleak neighborhood: warehouses, gin mills, tenements, streets littered with tin cans, newspapers, overturned garbage pails. I threaded my way through this clutter, watched by old harridans slouching over window sills, jostled by gangs of ragged children, deafened by the roar of trucks and the shrill cries of women in house dresses yelling at their kids. And then I puffed and blew my lungs out climbing the six stories to Wilson's apartment, scared half to death that I was going to stumble in the dark and fall through the sagging banister. But when Wilson opened the door I stepped into a quaint country cottage in Cornwall. The kettle was whistling on the hob, a canary was singing in a little cage by the hearth, there were

white, flouncey curtains on the windows, an engraving of Queen Victoria over the mantelpiece, and a high oak sideboard with rows of plates displayed on the shelves and dangling teacups, all clean and shiny, with country scenes depicted on them in blue. And there were geraniums blooming red and white in pots on the window sills and a small round-topped table covered with a white doily on which sat a tea caddy and a teapot. As I took all this in, realizing suddenly that it was quiet, that I could no longer hear the raucous noises of the street but only the whistle of the teakettle and the canary's song and the soft swish of the wind in the curtains, a sweet little lady wearing a broad white apron greeted me from her rocker by the hearth. That was Mrs. Wilson. I sat down and had a cup of tea with her. After a minute two young men in neat artists' smocks entered the room and she introduced them as her sons, who were studying to be painters. "Great artists," Wilson added from his stand by the mantelpiece. But it came out that the sons were not permitted to submit their work to magazines or show at galleries. "I will not consent to it," Wilson said. "They shall not venture forth until fully ready. I know art. I have modeled for the foremost artists of the day. I know the field. Talent must develop slowly, nurture and enrich itself. Give them time, give them time. They are not ready yet."

And that was Wilson's world—genteel, Edwardian England. I'm sure that when he looked out the window at the East River far below it was the Thames to him.

He worked hard to maintain all this. He supported the whole family, posing all day and far into the night. He did all the shopping, too, for his wife rarely left the apartment. His sons were grown men, but he would not permit them to take jobs. That would have been belittling; they were artists. (I saw their work; it wasn't too good.)

There's a wonderful bravery about a guy like Wilson. Right in the middle of the slums he had built a little world for himself and his family. Maybe he was hiding things from himself—his own failure as an actor and his sons' real abilities as artists. Still, faced with all that, he led his own life, making it out of nothing really, but making it coherent, complete, something that he liked, that he could believe in. There's courage in that.

And Wilson, like Antonio Corsi and the other models who posed at the League while I was a student there, was proud of his profession. He flatly refused to pose for a photograph, considering it degrading. He and Pop Fredericks, another old actor, had a great rivalry over who was the best model. One day Wilson announced that he had posed for eight hours straight, without a rest, on a horse for Joe Leyendecker. (Of course it wasn't a real horse, just a sawhorse with a saddle on it.) When Pop Fredericks heard about this he got hot and said eight hours was piffle, piffle and tripe; he could beat that any day; tomorrow; yes, tomorrow. The next day he entered my studio carrying a clock. "Ready?" he said to me. "You're really going to do it?" I asked. "Eight hours without a rest?" He flared up: "Eight hours? *No!* I'll do nine. Ten. I'll beat that piker. I'll show him up. Eight hours? *Piffle!*" And he sat down in the deck chair (he was portraying a man seated seasick in a deck chair aboard ship). It

was a long day. At noon I brought him his lunch on a tray; I had to help him with a bedpan several times. But he made it. He posed for eight and one half hours without getting up from the chair.

Wilson derided the feat, hinting darkly that Pop had dozed off once or twice, the cardinal sin among models. And he was all set to pose for nine hours. Or even ten. But none of the illustrators would co-operate; we didn't want to work for nine hours without a break. Besides, this "poseathon" had to be stopped; after nine hours came ten and then eleven and then twelve. Pretty soon one of them would have wanted to go on all night.

Many of the professional models were people who couldn't earn a living any other way, failures really. Because modeling wasn't a very lucrative trade. You started out as a model for the art schools and then graduated to being a model for individual artists. Ten, twenty years later you were still posing for artists and earning not much more than when you began.

But that was what made the professionals so wonderful to paint. Their faces were gnarled and wrinkled and corroded by failure, by the little cubbyholes they lived in, by disappointment, by the grubby life they led. One old model, Joshua Biengraber, asked me one day, "Were you ever actually hungry?" "Sure," I said. "No," he said, looking closely at me, "I don't believe it. You haven't got it in your face. You don't know what it is to be without a cent in the world. Or a friend either. I can remember sitting on a bench in Central Park just after I came to this country. I didn't know a soul; my pockets were empty. And I just sat there. For days it seemed like. I was so tired and hungry that I didn't even have the courage to get up. You don't know what it's like. You feel all hazy inside. And weak, like when you've been sitting in a hot bath for an hour." I always thought you could see that experience in Joshua's face. I don't know. I suppose it's a trite idea. But does only a man's mind change? Doesn't something change about his eyes? Or his mouth?

On the other hand, successful people are almost as much fun to paint as a slab of warm butter. They have succeeded in looking conventional—sleek, well groomed.

For obvious reasons, modeling was a popular profession with unsuccessful actors. Wilson, for one. And Pop Fredericks. Pop had been, as he told it, cheated of fame. When *Abie's Irish Rose* opened on Broadway, Pop was playing the part of the Irish father. At first the play didn't go so well. Then it caught on. Pop thought he was headed for big things. But suddenly, just as the crowds began to stream in, Pop was replaced by Burr MacIntosh, a famous actor. He felt this was a great injustice. But, he said, there was nothing he could do. It had always been like that. The leading players—Joseph Jefferson, David Warfield—were jealous of him. They cut his lines. They knew his magnetic personality had captured the audience. Their careers were at stake. Either get Pop off the stage or play second fiddle.

Edward Van Vechtan was another actor who earned his living as a model. One morning as I was unlocking the door of my studio a man came sauntering down

Silhouette of a Colonial Lady, Saturday Evening Post cover (24 September 1927).
Joshua Biengraber posed for this cover

Doctor and Doll, oil painting for *Saturday Evening Post* cover (9 March 1929).
John L. Malone posed for this cover

the driveway. "Mr. Rockwell," he announced. "Yes?" I said. "*Joy!*" said he, his eyebrows shooting up and his mouth opening wide. "Hello," I said, somewhat startled. "*Anger!*" he replied, squinting his eyes and turning the corners of his mouth down so that he looked like a sick mackerel. "Hello," I said again, even more startled. "*Sorrow!*" he exclaimed, rolling his eyes to the sky and thrusting a card in my face. I looked at it. At the top in fancy script were printed the words "Edward Van Vechtan, model extraordinary, who has posed for ALL the leading artists of America." Below this were five or six photographs of the man variously labeled: Joy, Sorrow, Anger, Chagrin, et cetera. "Oh," I said, "you're a model?" "I am," he said. "The best." And he drew back a step. "Versatility," he said, "is my forte." I looked at him. Nothing remarkable—medium height, sagging stomach, sparse black hair. But his gaunt, drooping face intrigued me. My test for a good model is whether or not he can raise his eyebrows halfway up his forehead. If he can do that his face is mobile enough to assume any expression. And this Van Vechtan could raise his eyebrows all right. Farther than anybody I'd ever met, in fact. "Well, come on up to the studio," I said. So we went on up and as I was hanging up my coat I studied his face. It just might do, I thought. All this time he was talking away at a great rate, explaining that he'd been an actor, telling me about all the artists he'd posed for. "I'm busy as a bee," he said, "all the time. I've been in and on all the magazines. I'm in the Metropolitan." We talked a few minutes. "I'll call you in a couple of weeks," I said. "I have a job you might do for." "You'll never regret it," he said, starting for the door. "I've posed for the best." Then he stopped and, pointing to a print of Rembrandt's *Portrait of Jan Six* which hung over the door, said, "I've posed for thousands of great pictures. You see that one on the wall there?" "Yes," I said. "I posed for that," he said. "That shows the kind of work I do." "But you couldn't have," I said. "Yes, I did," he said, and left. Well, I thought to myself, he's a queer one. Holds his age well, I guess. (I found out later that Van Vechtan always said he posed for everything. During the course of our acquaintance he vowed he had posed for a Velásquez, a Degas, a Vermeer, and several minor painters of the Italian Renaissance, not to mention all the contemporary illustrators.)

A month or so later I engaged him as the model for an ad I was about to do. The next morning he arrived carrying a big old alarm clock with a bell on top. "I pose for twenty-five minutes," he said, setting the clock on a table beside the model stand, "and rest for eight. My price was printed on the card." I said fine on both counts, though my other models only rested for five minutes and I paid them fifty cents less an hour. Then I posed Van Vechtan and began my drawing. After a while I congratulated myself. I'd been right about his face. It *was* wonderfully mobile. I had him roaring with laughter—mouth open, lips pulled back off his teeth, eyebrows up, eyes popped. And he did it beautifully. And he was grand to draw. The pencil glided, swam over . . . Burrrrrrrrr-ANG—the alarm clock exploded. "Rest," said Van Vechtan, hopping off his chair, "rest." And then he frowned at me. "You mustn't forget the rest," he said, wagging his finger in my face. "You must be fair with me. I'm fair with you, you know. I give you twenty-five full minutes." I dislodged my Adam's apple from where it had leaped and stuck in my throat, swallowed my heart to its proper

place, and asked weakly, "Do we have to have that clock?" "Ah," he said, looking slyly at me as if I'd just tried to pick his pocket, "you mustn't cheat. How are we to know when it's time to rest? You missed it the first time, you know. All work and no rest makes Jack a dull boy." "I guess so," I said. "Shall we get back to work?" "Ah, ah, ah," he said, "sixty seconds to go."

Well, I darn near went crazy painting that ad. I could hardly work waiting for that alarm clock to go off—BRANG! He'd placed it with its back toward me and I could never judge the time, so I was in a cold sweat during the last ten minutes before each rest period.

Only once did he forget to set the clock. And then he went to sleep. I was working on his legs at the time. I'll let him sleep, I thought. All of a sudden he woke up. "What time is it?" he squeaked. "What time is it?" I told him. "Why didn't you wake me up so I could rest?" he said, very disgruntled.

It was practically impossible to get him to assume a complete expression after the first day. "You can't paint my entire face at once," he'd say. "What side are you working on now?" "The left," I'd say. "*All right,*" he'd say, and he'd pull up that side of his mouth. "There," he'd say, "I'm smiling on the left side." "That's no good," I'd say. "You've got to smile on both sides at once." "What *do* you mean?" he'd ask. "You *told* me you could only paint one side at a time. And now you're painting the left side so I'm going to rest the right." And no matter what I said he wouldn't change his expression until I'd finished the left side of his face. Then he'd work his mouth around a few times and squinch up the right side. It's a constant wonder to me why I didn't bang him over the head with my trash bucket.

And to top all this, every time I took off my tie, laid aside a brush, or removed my jacket, he'd start up from his chair. "Now don't throw that away," he'd say. "Give it to me if you don't want it." Of course I had no intention of throwing whatever it was away. And then he'd look at my trousers. "My," he'd say, "that *is* a nice pair of trousers. When you get done with them, give 'em to me, will you?" Always gimme this, will you; gimme that, will you. Everything. My paints, brushes, books, prints, stretchers, canvas, costumes, chairs, tables. About the only thing he didn't ask about was the toilet seat. "Oh," he'd say, staring at a chair, "that's pretty old, isn't it? I expect you'll be getting rid of that soon. But don't throw it out. I can use it. I'll take it with me tonight if you'd like." "No," I'd say, "I wouldn't like." "Okay," he'd say, "I just wanted to be sure you wouldn't throw it out. Or that cracked frame in the corner there." What a nuisance that guy was!

When he left after I'd finished the picture I swore to myself that I'd never use him again. Two weeks later he came up to the studio and threatened to sue me for a new set of false teeth. "That laughing expression changed the shape of my mouth," he said. "My teeth don't fit any more." "Are you serious?" I asked. Well, *yes,* he was serious; he was going to call a lawyer. So I settled with him for fifty dollars. That, I said to myself, is *the end.*

But when I'd finished the painting, gee, it was wonderful. Even the sketches were good. And I had another idea which fitted Van Vechtan exactly. No, I said, I

Postman Reading Mail, Saturday Evening Post cover (18 February 1922).
Edward Van Vechtan posed for this cover

won't do it. I couldn't stand it again. Then I called him up and asked him to report for work the next day. I just couldn't resist the urge to paint him.

And that was the way it went for—oh, five or six years. I'd be determined not to use him again. But after a while I'd think about what grand pictures I could paint from him, and my determination would leak away, and I'd rehire him.

He didn't improve with use either. After we had become better acquainted he confided that he had been an alcoholic. Then one day during a binge, he said, he had wandered into a church and, happening to glance up, had seen the word "FAITH" emblazoned on the ceiling. So he had given up alcohol. Which was a fine thing, I guess. And I guess it was a sincere experience because he would never take a drink. But the way he'd go on about it—self-righteous, sanctimonious. It used to make my stomach feel all soft and pulpy inside, like a rotten orange. And right in the middle of the story he'd break off and say, "You aren't going to throw that brush out, are you? I'll take it." Maybe that's why he was such a good model. Because he riled me up so. I'd get all excited and paint better out of sheer spite and suppressed emotion.

No, all my models weren't pleasant working companions. But then, I suppose I was impossible, too, at times. Don't remember any of those times, though. The conveniences of memory. I've heard stories about other artists. A. B. Frost, the illustrator, was rather stingy. Van Vechtan told me that at the end of the twenty-five-minute posing period Mr. Frost would say, "Rest. Oh, and while you're resting would you mind running the lawn mower up and down a few times." And another illustrator used to surreptitiously set his watch back thirty or forty minutes. When the church bells rang at noon and the model started to get up he'd say, "Those darn bells. They're always wrong. See, forty minutes fast. I set my watch by the radio this morning." Forty minutes later the model would go out to lunch and find that it was quarter to one.

I got along well with most of my models, though. One of them, John L. Malone, used to read to me while he posed—Balzac, Turgenev, Tolstoy, De Maupassant. And most of the other models—Wilson, Van Brunt, Pop Fredericks and, yes, even Van Vechtan—had some interesting stories to tell me as we worked. Perhaps I was bored sometimes, but now that I use photographs and so don't have the models around the studio for any length of time, I'm sort of lonesome. I miss them. Van Brunt stomping up the stairs and into the studio all fire and fierceness to tell me about Chief Dull Knife or his current flirtation. Wilson with his triumph in Scranton. Pop Fredericks telling me about how, when a road company folded, stranding him penniless in some Midwestern village, he'd mix up a health elixir of wild ashes, gelatin, and sugar, cork it up in the labeled bottles he always carried in his trunk, and sell it to the yokels for his fare to New York. Old gimme Van Vechtan.

The Deacon goes society

I T WAS Sunday. I was putting on my coat to go home for lunch and watching Mr. Lischke back his car out of the garage while George and Franklin and Mrs. Lischke waited beside the driveway. Suddenly I thought, I can't stand it any more. I can't go home and sit down at the table with Irene's brothers and sister and mother again.

I didn't know why I couldn't face it again; her mother and brothers and sister had been living with Irene and me off and on since our marriage. It's ridiculous to object now, I said to myself, but I do. We ought to have a home of our own. And live alone in it. Every couple should.

I went home and called Irene upstairs. "Look," I said, "we ought to have a house of our own." "What do you mean?" she asked. "I mean we ought to live alone," I said, "away from your family." "But I want to live with them," she said. "Well, you'll have to choose between them and me," I said. "You don't have to do that," she said. "Yes, I do," I said. "Them or me?" "I can't leave my mother and Marie and Hoddy and George," she said. "All right," I said, and I packed my bags and went to New York. I wasn't mad; I just had to get out.

I rented a room at the Salmagundi Club and a studio at 80 West Fortieth Street. The first few weeks everything was fine. I had convinced myself that I was in the right. And one evening while I was visiting a friend who had a studio in the same building, we heard a rumbling in the wall. "Say," said my friend, "that must be the dumb-waiter coming up. I discovered it when the painters scraped off the wallpaper. Let's see what's on it." We went over to the wall and he opened a little door. Pretty

soon up came the dumb-waiter: three open shelves loaded with bottles of good liquor—champagne, scotch, French wines. "My Lord," I said as the dumb-waiter passed slowly up the shaft, "look at that, will you? Where do you suppose it's going?" "I don't know," said my friend, taking one of the bottles of champagne, "but let's not let an opportunity like this pass unmolested." A couple of days later as we were sipping highballs from a bottle of scotch purloined from the dumb-waiter, my friend suddenly put down his glass. "I know where it's going," he said. "Texas Guinan runs a speakeasy in the penthouse. She must store her liquor in the cellar." "You must be right," I said. "Supposing she catches us?" But she didn't. The elevator boys asked us if we knew anything about the dumb-waiter, but we said no, not us. And short of searching all the rooms, there was really no way to apprehend the bottle snatchers, for the dumb-waiter ran through all the studios from the cellar to the penthouse. And then, my friend and I were never hoggish about it. Just every so often, say when friends dropped by, we'd wait until the dumb-waiter rumbled up the shaft and then, opening the little door, say, "What'll you have?" and take a bottle.

So, as I say, the first few weeks passed off quite comfortably. Then I began to go into restaurants and order dinner and leave before the waiter brought it to the table. And I didn't sleep very well. I'd wake up in the middle of the night, dress, and walk around Central Park, disturbing the pigeons and commiserating with myself. You're a fool, I'd say to myself, but what are you going to do? You can't go back with your tail between your legs like a kicked cur. But you're miserable. So what are you going to do? I did nothing. Oh, I worked during the day—a *Post* cover, an Edison Mazda ad—and I'd call up Irene and ask her to send me some of my paints. And one day Joe Leyendecker told me I was looking pretty bad, sort of all yellow and green, and why didn't I get some exercise? So I joined the YMCA and three afternoons a week I threw a medicine ball around with a group of portly businessmen. But that didn't last long. I was sitting in the steam room and one of the businessmen, a huge walrus of a man, asked me, "What the devil are you doing here?" "Reducing," I said. "Reducing?" he said, looking at my skinny legs and body. "Are you kidding?" I quit the next day. It just seemed that everything I did turned out wrong; every time I opened my mouth I made a fool of myself.

I drifted in a kind of haze of misery for four or five months. Then, just as I was about to go all to pieces, what with loneliness and worry and kicking myself for being such a fool, I came down with tonsillitis. I went to the hospital, Irene visited me, and after I had recovered we bought a house in New Rochelle and went to live there by ourselves.

It was a cheaply built, imitation English cottage—stucco and half timbers—which a builder had thrown up on Premium Point out among the millionaires' estates. All through the nights the house creaked and groaned as it settled into the swampy ground. Pretty soon a crack opened up in the wall of the stairway into which I could put my arm up to the elbow. During rainstorms water flooded the cellar and put out the furnace. And one day as I was eating breakfast I heard a queer crunching noise

and, looking out, discovered that I no longer had a front lawn, just a gaping hole. The lawn had fallen into the septic tank.

I could stand all that, though. What made me desperate was the resentment of my wealthy neighbors who felt that fashionable Premium Point had been desecrated by my house. They were furious at the builder, his house and, by extension, me. One neighbor, a Colonel Somebody, erected an eight-foot spite wall alongside my house. The lot on which my house stood was very narrow and the wall loomed up just four feet from my sun porch, making it like a dungeon—no light, no view.

So I decided to move out. But nobody would buy my house. Then Irving Hansen, who owned a fine house way up on the other side of town at 24 Lord Kitchener Road, offered to trade houses with me. I was flabbergasted. "I couldn't do that to you," I said. "You know what my house is like." "I know," he said, "but my mother lives in the next house on Lord Kitchener Road and I'd like a good neighbor for her. You pay me a little and we'll trade houses." I objected again (halfheartedly), he overcame my objections (easily), and we completed the deal.

I immediately made plans to build a studio onto the garage beside my new house. Dean Parmelee, a friendly architect, or rather, a friend who was an architect, and I decided that the studio should be early American in design. (The great antique craze of the middle twenties was at its height.) So that everything would be authentic, we visited the Wayside Inn in South Sudbury, Massachusetts, which had recently been restored by Henry Ford. There we did research and I slept (badly) in a bed Paul Revere had once slept in (as I remarked to the desk clerk the next morning, I could see why Paul Revere rode at night so much).

Then we started the studio. We used rough fieldstone for the outer walls. Inside there were rough beams and a hand-hewn, wooden-pegged floor and a wagon wheel with candles in it suspended from the ceiling. Set into the south wall was a large fireplace made of old bricks. A fake balcony jutted out over it and two bookcases slanted out from it, one on each side. I hung a Revolutionary War musket below the mantelpiece and set some quill pens, pewter mugs, a ship model, and an old clock on it. Inside the fireplace we installed imitation bread ovens and a crane from which dangled an iron kettle. All around the room I hung relics and antiques—powder horns, a brass bed warmer, an old bullet pouch, steer horns, mountain goat horns, et cetera. My wood box was a baby's cradle (I later discarded it; dumping wood into a baby's cradle struck me as gruesome). The furniture was all antique—a wing chair, a battered stool, a Windsor chair, a long tavern table, a grandfather's clock. About the only concessions Dean and I made to modernity was putting a big studio window in the north wall and my easel and palette table in the center of the room.

When we'd finished I discovered that my love affair with the antique had cost me twenty-three thousand dollars. Which made me think. Though I can't remember what I thought. Not much of importance at any rate, for I liked my studio and considered it extremely up-to-date in an antique way.

The best families of New Rochelle were organizing the Bonnie Briar Country Club. Irene and I were invited to be charter members. We accepted. And suddenly

Boy Photographing Self-Portrait, oil painting for *Saturday Evening Post* cover (18 April 1925)

Boy Painting Girl's Slicker, oil painting for *Saturday Evening Post* cover (4 June 1927)

we were going social. We attended parties almost every night. I made connections with a bootlegger (it was smart to have your own bootlegger). We joined the Larchmont Yacht Club. I took up golf. I didn't see my old friends much any more and we were no longer regulars at the bridge club we belonged to. I was getting to be a snob.

It was an amoral and yet curiously naïve world, that of county high society. Everybody drank quite a lot and partook of everybody else without much regard for marital distinctions. The only rule of conduct was that nothing was to be taken seriously. As long as you didn't fall in love or become self-righteous or slip off furtively for a weekend, whatever you did was accepted. It was all very simple. And very, we thought, sophisticated and continental.

Yet, on the other hand, the silliest things were done with a kind of high seriousness, pompous gravity. One summer while Irene was visiting her mother at Louisville Landing, I lived in a room at the Larchmont Yacht Club. Every day after work I'd change into white ducks, blue blazer, saddle shoes, and a yachting cap and go over to the club. One of my friends owned a thirty-eight-foot Victory Class sailboat, and I was a member of the crew. We'd polish the railings or paint the mast for a while, then change into evening clothes and meet at the bar for cocktails. Pretty soon, maybe, I'd say, "This is a good drink." Everybody would look offended. After a minute I'd catch on and blush, terribly embarrassed. I was a sailor; a drink wasn't a drink, it was "grog." Or I'd drop my pipe. "Oops, dropped my pipe on the floor," I'd say. Everybody would look offended again. A floor wasn't a floor, it was the "deck." And if, during a race, as I lay flat on the deck holding the jib rope, I said, "Gee, look at the beautiful sunset!" the skipper would growl, "Don't look at the damned sunset. *Watch that sail!*"

Clothes were vital. When I took up golf (the genteel recreation; the proper place to sign a contract was on the links; only primitives did business in their offices), I bought a complete golfing outfit at Brooks Brothers—tight, trim, tweed knickerbockers; a jacket which buttoned to the neck and had a tiny outside cash pocket; shoes with a long tongue flapping over the laces; a tweedy cap. All very British. I rather fancied myself in my outfit with my golf bag over my shoulder and my pipe between my teeth. I didn't show too bad a leg either, somewhat on the skinny side, perhaps, but straight and lightly muscled below the knickers. (To show a good leg— that was the big thing.) Afternoons I'd dress up and ride to the club in my canary-yellow Apperson Jack Rabbit, a racy roadster, my golf bag propped up on the back seat, my cap at a jaunty angle, the wind whipping my pipe smoke out behind me. Oh, I was a sport, make no mistake. I was right off the links at St. Andrews.

Then the Duke of Windsor appeared on some golf course attired in loose, baggy knickers which reached almost to his ankles. So all of us discarded our old knickers for ones like his and considered ourselves very aristocratic.

What could be sillier than the elephantine gravity with which we regarded our clothes? And I didn't even enjoy golf; it took too much time and bored me. Still, it was smart; an integral part of being fashionable. The right clothes; the right opinions; the right games. My new friends used to tutor me. "Get your hair cut," one of them

would say. "People don't wear pompadours any more. And part it." So I had my hair cut and parted it down the middle. "Oh, my God," said my friend, "don't part it in the middle. Down the side, man, down the side." I wore a stickpin in my tie. "No, no, no," my friend said. "Stickpins went out during the Civil War. Look here . . ." I did everything he directed. Religiously, for I was immensely flattered by the attentions of society. That's why I went along with everything. I got awful sick of golf and saying "deck" instead of floor and going to party after party. I don't mean that I didn't enjoy myself, but it was more being in S-O-C-I-E-T-Y than anything else. I suspended judgment and lived in a sort of fog of imagined grandeur. The Deacon of the Art Students League moving in the *best* circles with the *best*, the "county" people. Sure, my family had made our own ice cream when I was a kid, but look at me now— wealthy, sophisticated friends; a member of the Larchmont Yacht Club, the Bonnie Briar Country Club; the gay man about town.

At the time I didn't realize that I was probably taken up by society as a kind of curiosity or conversation piece. Someone once remarked to me, "They're not asking you to dinner, they're asking your reputation." "When you're over, there's something to talk about," another said. Though if I had been aware of this I don't believe it would have changed anything. I was overcome.

My work didn't change. I kept right on doing the same dogs and little boys and old men. Somehow the parties and promiscuity and liquor didn't penetrate deeply; my view of life as reflected in my work remained constant. Not through any conscious effort on my part. I was just lucky, I guess. Or it was too engrained in me to be affected by even my own foolishness.

And Irene and I were getting along well. She was socially ambitious. We went to all the parties and acted just like everyone else. We were really fish out of water, however. What happened later proved it.

In the summer of 1927 I went to Europe with Dean Parmelee and Bill Backer. I remember it as a sort of sunny, carefree interlude. When I boarded the *Aquitania*, carrying a fat new sketchbook under my arm, I sloughed off the rather frenzied life I'd been leading. Like a snake shedding its scarred and worn-out skin in the spring. I stood on deck sniffing the raw, fishy smell of the docks. I was going to sketch my way across Europe. Like an art student. To hell with deadlines, money, bills, the right flannel trousers, and the country club.

Pretty soon Dean wandered up from our stateroom. Short, stocky; prematurely white hair cut short, bristling and shining in the sunlight like a new shoebrush; square, bullneck, snub nose, merry little grin. A likable fellow. "Let's not miss a thing," he said, chuckling at the thought of our trip, "not one damned thing. London, Paris, Venice, Madrid. We'll live it to the *full*. Be gay in Paris, swank in London, romantic in Madrid. We're going to have *experiences*." "And I'm going to sketch everything," I said. "Yes," he said, "we'll live it to the *full*."

We watched the people coming up the gangplanks. Knapsacks, duffel bags, and straw suitcases: tourist class. Cameras, leather suitcases, and bon voyage baskets bursting with oranges, bananas, purple grapes: cabin class. Brief cases, pekingese,

and cigarette holders: first class. "Where's Bill?" I asked. "He's talking to some sailor over on B deck," said Dean. "The sailor's a Bolshevik or something and Bill's arguing about Russia with him. Geez, what an arguer that guy is!" "Yes," I said, "he certainly takes things to heart." "Here he comes now," said Dean. We watched him thread his way through the crowds on deck. He was short, even shorter than Dean; black hair parted in the middle; jet-black eyes behind small rimless glasses; strong chin and nose. His face always wore a look of intentness as if he were trying to figure out a complicated chess problem—slight frown, his eyebrows drawn down in the center; lips pursed. "Look," he said when he was still four or five steps away from us, "if we recognize Russia it won't mean we favor Communism. They're an established fact. We've got to learn to deal with them. It's no good hiding our heads in the sand like ostriches, is it? They're here. They're not going to vanish overnight like a head cold." Dean and I didn't say anything (neither of us was much on politics). "Well," said Bill irritably, "they aren't, are they?" "I don't know," I said. Dean grinned. "The world's going to hell in a rowboat and you don't know," said Bill, and he leaned on the railing and stared down at the narrow strip of dirty water between the ship and the dock. Then he laughed. "God save the King and Calvin Coolidge," he said.

That was Bill—intense, irritable, argumentative, alert, interested in everything: politics, modern art, kindergartens, slums, the price of beer. His family was extremely wealthy, so wealthy, in fact, that, as he used to say, there was no point in his trying to earn money, he had too much already. Probably that's why he took life so seriously, tried to do everything right. Always talking to someone, asking them about their jobs, trying to find out what made them tick, concerned, listening intently. And he used to argue with everyone. He'd spend half an hour over a nickel with a subway conductor. He used to explain, half jokingly, that that was the only way he could earn any money. Not that he wasn't just as determined as Dean and I were to have fun on our trip, miss nothing. It was just that he couldn't escape his position, his everyday life, as Dean and I could.

At first the *Aquitania* was a disappointment. Stuffy. We were traveling first class and most of the passengers were British. A grave lot, not much given to chumminess or small talk with strangers. Men discussing stocks and cricket; women playing shuffleboard. Stewards bowing and scraping before Lord and Lady Cunard. William Randolph Hearst playing cards with his bodyguard, his long, unhappy, horse face bent over the table. Bill, Dean, and I regretted our decision to go first class.

Then we met a Dr. and Mrs. Furniss from New York and initiated a continuous game of Beaver. When you saw a man with a beard, flick the thumb of your right hand across your mouth, slap it into the palm of your left hand and yell, *"Beaver!"* The first to do this scored a point. "And whoever has the lowest score at the end of the voyage," said Dean, inspired, "pays a forfeit." But there weren't many beards on board so we made up new rules. We shouted, "Beaver," when a woman's slip was showing, at pekingese, at bald heads, when hats blew off, when anyone said "banana" or "albatross" or "whale."

*Dog Biting
in Seat of Pa
oil painting
Saturday Eve
Post cove
(18 August 1*

And then one afternoon a notice on the dining tables announced a costume ball. Dean ran off to the ship's barber and rented a costume. When I saw it, "Nobody wears a costume on the English line," I said, "I've been abroad on the *Aquitania* before." "Don't be silly," said Dean, pulling on a billowing clown's suit of satin decorated with squares and triangles of scarlet, yellow, green, brown, and blue. "It's a costume ball. We're going to live it to the full. Come on. Make up my face." "You'll feel foolish," I said. But I whitened his face with chalk, rouged two large spots on his cheek, reddened his nose, and exaggerated his eyebrows and grotesqued his mouth with burnt cork. He put on his tall dunce cap and, pompons bobbing, strolled into the dining room. Two steps beyond the door he stopped. Oh, a woman or two had draped shawls about their shoulders; a couple of men had carnations in their buttonholes. But all the rest were in somber evening dress. Dean slunk to our table, where Bill and I and the Furnisses began to buy him drinks to ease his embarrassment. But he was miserable. "Maybe I should get out," he said. "You know, run. Change my clothes." "No," we said, "sit still. Here, have some more wine."

After a while the wine got to him. "I've got to visit the men's room," he said, and staggered off through the cold, aloof stares. Ten minutes passed. Then fifteen. "You suppose Dean's all right?" I asked Bill. "Maybe I'd better go see." As I passed the men's room on the way to our cabin I heard groans and curses. Apprehensive, I went in. Dean was standing in the middle of the floor, his arms up over his head, his face crimson, shouting and moaning and swearing. A very proper British steward was kneeling beside him, frantically running his hands all over the costume. "Help," yelled Dean when he saw me, "help. We can't find the zipper. Help." All of a sudden, *"Damn!"* he screamed, and fell over. He had to buy the costume; it cost him forty dollars. And so his night as belle of the ball ended. The next day he refused to leave our cabin. "Somebody'll recognize me," he groaned.

By the time we reached Le Havre, Beaver had overrun the ship. Tourist class was playing raucously; cabin class was enthusiastic but slightly reserved; first class (our little group excepted) whispered, "Beaver," behind their hands, grinning sheepishly. When the lighter hove to beside the ship to take off passengers for France, a great shout of *"Beaver,* BEAVER" shook the sky. The lighter's captain stood on the bridge, his great blond beard glistening in the sunlight.

Our contest was decided. Dr. Furniss had lost. "Quick," said Bill. "What's his forfeit?" For Dr. Furniss was leaving the ship. We saw William Randolph Hearst walking down the gangplank. "He's got to speak to Hearst," I said. "That's the forfeit."

We watched Dr. Furniss (he was a most distinguished specialist and quite dignified but he had a fine sense of humor) board the lighter and edge toward Hearst, who was standing on the foredeck with his bodyguard. "Come on, Doctor," yelled Dean. And just as the lighter pulled away Dr. Furniss stepped up and spoke to Hearst. The long horse face continued to gaze out to sea; the bodyguard moved between them.

The Sightseeing Furnisses, ink drawing for postcard, c. 1925

In England we toured the southeastern coast in a rented Rolls-Royce, visiting among other things a castle dungeon which had been converted into a laundry (that seemed a curiously fitting fate for a dungeon, though I've never been able to figure out quite why), and craned our necks around a booth at Simpson's to see the King of Spain and the Prince of Wales eating roast beef and Yorkshire pudding.

After a few days' practice I developed a quick sketching technique, a sort of shorthand. At night in my room at the hotel I'd carry the rough sketches through while the subjects were still fresh in my mind, adding little touches of water color here and there. I sketched the guards at the Tower of London, castles, curious characters I saw in the streets—a chimney sweep, rag merchant, apple lady.

Then we decided to go to France. "How?" I asked. "We'll fly," said Bill. Dean and I agreed. Another adventure. In 1928 flying in an airplane was an adventure; I'd flown once, Dean and Bill never. We asked around about planes. "Don't fly in a French plane," everybody said, "take an English one. The pilots are safer and so are the planes." But when we arrived at the airfield all the British planes were filled. "I don't know," I said. "Maybe we ought to take a boat." Then Bill figured out that the insurance companies who were insuring plane passengers based their policies on odds of 20,000 to 1, so we decided that it would be safe to take a French plane after all.

We fastened our seat belts and prepared for the take-off. The only other passenger was a white-haired, elderly lady dressed in a tailored tweed suit. Very high-class; cultured-looking. That was reassuring. The pilot, who sat with his back to us, started the engines. Roar, cough, rattle, sigh, silence. Same thing two or three times. Shouting between pilot and mechanics. Then the pilot turned around and said, "Messieurs et madame, the plane will not march. Another is prepare. Follow me." So we trooped across the airfield and climbed into another plane. The pilot started the engines. Roar, wheeze, rattle, sigh, silence. More shouting. The pilot left the plane. Fifteen minutes later he returned and led us back to the first plane. The engines were running. "It is repair," the pilot said as we fastened our seat belts. And we took off. I fully expected the motors to wheeze into silence at any minute. Dean and Bill looked rather shaken too. But the elderly lady didn't appear to be disturbed, even when the plane began to buck and pitch, jouncing us around in our seats. After a while it got rougher; the plane bounced through the clouds over the Channel. I looked at Bill and Dean. Their faces were the color of warm pistachio ice cream; my stomach revolved slowly. All this time the copilot was sitting on the floor with his back against the pilot's seat, reading a paperback book. Every so often he'd laugh uproariously, slap his knee, and read a few words out loud to the pilot, who would laugh too.

"Young man," said the elderly lady, drawing a small silver flask out of her valise, "I wonder if you would care for some of this." "What is it?" I gasped. "A bit of scotch," said the lady. "Thank you," I said, taking a short swig. My stomach settled quietly into place, and I handed the flask to Dean. Then Bill had a drink.

By now we were over Le Bourget. But the plane didn't land. Instead it circled over the field, bumping up and down. Fog. "Perhaps," said the lady, "we'd all better

have another drink." Still the plane circled, rattling and clanking, the wooden floor boards jumping up and down. The copilot, steadying himself with one hand, continued to read, laughing to himself.

An hour later when the plane finally landed (it had to; almost out of gas), we could hardly stand. We'd been banged around so that our legs were wobbly and our heads swimming. "Would you have a sip with us?" I asked the elderly lady, and the four of us staggered into the bar. There, after we'd regained our equilibrium, she told us that she was the owner and headmistress of a fashionable American girls' school at Versailles. We told her what kind of a trip we wanted and how determined we were to have fun. "Why don't you visit my school?" she suggested. "I think I've an idea which will fit into your trip beautifully. Will you come tomorrow?" Sure, we said.

The school was located in an old French château set amid formal gardens. There were at least a hundred girls, all very pretty, ranging in age from seven or eight to eighteen. As we were strolling about the grounds before lunch the elderly lady explained her ideas on education. "I believe that young girls should do as they wish," she said. "Within limits, of course, but I never want them to feel inhibited. That is why I have asked you to visit my school. I have a favor to ask." And she looked at us closely. "You see," she continued, "the girls will be very disappointed if they return to America without having seen the Folies Bergère. I know that very well but I have been at my wit's end to find a way to take them. For they must have male escorts." "You mean," I asked, "that you want us to take the girls to the Folies?" "Precisely," she said. "To dinner and the Folies. The girls will be overjoyed and I think you might enjoy it too. Of course, you will be my guests." I looked at Dean and Bill. "We'd love to," we chorused.

When the elderly lady announced at lunch in the dining hall that we three men were going to escort the school to the Folies Bergère pandemonium broke loose. Scattered hurrahs, a babble, a ragged cheer, then hip hip hurrah three times in unison.

A few nights later we met two busloads of girls in party frocks and frills outside Fouquet's, a very exclusive Parisian restaurant. After a hectic (for all the girls ordered some exotic dish and no two would have the same thing) but pleasant (for the girls were very well mannered) dinner, we shepherded the girls to the Folies Bergère. They were thrilled, cheering lustily at the end of every skit. And when, during intermission, they saw the ladies of the evening, *les prostituées de première qualité*, promenading in the lobby, their night was complete. It was a very happy bunch of unfrustrated girls that we loaded onto the busses afterward.

My sketchbook was filling up. And it was good stuff if I do say so myself (Dean and Bill said so too). I was carrying it everywhere I went (as a precaution, I'd written my name and address on the endpapers, both front and back, adding, "A huge reward will be given to the finder," in French, German, Italian, English, and Spanish). Dean and Bill never rushed me. They'd wait patiently until I'd finished my sketch. We wandered around the back corners of places to find good subjects. I did a wonderful sketch of a priest shaking out his cassock behind Notre Dame cathedral at sunset.

Late one night as we were strolling down a street near the Place de l'Opéra, Dean stopped before a restaurant. "Aux Belles Poules," he said, reading the sign above the door. "The beautiful chickens." "No," said Bill, "literally, it means *to the* beautiful chickens. A free translation would be——" "Oh, c'mon," said Dean, "let's try it." And he pushed open the door and walked in. "I think we ought to try Fouquet's again," said Bill. "This doesn't look like much of a restaurant." "Well," I said, "Dean's already inside. We can't desert him." So we walked in and stumbled over Dean, who was standing just inside the door, staring at the ceiling. "What's the matter?" I asked. And then I looked around.

It was a big room, garishly decorated and lighted. On a bench built into the walls all around the room sat maybe twenty girls, laughing, chattering, smoking, patting their hair. They wore high-heel shoes and carried large purses—black, red, green, yellow. And that was all—just shoes and purses. Not one had a stitch of clothing on.

"Oopf!" said Bill. "This isn't a restaurant." "Let's get out of here," I said, backing toward the door. But before we could escape, all the girls grabbed their purses, rushed over to us, and herded us to one of the little tables by the dance floor. Dean, Bill, and I tumbled into chairs. The girls crowded around. "You buy me champagne?" said one. "I sit?" suggested another, shoving the girl beside her. "You nice fellow," said another. "You got a smoke?" asked another, elbowing her way to the table. It was a melee. Dean, Bill, and I sat at the table all hunched over, in a state of shock. Then one girl wrested a chair from a girl with fuchsia hair who was waving her green purse in my face and sat down beside me. Two others wedged their way through the crowd and plumped down beside Dean and Bill. At that the rest of the girls went back to the bench against the wall.

"*Well!*" I said to Dean. "Yes," said Dean. Bill looked as if he had swallowed a ripe peach. "My name is Henriette," said the girl sitting beside me, "and thees is Marguerite and thees is Hortense." The girls smiled and bobbed their heads up and down. Dean, Bill, and I nodded dumbly. "You like champagne?" asked Henriette. "I get you some." The waiter came and went. "Nice, English, *chap*," said Hortense to Dean. "Skiddoo," said Marguerite to Bill. I glanced around the room.

The tables and dance floor were thronged—soldiers with their hats on, tourists, here and there a woman in street clothes. A gramophone blared dance music above a babble of talk and laughter. A soldier was whistling "Lillibullero" over in a corner. A girl wearing a sailor's cap was singing a French song. Glasses were clinking, champagne corks were popping. The room was blue with smoke and redolent of the girls' professional perfume. Whenever the door opened there would be a clatter of high heels as the girls rushed to greet the newcomer.

Suddenly, fissst-bang! went a cork and Henriette squealed, "Hurroo!" The champagne had arrived. Hortense poured out six glasses, and after a bit Dean, Bill, and I relaxed as the girls toasted *le bel accord* of France and America. They loved Americans, they said, Americans were *très gentils.*

*The
Deacon
goes society*

*Help Your Eyes
Do the Harder
Work They Have
to Do Today,*
advertisement
for Tillyer lenses,
1929

*Airtone Is
'Air-Minded,'*
advertisement
for Arrow Shirt
Company, 1929

Then I noticed that the package of cigarettes I'd laid on the table was missing. I asked Henriette if she'd taken it. "NON!" she said, very offended. "That's not very nice," I said. "I buy you champagne. I'll buy you cigarettes. But you shouldn't take things without asking." "*Ough!*" she said, getting red in the face and stamping her foot. "I am a bad woman, oui, but I do not steal. Never have I steal. NON! You can search me." And she jumped up and emptied her purse on the table. I apologized. "I didn't mean it," I said, "I'm sorry." "I do not steal," she said, subsiding, "non, never." She sat down again.

After a minute I heard Bill, in his serious, interested way, ask Marguerite how she had come to embrace such a queer profession. Well, it was the usual sad story. She had run off to Paris from a farm in Brittany and had her innocence beguiled by a dissolute wine merchant. "That's too bad," said Bill (rather naïvely, I thought). "It's not a very healthy life." "Non," said Marguerite, somewhat surprised. "That's a bad cough you have," said Bill, for he had noticed that she had coughed while telling her story. "Oui," said Marguerite. "You should get outside more," said Bill in a fatherly manner, helping her to some champagne. "Get some fresh air into your lungs. It's very unhealthy being cooped up in here. The air's bad."

"What do you say we take them out right now?" I suggested, grasping frantically at any way of getting out of the place. "Yes," said Dean with alacrity. "All right," said Bill. The girls agreed. We called the madam over. Of course, she said, it was not unusual, though there was a special charge. So Henriette, Marguerite, and Hortense trotted upstairs to dress.

Ten minutes later they returned, dolled up in very short, gaudy silk dresses and trim little coats with enormous, moth-eaten fur collars. (From the rear of Henriette's coat there flopped a fancy fur tail.) Bangles sparkled on their wrists, their spike heels beat a quick tattoo on the floor, and the flowers on their perky hats bobbed up and down as they flounced toward us, all giggles and fluster.

We taxied to the Bois de Boulogne, where we rented a rowboat. "Climb in," said Dean, "we're going for a row." The girls hesitated. They began to look worried. "Come on," said Bill, and we helped them into the boat and shoved off. Out in the middle of the lake the girls got scared; they didn't understand what was going on. "M'sieu," said Henriette, "you take us to hotel now?" "Oui," said Marguerite, "we give you good time." Hortense just looked frightened. "No, no," said Bill. "We're going to give you some fresh air. You like Americans so we're going to show you how American girls live." "You not sadist?" asked Hortense, trembling. "Of course not," said Dean indignantly. "You not going to drown us?" asked Hortense. "Never," I said. "We just want you to have some good clean air."

Well, after we'd rowed about a bit the girls got into the spirit of the thing and began to laugh and shout and splash each other. Then Henriette took the oars and rowed and almost fell overboard when she pulled mightily and missed the water. Marguerite rowed, and Hortense toppled over backward into the bottom of the boat, squealing. Then we landed and played hide-and-seek among the trees and pick-up-sticks and leapfrog.

"Now let's give them a real American breakfast," said Bill. So we crammed ourselves into a taxi and drove to a swank all-night restaurant on the Champs Elysées which served American food, stopping on the way at our hotel to pick up my sketchbook. And while Hortense, Henriette, and Marguerite ate pancakes drenched in Vermont maple syrup, and waffles, and fried eggs with bacon, bouncing in their chairs, giggling, squeaking gleefully, I sketched them. I don't think the dignified proprietor of the restaurant quite approved of our picturesque group.

When we left them at the door of Aux Belles Poules, they thanked us quickly and ran inside to tell the other girls about their outing.

The next day Bill, Dean, and I left for Germany. We sailed down the Rhine on a steamer, sitting on the top deck in the sunlight, sipping beer and watching the blue-green mountains slide by. At every castle we passed, a German choral society which was traveling on our boat would sing that castle's song, its *Lied*.

One night in Coblenz we awoke to the dull, persistent thunder of marching feet and, looking out the window, saw the dimly lit street filled from curb to curb with young men marching. There was no sound but the rhythmic tramp, tramp of their feet on the cobblestones. And it went on and on, rank on rank of dark-shirted, goose-stepping, silent young men. The next day we learned that it had been the Nazi party parading.

We left the Rhine at Wiesbaden and journeyed to Munich to attend a beer festival. At the Hofbräuhaus, a famous beer hall in an enormous cellar divided by massive stone arches, we matched songs with a group of students from Heidelberg University and drank beer brought to the table by busty barmaids who carried twenty steins at once in their huge red hands. After a while the students invited us over to their table and we taught them American songs and they taught us German *Lieder*. We sang "Way Down upon the Swanee River"; they sang "Old Heidelberg"; et cetera. Then we asked them if they would take us to a Heidelberg duel. Dueling had been outlawed by the government but we understood that it still went on clandestinely. The students said we were right and, yes, they'd take us to a duel.

A couple of days later we met the students in Heidelberg and they drove us to the old dueling inn outside the city. Down in the cellar of the inn, where the duels were held, they explained that a Heidelberg dueling scar was a mark of distinction. But it had to be the right kind of scar—in a certain place on the right cheek. "Like this," said one of the students, pointing proudly to his cheek, down the center of which from just below his ear to his chin extended an ugly red welt as wide as a man's thumb. Another student said we were lucky, a spite duel was to take place today; the duelists would not wear masks as they did during practice or friendly encounters. Then two young men entered. Their seconds bound padding around their chests, strapped their feet into stirrups attached to the floor about eight feet apart, and handed them long broadswords. And after some formalities which I didn't understand they began swinging their swords viciously at each other. The only way they could hit each other was to lean forward in their stirrups and lash out with their

swords, stretching so far forward that only their stirrups prevented them from falling over. The duelists grunted as they fought, their swords hissing through the air and clanking together. Finally one of them missed his opponent, the force of his swing carried his sword to the floor, and the other slashed him across the forehead. The duel was over. The seconds of the wounded man helped him into an old barber chair which stood in one corner of the room. The arms, headrest, and top of the chair were encrusted, clotted, with dark, dried blood. "Bismarck sat in that chair," said one of the students. "It has been used for years." A disreputable surgeon cleaned the duelist's cut and bandaged it. "If it had been a good slash," said a student, "one in the right place as we showed you, the surgeon would have rubbed salt into it to make a scar. One does not obtain a scar easily; the wound must be irritated and kept open. Then the scar lasts until you die."

Back in Munich we decided to take a walking trip over the mountains from Munich to Hall. We bought rucksacks and Bill and I outfitted ourselves in complete Tyrolean mountaineers' costumes—leather shorts with suspenders attached, embroidered jackets, stockings which reached from the calf to the ankle, and jaunty little hats with feathers in them. My legs were long and thin and Bill's were short and thick so we complemented each other. Dean refused to wear such a costume. (Later on that proved a wise decision, for Bill's and my knees got painfully sunburned.)

Then we took the trolley line to the last stop and started into the mountains. Right off Bill insisted that we walk at the regulation army pace—something like ninety steps to the minute. I objected. Bill got all excited and we had a fierce argument. "If we don't do the regulation number of steps," he said, "there's no use going on this trip. We might as well go back and sit in the hotel." "But we're not in the army," I said, "we're out for fun." "If you can't do something right," said Bill, "there's no point in doing it." And he set out at the regulation pace and pretty soon left Dean and me behind. Then the trail steepened. Dean and I rounded a corner to find Bill sitting on a rock, puffing. "All right," he said, "all right." After that we (and the terrain) set our own pace.

We walked, finally, for ten days—from Munich to Venice. Through forests where the sun dappled the rocks and the thick, soft layer of pine needles; through high mountain passes, the wind rattling in the stunted fir trees and whisking away the dust kicked up by our boots; over narrow trails where we were suddenly engulfed in a herd of sheep, bleating and bumping against our legs as they scurried by us down the trail, driven by an old man or a couple of boys. One day as we were climbing through a wood a giant of a man dressed in a worn Tyrolean outfit came striding down the trail smoking a great meerschaum pipe and carrying the carcass of a deer slung over his shoulder. Though we spoke no German, everyone we met was very cordial, shouting a greeting as they passed or telling us with much gesturing of *das wunderschein* which we must be sure not to miss.

Nights we stayed in mountain inns. One Saturday we came at evening up a steep pass to an inn. All the mountaineers from miles around had gathered in the inn's

common room to dance and drink. A husky barmaid dressed in a tight, swelling bod-
ice and wide skirt served us our dinner while the men shouted and banged their steins
on the tables, for she was their dancing partner. And after she'd finished with us she
danced with them, one after another, kicking up her skirts and slapping her round,
full hips and singing. Every so often there would be a fight and the barmaid would
stop dancing and, gathering up the steins, fill them again. Then the clock on the man-
telpiece chimed midnight. The barmaid shooed all the men outside. We followed
them out to watch them go. There was a crackling thunderstorm in the valley below,
but where we stood was bright with moonlight. The mountaineers, all drunk, stag-
gered, one after another, down a narrow, rocky path, disappearing suddenly into the
silver clouds of the storm.

All one morning we walked through torrents of rain, arriving about lunch-
time, soaking wet, at a posthouse. There we gave our clothes to the chambermaid to
dry and wrapped ourselves in blankets. The afternoon dragged on; we began to won-
der where our clothes were. We called the chambermaid and told her we wanted
them. She no longer understood English. We gestured frantically from our cocoons.
She continued to shake her head and stare at us blankly. After a while she closed the
door and left. And there we were, trapped without a stitch of clothing. She didn't
return our things until the next noon and, of course, charged us for a night's lodging. I
made some funny sketches of Bill and Dean bundled in blankets, though, so it wasn't
a complete loss.

For two days we walked with a bride and groom who were on their honey-
moon. They walked hand in hand, swinging their arms and singing Austrian folk
songs. They insisted we accompany them to Innsbruck and though it was out of our
way we did. As we approached the top of the mountain from which we would get our
first view of the city they made us shut our eyes and led us to the brink. "Now," they
said, and we opened our eyes and saw Innsbruck far below, the sunshine glistening
on the tiny church spires and the blue sinuous river; flags waving in the breeze,
specks of color against the brown roofs, and a castle off to one side on a spur of the
great mountains which rose steeply—darkly green—all around.

After two days in Venice we took the train back to Munich and then to Paris.
Spain was next. But we had one evening in Paris. "Let's go back to Aux Belles
Poules," said Bill, "and see how the girls are." The minute we entered, Henriette,
Marguerite, and Hortense jumped up from the bench and rushed over to us. "Oh,
m'sieurs," they shouted, "you have come back." The madam trotted over. "Eh, mes-
sieurs," she cried, clapping her chubby hands together, "nevair, nevair, in my whole
life have I heard of such an evening. Vous êtes très gentils, très, très, TRÈS gentils. You
did not take my girls to a hotel but out to the Bois for games. They tell *tout le monde*
about it." And she sat us down at a table and ordered champagne and dinner for six on
the house, babbling on all the while about our *magnanimité,* our *bonté de coeur,* our
noblesse, our *grandeur d'âme,* delighted at how nice we'd been to her girls. And we
were a hit with all the girls too. Henriette wanted me to take her back to America. Her

dream was to go to *les Etats-Unis* and work in Macy's. "If you take me," she said, "I be a good girl. Please take me to Macy's."

The next day we left for Spain. I sketched a bullfight in San Sebastián, the beggars on the cathedral steps in Toledo. My sketchbook was practically full. Dean, Bill, and I treasured it.

Then one day in Madrid I went to the Prado. I'd been sketching all morning and was tired, so I walked directly to the gallery where *The Topers* by Velásquez, one of my favorite paintings, hung, and sat down on the round, cloth-covered settee in the middle of the room to rest. After a minute I got up to look at *The Topers* more closely, leaving my sketchbook on the settee. When I sat back down I had a feeling something was missing. I looked around. My sketchbook was gone!

I dropped to my hands and knees and crawled all around the settee. Nothing. I ran into the gallery on the right. Nothing. No one. I ran back to the first gallery, looked under the settee again. Nothing. I dashed out to the entrance of the museum and asked a guard if anybody had left carrying a sketchbook. A black one, big, about thirty inches by thirty inches. No, he hadn't seen it. I asked the people leaving the museum if they'd noticed someone with it. No. I went to the office and spoke to the director. He alerted the guards. But I never found my sketchbook.

It wasn't the work I'd put in. Or lugging it all over Europe. But it was the record of our trip. And it had come to symbolize the trip. And I'd done it just for my own pleasure. No deadline; I wasn't planning to sell it. I still almost cry when I think about it. I've never lost anything I felt so bad about.

We drove to Gibraltar to catch our boat for home. But having two or three days to kill before the ship arrived, we decided to visit Tangiers across the strait in Spanish Morocco. At first we wandered about the city by ourselves, watching the horse-drawn honey wagons trundling slowly through the narrow, crowded, foul-smelling streets while people ran out of the houses and dumped buckets of sewage into the wagon, raising black clouds of flies from the top of the load; and the story-tellers squatting on street corners who told serials, picking up one night where they'd left off the night before; and the children sitting cross-legged in a circle around their teacher, monotonously reciting the Koran. One would doze off, still mumbling, and the teacher would whack a mat hung behind him, startling the child into wakefulness.

Then we hired a guide. His name was Mohammed and Mohammed was a rascal. He was a tall, dark-skinned, handsome Arab dressed in long white robes, sandals, and a turban. Right off he announced that for an extra dollar he was prepared to smuggle us into a sacred mosque where no infidel was permitted under pain of death. He led us through dark alleyways to a little door, then, signing us to silence, up a dusty stairway, across a hall in a rush, and through a cobwebby room. He drew aside a tapestry and we peeked into the forbidden mosque. Ten feet in front of us a guide was explaining the beauties of the mosque to a group of American tourists. Mohammed laughed, we laughed, and he immediately proposed a visit to the sultan's

harem. We rode on donkeys up a little path to the top of a hill above the city. There Mohammed dismounted and, flinging out his arms, said, "Lo, the sultan's harem." We looked around. "Where?" I asked. "Lo," cried Mohammed, pointing to a building at the foot of the hill, "the sultan's harem and his concubines." In the courtyard of the building there were about fifty women—some mowing the lawn, some washing clothes, others sewing or running after children. We were very disillusioned. A sultan's concubine mowing the lawn? Doing the washing? "He must be a decadent sultan," I said.

To complete our disillusionment, Mohammed showed us (for three dollars) how the Arab magicians did the rope trick. At dusk the magician builds a great bonfire beneath a tree, piling on quantities of wet straw to make it smoke. When the tourists arrive later that evening, the smoke hides the tree, a boy climbs the rope, the confederate lets down the rope, the tourists leave, astounded.

Then Mohammed offered (for an extra two dollars) to conduct us to a dance where all the beauties of the Arab world would be assembled. By this time we'd realized that Mohammed was a rascal, but we went along anyway just to see what he'd dug up. He escorted us to a dingy dance hall in a side street. There were two or three Arab women among the crowd of hostesses, but the majority were French prostitutes, too old and decayed to work even the streets of Paris any more. Mohammed laughed, we laughed, and he accosted one of the hostesses. So for an hour or two, while we sat at a table, Mohammed danced wildly about the room, his white robes flying.

The next morning Mohammed said he could arrange to take us to Tetuán, which was held by the Riffs in rebellion against the Spaniards. His fee would be thirty dollars because of the danger ("After all, *señor*," he said, "I have four wives at home") and we must give him sixty dollars for expenses. "All right," we said, "but you don't get your money until we return to Tangiers and we'll dole out the expense money as we go along."

We drove through the mountains until we came to a group of grubby-looking Spanish soldiers standing in the middle of the road beside a tent. Mohammed asked for fifteen dollars and we all got out of the car. While we talked to the soldiers Mohammed drew the officer in charge to one side. After a minute they shook hands, a soldier attached a white flag to our car, and we drove off into no man's land. We heard a few shots in the distance, but to all appearances the countryside was peaceful. Pretty soon we came to the Riff lines: soldiers in dirty white robes with cartridge belts over their shoulders standing under a tree. Money changed hands again and we proceeded to Tetuán.

The city was full of tall, rough-looking Riffs carrying rifles and pistols of every description—even matchlocks. But nobody bothered us. We ate a very good dinner at the principal hotel and walked around for a while. Every street was chock full of Riff soldiers squatting beside campfires. There was a constant rumble of gunfire from the direction of the front lines.

The next day we returned to Tangiers rather disappointed. The only untoward thing which had happened was that I had contracted a bad case of hives. As we

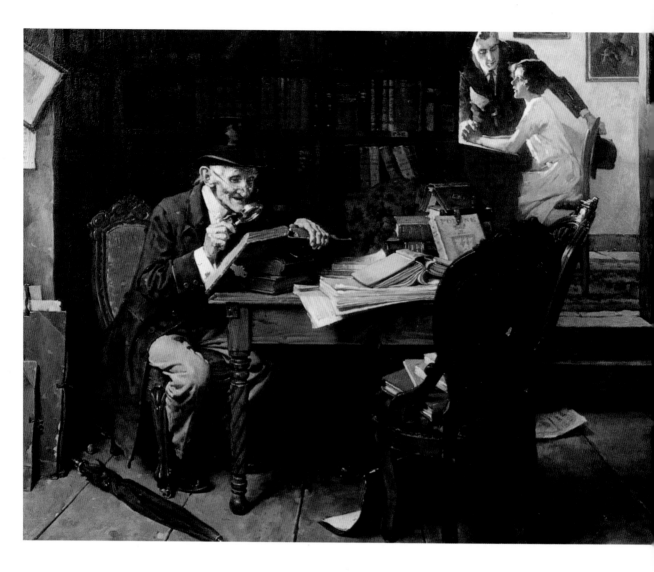

handed him his thirty dollars, Mohammed laughed, we laughed, and he went off to his wives and we to Gibraltar where we caught our ship for America.

As the ship entered New York Harbor all the other passengers pepped up and, as it docked, screamed greetings to their relatives and held up their children. We had no one to wave to; we'd thought it would be smart not to tell anybody when we were arriving. So we picked up our bags, taxied to Grand Central, and went home to New Rochelle. A flat ending to a wonderful trip.

The night after I arrived home there was a party at the Bonnie Briar Country Club. I didn't especially want to go. I had a lot of work waiting for me—some ads, a *Post* cover, a couple of stories to illustrate. "Do you want to go to the party tonight?" I

asked Irene at dinner. "Why, yes," she said. "Everybody's going to be there." So I put on my tuxedo and we went and stayed until four the next morning.

And there we were—right back in the merry-go-round of society. Parties almost every night. Sometimes Irene went to one and I to another. Sometimes we went together. But always with the same crowd. I planned my life around the evenings, scheduling my work so that it did not interfere with the parties. I would put off starting a picture until after a party. One night we caroused at the Country Club until midnight, then piled into cars and drove to a raucous affair in Westport, Connecticut, where all the guests were dressed in pink jackets and riding habits. And everybody was drunk and a woman fell into the swimming pool and I thought it was all very grand because I met F. Scott Fitzgerald, the famous writer, and heard him sing a rowdy song.

That spring I gave a party which cost me twelve hundred dollars. I had two orchestras—one in the studio, one in the house—and a canopy stretched between the house and the studio and five extra servants.

*he Book
Romance,
ainting for
stration in
ies' Home
Journal
ly 1927)*

It was an unnatural life for me. Irene, too, I guess, though she took to it more easily than I did. The people we were going around with were used to it. They'd lived with wealth and leisure all their lives and, having made the necessary adjustments and compromises, could handle it. I developed a principle: if you don't love anybody, I said to myself, if you don't become involved, then you won't get hurt. So I filled my days with work and my nights with parties and tried not to think about anything, succeeding pretty well. And after all I had my work and the habit of going out to the studio every day, which reminded me every morning that life wasn't just bootleg gin and pleasure. Then during that winter a queer thing began to happen. I noticed that my kid models, some of them sons or daughters of my Country Club friends, were shocked by their parents' behavior. Everything the parents did contradicted what they'd told the kids was right and honest. The kids had been told that you shouldn't drink too much, that you should save your money, be strictly moral, and yet they could see that their parents were drinking too much and throwing money around and not troubling themselves about morals or marital distinctions. When the kids talked about this they acted sort of bewildered.

But I was too far involved by this time. Nothing short of a catastrophe of some kind could have jarred me back to my senses. Besides, I had nothing to fall back on, no firm ground under my feet. My work kept me sane, but it couldn't do more than that. And after a while the parties and wildness even began to mix with my work. I'd delay a job for two or three days because it meant tiring myself or sticking to the easel and not attending some affair at the club. Then in the summer of 1929 I went to Europe with three couples. Again Irene stayed at home. In Europe we did all the right things. We stayed at the Ritz in London and the George Cinq in Paris. We visited the right night club on the right night. (I remember that you were supposed to go to the Embassy on Thursday; it was very vulgar to go there on any other night.) We went to the tennis matches and attended a party in a British lord's flat dressed in top hats and tails and carrying canes. I was living off the top. One day in Paris I said,

"Let's go to the Louvre." And somebody replied, "We've been to the Louvre." I didn't consider that a stupid remark. It was true; we'd been to the Louvre. Why go again?

That trip was the culmination of my career as a pseudo playboy. I thought I was at last really *in society*. I wasn't a hanger-on any more. I was one of the best people.

When I returned to New Rochelle everything collapsed. Irene asked for a divorce. She had fallen in love with someone else.

Looking back on it, I don't think I was surprised. I'd known for a long time that we weren't suited to the sort of life we were leading. I'd realized that something had to crack before too long, though whenever I'd thought about it I'd put it out of my mind, covering it up, not wanting to face it. But if I wasn't surprised I was hurt. It was as if my best friend had suddenly turned on me. I kept asking Irene, "Are you sure you want a divorce?" And she kept saying yes. And yet all the time I wanted her to say yes. One night we were in the living room and I asked her again if she was sure. "Yes," she said. "How can you leave all this?" I demanded, waving my hand at the furniture and then taking up a Royal Doulton figurine from the mantelpiece. "Can you really give all this up?" And I thought dimly, Don't say no. "Yes," she said. So I threw the figurine at the wall.

A few weeks later Irene went to Reno and I moved out of the house and into a studio apartment in the Hotel des Artistes on Sixty-seventh Street off Central Park West in New York City.

13

Mary

I T WAS a spacious apartment—two-story studio with a library, dining room, bath, and kitchen opening off it and a balcony with two bedrooms and another bath. I had an interior decorator in and she painted and made curtains and put up scalloped wooden valances over the windows and carpeted the stairs, bedrooms, and library. Then I moved in my furniture from New Rochelle, taking some from the studio and some from the house, and arranged it with great care, the decorator helping me. The first morning when I came out on the balcony from my bedroom and saw my easel and my palette table with the tiny blobs of paint set out around the edges and my chair grouped in the center of the studio before the wide, two-story window, I said to myself, This is the life for me; no more mess; you get involved and you get a mess; I haven't any ties and that's the way I'll keep it. And I skipped into the bathroom and shaved, whistling, then downstairs and prepared my favorite breakfast—shredded wheat and bananas—which I ate in the library, reading *Gentlemen Prefer Blondes*.

Afterward, because it was a sort of celebration—my new apartment and no bother or worries—I put on my jacket and walked through Central Park, admiring the sparrows' twitterings and the sunlight on the gray sidewalks and the babies being wheeled about in carriages by nurses wearing starched white uniforms. Then I strolled over to Dorlan's Livery Stable just down the street from the Hotel des Artistes and arranged for riding lessons. The riding habit I'd ordered at Abercrombie and Fitch wasn't ready yet, but I wanted to get started. For, you see, I was a bachelor again and still young and I was going to be fashionable, carefree, sophisticated, and gay. I had no illusions; I'd work and keep free of entanglements, which only led to messes and disrupted things for everybody concerned.

A week or so later my custom-made riding habit arrived. Handmade Italian boots, tan breeches, tweed coat with long skirt, black derby with a cord on the back which I hooked to my coat collar, light gray stock held in place by a horseshoe pin, leather riding crop. As I strode to Dorlan's, switching my boots with my crop, I felt I was the genuine article, a real horseman—the squire riding to hounds. Though I think the hounds, if they had been there, and any horse but the gentle old plug I rode would have disowned me, for I was unsteady in my seat and posting was beyond me. When the horse went up I came down, gritting my teeth.

I dined with friends almost every night. I attended the theater. At first I lunched three or four days a week with Emil Fuchs, a portrait painter who lived at the hotel, and his coterie of distinguished friends. He had a taut, trim body and a lean aristocratic face framed by graceful white hair and a full, elegant goatee. He had been court painter to Queen Victoria and King Edward VII. Around his rooms—two stu-

dios like mine combined into one magnificent apartment—hung his life-size portraits of Victoria and Edward, his sketches of the royal family playing cards or croquet or walking in the gardens at Windsor Castle, his painting of Victoria in her coffin, her death mask which he had sculpted. On pedestals in the corners, before the great window and scattered among the tables and chairs about the enormous room, stood his white marble sculptures—a slave with manacled hands, a mother and child, a nymph, busts of Greek gods and goddesses. In cabinets and on the delicate end tables were curios and exquisitely fashioned dishes and objets d'art, all of which had been given him by lords and ladies or by Victoria or Edward or some member of the royal family. For he had been the pet of English royalty. During the First World War, after Edward's death, he had lost favor at court—partly, I heard, because of his Austrian birth and slight German accent—and had come to America.

When he painted, standing before his easel, Emil Fuchs wore a linen apron over his velvet smoking jacket and held an enormous palette in his left hand. Every morning before lunch he fenced on the roof of the hotel with a private fencing master. His luncheons lasted from twelve until two. There was always some deep topic to discuss: the future life or art and morality. The food and wines were excellent. He lived, all in all, in the grand manner, surrounded by luxury and everything that wealth could bring.

I was flattered by the standing invitation to lunch at his levees. At first I went faithfully. But after a while, in spite of my feeling that I was associating with the internationally great, I became bored. The luncheons were rather pretentious and Fuchs was rather pompous and condescending. Stroking his goatee, he'd deliver himself of some high-blown opinion on the moral fiber of our times. He presented me with an inscribed copy of his autobiography, *With Pencil, Brush and Chisel,* which had been serialized in the *Saturday Evening Post.*

Besides, I couldn't give up two hours in the middle of the day three or four days a week. I was just a poor hackneyed illustrator who had to work for a living. So gradually I began to attend the luncheons less often.

And then, after my fine start in my bachelorhood—the riding, dining with friends, the theater, my apartment—things had begun to go to pieces. I ate alone four or five nights a week, and it was a miserable lonely business, going into a restaurant and dining all by myself at a little table. I always went to the Schrafft's on Fifty-seventh Street across from the Art Students League and after a while the hostess got to know me and would inquire every night if the dinner was all right. I'd try to engage her in conversation, asking her about her job and how the food was prepared. She was always too busy to talk with me.

But at least there were people to watch at dinner. Breakfast was worse. I'd get up and go into the bathroom and start shaving. And pretty soon I'd notice the silence in the apartment. I'd stand still a minute, listening to the water gurgling down the sink drain. Then I'd walk out onto the balcony and look down at the studio, half expecting to hear a clatter of dishes and the whistle of a teakettle from the kitchen. But no, and I knew it, there was nobody there. I was all alone. So I'd finish shaving with the tap

water swooshing loudly in the silence, and then go downstairs and fix my breakfast, which I'd eat standing up at the counter so as to get through with it as quickly as possible. Afterward I'd pile the dishes in the sink with last night's dirty coffee cups and change into my riding habit.

By now the wiry, sarcastic riding instructor was letting me go out by myself. I'd ride across Central Park West and into the park, praying that it was a gentle horse. I could never be sure; the instructor was always trying me out with new horses. One day he said to the groom, "Give him that horse," pointing to one which had just been shipped in from Chicago. "He isn't wild, is he," I asked, wanting to go home and give it all up but hating to show I was a coward, "after three days in a boxcar?" "No," said the instructor, "he's all right." I looked at the horse; the horse rolled his eyes and pawed the sawdust. The groom helped me up and I set out. At Central Park West the traffic cop, whom all the riders tipped every week, stopped the cars and we rode slowly across, the horse prancing sideways a bit. That's all right, I thought, we made the crossing. But as we entered the park the horse suddenly turned his head, gave me a look of loathing contempt and, jerking his head down, set off at a full gallop. "Whoa," I yelled, "whoa!" The horse galloped faster. I dropped the reins and grabbed him around the neck. "Whoa up," I shouted. The horse paid no attention. We went around the reservoir, the horse churning up clouds of dust with his clattering hoofs, I hanging on, jounced up and down, rumpety, bump, bump, bump, my derby flying out behind me on its string. When the cop at Central Park West saw us coming he flung up his hands, the cars screeched to a stop, and the horse thundered across without pausing. At Dorlan's he pulled up short and I almost tumbled over his head. "Well," said the instructor, "back so soon? You've broken the record for the circuit. Congratulations." I slid limply off the horse.

Horses frightened me and they felt my quaking knees and knew it. They're so darned tall, I thought, and you can never tell what they're going to do next. It's like eating dinner with a madman; every time he picks up a knife you don't know whether he's going to cut you or his meat. And all the while you're on a horse, feeling his sides go in and out as he breathes, you don't have any idea whether he's suddenly going to bite you or rear up or run wild.

Yet riding was better than setting to work right after breakfast. I'd tried that. Putting the dishes in the sink and going directly to my easel. It was too much like being locked in a prison cell. I had to see people, hear something besides the scrape of my chair on the floor or the water dripping in the bathtub or the soft rasp of my brush on the canvas. And the dim noises of the street outside. That was what bothered me most about living alone—the silence. I'd go nuts if I didn't speak to someone before the maid came in at noon to fix my lunch. So I kept on with the riding, hating it.

Emil Fuchs was showing his paintings and sculpture at the National Academy galleries. I received an engraved invitation. When I arrived he was seated at a piano, dressed in white tie and tails, playing Chopin. At a long table nearby waiters

served champagne. I walked through the almost deserted galleries, looking at the huge portraits and admiring the skill with which they had been hung. I could hear Fuchs running through a complicated series of arpeggios back in the first gallery. The paintings are pretty conventional, I thought, passé really. All those plush velvet drapes and noble poses. Like very good imitations of Sargent.

I wandered back to the first gallery and had a glass of champagne and congratulated Fuchs on his show. A few people drifted in. It's queer, I thought, I wonder where everybody is. Then a friend who lived at the Hotel des Artistes came in and after a while we left together.

As we were walking back to the hotel, "There weren't many people at the show," I said. "What do you suppose happened? I thought there'd be a crowd. You know, the court painter and all." "My God," said my friend, "don't you know about Fuchs?" "No," I said, "what?" "Why," he said, "he hired the galleries himself. Thought if he had a great and comprehensive exhibition of his work he'd establish himself as the leading portrait painter. Get the Vanderbilts and the Astors. You saw his stuff. It's good but old-fashioned. He can't get the top commissions any more and he's too proud to accept any others." "That's not true," I said, " I see him bustling out of the hotel every morning with his paintbox, wearing his wide-brimmed hat. He's going out on a job. Every morning." "Sure he goes out with his paintbox every day," said my friend, "but do you know what he really does? He walks over to that drugstore near the hotel and sits in a back booth all morning, drinking coffee. Then he comes back to the hotel. You know how proud he is. He just wants to make people think he's still getting commissions, the only kind he'll take, the big ones. Poor old guy, he's trying to bring back a world that's dead. You go over to the drugstore some morning about ten. You'll see."

So I did and sure enough, there was Emil Fuchs, sitting in a back booth with an empty cup before him and his paintbox on the seat beside him. It must be awful, I thought, watching him fiddle idly with his spoon, when the world's changed and you haven't.

"I don't see how Fuchs keeps up his courage," I said to my friend when I saw him again (I'd invited him to breakfast). "Yes," he said, "and his show was a flop, you know. Almost nobody came. Nobody, that is, who mattered to him. He'd invited the Vanderbilts and all. They didn't show up. . . . But," he said after a minute, "Fuchs doesn't seem to mind it. He keeps on having his luncheons and fencing on the roof." "I'd crack," I said, "I wouldn't be able to stand it." "Me either," said my friend.

For a while I went to Fuchs's luncheon levees more often. Out of sympathy; I was just as bored as before. But then I quit going. My own work was beginning to give me trouble. It wasn't anything I could put my finger on, really, just a general all-around feeling of dissatisfaction. Nothing seemed to go right. I'd put the paint on the canvas and it would look all right, I couldn't see anything wrong with it, but still it wasn't good, it didn't seem to make a picture. So I'd mess with it some more, then throw down my brushes and go for a walk in the park. And there always seemed to be a lot of drunks slouched on benches or beggars asking me for a dime. Which would

*People Reading
Stock Exchange,*
oil painting for
*Saturday Evening
Post* cover
(18 January 1930)

tire me out and I'd go back to the studio and try to get the picture right. Finally I'd say, "Oh, the hell with it!" and finish it up the best I could and send it off.

Years later I discovered that in one *Post* cover I did during this period, the one of the millionaire, grocery boy, et cetera, looking at the stock exchange quotations— January 18, 1930—I'd sort of put three legs on the boy. I'd shown him leaning forward, his legs bent, his hands on his knees. But there was another leg, not bent but straight, in the back of his pants.

And I got that feeling that I was making an ass of myself all the time. I don't think I was (except with the riding and the futile attempt to become a man about town); I just felt that way. Like when I went to see Mr. Lorimer. Mrs. Riddell, the art editor, showed me to the door. "Norman is getting a divorce," she said. "Oh," said

Mr. Lorimer. "Why?" "My wife fell in love with another man," I said. "What are you going to do about it?" asked Mr. Lorimer. "Nothing, I guess," I said. "In my day," said Mr. Lorimer, "we'd have shot the man." That made me feel, quite unreasonably, like a fool, as if I were less than a man.

And then the riding was going as badly as, if not worse than, before. One day the instructor pointed to a horse and said: "Take that one. He's privately owned, but he needs exercise." "Is he gentle?" I asked. "Oh yes," said the instructor. "The only thing is he's liable to act up if he sees a blowing newspaper or a baby carriage. So watch him." When I heard that I almost refused to ride the horse. But I thought, Oh well; he'll just think I'm a cowardly fool as well as an incompetent. So I took the horse. And out on the bridle path with hundreds of cars streaming by on the asphalt roadway beside the path, what should come along but a bright blue baby carriage. The horse whinnied, pawed the air with his forelegs, and kicked up his hind legs. I tumbled over his head into a mud puddle. Rubbing the mud out of my eyes, I sat up and looked around for the horse. He was standing about ten feet from me, munching grass. I struggled up and started toward him. He snorted and trotted on a ways. I ran after him, calling, "Here, horse. Here, horse. That's a good fellow. Here, boy." Some cars stopped on the roadway to watch me. Somebody yelled, "Get a car, fellow, get a car." I chased the horse, which had begun to trot briskly along the path. More cars stopped. Several drivers honked their horns, laughing. "Here, horse," I said coaxingly, running after him and trying to brush the mud off my clothes and put my derby on at the same time. "C'mon, boy." That darned animal finally trotted all the way back to Dorlan's. The cop stopped traffic for him at Central Park West, remarking to me when I came along that "he was a spirited beast, make no mistake; and smart, too, crossed at the light, not up the block." Well, at least I was a comical ass and gave people some enjoyment.

But it was all I could do to keep going what with the loneliness and all. I'd come home late at night and, standing before the studio window, look out at the smaller buildings which abutted the hotel in the rear. I'd watch the wash hung out on lines flopping in the moonlight or some woman sitting in her kitchen drinking a cup of coffee. And I'd remember how Irene and I had always talked over the day's events at night before going to bed. I'd go up on the balcony and switch out the lights in the studio. And I couldn't think what I should do, how I could change things so I wouldn't feel as if I were crouched in the bottom of a deep pit all the time, staring up at a blank gray sky. I could give up riding, I'd say to myself, but that would only make the mornings worse. Or I could go to Europe. But none of my friends can go with me and it'd be worse without my work every day.

So I just stuck doggedly to the routine I'd established for myself and sank deeper into the swamp.

One Monday Marie, the maid who tidied my rooms and fixed my lunch, rushed into the studio, all excited. "Mr. Rockwell," she said breathlessly, "it's terrible. Awful. Mr. Fuchs has killed himself." And she put down her mops, brooms, and pail, dropped into a chair, and told me all about it.

Emil Fuchs had been found sitting on his balcony in a Sheraton armchair, his head slumped down on his chest, a pearl-handled revolver in his hand. There was a glass on the table beside him with a few drops of wine still in it and at the other end of the studio, on easels arranged in a wide semicircle facing the balcony, were all his portraits of Queen Victoria, King Edward, and the royal family.

"He must have planned it deliberately," I said. "Yes," said Marie, "but why would he do a thing like that, killing himself and all?" And she went into the kitchen and began to wash up my breakfast dishes, muttering to herself. I looked out the window. Two little boys were playing leapfrog on a rooftop below me. *The poor old guy*, I thought. And I could see him during that quiet Sunday morning, propping his huge portraits on easels and shoving them about until they formed a semicircle in front of the balcony. Then he must have dressed himself carefully, looping the sash with his medals on it over his shoulder, brushing his graceful white hair and goatee. And, taking from the mahogany cellaret a bottle of port wine which Queen Victoria had given him and from a cabinet the tiny pearl-handled revolver inscribed "To Emil Fuchs from Edward, Prince of Wales," he climbed the stairs to his balcony. And until noon he sat there, sipping the wine, looking at the portraits. And then he shot himself.

He shouldn't have done it, I thought, watching the two boys on the rooftop. They were wrestling now, their faces and clothes covered with soot. He was rich, I thought, and his reputation was secure. Could fresh commissions mean so much? What I didn't know—what Emil Fuchs had kept secret from his closest friends until he wrote his suicide note—was that he was dying of cancer.

I was absorbed, just then, in my own troubles. Living as a bachelor was misery. But I didn't want to get into another mess. I'd learned my lesson that way. So I just waited for something to happen, hanging onto the dry remains of my gay bachelorhood. I gave a tremendous party—all my New Rochelle society friends, business acquaintances, an orchestra, three maids, and a butler. The elevator boy and his girl friend danced for us. Very good, too. Terrific buck and wing.

About one o'clock when everything was humming, the art director of *Good Housekeeping* and a friend wandered over to me. "Whatta ya say, Norman?" said the art director. "Nothing much," I said. "How 'bout that series I was talkin' to you 'bout?" asked the art director. "The Life of Christ. You wanna do that series?" "Sure," I said, thinking he was pretty well lit, "sure, any time." "Good boy," he said, patting me on the shoulder. "Good boy, you're a pal." And he and his friend went off to the bar.

Several days later the art director came up to the studio with his editor. "Well, now," said the editor after I'd hung up their coats, "let's get down to work on the Life of Christ you're going to do for us. I believe one painting——" "Hey," I said, "I didn't know you were serious. I can't do that series." "Sure we were serious," said the art director. "It's impossible," I said. "The *Post* wouldn't let me do it. Besides, I've got commitments. I haven't time." "Now look here," said the editor. "You said you'd do it.

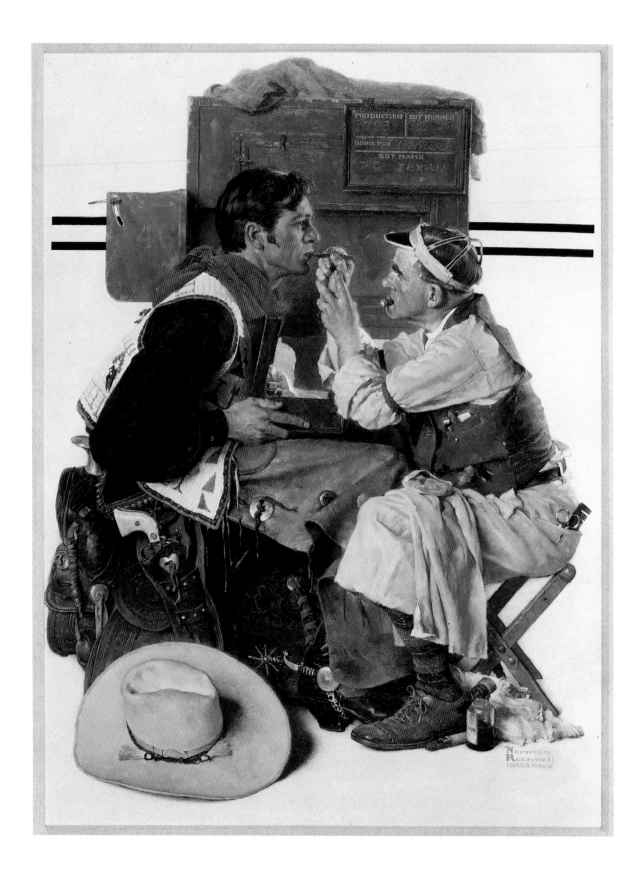

ABOVE: *Hollywood Dreams,* illustration for *Ladies' Home Journal* (July 1930)

OPPOSITE: *Gary Cooper as the Texan,* oil painting for *Saturday Evening Post* cover (24 May 1930)

We've got a witness. You better think it over. This is serious business." "No," I said, "I can't do it. That's flat." "We'll call you," he said ominously and they left.

The next day the editor called up and told me that if I didn't do the series *Good Housekeeping* would have to think about suing me. I grabbed my hat and coat and went to Philadelphia to ask Mr. Lorimer's advice. He sent me to the *Post*'s legal department. "That's Hearst," said the lawyers. "He likes to sue. They can't make you do the series but they sure will make your life miserable. The best thing for you to do is get out of town for a while. And fast. Don't let them serve papers on you."

I was scared but happy. Something had happened at last. Maybe it would bring a change. When the train arrived at Pennsylvania Station, I snuck out a back stairway, taxied home, and entered the hotel by the service door.

Now where would I go to hide out? Clyde Forsythe and Cotta, his wife, who were visiting me, said, "Why don't you come to California?" "All right," I said and we packed my bags and I crept out of the hotel and sidled onto the Twentieth Century Limited at 125th Street (and that's quite a trick to sidle onto a train with those high steps and all; you try it sometime).

All the way out on the train Clyde and Cotta told me about a wonderful girl they wanted me to meet. "She's a young schoolteacher," said Clyde. "Fifth, sixth and seventh grades—in Alhambra. She likes art and she knows your work and admires it. She's the daughter of an old friend of mine." "Oh," I said. "And she's pretty," said Cotta. "Not me," I said, catching the drift of their remarks, "I'm just going to work in the studio. I'm a bachelor and I'm going to stay that way." "Well," said Clyde, "we'll see. You ought to meet her anyway. You'd like her." "Okay," I said, "but no entanglements for me." Because, you see, what with the excitement of my escape from Hearst and the trip and the prospect of new surroundings, I'd become somewhat reconciled to my unmarried state and had forgotten, for the moment, my loneliness. And I was rather excited by California. I'd been there once before with Clyde and Cotta. They lived in Alhambra, which is near Hollywood, and the model situation was as rich and varied as a Christmas spicecake. All the extras, out-of-work actors—cowboys, old geezers, wizened crones, sleek matinee idols, lovely girls, plain girls. When I wanted a model—any type, it didn't matter—I just had to walk around Hollywood, looking at the people, and before long I'd find exactly the one I wanted. I'd done an illustration of a ham actor—decayed Hamlet type—an old woman and a girl—Mary Pickford type—sitting on a bench in a casting office. Right off I'd found the perfect man; decayed Hamlet types were as thick as bluebottle flies on a plate of molasses in August. I found an old woman with no trouble at all. And for the Mary Pickford type I got a girl who had won a Mary Pickford contest in, let's see, Nebraska, I think. Hollywood was full of them in those days. All over the country, towns and cities were holding contests to find the girl who looked most like Mary Pickford. Then they'd send the girl who won to Hollywood with a great fanfare—bands at the railroad station, cheering crowds. She was going to be a star. But of course ninety-nine per cent of the girls never got anywhere. And it was sort of sad. Because after their triumphant departure the girls didn't dare go back home as failures. So they'd stay on in Holly-

wood, working as drugstore clerks or seamstresses. The girl I used as a model told me she hardly got enough to eat. She had big blue eyes, blonde curls, pink cheeks—sort of delicately pretty like Mary Pickford. "But I'll get a break," she'd say, "one of these days. I take acting lessons and singing lessons when I can afford them. I'm not doing so well now, but something'll happen." And she'd smile cheerfully. I guess she just couldn't put aside her pride and crawl back home. And you couldn't blame her. Even too little to eat and sewing or clerking was better than admitting failure and returning to Nebraska a nobody with the station platform bare, only her mother and father to meet her. After that band and her picture in the local newspaper and the cheering crowds.

So, as I say, I was excited. Most of all by the change of scene and the prospect of new models, but a little, I have to admit, in spite of my protestations to the contrary, by the girl Clyde and Cotta told me about while I looked out the window at the gray industrial cities of the Midwest and the frosted stubble of the wheat fields in Kansas and the blue-green sagebrush and the white desert and, finally, after coming down out of the mountains, at the orange groves and the lines of green eucalyptus trees in southern California.

I met her at a dinner at the Forsythes' the second or third night after our arrival. Her name was Mary Barstow. She was wearing a bright orange dress and was extremely pretty and intelligent and charming. Well, I thought, I'll ask her out; it can't hurt; one date. But when I called her the next day she said no, she couldn't; she had a prior engagement.

That's that, I said to myself, she's not interested; and with reason; what young girl, pretty and smart and all, would be? In an old codger like me. Divorced, thirty-six years toward the grave, fourteen years her senior.

So I kicked the telephone stand and put her out of my mind and went back to work. I needed a rawboned, glamorous cowboy for a *Post* cover I was doing: an actor dressed in chaps, boots, and spurs having his lips painted by a hard-bitten little make-up man. I asked Clyde if he knew anyone who would fit the part. He took me to see a friend of his who was publicity director of Paramount studios. "Say," said the publicity director when I'd explained what I wanted, "how'd you like Gary Cooper? He's between pictures." "Sure," I said, flabbergasted. (Gary Cooper posing for me? Wow!) "I'll send him over in the morning," said the publicity director.

The next morning the door of the studio was quite literally darkened and Gary Cooper strode in. What a man! When I looked at him I actually *felt* my narrow shoulders and puny arms. He was a wonderful model and a very nice, easy guy. He was always playing some cute trick on Clyde and me—exploding matches, ash trays which jumped when you touched them.

But somehow I couldn't focus my mind on my work. Something—I didn't know what—was cavorting around in my head and distracting me. I'd put the piece of charcoal to the canvas and then forget what I was about to draw. So I'd stop and think a minute—Gary's nose or his hands?

Then Clyde asked, "Why didn't you take Mary out? I thought you were going to." "She didn't want to," I said. "Pled a prior engagement. You know what that means." "You dope," said Clyde, "she had to attend a PTA meeting. She told her mother she liked you." Well, for some reason I made a very good drawing that afternoon. And that night I took Mary to dinner. And two weeks later I proposed, she accepted, and we became engaged.

Then I began to show off. Impressing my young bride-to-be. Norman the cosmopolite, continental Norman loaded with money and savoir-faire. And Mary was impressed. (She just looked over my shoulder and said she wasn't impressed at all; she saw through me right from the start. But I don't believe it; she *was* impressed. And awed.) The Campbells, Mary's relatives, who were very rich, gave Mary and me a dinner. As a centerpiece for the table they had a rabbit sculpted in ice with a pink light inside. Ha, thought I, I'll go one better than that. So I gave a dinner and my centerpiece was an enormous swan sculpted in ice. And I was forever taking Mary to swank, expensive restaurants and to the theater. All of which thrilled her.

I might even have developed a swelled head. But luckily one day I visited a movie set with a publicity man. (I forget why.) Josef von Sternberg, a famous director, was seated in a chair on the end of a boom high above the ground. When one of his minions mentioned that I was on the set he stopped everything, beckoned me over, and had himself lowered to eye level. The publicity man led me right across the set and introduced me. "Meet Norman Rockwell," he said. "Not Rockwell Kent?" asked the director. "No," said the publicity man, "Norman Rockwell." "LIGHTS, CAMERA!" shouted Von Sternberg, "UP, UP!" And he zoomed upward. That took the starch out of my ego and set me straight and pigeon-toed again. (Incidentally, Rockwell Kent and I are often mistaken for each other. Not always with such soul-damaging results. Once Mr. Kent wrote me that he had just returned from abroad. At customs he had been expecting all sorts of trouble because the government was vexed with him over something he had done or said. The customs officer read his name on his customs declaration, smiled broadly, and said, "Oh, you're the artist does those wonderful *Post* covers. You go right on through.")

I wrote Mrs. Riddell that I was engaged to be married. A week or so later Thomas B. Costain, now a historical novelist, then Mr. Lorimer's right-hand man, called me from the Biltmore Hotel in Los Angeles and invited Mary and me to dinner. I laughed to myself; I knew what was going on. And at dinner that night Mr. Costain admitted it. Mr. Lorimer had asked him to look Mary over and see if she was the kind of girl I should marry. His report to Mr. Lorimer was favorable (I had received another OKGHL from Mr. Lorimer) and Mary and I were married on April 17, 1930, in the garden of her parents' home in Alhambra.

The next day we left for New York. Driving up Fifth Avenue, we saw a man wearing a top hat. Mary got all excited. People didn't wear top hats in California. So after we'd left our bags at the Hotel des Artistes, we went out to look for another top hat. And saw three of them getting into a Rolls-Royce in front of the Plaza.

14

Trials, tribulations, and Twain

THREE months after our marriage Mary and I gave up the apartment in the Hotel des Artistes and moved into the house on 24 Lord Kitchener Road in New Rochelle.

One day Mary received a letter from a friend in California. She was so sorry, the woman wrote, to learn that Mary was unhappily married. My cover of a husband and wife eating breakfast together, the husband absorbed in his newspaper, the neglected wife, for whom I'd used Mary as a model, staring wistfully into space, told her the story, the woman said. Obviously, if I could paint such a cover, Mary and I were unhappy together.

A ridiculous assumption. I'd thought the situation would make a good *Post* cover, that's all. So I'd done it. Mary and I were very happy. For, really, the first time in my life I had come to know what marriage is, what it means when two people love each other. It wasn't just that when I went in from the studio at night Mary was there and we'd have dinner together and talk over the day. She was interested in my work, not the money side of it but what I was trying to do with it. I could talk to her about it and she would listen hour after hour. She used to read to me while I painted. I guess I can't really explain it except to say that I felt I wasn't alone any more. I'd had friends before, people had been interested in my work. But no one had ever really cared about it as much as I did. When I'd had difficulties they'd given me casual advice. But now Mary—well, all I can do is repeat what I've already said: I felt I wasn't alone any more.

And I guess it saved me. I might have gone under without it. Because a few months after our marriage I began to have trouble with my work. Now that I was

settled again and happy, the frenzied life I'd been leading before the divorce, the divorce itself, and the lonely, rootless months in New York fell in on me like a ton of bricks. While I'd been living all that, caught up in it, I'd somehow, without knowing it, kept my work apart. Some inner defense had prevented it from reaching my work and tearing that down with the rest, so that though I had been miserable I had always had my work to hang onto. It had been the one sane element in my life. But now that it had brought me through, saved me, it collapsed.

Looking back, I guess the first sign of trouble was when I took up dynamic symmetry. Jay Hambridge, an illustrator with a scientific turn of mind, had decided that there must be some absolute rule or principle which, if strictly followed, would invariably enable an artist to paint a beautiful picture. One day in the British Museum he had noticed some strange diagrams way on the top of an ancient Greek column. He had deciphered them. They contained, according to Mr. Hambridge, the oracles' secret rules of beauty, which he called the theory of dynamic symmetry. By following this theory, anybody, even a clumsy amateur with hands like ham bones, could create a beautiful painting, pot, or portico. A masterpiece, claimed Mr. Hambridge, was nothing more than an algebra problem. You figured out a few things (I won't attempt to explain the theory; it is very complicated; besides, one shouldn't expend one's energies digging stale bread out of garbage heaps), adhered closely to the rules and, bingo, you had a masterpiece.

Some of my friends embraced dynamic symmetry enthusiastically. "You'd better use it," they told me, "or your work will crumble, die, go smash." So I painted a dynamic-symmetry *Post* cover (March 28, 1931). Unfortunately the *Post* is not a "dynamic" shape, and as there seemed no hope of persuading Mr. Lorimer to change the shape of the magazine to conform to the principles of dynamic symmetry, I gave up the theory after doing that one cover. And of course it's ridiculous to think that there is a formula for masterpieces. But that I even dallied with the idea shows, now that I look back on it, that I was beginning to doubt my work. I don't usually accept other people's advice so recklessly. But when I'm having trouble with my work—real trouble, not just the everyday difficulties and problems—I don't trust my own judgment and follow suggestions thoughtlessly because it's easier to do that than make my own decisions.

During the next few months my self-confidence deteriorated rapidly. I began to go out to the studio at all hours to look at my picture and reassure myself that it wasn't as bad as I'd suddenly remembered it to be. But when I'd get out there I couldn't tell whether it was good or bad. Or if I decided that it was bad I couldn't figure out why. I'd rub a head out and repaint it. No, that wasn't it. I'd change the color of a dress or shirt. No. I'd redraw a hand or eyes, repaint a face, try a different expression. No good, that wasn't it either. So, worn out, I'd sit there before the easel in the dead silence of early morning, hopelessly confused. And pretty soon, as the birds began to chirp sleepily in the trees along the street and the electric lights faded in the cold blue light of the dawn, I'd take the canvas off the easel and set it against the wall. I'd have to start over. I needed a new model.

*The Breakfast
Saturday Eve
Post cove
(23 August 1*

THE SATURDAY EVE

Volume 203, Number 8

August 23, '30

Fou

lin

5c. THE COPY
10c. in Canada

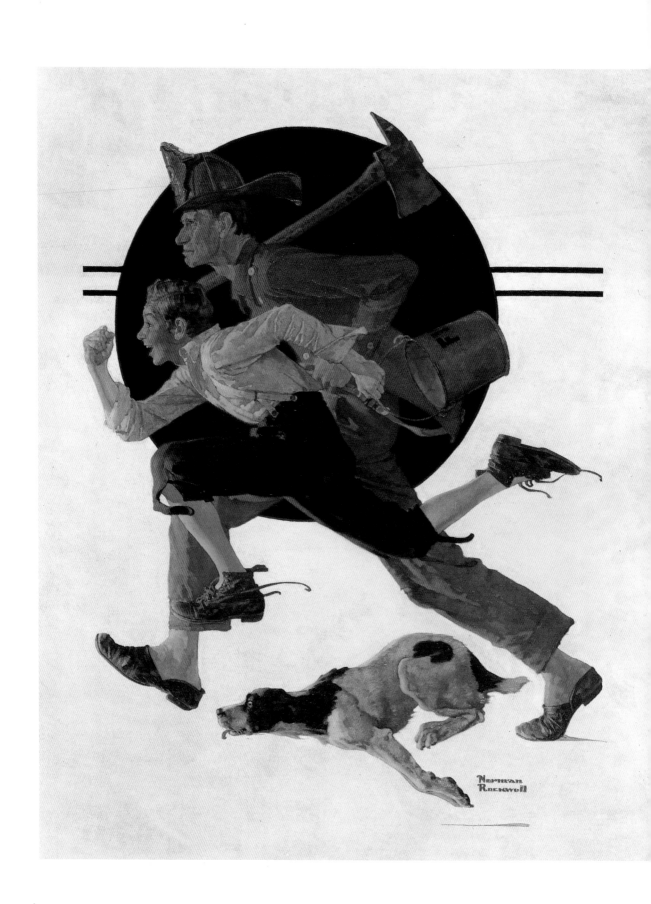

But that was just procrastination. It was easier to start the picture over than finish it. I painted one cover four times, using a different model each time, and then burned the canvases and discarded the idea entirely. I couldn't get a picture to jell in my mind. What I wanted kept eluding me. At breakfast I'd think I finally had it. I could see the completed picture in my mind. Then I'd go out to the studio and, after painting awhile, lose it, seeing only disconnected details—a hand, a mouth, a shoe. I'd get desperate and begin painting with no purpose, listlessly, filling in a piece here, a corner there, incoherently.

Then one day Billy Sundermeyer, one of my kid models, came into the studio and, seeing the same picture on the easel which had been there two months before, said cheerfully, *"Boy,* you're through, you're all washed up!" That scared me. I had to do something, anything, straighten myself out. My life was going down the drain. All I knew was painting and now that was failing me.

A week or so later Mary and I attended a play in which the hero, having trouble with his work, suddenly drew his savings out of the bank and went abroad. Going home, I decided that I'd better follow his example. Maybe a change of scene would help me. We put Jerry, our eldest son, born in 1932, in a wicker clothesbasket and took the boat for France. But it didn't do any good. I finished two pictures— wretched illustrations—during the eight months we lived in Paris.

When we arrived home I was in a worse state than before. I'd ask everybody who came into the studio what was wrong with the picture. "I can't see anything," they'd say, "it looks all right to me." "No," I'd say, "there's something wrong, I know there is; look closer." Finally I'd pressure them into saying, well, maybe the expression wasn't quite right. Or the girl's hands. After they'd left I'd paint the face or the hands again. I'd make change after change, hoping desperately that it would suddenly come right.

I tried using new brushes. I experimented with glazes. Not for long, though. I couldn't stay with anything—a picture, a technique. I tightened up, began to load my canvases with detail, spend hours on a shoe or a fancy belt. Nothing helped.

Of course I did manage to finish a job now and then. But every one dissatisfied me. And I couldn't get at the source of my dissatisfaction. It wasn't one thing— my drawing, say, or the colors. Maybe it was my ideas. Some of my friends asked, "Why do you always do the cheery, the sweet side of life? You know. Kids and Foxy Grandpas and funny things. Why don't you paint the seamy, sordid side? That exists too." So I did a picture of a gangster lying dead beside a bar, his face gray-green, a trickle of blood oozing out of his mouth and down his cheek to a pool on the floor, an automatic in his hand, a broken bottle beside him. "What are you doing that for?" asked my friends when they saw the picture. "Your work's fine as it is. We like it." And it was true; I couldn't (and can't) paint ugliness, the sordid side of life. It didn't look real. It was third rate.

All my stuff is third rate, I thought, down to the last brush stroke. But I don't know what's the matter. I'm doing everything just like before.

I'd talk it over with Mary. That was a comfort, to discuss it with someone who was really interested. But an artist works alone; he has to make his own decisions. And I couldn't; I was too bewildered.

So I did the only thing I could do. I painted, stuck to my easel like a leech. Whether I liked what I turned out or not. Every morning I went out to the studio at eight o'clock. I worked stubbornly until noon and, after lunch, until five or six o'clock in the evening. I stopped trying to understand why I was confused and dissatisfied. I don't know what's wrong, I thought, and I'll never be able to fathom it. I'll just paint, because it's all I've ever been able to do.

And in the end, after months of badly painted, out-of-drawing, lackluster covers, done one after another with a sort of dogged despair, I worked myself out of it. My self-confidence returned; I came up with several good ideas; I saw them as coherent pictures all the time I was painting them.

Even now I don't understand, really, what caused the trouble or how I gradually worked through it. Since then I've had other difficult periods. Each time, as I reached the point where I felt I was finished, at the end of my rope, I've managed to right myself. Always by simply sticking to it, continuing to work though everything seemed hopeless and I was scared silly.

About the time that I was dragging myself up from the depths I began to do a great deal of magazine illustration. And I think it helped me to recover my self-confidence because illustration has never been difficult, as compared with *Post* covers, for me. When painting a *Post* cover I must tell a complete, self-contained story. An illustration is merely a scene from a story. The characters and setting are fully developed by the author. So the illustrator has only to follow the story closely. His inspiration comes from the words, not, as in a *Post* cover, from himself. I don't enjoy doing illustrations as much as covers, but it's easier. I romp right through them. Still, I like to tell my *own* stories. It takes a lot more out of me, but when I've finished, it means just that much more. Not that I don't get an immense amount of pleasure and satisfaction from illustrating a truly fine story. I can remember how really thrilled I was when, in 1935, George Macy, the publisher of the Heritage Press and Limited Editions Club books, asked me to illustrate Mark Twain's *Tom Sawyer* and *Huckleberry Finn*.

Right off I decided I would try to do as good a job as I was able. After all, this was the chance of a lifetime. These were classics. I read through the books, making notes of which scenes would make good pictures. Of course certain scenes—for instance, Tom whitewashing his aunt Polly's fence—were required. And I had to space the illustrations evenly throughout the book; it wouldn't do to bunch all of them in one section.

I made rough little sketches of the scenes I wanted to do. Then I discovered that none of the illustrators—and there had been quite a few—who had done *Tom*

The Can...
Fontainble...
pencil draw...
1932.
A sketchb...
and one...
watercol...
(overlea...
survive fr...
Rockwell's ...
trip to ...
France...

sunshine

the Canal
Fontainebleau
April 9.

Paris Bridge,
watercolor,
1932

Sawyer and *Huckleberry Finn* had taken the trouble to visit Hannibal, Missouri, where Twain had lived as a boy. I'd go to Hannibal to get authentic details.

Driving up from St. Louis, I wondered if there'd be anything of Twain and his era left in the town. Maybe Hannibal had forgotten Twain and transformed itself into another slick chromium-and-neon metropolis. When I arrived I found that the exact opposite had happened. Mark Twain had swallowed up Hannibal. There was the Mark Twain Hotel, the Mark Twain barbershop, the Mark Twain meat market, the Mark Twain soda fountain. Everything was Mark Twain. And the house where he'd lived as a boy had been beautifully preserved. The little church he'd attended still stood, though it was no longer used. (I had to get the key from a farmer.) In fact the whole town had changed very little since his childhood. And there was a Mark Twain Museum, and about everybody you met let on to be a Mark Twain expert and would show you where he'd swum in the Mississippi, where he'd gone to school, where he'd smoked his first cigar. Some of this was apocryphal, but most of it was authentic. The people had studied up and gathered information from the old folks.

Now the great thing about illustrating a classic is that it is alive. When you read it the scenes—characters, setting, mood—jump right off the page, metamorphosed into pictures which are complete and perfect down to the last detail, the fly-specks on the walls, the worn, brown floor boards. Authors like Mark Twain have an eye for detail. Lesser men would say: Mary gave him a basin of water. Twain says: "Mary gave him a *tin* basin of water." That may seem inconsequential, but to an illustrator it's pure gold, because he has to attend to all such minutiae. That's what his picture is made of. And the details fit together, none jars. The great author sees the scene in his mind, he lives in it so to speak, so that as he moves around in it everything that is out of place or contradictory is eliminated and the scene comes to the reader whole and perfect and shimmering with life.

So I had all that behind me when I set out to illustrate *Tom Sawyer* and *Huckleberry Finn*. And in Hannibal I discovered something else almost as valuable to me. Twain had used Hannibal as the setting for his two books. And not just the general character of the town but the actual houses, streets, countryside. In Chapter Nine of *Tom Sawyer*, Tom climbs out of his bedroom window at night to meet Huck Finn: "a single minute later he was dressed and out of the window and creeping along the roof of the 'ell' on all fours. He . . . then jumped to the roof of the woodshed and thence to the ground." That's how Twain described it. When I visited the house he'd lived in, I was astounded to find that that was exactly what anyone would do if they left the bedroom by the window. The "ell" was there, outside the window, and below that the woodshed. And there had been a widow who lived on the hill above the town. (I met people who had known her.) And there was a labyrinthine cave not far from town. Almost every physical detail in the books was an actual fact, remembered by Twain from his boyhood.

I set about sketching everything—the houses, the church pews, the Mississippi at dawn and noon and dusk. One day I went over to the cave. The guide who conducted tours through it for devotees of Mark Twain told me I'd better come back

Pencil sk
of Robin
and Old
Cole fo
*The Lan
Enchantm*
illustrat
in the *Sat
Evening*
(22 Dece
1934

ABOVE AND OPPOSITE: Pencil and charcoal sketches for illustrations in *Tom Sawyer*, 1936

that night. During the day there were too many tourists; I'd be bothered and jostled. When I returned that night he took me a mile and a half into the cave to a place known as the Five Points. As I was getting out my sketchbook he asked, "You all set now?" "Sure," I said. "Okay," he said, "I'll be back for you in an hour." "You're not going to leave?" I said, suddenly aware of the black mouths of the five tunnels which led away from the chamber. "Oh yes," he said. "My wife's having a baby and I gotta stay with her." And he propped the acetylene lamp on a ledge and walked off.

I sat there for a full minute, looking around at the blackness outside the circle of light from the lamp. Then I grabbed my sketchbook and set to work feverishly. And pretty soon I'd forgotten I was alone a mile and a half under the earth. I discovered that all the other illustrators had been wrong. They'd painted the cave with stalactites hanging from the roof and sides. It wasn't like that. The rock formation was all horizontal, jutting ledges piled one on top of the other.

But in fifteen minutes I'd made all the sketches I wanted. As I put my pencil in my pocket something brushed my ear and squeaked. I jumped up, almost knocking over the lamp. There was a low clatter of rocks down one of the tunnels. Sounded like somebody creeping up. Suddenly I remembered that there had been a bank robbery in St. Louis that day. And it had been rumored in Hannibal that the robbers had fled to the cave. The lamp flame wavered. Shadows flickered on the walls. There was a splash of water down a tunnel to the right, a rattle of stones in one behind me.

Well, by the time that guide returned I had all the material I wanted for the picture of Tom and Becky lost in the cave. A surplus, in fact. I was overflowing with it. So loaded down with it that my knees were trembling.

After I'd been in Hannibal for a few days I had a sketchbook full of authentic details. I'd already decided what models I would use when I started to paint back in New Rochelle. Still, I was troubled. It was the clothes. How, in suburban, civilized Westchester County, was I ever going to get or even approximate Huckleberry Finn's costume? "Huckleberry was always dressed in the cast-off clothes of full-grown men. . . . His hat was a vast ruin with a wide crescent lopped out of its brim; his coat, when he wore one, hung nearly to his heels and had the rearward buttons far down the back; but one suspender supported his trousers; the seat of the trousers bagged low and contained nothing; the fringed legs dragged in the dirt. . . ." You can't buy a straw hat and make it look old by rubbing dirt into it. I'd tried that; it doesn't work. A hat has to be *worn* in the sun and sweated in and sat on and rained on. Then it'll *be* old. And look it.

I drooled when I saw the hats and jackets and pants which the farmers wore around Hannibal. Just right. But how could I get them? Impossible. Then one day as I was driving through the countryside I saw a man walking along the road wearing a straw hat in a beautiful state of decay—sun-bleached, ragged—and trousers patched and stained and tattered and boots down at the heel and out at the toes. I stopped the car. I was desperate. "Will you sell me that hat?" I asked the man. He stopped and looked me all over slowly. "Waal now," he said, scratching his head, "Ah don't rightly

know. Iffen Ah sell this here hat, I'll have to buy another. Don't see no profit in that." "I'll buy you another," I said, "and you can have my hat to boot. And I'll do the same with your trousers and jacket." The man looked at me shrewdly, sizing me up. "Store bought?" he asked. "Sure," I said. "Top quality?" I nodded. "Don't mind iffen Ah do," he said. And he climbed into the back seat of my car and I into the front, I pulled down the curtains, and we swapped clothes. Then we drove into Hannibal and I bought him a new outfit.

That afternoon I cruised around the countryside, buying old clothes. I even bought the hat off a man's horse. By evening I had a carload: felt hats, straw hats, suspenders, overalls, sunbonnets, aprons, gingham dresses, overcoats, vests. All old and rotten, battered, tattered, and splotched.

The next morning when I walked out of the hotel there was a crowd of people standing on the sidewalk, their arms piled high with old clothes. One man had four moth-eaten hats on his head. A little boy was all but buried under three overcoats. When the crowd saw me they all sang out at once. "Say, mister, lookee here." "This coat ain't fitten fur pigs, mister." "Quarter apiece," yelled a lady, holding up a dozen or so dusty aprons. "Y'awl won't find no worst in a rag bin," shouted another. *"Them's* old, mistah," said the little boy, dumping his overcoats at my feet.

I retreated back into the hotel, saying, "No. Thanks very much. I've got enough, thank you." By noontime the crowd had drifted off. All but the little boy. When I ventured forth he was sitting on the steps, his overcoats heaped beside him. So I bought them. I discovered later that the local newspaper had reported that there was a crazy man in Hannibal buying old clothes for high prices.

When I got back to New Rochelle and started painting the illustrations I congratulated myself. The clothes were perfect. With them backing me up and the authentic details I'd gathered, the illustrations glided along like a raft on the Mississippi in flood. The originals are now in the Mark Twain Museum in Hannibal.

If I have an illustration to do in a special setting I always try to get the feel of the place. In 1937 when the *Woman's Home Companion* commissioned me to illustrate a biography of Louisa May Alcott I went up to the Alcott house in Concord, Massachusetts, and made sketches of her bedroom and the attic where she used to write and the rats would come out on a beam and she'd talk to them. Sitting in her bedroom, where everything was just as it had been when she was alive, I had a real sense of the period; the old lamps and the lace curtains and hooked rugs and the Boston rocker took me back. And I think I did better illustrations because of it. I felt as if the door would suddenly open and Miss Alcott would walk in with a shawl about her shoulders and the unfinished manuscript of *Little Women* in her hand. It was the same sort of feeling I once had in the American Wing of the Metropolitan Museum when I noticed a sign saying, "These Rooms Must Be Cleared at *Twilight*" (not closing time or five o'clock but "twilight"); I felt that if I stayed I'd see colonial men and women come out of the walls.

Illustration for "The Most Beloved American Writer" by Katherine Anthony
(*Woman's Home Companion*, December 1937)

When I had a prize-fighting picture to do I went to St. Nicholas Arena and drank up the atmosphere. (And darn near choked—all that smoke and the smell of rosin and sweat.) To prepare myself for an illustration of a blacksmith's shop I spent a morning in a smithy in South Shaftsbury, Vermont, watching the blacksmith pound out horseshoes, the sparks shooting from his hammer.

Sitting in the studio, I may imagine a special setting and think it real and complete, but when I search out the actual counterpart there's always some little detail that I've forgotten and that will make the illustration ring true so that the reader, whether he's ever seen such a place or not, says immediately, "That's it, that's true." The sign outside the blacksmith shop in South Shaftsbury was such a detail. It read "Practical and Artistic Shoeing"; I'd never have been able to think up that.

And I've made it a rule never to fake anything, always to use, if possible, authentic props and costumes. I feel that no matter what the quality of my work is, at least it won't be dragged down by fakery, a jarring note in the costumes or props. (For the same reason I never skimp on materials; I always use the best—fine brushes, linen canvas.)

I had a terrible time finding a full-length, stand-up mirror once. Another time I dragged a motorcycle up the stairs to my studio. I had some props—notably an old milk stool and a straw basket—which I used over and over again. For one cover I bought a secondhand Victorian pump organ. After I'd finished the picture I had it restored and put in a corner of the studio. At dusk I'd play "Nearer, My God, to Thee" with chords. I'd sing away at the top of my voice: "Now the day is ohhhh-VER, night is drawing nigh; shadows of the evening steal across the sky"—pulling out the stops and pumping with my feet and swaying in my seat, the chords rolling majestically around the studio. Oh, it was grand! Then an evangelist came to town. He heard I had an organ. "I can save ten thousand souls with that organ," he said. So I gave it to him.

Nowadays authenticity in illustration (and television and the movies) consists of what everybody has decided should have been worn or used. No matter if it really was. People have got an idea in their heads and it can't be violated. Take the TV westerns. You'd think the West had an immense surplus of laundresses and tailors. Didn't anybody ever wear a dirty shirt or a ragged vest? The sailors on whaling vessels in the early nineteenth century used to wear shiny patent-leather hats when they dressed in their Sunday best. But you can't show such a hat. Everybody's ideas of sailors of that time don't include such hats.

I ran head on into this attitude in Hollywood once. I had a studio in the Los Angeles County Art Institute at the time. Because the telephone was such a long way from my studio—down a flight of stairs, across a hall and yard, up another flight—the secretary in the director's office used to take my calls and at the end of the day hand me a list. Well, every afternoon for about a week there was a call from a Mr. Goldwyn on the list. I didn't know any Goldwyn so I didn't bother with it. Then one

Oil painting
for the story
"Love Ouanga"
by Kenneth
Perkins
(*American
Magazine,*
June 1936)

day the secretary came all the way up to my studio and said, "I really think you should come to the phone and speak to Mr. Goldwyn." "Oh," I said, "it's probably some pest. I don't know any Goldwyn." "It's *Samuel* Goldwyn," the secretary said, "the movie producer." I went to the phone.

"Hello," I said. "How's the weather up there in Vermont?" shouted Mr. Goldwyn. "I'm not in Vermont," I said, "I'm in Los Angeles." "My God," shouted Mr. Goldwyn. "Why don't they tell me these things? Come to lunch tomorrow." "All right," I said, and we hung up.

At lunch in his private dining room, which was, by the way, a perfect duplicate of a dining room in a Cape Cod cottage—knotty pine walls, red and white checkered tablecloth, fireplace, Boston rockers, frilly curtains on small paned windows, and the waitress, who was a stout, sweet old lady and wore a wide gingham apron and served us delicious codfish cakes on quaintly patterned china (I heard later that Mr. Goldwyn was going in for Cape Cod simplicity that year)—Mr. Goldwyn said he wanted me to do a billboard for a movie he was producing of the Hatfield and McCoy feud. I asked him what sort of thing he had in mind. Lots of people, single figure, action? He took me down to the set where the movie was being made and introduced me to the principals. The girl, very beautiful of course, had on an extremely revealing dress. The man (Farley Granger if I remember rightly) was wear-

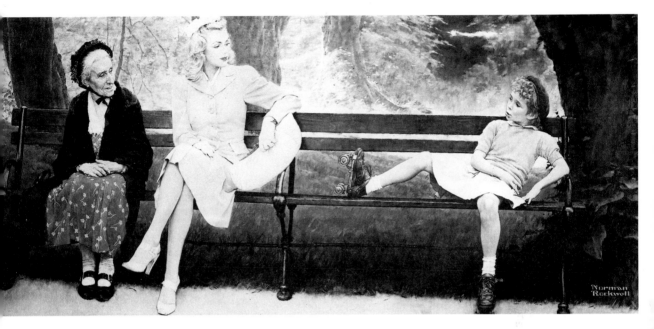

ing a picturesque felt shirt which laced up the front with leather thongs. "I'll be glad to do your billboard, Mr. Goldwyn," I said, "but I couldn't use those costumes. They're not authentic. At that period Southern mountain girls wore long gingham dresses tight at the neck and the men blue jeans and work shirts." Mr. Goldwyn was furious. "My God," he said, "I have six months of research by six men and *you* tell me the costumes aren't authentic?" So I never did the billboard.

Today much of the best illustration is done for children's books. The characters always go adventuring, they do things, so that there is something to illustrate, scenes which are pictorial and active. In the modern, psychologically oriented story nothing happens except in the characters' minds and you can't make a picture of that.

And too many limitations have been imposed on magazine illustration. Editors think of it merely as an enticement to the reader to read the story. Therefore it has to conform to the editors' ideas of what the reader wants. Some years back the *Ladies' Home Journal* conducted a poll and found that the vast majority of women want to read about young love. A while later they assigned me a story about an old bohemian etcher in Paris. I decided to do a picture of the etcher working over his etching press. That's what the story was about. I hired a model—an old fellow with a gnarled face—and located a wooden etching press. Then the *Post* editors asked me not to do the

Oil painting for the story "The Meeting" by Edward Stevenson (*Good Housekeeping*, September 1942)

illustration, because they wanted my time for covers. I returned the story and it was assigned to another illustrator. Several months later it appeared in the magazine accompanied by a picture of a very beautiful young woman being kissed by a very handsome young man. That's funny, I thought, it's the same title. But it can't be the same story. The only woman in the story I read was one who came to the door to see the etcher about posing for him. So I asked the art director about it. "The polls show women don't want to read about old men," he said, "they want young love." "But there's no young love in the story," I said. "Oh," he said, "we had the author write in just enough so we could make an illustration of it."

The one unforgivable sin in American illustration is to paint a woman who is not ravishingly beautiful. Even a normal-looking woman is barred. A friend of mine was once assigned a story entitled "The Ugly Woman." He stewed over it for months. Finally he figured that the only thing to do was show the woman's back. And you can't paint an ugly man either. Rugged, maybe, but pretty darn handsome all the same. I find it boring, dull, and silly.

Of course the illustrators aren't always absolutely faithful to the story. I try to find the best picture possibility. Sometimes I have to stretch a point. In the story there'll be something like: "He remembered when he was a little boy sleeping in the attic among the trunks. That was how he felt now." So I'll illustrate that—the little boy in the attic. It has nothing to do with the story really, but it makes a good picture.

I don't do illustration any more. To tell the truth, I've priced myself right out of the market. And then, frankly, I'm not too interested. I like to paint my own ideas, tell my own story.

One day I answered the telephone and a voice said, "This is the Public Relations Department of the New York Central. Where are you? We've had the Pullman car on the siding all day with a porter in it and the beds all made up and flowers in all the rooms. What are you going to do with it? We've done what you asked. Now when are you going to show up?" "You must have the wrong number," I said. "I don't know anything about a Pullman car." "Aren't you Norman Rockwell? The illustrator?" asked the voice rather testily. "Yes," I said. "Well, yesterday you came up here and asked that a Pullman car be put on a siding," said the voice. "You wanted to do the interior for the *Post*. You said you'd come around today." "Not me," I said, "I was here in the studio all day." "Say, what goes on?" demanded the voice. And he told me how this man, claiming to be me, had arranged for the Pullman car, saying he'd be back the next day to make sketches. "It must have been an impostor," I said. "Gee-zus," said the voice, "wait'll I catch that guy. Sorry to have troubled you."

Four or five days later the Cunard Steamship Line called me up. Same story. Where was I? I'd arranged to photograph a stateroom on the *Queen Elizabeth*. They'd fixed it all up. I explained to them about the impostor.

I couldn't figure the guy out. There was no money involved or possible advantage to be gained by doing these things. Once, a year or so after I'd started doing *Post* covers, I had received a letter from a lawyer in Texas. His client and her

family were instituting a suit against me for breach of promise. I'd spent many evenings at their home, promised the girl marriage. Now she was pregnant. That impostor had gained something by impersonating me. (My lawyer sent an affidavit proving I'd never been in Texas and we heard no more about it.) But this fellow who'd ordered the Pullman car and the stateroom. Why was he doing it? Did he get pleasure from giving people trouble? Did it give him a sense of power? Or was he off his nut?

The next week the public relations man for the Yankees telephoned me. He just wanted to check with me, he said. Did I arrange to take photographs in the locker room at the stadium? Ask that ten or fifteen ballplayers be there at ten tomorrow? "It's an impostor," I said, and I told him about the New York Central and the Cunard Line. "Good," he said, "I think we'll catch him. He acted sort of funny and I got suspicious and told him to come back today to complete the arrangements. I'll let you know what happens." That afternoon he called me back. The impostor had shown up all right and, when confronted, had admitted his impersonation. The public relations man had bawled him out, taken his name, and let him go. That was the last I ever heard of him.

These impostors chose to impersonate me because my name was generally known but my face wasn't. Another man made, for a year or so, a real career out of this sort of thing. I began to receive large bills for lodging, meals, and entertainment from hotels in widely scattered towns and small cities in southern Pennsylvania, Tennessee, Kentucky, and West Virginia. When I returned the bills unpaid with an affidavit proving I'd been home in New Rochelle all the time, most of the hotelkeepers, obviously chagrined at having been duped, made no reply. But after this had been going on for six months one man did write me about the impostor. He had arrived at the hotel with a sketchbook and a copy of my latest *Post* cover under his arm. When he signed the register, using my name, the desk clerk had put two and two together and inquired if he was, by any chance, *the* Norman Rockwell, the artist. The impostor had modestly admitted that he was. The clerk had told the hotel manager, who had asked the impostor if he would be so good as to give a little talk at the Rotary luncheon the next day. Why, yes, the impostor would be glad to. And he had made a very nice speech describing how he (or I) did a *Post* cover, illustrating his talk with numerous examples of my work and enlivening it with several humorous anecdotes of the artistic life. And then the local Kiwanis Club had given him a dinner and the ladies' club a luncheon and he had lectured the art club on "Commercial Illustration: Pitfalls and Principles." After a week or so he left town, asking that his bill be sent to his home in New Rochelle. My informant wrote that the impostor had been very well behaved and polite, quite a credit to me, in fact. The whole town had formed a good opinion of me and had expressed the wish that if ever I was passing by that way again I must be sure to stop. Many people refused to believe that the man had been an impostor.

The bills continued to arrive and I continued to return them unpaid for over a year. Then, all of a sudden, they stopped. As far as I know the authorities never caught up with the impostor. I guess he got tired of me after a while and took on someone else.

Nowadays people know what I look like as well as my name. I haven't had an impostor in over twenty years. People do say they've posed for me when they haven't. I remember once at a banquet in Wilmington, Delaware, a woman sat down beside me and said, "Oh dear, I'm so tired. Just worn to the bone. I've been posing for Norman Rockwell all day and he certainly does work his models to a frazzle."

Late in 1936 I attempted another quasi-modern *Post* cover. I have enough sense to know I can't do anything but my own kind of work. Still, now and again the pressure builds up and I begin to worry about being old-fashioned, outside the main stream of art in our age. Most times I rid myself of this feeling by experimenting with new techniques. But every so often I try a whole new approach. So, in 1936, I painted what I thought was a *Post* cover in the modern manner. I don't remember anything about it except that it wasn't very good. But my blood was up, blinding me to its lack of merit, and I took it down to Philadelphia and submitted it to Mr. Lorimer.

He stood before it for a long time, almost ten minutes, without saying anything, his burly shoulders slightly hunched, his big hands folded behind his back. Then, not turning toward me but still looking at my painting, he said, "I don't know, Norman. I don't know. Some of my editors tell me I should be more modern." And he stopped. I noticed that he was squeezing the fingers of his right hand in those of his left. "I'll tell you what," he said finally, walking over to the window and looking out, "you leave it here. Let me think it over. All right?" "Well, sure, Mr. Lorimer," I said, "sure." "Fine," he said and he seemed to shake himself as if to clear his thoughts of something troublesome. "I'll let you know."

I was shocked. I didn't particularly care about my cover any more. That didn't matter. I saw, now, that it wasn't very good. But what had happened to Mr. Lorimer? This was the first time he had ever put off a decision. And that bit about his editors telling him he should go more modern. It wasn't like him. He'd never doubted his own sense of what the readers wanted. At least he'd never shown it. What could have changed him? I didn't know, but it scared me.

A week later Mr. Lorimer rejected my cover and I burned it cheerfully, for in the meantime I'd got back onto my own track and my work was going well. Several months passed. I wondered now and again about Mr. Lorimer—his nervousness, his indecision. But everything seemed all right, and I got over being frightened.

Then Mrs. Riddell sent me a note, saying that Mr. Lorimer would like to see me. When I walked into his office I thought for the first moment that he wasn't there. Usually he greeted me standing before the two large windows behind his desk, powerfully silhouetted against the light. But the windows were empty. Then I saw him. He was seated to one side of the windows, lost in thought. I was halfway across the room before he noticed me. He rose and said, "Well, Norman, I guess I won't be around much longer." "What's the matter?" I said, and all of a sudden I felt kind of sick. He walked to his desk and glanced absent-mindedly at a manuscript. "I guess I'm not the right man any more," he said. I didn't know what to say. There were tears

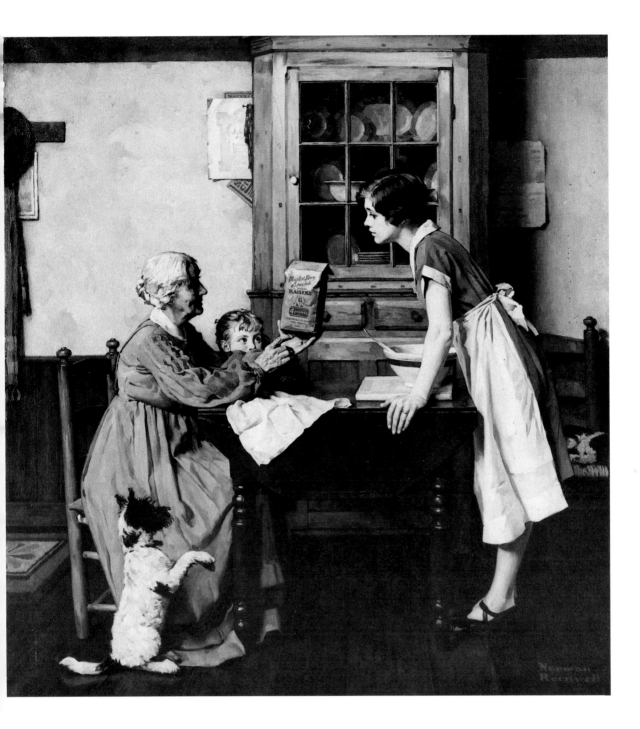

Market Day Special, oil painting for Sun Maid advertisement, 1930s

in his eyes. He had built the *Post;* it had been nothing and he'd made it a great magazine—his magazine. And now, after thirty-seven years, he was retiring. I mumbled something about being terribly sorry. "No," he said, "no. Perhaps I am growing old. Maybe a younger man . . ." And his voice trailed off. "You'll be all right, Norman," he said after a minute, "Wesley Stout is to take over."

I couldn't believe that this was the Mr. Lorimer I knew, and of course it wasn't. He was sixty-eight years old and visibly failing in health. I never saw him again. A year later, when he died, it seemed to me like the end of an era. All I could remember was how strong he had been, how certain of his judgment, and how kind.

At a dinner at the Society of Illustrators, William Oberhardt, a fellow illustrator, grabbed my arm and said bitterly, "I hear you've gone over to the enemy." "Hunh?" I said, faking ignorance because I realized right away what he was referring to and was ashamed of it. "You're using photographs," he said accusingly. "Oh . . . well . . . you know . . . not actually," I mumbled. "You *are,*" he said. "Yes," I admitted, feeling trapped, "I am." "Judas!" he said. "Damned photographer!" And he walked away.

The full weight of my guilt plumped down on my shoulders like a wet sack of grain. I *was* using photographs. I wasn't painting from the model much any more. I photographed the model and painted from the photographs. And I felt terribly guilty about it, partly because just six months before I'd been so vehement in my denunciations of illustrators who used photographs. Then it had seemed a low form of cheating, a dishonorable crutch for lazy draftsmen, a betrayal of artistic principles. "Are you going to be an artist or a photographer?" I'd asked myself and others over and over. I'd always photographed children under eight and unruly animals. But that was different; I could do that without losing my self-respect. They wouldn't hold still. But to use photographs for anything else? Never! It was like plagiarism to a writer. Oh, I'd been very stiff-necked about it.

But gradually, protesting every inch of the way, I'd given in. A slow process, but inevitable because the pressures were irresistible.

First there had been the model situation. In recent years it had deteriorated. The old ones had died off or taken jobs which paid better than modeling. Most of the younger ones refused to pose for me all day; they could make more posing for photographers, who paid ten to fifteen dollars an hour and needed a model for at most two hours. Three or four appointments a day at ten dollars an hour would net a model thirty or forty dollars. I couldn't afford to match that. Yet the bulk of my models had to be professionals. No non-professional, someone who made his living at a job other than modeling, could spare the time to pose for me. It took me four days to paint a single figure from the model, and no one could absent himself from his job for four days. So I was in a dilemma. Either pay a professional model ten dollars an hour, which was impossible, or find a way to do a figure in a few hours, which was also impossible. Unless—and I renounced the idea as soon as I thought of it—unless I used photographs.

Then there had been the invasion from the Middle West. Suddenly a whole army of new, young illustrators—among others, Al Parker, Emmet Clark, John Falter, Stevan Dohanos—had sprung up, challenging the established illustrators. These young fellows did pictures at weird angles—looking through girders, up staircases, down from rooftops—angles which it was difficult, if not impossible, to get working from the model in the studio. You had to use photographs if you didn't want to spend six weeks getting the perspective right.

This new approach was partly a result of the recent discovery of candid photography. Before that everybody had taken pictures straight on. Then they began to take them from strange angles. The young illustrators had adopted photography and the new angles which it made possible. They scorned the purists' attitude. "Heck," they said, "you don't drive a horse and buggy any more, do you? If photographs will help, why not use them?"

The art directors, a restless lot at best, agreed. One day Henry Quinan, the art director of *American* magazine, *Collier's*, and *Woman's Home Companion*, said to me (and I listened because he was one of the best art directors of his day), "Norman, it always looks as though the model and you are seated on chairs ten feet apart." "We are," I said. "You ought to break it up," said Mr. Quinan. "It's monotonous. Try some new angles, some new poses, positions. Paint the model from below. Or above." "All right," I said doubtfully, for though I could see his suggestion was good I couldn't see how I was going to act upon it.

I went home and mulled. That dread word—photographs—kept creeping into my mind, but I stubbornly quashed it. Finally, in despair, I constructed a six-foot-high, telescoping platform and persuaded the model to mount it. Then I worked looking up from below. For my next illustration I hauled my easel up onto the platform and posed the model on the floor. Down view. But it was a cumbersome arrangement and didn't go very far toward solving my problems. And one day I stepped back to admire my picture and nearly toppled off the platform. Obviously it was useless to continue using it.

So I asked Mr. Quinan how I could get the new angles, knowing full well what his answer would be. Sure enough. "Use photographs," he said, "a lot of the other fellows do." There. It was out. I thought it an immoral suggestion. I rejected it. Still, I didn't want to be left behind by the young illustrators. I knew survival hinged on the ability to accept new ideas and techniques. You either changed or you held fast, congealed, and were buried. And what about models? The same thing applied to that situation. I had to adapt myself or drown. So I hired a photographer and took photographs for an illustration. It was quite a wrench, I felt like a traitor to my profession, but I set my teeth and plunged in.

At first I used photographs only occasionally, trying to hang onto at least the shreds of my self-respect. But it was like taking a touch of morphine now and then. Pretty soon, before I knew it, I was an addict. A guilty, shamefaced addict, but an addict nevertheless. Because photographs cleared up all my difficulties immediately.

Shuffleton's Barbershop, pencil sketch for *Saturday Evening Post* cover (29 April 1950)

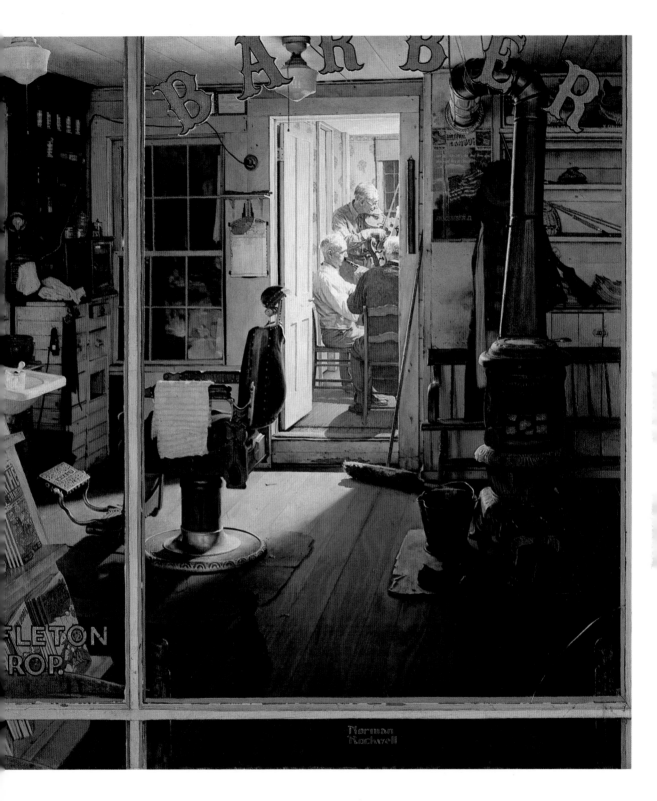

Shuffleton's Barbershop, oil painting for *Saturday Evening Post* cover (29 April 1950)

I could get the new, weird angles. I no longer had to depend on the professional models. Now anybody could pose for me.

Nowadays I use photographs for all my work. I still feel guilty about it. Whenever somebody comes into the studio I slip the photographs into a drawer. But I comfort myself with the thought that many of the great painters used aids to drawing: the camera obscura, the camera lucida, mirrors, et cetera. Holbein had a system for drawing on glass. Albrecht Dürer invented and presumably used a drawing aid. Toulouse-Lautrec and Degas worked from photographs sometimes. These men used the camera and the various other devices as *aids*, never slavishly. I think I do the same.

I don't copy photographs. Lots of people have the idea that when you work from a photograph you just tint it. If that were so, anybody could paint a *Post* cover, which they manifestly cannot. I use on an average of a hundred photographs for a single *Post* cover. They are guides, nothing more. The essential ingredient in every one of my finished paintings is me—my feelings, ideas, skills. Photographs, I repeat, are only aids. After all I did paint directly from the model for over twenty-five years. And I have continued to draw from models; for instance, for the past three years I have attended a sketch class every Tuesday at Peggy Best's studio here in Stockbridge, Massachusetts.

Working from photographs has many advantages. Take models, for instance. Now, if I want a bank president, why, I call up a bank president and ask him to come over to the studio for an hour or two. Before, I had to fake it, putting Pop Fredericks in a wing collar and business suit, trying to make him look like a bank president, which he didn't. Now I can get the real thing. I no longer have to depend on four or five professional models, painting them over and over again. I can use anybody—the butcher, the baker, the plumber, Mrs. Grundy, Grandma Wilcox.

And settings. There were details, accidents of light, which I'd missed when I'd been able to make only quick sketches of a setting. For example in Rob Shuffleton's barbershop in East Arlington, Vermont: where Rob hung his combs, his rusty old clippers, the way the light fell across the magazine rack, his moth-eaten push broom leaning against the display cases of candy and ammunition, the cracked leather seat of the barber chair with the stuffing poking through along the edges over the nickel-plated frame. A photograph catches all that. And I can pose the model in the actual setting, whether it's a church or the town clerk's office. Then I'm sure of the proportions, the light, the whole complicated business of relating the figures to the background.

And costumes. I don't have to be so particular about the clothes the model is wearing. Working from the model, I had found it impossible to paint a green sweater from a red sweater. It sounds silly, but I just hadn't been able to do it. So I'd had to hunt up the right sweater in green. A nuisance.

And expression. I work with the model (I never take the photographs) and when the smile has widened and the eyebrows are way up and the eyes are sparkling, the photographer snaps the picture and I have it. Before, as the hours passed, the

expression would sag or freeze into a grisly parody of glee. Same thing with poses. I'd had to settle right away for a fairly static pose. There was a limit to the number of sketches I could make; nor could I keep changing the pose. But now, with photographs, I can try endless variations.

So, all in all, I feel justified in using photographs. Not so cleanly justified, however, that I don't squirm and grin sheepishly when someone mentions it. But I don't think it's changed my work. I challenge anybody to show me when I started to use photographs. I've always been known as The Kid with the Camera Eye.

ABOVE LEFT:
Portrait of Jerry Rockwell,
charcoal, c. 1940

ABOVE RIGHT:
Portrait of Tommy Rockwell,
charcoal, c. 1940

LEFT:
Portrait of Peter Rockwell,
charcoal, c. 1940

15

Three o'clock in the morning

I WAS restless. I had lived in New Rochelle for over twenty years, and the town seemed tinged with everything that had happened to me during that time. The studio was somehow musty; the events of thirteen years were piled up in the corners—all the paintings I'd done, the parties, things I liked to remember and some I didn't—gathering dust. I had the feeling that a part of my life had ended. Mr. Lorimer was no longer editor of the *Post*. Most of my old models—Van Brunt, Harry Seal, Wilson, Van Vechtan—had either died or disappeared. It was time for a change.

Mary and I decided to go to England. That would do as a starter. So in the summer of 1938 we sailed with our three sons—Jerry, Tommy (born in 1933), and Peter (born in 1936). Having read in some travel book that a trip was more enjoyable if it had a definite purpose, I determined to visit all the English illustrators whom I admired so much. In London I asked an English friend how I should go about it. "I'm frightfully glad you asked, old fellow," he said. "We English, you know, are rather more formal about such matters than you Americans. You'd best write a letter requesting an interview." I returned to my hotel, wrote ten stiff and awkward drafts, tore them up, and despaired. Then the hotel porter told me that Arthur Rackham, who was first on my list, lived in Kent. What the heck, I thought, I'll call him up like the brash, informal American I am. A pleasant woman's voice answered. "Is Mr. Rackham in?" I asked timidly. "Ar-THUR," shouted the woman, "telephone!" I explained to Mr. Rackham that I was an American illustrator and had always admired his work and would it be possible to see him sometime? "Of course," he said. "I'll be coming down to London tomorrow. Why don't you stop over in the afternoon?" And he gave me the address of his London studio.

It was a rather small studio in a quiet mews, unpretentious, sparsely furnished with comfortable couches, a few chairs, and drawing boards. In one wall was a large window; the other three were for the most part bare. Rackham, who must have been about seventy, was a little bit of a man with a thin face and gentlemanly manner. He introduced me to his model, who was just leaving, for it was late afternoon and the light had dimmed. She was a tiny, wizened woman with wonderful scrawny hands (she looked like a Rackham drawing) and that day she had been posing for Toad of Kenneth Grahame's *The Wind in the Willows*, which Rackham was illustrating. She had posed for Rackham for many, many years. There was a pile of costumes, mostly old rags, in one corner of the studio. He'd drape a few of these rags on her to simulate a costume, any costume really, for she posed for everything—men, women, children, animals.

As I was telling him how much I admired his work Rackham asked me which illustration of his I liked best. "That one you did for Hans Christian Andersen's *Fairy Tales*," I said, "of the house with one wall cut away so everything that's going on inside can be seen." This delighted him. "You know I did that just a few years ago," he said. "When you get to be my age it's very discouraging to have people say they like most of all something you did at twenty. It makes you think you haven't progressed, just grown old." And he invited me to stop back the next afternoon for tea.

When I returned he presented me with a copy of the edition of Poe's *Tales of Mystery and Imagination* which he had illustrated. It was bound in white vellum and he had made a drawing and inscribed it to me in the front. After we'd talked a bit about American and English illustration (he mentioned that when he did anything for an American publisher he was paid about five times more than when he did something for an English publisher), I asked him how I should go about seeing the other illustrators. "I'll give you their addresses," he said, "and you just drop in on them."

The next day I visited Edmund Dulác. He was the direct opposite of Rackham—a suave, exquisite, continental man, residing in a fashionable apartment in a fashionable section of London. We sipped cocktails and I bought a couple of his drawings.

Then I went to see George Belcher. He had made a tremendous success doing drawings of charwomen, chauffeurs, taxicab drivers. In recent years he had begun to do paintings of these same characters and send them to the Royal Academy. The Academy had made him a member and asked for a self-portrait, which he was painting, when I visited him, by standing before a mirror. Though it was still early morning, he poured me out half a water glass of whisky. He was a portly, red-faced man with a gruff, hearty manner. I thought he looked the archetype of an English country squire, partly, I dare say, because he was wearing a pink hunting jacket.

After we'd talked a bit he said, "You a pretty good draftsman?" "Oh yes," I said, "I guess so." "Here," he said, handing me a pencil and a piece of paper, "make a little sketch of me." When I'd finished he looked at it for a minute. "All right," he said. "Paint the eyes into this portrait. I'd do it myself but I can't see without my glasses and I don't want to paint myself with glasses. Look like a fool with glasses." So I

painted the eyes in his self-portrait and am very honored to say that I now have two eyes in the Royal Academy—blue ones, I think, though I'm not sure.

We spent the rest of our stay in England at the White Swan Inn near Oxford. I bicycled about the countryside, usually with either Jerry or Tommy on the handlebars.

Those hours in the open air, riding down country lanes with the cows raising their heads to watch us pass and the warm dry smell of the newly cut hay and the birds singing in the hedgerows, recalling as they did my summers in the country as a child, made me receptive to the idea of buying a farm when, back in New Rochelle, Mary and I saw a real estate booklet listing houses for sale in Vermont. At any rate I jumped at the idea. My restlessness had not been cured by England. I had the feeling on our return to New Rochelle that it was beginning to run dry for me there, I'd got out of it about all I was ever going to. When I've lived in one place for too long ideas begin to come harder. Things go dead for me because I'm too familiar with them. They become a pattern. I need a change—new people, new surroundings—to set my mind thrashing again, stimulate me. That's why I take so many trips—to Europe, California (many of these I haven't mentioned).

So Mary and I drove up to Vermont to look at farms. We didn't plan to move there lock, stock, and barrel. Just a summer hide-out. In Bennington we met a couple who said they'd show us around. But it was the hard cider season and they began to stop at every roadside stand and pretty soon were wildly soused. I asked them to drop Mary and me at our car. "Oh no," they said, "we wouldn't let you down now." And we careened around the countryside all afternoon, the woman leaning out of the car window cursing passers-by, the man driving with a gallon of cider cocked on his arm. When we finally escaped I said to Mary, "I'm going back to New Rochelle. Vermont's too wild for me." But Mary, who has more sense, said, "No. It can't all be as bad as this. Let's try farther north."

In Dorset a flouncey real estate woman told us, "Oh, you'll *love* Dorset. There isn't a *single* afternoon you won't go to a cocktail party. And we have po-*lo*, and golf." I looked at Mary, she nodded, and we excused ourselves. "I agree," said Mary when we'd reached our car. "Let's go back to the peaceful suburbs. I've had enough of the raucous country."

We stopped for the night at the Colonial Inn in Arlington, a small town about midway between Dorset and Bennington. After supper we sat on the wide lawn before the inn, watching the dusk gather beneath the huge elms which lined the street and around the gray stone church and the old graveyard across the way. After a while stars came out in the luminous blue sky above the dark mountains and a wind soughed through the pine trees around the graveyard. We walked down the street past the Martha Canfield Memorial Library, the town hall, and the Arlington Inn to George Howard's General Store, where I bought a packet of smoking tobacco.

At breakfast, "Happy" Bottom, the proprietor of the Colonial Inn, told us that Vermont wasn't really all hard cider, cocktail parties, and polo. "Arlington's a nice

town," he said. "Why don't you let me call Bert Immen, our local real estate man. He can show you some beautiful places." Well, we guessed it wouldn't hurt to have another look.

That morning Bert showed us a farmhouse with an apple orchard, a river, two barns, broad fields, and sixty acres of land. "You see that island in the river there?" he asked as we stood in front of the house. "On it the only person killed in Arlington during the Revolutionary War was shot. He was apprenticed to the doctor who lived in that house across the river, in ruins now but once a fine mansion. The apprentice had run off and joined Ethan Allen's army at Bennington, but Allen asked all the soldiers to forage for cattle so the apprentice came back to Arlington to steal the doctor's cattle. As he was driving the herd up the river at dawn (he did that so there wouldn't be any tracks), the doctor came out of his house and, thinking the apprentice was about to draw a pistol, shot him. So you see the house is a historic spot, so to speak."

I looked over at the island and I could imagine the doctor running out of the house with his nightshirt flying and his wig askew, holding up his breeches with one hand and carrying his flintlock in the other. And the apprentice, startled, making a sudden movement whereupon the doctor had put his flintlock to his shoulder and fired. And the apprentice had fallen, perhaps, into the water and his blood had run into it, disappearing in the white foam and sparkle of the rapids. And the cattle standing over him, chewing their cuds; the doctor, aghast at what he'd done, splashing over to the island and picking the boy up, yelling for his wife.

Somehow the story added to the attractiveness of the place. (I admit it was more my imagination than the story, but let it go.) So at lunch Mary and I decided to buy. The next day we signed the papers. After arranging with a builder to transform the smaller of the two barns into a studio and make some changes in the house, we left for New Rochelle, all excited.

The winter dragged; we could hardly wait for summer. But after a time the snow changed to dirty slush on the sidewalks and the spring rains came, making the suburb dismal and gray, and finally the asphalt became splotched with soft tar bubbles, which meant summer had come, and we left for Vermont.

And that summer lived up to all our expectations. As we drove up the little dirt road past the broad river meadow where the hay was greening in the sun, our car loaded down with bags and parcels and Jerry and Tommy scrambling over one another to look out the windows, Peter chortling delightedly at the birds, I remembered how back in New Rochelle the leaves on the trees had been sort of limp with the heat and you could smell the tar from the streets. And then we bumped over a rise in the road and there was the house, white against the deep green mountainside, and the two red barns and at the bottom of the lawn the Batten Kill River. It formed a backwater there behind the small island. Perfect for swimming. Well, I thought, it looks like one of those potboilers my grandfather used to paint for the city trade.

Sweet pastoral peace. What I used to dream about when I was a kid playing in the vacant lots on Amsterdam Avenue. We've fallen into utopia.

And for a while it appeared that we had. I took long walks on the mountains, climbing through the orchard of gray, twisted apple trees and into the forest of birch and pine and oak. The deer started from the thickets, their white tails up. A red squirrel gave his sharp, stuttering cry as he scurried along the top of a stone wall which ran up the side of the mountain through the forest, crumpled by trees, overgrown with wild morning-glories. We picked blueberries on the crest of Bald Mountain, which somebody mysteriously burned off every year to improve the blueberries. And everyone had to turn out and climb the mountain to fight the fire, but no one complained. Though illegal, it was an institution, like the Fourth of July; the crest had to be burned off or there wouldn't have been any blueberries.

The kids swam in the river from sunup to sundown. And when I awoke in the morning and looked out the window I saw, not the crowded houses and neat hedges of New Rochelle, but the steep, forested side of Red Mountain with the black scar of Rattlesnake Rock high up it. And the Batten Kill, maybe brown and swirling among the trees on the little island after a rain, or clear and sparkling in the sunshine.

The people we met were rugged and self-contained. None of that sham "I am *so* GLAD to know you!" accompanied by radiant smiles. They shook my hand, said, "How do," and waited to see how I'd turn out. Not hostile but reserved with a dignity and personal integrity which are rare in suburbia, where you're familiar with someone before you know him. In Vermont you earn the right to be called by your first name.

But I soon realized that we hadn't discovered utopia.

Across the way, in a ramshackle house, lived a poor family—mother, father, five or six kids, and a grandmother. The kids played all day in the dirt under the two big maples in front of the house.

Once or twice a week I'd see old Hoddy Woodward shuffling along the road with his gunny sack over his shoulder. His faded blue overalls sagged at the seat, the cuffs dragged in the dust. His white hair draggled over his ears beneath a crumpled felt hat. But they said he worked hard when he had a mind to.

Sometimes on my walks I'd stop to watch a farmer pitching hay in a field. There'd be a boy bunching the hay into piles for him and another boy and maybe a girl stomping the hay down on the wagon as the farmer forked it up to them. And the horses would stand, lifting their hoofs and switching their tails over their rumps, until the farmer said quietly, "Gee-up, Dick, Prince."

I'd gotten to know Harvey McKee, who was an undersheriff. He was a small, soft-spoken man with white unruly hair and a black, drooping, handlebar mustache. But his size and manner belied his spirit. Some of the tales he told of jailing drunks and rowdies were hair-raising. After I'd studied him awhile and listened to his stories, I got an idea for a *Post* cover. Harvey, the sheriff, sitting outside a jail cell listening mournfully to a condemned prisoner playing the harmonica. I asked Harvey to pose for me. He said sure.

A couple of days later he turned up at my studio with a broken collarbone and a swollen hand. I asked him if he'd rather come back another time. No, he guessed he could pose, wasn't nothing serious. "What happened?" I asked, expecting him to say he'd been kicked by a cow or fallen off a horse. Well, it appeared that two Sandgate boys, husky reckless fellows, had got a girl in a deserted shack in the mountains. Harvey had gone up to rescue the girl and the two boys had thrown him down a gulley. At that a posse had been formed, led by Ken Wilcox, who was over six feet tall and must have weighed two hundred and fifty pounds, all muscle. The posse had surrounded the cabin and Ken had yelled for the boys to come out and give themselves up. They had answered by firing on the posse. So Ken had crept around to the back of the cabin, the rest of the men had hollered and thrown rocks from the front, and Ken had barged into the cabin and knocked the boys' heads together.

I'd go into a barn late in the afternoon and watch a farmer milk his cows. He'd sit on a little stool with his head leaning against the side of the cow and the milk would ring on the bottom of the pail and then, as it rose in the pail, there'd be only a hiss and gurgle. And after a while the farmer would get up and dump his pail into a large can and, shoving the cows apart so he could get between them, start on the next cow. It looked like hard work.

One night a fisherman was reported missing. The townspeople and farmers turned out to look for him along the stretch of river where he had last been seen. Early the next morning a farmer found his body lodged against the roots of a tree. His fishline had wound round and round his body as the swift current rolled it downstream. His face had been slashed by the rocks and his clothing torn. The farmers dragged him out of the river onto a meadow and called Dr. George Russell, the town doctor. Gradually, as the news spread, a crowd gathered in the meadow. The sun rose, weak through the morning mist floating off the river. From a cluster of red barns across the meadow a cock crowed. The rawboned farmers stood silently in a circle about the body. Their wives talked softly together in little groups farther off. Dr. Russell came and, walking up to the body, looked at it for a minute, the torn and bloated face, the matted hair. Then he leaned down and picked up the creel fastened to the body with a short rope. He opened it and counted the fish inside it, sizing them up with his practiced eyes, for he was a great fisherman himself. Then, laying the creel back down beside the body, he said, "Twelve good fish. He died happy."

Mary and I would go to a covered-dish supper at the Grange Hall. On the long tables there'd be dishes of potato salad, scalloped potatoes, ham, fried chicken, pickles, crocks of baked beans, apple pies, blueberry pies, pumpkin pies, pitchers of milk and hot coffee.

No. It wasn't utopia. It was too lively. People worked too hard. Life was as varied as a patchwork quilt. Something was always happening.

One night an hour or two after dusk an old jalopy rattled past the house at about sixty miles an hour. I didn't think much about it. Then all of a sudden I could hear it go by again, just as fast. I went to the door of the studio. And here it came again, sort of slow until it got to within a hundred yards of the house and then with a

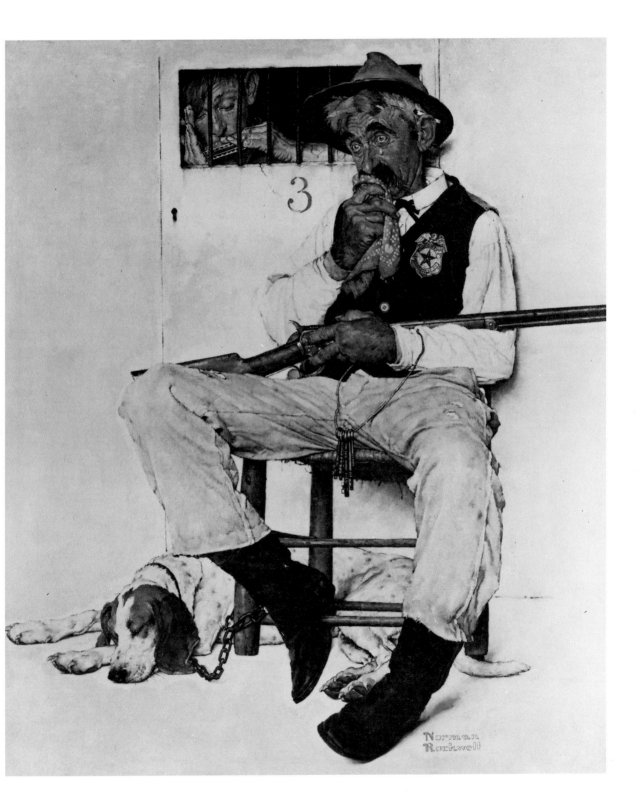

Music Hath Charms, oil painting for *Saturday Evening Post* cover (4 November 1939)

roar, wheels spitting gravel, it accelerated and sped by. This happened three or four times. Just as I was about to call the sheriff, for I was sure it was the mountaineers come to massacre the city slickers, the car stopped and a young man got out and went up to the front door. First he kicked the steps a minute, then he pulled a comb out of his back pocket and, squinting at the dark window, combed his hair. Then he put his hand out to knock, thought better of it, started back down the steps, stopped, brushed his clothes, went up the steps, straightened his tie, unbuttoned his jacket, buttoned it, and knocked. The door opened and he went in. I ran up to the house. "Mary," I shouted, "are you all right?" "Why, yes, Norman," she said. "What's the matter?" "Who was that fellow that just came in?" I asked. "Oh, he came to see Jane," said Mary. "Did you finish the picture?" Jane was the girl we'd hired to take care of the kids and the washing.

Later on I became acquainted with Jane's boy friend. He told me he'd driven past so many times simply because he was a whole lot scared of city people and a little of Jane. Every time he'd gone to stop he'd lost his nerve and stepped on the gas.

Haying time arrived. Bert Immen had told me that I could sell the hay on the river meadow to pay my taxes. But when I asked several farmers if they'd like to buy my hay they said thanks no, they had enough already. I knew it was bad for the fields if the hay wasn't taken off, so I asked them would they take it for nothing. No, they didn't want it. So I arranged to pay one farmer to remove the hay. One bright summer morning I was in the studio listening to the Farm and Home Hour on the radio. I could hear the mower clacking in the field outside. The radio announcer began quoting the current prices of various farm commodities: eggs, milk, fowl, hay. Hay! "The price has skyrocketed," said the announcer, "the highest in fifteen years." I didn't think much about it. I'd arranged to pay the farmer and I was stuck with it.

An hour later I suddenly noticed that the mowing machine had stopped. I could hear shouts. The mowing machine started again. Another one joined it. Then another. Then all stopped at once. More shouts. Curses. I went out. Three mowing machines were parked in the meadow, their owners standing beside them arguing. It appeared that the two farmers who had just arrived had heard the same announcement about the price of hay that I had. So they'd hitched up their machines and come over to take off the hay as I had asked them to. "But," I said, "you didn't want it." "We want it now," they said. "Not on your life," said the third farmer, "I'm being paid to cut this hay and nobody ain't going to come between me and it." Finally I divided the meadow into three equal parts, one for each farmer. When I suggested that all three pay me for the hay they would have none of it. I had to stick to the original arrangement. So I ended up paying the one farmer to take off the hay on his part and giving the remainder to the other two.

It was like living in another world. A more honest one somehow. Because almost everyone had lived in the town all his life and had known one another since childhood and even everybody's parents and grandparents, there could be little pretension. And because farming was a hard life and yet not competitive, there was a

great neighborliness. If Harvey McKee was taken sick Jim Edgerton would do his milking for him.

Dr. Russell once remarked to me, "You know, there really isn't a bad person in this town." And it was true. No robbery, for instance, had been committed in Arlington for twenty-six years. If a man was an out-and-out thief his neighbors knew it and he couldn't live in the town. The pressures were very strong, not toward conformity, but toward decency and honesty. A mean-tempered man soon found himself isolated. His neighbors just wouldn't bother with him. Oh, a man could abuse himself—drink too much, say—but if his bad or unpleasant habits interfered with others he didn't last long in the town.

I'd met one or two hundred people I wanted to paint. Walt Squires, Clarence Decker, Nip Noyes. A whole raft of them. And ideas were jumping in my brain like trout on the Batten Kill at sunset. I'd found what I'd wanted—new people, new surroundings.

The next summer we moved to Vermont to stay.

After our first winter in Arlington we were no longer summer people, transients. We had endured the winter—snow, bad roads, 35° below zero five mornings in a row—along with everybody else. We were not yet Vermonters (they say you have to live in Vermont twenty years before you're a real Vermonter) but we had a recognized place in the community. I'd stomp into George Howard's General Store in my arctics and heavy lumberman's jacket and mufflers with the ear flaps on my cap pulled down over my ears and my mittens on, and everybody would talk about the weather, the old people saying winters wan't what they used to be, the young ones saying it was bad enough for them just as it was. There was a sort of camaraderie about it.

Mary and I took the oath of allegiance to the state of Vermont before Harvey McKee so that we could vote in the state, and joined the Grange. And so we settled into the life of the community.

Moving to Arlington had given my work a terrific boost. And then during our second summer in Vermont Mead Schaeffer, a fine illustrator, and his wife Elizabeth bought a place in Arlington. I had known Schaef slightly back in New Rochelle; we had used many of the same models. (I'd always ask the model, "What did Mr. Schaeffer work on yesterday?" "Oh," the model would say, "he did a picture of a lumber camp." "How many figures?" I'd ask. "Five or six," the model would say, "and a horse." This would drive me crazy. I was spending days painting a single figure.) In Arlington Schaef and I became fast friends. We helped each other take photographs, we criticized each other's pictures, talked about art, inspired each other. We were going to bring back the golden age of illustration, the glorious days of Howard Pyle, Remington, Abbey.

This friendship with Schaef—a working illustrator, someone who shared my ideals, understood my problems—stimulated me. I guess it helped my work almost as much as moving to Arlington.

Schaef was a slight, agile man. Yet he had a tremendous ability for painting the powerful, broad-shouldered, heroic man, sheer physical courage, man against nature. He had illustrated *Ivanhoe, Moby Dick, Typee,* Zane Grey, Sabatini, and done it beautifully. His illustrations give one a real sense of robust, swashbuckling manhood.

His attitude toward life was the same as that in his paintings. I remember once Elizabeth showed me a photograph of Schaef as a child of five or six. He was wearing a great belt and scabbard; his feet were planted wide apart and he was brandishing a cutlass and glowering belligerently at the photographer. That seemed to me to be typical of him. He was a dedicated hunter and fisherman—a real outdoorsman. Yet—and I've never understood this—he could be strangely tender with animals. At one time he had a pet chicken named Sally. He fed it every day and petted it. After a while it got to know him. But then it grew old and Elizabeth, without telling Schaef, cooked it and served it for Sunday dinner. When Schaef learned that he had eaten Sally he was furious. I couldn't understand it. He shot pheasants and fished. Why worry about a chicken? "It hurts the pheasants," I said. "It's just as cruel to yank a fish out of the water with a hook in its mouth as it was to kill Sally." "No," he said, "it's different. If you fished and hunted yourself, you'd understand."

Well, there was a lot I didn't understand about hunting and fishing. I had to admit that. Somehow I could never get interested. And it used to tire me—all this talk about how to tie a fly, the right one to use at sunset or dawn, how to shoot a partridge. I had a stuffed owl in my studio. The poor old bird had a bare rump because Schaef was always plucking out the fluff under its tail to use in his dry flies. "Get away from there!" I'd yell, catching, out of the corner of my eye, a glimpse of Schaef edging toward my owl. But pretty soon, noticing an ominous silence, I'd look up from my work and he'd be at it again, standing with his back to the owl, one arm snaked around behind him, plucking. He just couldn't resist that fluff; it was considered the choicest material for a dry fly.

But it wasn't only Schaef. All the Vermonters hunted and fished and, what was worse, talked about it. On the first day of deer season in November the whole town shut down to go hunting. The postmistress closed the post office; Mack Molding, the local factory, gave the workers a day off; the storekeepers locked their doors and went off to the mountains. Then for the rest of the year they all described how they'd shot their deer or how they'd missed it, how they'd tracked it, where the deer were feeding that year, their guns, gun sights, ammunition. And when they'd worn deer hunting to a frazzle and beat all the interest out of it, there was fishing and rabbit or pheasant or squirrel hunting. I got awful sick of being left out of the conversation. It was frustrating.

Then a fellow told me about a place in Canada where I could shoot a moose. Ha, I thought, that's the solution. I'll get a moose and mount the head and hang it in the living room. And when anyone starts to talk about hunting or fishing I'll just point to my moose.

So I went to Canada to this hunting lodge in the wilds north of Quebec. A

guide was assigned to me, a French-Canadian called the Cat. I told him (through an interpreter; he didn't speak English) that I'd give him a hundred dollars if I got a moose. I wanted him to know that I was as serious as a stone. Because shooting a moose is not a simple matter, or rather, shooting it is simple—the moose, not being afraid of anything, will stand looking at you while you fire at it—but finding a moose to shoot at is extremely difficult. The Cat nodded his head vigorously. He understood; he would find me a moose.

We spent five nights and six days in the woods. At night we slept in small cabins scattered through the forest. During the day we traveled from one cabin to another. It was virgin forest, which I'd always thought of as a sort of park—enormous trees evenly spaced on clear, leaf-strewn ground. I'd been wrong. Fallen trees overgrown with brambles littered the floor of the forest. We clambered over one mammoth log and plunged into a snarl of brush, rotten branches, and vines, climbed over another log and into another snarl of brush. On and on we went, the Cat traveling at a steady lope, I struggling on behind, exhausted. Even when he was carrying a canoe the Cat never slackened his pace. He didn't allow me to carry anything; if I removed my jacket he took it. Still, I could hardly keep up. And it rained continually; my clothes were never dry.

When we reached a cabin at sunset the Cat would get the stovepipe from its hiding place in the woods (the cabins were never locked; hiding the stovepipe prevented unauthorized persons from using a cabin) and light a fire. After supper we'd smoke our pipes, grunt at each other, and roll up in our blankets. An hour before dawn the Cat would roust me out and we'd trot to the side of a lake. There we'd crouch in the brush and the Cat would sound his moose call. The water would seep over the tops of my boots, the mud freeze on the seat of my pants, and I'd think of the stories I'd heard back at the lodge about the guide whose call had been so realistic that a bull moose had galloped up and trampled him under its hoofs. When the sun was well up in the sky we'd start for the next cabin.

The third day I said to the Cat, "I've had enough. Take me back to camp." He looked at me blankly, blinking his eyes. "WE . . . GO . . . BACK!" I said. "BACK, BACK. We quit, quittez." "Moose," replied the Cat. "Back," I said. "Boom, boom moose," said the Cat. I gestured frantically. The Cat stared at me for a minute, then poured out a cup of coffee and handed it to me.

I never did make him understand. And we never saw a moose. And when, after six days of bone-cracking struggle with the wilderness, we returned to camp, we learned that the son of the owner had shot a moose from the front porch of the main building during our absence. A magnificent moose. It took the guides all afternoon to pack in the meat from the swamp where the moose had fled to die.

Back in Arlington, seated in my chair before a blazing fire of applewood, I thought to myself, Let 'em talk; let 'em work hunting and fishing into the grave, talk it and me to death; I won't hunt again. And after that I cheerfully endured the endless stories of tracking deer through the snow, hooking a two-foot trout. Not even bored frustration could wrench me from my easy chair and fire again.

By 1942 I had been painting *Post* covers for twenty-six years. It had been a constant challenge. If a cover was unpopular, I felt my work was sagging and, becoming scared, thought, I'll be dropped from the *Post*. Every new illustrator had been a threat. Perhaps he'll be better than I, I'd thought, and force me off the *Post*. So for twenty-six years I'd had to prove myself all over again with each cover I did.

Now, suddenly, it looked as if I would soon be free of the gnawing responsibility of trying to stay on the *Post*. One day in New York an art director of an advertising agency asked me, "How's the *Post* getting on?" "What do you mean?" I asked. "Oh," he said, "there are rumors about. You know. They say everything's not right down there." "*Not right?*" I said. "Yes," he said, "the man I heard it from said the *Post* was in the doldrums, just sort of plodding along, no direction." "Is that bad?" I asked. "I don't know," he said. "It could be."

During the next few weeks I heard more rumors. My imagination began to churn, exaggerating them. Pretty soon, in my wild way, I had decided that the *Post* was about to collapse. I was dismayed. But I was also relieved. The challenge was over. The *Post* meant a great deal to me; it was the only outlet, really, for the kind of work I liked to do best. And I couldn't have admitted to myself and others that the pressure of doing covers was too much for me or that my work was slipping. I could never have deserted the *Post*. But now it was, so to speak, deserting me. And I felt an immense sense of relief, as if a lead weight had been lifted off my neck.

In the past five years, ever since Wesley Stout had become editor of the *Post*, my feelings of insecurity had been aggravated. Under Mr. Lorimer I had always known, at least, whether or not he liked a cover. With Mr. Stout I was uncertain. Every time I submitted a cover he asked me to make some little change. "That's fine," he'd say, walking back and forth in front of it as Mr. Lorimer had done, "but I think it would be better if the kid's shoes were black instead of brown." I wasn't able to paint a cover with any conviction because I knew, as sure as three came after two, that some little thing would be wrong with it. The constant nagging sapped my inspiration, made me unsure of myself.

So, as I say, I was relieved when I *imagined* that the *Post* was about to go under. The loyalties of twenty-six years, the drive inside me to excel, my strong sense of competition, would never have permitted me to stop painting *Post* covers. But now the ship was going down and I would go down with it. There was something noble and easy about it.

Then late one afternoon Pete Martin, the art director, telephoned me. Tomorrow morning's papers, he said, would carry the news that Ben Hibbs had been appointed editor of the *Post* in place of Wesley Stout. But I wasn't to worry. Mr. Hibbs liked my work. Would I get some sketches together to show him?

And all of a sudden there it was again: the challenge. Perhaps Mr. Hibbs couldn't save the *Post*, but I had to prove to him (and myself) that I was as good as ever, good enough anyway to stay on the *Post*.

I worked up nine ideas, all, I thought, my very best. I wasn't taking a chance on any filler. I expected that Mr. Hibbs would reject several as Mr. Lorimer had been

in the habit of doing. But if I included a few bad ideas he might reject the whole batch and I'd be off the *Post*. Believe me, I put everything I had into those nine sketches. And I went to Philadelphia with a trembling heart.

The editor's office—Mr. Lorimer's office (I'd never thought of it as Mr. Stout's office; my memories of Mr. Lorimer were too strong)—hadn't changed. There were the same pictures and furniture, the same large windows behind the desk. But instead of Mr. Lorimer (I remembered suddenly how he used to stride toward me, his heels thudding on the carpet, his big hand thrust out to me), there were two rather young men seated at the conference table in their shirt sleeves with their feet up on the table. One of them, a tall, lanky man with a serious, comfortable face, rose to greet me. "Hello, Norman," he said, "I'm Ben Hibbs." "How do you do, Mr. Hibbs," I said. "For heaven's sake," he said, "call me Ben." "All right," I said, mightily startled by this informality (in twenty years I'd never even thought of calling Mr. Lorimer by his first name; to me the editor of the *Post* was *Mister*). Ben introduced me to the other man, Bob Fuoss, the new managing editor. Then he asked, "What have you got to show us, Norman?" I laid my nine sketches on the desk and acted them out. Rather lamely as I recall, for my mind kept superimposing the image of Mr. Lorimer's massive head with its shock of hair, square jaw, and piercing eyes on Ben's face and when it wouldn't fit I'd get confused and lose track of what I was saying. But when I'd finally finished Ben said, "Those are fine." "Which ones do you want me to do?" I asked, thinking, Now he'll reject a few like Mr. Lorimer. "Which ones do you like?" asked Ben. "I like them all . . . uh . . . Ben," I said, the name coming strangely from my mouth, but I grappled with it and brought it out, feeling that I was somehow commit-ting a sacrilege, "I like them all. You know you're the new editor and I really beat my brains out to get some good ideas." "Well, why don't you *do* them all?" said Ben.

When I got back to Arlington I said to Mary: "They're awful nice, the new editors. Ben Hibbs is a wonderful fellow. But I don't think he'll last long. He accepted all my sketches, *all nine*. He didn't turn down one. It's wonderful but I don't think it's going to last. You can't run a magazine that way."

But I was blinded by my twenty years under Mr. Lorimer, believing that because Ben wasn't the same kind of man as Mr. Lorimer he would not succeed as editor of the *Post*. Now I'd been wrong before and I've been wrong since, but I guess that time I laid it over anything for pure white, out-and-out wrongness. My capacity for that sort of thing (and it's huge) must have been strained and weak for months afterward. Because Ben took that magazine (it was not, as I had imagined, about to collapse, but it was ailing a bit) and nursed it back to health. And that took more courage and hard work and downright grit than I ever hope to see again.

I don't know much about the struggle to resuscitate the *Post*. I wasn't, of course, there in Philadelphia to see it. I do know that Ben Hibbs and Bob Fuoss and the other editors worked seven days a week and nights. They re-evaluated the inven-tory of *Post* covers, discarding most of them. I remember the storm of protest when they changed the appearance of the cover, blowing up the word "*Post*" and putting it

Oil sketch for *Saturday Evening Post* cover *Springtime. Boy with Rabbit* (27 April 1935)

Crying Baby with Nursemaid, oil painting for *Saturday Evening Post* cover (24 October 1936)

"Deadline," oil painting for *Saturday Evening Post* cover (8 October 1938)

Charcoal sketch for *Saturday Evening Post* cover *Marble Champion* (2 September 1939)

in the left top corner. (Before, the words *"The Saturday Evening Post"* had run in two lines all across the top of the cover.) Some readers even wrote to me about it. The world is breaking apart, they said (it was early 1942, remember), and now the *Post* has been changed. How many editors, when their magazine is sick, would dare to incur the wrath of their readers by making a change like that, however necessary? Not many, I think. (Perhaps I should add that the storm of protest died away in a few months; readers soon came to like the new cover format.)

Mr. Lorimer had a domineering, almost ruthless personality. Like all the great tycoons—Ford, Rockefeller. He had created an institution in his own image, out of himself, and of course he was one of the great magazine editors of all time. He was, in a sense, the *Post*, all of it. It was his magazine from the front cover to the back. And he had to assert himself constantly in everything—rejecting three out of five of my sketches, for instance—because if he had relinquished one prerogative the whole complicated structure which he had built would have collapsed. (Not really, of course, but he must have felt that way subconsciously.)

Ben Hibbs was a different sort of man. He was neither domineering nor ruthless. He could delegate responsibility. He didn't feel that he had to do everything himself. (Bob Fuoss, who had the title of executive editor, was virtually co-editor of the magazine, and Kenneth Stuart was art editor in fact as well as in name. Ken was given great latitude in everything having to do with the physical appearance of the magazine.) In fact I'd always thought of Ben Hibbs as the archetype of the easygoing, good-natured Midwesterner. But there was iron in his soul. And something rarer. I once asked Bob Fuoss what Ben had that set him apart. "He's got that rare thing," said Bob, "integrity, absolute integrity."

I guess it takes one kind of man to create an institution and another kind to maintain it. The creator is a lone wolf; he begins with nothing and builds an institution out of himself. The consolidator is a team man; he inherits a machine and must keep it running.

I certainly did have a time sorting out Ben Hibbs and Mr. Lorimer at first, though. About a year after our first meeting, Ben, Bob Fuoss, Jim Yates (the art editor) and their wives came up to Arlington on a visit. It was a harrowing experience for me.

Several months previously Ben had asked, "When are you going to invite us up to Arlington?" "Oh, any time," I said. "Come up any time." And I thought no more about it. I hadn't recovered from Mr. Lorimer yet; in my mind the editor of the *Post* was still some exalted type of superhuman being, and it never entered my head that Ben would come to Arlington even if I asked him. But he kept mentioning it and then Jim Yates said, "You know, Norman, they really want to come up. They feel sort of hurt that you haven't asked them." So, terrified (the editor of the *Post*—my humble dwelling), I extended the invitation, it was accepted, and bolstered by Mary, Schaef, and Elizabeth, who didn't share my awe and foolish fears. I staggered, scrambled,

mumbled, and trembled my way through the weekend. By the time we put them on the train in Arlington I was a wreck.

But I held myself together and waved good-by, smiling cheerfully. When the train had disappeared around the corner I went back into the station house and lay flat down on my back in the middle of the floor. "Ahhhh," I sighed, taking deep breaths and staring up at the peaceful sooty ceiling. "Ahhhh. Whew!" I could feel my tense muscles relax, turning to warm jelly. "Come on," said Schaef, "let's go." "No," I said, stretching out my legs and arms luxuriously. "It's over and I'm recovering. Leave me alone." Then I heard the station-house door open and, rolling my eyes back, saw upside down the startled faces of Ben Hibbs and Bob Fuoss. "Hello," said Ben. "The train was derailed so we came back." And they entered the room and looked at me, rather puzzled, I guess.

I closed my eyes, opened them, blinked three or four times, too thunderstruck to say anything. Then I moaned softly. "Norman," said Mary sternly. "Boy, gee," I said, still lying flat on my back, "you people are so darn nice and easy. I was trained under Mr. Lorimer. Entertaining the editor's been a strain. And here you are back again." And I laughed naturally for the first time in three days and jumped up.

Having admitted my tenseness, I no longer felt it. They stayed over that night and I had a very enjoyable time and I think they did too. And so the ghost of Mr. Lorimer was banished once and for all.

But when I left Ben Hibb's office that day in 1942 after he'd accepted all nine sketches, I was, as I say, still confused. In his shirt sleeves? I thought. The editor of the *Post* in his shirt sleeves? I couldn't understand it. Ben? I thought. Not Mr. Hibbs? I was flummoxed.

Partly, I think, because at the time I couldn't concentrate properly. I was wrestling with a new project and it occupied the better part of my brain. Schaef and I were going to offer our services to the government. Since we were too old to enlist, we had decided that the best way for us to contribute to the war effort was by doing posters for the government. We had already worked up some ideas and were going to set off for Washington any day now. The only thing that was delaying us was me. I hadn't come up with a really good idea yet, one I could get excited about. I had a poster of a machine gunner and a couple of other ideas sketched out, but they didn't satisfy me. I wanted to do something bigger than a war poster, make some statement about why the country was fighting the war.

When Roosevelt and Churchill issued their Atlantic Charter, with its Four Freedoms proclamation, I had tried to read it, thinking that maybe it contained the idea I was looking for. But I hadn't been able to get beyond the first paragraph. The language was so noble, platitudinous really, that it stuck in my throat. No, I said to myself, it doesn't go, how am I to illustrate that? I'm not noble enough. Besides, nobody I know is reading the proclamation either, in spite of the fanfare and hullaba-loo about it in the press and on the radio.

So I continued to stew over an idea. I tried this and that. Nothing worked. I juggled the Four Freedoms about in my mind, reading a sentence here, a sentence

there, trying to find a picture. But it was so darned high-blown. Somehow I just couldn't get my mind around it.

I did a *Post* cover and an illustration, went to town meeting, attended a Grange supper, struggling all the while with my idea, or rather, the lack of it, what seemed to be a permanent vacuum in my head.

Then one night as I was tossing in bed, mulling over the proclamation and the war, rejecting one idea after another and getting more and more discouraged as the minutes ticked by, all empty and dark, I suddenly remembered how Jim Edgerton had stood up in town meeting and said something that everybody else disagreed with. But they had let him have his say. No one had shouted him down. My gosh, I thought, that's it. There it is. Freedom of Speech. I'll illustrate the Four Freedoms using my Vermont neighbors as models. I'll express the ideas in simple, everyday scenes. Freedom of Speech—a New England town meeting. Freedom from Want—a Thanksgiving dinner. Take them out of the noble language of the proclamation and put them in terms everybody can understand.

I got all excited. I knew it was the best idea I'd ever had. I ran downstairs to call Schaef. But I couldn't do that; it was three in the morning and I'd disturb all the other people on his party line. So I got my bicycle out of the shed and bicycled over to his house. When I woke him up and told him my idea for the Four Freedoms he got excited too.

In the next couple of days I made rough sketches of the Four Freedoms. Then Schaef and I set off for Washington to offer ourselves to the government.

Orion Wynford, the head of the Creative Department of Brown and Bigelow, a calendar company for whom I did the Boy Scout calendar, met us at the Mayflower Hotel, his white suit and swelling mane of white hair sparkling in the sun. Orion was to take us around to the various government agencies and introduce us to the right people.

We set out the next morning. As we entered the first office the secretary jumped up. "Oh, Mr. Wynford," she said, "thank you so much for the lovely bouquet of roses. And the candy was delicious." Orion smiled and made a deprecatory gesture. At the door of the second office we visited the security guard said, "Swell party, Mr. Wynford. Go right in. *You* don't have to be checked." Evidently Orion had oiled the works.

But, just as evidently, the oil had not penetrated beyond the anterooms. None of the government officials could help us. The war was going badly; nobody had time for posters. Robert Patterson, the Undersecretary of War, said, "We'd love to print your Four Freedoms, but we can't. I'm sorry. We just don't have the time to spare to arrange it. I think they'd be a fine contribution. We'd be delighted if *someone* would publish them."

Schaef and I became more and more discouraged as we were turned down by one official after another. After a while even Orion became rather subdued. Not because our posters weren't being accepted but because his weren't. He was trying to drum up business for Brown and Bigelow. He had a portfolio full of sketches which

his company's calendar artists had done. For instance, a beautiful girl leaning forward, bosoms rampant, captioned: Will YOU help?

That was all right. Schaef and I didn't mind if he stropped his own razor while showing us around. But he kept interrupting us. Schaef and I would no more than begin to exhibit our work and explain that we didn't want to be paid for anything, we just wanted to do something for the war effort, than Orion would pull a girly poster from his portfolio and, laying it on the desk in front of the official, say: "Mr. Secretary. I have here a poster calculated to stir, to inspire, *pride* of country in every American breast. We ask no more than paper to print it on." And he'd continue in this vein, displaying one poster after another, until the Secretary ushered us out of his office, pleading urgent business. So Schaef and I never got to tell our story.

But I doubt whether it would have made any difference. Once Orion excused himself for a minute and we almost jumped on the army colonel in whose office we were at the moment. "We don't want money," we said. "Just let us do our posters." But no, the colonel was sympathetic but helpless; he couldn't arrange it.

Finally, late in the afternoon, we found ourselves in the Office of War Information (or, to speak plainly, the propaganda department). I showed the Four Freedoms to the man in charge of posters but he wasn't even interested. "The last war you illustrators did the posters," he said. "This war we're going to use fine arts men, real artists. If you want to make a contribution to the war effort you can do some of these pen-and-ink drawings for the Marine Corps calisthenics manual. But as far as your Four Freedoms go, we aren't interested." "Well, I don't know," I said, leafing through the layouts of the calisthenics manual (you know, simple drawings of men arms up, arms out, arms to the side), and remembering what high hopes I'd had when I conceived the Four Freedoms, "I guess not." And Schaef, Orion, and I left the office and went back to the hotel. That was the final blow. Schaef and I decided to give up trying to interest people in our posters and my Four Freedoms. The next morning, depressed and discouraged, we took the train back to New York.

But I got off at Philadelphia; I had some sketches to show Ben Hibbs. As I was discussing the sketches with Ben I happened to mention that I'd just been in Washington. "Why?" asked Ben. "Schaef and I were offering our services to the government," I said. "He had some posters and I had a series I wanted to do called the Four Freedoms. No one was interested, though." "Let's see it," said Ben. So I hauled the sketches out and showed them to him, explaining rather listlessly what they were all about, what I'd been trying to do. Ben listened attentively. Then he broke in: "Norman, you've got to do them for us." I could see he was excited. "I'd be delighted to," I said. "Well, drop everything else," said Ben, "just do the Four Freedoms. Don't bother with *Post* covers or illustrations."

So I went back to Arlington, rejuvenated, and set right to work. I spent, finally, six months painting the Four Freedoms and it was a struggle. I had a terrible time. I started the first one I did—"Freedom of Speech"—over four times. I practically finished it twice, finding each time when I had just a few days' work left that it wasn't right. At first I planned to show an entire town meeting, a large hall full of

people with one man standing up in the center of the crowd talking. But when I'd got it almost done I found that there were too many people in the picture. It was too diverse, it went every which way and didn't settle anywhere or say anything. So I had to work it over in my mind and, as it turned out, on canvas, until I'd boiled it down into a strong, precise statement: the central figure of the man speaking in the midst of his neighbors.

I wrestled with "Freedom of Worship" for two months. Most of the trouble stemmed from the fact that religion is an extremely delicate subject. It is so easy to hurt so many people's feelings. And the picture was further complicated by my desire to say something about tolerance. I wanted it to make the statement that no man should be discriminated against regardless of his race or religion. My first sketch was of a country barbershop: a Jew in the barber chair being shaved by a lanky New England barber (obviously a Protestant) while a Catholic priest and a Negro waited their turns. All of them were laughing and getting on well together.

But when I'd just about completed the picture I found that it was no good. The situation bordered on the ridiculous. And the Catholics who came into the studio all said, "Priests don't look like that." (I'd done a stout, rosy-cheeked priest with a bit of a double chin.) And the Negroes thought the Negro's skin should be lighter or darker. And the Jews didn't like my portrayal of the Jew.

So I discarded the picture and started another (I don't remember what it looked like). But that didn't work out either. I started another, junked it. I began to be rather sharp with Jerry and Tom and Peter when they came into the studio to show me a turtle or a frog they'd caught. One day the art editor of the *Post* appeared at the door. Where were the Four Freedoms? "I'm doing them as fast as I can," I snarled politely. Then I wrenched the sketch of the final version of "Freedom of Worship" out of my head and painted it. There is a mystery about the phrase which is lettered across the top of the painting—"Each according to the dictates of his own conscience." I know I read it somewhere but no one has been able to find it in any book or document.

With "Freedom from Want" and "Freedom from Fear" I had little trouble. I painted the turkey in "Freedom from Want" on Thanksgiving Day. Mrs. Wheaton, our cook (and the lady holding the turkey in the picture), cooked it, I painted it, and we ate it. That was one of the few times I've ever eaten the model.

"Freedom from Fear" was based on a rather smug idea. Painted during the bombing of London, it was supposed to say: "Thank God we can put our children to bed with a feeling of security, knowing they will not be killed in the night. I never liked "Freedom from Fear" or, for that matter, "Freedom from Want." Neither of them has any wallop. "Freedom from Want" was not very popular overseas. The Europeans sort of resented it because it wasn't freedom from want, it was overabundance, the table was so loaded down with food. I think the two I had the most trouble with— "Freedom of Speech" and "Freedom of Worship"—have more of an impact, say more, better.

Right about here, with all due immodesty, I'd like to drop in a few paragraphs which Ben Hibbs wrote about the Four Freedoms after reading my account of their

Freedom of Speech, oil study for final version, 1943

inception. "Norman," he said, "I think you ought to say something about what happened after you delivered the Four Freedoms to us." "I can't," I said, "it would sound like boasting." "Well, let me write something," he said. And he did. It delights me. Here it is:

"The result astonished us all," Ben wrote. "The pictures were published early in 1943, not as covers, but as inside features, and each was accompanied by a short essay by some well-known writer, saying in words what Rockwell was saying on canvas.

"Requests to reprint flooded in from other publications. Various Government agencies and private organizations made millions of reprints and distributed them not only in this country but all over the world. Those four pictures quickly became the best known and most appreciated paintings of that era. They appeared right at a time when the war was going against us on the battle fronts, and the American people needed the inspirational message which they conveyed so forcefully and so beautifully.

"Subsequently, the Treasury Department took the original paintings on a tour of the nation as the centerpiece of a *Post* art show—to sell war bonds. They were viewed by 1,222,000 people in 16 leading cities and were instrumental in selling $132,992,539 worth of bonds.

"Following the war, the original paintings—they are of heroic size—were hung in our offices. The two which I consider the finest of the four—'Freedom of Worship' and 'Freedom of Speech'—hang in my own office, and I love them. They are a daily source of inspiration to me—in the same way that the clock tower of old Independence Hall, which I can see from my office window, inspires me. If this is Fourth of July talk, so be it. Maybe this country needs a bit more Fourth of July the year around.

"Visitors who come into my office almost always exclaim over the paintings. They marvel at the depth of feeling which Norman was able to build into those pictures. The Four Freedoms originals have been borrowed countless times for art exhibits, and even today we still receive many requests to reprint. However, we have now reached a point where we regard those paintings as so valuable that we rarely permit them to be taken outside the office.

"Many people have asked me whether I regard the 'Freedom of Worship' and the 'Freedom of Speech' as great art. I do. Norman himself probably would disagree. He has always modestly labelled himself an 'illustrator' with no pretensions to fine art. I suspect art critics would say that those two pictures are excellent examples of an illustrator's work at its best, but not great art. I am no art critic, but I still disagree. To me they are great human documents in the form of paint and canvas. A great picture, I think, is one which moves and inspires millions of people. The Four Freedoms did—and do."

To start the war bond drive I went to Washington. At the banquet that night I sat beside a Mrs. Du Pont. She kept trying to bring me out. "Where do you live, Mr.

Kent?" she asked (she thought I was Rockwell Kent). "I live in Vermont," I said. "Oh, Thurman," Mrs. Du Pont said, turning to Assistant Attorney General Thurman Arnold who was sitting beside her, "did you hear what Mr. Kent said? The most interesting thing. He said he lives in Vermont." And Mr. Arnold cast a cold, steely, crimebuster eye on Mrs. Du Pont and said nothing. Then Mrs. Du Pont turned back to me: "What is it like in Vermont?" "It's pretty cold," I said. "Thurman," she said, "do you know what Mr. Kent just said?" Again the cold eye: "No." "He said it's quite cold in Vermont." "Ah," Mr. Arnold replied gravely, leaning forward to look at me.

I was flummoxed. I hadn't had a chance to drink a cocktail; I wasn't managing to get anything to eat. Someone was always dragging me off to meet ambassadors or other dignitaries. When the oysters came I was called away for photographs. Just as I sank my fork into the capon some reporters demanded my presence. And now I was being brought out by Mrs. Du Pont. Or rather Rockwell Kent was. In desperation I passed a note to Ben Hibbs: "I'm terrified, and besides, Mrs. Du Pont keeps calling me Rockwell Kent. What'll I do?" Ben didn't reply and I endured celebrity alone, consoling myself with thoughts of the peaceful green hills and rippling breezes of Vermont.

The next morning, seated on a dais in the midst of a churning sea of people, I autographed reprints of the Four Freedoms at Hecht's Department Store. Women in the crowd were fainting; a lady's petticoat dropped around her ankles as she was standing before me—the place resembled Noah's ark on a hot night.

Late that afternoon I was asked to travel with the Four Freedoms show which was to tour the country, selling bonds. I scratched my head, too worn out to answer. But Ben, God bless him, said, "No. Norman's going to stay home and do *Post* covers." And so the ordeal was over.

I rise from the ashes

AFTER finishing the Four Freedoms—large (44 by 48 inches), serious paintings which sucked the energy right out of me like dredges, leaving me dazed and thoroughly weary—I relaxed by doing a small, crazy *Post* cover—my first April Fool's cover, in which an old man wearing roller skates and an old woman wearing ice skates are playing checkers without checkers, surrounded by bottles suspended in air, flying ducks, a dozing deer, a zebra coming out of a picture frame, a woodpecker, a skunk, a fish leaping up a cascade in the stairway, a rug sprouting toadstools, et cetera. It was the perfect relaxation. It was tiny—only 11 1/4 by 10 5/8 inches, the exact size of the *Post*—and nuts. I didn't have to worry about mistakes or authenticity or saying something. Everything in the cover was impossible and wrong. April Fool, I said to myself as I painted along lightheartedly, April Fool. I've fixed the mistake mongers. (Though, of course, I hadn't: I put forty-five mistakes and incongruities into the picture; a man wrote me from South America claiming to have found a hundred and twenty.)

Then, still recovering from the Four Freedoms, I painted a Boy Scout calendar, shipping it off to Brown and Bigelow in St. Paul, Minnesota, late one afternoon. And that night my studio burned to the ground.

It was my own fault. Schaef and I had attended a hunting and fishing lecture given that evening at the high school by a mutual friend, Lee Wulff. Afterward the three of us had returned to my studio and talked until about half past eleven. As we left, I leaned over to switch off the fluorescent light, and ashes must have dropped from my pipe onto the cushion on the window seat, because the next thing I knew it

April Fool: Checkers, oil painting for *Saturday Evening Post* cover (3 April 1943)

was one-thirty in the morning and my son Tom was banging on the bedroom door and yelling, "Pop, the studio's on fire!"

I looked out the window. A storm of flame crackled red and molten gold in the interior of the studio and rolled in a thundering cloud of sparks and smoke through the roof. The leaves of the apple tree by the driveway glinted against the surrounding darkness.

Pulling on a pair of pants and buttoning my shirt, I ran downstairs and tried the phone. Dead. The wires came across the river and through the studio. Mr. Wheaton, our hired man, rushed out of his room, disheveled, his black hair flapping over his gaunt, bony face, his night shirt about his knees. He looks, I thought, like Ichabod Crane pursued by the headless horseman, and I dispatched him in the car to Walt Squires' house, a half mile up the road, to call the fire department. Then I ran outside to see if anything could be saved.

But it was no use; I couldn't get within thirty feet of the studio. After a minute the .22 and shotgun shells I'd kept in a drawer began to explode. I went back to the house and helped Mary bundle the kids in blankets (all three had the measles) so they could watch from the living room.

Pretty soon, above the roar and crack of the flames, I could hear the wail of a siren. The fire truck drove up, volunteer firemen hanging on all over it, their shirttails flying, some still in pajamas, but all proudly wearing their firemen's helmets. They tumbled off the truck as it skidded to a stop, somebody yelled, "Save the barn, the studio's gone!" and five or six grabbed a hose and ran to the river while the rest set themselves before the barn with another hose.

The stream of water arched through the firelight and vanished in the flames, hissing impotently. Sparks flared among the shingles on the barn roof. "Nope," said Chief Safford, "it's gone. Out of control." "Too much of a start," said a fireman. "A-yuh," said another.

In half an hour's time the front lawn was crowded with people who had come to see the fire. I walked around among them. Everybody said how sorry they were and told me about the fires they'd had or ones they'd seen and asked me if I was insured and commented on how fiercely painted wood burned and how, if the wind had been wrong, the house might have gone up too. And one woman slapped her little boy on the head and said, "There. That's what you get playing with matches. See?" And Chief Safford emerged from the barn at the last moment, carrying a flaming parasol and singing, "It ain't gonna rain no more, no more . . ." And five or six little boys pegged rocks into the fire, their faces serious and intent. And a little girl got scared and began to cry, burying her head in her mother's skirts. Then the walls of the studio caved in with a crash and a shower of sparks which lit up the mountains across the river, and everybody said, "Ahhhh," and fell silent, staring at the fire.

After that people began to drift off, feeling, I guess, that the climax had been reached. The sky in the east lightened. The flames crackled contentedly in the rubble. Mrs. Wheaton and Mary brewed a big pot of coffee and put doughnuts and cookies on plates, and I opened a couple of bottles of whiskey. Then we all sat about on the

front lawn—the firemen and Mr. and Mrs. Wheaton and Mary and I and the few people who had stayed to see the end—and had a picnic, watching the glowing heap of embers with here and there a last spurt of flame as the fire discovered an unburned piece of wood or caught a sudden breeze.

I didn't feel sad at all. Maybe I was in a state of shock. I was a bit troubled by the loss of all my pipes, but later that morning as I was poking about in the ruins several of the men in town arrived, bringing me some new pipes. The only thing which seriously worried me was the loss of some sketches I'd made recently at the White House for a double-page spread to be published in the *Post* entitled: "So You Want to See the President." I'd spent four days at the White House, sketching what a visitor to the President would see from the moment he passed through the gates of the White House until a secretary ushered him into the President's office. I wonder, I said to myself as I kicked a charred board, if they'll let me hang around again long enough to replace the sketches.

But the next day I called one of the secretaries at the White House and she said, "You come right on down. You'll be welcome any time. We heard about your fire."

So two days after my studio burned I went to Washington. I had a grand time. Knowing that you've had a disaster seems to make people warm up to you quicker. They treat you almost as if you're a hero. And then during my previous visit I'd become acquainted with most of the White House staff—the secret service men, the secretaries—and they all went out of their way to see that I got what I was after and told me about life at the White House whenever they had a spare moment. They explained how the President's meals were brought to him in a cart and how no visitors were ever allowed in the kitchen for fear one of them might tamper with the President's food. The secret service men explained their duties to me. How they have to have their bags packed at all times so they can leave with the President on a moment's notice; how they handle crowds during a parade (each secret service man accompanying the President—walking beside his car or riding in another car behind—watches a different thing; some watch the hands of the crowd on the sidewalk, some the faces, others the first floor of the buildings the parade passes, others the second floor, still others the third floor, and so on); how, when the President is to visit a town, they go there a week or so in advance and find out from the local police about all the cranks. One of the most difficult times to protect a President is, they said, when he goes to Griffith Park to throw out the first ball to start the baseball season.

Inside the White House the secret service men don't leave you alone for a minute. They even follow you downstairs to the bathroom and wait for you. I guess so you won't plant a bomb under a sink.

And I met senators and politicians, generals, a beauty contest winner, a delegation of school children, and a movie actress and talked with them all.

So I spent a very interesting and lively four days at the White House and wasn't melancholy about my studio fire at all. But when I returned to Arlington and saw the black mound of ashes with the chimney sticking up at one end, all by itself,

My Studio Burns, charcoal drawing for *Saturday Evening Post* illustration (17 July 1943)

and the charred skeleton of the barn, I remembered for the first time what I'd lost in the fire: all my antiques, my favorite covers and illustrations which I'd kept over the years, my costumes, my collections of old guns, animal skulls, Howard Pyle prints, my paints, brushes, easel, my file of clippings—everything, the accumulation of twenty-eight years of painting, traveling, collecting. It gave me an empty feeling in the pit of my stomach. Every time I turned over a crumbling board or stirred a pile of rubble with my foot I remembered something else that I'd lost in the fire. "Hunh," I said, looking at a lump of metal. "That must be my pewter mug, and there's the barrel of my African rifle. Or what's left of it. And right here's where my easel stood." And I closed my eyes and I could see just what the studio had looked like. "It's just like losing your left arm," I said, "and waking up in the middle of the night and reaching out for a glass of water and suddenly realizing that you haven't got anything to reach with."

So I went over and sat down on the seat I'd had built around the old apple tree. The wind kicked up little swirls of ash in the ruins. No, I thought after a while, I won't rebuild the studio. I'll sell the place and move somewhere else. In Arlington, but nearer town, maybe, or down the river in West Arlington. I never liked the isolation of this place—half a mile from our nearest neighbors—anyway. Turning off the last light at night is like pulling a black bag over your head. It's like living in a wilderness. (I guess I was still something of a suburbanite.)

That night I talked it over with Mary. She agreed with me, and the next day we bought a house on the village green in West Arlington.

It was one of a pair of houses standing not more than fifty feet apart on a slight rise above the green. The mountains rose steeply almost from the back door, and the two houses, dating from the late eighteenth century, were shaded by tall, old maples. Across the green at the foot of the mountains on the opposite side of the narrow valley ran the Batten Kill, spanned here by a covered bridge. On one side of the green there was a one-room schoolhouse; on the other a dance pavilion and a white, typically New England church with a community hall attached.

If anyone but Jim and Clara Edgerton had lived in the house beside the one for sale, I don't think I would have bought it. But Jim and Clara were about the nicest, finest people I've ever known. I didn't worry about living so close to them, I positively jumped at the chance.

Jim was a farmer. He was a stocky man of about medium height with a ruddy, good-natured face and black hair. Clara, his wife, was a pretty woman—lively, warm-hearted, and cheerful—with bright red hair. Farming is a hard life in Vermont. The growing season is short; there's little flat land; the fields are rocky. Jim had especially hard luck. One year he lost his herd through disease; another year he lost it when the barn floor caved in and choked the cows in their stanchions. But the hard life and misfortune didn't sour Jim and Clara. I don't think they knew how to be mean-spirited or nasty. When I finally moved away from Arlington the thing I most regretted was leaving Jim and Clara.

That first summer, while Walt Squires was building my new studio behind the house, I worked in the one-room schoolhouse on the green, bicycling down the back road from our old place every morning with my lunch in a basket. A dog ate my lunch a couple of times, but other than that it was rather pleasant. And I could watch my new studio rising on its foundation.

I involve myself through my work. During elections I don't campaign actively, ringing doorbells, passing out handbills; I paint an election cover, maybe a picture of an indecisive voter standing by a voting machine, maybe portraits of the candidates. During the war I did not collect scrap or work in an airplane factory; whatever contribution I made to the war effort was through my work—posters, *Post* covers of wartime scenes, the Four Freedoms.

For a time, however, I was deputy commander of Civil Defense for the township of Arlington. But I didn't last long; during the first exercise I disgraced myself and was promptly demoted.

The Civil Defense organization had been formed to defend the town against Hitler, some famous reporter having predicted that the Nazis would strike at the United States from Canada, invading Vermont and penetrating down Route 7, which ran smack through the center of Arlington. There were the rescue squads (nurses, Red Cross ladies, stretcher-bearers), the fighting squads which were to push trucks loaded with cans of gasoline down on the Nazi tanks, the plane spotter corps (a certain spotter team consisted of two elderly women: one had no teeth and could hardly be understood over the phone, the other couldn't see very well. But together they made a team, the former spotting the planes, the latter phoning them in to the control center). Everybody wore arm bands and used code words and said, "Roger!" instead of yes. As deputy commander, I was assigned to a telephone in the control center. My job was to relay reports to the commander.

The imitation Nazis—two schoolteachers, a man and wife, with swastikas painted on cardboard strapped to their chests—entered the town from the north. An outpost spotted them. "Panzer division advancing down Route 7 by the Wagon Wheel Restaurant," I announced to the commander. "Roger," he said.

And the holocaust of war descended on Arlington. A massacre at the high school! Houses aflame! The covered bridge at Chiselville blown up! Four bodies, bomb casualties, in front of the Colonial Inn! The control center was a flurry of activity.

Then the guard at the Chiselville bridge phoned in, very distressed. Dr. Russell insisted on crossing the bridge, he said, but it was blown up. What should he do? "I don't know," I said. "Wait a minute. I'll ask the commander." "You'd better speak to the doctor," said the guard, "he's hopping." "Okay," I said, "put him on." "Listen, Norman," said Dr. Russell, "I've got a woman who's going to have a baby across that damned bridge. I'm going across whether it's blown up or not." And he hung up (and crossed the bridge).

LEFT:
Willie Gil
oil painting
Saturday Ev
Post cove
(16 Septembe

OPPOSITE
Willie Gi
in Colleg
oil painting
Saturday Ev
Post cove
(5 October

The thought of Dr. Russell fuming while the guard, standing in the center of the bridge, explained that the doctor could not cross the bridge because it was lying at the bottom of the ravine, smashed by bombs, was too much for me. I got to giggling and garbled my reports. When the commander said, "Rog·ER!" I dropped the phone and then I couldn't find it under the table. In short, I disgraced myself. And the next day I was demoted. From deputy commander of Civil Defense for the township of Arlington to assistant to Jim Edgerton, whose duty it was to alert West Arlington by banging with a crowbar on a piece of railway track hung from a tree. If Jim wasn't home when the attack came, I was to do the banging.

So I went back to my painting.

There was, for instance, the Willie Gillis series. After the first draft call (but before Pearl Harbor) I had conceived the idea of a series of *Post* covers depicting the

army experiences of a young civilian, sort of an innocent little fellow who suddenly found himself caught up in a completely strange life. Mary had thought up the name for the series and one night at a square dance down on the West Arlington green I had discovered the perfect model. His name was Bob Buck and he was, luckily, exempt from the draft. I painted him in situations which I thought were typical of an average draftee's life in the army: receiving a food package from home, sleeping late during a furlough, peeling potatoes. The series became quite popular and I figured I was set for the duration.

Then, gosh darn it, Bob Buck somehow or other managed to get himself into the navy. So I sorrowfully laid Willie to rest.

No! said the editors of the *Post.* You can't drop him; he's too popular. Which posed a problem. I didn't have a model. All I had were old photographs of Bob Buck.

I painted Willie's girl faithfully sleeping at midnight on New Year's Eve, three photographs of Willie tacked on the wall above her bed.

And then I had a really bright idea. I did Willie and his warlike ancestors, portraits of the Gillis men in uniform from Great-great-great-grandfather Gillis in his Revolutionary War uniform down through Great-great-grandfather Gillis (War of 1812), Great-grandfather Gillis (Civil War), Grandfather Gillis (Spanish-American War), Willie's father (World War I) to Willie himself, grinning innocently from under his khaki kettle of a helmet. The six portraits were all painted from the same photograph of Bob Buck, but I altered the expressions somewhat, crowned each Gillis with a different hairdo, made the portraits different shapes and sizes, put them in a variety of frames, hung them on a flowered wallpaper and, presto-whiz-bang, I had a *Post* cover. Beneath the portraits I painted in a row of books with titles like *The Gillis Family Genealogy, A History of the United States and the Gillis Family, With Gillis at Valley Forge, Gillis and Lincoln*—purely imaginary titles, but I needed an anchor for the bottom of the picture. The cover was very popular, mostly, I'm sorry to say, because of those books. All the Gillises in America wrote to me asking where they could buy them.

That cover was published on September 16, 1944. By that time the war was, though of course I didn't know it then, almost over. So I was saved the racking problem of thinking up another Willie Gillis cover which I could do without a model. After the war when Bob Buck had returned from the Pacific where he'd served as a navy pilot, I painted the last of the series (the eleventh): Willie as a college student sitting in a dormitory window reading a book. The last I heard of Bob Buck he was running a beauty parlor somewhere upstate.

Most of the pictures I did during the war took their subjects from the civilian wartime scene—the armchair general, women war workers, the ration boards. That was what I knew about and what I painted best. During the First World War I had done pictures of the doughboys in France, but it had all been fakery. I'd taken familiar scenes—a little girl pinning a flower in a soldier's buttonhole, a mother mending her son's socks—and altered them to fit the new locale by dressing the models in costume—soldiers' uniforms, Dutch caps, wooden shoes. It hadn't seemed to matter that the pictures lacked authenticity. I had been young then and unsophisticated, just trying to get ahead, establish myself as an illustrator. But in the intervening years I had developed a style and a way of working. Now my pictures grew out of the world around me, the everyday life of my neighbors. I didn't fake things any more. So, naturally, I didn't attempt to do battle scenes—the troops in Italy or on Saipan. I painted scenes and people I knew something about. And if I had a picture to do of a scene with which I was unacquainted, I researched it.

There were, for instance, the sketches of a troop train. For that one I visited a paratroopers' training base.

I went up with one squad of paratroopers when they made their fifteenth jump. As I boarded the plane the pilot pulled a parachute off a rack and, turning me

329

*I rise
from the
ashes*

Pencil sketch
for *Saturday
Evening Post*
illustration
*Norman Rockwell
Visits a
Ration Board*
(15 July 1944)

around, started to strap it on my back. "Oh no," I said, "not me." "Supposing the plane crashes?" suggested the pilot, kicking the side of it so that the metal plates rattled tinnily. "I'll stay with it," I said. All the paratroopers laughed. They were a wild, crazy bunch. Small, wiry men for the most part—daredevil, proud, and fierce. The officers encouraged these qualities in their men. You had to be proud, daredevil, absolutely courageous, and even somewhat wild to jump from a plane, usually behind enemy lines. Though it created something of a problem, the officers said. Because the paratroopers were so hopped up that they didn't save their fierceness for the Nazis; they brawled with soldiers from other outfits and with civilians.

While we were circling the drop area the captain commanding the troops in the plane came over to me. "Everybody's sort of nervous today," he said. "Two of the men who jumped last night got their chutes tangled together, landed in a river, and drowned." "Think it'll go all right?" I asked. "Sure," he said, "but we're going to have trouble with that guy. See, the tenth man from the door." I looked over at the man. His face was green, sort of the color of rotten grapes, and his lips were trembling. He kept jerking at the straps of his parachute. "Is it the two men that drowned?" I asked the captain. "No," he said, "not particularly. Though that doesn't help. This happens quite often, even on the fifteenth jump. Could be indigestion or bad news from home. But he'll have to go. You watch him." And the captain walked back to the open door.

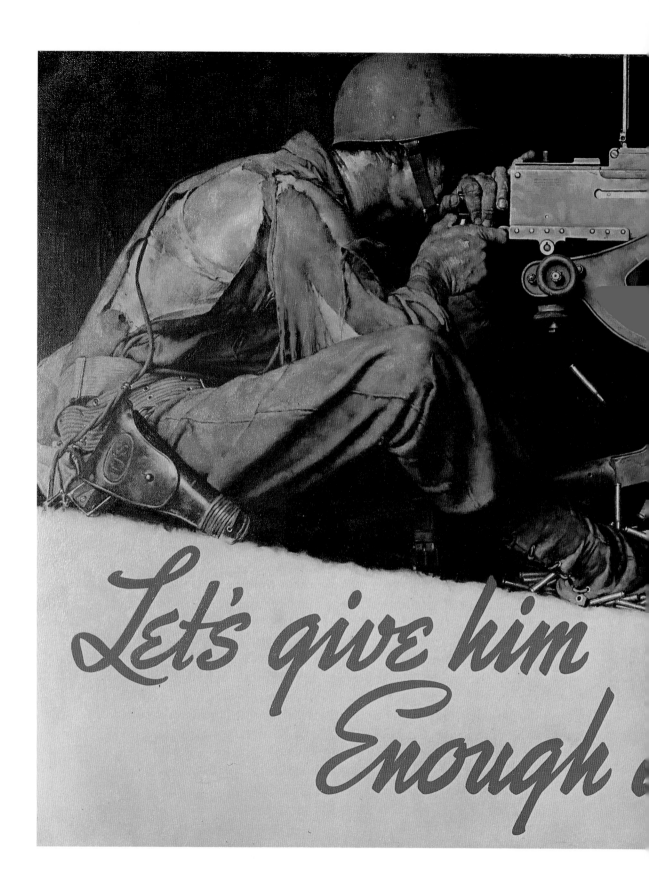

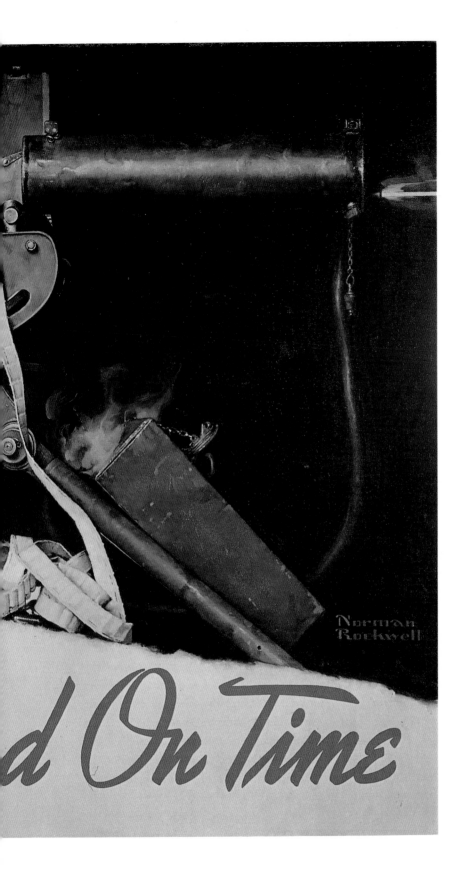

Let's Give Him Enough and On Time, oil-painting for United States Army poster, 1942

As the plane banked, coming around to level off over the drop area, I could see the fields way down below, a truck moving along a road like a tiny black bug, the river like a bent silver needle. The paratroopers stood up and at the command hooked their rip cords to the metal track which ran along the ceiling of the plane. The first man shuffled to the door, blocking my view of the fields and the river falling away now as the plane leveled off. "Number one," shouted the captain above the roar of the plane's motors, and he slapped the man at the door on the back. And the man, yelling, "Geronimo!" vanished. For an instant the sky filled the door; I caught a glimpse of clouds piling up, white with dark underneath. "Number two," shouted the captain, "number three, number four." The line of paratroopers shuffled through the door, jumping in rapid succession. A sergeant kneeled on the opposite side of the door from the captain, looking out and to the rear and calling, "Number one okay. . . . Number two okay," as he saw each man's chute open. It was a queer sensation to see a man standing bulky in his equipment at the door one moment and the next see the door empty.

"Number ten," yelled the captain, and slapped the man on the back. But he didn't jump; he froze, gripping the sides of the door, his knuckles white with the strain. The captain and the sergeant ripped the man's hands off the doorjamb, clawing viciously at his fingers, wrenching them free, and pushed him out. For a moment no one spoke. I could hear a gun barrel clank against the wall of the plane through the steady roar of the motors. Then, "Number ten okay!" shouted the sergeant. After that the jump went smoothly, without a hitch, the line of paratroopers dwindling steadily until, with a start, I noticed that the sunlight was streaming through the door and the sergeant, standing up and wiping his hands on his trousers, said, "That's that," and walked to the front of the plane.

When we landed back at the airfield the number ten man was running and leaping about like a colt in the spring. "I did it, I did it," he yelled. "Did ya see me? I jumped!" "He's cured," said the captain. "That's all a man needs. One jump and he's got his confidence back."

The next day I went up with Major Barney Oldfield II, the public relations officer for the paratroopers. Everybody in the paratroops, including the cooks, chaplains, public relations men, chauffeurs, had to jump once in a while or leave the outfit. (The Catholic chaplain used to jump more often than necessary to encourage the men.) And now the time had come for Barney to jump. He was out of shape and kept saying as we walked to the plane and it took off and climbed, "Gee-sus, I *know* I'm gonna land like a bag of mush." (Mush isn't what he said, but that's as close as I'd better come to it in print.) Pretty soon we were over the drop area. "Gee-*sus*," said Barney, shaking his head, "I'm gonna land like a bag of mush." "All set," yelled the pilot. Barney looked out the door. "Like a bag of mush," he said, "like a big old bag of *mush*." "*Okay*," yelled the pilot. "Geez," said Barney. "Go around again, will ya?" So the plane circled again. "Let's go," said the pilot. "Ugh," said Barney, staring out the door at the fields below. "Just go around once more." "Lemme go first," said Barney's

chauffeur, who was also jumping. So he jumped. Barney stood at the door. "Like a bag of mush," he said. "Geronimo!" And he vanished.

When we landed Barney was waiting for us. "What'd I tell ya?" he asked as I got off the plane. "Geez, I landed like a bag of mush."

I sketched all the time at the base and during the train ride to the port of embarkation. (I was put off the train before we reached the port, however, because it was top secret and no one was allowed to know what it was.) Then I went home to Arlington and the paratroopers boarded their ship and sailed to England. A few months later they were dropped behind the German lines in France on D-Day.

And, finally, there were the homecoming covers—the marine describing the landing at Iwo Jima to his friends in a garage; the sailor basking in a hammock on the front lawn of his parents' house; the soldier surprising his family and friends in the back yard of his tenement home. His mother is holding out her arms to him, his little brother is running to meet him, people are looking out of windows, boys in trees are shouting, his girl is standing quietly to one side. The whole neighborhood is surprised and happy. He has come back. The war is over.

Incidentally, Ben Hibbs always liked that cover of the soldier's return. At the risk of appearing immodest again, I'd like to quote a paragraph he wrote about it: "The homecoming cover now hangs above my desk in my study at home and it has been borrowed many times for art exhibits, including at least one exhibit in the Metropolitan Museum of Art in New York. I regard it as the finest cover Norman has done; in fact, I have always felt that it is the greatest magazine cover ever published. Many readers, I should add, would not agree with me. A Rockwell popularity poll which we once took among our readers was won hands down by the cover of the little old lady saying grace in the restaurant at the railroad station on Thanksgiving Day."

It is rare to find an artist who is successful at one and the same time in commercial art and fine arts, one like John Atherton, my friend in Arlington, who was a recognized abstractionist with paintings in the Metropolitan, the Museum of Modern Art, and the Chicago Art Institute and also did covers for the *Post* and *Fortune* and advertisements.

A fine arts painter has to satisfy only himself. No outside restrictions are imposed upon his work. The situation is very different in commercial art. The illustrator must satisfy his client as well as himself. He must express a specific idea so that a large number of people will understand it; and there must be no mistake as to what he is trying to convey. Then there are deadlines, taboos as to subject matter (for years the *Post* would not allow me to show a cigarette; now I may show a man smoking but not a woman. I once painted a man holding a glass of beer; the *Post* changed it to a glass of milk); the proportions of the picture must conform to the proportions of the magazine.

Most fine arts painters feel that these restrictions constitute pure slavery. An artist friend once said to me, "If the average person liked a painting of mine I'd destroy it." A young art student remarked once, "I think I'll take up fine arts. Com-

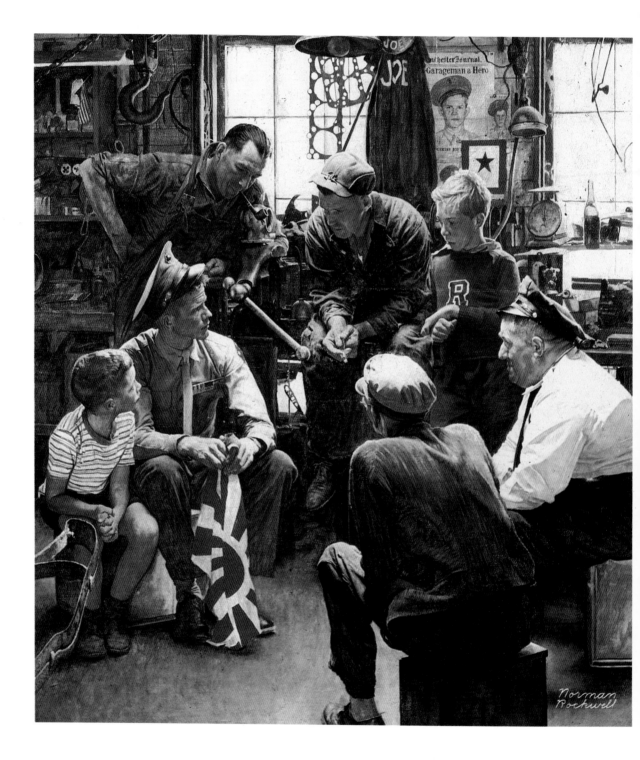

Homecoming Marine, oil painting for *Saturday Evening Post* cover (13 October 1945)

mercial art is too difficult." Which was a silly thing to say, because obviously the requirements of fine arts are as exacting as those of commercial art. But they are self-imposed. Fine arts painters, working entirely out of their own instincts and feelings, refuse to allow any restrictions to be superimposed on their paintings by others.

One summer ten or fifteen years ago I was working in Provincetown, Massachusetts. A bohemian art student—beard, long ragged hair, sandals—kept hanging around my studio. I guess I sort of fascinated him (morbidly, I'm afraid). One day I was working on a painting of Johnny Appleseed—an old man with an iron kettle on his head and a burlap bag for a coat striding barefoot across a hilltop, flinging out handfuls of seed from a gunny sack hanging around his shoulder. The art student, squatting on a chair, his head in his hands, was watching me. Suddenly he groaned. "Whatta ya do it *that* way for?" he asked. "What do you mean?" I asked. "Whyn't ya do it with more *feeling?*" he said. "Like this." And jumping off the chair, he ripped a big piece of paper from my drawing pad, flung it on the floor, pulled some stubs of colored chalk out of the back pocket of his faded blue jeans and, kneeling down, outlined a long rectangle on the paper. "Now," he said, coloring in with light brown chalk a shape like a hawk's beak, "that's old Johnny's body because it was browned by the wind and sun. Okay?" I nodded, startled. "*Okay,*" he said, and above the hawk's beak, which looped up and out from the lower right corner, he divided the rectangle into a red area and a white area, both roughly triangular. "You say he was kind of a religious fanatic," he said. "Right?" I nodded dumbly. "So the white's his spirit," he said, "and the red's the physical part of him and they're contending, the physical and the spiritual." Then he furiously rubbed blue chalk over the area below the hawk's beak ("That's nature," he announced), made the base of the rectangle dark brown ("That's earth") and drew a hand casting a seed, the wrist coming out of the hawk's beak.

"But," I said when he'd finished, "nobody knows it's Johnny Appleseed." "Whatta ya mean?" he asked, holding up his sketch and gazing at it fondly. "Only you know it's Johnny Appleseed," I said. "Nobody else does. The readers won't be able to tell who it is." "So?" he asked. "What difference does it make about anybody else? *I* know it's old Johnny. I'm painting it for myself. Who cares about the unwashed masses?" "Besides," I said, trying a new approach though I could see I was up against a stone wall, "besides, your picture won't fit into the book it's supposed to appear in. The proportions are wrong. You've got it too tall." "So make the book tall," he said.

All of which demonstrates, I think, that an illustrator and a fine arts painter don't go at a picture in the same way. (I realize the incident is pretty silly, but it will do as an example.)

But Jack Atherton was capable of separating his commercial work from his fine arts work and looking on each with a different viewpoint. He could do an abstraction in the morning, painting only to satisfy himself, brooking no interference from others. (One day someone, pointing to a smokestack in an abstraction Jack had done of an industrial scene, remarked, "You know that wouldn't work that way." Jack

got furious, storming at the man: "What difference does it make whether it works or not? My God, this is a picture, a *picture!*") And in the afternoon he could start a *Post* cover, making sure that it had the correct proportions and that the idea was clear and absolutely comprehensible to everyone. And when the editor suggested a change Jack would discuss it with him calmly, and if they decided that the change was beneficial Jack would make it.

I guess one of the reasons that Jack was able to do both commercial and fine arts work was his extraordinary facility. He could use any medium, letter beautifully. And he always knew just what he was going to do each time he put brush to canvas, pencil to paper. He never, as far as I know, fumbled over a picture, uncertain of what he wanted. And he never did a picture over twice. He'd sit down at his easel and paint a beautiful trompe l'oeil—a brace of pheasants hanging on a wall, say—in two or three days without a moment of hesitation or uncertainty. Once he painted six *Post* covers in two weeks. (He didn't send them all in at once, however. He decided that the editors might feel that he hadn't worked hard enough on the covers. So he sent them in one a month during the next six months.)

Everything Jack did—skiing, tennis, painting, fishing, skating—he did to perfection. Something inside him forced him to excel, though it wasn't particularly competitive. It was more, I always thought, a deep abhorrence of sloppiness, of amateurishness, of slipshod performance in anything.

I guess that's why he defended my work, even seemed to admire it at times, in spite of his profound detestation of human-interest pictures. (He never did people or human situations himself; his work consisted mostly of landscapes, still lifes, factory scenes—treated realistically in his commercial paintings, abstractly in his fine arts.) Any painting, book, movie which was the least bit sentimental would irritate him terribly, throw him into a positive agony. He couldn't stand it; it hurt him, like a cold needle driven into his brain.

Jack was a large, hulking man with powerful shoulders and big hands and arms. But his head was curiously small, and round and completely bald except for a fringe of light brown hair about his ears. His features were small. Whenever something irritated him—and something did almost every day, for his threshold of irritability was low—he'd groan and wrap his arms about his head and sway from side to side as if you were sticking red-hot knives into him. I remember once when I was painting the annual Boy Scout calendar, which I've done every year since 1920, I went over to his house. After we'd talked about miscellaneous subjects for a bit he asked, "What are you working on now?" "Oh, you don't want to know, Jack," I said, for I knew how he despised the Boy Scout calendar. "Yes, I do," he said, visibly preparing himself for the worst. "All right," I said, "I'm doing the Boy Scout calendar." He moaned and began to crush the fingers of his right hand in his left. "Why do you do it?" he asked. "It's *propaganda,* it's sentimental *trash.* Why in God's name do you do it?" "Well, I *like* to do it," I said. He cracked his knuckles viciously and asked in a pained voice, "What's the subject?" "You don't want me to tell you, Jack," I said. "Yes, I do," he said. "What is it?" "A handsome, one hundred per cent American Boy Scout," I

said, watching Jack begin to knead his skull furiously with his hands, "and a fine-looking, upstanding American Cub Scout." "Oh, my *sweet* Judas," moaned Jack, swaying from side to side and wrapping his arms about his head. "What are they doing?" "You *don't* want to know," I said. "Yes, I do," he said. "Well, they're looking at something," I said. "What're they looking at?" he asked, gritting his teeth and groaning as if in actual physical torment. "Don't make me tell you," I said. "It'll kill you." "Tell me," he panted, "tell me." "They are looking," I said very distinctly, "at a cloudy vision of George Washington kneeling and praying in the snow at Valley Forge." Jack grunted horribly and grabbed at his back, twisting about in his chair as if he'd been stabbed.

But Jack was deeply loyal. If anyone else disparaged my work he'd light into them. Whenever I'd get discouraged and begin to bellyache about my work he'd become furious with me. "Do you think if I could do the kind of work you do I'd paint the stinking stuff *I* do?" he'd demand. And he was always telling everybody that I should get more recognition, the critics should discuss my work and comment on it (favorably). One day he brought Robert Coates, who wrote on art for the *The New Yorker* magazine, over to my studio. Coates is a tall man with a shock of red hair and he just stood there, not saying anything, while Jack spread out my sketches and paintings on the floor. Finally Jack got disgusted. He'd displayed everything I had in the studio and Coates still hadn't said a word. So, "What do you think?" asked Jack. "Well," said Coates, scratching his chin, "he certainly is a hard worker."

Which stumped Jack. Which, in turn, surprised me. For Jack was a volatile man, exploding with a roaring, raging torrent of words and profanity at the slightest pretext. He seemed to have vast reserves of irritable energy stored up inside him. Sort of a volcano which, if disturbed, would vomit forth fire and brimstone. Late one afternoon Schaef, Jack, and I were walking down to the Batten Kill River. The foam of the rapids was streaked with the gold and purple light of sunset, and the still pools mirrored the red clouds and the darkening sky. Jack was fifteen or twenty feet ahead of Schaef and me and all of a sudden he stopped dead and began to curse violently and stamp his feet. Schaef and I rushed up and asked him what was the matter? "Just look at that blankety-blank blank damned river," said Jack. "Isn't that beautiful?" And he cursed some more.

Jack and Schaef were devoted fishermen. But they rarely killed and ate the fish they caught. That was vulgar. Catching a trout—the skill and sport of it—was what they cared about. One day I went fishing with them and, hooking a fat brook trout, started to haul it up on shore. "Play it, play it!" shouted Schaef and Jack, incensed. I jerked my rod, flipped the fish over my head, and pounced on it. "Damn, damn, *damn!*" said Jack. "You've ruined a perfectly good trout." "You should have played it," said Schaef. "It's no fun if you don't play it. And besides, you've hurt its jaw and we'll have to kill it." "I'm sorry," I said, crestfallen now that the excitement was over and I remembered how careful Jack and Schaef were of the fish. All summer they'd hook the same fish over and over, throwing them back into the river every time. It got so they'd give the fish pet names. "Did you catch Jake last night?" Schaef would

ask Jack at dinner. "Yes," Jack would reply, "and Charley, David, and Benjamin too." And he'd explain how he'd caught the fish—what fly he'd used, et cetera.

I always thought it was awful hard on the poor fish, being hooked, played, netted, and thrown back thirty or forty times a summer. It was a wonder they didn't have nervous breakdowns and go sulk on the bottom and starve.

But every so often—and this used to drive Schaef and Jack wild—after a rain, when the fish would all come to the surface to feed, some Vermonter would impale six or eight obese worms on a hook, drop it into the water, and yank old Charley or Jake or Benjamin out, crack his back against a rock, and take him home and fry him. Then Jack would go down to Charley's pool the next day and . . . no Charley. So he'd curse and grab his ears and splash about the river in his waders, his bald head pink with fury. Though I dare say Charley was relieved.

One day Frank Hall, a local restaurateur, asked Jack, Schaef, and me to come over to his Wagon Wheel Restaurant for a lobster dinner. "Just a quiet dinner," he said. "The place is closed tonight. I want to talk to you fellows." "What about?" I asked. "I've got an idea," he said. But he wouldn't tell me what it was. I grew suspicious, for Frank is a promoter. He has a lean, furrowed, world-weary face. As a young man, he ran away from his home in Vermont to go on the vaudeville stage. His career as a song and dance man was not a success. He told me once that his partner, dressed as a cowboy, would go into a saloon and, sitting down at the piano, play a few tunes. Frank would wander in. After a minute, "That's great," he'd say. "Can you play 'Home on the Range'?" His partner would play it. Frank would suggest several other numbers. Then he'd say to the cowboys standing at the bar, "What d'ya say we take up a collection? I'll start her with a buck." And he'd put a dollar bill in a hat and, after passing the hat around, give it to his partner. Later, around the corner, they'd divide the money.

After years of this hand-to-mouth (or hat-to-hand-to-mouth) existence, Frank returned to Arlington and opened a restaurant. But he remained a vaudevillian at heart. His ideas were grandiose. Jack, Schaef, and I decided to go just out of curiosity.

All through dinner Frank refused to tell us his idea. "Wait a bit," he'd say. "Enjoy your lobsters." When the table had been cleared he lit a cigarette and leaned forward in his chair. "Now," he said, "here it is." And he outlined to us, as we sat rooted to our chairs, the following plan. At one side of the restaurant entrance there was a gift shop. He would replace the gift shop with three little booths. Before each booth a curtain would be hung; above each booth would be a sign. One sign would read: JOHN ATHERTON; the next: MEAD SCHAEFFER; the last: NORMAN ROCKWELL. A tourist, entering, would take his choice and slip a quarter into the coin machine affixed to the side of the booth. The coin would rattle down into the machine. There would be a click and a snap. *And* the curtain would open, a light would flick on, disclosing *a life-size wax figure of Jack, Schaef, or me sitting at an easel, painting.*

I looked at Jack. He was glassy-eyed, rigid. The corners of Schaef's mouth were twitching.

Going and Coming, oil painting for *Saturday Evening Post* cover (30 August 1947)

Frank continued. Behind the wax figures, which would, of course, be dressed in everyday working clothes, would be a picture of our studios. Everything, he assured us, would be lifelike. He had contacted a man who had worked in a wax-works. Perfect likenesses would be made. Nobody would be able to tell Jack, Schaef, and me and our wax figures apart.

"Well," said Frank, "whatta ya think?"

"*Je-hos-a-*PHAT!" exploded Jack, wringing his head in his hands.

Schaef put his head on the table and laughed uncontrollably.

"Can I come over and dust my eyelids?" I asked. "I've never liked the way dust collects on the eyelids in waxworks."

"No," said Frank, "seriously. It's a great idea. You'll be immortalized in wax."

Jack snorted like a wounded bear. Schaef was still laughing into the tablecloth.

"Nothing permanent," I said, "but I'd dearly love to see myself in wax just once."

And I meant it. I'd still like to have seen that waxworks. I'd put a quarter in the slot, the curtains would creak open, a light flash on, and there, as big as life, with rosy cheeks and horsehair hair, a brush in my waxen fingers, would be . . . ME!

But I never saw it. Jack, Schaef, and I decided without too much deliberation that we did not wish to be immortalized in wax.

Jack wasn't set on reviving the golden age of illustration as Schaef and I were, but he joined in our discussions of art, damning sentimental, human-interest pictures one minute, the next loyally (and violently) upbraiding us for down-grading our work, which was, after all, human-interest and (some of it anyway) sentimental.

Jack died on a fishing trip in Canada in 1952. I doubt if I will ever meet a man as volatile and stimulating, or have a friend as loyal.

After the war I became acquainted with Grandma Moses, the famous painter of American primitives. She had started painting seriously at the age of sixty-seven after the death of her husband. Using dime-store brushes and house paint, she did scenes of country life which she remembered from her childhood. For ten or fifteen dollars she would paint a picture of someone's house, making a sketch of it from the front lawn, then doing the finished picture at home in her bedroom. If there were five children in the family she would put them into her painting. If there were two dogs and a cat in the household, two dogs and a cat would be in the painting. But the children would be dressed in old-fashioned clothes and there would always be a sleigh or buggy before the door. Everything she painted was metamorphosed into the world of her childhood, rural America in the second half of the nineteenth century. As far as I know, she never painted anything up to date. A car became a buggy; a tractor, a team of horses.

One day a New York art dealer stopped at a local drugstore in which Grandma Moses was having an exhibition of her work. Realizing that she was a fine painter, he took her work to New York. She became famous.

When I knew her she was over eighty-five years old, a spry, white-haired little woman. Like a lively sparrow. She still painted in her bedroom on the third-story of her farmhouse, using the same cheap brushes and house paint, though her paintings were selling rapidly for very good prices. She worked sitting down at a flat table in front of a dormer window. The ceiling of the room slanted, and the light was, I thought, bad. There were paint pots on the chairs, the dresser, and the tables. She always had coffee brewing on a hot plate.

Once when I was visiting her someone asked, "Grandma, if you had a grand-son who wanted to paint, how would you go about starting him off?" She replied that she would give him paints and brushes, set up an easel on the front porch, and make him paint the landscape reflected in the window on the porch. "Why the reflection?" she was asked. "Why not work directly from the landscape?" "Because then," she said, "he'll make it look like a photograph. If he paints the reflection in the window he'll have to use his imagination." I looked at the window; the panes were of old glass, rough and uneven, pocked with air bubbles. Grandma Moses was right; it would teach the boy to use his imagination. He'd get something of himself into the painting.

She had a creative mind. To the profound annoyance of her family and the art dealer, she was always experimenting. Once, having grown tired of the scenes of the four seasons which were her usual subjects, she decided to do a painting of a thunder-storm which she remembered from her childhood. But the experts decided the cus-tomers didn't want a thunderstorm; they wanted one of her typical scenes of winter, spring, summer, or fall. So Grandma was talked to until she said all right, and gave up the thunderstorm.

Another time she became interested in weaving pictures in worsted. But there was a waiting list for her paintings. Nobody wanted worsted pictures. And they took up too much of her time. The experts moved in again. Grandma gave up worsted pictures.

She was intensely curious. When she visited my studio she always had to know all about what I was doing. And she'd poke about in all the corners, look into the darkroom, traipse upstairs into the attic balcony. She would want to know what kind of paints and brushes I was using and why. Having learned that I worked from photographs, she tried to. But she couldn't do it. The photograph interfered with her imagination and the flow of her memories.

Her pictures are never phony. Even after she began to turn them out regu-larly—she'd go up to her bedroom and paint ten or twelve skies, then ten or twelve houses under the skies, et cetera, until the pictures were finished—they were good, honest pictures. She has an unerring sense of color and somehow the source of her paintings—her memories—remains fresh and vital, so that no matter how many times she does a winter scene it still retains its charm and sense of life. An amazing thing, when you come to think of it. And memories which are seventy-five years or more old. The world of her childhood is more vivid and real to her than the modern world. All the years have not effaced it.

Christmas Homecoming, oil painting for *Saturday Evening Post* cover (25 December 1948)

Game Called Because of Rain, oil painting for *Saturday Evening Post* cover (23 April 1949)

Murder Mystery, charcoal and pencil sketch for an unpublished *Saturday Evening Post* cover, c. 1960

17

Flops!

FREQUENTLY, after a monstrous struggle, thrashing about, and noise—sketches made, props gathered, a set constructed, models selected, photographs taken . . . and then . . . more sketches, new models, more photographs—I find that the picture isn't a picture, it won't go, I've been molding a handful of air. And the weeks of work have been all for nothing. Which is sometimes discouraging, because I had such high hopes for the idea, and sometimes not, because I'm happy to be shut of the idea which caused me so much trouble. Though a failure always makes me wonder. Why, by all that's holy, I think, didn't I see that there wasn't a picture in that idea? If I'd only stopped a moment and looked at it calmly. The flaw, the contradiction, was certainly always there. And yet I hadn't seen it; I'd gone merrily along, chanting: This is going to be a good one, one of my best *Post* covers. Until one day it vanished like a puff of smoke on a windy morning.

There was, for instance, the affair of me and the eight movie stars. Oh, it seemed a beautiful, really first-rate idea when I roughed it out for the first time on a piece of scratch paper—a cock among hens, a rose among dandelions. I patted myself on the back. A murder mystery for a *Post* cover. It was, I thought, punning badly, a killer. I'd show a murdered man surrounded by his friends and relatives, one of whom had done him in. The clues to the solution would be present in the picture and the readers of the *Post* would be asked to solve the crime. For a prize maybe.

I laid aside my other work (Let it be late, I said, I can't stop now; I've got a comet by the tail!) and called the FBI in Washington to find out about poisons. Poison—deadly quick—seemed to me to offer the most obscure and baffling way to kill

my corpse. "I want," I told the chief of the FBI's poison division, "an esoteric poison, one which most people wouldn't know about." There was a stunned silence on the line. "Oh," I said, "I want it for a picture. Name's Norman Rockwell. I do covers for the *Saturday Evening Post*." And I explained my idea. The poisons expert, rather relieved, I thought, by my explanation, advised me to get in touch with Professor Brainerd Mears of Williams College in Williamstown, Massachusetts, just forty miles south of Arlington. He was the foremost authority on poisons in the country.

The next day I went to Williamstown to see Professor Mears. After treating me to a most fascinating discourse on poisons, he recommended the juice of an African plant. "Boiled," he said. "A single drop is deadly, will kill in a matter of seconds." "Where could I get a plant of it?" I asked, thinking, Perfect—I'll put a broken teacup by the corpse and the plant on the table; the old lady in the picture has stewed a leaf of the plant in the tea and served it to her nephew . . . the corpse. "Let's see," said Professor Mears. "The movies use it. I know Twentieth Century-Fox has a plant." I thanked him and left.

A few weeks later I arrived in Los Angeles and went straight to Twentieth Century-Fox. Yes, said the prop department, we have such a plant, and they took me out to the prop garden. There, in a fenced-off, barred, and bolted hothouse, was the studio's collection of poisonous plants. "For heaven's sake," they said, giving me the plant I wanted in a pot, "don't leave this around. Somebody might want to do away with somebody else and we'd be blamed."

Back in my rented studio, gazing rapturously at my African plant, I was seized by another idea. Why not see if Twentieth Century-Fox would get me movie stars as models for the picture? Aboil with my new idea, I rushed over to the public relations department. When I'd explained what I wanted, "We'll get you the greatest cast ever assembled!" they said. "How many people do you need and what types?" "It's a parody of an English murder mystery," I said. "The scene's a castle. There's the old lady who owns the castle." ("Ethel Barrymore!" shouted one of the public relations men, all excited.) "And a sinister chef, hulking, craggy-faced." ("How about Boris Karloff?" asked another public relations man, excited too.) "And a scandalous, glamorous actress." ("Linda Darnell!") "And a demure upstairs maid." ("Loretta Young!") "And a wastrel, holding a ferocious riding crop with a massive, ivory, blunt-instrument head on it." ("Richard Widmark. He's the wastrel type.") "And a butler, cold as glass and haughty." ("Clifton Webb.") "And then," I said, "I thought I'd have a dog." "By George," said one of the public relations men, "we'll get Lassie. It's the spectacularest cast ever assembled. No movie could afford it." "Do you think they'll all do it?" I asked. "Ethel Barrymore's the key," he said. "If she'll do it the others will. Get her and they'll all come tumbling in. I'll call her agent." "The corpse," I said. "We've forgotten the corpse." "Well," said one of the men, "what kind of a corpse do you want?" "Male," I said. "Only his feet will show, though, so I don't guess we need anyone in particular." "We can't let down now," he said. "How about Van Johnson?" "Okay," I said. And so the greatest cast of the century was assembled.

Then Twentieth Century-Fox turned over to me a set of an oak-paneled baronial room with a huge marble mantelpiece. Electricians, carpenters, prop men, and a cameraman were assigned to help me. The stars were pulled off pictures they were making to pose for me. Ethel Barrymore swept in, recognizing me from the days when I had taken her and her friend sketching. (And then she said, "Tell me, Mr. Rockwell, *whom* have I *murr*dered?" "Van Johnson," I said. "*Superb,*" she said, "I have *always* wanted to *murr*der that boy.") And Loretta Young, Richard Widmark, Boris Karloff, Van Johnson, Linda Darnell, Clifton Webb, and Lassie posed. For four days I worked hard, directing them; they worked hard, posing; the carpenters hammered and sawed; the electricians set up lights, took them down, rearranged them; the prop men shifted furniture about and hung and rehung drapes; the cameraman took photograph after photograph. In short, everybody toiled away so that everything would be just right.

And then I did the charcoal drawing of the cover (it was a job, too, six and a half figures—the corpse being the half—and a dog), and sent it into the *Post* for final approval. Wellll, they wrote back, if you *really* WANT to paint it, go ahead. But we don't think it's up to scratch. The movie stars kill it. The readers will be so busy recognizing the stars that the idea will be lost. They'll say, There's Ethel Barrymore and Linda Darnell, et cetera, and miss the whole point of the cover.

I went out to my studio, unwrapped the charcoal, and looked at it for the first time with unfogged eyes. The editors were right. It wasn't up to scratch. The stars distracted, confused. And that broken teacup and African plant were pretty slim clues. And how would anyone know the old lady brewed the tea?

I rolled the charcoal up and put it away in a drawer. It's still in a drawer. For, you see, in the excitement of getting the poison plant and the movie stars and arranging everything, I hadn't stopped to evaluate the picture. When I did, finally, consider it calmly, I discovered that it didn't make a *Post* cover. Which, after all the trouble I'd caused, made me feel about as big as a dried lima bean. . . . Nowadays I avoid Hollywood. Suppose I met one of the public relations men on the street? Or Loretta Young? "Oh, Mr. Rockwell, whatever happened to that cover?" "Uh, uh, uh," I'd be forced to reply, feeling like a stewed prune, which isn't comfortable.

Though why that sort of thing should faze me is a mystery. It happens all the time. Not too many years ago I came up with what I thought was an excellent idea for a *Post* cover. The scene was a baseball park. A brawny gorilla of an umpire was daintily dusting home plate with a little whisk broom while the batter and catcher waited. The contrast between the squatting umpire—big, red-faced, square-jawed, broadshouldered—and his finicky, housekeeping gesture seemed humorous to me.

I called Ken Stuart, the art editor of the *Post* since 1944, and told him the idea. He liked it and suggested that I use actual major league baseball players as models. "And we'll run the cover during the first week of the season," said Ken. "I'll get the catcher and the star of two teams which are going to play each other on opening day and the umpire who's going to work that game." "Wonderful," I said. "It'll be authentic."

A couple of weeks later I flew to St. Louis. Ken had gotten me Stan Musial for the batter, Joe Garagiola for the catcher, and Al Barlick for the umpire.

We all rode out to the ball park in two taxis (two because five or six newspaper reporters and photographers came along to cover the story). It was late fall and the playing field was wet and ragged. But the grounds keepers had dried it off and groomed it around home plate, marking off the batter's box and the foul lines in white and setting the plate in the ground. "It was quite a job," one of them remarked to me as my photographer was setting up his camera. "Well," I said, carefree as a lark, "we'll get a *Post* cover out of it. That's worth the trouble." "Sure," he said seriously.

So by now I'd involved the art editor of the *Post*, two ball clubs (I forgot to mention that Musial's and Garagiola's uniforms had had to be taken out of storage), five or six grounds keepers, Stan Musial, Joe Garagiola, and Al Barlick in my cover. I had the best intentions; in my mind a *Post* cover justifies any amount of bother. And I had no doubts about this cover; it was a good one; I was sure of it.

I posed Garagiola and Musial, fussing and carrying on until their expressions were just what I wanted. Then I showed Barlick how I wanted him to stand—bent from the waist and facing the pitcher's mound, his rear up and toward the grandstand. "You know," remarked Garagiola casually, "the ump doesn't generally stand that way." "Oh, it'll be all right," I said, not paying any attention, for I was adjusting Barlick's cap to the correct angle and it kept slipping over his forehead. None of the reporters, photographers, or grounds keepers backed Garagiola up. Neither Stan Musial nor Al Barlick said anything. The remark was forgotten. We finished taking the photographs and later that day I flew back to Arlington.

There I did the charcoal drawing, traced the outlines of the figures on canvas, and commenced painting them. A week or so later, when I was about half done (and it was shaping up, make no mistake; it'll be a good one, I thought, and popular, oh boy!), Jim Edgerton came into the studio. "How do you like it?" I asked him confidently. "Fine," he said, and sat down on the window seat to watch me paint for a while. "Say, Norman," he said after a minute, "I don't think an umpire stands like that. Doesn't he turn his back to the field and face the stands?" I panicked immediately, suddenly remembering Garagiola's casual remark. "You sure?" I asked weakly. "Well, I've never seen a game," said Jim, "except on television. But as I recollect it, that's not how an ump stands."

I called Ken Stuart. He investigated. Jim was right. There's nothing in the rule book which says an umpire must face the stands when he dusts the plate, but it's an unwritten law. You watch the umpire sometime. He never puts his rear to the grandstand.

So there I was—flopped on my ear again. I tried turning the umpire around. But the *Post* didn't want his rear in its readers' faces. Besides, the cover wasn't funny if you couldn't see the expression on the umpire's face or the dainty way in which he was dusting the plate. And it was no good switching the scene all around and painting it as if I was sitting in the grandstand. That didn't look right either, because then the batter and catcher, standing on either side of home plate, would loom up larger than

the umpire, squatting in front of the plate. And anyway, without the dark, colorful background of the stands, the picture went all to pieces.

So into the dustbin it went. At first I felt like crawling in with it. But after I'd lived with myself for a few days and kicked myself a bit, saying, "You're insane, dragging all those people out to the ball park and bothering everyone before you know what's what," I reflected that it had been an innocent error and, after all, I'd worked hard for nothing too. . . . Still, nowadays I avoid St. Louis. I might meet Stan Musial or Joe Garagiola. What could I say if they asked about the cover?

But my worst enemy is the world-shaking idea. Every so often I try to paint the BIG picture, something serious and colossal which will change the world, save mankind. Humor's all right, I say to myself, but if I'm to be remembered I'll have to do something significant, a picture which will reflect the large view, which will have a memorable subject. So I exchange my gentle old back-yard plug for a prancing, majestic stallion and my customary blue work shirt for a coat of shining armor. And before I know it I'm sprawled on the ground with my nose in the mud, battered and bruised.

I just can't handle world-shattering subjects. They're beyond me, above me. Not that I ever stop trying. I'm very forgetful of my failures, and every new idea fills me with hope. This is the one, I say to myself, this is it; I've never had an idea like this. And off I go, stretching my neck like a swan and forgetting that I'm a duck. And pretty soon all I've got for my pains is a crick in the neck, a batch of useless photographs, a sheaf of useless sketches.

I do ordinary people in everyday situations, and that's about all I can do. I didn't use to think so, but now I know my limitations. Whatever I want to express I have to express in those terms. And I find that I can fit most anything into that frame, even fairly big ideas. "Freedom of Worship" is a pretty big idea. So's "Freedom of Speech." But, as I say, every so often I get to hankering after immortality and, or so I think at those times anyway, that requires a picture tremendously conceived and tremendously executed.

There was, for example, my United Nations picture. I was deeply serious about that one. And it wasn't so much personal aggrandizement. I sincerely wanted to do a picture which would help the world out of the mess it's in. And as it seemed to me that the United Nations was our only hope (I still think so; at least there's a semblance of friendly co-operation between nations in the UN), I decided to do a picture of a scene at the UN.

My first idea was to show the Security Council chamber after all the delegates, their secretaries, and the translators had gone home for the day. The lights would be dimmed and there'd be a cleaning man, an old fellow, sweeping up around the delegate's chairs. He'd be turned toward the rear of the chamber as if he'd suddenly felt a presence in the chamber and glanced up. And there, in the darkness, would be the figure of Christ. And maybe Lincoln. Or just Lincoln, perhaps. I hadn't worked it out yet.

But when I visited the UN building in New York I found that there was no place in the rear of the Security Council chamber for Christ or Lincoln to stand. I hadn't been particularly happy with the figures of Christ and/or Lincoln anyway. They weren't universal enough. I wanted to include representatives of all the peoples of the world. And so, after four or five weeks of brain-cracking effort (I was doing my regular work more or less efficiently at the same time), I completed another sketch.

In it the delegates of the U.S.S.R., the United States, the United Kingdom, and Chile (which happened to be on the Security Council at that time) were seated in their places, debating. Beneath them in the foreground of the picture were the various secretaries and translators. All this was brightly lit. But behind the delegates, in the shadows, was a mass of people—Chinese, Koreans, Africans, Italians, Poles, Indians—men, women, and children—soldiers and civilians—sixty-five persons in all, representing the people of the world waiting for the delegates to straighten out the world so that they might live in peace and without fear.

When I submitted this sketch to Ben Hibbs and Ken Stuart they were wonderful about it. "If you think there's a picture in it," they said, "do it." So Ken and I went to the public relations department of the UN. They liked the idea and gave me special permission to take photographs inside the UN building. (The major painting was to be accompanied by four pages of black and white drawings of people and scenes around the UN—an Arab delegate in his robes, Vishinsky having a cup of coffee, et cetera.)

The four delegates who were to appear in the painting I photographed in the council chamber. I did Henry Cabot Lodge, the American delegate, first. He was not a good model, staring rather stolidly into the camera. "Would you smile, Mr. Lodge?" I asked. "Look more pleasant?" "No," snapped Mr. Lodge, "I can't do that. You take it like this." And neither the British nor the Chilean delegate could act; they looked unhappy in the pose too.

So I was rather discouraged when I got to Andrei Vishinsky, the Russian delegate. Through a Russian photographer on the staff of the UN, a cute little woman with frizzy hair, I had obtained permission to photograph Vishinsky. (Incidentally, she worshiped Mr. Vishinsky. One day he passed us in the hall. "Oh," said the little photographer adoringly, "there he is. Excuse. I must follow him." And she ran off. A few minutes later she returned, crestfallen. "Where did he go?" I asked. "To the men's room," she said.) She had taken Mary (for some reason she felt it would be better if Mary rather than I went) to see the Russian ambassador one day when he was visiting the UN. Mary had shown him my sketch and explained that I would not caricature Mr. Vishinsky and that there would be nothing derogatory to the Russians in the painting. The ambassador had given us his okay. But he had been unable to tell us when Mr. Vishinsky would be available. For security reasons no one was permitted to know when Mr. Vishinsky would arrive at the UN. So for two days my photographer, his assistant, Mary, and I sat in the Security Council chamber, waiting. Late in the afternoon of the second day a messenger from the Russian photographer, who had

promised to notify us the moment Mr. Vishinsky arrived, came running in. "Vishinsky's here," he said. "He's coming right up."

"Quick, Mary," I said, all atwitter, "you get in Mr. Lodge's place. Mr. Vishinsky is supposed to be looking at him." The photographer and his assistant fussed with their camera and film; I picked up my sketch and rubbed an invisible smudge off the mat.

Then the door opened way across the chamber and in walked Mr. Vishinsky, flanked by two bodyguards, brawny men dressed all in black with their hands ominously plunged into their pockets. An interpreter trotted in front.

Mr. Vishinsky bowed to me most cordially. He didn't look like the vicious prosecutor he was supposed to be. I thought that with his red face and white hair he looked rather like an elderly grocer. "What do you want Mr. Vishinsky to do?" asked the interpreter. "Would you . . . ah . . . kindly ask him to go to his seat?" I said, somewhat worried, for Mr. Vishinsky was all smiles but Mr. Lodge and the British and Chilean delegates hadn't smiled. And I couldn't paint the picture that way. So, "Would you ask Mr. Vishinsky not to smile?" I said to the interpreter. "Ask him just to look pleasant." Mr. Vishinsky stopped smiling; his face assumed a benign, good-natured expression. "Oh," I said, "and would you ask him to look over at Mrs. Rockwell. She's taking Mr. Lodge's place." Mr. Vishinsky turned toward Mary, bowed slightly, smiled, and said in perfect English, "It will be a pleasure to look at Mrs. Rockwell."

Well, I thought, I guess I'll have to fake expressions on the other three delegates. I can't be partial to anyone and, as it is, Mr. Vishinsky is going to look like Santa Claus strayed into a den of Scrooges.

Back in Arlington I took photographs for the mass of people in the background of the painting. I didn't use sixty-five different models, but I must have used thirty or forty. I don't remember the exact figure. At any rate I spent at least a month taking the photographs. And I spent another month on the preliminary charcoal drawing, doing each of the more than seventy figures in detail. Then all of a sudden Mr. Vishinsky was temporarily recalled to Moscow and a new delegate sent over in his place. I went to New York and took new photographs.

By this time I was exhausted. I propped the charcoal on a spare easel in a corner of the studio and set about catching up on my regular work. Weeks passed. I tried to forget the picture so that when I found time to return to it I would be fresh and excited. Somehow I'd gone stale on it.

But as time passed and I looked at it day after day I began to have doubts about it. Maybe I was getting in beyond my depth. Perhaps it was too ambitious. I turned the charcoal to the wall. I couldn't stand to look at it any more. It seemed empty and pretentious. Then I rolled it up and stored it away in the back room.

I've never gone back to it. Every so often I unroll the charcoal, but the picture seems dead to me, I can't generate any enthusiasm for it. I don't know why exactly. I can't see anything particularly wrong with it. I guess it's just not my kind of picture.

Nowadays I avoid the UN building. Suppose I ran into one of the public relations people who arranged things for me? After all the fuss I made, what could I say but "Uh, uh, uh," or do but feel like a fool?

The purely commercial failure is not nearly as distressing as a good idea gone bad. It's upsetting, I'll admit that, for I'm very sensitive to the public reaction to my work. But usually it's not the quality of the picture which is at fault and that consoles me. For instance, my calendar of Mrs. O'Leary and her cow. You remember the story: while Mrs. O'Leary was milking her cow, the cow kicked over a kerosene lantern, causing the great Chicago fire of 1871. I thought it would make a good calendar, so I painted it—rear view, the cow's behind prominently displayed, occupying, in fact, the better part of the picture—and Brown and Bigelow published it. Unpopular? We thought no one would buy it. Turned out to be my worst failure. Not that it was a bad painting. But who wants to look at the rear end of a cow for twelve months? And that's how long a calendar hangs on the wall.

What you want in a calendar is a quiet sentiment (or sentimentality, if you will). Something that will last for an entire year, that people won't get tired of looking at. Nostalgia's good. Or a pretty girl. Or a bouquet of flowers. A joke is bad; it's sure to pall by April. To fill a calendar with a cow's hind end is sheer folly.

Another of my calendars was paradoxically a commercial failure and my most popular. People still write in to me for reproductions of it. But it sold badly. One of the Four Seasons calendars, it depicted in four pictures the various stages of love: child love, young love, middle-aged love, and old-aged love. Women liked it, but unfortunately men do the calendar buying (most calendars are sold to companies which send them out to their customers as advertising) and they were bored by it.

Christmas cards require a special kind of picture too. And I've missed it three or four times. With disastrous results. The Christmas card is the only kind of illustration which is sold only for itself. A calendar is usually advertising; at any rate, it always shows the date. A magazine cover or illustration is backed by stories and articles. But a Christmas card has only itself. So it's either right or a flop.

First, it has to be colorful; a card lacking strong color will be lost in the sea of other cards on the display rack. Second, it has to be as vague, impersonal, and generalized as possible. You can't do a Christmas card showing a man or woman either underweight or overweight because the person who receives it will take it as an insult. I once did a card of Santa Claus peeking over the back of a chair in which a little boy and girl were sleeping. It didn't sell. You couldn't send it to a family with two boys and two girls or one with two boys or two girls; you could only send it to a family with one boy and one girl.

And then there's advertising. And my most disappointing fiasco. A few years back Wally Elton, a vice-president at the J. Walter Thompson advertising agency, asked me if I would like to go around the world for Pan American Airways. I would visit all the major cities at which the Pan American clippers landed and make sketches. When I returned the sketches would be published as advertisements for

Mrs. O'Leary's Cow, oil painting for a Brown & Bigelow calendar, c. 1945

Santa Looking at Two Sleeping Children, watercolor for Hallmark Cards, Inc., 1952

Pan American. He explained that he'd thought up the trip because it was so difficult to advertise an airline. Practically all the airlines use the same planes; they all serve about the same food, have pretty stewardesses who give the customers the same courteous service and attention. How, then, are you going to persuade the public to travel by this airline in preference to all the others?

I accepted enthusiastically. The fly showed up in the gravy in London. The first night there I returned to the hotel and showed my sketchbook to Wally. He leafed through the drawings of people feeding pigeons in Trafalgar Square, a railroad station, et cetera. "They're swell," he said, "but they won't sell tickets. You can feed pigeons in St. Louis. Drawings of railroad stations don't sell airplane tickets." "All right," I said, assuming that he wanted me to sketch the people I saw and the strange sights, sort of get the flavor of the cities we passed through. And that's what I did. In Paris, Barcelona, Rome, Istanbul, Beirut, Karachi, Calcutta, Benares, Rangoon, Bangkok, Hong Kong, Tokyo, Hawaii. People from bullfighters and priests to snake charmers, monkey tamers, Arabs, and Geisha girls. Scenes from a fountain in Rome to a camel-elephant-water buffalo-bicycle-and-beggar-thronged street in Karachi.

But when I returned home and submitted my sketchbook it was rejected. Oh, I did a few ads. Nothing to justify the time and money which had been spent, though. Because the agency and Pan American did not want pictures of the strange lands and people. "Those would only frighten tourists," they said; "we want pictures of smart-looking tourists sunning on smart beaches in front of smart hotels." But that's not the kind of picture I can do. So I did nothing.

I can't understand their attitude really. If tourists want only to sit on beaches, why do they go abroad? Florida's full of fashionable hotels and smooth white sand. And you certainly wouldn't go all the way to Hong Kong or Rangoon to get a tan.

But I dare say I'm wrong. Selling tickets for airplane rides is not exactly my strong point after all. And of course I might not have been able to do the kind of ads I wanted to. I'm better in my own back yard, painting my neighbors. Still, it's a shame to waste a trip around the world. It gives me a guilty feeling whenever I think about it. Maybe I'll do something with the sketches sometime.

I'd better. Everywhere I went people asked me, "What are you sketching for?" "For advertisements to appear in all the magazines," I said. Which pleased my questioners no end. "We'll be looking for our pictures," they said. So . . . now I avoid London, Paris, Barcelona, Rome, Istanbul, Beirut, Karachi, Calcutta, Benares, Rangoon, Bangkok, Hong Kong, Tokyo, and Hawaii. If I have any more wide-ranging fiascos like that one I'll have to go live in a closet.

That's the story of my flops. There are more but, as I say, I'm very forgetful.

ABOVE AND FOLLOWING PAGES:
The Day I Painted Ike, oil paintings for *Saturday Evening Post* illustrations (11 October 1952)

18

The wayward pill

ONE DAY in the summer of 1952—a viciously hot day as I remember, the heat waves shimmering across the lawn outside my studio window—Ken Stuart called me. "Norman," he said, "you have two and one half hours with General Eisenhower tomorrow morning in Denver. We want you to paint his portrait for the *Post*." "Tomorrow morning?" I asked. "I'll never make it." "Get a train to New York," said Ken. "We'll have a man meet you at La Guardia Field with the plane tickets." "All right," I said. "Don't let us down," said Ken. "We had a terrible time arranging it. The general's just arrived in Denver from the convention; he's going to take a short vacation before the presidential campaign starts. You won't get a second chance." "I'll try," I said, rather worried.

Suppose, I thought, I get airsick on the flight to Denver and, feeling under par, mess up the job. I'm sort of groggy as it is—this heat and all. I need protection, a pill maybe. That's it—a pill. So I drove up to town and explained the job to Dr. Russell. "Got just the thing," said the doctor, rummaging about in a drawer. "Here. This'll do it." And he held up a long, three-colored pill. "It looks powerful," I said. "It is," he said. "The first part puts you to sleep, the second part keeps you asleep, and the third part prevents a hangover. Remember now, it's potent. Be sure you get in your seat on the plane before you take it."

At La Guardia that night I boarded the plane and took a seat by a window. Everyone was in an uproar. This was to be the first non-stop flight ever made to Denver. It's a good thing I've got this pill, I thought, and popped it into my mouth. Two hours later I was jolted awake by the man sitting beside me. "Hey," I said groggily,

"you shoved me." "Look at that guy," said the man, poking me with his elbow again. "He's gonna die sure." I pried my eyelids open and, craning my neck around the seat, looked up the aisle. In the front of the plane a nurse was pulling a man back into his seat. The man was gasping hoarsely, his face white as ivory, the muscles of his neck bulging. "Tuberculosis," said the man beside me.

In spite of the pill, I couldn't get back to sleep. The man up front continued to gasp, the man beside me to comment. The pilot came in from the cockpit. The stewardesses ran up and down the aisle. Then the plane made an emergency landing to let the sick man off.

When we arrived in Denver I staggered into a taxi. My eyes felt like soggy tennis balls, my head like a ball of soft lard. It was six o'clock in the morning; the breakfast room at the hotel wasn't open. If I don't get some orange juice, coffee, and rolls I'll drop, I thought, and went off looking for an all-night restaurant. But as I walked along the street I began to feel better. My head cleared, my eyes came into focus. I found a restaurant and by the time I'd finished breakfast I felt wonderful. Like a bright spring morning—sparkling sunlight, birds singing, a cool breeze. The third part of the pill had worked.

At eight o'clock sharp I met James Hagerty, General Eisenhower's press secretary, in the lobby of the hotel. He took me up to the room in which I was to see the general. Right away I saw that I couldn't work in that room. The light was bad—gray and sickly. "Can't we use another room?" I asked. "One higher up where the other buildings don't cut off the light?" "No," said Mr. Hagerty. I gathered that he didn't

think much of the whole idea of my painting the general. But I insisted on another room. "Well," he said, "all right, if the hotel manager will give you one." The manager was happy to oblige and showed the *Post*'s Denver photographer, who was to take my photographs for me, and me to a well-lighted room on the eighth floor. We rearranged the furniture so that the general would be in the best light. Then I went back downstairs and waited outside the general's suite, talking to the secret service men and the Denver police chief, who were guarding the general.

Pretty soon Mr. Hagerty opened the door and asked me to come in. And I was introduced to General Eisenhower. Right off I knew he was going to be a good model. He was smiling as he greeted me but as we rode up in the elevator to the eighth floor his face relaxed, becoming almost sad, so that I wanted to say something to cheer him up. But before I could a woman in the rear of the car asked, "Oh, General, will you shake hands with me?" And his face lit up—his eyes sparkling, his mouth curving in a wide grin.

It's the range of expression that's so appealing, I thought later as I was making a color sketch of his face, one moment sort of a quiet melancholy and the next a radiant smile. And it's his wide, mobile mouth and his expressive eyes that do it. Watching him is like watching a diamond revolved in the sunlight, flashing colors and light. His face does the same thing; it's changing all the time, a real rubber face.

"You know, General," I said, "you're a wonderful model." He laughed and asked me how much I paid my models and, when I told him, decided he'd stick to painting. What he did wasn't very good, he said, but he enjoyed it, and, say, did I use

black on my palette? Somebody had told him not to. "It's better if you mix it from your other colors," I said. "Otherwise it's too strong."

Just then Mr. Hagerty came into the room and asked if I was through yet. About the fourth time he'd done it, too. I got rather irritated. I'd no more than get the general relaxed and easy than Mr. Hagerty would come in and disturb him. "I understood I was to have two and one half hours," I said. Then the general said he'd call Mr. Hagerty when he wanted him.

I guess General Eisenhower was more considerate of me than I was of him. Because he kept telling me not to hurry. "You just take your time now," he said. "I'm not going fishing until this afternoon." (I'd told him about my trip out to Denver.) But I worked *him* pretty hard. I wanted to be sure to get everything I'd need. When we began to take photographs I asked for a series of different expressions. "Could you act as if you're whipping out a command?" I asked. "Forrr-ard HARCH," he barked. "That's it," I said, thinking, He likes to act and he can do it, too. Then, "Look as though you're worried," I said. His mouth sagged glumly; his brows contracted. "Now laugh," I said. "Gee," he said, laughing, "don't show this gold tooth. Mamie doesn't like it." "Now," I said, "don't think of anything funny. Think of something pleasant. I want a happy expression. What do you like best? I tell children to think about ice cream. Something like that." "Well," he said, "I've got some pretty nice grandchildren." And his eyes sparkled, the corners of his mouth turned up, and his cheeks seemed to glow. I honestly think he has the most expressive face I've ever painted.

The general and I didn't discuss politics or the campaign. Mostly we talked about painting. And fishing—he told me about the trout he was going to catch and cook, adding that he was a darn good cook. But what I remember most about the hour and a half I spent with him was the way he gave me all his attention. I felt that he wasn't thinking about anything but what I was saying. He was listening to *me* and talking to *me*, just as if he hadn't a care in the world, hadn't been through the horrors of a political convention, wasn't on the brink of a presidential campaign. That's a rare quality. Most people, even if they aren't caught up in something important, give you about half their attention. But not General Eisenhower. When you're talking to him you feel that he's interested. You're not just a cipher, you're a person.

When we said good-by, shaking hands, I wished him luck in the campaign. He thanked me, adding that he hoped he'd see me again sometime.

I hoped so too, because I'd liked him. But I didn't think I would see him again. Then, about two years later . . . No, I'm getting ahead of myself. I'd better sketch in those years first.

Because in 1953 I left Arlington and moved to Stockbridge, Massachusetts. Restlessness again. And then I was having trouble with my work and thought that maybe a change of scene would help me. It didn't. I sank deeper into the muck. I was dissatisfied, doubted my ability; decisions made in the morning evaporated by three o'clock. I started to lean on advice, not sort it out, using the good, rejecting the bad. Among those I listened to were several psychiatrists from the Austin Riggs Center,

a psychiatric institution in Stockbridge. And that, finally, was how I recovered from the crisis.

I don't think I'm what you'd call a temperamental artist. For over forty years I've done commercial work, which involves deadlines and various other restrictions. I've painted over three hundred *Post* covers; I've done the Boy Scout calendar for thirty-four years; I've handled many advertising accounts for long periods—for instance, Massachusetts Mutual Insurance Company for twelve years. No, you can't say I'm temperamental or flighty. But every so often I get into a hassle over my work. I get all tied up in a knot. Why, I don't know. Usually I work my way through the crisis by myself. And it's a slow business, rather like getting up in the middle of the night in a strange house and trying to find the light switch. You bump into tables, bruising your shins; bang your head on doors; stumble over rugs; groping, straining your eyes, and all the while feeling that maybe the next step will be into nothing and you'll tumble down a stairway you can't see and split your skull.

But in Stockbridge, for the first time, it wasn't, to my relief, like that. Because I got to talking with Erik H. Erikson, a psychoanalyst on the staff of Austin Riggs Center. Sort of casually to begin with, but pretty soon I found myself seeing him regularly. He helped me to understand the crisis. And I came through it rather more easily than I would have plodding along by myself.

I wasn't mentally ill or anything like that. I don't think I would have cracked up. But you don't have to be desperately sick, on the point of death, before you call the doctor. I sure owe a lot to Erik Erikson.

My first studio in Stockbridge was right in the center of town—two rooms over Sullivan's meat market. (I became poverty-proud: another illustrator would tell me about his new twenty-thousand-dollar studio. Then, "Where's your studio?" he'd ask. "Oh," I'd say, "it's over the local meat market. Just two small rooms.") After a while I knew everybody in town.

One afternoon, returning from a morning spent searching for a model in Pittsfield, I found three or four people talking excitedly at the foot of the stairs leading to my studio. "Hey, Norman," one of them said as I got out of my car, "we've been looking everywhere for you. The White House is on the phone." "What d'you suppose they want?" asked another. Four or five more people ran up. (News spreads fast in a small town.) I dashed upstairs. It was a secretary on the White House staff; she wanted to know if I could attend a stag dinner to be given by President Eisenhower at the White House. I said yes, I could, and she asked me to keep it confidential.

I rushed right out to tell Mary, mystifying the crowd at the foot of the stairs, for when they asked me what the White House had wanted I frowned and looked mysterious, saying, "Top secret."

A couple of days later I received a note from the President inviting me to dinner. I quickly posted my reply—"I'd be delighted"—and ran home to dig out my tuxedo. But as I pulled it from a steamer trunk in the attic a cloud of moths flew up.

*Portrait of
Erik Erikson,*
charcoal drawing,
1962

The sleeves were tattered, the seat ragged, and the lapels threadbare. I hurried to a local haberdasher to buy a new one.

When I tried on his *best* tuxedo I thought it looked kind of cheap. It was blue ("Midnight blue," said the clerk, "the latest thing"), not black, and the silk lapels dropped in fat, glittering curves to the waist, which was encircled by a cummerbund. "You're sure it's fashionable?" I asked. "Oh, yes," said the clerk. "That's the shawl collar. A cummerbund is à la mode." So, in spite of my misgivings, I bought the tuxedo.

That wasn't the end of my preparations. I figured to be pretty nervous, maybe even scared, at the dinner. And, I thought, supposing my mouth dries up and my throat clogs and I'm unable to speak? What then? . . . What then? Why then you'll be ashamed of yourself.

Well, I thought after several minutes of agonized imaginings ("Hello," says the President—"Gargle," say I, tongue-tied), take precautions then.

I repaired to the office of Dr. Donald Campbell. Again medical science came to my rescue. This time with what is known as a "happy" pill. "Take it twenty minutes before you go to the White House," said Dr. Campbell, "and you won't be afraid of a thing. It obliterates apprehension, tension, and dread."

Armed with my pill—pea green—and my tuxedo—midnight blue—I went off to Washington. You are, I said to myself on the plane, bulwarked against catastrophe. Even the state dining room (which Ben Hibbs had told me was awe-inspiringly magnificent) can't lump your throat or quake your knees. And I opened my stud box and gazed fondly at my pill, nestled securely in a wad of cotton.

On arriving at the Statler Hotel, I inquired how long it took to drive from the hotel to the White House. Upstairs in my room I worked out a schedule. Then I sat down on the bed to wait.

After a while I decided that the clock had stopped. I called the operator. No, the clock hadn't stopped. I cleaned my pipe. I counted the panes in the window. I recited all the poetry I could remember. I whistled, hummed, and swung my feet back and forth, back and forth. Pretty soon the bottom dropped out of my stomach. I began to feel lightheaded. The clock ticked. I waited. I thought I wouldn't make it; I'd collapse with nervous exhaustion.

But finally it was six-thirty, exactly one hour before the dinner. I gave my tuxedo to the valet to press. At seven o'clock he brought it back. As I fumbled for a tip I noticed him looking at the tuxedo queerly, as one might look at a mongoose if one turned the corner of Fifth Avenue and Fifty-third Street and stumbled on it during rush hour. "What's the matter?" I asked. "Nothing, sir, nothing," said the valet, instantly recovering the customary blank stare of a valet waiting for a tip. "There is," I said. "The tux isn't right, is it?" "Well, sir," said the valet, "I might say that I have never seen that *particular* shade of blue before." "Oh, Lord," I said, handing him his tip, "I knew it." And after he'd left I stared morosely at my reflection in the shiny lapels of the tuxedo, patting the pill in my coat pocket and thinking, At least you've got that; you may look like a fool but you'll feel like Grant at Appomattox.

I marched into the bathroom, drew a glass of water, and shook the pill out of its box into my hand, where it landed on its edge and promptly rolled into the sink and down the drain . . .

"In fifteen years," I said out loud, "I'll laugh at that." And, stunned, I went into the bedroom, pulled on my extraordinary tux, tied my tie, and went downstairs.

As I reached the taxi stand outside the hotel a battered old cab chugged up, clanking and rattling. At the wheel was a stout, robust, middle-aged woman with a chauffeur's cap cocked rakishly over one eye. The doorman waved her away. I signaled her to stop, feeling in my tender state that we two, the cab and I, victims of adversity, should stick together.

"Where to, mister?" asked the driver.

"The White House," I replied, still in a daze.

"*My land!*" she exploded heartily. "You going to the *White House?* Whatta you going to do *there?*"

"I'm going to dinner," I said, recovering somewhat under this onslaught of good nature.

"*Wow!*" she exclaimed. "I ain't *ever* before taken nobody to the White House before. I'll get ya there in five minutes flat." And the cab leaped forward with a roar like a wounded rhinoceros.

"Wait!" I yelled. "Hold on. I don't want to be early. What I want you to do is go up to the White House and then drive back and forth in front of it until the dot of seven-thirty."

"Okay, mister," she said.

While we were cruising up and down Pennsylvania Avenue she asked, "What's your name? You famous?"

"I do covers for the *Saturday Evening Post,*" I said. "My name's Norman Rockwell."

"Ha!" she said. "I've seen your stuff. You scared?"

"Yes," I said, studying my watch. "Get ready now, it's almost time. . . . NOW!"

We turned into the White House gate and jolted to a stop. The guards checked my invitation. We continued up the circular drive, waited while a chauffeur helped a gentleman out of a large black limousine, and then jerked forward, the cab backfiring, and halted before the entrance. A crowd of secret service men and flunkies was standing on the steps and beside the white pillars. I paid the fare and started up the steps. "Hey, Mr. Rockwell," boomed a voice behind me. I turned around. The cab driver was leaning across her cab and waving at me. "Good luck, Mr. Rockwell," she shouted, "good luck." The secret service men and the flunkies laughed. I waved back. "Thanks," I called.

A secretary ushered me upstairs and into a sitting room. I almost panicked as I crossed the threshold, for all the tuxedos were black with thin, dull lapels, and there wasn't a cummerbund in sight. But a minute later President Eisenhower greeted me warmly and I felt right at home.

Then the President, raising his voice a trifle, welcomed us. He went on to explain the purpose of his stag dinners. As President he is forced to spend most of his time with politicians, generals, statesmen, and experts, discussing weighty problems. Once in a while he likes to forget the cares of state and relax for an evening with people he enjoys talking to. His stag dinners are informal get-togethers, he told us, adding that he hoped we would not talk to the press about the dinner. In the past a guest had done so and it had been very embarrassing. "I feel that this is a personal get-together with people I like," he said, "and I'd like it to stay that way."

So I'm afraid it's going to be an anticlimax, because I don't feel that I should discuss what went on that evening, though I *can* say that I had a fine, easy time and enjoyed myself very much.

When we were about to leave the table after dinner I wanted to take the place card, matches, and menu as souvenirs. But I hesitated, afraid of looking silly. Then, glancing around, I discovered that all the other guests had taken theirs. So I took mine.

And after leaving the President, as we were standing on the steps of the White House, we sounded like a bunch of kids discussing the high school football hero. A secretary had told us that our evening had lasted *one half hour longer* than any of the President's other informal evenings. We were delighted and flattered. Which shows how President Eisenhower affects people. You just can't help liking him.

I have one dark, deep confession to make. Before each place at the dinner table was a small jackknife, a present from the President to each guest. There was no inscription on the knife, however. So when I arrived at Penn Station the next day I walked up Eighth Avenue to a jeweler's. "Could you engrave 'From DDE to NR' on this knife?" I asked the jeweler. "Sure," he said, "have it for you tomorrow." "I'll give you twenty dollars if you can get it done for me today," I said. "Sold," he said. That night at home I showed my knife to Mary and the boys. "See," I said proudly, " 'From DDE to NR.' How about that?" They were very impressed. And during the next few months, whenever I took out my knife, always being careful to show the inscription, people would ask, "DDE? Is that President Eisenhower? Where'd you get that knife?" So I'd get a chance to describe my evening at the White House. Ah, vanity, vanity, thy name is Norman.

In 1956 I again painted President Eisenhower's portrait for the *Post*. Nothing out of the ordinary happened (by this time I was immune to fear and trembling at the prospect of meeting the President), except that I had a terrible time getting to see him. It was, of course, after he'd had his ileitis attack and our appointment was called off four times because he wasn't looking at all well. His advisers did not want a portrait showing him like that to appear on the *Post*.

But finally I was told I could have a few minutes with him. No more than a few, however; he was still feeling ill. "As soon as you arrive in Washington," said Ken Stuart, who as always arranged everything for me, "you are to call Murray Snyder, the acting press secretary, to confirm the appointment. Call him no matter how late it is." When I did so and said I'd be over at the White House at eight sharp with my photographer, Mr. Snyder said, "You can't bring a photographer." "I've got to," I said, "I can't make a finished sketch in ten minutes." "Well, you can't bring a photographer," he said. "If we let you, all the other magazines will insist on taking pictures and we can't allow it. We'll give you a press photograph; we've plenty of those." "That's no good," I said, "I have to direct the photographs." "It can't be done," he said. "It was understood," I said desperately. "The *Post* arranged it. I *must* have my own photographer." "Oh, all right," said Mr. Snyder, "bring him along. But for God's sake have him hide his camera. Who is the photographer anyway?" "Ollie Atkins," I said. "That's *something*," he said. "He's all right; I know him. But you tell him to hide his camera

and come in the back way and don't tell anybody you're coming. If the other magazines hear about it they'll all want a private session with the President."

The next morning Ollie and I, he with his camera and tripod under his coat, I with his film packs under mine, snuck into the White House, down through the cellar, and into the President's private office. Pretty soon President Eisenhower came in. He had the same old smile and magnetism, but he looked awful—thin, drawn, pale. I noticed that his eyebrows had turned white since I'd seen him last. But he was just as nice and kind as before. On the way out I said to a secretary, "Gee, isn't he wonderful?" "Everybody who comes out says the same thing," she said.

That year I also painted a portrait of Adlai Stevenson for the *Post*. (I took photographs and made sketches of Averell Harriman and Estes Kefauver too, because the *Post* thought I'd better not take a chance on waiting until after the convention to do the Democratic candidate; I might not be able to arrange an appointment.) Painting both candidates didn't exactly clarify my political views, because, as it turned out, ex-Governor Stevenson was very likable and charming too. "I'll vote for you if you make Chester Bowles your Secretary of State," I said to the governor. He laughed. So I had to go home and struggle it out all by myself. (I was born and raised a Republican, but then I voted for Harding and got pretty discouraged. Now my politics are sort of ragged; I'm not rigid either way.)

I paint another Post *cover*

APRIL 27, 1959: Thought I'd make a diary of a *Post* cover to show people how I work. (Probably interest me more than anybody else. That seems to be a characteristic of most diaries—authors fascinated, readers bored. Well, let it go. Begin.) So.

April 27, 1959: (Fresh start, having overcome misgivings about making diary.) Woke up this morning faced with prospect of idea session. Batch of ideas okayed by *Post* two years ago ran out months ago. Scraping bottom of barrel since, doing old ideas I'm not crazy about, new ones I haven't thought out sufficiently. Bad practice, but anything to postpone idea session, which is worst, hardest work I do. Needle in a haystack. Fishing for coins down a sidewalk grate with a piece of string and chewing gum. Terrible. But . . . knew I had to begin today.

After supper, got out manila envelope labeled "Possible *Post* Ideas," containing tentative sketches, old ideas which never worked out, newspaper clippings, and letters from *Post* readers with idea suggestions. Nowadays I don't start idea sessions by drawing lamppost, drunken sailor leaning on lamppost, sailor darning socks, mother mending son's pants, et cetera, as I used to. I sort of ease into it. Go over contents of "Possible *Post* Ideas" envelope several nights running. Think of current crazes, what people are talking about, what's occupying their minds. Ransack my memory for things I've seen or done in past two years which might make a *Post* cover. It's rather like searching long and hard for something in a dusty, rubbishy attic and all the while not knowing quite what you're looking for. Then suddenly, after turning over boxes and trunks, opening old bureaus, wardrobes, shuffling through piles of damp newspapers and rotten magazines, you come upon what you're searching for

and know it's the right thing immediately. But it's tiring work. And discouraging. Because after a few days, usually just before the ideas begin to come, I fall into a blind, blank funk. I'll never get one, I say to myself, flinging recklessly about in the dark, empty corners of my brain, I'm . . .

But I'd better stop scaring myself. And bellyaching. I need ideas. Telling myself how bad it's going to be and moaning isn't going to help. I'll go up to bed now, having, as I expected, discovered no inspiration in the "Possible *Post* Ideas" envelope tonight.

April 28: Muddled with tentative sketches after supper. Nothing. Couldn't jell any of them. Sometimes it takes me years to perfect an idea. My gossips cover, for instance. First thought of it twenty, thirty years before I painted it: heads of fifteen people in five rows on *Post* cover—thirty heads in all, for the people are passing on a luscious tidbit of gossip and you see each person twice, as he hears the gossip and as he tells it. But couldn't figure out how to end it. Last person in bottom row telling gossip to nobody? No good. Stewed over idea off and on for, as I say, twenty or thirty years. Finally dredged up solution. The gossip would come round at the end to the person it was about.

Dumped tentative sketches back into envelope at nine-thirty, tossed envelope on kitchen counter, disgusted. Watched television.

April 29: Tried to wring something out of readers' suggestions. Nothing came. Can't squeeze blood from a kippered herring.

April 29: (Again. First entry for day too short. Shouldn't shirk my diary. So.) Let's see. Well. Readers' suggestions. I receive a great many, but unfortunately can use hardly any (only four in forty-three years). For instance: photograph of reader's grandson—cute little boy but one swallow doesn't make a summer and a little boy doesn't make a *Post* cover. For instance: letter from Nebraska—"Mr. Rockwell, you ought to see our local cobbler; everybody says he would be a wonderful cover"— perhaps, but it's quite a trip to Nebraska. Many suggested ideas have been done before. Once in a while a reader who wants to sell his idea refuses to tell it to me until I pay him, afraid, I guess, that I'll steal it.

BUT. Some suggestions *are* fruitful. Basic idea for most popular cover I ever did was given me by a woman from Philadelphia. She'd seen a Mennonite family saying grace in an automat. Starting with that, I painted my Thanksgiving cover of an old woman and a little boy saying grace in a railroad cafeteria, watched by the people around them—some surprised, some puzzled, et cetera.

So I keep any suggestion which has even a remote possibility of becoming a picture. Rare, though, because an idea which comes out of my own experience, feelings, is best. I get more excited about it and do a better job. After all, you love your own child best.

Charcoal
pencil sketc
Saturday Ev
Post cov
Saying G
(24 Nover
1951)
In the fir
version,
backgroun
less clutte

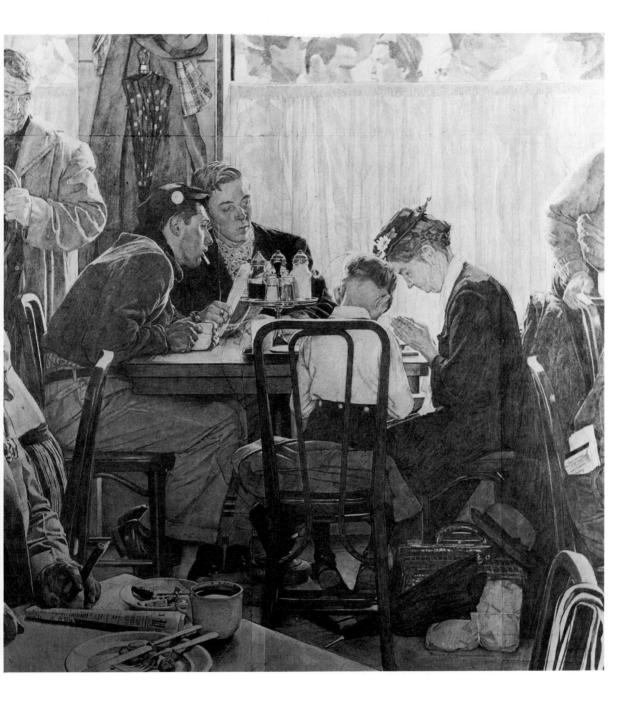

Don't think for a single minute that I don't enjoy receiving the suggestions. I do. Immensely. It warms the cockles of my heart to know that people are interested in my work. And interested enough to take the trouble to write a letter.

Good night.

April 30: Felt as if there was a dense black cloud in my head. Groped around

Pencil sketch for *Saturday Evening Post* cover *Art Critic* (16 April 1955). For the final version, Rockwell added a palette and easel strapped to the artist's paint box

Pencil sketch for
Saturday Evening Post
cover *The Jury*
(14 February 1959).
In the final
version,
the whole scene is
reversed and many of
the details are different

awhile. Found nothing. No ideas, not even a glimmer of one. Gave it up early and tore some paint rags from a bale of diaper cloth to distract myself. (I use diaper cloth for paint rags because it's so absorbent.)

I can't think of anything to write. Painted on Boy Scout calendar today (I work on ideas only at night; plug away at other jobs—ads, et cetera—during the day). And so to bed.

May 1: Small "eureka!" Leafed through tentative sketches after supper. One stuck in my mind. View from sidewalk of interior of University Club in New York City. The massive outside wall of dark gray stone blocks and, five or six feet above the sidewalk, the large, tall window through which can be seen the plush, richly lit interior where the old gentlemen sit all day long in their overstuffed, leather-covered armchairs, reading their newspapers. Roughed out new sketch. No idea in that. Another sketch. Still no. Doodled and . . . and . . . like a cat on a mouse, *pounce*—I had an idea. Fat, juicy. A sailor and his girl standing beneath the window, talking. Young, brawny sailor; red-cheeked, blooming girl. The old gentlemen, fat, tired, old, full of wealth but not vitality, have risen from their armchairs and are watching the sailor and his girl sadly, forlornly. Contrast.

Pencil sketch for
*Saturday Evening
Post* cover
Breaking Home Ties
(25 September 1954).
In the final version,
the father and son are
alone together, seated
on the running board
of a car

The peculiar way a sailor stands when talking to a girl—slouched above her,
left leg straight, hip out, right leg bent at knee, right arm propped on wall behind her
head—has always fascinated me. I've wanted to draw it for years.

To bed smiling. Though I'm not finished yet. I always try to think up six or
seven good ideas during each idea session. Then I have all the ideas I'll need for the
coming year. So—one down, six to go.

May 2: Five ideas today! I won't describe them, though. Tedious. Besides,
I'm exhausted.

May 3: This morning while shaving——My most creative time. Why, I
don't know. Brain fresh as a young pear, perhaps, unbedraggled, untattered by work,
day's events. Or maybe hot water and soft, warm, bubbly lather heats brain up. I don't
know. Anyway, while shaving, I was hit by an idea. A family lineage chart. Like the
charts made to show the genealogy of kings. Only with faces instead of names.

Splashed water on face, all excited. Ran out to studio. Sketch. Snag: chart too
broad, spreads too quickly. Too many heads. I couldn't fit sixty-three heads on a *Post*
cover. (That's counting the final descendant, two parents, four grandparents, eight
great-grandparents, sixteen great-great-grandparents, thirty-two great-great-great-
grandparents.) And the idea's no good unless I go back that far. Or further.

Pencil sketch for *Saturday Evening Post* cover *Mermaid* (20 August 1955)

Another sketch. Another. Another. Threw down pencil, walked around studio and, happening to glance in the mirror, discovered that I'd forgotten to shave my upper lip. So back to bathroom where I found (creativity returning as I lathered up my lip) the solution. A tree. A family tree. Like the ones in the old documents. The great-great-great-grandfather at the roots of the tree; the final descendant at the top; in between, the intermediate stages.

Back to studio (I finished shaving first, however) and called Bob Newman, librarian of Pittsfield Library, to see if he had a picture of a family tree. Yes, and he'd bring it down with material he'd collected for a mural I'm going to do for the Berkshire Life Insurance Company's new building.

Sunlight and roses. Newspaper clipping of family tree of royal family of Holland, tracing only the royal heirs, the direct line, omitting superfluous second sons and daughters, aunts, uncles, parents of wives and husbands who married into the family, et cetera, which narrows tree sufficiently so that it will fit on *Post* cover. Tree in clipping—large-leaved, sinuous (wonderful)—had shields with coats of arms on them hanging from branches. Appropriated tree, substituting heads for shields, starting at bottom of tree with pirate (born 1700), ending at top of tree with little boy (born 1950) with shining face, bright eyes—the hope of the world.

I don't have the slightest inkling where that idea came from. Oh, I've seen genealogical charts in books. But not recently, as far as I can remember. I guess it's inspiration. Though that's a poor word for it. Too noble, somehow. It's more, I imagine, like a whistling teakettle. You put it on the fire and it heats and heats and pretty soon, when the temperature's right and the water's boiling, the whistle screeches. So I go through the "Possible *Post* Ideas" envelope and think of crazes and ransack my memory and pretty soon, when my brain's worked up to the right pitch, an idea pops out of it.

Once, I remember, after three or four days of searching for ideas, I was sitting at my drawing board lacing up my tennis shoes and wondering if the rain would hold off long enough so that I could get in a set or two, when all of a sudden an idea for a *Post* cover strolled into my head. A zoo guard seated in front of a lion cage eating a sandwich stuffed, overflowing, with red meat while the lion in the cage gazed hungrily, ravenously, and at the same time a little sadly, at the sandwich over his (the guard's) shoulder. Where did that one come from? There's no possible connection between tennis and lions or tennis and roast beef, rare, medium, or well done. At least none *I* can see. Inspiration.

Though, now that I think about it a bit, the family tree idea probably came to me because I was working on this autobiography and digging back into my relatives, parents, and grandparents.

Now (10:30 P.M.), the dragon conquered, St. George (me) goes off to bed. A remarkably painless idea session. (Maybe I exaggerate the difficulty.)

May 4: Made finished sketches of ideas from roughs. Acid test. Some ideas *talk* well but refuse to shape up on paper. Because you can't explain a *Post* cover; there

has to be total communication. If it doesn't tell a complete story, if words are required to fill up holes in the story, it won't do as a *Post* cover. Luckily, all the ideas worked out this time.

Added a galleon sinking in flames, a galleon sailing, and a treasure chest to background of family tree sketch (all this because the founder of the family is a pirate). As I make the final sketches I refine the ideas, perfect them. I think best on paper.

Matted sketches after supper.

May 5: To New York. Evening: spoke at dinner of artists' supply dealers' association. Sneezed and froze—air conditioning blowing over ice sculpture right at me. Al Dorne, president of Famous Artists Schools, of which I am a faculty member, introduced me.

May 6: To Philadelphia for lunch with editors of *Post.* Showed sketches to Ken Stuart before lunch. My favorite art editor. Lets me do my own work, doesn't hold me back or try to paint the picture himself (some art editors want to get in on every brush stroke). But Ken's helpful. Always arranging things for me. Makes valuable suggestions. He gives me the feeling that he believes in me and only wants to help me realize my own ideas. Ben Hibbs once said that an editor's job is to create an atmosphere in which artists and writers can do their best creative work. That's what Ken does. To perfection.

In Mr. Lorimer's day the art editors of the *Post* made relatively few final decisions. They had to get his okay on most major work—and so, in the end, the decision to accept a cover or illustration was usually Mr. Lorimer's rather than the art editor's.

It's all different now. Ken runs the art department. He makes the decisions. He is, in function as well as title, the art editor. And I think he does a tremendously creative job. For one thing, he has transformed the cover. In the old days each cover was selected according to a routine formula—pretty girl, dog, human interest. Roughly speaking, every fourth cover was a picture of a pretty girl (the girl never changed, only the trappings—one time she'd be holding a golf club, the next a tennis racket, the next a telephone). Then there would be a dog cover—two cute spaniels, for instance (these had great popular appeal). Then two human-interest covers such as I do. Then back to the pretty girl. (Sometimes the order varied. But the system remained.)

Ken dropped the pretty girls and dogs and organized the covers so that collectively they became a pictorial portrait of America. Each one is a scene from American life. And people recognized this and appreciated it.

Of course, now that it's been done, it sounds obvious. The *Post* is a national magazine; therefore the covers should be a portrait of the nation. Simple. Sure—now that it's been done. However, it takes a really creative mind to break through an established pattern.

So now Ken has to get fifty-two separate, untitled, storytelling pictures every

year. A very, very difficult task. If he had stuck to the old formula his job would have been much simpler. Illustrators who can paint dogs or pretty girls are relatively easy to find; illustrators who can paint storytelling pictures, who have a feeling for people, are scarce. But Ken somehow manages to get the fifty-two covers every year. And he's done it for sixteen years; that's 832 covers in all. Moreover, he's responsible for all the illustrations and the layouts and photographs inside the *Post.* Yet Ken never hurries me, doesn't call up every other day to ask, "Where's the picture? Where's the picture?" as some art editors do. And when I call him up he's always ready to help.

Ken was a successful illustrator before he became art editor of the *Post.* He had studied abroad, where he knew Brancusi, Pascin, and other modern painters and sculptors. In other words, he has a thorough artistic background. No wonder he understands illustrators. Just as there is no better way to understand the Hottentots than to go and be one, so there is no better way to understand illustrators than to be one.

I often marvel that along with his artistic talent Ken has the executive ability and detachment not only to run his department but to handle a stable of highly temperamental illustrators as well. Artistic talent and executive ability don't often go together, but Ken has both.

The *Post* cover is my best and only opportunity to express myself fully. And Ken lets me do it. *He* doesn't impose any restrictions. He has created for me the atmosphere in which I can do my best work.

After lunch with the editors I acted out my sketches for them. They okayed all eight, though I could see they weren't strong for a couple. Didn't say no, but didn't say yes. "You'll make something of it," said Ken to one sketch. But the ones I liked, they liked. Which satisfied me.

Then Ken and I worked out the order in which I would do the ideas. The family tree cover first. So that's the one I'll be talking about.

May 7: Back to Stockbridge. But

HIATUS

because I've got to catch up on my other work before going ahead on the family tree cover. I have six or eight jobs due in the next four weeks. So I'll discontinue the diary while I do them.

May 15: In reading over the diary, I find that I have forgotten to mention my new studio. Several years ago I sold my house by the cemetery in Stockbridge, bought another, and remodeled the barn behind it as a studio. So I'm no longer over the meat market on Main Street. The new studio is cooler in summer, warmer in winter, less noisy, more private and convenient (fifteen steps behind the house), and roomier. I'm blissfully happy with it.

May 23: Well, I've finished five jobs. Four to go. (I discovered the ninth job

in the bottom of a drawer yesterday after a frantic call from the art director.) I'm begin-
ning to pine for the family tree cover. (*That's* an awful pun!) But I *must* finish up my
other work—ads, mostly—first. So back to the easel.

June 3: I can't restrain myself any longer. The sketch of the family tree cover,
propped these four weeks on the print shelf to the left of my easel, has finally forced
everything else out of my head. At three o'clock this afternoon I looked longingly at it
for the twentieth time since noon, sighed, and returned to sorting out the photographs
for an ad. Then, "Schedule be damned!" I said, bundled up the remaining advertising
jobs in rubber bands and manila envelopes, arranged them carefully in a drawer, shut
the drawer, swept out the studio, and determined to start tomorrow on the family tree
cover. It's a foolhardy thing to do. I know I shouldn't. My schedule's all snarled up:
two jobs overdue, three others due next week. But I can't help it. I can't wait. The art
directors will have my heart, liver, and head for it. All right. They deserve them. But
they can't have my attention and time. The family tree cover is going to get that.

June 4: Selected the model for the pirate: Frank Dolson, a magazine represen-
tative who lives over behind Malumphy's lunchroom in the Guerrieri block here in
Stockbridge. The pirate's direct descendants will all bear a family resemblance to the
pirate, so I'll use Frank Dolson as a model for them too. I'll give each one of them a
different expression, hair-do, and hat, slap on a beard here, sideburns there. Each
character will be a typical representative of the historical period in which he or she
(supposedly) lived. Then they won't all look like the same person.

Of course I'll need ten other models to pose for the wives and husbands who
married into the family and who therefore do not resemble the pirate.

I believe I've selected the right model for the pirate. I don't anticipate any
difficulties on that score. I often have trouble finding the right models for a picture.
Sometimes I change models three or four times—taking a new set of photographs
each time—before I'm satisfied. But in this cover the characters are exaggerated
types—the villainous pirate, the George Washington colonial planter, the floozy, the
fur trapper—and so I don't have to be *too* careful in the selection of a model. I'll get
the basic facial structure from the model, then go to work with my pencil, creating
characters.

A few random thoughts on models:

Most people enjoy posing. At least very few refuse. Once when I asked a man
to pose he said very indignantly, "Not me. You aren't going to make no funny picture
of *me!*" One Sunday morning Gene Pelham, my photographer, and I were standing
in the middle of a railroad track in Troy, New York, taking pictures of a row of shabby
houses which fronted on the track. Suddenly a window in one of the houses banged
up and a woman stuck her head out. "I know you reporters," she yelled, shaking her
fist at us. "Dirty blabbermouths. You get outta here. You ain't gonna ruin my business.
Go along now, 'fore I send my man out, no-good, foul, obscenity, blankety-blank
dogs." Gene and I stood rooted to the spot. What the devil was going on? "Say," I

shouted, "we're just . . . " *"Look out!"* yelled a man from the signal tower up the track. "Here comes a locomotive." Gene and I snatched up the camera and jumped off the track. A locomotive thundered by. "Serve you right," yelled the woman when the locomotive had passed, leaving us gasping for breath in a dense white cloud of steam. "You damned reporters. Always pryin', puttin' your snotty noses in where they don't belong. Go on, get outta here." Gene and I walked up the track to the signal tower. "What's the matter with that woman?" I asked the man in the tower. "We aren't reporters." "Aw," he said, "she thinks you're exposing her. The newspapers been makin' a stink." "A stink?" I asked. "Yeah," he said, "this is the red-light district. They been tryin' to clean it up." "Oh," I said, "thanks." And Gene and I went elsewhere.

My unfortunate practice of changing models in mid-picture is sometimes a source of trouble and embarrassment. I use one person, decide he's not right, and get another. But in the struggle with the picture I often forget to inform the first model that he is no longer being used. So he tells all his friends, "Wait until you see me. I'm coming out on a *Post* cover next month. You watch for it. I'm the man holding the shovel." Then the cover appears. He's not on it and is quite understandably embarrassed.

And then sometimes the people who *do* appear on the cover are not very pleased with what I've made of them. If it doesn't look exactly like them, they (and their neighbors) consider the picture an absolute failure. A mustache added is a betrayal. In a small town a picture is good if it's an exact portrait of the people who posed for it, bad if it isn't. No one realizes that on a national magazine his faithful likeness is not important.

Once one of the foremost matrons of New Rochelle posed for me as a fat cook. But I "forgot" to tell her she was to be a cook. When the cover was published she was furious and refused ever again to speak to me. I used my neighbors in Arlington as models for the gossips cover. "Gee," they said when I showed them the sketch, "we're not gossips, are we?" So I put Mary and myself into the cover to avoid any suspicion that I was insulting my neighbors. Still, one woman was very angry when the cover came out. I dare say the proverbial shoe fit a bit too well.

People naturally want to appear at their best. Women I've asked to pose because of the way they looked in a house dress without make-up will appear at the studio dressed to the teeth, rouged, manicured, and mascaraed. Once, on a bench in Central Park, I discovered a bum with a wonderful scraggly white beard down to his chest, smudged stained tattered patched clothes, and a hat of vast experience. I gave him ten dollars and told him to report to my studio the next day. He turned up all slicked out in a clean, well-tailored, new-secondhand suit—his beard shaved off, his hair plastered down with a sweet tonic.

But in spite of occasional vagaries I couldn't ask for better models than my neighbors. Or more obliging ones. I put them through hell, asking them to assume (and hold) postures which would lay out a yogi, expressions which would exhaust a mime. And they do it happily, refuse to get mad. I don't know what I'd do without them. The professional models of today are useless for my purposes. They frighten

me. The girls are so unbelievably beautiful that they aren't human, and the men are so handsome that I always feel like a pile of old rags in the corner. I paint human-looking humans and the professional models just don't qualify. I guess if my neighbors weren't so pleasant and obliging I'd have to give up work. I couldn't do it without them.

June 5: Attack of guilt over my neglected work. So I drove up to Pittsfield High School to select models for a Parker pen ad. The dean of girls, Miss Rosemary Cummings, showed me around and I picked out seven girls. I only need three, but it's hard to tell which ones are right for the picture until I set up the pose. I'll take the photographs tomorrow along with those for the family tree cover.

Two of the girls will drive the others down from Pittsfield. No chaperons. The world has changed since I was young. Forty years ago no respectable girl would have set foot in an artist's studio without a chaperon. Artists' studios were dens of iniquity (or at least people hoped they were). To create, an artist had to *live*, experience everything; ergo, ipso facto, artists were loose, wanton fellows, their studios dens of iniquity, temples of promiscuity. When I worked in the Clovelly Building in New Rochelle before the First World War, a clerk from one of the stores downstairs was always hanging around my studio. "Geez," he'd say, "what happens when you're alone with the girl models?" "I paint," I'd say. "Don't kid me," he'd say. "C'mon, tell me what happens." *"Nothing,"* I'd say. "What do you think artists are anyway?" "Yeah?" he'd say. "Yeah? Well, how about that fellow who has the Turkish corner in his studio? How 'bout him? Hunh?" Well, I knew who he meant—another illustrator who *was* quite a man with the ladies. But I wouldn't let on to it; it would damage my reputation by inference. So, "He just uses the corner to rest in when he's tired," I'd say. "Yeah," the clerk would say skeptically, "sure."

This went on for some time. The clerk bothered me continually. After a while I perceived that his belief in the lawless iniquity of artists was unshakable. And it was precious to him. And sweet. He cherished it. And who am I, I thought, to deprive him of the thrill of associating with rakes and free lovers, living in the midst of hidden orgies? Why shouldn't I rather confirm him in his belief? After all, man does not live by bread alone. So I went to the other illustrator, carrying my wooden manikin, and we cooked up a plan.

The next day I ran into the store and took the clerk aside. "Look here," I said, "Joe" (the other illustrator) "has a girl in his studio now." *"Geez-us,"* said the clerk, taking off his apron, "let's go peek through the keyhole." So we ran off and snuck up the stairs to the door of the other illustrator's studio. The clerk looked through the keyhole. "What'd I tell ya?" he asked after a minute, all excited. "He's kissing her in his Turkish corner!" "Let me look," I said, kneeling down and putting my eye to the keyhole. And there, sure enough, among piles of pillows on a low couch, sat the other illustrator with a girl in his arms. The walls of the corner were hung with Turkish rugs; on a low table in front of the couch there was an imitation Turkish lamp and an incense burner billowing smoke. "See that incense," I whispered. "It's an aphrodis-

iac." "No kidding," said the clerk. "Lemme see." And he pushed me away and pressed his eye to the keyhole, bumping his head against the doorknob in his eager haste.

I sat down on the stairs, half sick with suppressed laughter. Because though the furnishings of the corner were real (Turkish corners were very popular at the time), the girl was my wooden manikin dressed in woman's clothes. I pulled the clerk away and we crept silently down the stairs. He was stunned. "What a life!" he kept saying. "What a life!" He didn't get over it for months. But he stopped bothering me and spent all his spare time in the other illustrator's studio hinting slyly that he'd certainly like to know what went on and, *boy*, would *he* like to be an artist.

June 6: I knew I would not have time to observe myself while directing the photographs today, so I asked my son Tom to take notes. Here they are—verbatim:

To studio 9:30. Pop and Louie Lamone, his man Friday, already there. Louie tall, rugged Italian fellow—large, gaunt face, jet-black hair, long arms, big hands. Lincoln type. Pop slight, skinny—gray hair, vast forehead, collapsed bags under eyes. Pop tells joke. I laugh, Louie laughs. Both being polite, joke terrible. Two cars drive into yard. Seven young girls in Bermuda shorts disembark. Pop looks out window, makes bad joke about seraglio. Off his form today. Girls enter, chattering. Assorted shapes and sizes. Pop: "I don't know if I can use all of you." Stunned silence, long faces. "But I'll try." Smiles. "You don't mind waiting, do you? I've got to take photographs for a *Post* cover first." Chorus: "No, we don't mind, Mr. Rockwell." Pop: "Let's see now. Did you all bring dresses and extra blouses?" Much displaying of clothes for Pop, gnarled oak among budding willows. Clem Kalischer, Pop's photographer, enters. Small fellow—tiny reddish mustache, large eyes, square head. Model for family tree, Frank Dolson, follows. Burly. Clem sets up tripod, Pop seats model in chair in front of huge studio window (north light). Pop: "We'll do the pirate first. Make your mouth hard, frown a little. You're a pirate. That's it. Draw in your chin, tighten your lips." (Pop grimacing awfully, following his own instructions.) "Don't frown quite so much, just look fierce. That's it." (Clem snapping pictures all the while.) "That's it. Okay, now we'll do George Washington. Head up a little, we don't want a double chin. No, no smile. Now turn your head a bit to the right. Back a little. Little more." (Model suffering; Pop raising and turning his head as per his own directions; Clem clicking shutter.) "The preacher's son now. He's a problem. I haven't quite figured him out yet. Well, I'll make him sort of a timid soul. Raise your eyebrows. Farther. Farther." (Pop goes over to model and pulls up his eyebrows.) "That's it. Hold that. Look halfway up the window. No,

down a little. Don't move your eyebrows. Hold it." (Pop leaning forward, popping his eyes, his eyebrows climbing up his forehead, his lips pursed . . . and, relaxing suddenly.) "Good." Et cetera, et cetera, through Confederate soldier, fur trader, frontiersman, sea captain, preacher, pirate's son. Pop: "That's all." Model, rubbing his neck: "Whew!" Pop, looking at sketch: "One more. The modern man. Just look reasonably pleasant. Okay." Slave driver. Works his models hard. Single-minded. [NOTE: *I guess I do work my models pretty hard. But I have to; otherwise I won't get what I want. Some models say they'll pose for nothing. "Oh no," I say. "After I'm through with you, you'll want it." I always pay the models. I can't afford to treat anyone like a guest; I have to go right ahead and get what I want. As for my grimaces: I've found that if I act along with the models they lose their self-consciousness, fall off their dignity. And so back to Tom's notes.*] Pop (to me): "I could use a few of the girls in the family tree cover. What do you think?" Me (brilliantly): "Sure." Walks behind white screen which serves as background for model to couch where girls are sitting, standing, kneeling. Pop, pointing at one: "You first, I guess." Girl—pleasingly plump, blonde bob, pert face—sits down in model chair. Pop: "Ha. Flirty-Gerty. Perfect for the wastrel's wife." Me: "Which one?" Pop: "The wastrel. The pirate's son." Me: "Oh." Pop (to girl): "Tilt your head to the right. Chin up. Fine. Roll your eyes, raise your eyebrows." Aside to me, chuckling: "Flirty-Gerty. Just right." To girl: "Tilt your head more. More. Here let me show you." Girl gets up. Pop sits down, tilts his head to one side, rolls his eyes, makes a mincing mouth. Pop: "See. Look devilish. You're a loose woman." (Much giggling behind screen.) "Now you try it. That's it. You've got it. Hold it. Don't move anything, just relax your neck. I'll tilt your head." (Grabs girl's head in both hands, tilts it into agonizing position.) "There. Got it, Clem? Now." Goes behind screen and looks girls over. "The tall brunette next. Yes, you please," looking at her, hands on hips. "Let's see. Could you part your hair in the middle?" Girl: "I'll try." Pop (to another girl): "Would you help her?" Two girls and Pop manage to part the girl's hair in the middle. Messy part. Pop: "It'll do. You're a strait-laced, stiff-backed woman. Here, look at me." (Pop tightens his lips, frowns severely.) "Like that. As if you've been sucking lemons. That's it. Purse up your mouth. . . ." Et cetera, et cetera, through all the women in the family tree cover and all seven girls. Then, Pop: "I'll be the downtrodden cleric, Clem." Sits down in model chair. Face sags dolefully, mouth turning down at corners, eyebrows slumping, cheeks drooping. Clem snaps picture. Pop, getting up: "Now you, Louie. The Victorian villain, the spurious Italian count. Steals women's hearts and jewels. Lift one eyebrow. Snarl.

Louie, you must have noble blood in your veins. You *look* like a count."

Pictures for Parker pen ad. Three college girls standing together, ohing and ahing over new Parker pen sent to one of them by her mother. Commotion. Pop arranging their heads, shoulders, hands, wrappings of pen, card from mother, urging models on. Pop:

"You're excited. Lift your eyebrows. Up. Up. Oh *boy*, look what I've got! Mother sent me a *beautiful, beautiful* Parker 61 pen!" Me (bored): "I'm going into the house." Pop: "We haven't finished." Me: "I'm through."

End of Tom's notes. He forgot to mention several models. And after he left we took pictures of Mary, Clyde Schneyer, the town tree warden, Clem's wife Angela and Gail, Tom's wife, some for the family tree cover, some for other jobs. But there's enough to give you an idea of how I take photographs.

It's very tiring, all the acting I have to do, worming the self-conscious dignity out of the models. Not so bad today, however, because I only needed heads. When the models must assume complicated poses with their entire bodies it's more difficult. Clem takes picture after picture; I work with the model until both the model and I are worn to a frazzle.

I have never taken my own photographs. I couldn't. I have to concentrate on the model. Clem, a wonderful photographer, attends to the camera. I never worry about the lighting, focus, exposures, or anything but the feeling I want the model to convey. That's trouble enough.

I've had some queer experiences with models. Once a father brought his son over to the studio to pose. As they entered, I noticed that the little boy—he was five or six years old—had his eyes closed. And not just closed, but all squinched up as if he were holding them as tightly shut as he could. I looked inquiringly at the father, but he motioned to me not to say anything. So I posed the boy and Gene Pelham inserted the film in the camera and cocked the shutter. "Come on, Bill," said the father to his son, "open your eyes now. That's a good boy." The kid's eyebrows contracted in a fierce frown; his cheeks drew up to meet them. "I think he's trying to shut his eyes *tighter*," I whispered to the father. "He's bashful," said the father. "Oh," I said, "what'll we do?" "Open your eyes, Bill," said the father. "There's nothing to be scared about." Dead silence—the kid's face twitched; it looked as if he was trying to pull his eyes back into his head. "Nobody's going to hurt you," I said. "We just want to take your picture." Not a sound from the kid, his eyes still squinched up like two old wrinkled prunes. "He's got to open his eyes," I said. "I don't know what to do," said the father. We coaxed, threatened, cajoled, and offered bribes to no avail. Finally, "Leave me alone with him," said Gene. "I'll get him to open his eyes." "Don't hurt him," I said. "No," said the father. "Don't worry," said Gene, "I won't. You just leave him alone with me." So the father and I went outside, leaving Gene, who was a tall, robust man, standing over the little boy, his eyes still shut. Five minutes later Gene called us and we returned. The kid's eyes were open. I took Gene aside. "How'd you do it?" I asked. But he wouldn't tell me. I don't know to this day how he persuaded that kid to open his eyes.

Another time I was taking photographs of a baby. I wanted him to cry but he wouldn't. I'd make horrible faces at him and he'd chortle and drool and laugh, reaching out a fat pink hand for my nose. Then I'd growl and bark, thinking he might be

scared of dogs. But no, he'd squeal gleefully. So then I put the photographer's black cloth over my head and moaned. The baby clapped. I stuck my head out from under the cloth suddenly and said, *"Boo!"* "Goo," said the baby, grabbing my ear. "He won't do it," I said to the mother, who was sitting behind me, watching. "That's the good-naturedest baby I ever met. He just will *not* cry." "Oh," said the mother, "you mean you want him to cry? Why didn't you say so?" And pulling a large pin from the lapel of her coat, she walked over to the baby and stuck him with it. "Yee-ow!" yelled the baby, and proceeded to bawl his head off. My photographer snapped the picture. "All right?" asked the mother. "Yes," I said, "but you didn't have to——" "Oh, you just don't know how to handle babies, Mr. Rockwell," she said, picking up her son and comforting him. "No," I said, "I guess not."

Once I was making a color sketch of a young woman in bed with the covers tucked under her chin. Noticing two strangely large humps in the covers over her chest, I said: "Betty, take your hands off your chest. They're making humps in the covers." "Those aren't my hands, Mr. Rockwell," said Betty, blushing deeply. "Oh," I said.

June 7: Put sketch of family tree cover into Balopticon (machine for enlarging sketches, photographs, et cetera) and blew it up roughly onto drawing paper. Sketch is 10½ by 11½ inches; but the preliminary charcoal drawing, which is what I am working on now, is 43 by 47 inches. The painting will be the same size as the charcoal.

June 8: Worked on ad. Finished rough blowup of family tree sketch. I keep my spirits up in the midst of dull jobs by working a bit on the family tree each day.

June 9: Same. Ad again. I must have an overdose of mediocrity in me to be able to keep repeating the same old thing—kids—year after year for forty-eight years. I wonder how many kids I've painted in all that time. Thousands, I guess. And I still enjoy it. I got a kick out of painting Billy Paine in 1915 and another out of painting the kid today, 1959. Which makes me a . . . what? I don't know.

Clem brought over the photographs of the models for the family tree cover.

June 10: Spent entire day in darkroom, trying out characters on the family tree cover. I'd put a photograph into the Balopticon, trace the head on the drawing paper, decide it wasn't the right sort of face, take it out, put in another photograph, try that. No. Try another, et cetera, until I got the right character. Then I'd rough in the hair-do (for instance, the braids of the Indian squaw) and the hat, which serve to fix the character in his or her historical period. Then I'd go on to the next character.

Presented the pirate with a wife. After all, the family has to have a mother as well as a father to start with. The pirate didn't have a son all by himself. His wife is a Spanish maiden—dark-haired, demure, aristocratic, with a mantilla on her head— whom he stole off the burning galleon in the background. The villain!

Cut out pirate's son and daughter-in-law. The rake and the barmaid. The picture was too crowded at the bottom. Now the pirate's son is the George Washington colonial planter.

June 11: I eat my words. (As I will many times before I've finished the picture.) I put the rake and the barmaid back on the family tree. The colonial planter couldn't have been the son of the cutthroat pirate. He's too aristocratic, refined. I need a transition generation.

Of course, now I have twenty-three heads to paint instead of twenty-one. But I can't worry about that. The story I'm telling has got to be right.

Still roughing in the characters. It's going to be a pile of fun to take the basic structure of Frank Dolson's face and create the different characters on it. He's got a good face. *Strong*—strong jaw, mouth, nose (the broad bridge is a characteristic which will carry through from the pirate to the modern man very nicely—noticeable, but not obtrusive, so that the pirate's descendants will bear a family resemblance to each other but won't look exactly alike); heavy eyebrows.

And then there are the wives. I'll have fun with them too. The haughty barmaid, the empty-headed doll, the dour squaw, the flamboyant 1890s dance-hall girl, et cetera. All those different characters to create. It makes the hair on the back of my head stand up just thinking about it. I'm that excited.

June 12: Lots of changes. Overflowed with them. What a day! The tree splits above the great-grandson of the pirate—the sea captain—into two branches which, three generations later, are reunited in the modern couple. The sea captain's daughter married a Confederate soldier; his son was a preacher. But, says I to myself this morning at seven o'clock when I arrived in the studio, *but*, it'll make a better story if I drop the sea captain's daughter, give him two sons, and make one a Confederate soldier and the other a Union soldier. Lots of brothers fought against each other in the Civil War. It makes the story more American.

So I did it. But then where was I going to put the preacher? I liked that preacher. All right, says I after I'd roughed in the soldiers, I'll make the preacher the son of the Union soldier. *No!* I'll make him the son-in-law, and the daughter, his wife, will be a tight-lipped, stiff-backed shrew. She'll look like the pirate, like Frank Dolson—a real, domineering, masculine woman, a direct descendant of the male members of the family in personality and features as well as blood. And then I can use myself as the downtrodden cleric. Which is why I had Clem take a photograph of myself in that role. Though I didn't know it at the time. I must be clairvoyant.

I rubbed out the nondescript couple who had been the preacher's son and daughter-in-law and replaced them with the preacher and his indomitable wife.

And that brought me to the next couple up the tree. The slick ne'er-do-well with the waxed mustaches and his fat wife. Somehow they didn't seem right. Too old-fashioned, stereotyped. The dime-novel villain who forecloses on the heroine's farm in an 1890s melodrama. He wasn't real. So I stewed over that until Mary rang the

buzzer calling me in to lunch. And thought about it over lunch, and after lunch, and didn't come up with anything. Which made me think I wasn't so darned clairvoyant after all. Because I hadn't foreseen this problem.

But then I decided to go at it systematically. What kind of son (it has to be a son; I don't want two daughters in a row) would the domineering shrew and the downtrodden preacher have? I asked myself. Well, if she dominated her husband she'd dominate her son. So he'd be somewhat . . . what? A *sissy!* Sort of effeminate, weak. But handsome. And he'd produce a girl, so I'll have to switch the modern couple around, making the woman his daughter and the man the son of the rancher on the other side of the tree.

And when I'd made all these changes the picture looked about a hundred times better. So I congratulated myself and went in to supper.

June 13: Painting of single Boy Scout for cover of new *Boy Scout Handbook.* Had to start it. Deadline. I don't like to let on to be smarter than the next man, but I know one thing: there won't be any deadlines in heaven. I have suffered meeting (and missing) them for forty-six years. A deadline is like a mean-tempered terrier, it won't leave you alone for a minute. You run and hide behind a tree and after a while, thinking you've escaped him, step out and . . . *rowf!* he's got you by the heel. It's the same way with a deadline. You try to forget about it and finally you do. But then you become uneasy about something. What could it be? you think. And all of a sudden you remember the deadline, and it chews away at you so that you can't work, sleep soundly, or digest your meals properly. Indigestion sets in. Goes to the head. Upsets your brains. Brain fever. Coffin. Daisies.

Though I have to admit that I've become pretty casual about deadlines. I've found they can almost always be stretched. Still, they nag; they're troublesome. But, like worms in apples and rattlesnakes in clover, they are a part of life. You have to accept them. At least if you're an illustrator.

I realize now that every so often I will have to interrupt work on the family tree cover to do other jobs. So I'll just skip those days in this diary.

June 14: Early this morning as I was sharpening charcoal in preparation for a day's work on the family tree cover, I happened to glance out my studio window at the ice house, which I've fixed up as a studio for the mural I'm painting for the new Berkshire Life Insurance Company building. Oh, oh, I said to myself, how about the color sketch of the mural? I promised it for this week.

I thought about it for a few minutes and finally decided that I'd better start the color sketch. By lunchtime, much to my surprise, I'd completed the first sketch and it looked pretty good. The color scheme is a bit quaint and old-fashioned. I don't know if it will fit into the modern room where the mural will hang. But still, it's a start.

The mural will show a street scene in Pittsfield around 1860. A block of buildings—a church, stores, offices (among them, the second Berkshire Life building)—with a park at one end. It's a holiday and the street is thronged with people. In

the park Professor So-and-so is conducting a balloon ascension. A brass band is marching up the street. Horses are rearing, children playing tag, et cetera. Behind the buildings are the green hills of Berkshire County.

It's a good subject for a mural. There's lots of activity and color. I get frightened when I think of painting it on a canvas six feet by eighteen feet, but I'll worry about that later.

Afternoon: charcoal of family tree cover. I don't believe I'll finish it up, just transfer the rough charcoal to the canvas and begin painting.

June 18: Worked on family tree all day. Well, it's going fine. I have to admit it. (Just to be safe, I knock on wood as I say this.) Though I didn't think the charcoal would take this long.

The pairs of heads were not evenly spaced. An awful crowd at the bottom. So I cut out the heads, pasted another piece of paper under the charcoal, and tried the heads in different positions, thumbtacking them on. Then, when I'd decided where they should go, I pasted them onto the charcoal in their new positions. That's a trick I learned back in the twenties. The old pro and his bag of tricks.

Made a few small changes. Reorganized the leaves of the tree.

Peter, my youngest son, and his wife Cinny arrived a couple of days ago. He's studying to be a sculptor.

My eldest son, Jerry, lives in San Francisco. He's an artist. His work is modern; not abstract, but definitely modern. I don't always understand it. But it's good.

June 23: I'll certainly finish the charcoal of the family tree cover tomorrow.

June 24: I didn't.

June 25: I wish I could say I'd finished the charcoal. Every day I think I can. But it interests me so much; I keep changing it here and there. Well. I'm improving it. So the time is well spent.

Tried to blow up a galleon for the background out of a book. It looked good in the book but lousy in the picture. I'll have to do it over again.

Changed pirate's son. He was a respectable type. Now he looks as though he drinks too much: bloated cheeks, hair draggling over forehead, pale, pasty complexion (good contrast with swarthy pirate). But he married a proud barmaid and their son became an aristocrat.

After supper while Mary was driving Mrs. Bracknell home (Mrs. Bracknell cooks dinner for us; her Yorkshire pudding is, incidentally, a marvel—soft on the inside, crisp on the outside. She is seventy-six years old, white-haired, pink-cheeked, spry, cheerful, and hasn't, she says, been sick a day in her life. We don't know what we'd do without her.) But as I started to say before I interrupted myself: while Mary was driving Mrs. Bracknell home I returned to the studio for one more look at the picture. It looked, if I do say so myself, who shouldn't, *good*. So I touched it up here

and there, working down from the preacher. And working happily until I arrived at the sea captain, where I bogged down. He wasn't right. Looked too much like a New Englander, a whaling captain from Nantucket. And that's not good, I thought, a New Englander wouldn't have had a Confederate soldier for a son. I've got to locate the fellow more to the south. In Baltimore, say. Then it's probable that one of his sons would have fought for the Confederacy and the other for the Union.

I erased the sea captain. Baltimore, Baltimore, Baltimore, I thought, who lived there in the 1820s, '30s? . . . Who knows? Doctor, lawyer, merchant, thief. Merchant. Businessman. That's it. The son of the George Washington colonial planter might very well have been a Baltimore businessman.

So I sketched in a solid, staid businessman in a beaver top hat, decided I'd solved the problem, and went back into the house, gloating over my success.

June 26: FINISHED CHARCOAL! At last.

Ken Stuart called to tell me that the National Educational Association is awarding me a medal for my cover of the boy graduate. James Conant, Jacques Barzun, Margaret Mead, and several others are to receive medals too. I'm very pleased and proud, though I can't help thinking it's slightly ridiculous. James Conant belabored his brains for two or three years (and what a set of brains, too!) writing a book and then I get the same medal for a *Post* cover. Well.

I told Ken he should get half the medal. After all, he designed the background of the cover: the newspaper headlines screaming disaster on which the figure of the boy is superimposed. That's why the boy is looking bewildered. All these problems, he's thinking, juvenile delinquency, atomic fallout, strikes, Communism; is that the sort of world I'm entering?

June 27: Did master tracing of charcoal. I trace the charcoal onto a piece of tissue paper—that's the master tracing. Then Louie, my man Friday, tacks it over the canvas, inserts carbon paper between it and the canvas, and traces it onto the canvas.

While he is doing his part tomorrow I'll work on an ad for Massachusetts Mutual Insurance Company. Good old efficiency-Edgar, that's me. No time wasted.

June 28: Today a man asked me to do a portrait of his wife. I said no. "I'll pay well," he said. "No, thank you," I said, "I never do portraits."

I gave up formal, paid portraits thirty or forty years ago. (Occasionally I do an informal portrait of a friend.) Just three months, to be exact, after the president and owner of *Delineator* magazine asked me to paint a portrait of his father, a rugged old farmer, gnarled and weather-beaten. "I want it to look just like Father," he said. "Don't change him or flatter him in any way. Paint him in his everyday clothes." "All right," I said innocently. But when I showed him the finished portrait of his father in a work shirt with all the wrinkles and creases in the face and the pouches under the eyes, he hemmed and hawed, walking back and forth in front of it and stroking his

Charcoal sketch for *Saturday Evening Post* cover *Family Tree* (24 October 1959)

chin. "I don't think," he said, "somehow I don't think you've caught the essence of Father." And he launched into a rambling description of his father's spirit. "Deep down," he concluded, "Father is a formal man." I groaned inwardly, for I could see what was coming. "Perhaps," he said, "to catch his essence we should formalize his clothes." And then, letting go, he said, "And don't you think you've emphasized his wrinkles too much? And I don't believe he has such big bags under his eyes," et cetera. So I went home and smoothed out the old man's face and put him in a stiff wing collar and bow tie and slicked down his hair and removed his jowls. Whereupon the son was overjoyed. "You've caught Father's essence exactly," he said. "A beautiful job." . . . I never do formal, paid portraits.

John Singer Sargent once defined a portrait as "a painting of somebody with something wrong with his mouth." That's looking at it from the family's viewpoint. They don't compare the portrait with the subject, they compare it with their conception of the subject, which has been created, like a Frankenstein, out of their own minds. So, naturally, the painter, working (poor benighted fool) only from the subject, never does a satisfactory portrait. "It's nice . . . but don't you think you've missed the sparkle in the eyes?" "It's grand . . . but don't you think you've overemphasized the jaw?" That excruciating, crucifying, tooth-grinding moment—when the family comes to see the portrait.

Leon Gordon, a portrait painter I once knew, used to contrive by devious means to smother the family's objections. When he ushered them into his studio another artist and I would be standing before the portrait. "Two artist friends," he'd say. "Permit me to introduce you. Mrs. Pers——" "*Leon!*" I'd burst out, ignoring the family. "You've got to promise us you won't change it!" "Don't *touch* it!" the other artist would say. "It's a masterpiece!" "Boys, boys," Leon would say gravely, "*please.*" "Ah," I'd say, "Sargent never did a better. Give us your word you won't mess with it. Hunh, Leon, promise?" And we'd praise the portrait to the skies, imploring Leon not to alter it. The poor family never had a chance to get their feet under them; this onslaught of praise *from two artists* bowled them over, left them gasping. They accepted the portrait humbly, without alterations.

June 29: Started the underpainting, which means that I began to paint the picture, using only one color, Mars violet. I define the heads, shaping them with light and shadow, so that when I begin to paint in full color I will be working on rounded, fully realized heads (a cheek doesn't look like a cheek until the shadow of the cheekbone is put on it), instead of the flat shapes of the tracing.

I underpaint in Mars violet because it imparts a richness to the glazes of color which are later placed on top of it. The selection of the underpainting color is determined by the effect and feelings which the artist wants to convey. Titian and Rubens, who wanted a feeling of sensuousness, also used Mars violet, a "warm" color. El Greco used black, which is a "cold" color and gives a harsher or, you might say, more ascetic effect. I use Mars violet because I like to get a feeling of warm humanity in my pictures.

June 30: Underpainted eleven heads today. Which was pretty good considering it was so terribly hot—97° in the shade.

July 1: Nineteen heads done; four to go.

I washed a little color—reds, blues, greens, yellows—over the Mars violet underpainting. Getting color into the top of the picture is going to be a problem. The fancy hats are all at the bottom of the picture; they'll be colorful. But the modern man and woman and their son, the hope of the world, aren't wearing hats. I'll have to give them red hair. And perhaps, by making the leaves of the tree dull green at the bottom and bright green on top, I can balance the picture. I'll do the same with the trunk of the tree—dark roots, light upper branches. It'll be symbolic. In an obscure sort of way. I can't quite figure it out myself.

July 2: Underpainted leaves in flat green. Looks fine. Indian trouble. The squaw is too masculine. And no wonder; I modeled her after a photograph of a Sioux warrior which I found in a book. Tried a pretty Indian maiden. No good. Takes all the gag out of it. Tried Gail, my daughter-in-law, but she doesn't look like an Indian. I'll have to find a photograph of a squaw in a book and work from that.

July 3: As usual I have to contradict myself. In the cold, clear light of morning the green leaves looked cheap, like . . . I don't know, the emerald green of Ireland or something. All wrong. And making them dark green at bottom, light green at top was too realistic. The heads looked as if they were hanging on a real tree. Which confused the issue. The tree is just a prop, a device. It should look like a family tree in an old document. Only the heads are supposed to look real.

So I painted over the green with Mars violet. Still wrong. Fussed with other colors. Finally arrived at a kind of golden brown with green in it or a brown-green with gold in it. I can't quite tell what color it is. There's black in it. And gold, muddy brown, and green. Anyway, it's the right color.

Very tired. I had to stand up all day to paint the leaves.

July 4: A big day on the picture!

This morning Erik Erikson said, "The pirate troubles me. Do you think you ought to start off the family with *him*, a cutthroat, a barbarian?" And then he (Erik, not the pirate) went out, leaving that seed to germinate in my fertile brain. An hour later it was a giant weed. The pirate had to go.

He had been bothering me for quite a while. Several people had remarked, "The pirate? Oh yes. The pirate. I never knew anybody who was descended from a pirate." And they were right. It was ridiculous. American families didn't start with pirates.

So there I was. I've killed off the pirate, I thought, but who shall I put in his place? How about a Pilgrim? No, too early. Figure thirty years between each generation; there are eight generations, that's two hundred and forty years ago; about 1700.

A Puritan. They were going strong in 1700. A dour, gloomy Puritan in a tall hat. That's typically American.

I chewed over that for a while. Finally, "It's right!" I said out loud, startling myself. The Puritan is more reasonable. I don't want to start the family with a vicious criminal. Which is what the pirates were, in spite of later romanticizing. And if I take the romantic approach it's a fake. So I scrubbed the pirate and his stolen bride off the canvas. Then I rubbed out the pirate's galleon and the burning ship.

I'll replace the galleon with the ship which brought the Puritan to this country in 1600 and something, I thought, and the burning ship with the rock-bound coast of New England. It's perfect. Everything fits.

I don't think I'm pollyanna-ing the picture by removing the pirate. With the puritan it's just a better, pleasanter story. That's how most American families started —with immigrants from Europe, not pirates. The pirate was too outlandish.

July 5: Made a charcoal sketch of the Puritan. He still looks better than the pirate. Tomorrow I'll put him on the canvas. With his wife. I figured her out today. A busty, bumptious woman smiling down at him, as if she knows that he's not quite as gloomy and sour as he looks.

The Puritan is not as picturesque as the pirate, but he's more sensible, makes the picture a real family tree, not a put-up job.

I made a few other changes today. Fixed up the Confederate soldier with a new bride—a coy, winsome Southern belle with curly blonde ringlets, instead of the dark-haired girl I had before. Changed the wife of the sissified man (son of the domineering shrew and the downtrodden preacher) from a woman in a Victorian hat to a woman in a 1920s hat. I did this to modernize the couple. Their date should be 1920, not 1890.

Telling a story in a picture isn't as simple as it looks. It's a struggle. At least for me. The original idea has to be refined, perfected. All the parts must fit together, interlock. If one contradicts another the story crumbles. Of course I could have painted my original sketch of the family tree. I doubt if anyone would have objected. But it wouldn't have told the story as well. Each change makes the story more coherent or more interesting. For instance, giving the Baltimore businessman two sons, one a Confederate soldier, the other a Yankee soldier. That (I just realized it) explains why the characters on the left branch of the tree are Western types and those on the right branch are New England types. After the Civil War many Southerners went West to reclaim their fortunes, shattered by defeat. So the son of the Confederate soldier is a frontiersman and his son a rancher. But the Union soldiers had no reason to go West. They hadn't been defeated, their society had not been broken up by the war. So they stayed home. Hence the children and grandchildren of the Union soldier are New England types. It's a minor point but it improves the story.

July 6: Last night when I went to bed I was determined to start the family tree with the Puritan. Oh, it talked big—he represented the immigrants who settled

America; there was the rock-bound coast of New England, the promised land; he was a more sensible beginning than the pirate, et cetera.

But this morning as I was shaving (you know, if I didn't have to shave, my work would go on the rocks) I realized that the Puritan was dull. I didn't want to start the family tree with a gloomy sourpuss. It was sensible, typically American, but dull as an old sneaker. And suddenly I decided to begin the family tree with a jolly, robust, rollicking buccaneer. Maybe he pirated a bit, burned a Spanish galleon or two, but he was a gay dog, not a snarling, vicious criminal like the first pirate. A lusty fellow, like those Dutchmen Frans Hals used to paint.

I ran out to the studio and sketched my merry buccaneer in charcoal. The Puritan's wife, a busty wench, Moll Flanders type, fitted the buccaneer perfectly. So I rejoiced and returned to the house for breakfast.

It took me a good part of the day to get organized. But I made a finished drawing of the buccaneer and his wife and it's good. I mean it. I've solved the problem.

Of course I had to change the background all around, rubbing out the Puritan's ship and the rock-bound coast and putting the galleons back again. But it improves the picture. The rock-bound coast would have been terrible, sitting there above the roots of the tree like an island floating in air.

Very tired. All these changes, these inspirations which turn out not to be inspirations, these decisions and counterdecisions wear me out. I don't know why I have to go through all this just to paint a picture. It's a pretty stupid business. But I don't know any other way to do it. So . . . Well. To bed.

July 7: I figure I'm one of three things: (1) I'm unbelievably untalented but excessively persistent, or (2) I'm unbelievably stupid, or (3) I'm an artist. Right now I lean toward classifications 1 and 2. Because I'm back to the pirate. I've junked the merry buccaneer. And I can just see you shaking your head; my word, you're thinking, how can a man be so confused and still manage to make a living? Well, I admit it. I'm confused. But how——Let it go. I'd better tell you how it happened.

Today is Tuesday, and on Tuesdays my business manager, Chris Schafer, spends the morning in the studio. I'm always somewhat embarrassed that I haven't got further along on the picture since the previous Tuesday. Chris doesn't say anything; he's very nice about it. But still, I'm embarrassed. So this morning I explained all the troubles I'd been having. "I think I've finally got it, though," I ended up. "The jolly buccaneer solves everything. Don't you think so?" "To be honest," said Chris. "Yes?" I asked anxiously. "To be honest," he said, "I don't like the buccaneer. He doesn't look like a seafaring man at all. He looks like one of the three musketeers."

Well, in a minute I saw it too. The buccaneer looked like a French cavalier. Certainly he did not look like an *American* buccaneer, privateer, or pirate. So there I was again. I darn near collapsed. I tried to think of a way out but couldn't clear my head of the Puritans and buccaneers and pirates whirling around in it. Then I decided

Girl with Black Eye, oil painting for *Saturday Evening Post* cover (23 May 1953)

Girl at Mirror, oil painting for *Saturday Evening Post* cover (6 March 1954)

to work on an ad. Maybe if I put the family tree aside for a few days, I thought, I'll be able to think more lucidly about it. So I got out a drawing for an ad and set it on the easel. But it was no use; I couldn't shake the family tree; it hung onto me like a bull-dog and shook me and worried me. I couldn't think about it calmly and I couldn't think about anything else. After lunch at the Marching and Chowder Society (an informal group which lunches together every Tuesday), I couldn't even take my cus-tomary nap. I went out to the studio and thought about it . . . and thought about it . . . and *thought about it,* raising a few limp and tattered ideas from the mudhole of my brain and discarding them as quickly as I raised them. Then I got out the original sketch of the idea. And after I'd looked at it awhile I decided (reluctantly, for it was hard to admit that four or five days of work and struggle had been all for nothing) that the original pirate was the best way to start the family tree. He was picturesque but American. And if I didn't want to found the family on a vicious criminal I could make him more respectable. So I (wearily) made another sketch, removing his snarl and his baleful look and giving him a full beard. And the sketch looked all right. I guess I've got it now.

July 8: I've done it; I've come full circle. Hey ho! I'm back to the original pirate, snarl, viciousness, and all. And I've reunited him with his stolen Spanish maiden. Why, I don't know. It just looks better. Starts the picture off with a bang. It's not sensible, I suppose, but it's exciting and picturesque.

Got a good night's sleep and out to the studio at 7 A.M., cheerful. Decided the full beard made the pirate look like a biblical patriarch. So Captain Kidd has returned. The Puritan was dull; the jolly buccaneer was French; there's no such thing as a respectable pirate. I only wish I'd realized this four days ago.

July 9: Finished the underpainting. Tomorrow I'll work on another color sketch of the mural. Then I'll do a couple of ads. Then I'll start painting the family tree cover.

July 14: Low mood. No fan mail to speak of in a week. I don't exactly *live* on fan mail. I mean I do eat food, drink water, tea, and Coca-Cola. But it's like a vitamin supplement for me. Without it I feel logy, depressed, out of sorts, adrift. I don't know where I stand. Because, aside from occasional visitors to my studio, fan mail is the only contact I have with the people I do covers for. It's the only way I can gauge the reaction to a cover. Good—lots of warm letters. Bad—lots of critical letters. Indiffer-ent (which is, somehow, the most discouraging)—no letters.

I dare say it's not a particularly good way to judge what the public thinks of a cover. After all, they may like a cover and yet not be moved to write me about it. And perhaps I shouldn't be so sensitive to others' opinions of my work anyway. Maybe I should rest secure in my own opinion of a cover. If I think it's good, well, then it's good. If I think it's bad, then it's bad. But I don't work that way. I thrive, or conversely wither, according to the public reaction to my work. Oh, I disagree at times, but I

never consider a cover a success unless it has been favorably received. I'm not, as I think I've said before, a rebel.

And yet I don't cater to anybody, slavishly (and cynically) setting out to "give 'em what they want." I paint what I like to paint. And somehow, for some reason, a good part of the time it coincides with what a lot of people like, it's popular. Which, some (the art critics, for instance) would say, makes me a low type, mediocre, slightly despicable, et cetera. And it may be true (when I'm depressed I think it is). After all, I'm not exactly in the main stream of art in our time. But there's really nothing I can do about it. I paint the way I do because that's the way I'm made. I don't do it for money or fame or any of the other degrading motives which are thought to be the source of popular art. I paint what I do the way I do because that's how I feel about things.

And of course I don't really believe my work is despicable. If I did I'd quit. It's not great. I know that. But still . . . Well, I don't know what I think about my work. One day I think it's bad, the next I'm sure it's good. Sometimes I'm on the fence. But I am always doing it—painting. And that, at bottom, is what really matters. To me, anyway.

July 25: I've been in a stew since the fifteenth. That darned pirate all over again. I got so involved that I forgot about the diary. Every morning I'd wake up wild with enthusiasm. I had it, I'd solved it, there was no longer any problem. But by the end of the day I'd be down in the dumps again. I didn't have it, I hadn't solved it, there was a problem still. Then my brains would feel like a twisted, knotted, soggy ball of yarn, and I'd go to bed discouraged. The next morning I'd jump out of bed, revived, cheerful. Then . . . well, I guess you see how it was.

I have a mercurial temperament—up one minute, down the next. I dare say it comes of working alone. I have only myself to depend on; I can't ask someone else to solve a problem for me (though I'm forever trying to; I'm always soliciting advice), I have to solve it myself. And when I'm stuck, when it looks as if I've failed, I naturally begin to despair. I can't hire someone to paint the picture for me; but I can't paint it; so I'll have to give it up.

The struggle started this time when I decided to jolly up the pirate. (I won't bother you with the voluminous parcel of reasons with which I justified each step.) And then I gave him a wife who, now that I look at her objectively, appeared to be a rummy—her hair mussed, a tipsy smile on her face. By nightfall of the following day the glory of this sketch had worn pretty thin. But the next morning I woke up with *the greatest inspiration the world has ever known!* I was going to give him *two* wives—the tipsy moll and the Spanish maiden. I fooled with that idea for four or five days and finally, cursing myself for a dunderhead, discarded it. Then I made a new charcoal sketch of the original pirate and his Spanish bride, hemmed and hawed awhile over it and, feeling silly, accepted the inevitable and traced it onto the canvas. So I had gone around in a circle again.

I also made several minor changes during this time. I painted the background a new color—warm tan instead of cold gray. I did four sketches of the squaw, finding

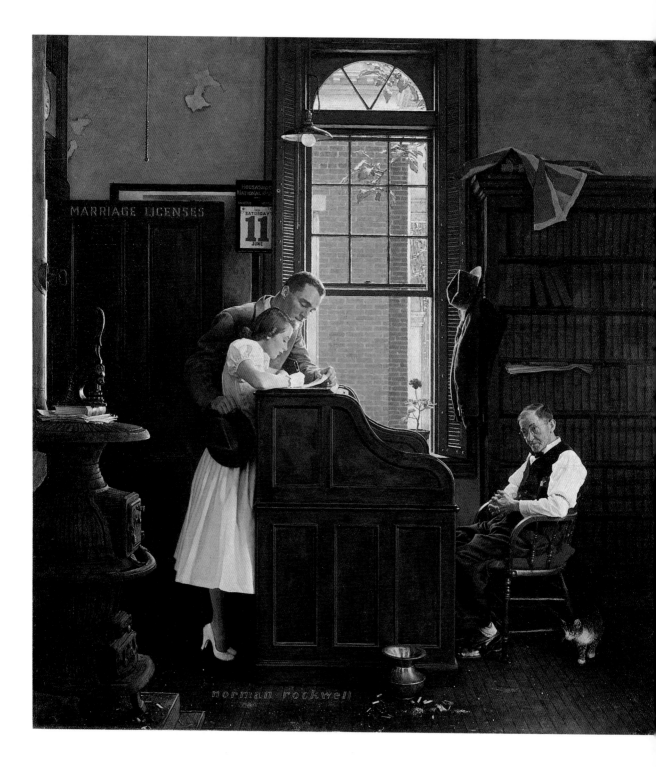

The Marriage License, oil painting for *Saturday Evening Post* cover (11 June 1955)

in the fourth sketch the face I wanted (of the other three sketches, two were too pretty and the third too goofy). I moved the treasure chest slightly to the right because it interfered with the heads and put the initials H.P. on the chest as an acknowledgment of my steal of the galleons from Howard Pyle.

Then I decided that the picture was ready to be painted. That decision endured for a day. *Sic transit gloria mundi.* The next morning the tree looked too realistic. The heads were like apples hanging on an actual tree. So with a dry brush I dragged the background color across it. That made *the whole picture* look slick and commercial. Tearing my hair and moaning, I decided to work the background until it would have the appearance of being a piece of old parchment. Then I'd have the effect of a document, which was what I wanted. I spattered the background with brown, stained it, and painted in trompe l'oeil cracks. When I'd finished, it really looked like a piece of old parchment. But phony, fake, in short, awful.

So the next morning I rubbed dirt on the picture. I went outside, filled a pail with dry dirt mixed with sand, gravel, and twigs, laid the picture on the floor of the studio, and rubbed the dirt into it, shook the dirt off, and rubbed some more in. I rubbed so hard that I very nearly scraped the skin off my hands. Then I sandpapered the picture.

No, I wasn't out of my head, crazy. Or I might have been, but it doesn't matter, because the dirt treatment worked. It gave the background a beautiful texture. Before it had looked like a painted background; now it doesn't.

So I had Louie restretch the canvas (all the rubbing had loosened it), and tomorrow I'll start painting the picture. No, I must do the postage stamp commemorating the fiftieth anniversary of the Boy Scouts and several ads first. Good thing, too. Give me a chance to rest. I'll return to the family tree with gusto, fire, and zest, hot-blooded.

July 30: I don't know. The picture doesn't look so good today. Maybe I'd better blow it up on a smaller canvas, make a beautiful drawing of the tree in Wolff pencil, then do the heads rapidly in color.

No. It's always like this. I start a picture believing it will be a masterpiece. When I'm about half finished I decide it's no good. I'll have to start it over or, better yet, give it up. Then I discipline myself and paint it. Toward the end it improves. But it never quite fulfills the high hopes with which I began it.

I'm just scared to start painting. It's like jumping into an ice-cold bath. I have to nerve myself up to it.

I know how I want to paint it—loosely, with large brush strokes, so it will have a lot of gusto and pep. I'll work fast, try to avoid painting with tiny brush strokes. Otherwise I'll tighten up and carry the heads too far. They'll become stiff, overworked. They'll look dead.

Maybe I'll use large brushes. Then I won't be able to tickle up the heads. Sometimes, just as an experiment, I paint with a brick or half a shingle. You can't be clever or slick with a brick or a shingle. You *have* to paint loosely. And then I've tried

painting with my left hand or half asleep or drunk. Anything so I won't tighten up, anything to break my habit of overworking a head.

July 31: Well, I did it. I started painting this morning. After I'd tidied up the studio, swept the floor, arranged and rearranged my brushes, done everything, in short, to avoid setting to work. And when I finally got down to it I felt like a fifteen-year-old art student beginning the first human head he has ever painted. But I willed myself to it. By noon I was exhausted. Just the nervous strain. It's silly. I don't know how many thousand heads I've painted.

At any rate, I did two heads today: the little boy on top and his father, the modern man. The man looks too dark now. Probably because the other heads are not painted yet, just washed in, and look weak and colorless. I hope so. The man should be dark-complexioned anyway; he's the grandson of an Indian squaw.

I made the little boy a red-haired, freckle-faced kid. I'm going to run the red hair down the right side of the tree to the wife of the Union soldier. She brought red hair into the family and it's stayed there ever since. A small point, but, I think, a good one. Emphasizes that it's a family, that the characters on the tree are related to one another. And it will put color into the top of the picture. That's still a problem. I'm working on that. I gave the boy big, bright blue eyes, put a green bow in the hair of the rancher's wife, and made the 1920s hat green on top and red underneath.

August 1: Painted the rancher, the squaw, and the mother of the little boy. I was lucky with the squaw. I thought I'd have trouble with her.

Tom came in today. Asked me where I start a head—the ear, nose, mouth? "That's not it," I said. "You don't start with the right eye and finish that up before you begin on the rest of the head. You lay in the whole head, go over it all lightly. Then you keep the whole thing moving at the same rate. You paint awhile on an eye, then on the nose, then the cheeks, then the ears, et cetera. That way you get the feeling of the whole head. Otherwise you'll get lost in details and the result won't be a head, it'll be an eye, a nose, cheek, ear, mouth, all jumbled together without any relation to each other."

And then I thought awhile and added, "But I'm trying not to paint the head. I want to *feel* it. I don't paint it, I caress it." Well, Tom thought that was pretty silly. "Caress it?" he asked. "Are you kidding?" "No," I said, "that may be the wrong word for it, but it's as close as I can come. I'm not applying paint. You do that to houses. I'm shaping the head, and I've got to get some feeling into it." "All right," said Tom, and sat down on the window seat.

After a minute he said, "I like it." "Thanks," I said rather dryly. "Seriously," said Tom, "it's going to be a good one." "I guess so," I said, "another *Post* cover." "So?" asked Tom. "Well," I said, "it ain't Picasso by a long shot." "Oh, cut it out," said Tom. "You worrying about being old-fashioned again? You aren't Picasso, so you don't paint like him." "I know, I know," I said, "but still and all I don't like to be called old-fashioned." "You wouldn't worry about it so much if you didn't believe it," said Tom. "It's true," I said, "unfortunately. I'm like the Russian artists. I believe in

things." "Don't bring up those damned Russians again," said Tom. "You agreed their art stank after you'd seen it at the Coliseum." "Sure," I said, "but it's a positive art. Our modern art is to a great extent decadent. But they communicate an idealism. Their art has a constructive viewpoint. At least in terms of their own country. Doesn't a picture of a healthy woman worker do more good than a picture of a woman all broken into pieces or the disordered mind of the artist?" "Who said art has to do good?" asked Tom. "That's just what I mean," I said, getting angry. "Don't artists have an obligation to humanity? The world's falling apart. Does an artist live on an island all by himself? Is his only obligation to express his own insides? Or does he have an obligation to help?" "Well," said Tom. "I think," I said, growing hotter, "and it may be silly—but I think that everybody has a responsibility to everybody else. *I* think that everybody should try to leave the world or one corner of it or one corner of one room a little better than when he was born." "That's nice," said Tom, "but what're you going to do—prohibit modern art? Like the Russians?" "No," I said, cooling down, "I guess not." "You mean you wish people would stop denouncing the way you paint," said Tom. "I suppose so," I said. "But look—and Erik said the same thing a while ago—freedom has become license. There's no discipline any more. There's not enough idealism. We're going after culture, but not as something that would help the country or the world but as something for ourselves, to satisfy our own little cravings." "But you like modern art," Tom said, "at least some of it." "Yes," I said, "but when someone attacks my work in the name of modern art I naturally attack modern art in return." "You're confused," said Tom. "I'm an angry *old* man," I said. And after a while I added, "But I still believe that about having an obligation." "Well, you're sort of right," said Tom, "but you can't force people to paint that way." "No," I said.

August 3: Not much progress today. Fooled around, making small changes. Put the round black bonnet back on the domineering shrew, wrapped a bright red kerchief around the rancher's neck, moved the sea line and the galleons down—there was too much empty space between the sea line and the roots of the tree; it was confusing, looked as if the galleons and the sea were floating in air. I'm going to make the left side of the ground in which the roots are growing a cliff; otherwise it will interfere with the galleon. And I think I'll enlarge the galleons.

Messed with the frontiersman's hat, trying out different colors. After a while I got the right color and a very nice texture. Someone once said that the only way to get texture is to have trouble. You paint a hat, rub it out, paint it again, scrape it, rub it, try five or six different colors and all of a sudden you've get an interesting texture. All the partially removed layers of paint, scraped and rubbed, combine and become texture.

August 4: Painted the pirate's son and the Confederate soldier. Pirate's son robust, red-cheeked, bloated; he sits in dark bars all day drinking. Confederate cold and gray, an aristocrat. Both came out as I wanted them to.

Doing two heads in a day doesn't sound like much, but it exhausts me. Each one is a totally different character. No two can be painted in the same way or with the same feeling. So it's pretty intensive work. And then, when I finish a head and am

The Discovery, oil painting for *Saturday Evening Post* cover (29 December 1956)

The Runaway, oil painting for *Saturday Evening Post* cover (20 September 1958)

about to congratulate myself and be pleased and happy, I look at the picture and groan: sixteen more heads to do, I'm not even half done.

August 6: I did only one head today—the pirate. Not exactly my fault. Every time I'd get into the head, working along nicely, the phone would ring or someone would come into the studio. Interruptions, interruptions, interruptions. Terrible bother. Distracting. Like trying to work in a crowded telephone booth. Though I have to admit that this morning when I started the pirate I wasn't altogether sure what I wanted to do with him. I tried him smiling. No. I tried him with black hair. No. I tried him with blue eyes. No. And so on. Finally I gave him cold gray eyes, brown hair, a patch over one eye, and a red hat trimmed with gold. He's all right, a solid character.

August 7: The pirate's wife and his daughter-in-law. Put a green glaze over the pirate's wife; she's the mystery woman. I don't know if the bright baby blue of the daughter-in-law's bonnet is in good taste, but it certainly sings, it's noisy.

Character is my chief concern when painting a head. I want to create an individual with a definite personality. The pirate's daughter-in-law, for instance. If her head is well painted, people will know that she is a proud hussy, voluptuous (because her head should indicate what her body is like), self-willed, arrogant. Men slap her on the behind and she turns and stares them down, haughtily, but still you know she likes it. Everything about her—the tilt of her chin, her eyes, the expression of her mouth, the way her hair is fixed, the color of her hair and bonnet and complexion— should contribute to the over-all impression.

While painting a head I don't worry about how it fits into the picture as a whole—whether or not it moves the story line along, for example. That I've usually figured out beforehand. I just concentrate on creating a living personality. Of course I don't start with a fixed, immutable idea of the personality. I have a general idea of the kind of person I want to create, and as I paint it changes, evolves. For that reason the people in the charcoal never look exactly like the people in the finished painting.

August 8: The Baltimore businessman and his wife. The staid, stern, substantial citizen and his flippant child bride. It makes a good contrast. I got scared on the wife, tightened up. You can see it. Oh well.

After I'd finished this couple late in the afternoon I swept out my studio and started to wash my brushes at the sink in my studio bathroom. But something was bothering me. My mind wasn't easy. I laid my brushes in the sink and had another look at the picture. The Baltimore businessman and his wife were good. So were the pirate, his son, and their wives. Nothing's wrong, I said to myself, you're just tired. I returned to the bathroom and rubbed the brushes against a cake of soap. Then I rinsed and dried them, still nagged by a sour foreboding. Relax, I said to myself as I arranged the brushes on the shelf of my easel, r-e-l-a-x, the picture's fine. . . . I don't know. It doesn't feel right. I stepped back to look at it, couldn't see anything wrong,

looked at it through my cupped hands, still couldn't see anything wrong, looked at it in the mirror (because that reverses it, giving one a different viewpoint), studied it . . . and discovered what had been bothering me. The George Washington colonial planter. He didn't look like the son of a wastrel and the grandson of a pirate. Too aristocratic. And he didn't have any bounce, he was a weak, colorless character. Damn, I thought, what'll I do? Who can be the son of a wastrel and the father of a businessman? What's the intermediate stage? And he's got to be an interesting character.

Well, I mulled it over all during dinner (and hacked up the leg of lamb because I wasn't paying attention to carving it; which made Peter mad—"Cut me a slice," he kept saying, "I don't want shavings. A *slice*, not dribs and drabs"). And after dinner I returned to the studio and mulled some more. A wastrel and a businessman, I thought, and in between? The son of a wastrel and a proud, voluptuous barmaid. A clerk? A clerk who worked himself up in business? No. He wouldn't be interesting, no bounce. A sea captain? A printer? The clerk's not bad. I could put one of those queer, floppy, velvet hats of the period on him, give him a pale, pinched face, stick a quill pen behind his ear. A deep red velvet hat. And those small oblong spectacles. A miser type. Grubs for money. Neglects his pretty wife.

I made a charcoal sketch of the character and propped it on my print shelf. It looked pretty good. I'll decide whether or not to use it in the morning.

August 9: He's a strange, outlandish character, that miserly scrivener. Maybe he's too unbelievable. But that red cap of his makes a nice spot of color. I'm of two minds about him. But I'll try him. At any rate, he's better than the colonial planter.

I painted the Confederate soldier's wife today. A saucy Southern belle. The ribbon in her hair is gray, the color of the Confederate army uniforms. The ribbon dangling from the bonnet of the Union soldier's wife will be blue, the color of the Union soldiers' uniforms. The blue and the gray. The colors emphasize the story.

I also did the frontiersman today. He looks like a bear. That enormous, scraggly beard of his. He's seen some rough times in the West.

And I titled the picture. Along the limb just above the pirate's son and his wife I lettered: "A Family Tree by Norman Rockwell." I had been wondering where I would sign the picture.

August 12: I had a terrible struggle with the Union soldier and his wife. I couldn't seem to get any character into their faces. The two heads looked like amorphous lumps. Then I became confused, tried silly things—for instance, a bloody bandage around the soldier's head (that, I dare say, because I've had a splitting headache all day). But I plugged away; they began to show some signs of life; and finally they rose from the dead. The soldier robust and healthy; his wife sweet and soft—a pleasant, ordinary couple. The wife has auburn hair. So she didn't bring red hair into the family after all. That device for relating the characters has fallen by the wayside.

The struggle today was typical. I've more or less mastered my technique for

painting a head. That no longer causes trouble. But creating a character. I have to wrestle with that. I've never found an easy way of doing it.

August 13: It was like stepping on the prongs of a rake so that it springs up and cracks you in the mouth. I painted the scrivener and his wife. Good, I thought just before going in to supper, her white headpiece and his red cap go well together; a satisfactory couple. Then after supper, Bad, I thought, he's too preposterous, incredible. I rubbed him out with turpentine.

And now I feel sore all over—my bones ache, my head aches, my mind's logy—just as if I was coming down with the grippe. I suppose I'll have to go back to George Washington. The picture looks dull, dead. Reminds me of a drowned cat. Well. I don't know. Maybe it'll look better in the morning. I doubt it.

August 14: Slow day. Only painted George Washington. His white wig and his wife's white, flouncey headpiece sparkle dully. There's some snap to the couple: that white against the colorful hats of the pirate's son and his wife and the Baltimore businessman and his child bride. But it's an empty, lackluster snap. And the couple doesn't improve the picture any.

August 15: The domineering shrew and the downtrodden preacher. The picture doesn't hold together. Seems as if it isn't a story any more, just a collection of heads dangling from a tree. Some people came in today and didn't understand it. I guess there's nothing to do but finish it up, then decide whether or not to send it down to the *Post*.

August 16: I painted the 1890s dance-hall girl (the wife of the rancher) today and she picked up the whole picture. All of a sudden it looks good again. Her head made all the other heads snap. Everything fell into place. I put a rose behind her ear, blue shadows under her eyes, and gave her scarlet lips and bright blonde hair. She's a dance-hall floozy in a gambling den. Right out of a Western. Tomorrow I'll paint the sissy and his wife. I've decided the sissy will wear a straw hat. With its band of blue cloth around the crown, the hat will give color to the top of the picture.

August 17: The sissy and his bride. At first I felt as if the sissy's head was running away from me. I couldn't seem to do what I wanted with it. But gradually I got control of it again, got it going right.

The picture still looks good. Not as I'd hoped it would when I started; I'm not satisfied; but it's not a flop.

August 18: Touched up the galleons, the roots and leaves of the tree, and the treasure chest. *I'm finished!* IT'S DONE! I hope the *Post* likes it. I'll send it off tomorrow. Gee, what'll I do if they reject it?

Family Tree, oil painting for *Saturday Evening Post* cover (24 October 1959)

I got chicken this afternoon. I always do just before I send off a cover. All that struggle, I thought, and maybe people won't understand it. Or the editors will *think* people won't understand it. Or they'll find fault with the pirate, objecting that they never heard of anyone who was descended from a pirate or that, gosh, they're glad *their* great-great-great-great-great-great-grandfather wasn't a pirate, a low criminal. And the pirate's son. A drunkard. And the dance-hall floozy. What'll I do? I can't let it go like this.

As I was in the midst of these fainthearted thoughts Erik Erikson came in. I told him what was worrying me. "Why don't you change the title to 'Willie's Family Tree?' " he asked. "And letter the name 'Willie' under the little boy on top." "That's it," I said, all excited, "that cuts the ground from under *all* the possible objections. Then it's Willie's fantasy of his ancestors. Every kid wants to be descended from a pirate or a glamorous dance-hall girl. Little Willie imagined the whole thing. If people find fault with the pirate I'll say, "Well, you know, it's a kid's dream. It's not a real family tree." So I changed the title and named Willie.

But at supper doubts assailed me. Everyone had a different opinion of the change in the title. Tom was here. I told him about the change. "You're chicken," he said. "You're scared to stand behind your own work. You're trying to fob it off on Willie." "Yes," I said, "but the pirate." "What *is* the matter with the pirate?" asked Tom. "I never could understand it. Who cares about who their great-great-great-great-great-grandfather was?" "One more great," I said. "Oh nuts," said Tom. "Why don't you send off the picture? It's fine."

I went out to the studio and changed the title back again and rubbed out the name "Willie." The objections to the pirate are bosh and old candles, I thought, I hashed that through all by myself. Twice. The pirate is good. Everybody had a horse thief or two in his family.

But, I thought, supposing Ken objects to the pirate. He might. You never can tell.

So I got scared all over again and began to stew. Then Mary came out to the studio and, recognizing the signs, said, "Norman. Wrap up the picture. You're being silly. Ken and everybody else will love it." "I don't know," I said. "It doesn't feel right. Maybe the Willie bit is better. I don't——" "*Wrap it up!*" said Mary. So I did. And Ernie Hall, who runs the local taxi service, picked it up at ten o'clock. One of his men will drive it down to Philadelphia tomorrow. "Tell the driver not to worry about the car," I said. "If it crashes, let it burn. *Save the picture.*" And then I began to worry about losing the picture. I didn't know whether or not Ken would like it, but I wanted him to see it anyway. I went to bed preparing for the worst. The picture would be burned or someone would kick a hole through it. But if it did get to the *Post*, Ken wouldn't like it.

August 19: I woke up still preparing for the worst. I always do this; I don't like to be surprised by failure.

Couldn't work all morning waiting for Ken Stuart to call. Doubts, worries, sinking feeling in the pit of my stomach, hollow sensation in my head. Looked at a photograph of the picture. Saw fifty ways I could have improved it. Wanted it back. Impossible. Nerved myself for rejection. And . . . and . . . and Ken called. "Hello," I said in a jolly, not-a-care-in-the-world voice. "It's wonderful," said Ken, et cetera, etcetera.

So the family tree cover is finished. And the diary. And here I am right up to the present. Which means that this book is almost finished too.

I suppose that the end of a book calls for some sort of a conclusion, a summing up. The world and Norman Rockwell. My ideas on art and life. But . . . no, I have no concluding thoughts. I'm not much wiser now than I was fifty-five years ago when Amy the Wild Woman chewed on my foot and I howled. I've lived life as it came to me. And now, at this moment, my memories are peculiarly sharp and vivid, for remembering my life and telling about it has been, in a sense, to relive it. There is, too, the almost funereal sense of an END, as if not only the book but my life as well is finished. Yet I'm thinking about my next picture. Seven ads are waiting quietly in a drawer; the canvas for the mural is hanging in the ice house; sketches for seven *Post* covers are lined up on my print shelf. I guess I'd better get to work.

These may be my last words here, but they aren't my LAST WORDS. That noise of hammering you hear is not the undertaker nailing up my coffin, it's me, stretching a canvas for my next picture. I've still got things I want to say. Just yesterday I saw a little girl with a pert, saucy face. She was up a tree. "Yaw, yaw on you," she was yelling at a boy standing beneath the tree. Then, seeing me, "Hello, Mr. Rockwell," she said, smiling and wrinkling up her nose. I want to paint that little girl. No, I'm afraid you're not shut of me yet. (No groans, please.)

I've got pains in my knees and my hair is almost white. I've developed a fondness for afternoon naps. I go to bed early almost every night.

BUT

I get up early every morning. I'm at work by eight. I still play a fair game of badminton.

I no longer believe that I'll bring back the golden age of illustration. I realized a long time ago that I'll never be as good as Rembrandt.

BUT

I think my work is improving. I start each picture with the same high hopes, and if I never seem able to fulfill them I still try my darnedest.

So—long life to you, gentle reader (as they used to say in books) . . . and to me. The daisies still look better from above than from below. Somebody once asked Picasso, "Of all the pictures you've done, which is your favorite?" "The next one," he replied.

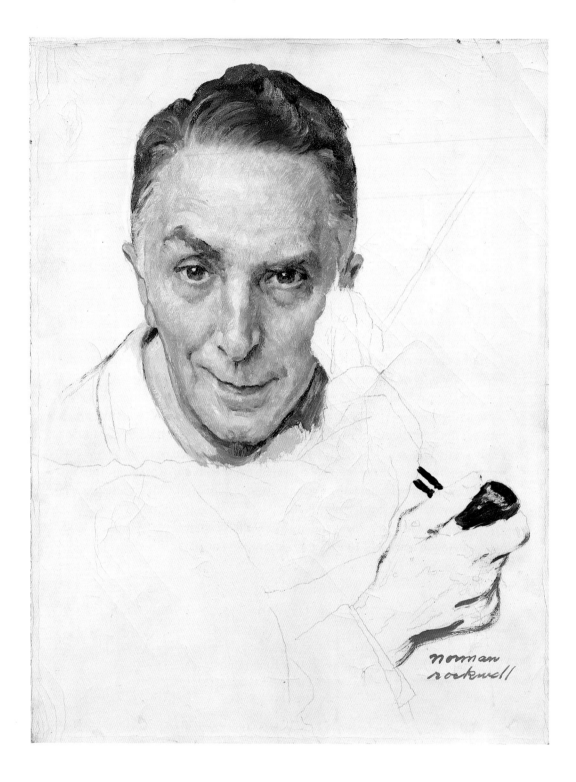

Oil study for *Triple Self-Portrait,* 1959

Afterword

BY TOM ROCKWELL

As I thought about writing this chapter continuing my father's life, I couldn't decide what to call him. One of my two brothers, Jarvis and Peter, or I had started to call him Pop when we were adolescents; I suppose we were trying to establish ourselves by diminishing him with a nickname like that. He never objected—to us, anyway—though once when a friend my younger brother had brought home from prep school started calling him Buster, he complained a little. Now it seems awkward to call him "my father"—or worse, "our father." Perhaps after a while "Pop" will come to have the same special connotations for you that it does for us.

In August 1959, shortly after Pop and I had finished the autobiography, my mother died. After lunch one day, she and Pop had gone upstairs in the house in Stockbridge to nap as usual. Half an hour or so later when Pop woke, Mother was still sleeping. But when he came back into the house from his studio an hour or so later and saw she hadn't come down, he went up to wake her and discovered she had died, probably in her sleep. They had been married twenty-eight years.

Pop didn't stop working. He handled his grief partly by working in spite of it; his work was the structure of his life. He did a portrait of Mother for the dedication page of the book and the "Triple-Self Portrait" for the cover of the first installment in the *Post*. We worked on the *Norman Rockwell Album*, the book on his work which was published shortly after the autobiography. My younger brother, Peter, and his wife, Cinny, had been staying in Stockbridge that summer, and after they left for Phil-

adelphia, where Peter was studying sculpture, my wife, Gail, and I spent time with Pop in Stockbridge. Still it was a difficult time for him, especially since he worked alone in his studio, except for Tuesday mornings when Chris Schafer came to help him with the business side of things, and weekends when Louie Lamone, who stretched canvases and wrapped packages and, later, took photographs for him, was usually there. At one point his therapist, Erik Erikson, who was also a good friend, became so concerned about Pop's depression that he had Pop give him his .22 pistol to keep till Pop felt better. (Later Pop used to joke that Erik had never given the pistol back—but it occurs to me now that Pop never asked for it, either. I think he liked the story better than the pistol; he was never really interested in shooting, though he liked to have antique guns hanging in his studio.)

In the summer of 1960, to get himself out of his studio and improve his work, he and Gail joined a sketch class at Peggy Best's studio in Stockbridge. He continued to work on a mural with the illustrator, Dean Cornwall, for the Berkshire Life Insurance Company in Pittsfield, did some advertisements, and painted his thirty-seventh Boy Scout calendar, his last Four Seasons calendar, three *Post* covers, and portraits of the presidential candidates, Kennedy and Nixon.

Pop used to enjoy painting the presidential candidates, though he didn't particularly like to do portraits and felt he should try to make each candidate look as good as he could and keep his own feelings, political or otherwise, out of the paintings. He genuinely liked Dwight Eisenhower. Sometimes Pop used to write doggerel verses for family celebrations; one from 1956 went,

> Oh, son and daughter at my knee
> A greater wisdom learn from me,
> If o'er the world the storm clouds lower
> Just cast your vote for Eisenhower.

He never said much about Kennedy, though he was moved by his assassination, sharing the feeling of many that his death had cut off a chance for a new idealism. He painted Kennedy twice after his death, first in "A Time for Greatness," standing before the convention that nominated him, and then as the leader of the Peace Corps.

Of Nixon, he used to say he was "very hard to do. I niced him up. That bulbous nose." In a 1971 interview with Richard Reeves of the *New York Times* he said:

> Nixon is no fun to paint. I've done him a number of times. The last time was in 1968 in the Plaza Hotel. I had a corner room—for the good light, you know—and he came down the hall and stopped when he saw two chambermaids. "How are you?" he said to them in his unbelievable voice. He wanted to be President so bad. I never saw a man who wanted it so bad. He said to these two women, "How are they treating you? If they don't treat you well, come down to see me at

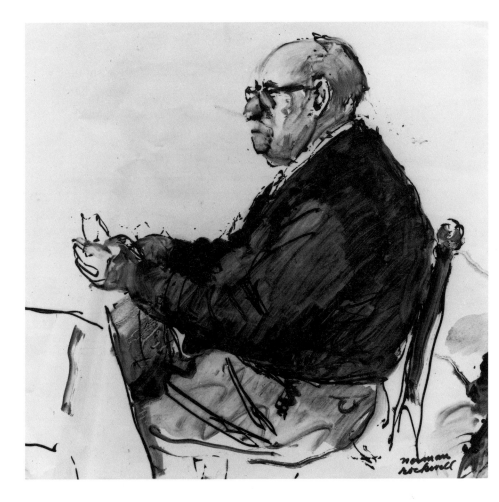

RIGHT:
*Portrait of
a Man Seated*,
ink sketch from
Peggy Best's
sketch class,
c. 1960.

OVERLEAF:
*The Problem We
All Live With*,
oil painting for
an illustration
in *Look*
(14 January 1964)

the White House." I amuse myself by imagining those two cleaning women being treated badly by the Plaza and going down to the White House and trying to see Nixon.

But then a year later when asked by Nan Robertson, another *Times* writer, about that, Pop welched on himself—which was characteristic, because he wanted people to like him: "I don't think I should have said that. He's not Abraham Lincoln—he would have been fascinating to paint—or George Washington, but I wasn't around at the time." Pop told Robertson that Nixon, "isn't awfully easy to paint, but he was cooperative, and I did the best I could." When asked why he wasn't easy to paint, Pop answered, "You take a look at Mr. Nixon and you'll see."

Pop also painted President Johnson, who was "very brusque when I went into his office, and when I asked for an hour to make sketches, he almost hit the ceiling." Johnson, however, was delighted with the resulting portrait: "I took out the wattles under his chin and shortened his ears a little." Later, the artist Peter Hurd painted a portrait of the President that Johnson was reported to have called, "the ugliest thing I ever saw." Hurd told the *Times* that Johnson, "yanked a reproduction of a Rockwell likeness of himself out of a desk drawer after saying icily: 'I'll show you

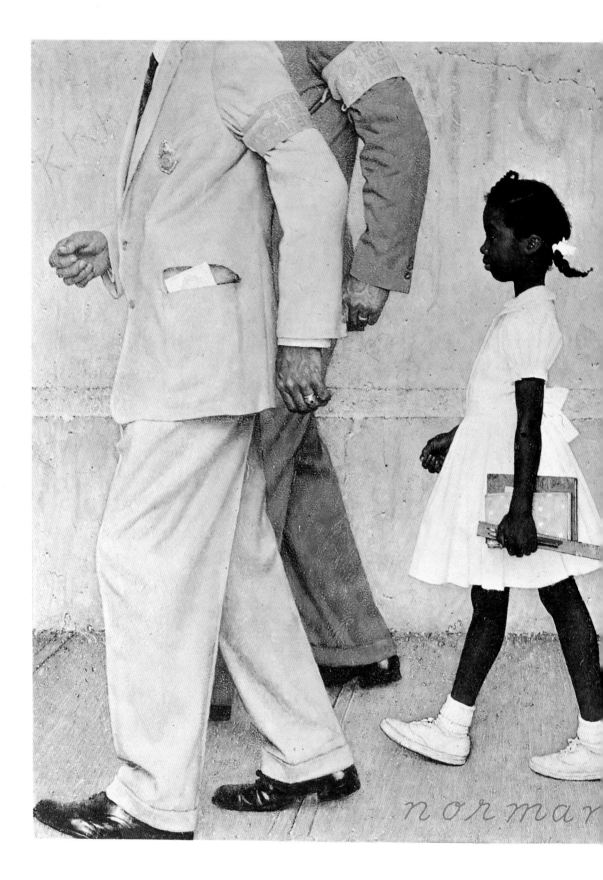
norman

rockwell

what I like.' " As Pop commented, "Hurd, of course, had painted him as he was, while I had done him as he would like to think he is."

I can remember Pop being seriously interested in only two political issues, the Nuclear Test Ban Treaty, in which a lot of people he knew in Stockbridge were involved, especially Tony and Rena Phillip, the young psychologist and his wife who lived in the apartment in the back of Pop's house, and the Civil Rights Movement of the 1960's. He had always felt strongly about tolerance, though it shows only indi-rectly in his *Post* covers and most of his other work, since the cover of the *Post* and most advertising had to be politically neutral—or rather, neutered. There was, of course, "Freedom of Worship" (1943), which is about religious tolerance. Pop always felt it was the best of the Four Freedoms. "Saying Grace" (1951) is really more about tolerance and nostalgia (another favorite theme) than religion, and one of his last *Post* covers was "The Golden Rule" (1961). During the years of the Civil Rights Movement, however, he was able to do paintings for *Look* magazine that dealt directly with the issues. Two more of his verses from 1956 went:

> Tolstoy, Krushef, Dostoievsky, Bulganin,
> Of course shouldn't *all* be blasted by cannon
> So don't lump everyone by sheer rationality,
> According to his or to her nationality
>
> The same thing pertains in regard to color
> If black is the skin of this gal or that feller
> A potato peeler applied to anyone's bottom
> Reveals much the same be he white or Hottototten.

In the spring of 1961 Pop joined a group which met one evening a week to study poetry, which he had tried as a boy—an incident that was left out of the first edition of the autobiography:

> I went up on this hill . . . and it was getting near sunset and I got all excited and I must have had a pencil and paper with me, because I started this poem. I remember the way it started:
>
> > Oh God I thank thee for the sight
> > of sunset from mountain height.
> > To see the glory of the sun
> > descending as the day is done.
>
> And I was going to go on and write the rest but the sun had gone down so fast I couldn't see to write. That was the end of the poem.

One of the group's leaders was Molly Punderson, who had grown up in

*Portrait of
Norman an
Molly Rocku
Walking Pitt
pencil drawi
for Rockwe
Christmas ca
1962*

Stockbridge and then taught literature at Milton Academy outside Boston for many years. It was an unsettled time for Pop. Gail and I were about to have our first child, so Pop knew we weren't going to be able to spend as much time in Stockbridge. He may also have been a little apprehensive about what would be expected of him as a grandfather, probably because of the summer Peter and Cinny and their first baby, Geoffrey, had spent with him. He made a point of telling Gail he had never changed a diaper even for Jarvis or Peter or me. Ben Hibbs, who had been editor of the *Post* since the early 1940's, retired, and the cover of the *Post* was redesigned. Pop did the first cover for the new *Post*, but he knew the *Post*, like most of the other mass circulation magazines, was being hurt by television. Then in September Pop surprised us all by announcing in his usual abrupt way that he and Molly Punderson were getting married. Everyone was pleased, and they were married in October and spent their wedding night at the home of Ken Stuart, the art director of the *Post*, outside Philadel-

phia. I can't help but be reminded of George Horace Lorimer's sending one of his assistants to check out my mother just before she married Pop in 1931, though I think any real connection would have been only in Pop's mind and buried deeply.

Meanwhile the *Post* continued to slide. Ken Stuart left. In the summer of 1962 the editors decided to use mostly portraits or photographs on the covers, and in November Pop and Molly began a series of trips for the *Post*: to India, Moscow and Rome, to Cairo and Yugoslavia. They travelled as a sort of "task force" with Ollie Atkins, the *Post*'s Washington photographer and Robert Sherrod and his wife; Sherrod, who had been with the *Post* during the Hibbs era, was now the editor, and was to write the articles to accompany the portraits. Pop did portraits of Nehru, Nasser, and Tito.

Sherrod remembers that on their trip to New Delhi,

we arrived at the Ashoka Hotel in separate taxis. The first thing I knew, Norman was peeling ten-dollar bills off a thick stack he carried with him, and handing one to every bearer in sight—and Indian hotels had literally hundreds of bearers to spread the work around.

I said, "Norman, you will upset the economy of the country; these bearers don't make ten dollars a month." Said Norman: "No matter. I also tell them there is more where this came from."

"Why, Norman?"

"Because," said Norman, "if there is a fire I know who will be the first one rescued" [Pop was unusually apprehensive about fires since his studio had burned].

The editorial turmoil at the *Post* got worse. Pop had a contract with Heritage Press, which had published his illustrations to Mark Twain's *Tom Sawyer* and *Huckleberry Finn*, to do Benjamin Franklin's *Poor Richard's Almanac*. He was "behind in his work" as he usually was and knew the trips for the *Post* would cause further delay. The editors, who probably realized Pop didn't want to do just portraits, suggested that he illustrate the Bible. The *Post* would use the illustrations in the magazine, Heritage Press would publish them as a book. Pop got excited at first; he was always looking for the "big" picture, an important subject which would help make the pictures he painted of it important, lift them above the level of his ordinary work. On the trip to Cairo he made some rough sketches, and in the lobby of the hotel he noticed an American businessman who he thought would be a wonderful model for Moses, so he took photographs of him in white Arab robes up in the hotel room. But when he asked Helen Macy of Heritage Press about the project, she was not particularly interested and remained adamant about *Poor Richard's Alamanac*. And then Pop realized how much he disliked committing himself to a series of paintings, especially with a subject which was so serious, not to say, solemn. He was always a little uncomfortable or ambivalent about religion. He felt his parents had forced it on him when he was a child and that had turned him away from it after he left home. One can see this

ambivalence in most of his paintings that touch on religion, even "Saying Grace." He never went to church, except for weddings and funerals, even with Molly, who was a regular churchgoer and taught Sunday school. He used to recite, laughing at himself but also very moved, "Abou Ben Adhem," a poem by Leigh Hunt that he had learned in grammar school. Abou Ben Adhem has a vision of an angel with a "book of gold," only to find that he is not listed in it as one "of those who love the Lord," probably, judging by his Arab/Moslem name, because he is not a Christian.

> Abou spoke more low,
> but cheerly still; and said, 'I pray thee then,
> Write me as one that loves his fellow-men.'
>
> The angel wrote, and vanished. The next night
> It came again with a great wakening light,
> And showed the names whom love of God had blessed,
> And lo! Ben Adhem's name led all the rest.

At the *Post* another new editor and art director were appointed. Pop's portrait of Tito was not published, ostensibly because of "technical difficulties" but evidently because one of the powers at the crumbling *Post* had said he'd be damned if he'd have that Communist on the cover. Pop was approached by *McCall's* and *Look* magazines to do work for them. In the late 1940's Pop had had a contract to do editorial work only for the *Post*, and when that contract had lapsed, it had been succeeded by some sort of understanding that he would not do covers for other magazines and would work mostly for the *Post*. But that understanding had been with Ben Hibbs, Bob Fuoss, and Ken Stuart, all of whom had by now left the *Post*. Twice before, in the 1940's, Pop had almost broken with the *Post*, both times because he had felt the editors were interfering with his work, trying to tell him how to paint, asking for lots of niggling little changes—once, even, painting out a horse's head without consulting him (the cover of September 24, 1949)—so that he was losing confidence in himself. But both times the situation had been successfully resolved, much to Pop's relief. Now, after a struggle, he finally wrote to Robert Sherrod, who was no longer editor but editor at large, on June 10, 1963:

> I write this letter only after a lot of thought and consultation with my doctor, Frank Paddock, and my friend, Dr. Howard, who is a psychiatrist on the senior staff of the Riggs Foundation.
>
> I started off this task force operation full of enthusiasm and with a sense of high adventure. On this last trip though, as you know, I was laid up ill at times. I came back completely exhausted, and have not been able since to get back into good working form. My doctors say that at my age I simply should not undertake any more such trips except under very definite conditions. The first is that I should have

time to regain strength and assurance by getting started on my other work, to which, as you know, I am irrevocably committed. The second is that I should know with certainty that no more than one month will be required of me for traveling *and* painting. The third is that I should have a free hand to create my own design after getting the feeling of the country and the person, and assurance that the picture will be used.

In the light of these conditions, the December trip to Moscow, without any further commitments, seems the most possible, and I should be delighted if it could be arranged.

Please, Bob, understand that I very much enjoy working with you personally, and feel sad that I have to put such strict limitations on the part that I can play. It just is a fact of life that I must limit myself. I realize that you will have to get someone else to fill in, and I'm terribly sorry.

This was Pop's way of breaking-without-quite-breaking with the *Post*, for which he had done covers for forty-seven years. The rest of the story can be filled in with the memorandums of Sherrod and his secretary. The first is from Sherrod to Clay Blair, Jr., then editor of the *Post*, dated August 7, 1963, and marked "Urgent":

I told you last week that Norman Rockwell is getting offers from other magazines. He phoned this morning to say that he had decided he wants to free-lance, but he is anxious to have the *Post's* blessing (Norman has a horror of doing anything awkwardly or surreptitiously).

Specifically he has been approached by Herb Mayes of *McCall's* and Dan Mich of *Look*. Both have promised to let him paint anything he wants to, in whatever way he wants to paint it, anywhere in the world. He has told them that he will not do his old *Post*-style covers for them, although *McCall's* has asked him to paint some of his covers for them.

He would still be able to do a portrait now and then for the *Post*. He stands by his promise to do Khrushchev for us and I think we might get him to do others occasionally. He would be available to do the presidential candidates next year if we want him.

I take it that all Norman wants is our approval, and I don't see how we can refuse to let him take on other work—particularly since no contractual agreement exists between him and the *Post*. He will telephone me at three o'clock this afternoon. Do you want me to say "God bless you, Norman" or what?

Evidently, relations soon deteriorated further. Sherrod received the following

letter from his secretary, Pat Brown, two months later while traveling in Canada:

> It was good to talk to you this morning . . . Just after we finished the telephone rang again and it was Mr. Rockwell. He knew that you were out of town but he called me purposely to act as his go-between with you. Isn't he a character? He wanted to tell you that he had severed relations with the *Post* and he didn't know if that would change what he considers to be your friendship. Therefore, by doing it through me, he left you the option of calling him when you get back. He expressed his fondness for you and told me how impossible it had gotten—i.e. Asger [Jerrild, the Art Editor of the *Post*] went up to Stockbridge and spent one whole day telling him how to make the brushstrokes on the Jackie [Kennedy] painting. [This, the last work Pop did for the *Post*, appeared in the October 26, 1963 issue; it is, not surprisingly, a very poor portrait.] Asger told him "not to communicate with Bob Sherrod" because he (Asger) was handling things, etc. etc. Well, I promptly assured him that you understood completely . . . He is doing "some exciting things" for *Look* and *McCall's*, which he will tell you about when he talks to you . . . among them, apparently, trips to Moscow and Ethiopia ("just the sort of thing that Bob and I wanted to do"). And, he says, "they want me to paint the way I paint." Apparently, the boys over at 666 [the editors of the *Post*] wound up pitching him some kind of harebrained scheme about doing the Bible in pictures ("I couldn't work for four straight years without humor at my age, sixty-nine"), when he finished it they were going to publish it in book form—you know, all those grandiose, overblown MJC ideas [Matthew J. Culligan, the president of the Curtis Publishing Company, which published the *Post*.]
> He's a darling!

In 1969 the *Post* suspended publication. When publication was resumed under different ownership in 1971, Pop allowed himself to be photographed with a *Post* newsboy for the cover of the first issue. But when the editors asked him to do some work for the magazine, he wavered. Finally Molly said, "Norman, you *mustn't!*" and so he told the editors, no. If he had really wanted to, of course, he would have, since though he liked to be agreeable, even compliant, he had an iron will where his work was concerned, though it often surfaced only hesitantly and after a struggle with himself.

Molly had more pronounced opinions than Pop, but since he had painted so long from a deeply rooted emotional bias, her influence had very little effect. From the 1971 interview with Richard Reeves:

> "The Marines had me down at Quantico. I was supposed to do a

portrait of a Marine in Vietnam kneeling over to help a wounded villager and love shining in their eyes . . . I thought about it a lot and (Molly) said, 'You can't do that and you know you can't' . . . I don't think we're helping the Vietnamese people lead better lives, do you?"

Looking at his portraits of Richard Nixon and Hubert Humphrey as Presidential candidates in 1968, he says, "I wanted to do one of George Wallace, too—against a black background—but *Look* didn't want it." When someone said his painting of Vice President Agnew for the cover of TV Guide (May 16, 1970) didn't seem to be his style, he answered, "Neither is Mr. Agnew."

His wife, he says, almost stopped talking to him when he agreed to do Agnew. "She's a Radcliffe girl, you know," he said with a chuckle as if that explained everything.

"I'd feel very badly to have his image frozen in the good old times," said Mrs. Rockwell. When they are together and someone asks Rockwell why he wouldn't do something the same way again, she sometimes gives the answer: "It's because you don't feel that way anymore, dear."

uthern Justice, painting for an tration in Look *9 June 1965)*

But a few years later Pop wrote to Top Value about the painting he was doing for the cover of the Top Value Stamp catalog:

I think a cute family dog watching on the floor left side will make the picture more amenable to the catalog format. Public loves family dog in pictures.

P.S. Can the (model for the) bride keep the dress as she is getting married soon?

Pop did one *Post*-style cover for *McCall's* (December 1964), but since both *McCall's* and *Look* almost always used photographs on their covers, most of his work for them was what he used to call "subject pictures." In the *Norman Rockwell Album* (1961), he wrote, "Like a *Post* cover, the subject picture . . . tells a story. But unlike a *Post* cover, it is titled and has a caption. It is usually a quieter picture, lacking the immediate impact of a *Post* cover." Most of his work for *Look* focused on issues or subjects with which the country was enormously concerned at that time: the Civil Rights Movement, the space program, Russian education, the Peace Corps, the War on Poverty, the presidential candidates. He did less work for *McCall's* and it was usually of less timely subjects: "Christmas in Stockbridge," "Spring Flowers."

Pop never felt really secure. He was always afraid of becoming "old hat" and being replaced by the younger illustrators, even though by the late 1960's he had been one of the leading American illustrators for over forty years and probably the most well-known for twenty-five years. He worried that he suddenly wouldn't have enough work, that the interest in his work would fall off, that he'd end up forgotten, as

he felt J. C. Leyendecker had. He hated to turn down any job, even those he didn't particularly want to do. He used to worry a lot about "tightening up" or overworking a painting, and he was always trying different ways to "loosen up." In 1964 he did a painting for *Look* magazine to commemorate the murder of the three civil rights workers in Philadelphia, Mississippi, but the editors decided his sketch had more impact than his finished painting. Pop was a little chagrined; I remember being surprised it didn't bother him more.

A few years ago when my brother Jarvis and I were sorting through some family papers, we found some notes Pop had written at 3:00 A.M. one night, probably in May of 1965. I don't think he did this often; usually he talked about what was bothering him to someone he trusted; however, the notes do give an insight into his struggles with himself.

> If only I can hold onto it. To hell with the magazines, my responsibilities. You [Molly] will help, be with me . . . If only I have the steadfastness and get out of the rust [he probably meant to write: ruts] of fear not a masterpiece and publicity and popularity (cheap) Maybe even no photos Isn't a Peace corps picture the answer. Youthful dedication. Something bigger than yourself. Maybe not art but my only answer, not some magazine or art editor or publicity but of my own free will Have I the steadfastness???? *with you* It isn't just a glorious hollow gesture. Is it? It's late I must do it soon Isn't the Peace Corps the answer. Maybe don't go to them do it on our own. *You and me.* But I mustn't be silly. obligations to commitments family Can I keep it up? . . . doubts, weakness, fear . . . Not the Peace Corps one that allen [Hurlburt, the art editor of *Look*] like but the one I like and believe in. . . . Am I dogging life? *No* . . . anyone I respect would respect *this*.

He still worked seven days a week, though now he took a nap after lunch every day, and whenever he had to go away from Stockbridge he had somebody drive him while he slept in the back seat with a soft old black sock over his eyes. He rarely watched television, but when he did, he usually answered fan mail or tore diaper cloth into paint rags, carefully plucking off the frayed threads all around the six-by-six-inch squares. He would go off to bed about eight thirty but then wake up about eleven and come padding downstairs in his slippers and bathrobe for a cup of tea at the kitchen table with whoever was still up. Then he would take two Seconals and a Miltown to get himself back to sleep.

Pop didn't have a lot of time for his grandchildren because of his work, but he used to enjoy them: Geoffrey, Tom and the twins, Mary and John, Peter's children, whom he saw mostly on his trips to Italy; my children, Barnaby and Abigail; and Jarvis's and Susan's daughter, Daisy. Pop used to contribute to the commotion at the dinner table on Thanksgiving and Christmas, sometimes by reciting rowdy poems— for instance, this one, with these slight changes until the grandchildren were older:

Here's to the American eagle
With feathers so bright and gay.
He soars over Illinois
And poops on I-o-way.

Here's to good old I-o-vay
Mit soil so fertile and rich.
It's needs no turd
from your goldarn bird,
You Illinois son of a bitch!

Once when Barnaby was under the table at Christmas dinner, whacking at everyone's shoes with his new toy sword, Pop surprised all of us (Barnaby most of all) by reaching under and whacking him. Even toward the end of his life Pop enjoyed the plays Abby and Daisy used to put on in the hall between the library and the living room—in which they were sometimes assisted by Barnaby, though he was usually just enough older to be embarrassed, and Tom, who liked all kinds of theatrics and would play even a tree with terrific quaking and bending enthusiasm.

Pop used to like to have the grandchildren visit him in the studio when he was doing something that didn't require all his concentration, like tracing, or painting a part of the picture that wasn't difficult—a background rather than a head, for instance. He once helped Barnaby dress up in the cowboy hat and boots, holster and pistol that hung in the studio, so Barnaby usually did that, just as my brothers and I had dressed up in Pop's costumes when we were young. Daisy or Abby usually drew or read. Or they would sit under the big window and bang their heels against the bottom of the long bench and watch Pop paint until it got boring. He painted slowly, using tiny brush strokes and jumping here and there, seemingly at random, all around the painting in a way I could never figure out when I was young. He did drawings of all the grandchildren but Abby and used several as models. When John Wayne came, ten feet tall and dressed in a cowboy outfit, to be photographed, Pop invited Barnaby and Abby out to the studio. Barnaby loved it, but after about fifteen minutes, Abby, who was five, came back into the house; when we asked her why she hadn't been interested, she said, "Well, if it had been *Julie Andrews*. . . ."

Pop and Molly traveled a lot in connection with his work, and he also began to take vacations two or three times a year. He often did some sketching while on vacation, but Molly said that even with that, he would usually get restless after a week or so and want to get back to the studio. He was quoted in 1971: "I work from fatigue to fatigue . . . at my age there's only so much daylight left."

In 1966 he wrote and illustrated "Willie Is Different, a True Picture Story." Willie, a thrush, devotes "his genius to first singing the simple song of the Thrush followed by cadenzas inspired by his own moods." A spinster, Miss Purdy, "hears his miraculous rendition," and Willie is "recorded, photographed, reported and sculptured." But when he is taken to Washington to a special aviary built just for him, he is

"struck dumb by his strange and grand surroundings. . . . He was a celebrity but he feared the great world. He was a stranger to his own family but he loved and trusted Miss Purdy." And so Miss Purdy takes him back to Stockbridge. "Then very softly he and his true old friend brought to life the songs they had created together." Pop's text is very short, only fourteen pages of his large handwriting, and the literary agent he contacted felt it would have to be expanded, so Molly rewrote the text and it was published in 1967 as *Willie Was Different.*

That same year Pop and some other Stockbridge residents bought a large eighteenth-century Georgian house on the Main Street so that it would not be torn down and replaced by a gas station. They decided to call it the Old Corner House and use it for an exhibit on the history of Stockbridge. When that proved unsuccessful, Pop offered to let them exhibit some of his paintings, and the Old Corner House became the Norman Rockwell Museum at Stockbridge. Today, over 100,000 people visit the Museum every year, and the old house will soon be superseded by a new, modern museum building just outside town.

Though the demand for his work by editors and art directors had never slackened, so that he had always had more work than he could do, Pop was in a sense rediscovered in the early 1970's when a book on his work was published by Harry N. Abrams, Inc., a prestigious art book publisher. Abrams told Richard Reeves of the *Times* that the book came about when he visited an exhibition of Pop's work at the

Bernard Danenberg Galleries in New York in 1968. "On the way, he saw long lines outside the Whitney Museum, waiting for a chance to get into a Wyeth exhibit. There was no one at the Danenberg Galleries, just Rockwell—'It seemed very sad,' Abrams remembers—and the publisher offered to do a book of Rockwell reproductions."

Since Abrams was a very shrewd and successful publisher, one wonders if that was the whole story. In any event, Pop was enormously pleased and flattered and even refused to accept a royalty from Abrams, though after the book had become so successful (the first printing, 57,000 copies, sold out in six weeks and the book is still in print), Pop was persuaded to take a small royalty. Pop was proud of the book, partly because in the introduction, Thomas Buechner, the director of the Brooklyn Museum, looked at Pop's work seriously as a part of the tradition of genre painting and illustration. Pop used to kid himself by saying the book weighed thirteen and a half pounds, wow, a thirteen-and-a-half-pound book all about him and his work! But then when fans began to send him the book to be autographed and he had to carry two or three of them home from the post office, he used to complain ruefully about how much the darn thing weighed.

The Abrams book—and probably the television tour Pop undertook to promote it—vastly increased the interest in his work, partly because it reintroduced his whole remarkable career, spanning six decades from 1912 to 1972, just as public

Dutch Landscape,
pencil sketch,
1960

interest in America's past was deepening. He began to be seen as not just an American illustrator but an American institution. In 1972 the Danenberg Galleries organized a highly successful sixty-year retrospective. The show was exhibited at the Brooklyn Museum and the Corcoran Gallery of Art in Washington, D.C., and other museums around the country. But John Canaday, the art critic for the *New York Times* reviewed it scathingly—which distressed Pop since he had always liked Canaday's articles in the Sunday *Times.* The secondary uses of Pop's work, in books, as prints, and on such products as collector's plates, also increased, and Pop did his first work for the Franklin Mint, which had other artists transfer Pop's drawings to, for instance, sets of medals.

Pop enjoyed being famous, but he couldn't altogether believe it and he used to kid himself about it. When he went abroad, he missed being recognized. Once on a Moscow street a beautiful, red-haired young woman suddenly called out, "Mr. Rockwell." But when she caught up with him, she said, "You must be Miss Pundy's husband!" It was one of Molly's former students from Milton Academy; he hadn't been recognized for himself at all.

Pop and Molly rode their bicycles five or six miles almost every day. Pop still went out to his studio in back of the house seven days a week. In the evenings he often signed prints, either for the museum to sell or for the limited editions which were now being published, as he often said, at prices which were much more than he had received for the original paintings.

But his work had begun to show the effects of age, only occasionally at first and usually just in his painting. His pen and ink portrait of Harry Abrams, done in 1971, is up to his usual standard, but the painting of Audubon, published in *Look* in October of that year, is not. His sense of color was going wrong; sometimes the paintings were too bright, almost garish. He lost his ability to paint close detail, so that ironically the paintings finally look as if he is "loosening up," using larger brushstrokes. Or sometimes the definition between, say, a face and the wall behind it, is too harsh.

In March 1974 at the resort of Little Dix in the Caribbean Pop and Molly went for a bicycle ride, but when Molly got back to the hotel and looked around for Pop, he was nowhere to be seen. She got someone from the hotel to drive her back, and they found Pop sitting beside the road, dazed. He couldn't remember falling, but he evidently had, either accidentally or because of a minor stroke. He seemed to recover, but then in April, back in Stockbridge, he fell off his bicycle again. He was still working, but much more slowly. When he was painting his portrait of John Wayne in 1974, he was distressed that he just couldn't seem to get things right, but then he managed to finish it and send it off. Early in 1975 he and Molly decided that he would be unable to finish a group of portraits he had already begun, and he was told that someone else was to do the next Boy Scout calendar. Some months later an editor had to insist a painting was finished and almost literally take it away from him.

All this distressed him, but my older brother, Jarvis, who was then living in Stockbridge, does not think Pop really understood why it was happening. He continued to work on drawings to be transferred to medals and, sporadically, on a large painting of a Stockbridge subject, John Sergeant and Chief Konkapot. Knowing that he really didn't have enough to do in the studio all day, I suggested—in a letter, since he was also having trouble remembering things—that he do some drawings for another edition of his autobiography. He still seemed able to draw in black and white and his memory for the distant past was good. But he wasn't particularly interested, partly because of his increasing bewilderment; partly, Molly and I felt, because we had made the suggestion, not an editor or publisher. He felt that a picture wasn't really serious unless it was a definite commission. He began to have increasing difficulty walking. In the spring of 1975 my wife, Gail, and I were helping him across a street in Boston, where we had had to go because of a lawsuit against him that was eventually dropped, and he suddenly came out of his rather bewildered preoccupation with his feet and said, "It's a good thing I don't make my living by dancing."

In July of 1976 his last magazine cover appeared on *American Artist*, a painting of himself wrapping a Happy Birthday ribbon around the Liberty Bell for the bicentennial. He was still signing prints, which he enjoyed because he had a lot of the restless drive that had kept him working so hard for so long. He had never managed to save much money and without the income from the prints would probably have been less comfortable during these last years. He was mostly confined to a wheelchair now, and nurses helped Molly care for him. In February 1977 he was awarded the Presidential Medal of Freedom by President Ford. He still occasionally asked to be

taken out to the studio, but then when he got there, couldn't accomplish anything on "John Sergeant and Chief Konkapot" or would forget why he had come. Sometimes he worried what would happen to his studio but seemed reassured when Molly or Jarvis told him it was going to go to the Museum. Even after he was confined to his bedroom, he occasionally asked for paper and pencil and tried to draw. He died on November 8, 1978.

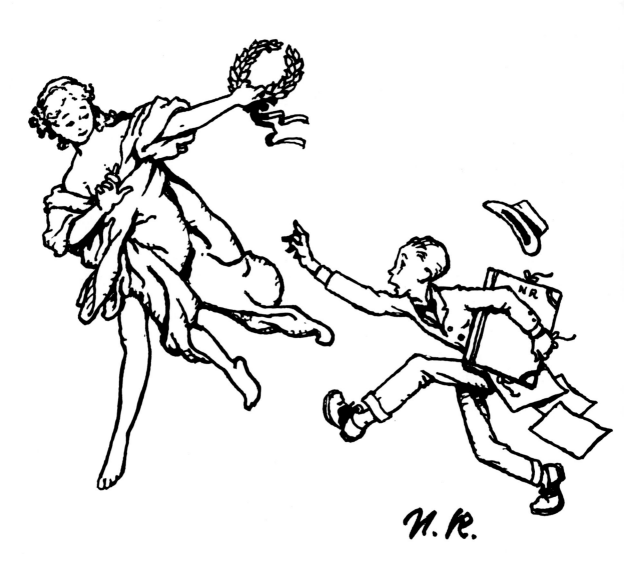

List of Illustrations

Credits